The Egyptian Revival

In this beautifully illustrated and closely argued book, a completely updated and much expanded third edition of his magisterial survey, Professor Curl describes in lively and stimulating prose the numerous revivals of the Egyptian style from Antiquity to the present day, drawing on a wealth of sources. His pioneering and definitive work analyses the remarkable and persistent influence of Ancient Egyptian culture on the West.

The author deftly develops his argument that the civilisation of Ancient Egypt is central, rather than peripheral, to the development of much of Western architecture, art, design, and religion. He charts the persistence of Egyptian motifs in design from Graeco-Roman Antiquity, through the Mediaeval, Baroque, and Neo-Classical periods, and goes on to trace the rise of Egyptology in the nineteenth century, twentieth-century manifestations of Egyptianisms prompted by the discovery of Tutankhamun's tomb, and various aspects of Egyptianising tendencies in the Art Deco style and afterwards.

For students of art, architectural and ancient history, and those interested in Western European culture generally, this book will be an inspiring and invaluable addition to the available literature.

James Stevens Curl, Professor Emeritus, has held Chairs in Architectural History at The Queen's University of Belfast and The School of Architecture, De Montfort University, Leicester. He is the author of many acclaimed books, including *The Oxford Dictionary of Architecture and Landscape Architecture* (2005), *Classical Architecture* (1992 and 2002), and *The Victorian Celebration of Death* (2000 and 2004).

Since what unnumbered year
Hast thou kept watch and ward,
And o'er the buried Land of Fear
So grimly held thy guard?

HENRY HOWARD BROWNELL (1820–72):
The Sphinx, stanza ii, lines 1–4.

Egypt, thou knew'st too well
My heart was to thy rudder tied by th'strings,
And thou shouldst tow me after.
WILLIAM SHAKESPEARE (1564–1616):
Antony and Cleopatra (1606–7), Act III, Scene 9, lines 56–8.

The higher Nilus swells,
The more it promises: as it ebbs, the seedsman
Upon the slime and ooze scatters his grain,
And shortly comes to harvest.
Ibid.: Act II, Scene 7, lines 23–6.

THE EGYPTIAN REVIVAL

Ancient Egypt as the Inspiration
for Design Motifs in the West

JAMES STEVENS CURL

Routledge
Taylor & Francis Group

LONDON AND NEW YORK

First published 2005
by Routledge
2 Park Square, Milton Park, Abingdon, Oxon OX14 4RN

Simultaneously published in the USA and Canada
by Routledge
270 Madison Ave, New York, NY10016

Routledge is an imprint of the Taylor & Francis Group

© 2005 James Stevens Curl
Foreword © Peter A. Clayton

Typeset in Bembo by Peartree Design of Manchester and
Florence Production Ltd, Stoodleigh, Devon
Printed and bound in Great Britain by St Edmundsbury Press,
Bury St Edmunds, Suffolk

British Library Cataloguing in Publication Data
A catalogue record for this book is available from the
British Library

Library of Congress Cataloging in Publication Data

ISBN10: 0–415–36119–2 (hbk)
ISBN10: 0–415–36118–4 (pbk)

ISBN13: 9–78–0–415–36119–4
ISBN13: 9–78–0–415–36118–7

To us in western Europe today the Egypt of the Pharaohs is a strangely remote and lost land. The temples and pyramids, the creeds and cults of the Nile elude our understanding. A modern mind is easily baffled by the apparent confusions and illogicalities of Egyptian religion. For our western world to appreciate the civilization of the Nile is hard – the agricultural way of life instead of an industrialized society, the belief in the king's divinity instead of democracy, the worship of animals and gloating regard for the mummified dead instead of the far more spiritualized faith of Christianity. Factories and machines, swift strides in science and technology, space probes and now the treading of the Moon by astronauts all seem to cut us off from Egypt and its early achievements. Its culture and its gods, we tell ourselves, belong to a past we have long outgrown.

<div align="right">

REGINALD ELDRED WITT (1903–1980):
Isis in the Græco-Roman World
(London: Thames & Hudson Ltd, 1971), 13–14.

</div>

for

Stanisława Dorota

as a token of a decade

te spectem suprema mihi cum venerit hora;
te teneam moriens deficiente manu . . .

Interea, dum Fata sinunt, iungamus amores:
iam veniet tenebris Mors adoperta caput;
iam subrepet iners ætas, neque amare decebit,
dicere nec cano blanditias capite.

<div align="right">

ALBIUS TIBULLUS (*c.*55–19 BC):
Elegies (*c.*27BC), **i**/1, lines 59–60 and 69–72.

</div>

Egypt! from whose all dateless tombs arose
Forgotten Pharaohs from their long repose,
And shook within their pyramids to hear
A new Cambyses thundering in their ear;
While the dark shades of forty ages stood
Like startled giants by Nile's famous flood.

<div align="right">

GEORGE GORDON, 6TH LORD BYRON (1788–1824):
The Age of Bronze (1823), pt. v.

</div>

The mighty pyramids of stone
That wedge-like cleave the desert airs,
When nearer seen, and better known,
Are but gigantic flights of stairs.

<div align="right">

HENRY WADSWORTH LONGFELLOW (1807–82):
The Ladder of St Augustine (1850),
No. 2 from *Flight the First* in *Birds of Passage*, stanza viii.

</div>

She has seen the mystery hid
Under Egypt's pyramid:
By those eyelids pale and close
Now she knows what Rhamses knows.

<div align="right">

ELIZABETH BARRETT BROWNING (1806–61):
Little Mattie (published in *Last Poems* [1862]), stanza ii, lines 9–12

</div>

Contents

A good Memory is the best Monument. Others are subject to Casualty and Time, and we know that the Pyramids themselves doting with age have forgotten the names of their Founders.

THOMAS FULLER (1608–61): *The Holy State,* Book iii (1642): *Of Tombes,* last paragraph, lines 1–4, in the 1647 edition (Cambridge: Roger Daniel).

Chapter III
Further Manifestations with Egyptian Connotations in Europe from the Renaissance to the Beginning of the Eighteenth Century

Chapter IV
Egyptian Elements in Eighteenth-Century Europe to the Time of Piranesi

Chapter V
The Egyptian Revival from the Time of Piranesi until the Napoleonic Campaigns in Egypt

Chapter VI
The Egyptian Revival after the Napoleonic Campaigns in Egypt

List of Illustrations

O'er Egypt's land of Memory floods are level
And they are thine, O Nile — and well thou knowest
That soul-sustaining airs and blasts of evil
And fruits and poisons spring where'er thou flowest.
Beware, O Man — for knowledge must to thee,
Like the great flood to Egypt, ever be.

PERCY BYSSHE SHELLEY (1792–1822):
Sonnet: *To the Nile* (1818), lines 9–14.

Sources for illustrations are given in parentheses in abbreviated form in italics after each caption. Those abbreviations give the publication and/or collection from which the illustration was derived, with the reference-number or shelf-mark where relevant. Publications listed in abbreviated form are given in full in the Select Bibliography. The key to abbreviations in captions is as follows:

AF	*Archivio Fotografico*
ÄM	*Ägyptisches Museum*
BAL	Bridgeman Art Library
BAV	*Biblioteca Apostolica Vaticana*
BL	By permission of The British Library, London
BN	*Cliché Bibliothèque Nationale de France, Paris*
BROWN	Richard BROWN (1842): *Domestic Architecture* . . .
DENON	Baron Dominique Vivant DENON (1802): *Voyage* . . .
Description	COMMISSION des Sciences et Arts d'Égypte (1809–28): *Description de l'Égypte* . . .
DM	Giovanni Battista PIRANESI (1769): *Diverse Maniere* . . .
DTMFCZ-S	*Deutsches Theatermuseum*, Munich: *Clara Ziegler-Stiftung*
GANDY	Joseph Michael GANDY (1805*b*): *The Rural Architect* . . .
GB	Geremy Butler
GG	© Guy Gravett 1978
GIR	Giraudon
GLCL	Guildhall Library, Corporation of London
GLPL	Greater London Photographic Library, London Metropolitan Archives, Corporation of London
GN	Godfrey New Photographics
HA	Cabinet des Estampes, Bibliothèque Nationale, Paris
HOPE	Thomas HOPE (1807): *Household Furniture* . . .
IK	*Inventar-Kennziffer, Deutsches Theatermuseum*, Munich
JRULM	John Rylands University Library of Manchester
JSC	The Author, or from his collection
KuSdZ	*Kupferstichkabinett und Sammlung der Zeichnungen*
LANDI	Gaetano LANDI (1810): *Architectural Decorations* . . .
LEPSIUS	Carl Richard LEPSIUS (1849–59): *Denkmäler* . . .
MAURER	Carl MAURER (1812): Handzeichnungen . . . *(Čaplovičová Knižnica, 02601 Dolny Kubín, Matica Slovenská)*
MaCh	Martin Charles
MC	The Mansell Collection, TimePix, New York

ME	*Museo Egizio, Musei Vaticani,* Rome
MONTFAUCON	Bernard de MONTFAUCON (1719–24): *L'Antiquité* . . .
MV	*Musei Vaticani,* Rome
NMR	Reproduced by permission of English Heritage.National Monuments Record, followed by the NMR photographic reference number.
NORDEN	Frederik Ludvig NORDEN (1757): *Travels* . . .
NORMAND	Louis-Marie NORMAND (1832): *Monumens* . . .
PAC	Peter A. Clayton
RCAHMS	Royal Commission on the Ancient and Historical Monuments of Scotland
RIBA	Royal Institute of British Architects Library
RIBADC	Royal Institute of British Architects Drawings Collection
RPAGMB	Royal Pavilion, Art Gallery, and Museums, Brighton
SAL	Society of Antiquaries of London
SI	Cooper-Hewitt, National Design Museum, Smithsonian Institution. Museum purchase through gift of various donors and from Eleanor G. Hewitt Fund, 1938–88–3950 and 3951
SM	By courtesy of the Trustees of Sir John Soane's Museum, London
SMB	*Staatliche Museen zu Berlin*
TATHAM	Charles Heathcote TATHAM (1826): *Etchings* . . .
THIELE	Carl Friedrich THIELE (1823): *Decorationen* . . . Illustrations by Thiele after Schinkel's originals
TMK	*Theatermuseum des Instituts für Theaterwissenschaft der Universität Köln*
UC	By permission of the Syndics of Cambridge University Library
UGLE	By permission of The United Grand Lodge of England
V & A	Courtesy of the Trustees of the Victoria and Albert Museum, London

Colour Plates

Black-and-White Plates

Figures

Foreword

As northward, from its Nubian springs,
The Nile, for ever new and old,
Among the living and the dead,
Its mighty, mystic stream has rolled;
So, starting from its fountain-head
Under the lotus-leaves of Isis,
From the dead demigods of eld,
Through long, unbroken lines of kings
Its course the sacred art has held,
Unchecked, unchanged by man's devices.

HENRY WADSWORTH LONGFELLOW (1807–82):
The Golden Legend (1851), Part I.

The myth of Ancient Egypt, her myriad gods and goddesses, magnificent monuments and, not least, her enigmatic and (until 1822) undeciphered pictorial script has held sway in the European imagination for over two millennia.

Perhaps the first iconographic contact may be identified in the posthumous portrait of Alexander III (the Great) of Macedon that appeared as the obverse type (head side) on the silver tetradrachms of his erstwhile general, Lysimachus (*c*.355–281 BC). Here Alexander is seen with the ram's horn of the god Amon featured as part of his head-dress (**Colour Plate I**), an allusion to the apparent recognition of Alexander as the god's son when he visited the deity's oracular shrine at the oasis of Siwa in Egypt in 332 BC. From that point, Europe has not looked back. In Antiquity the Egyptian influence reached its height after the defeat of Mark Antony and Cleopatra at the battle of Actium in 31 BC and the entry of Octavian (later the emperor Augustus, 27 BC-AD 14) as conqueror into Alexandria on 1 August 30 BC. It was not long before Egyptian antiquities were making their way to Europe, and even massive obelisks were removed to grace circuses in Rome itself. The rediscovery of some of these obelisks, all tumbled save one (at the Vatican) in Late Antiquity, first by Pope Sixtus V (1585–90) (**Colour Plate II**) and then by other Popes, set a fashion that was not to diminish. The 'traffic' was not all one way as Roman emperors were themselves to appear in the guise of Egyptian pharaohs on temples in Egypt (**Plates 3** and **4**).

From the Middle Ages onwards the challenge of Egypt's mysterious script found many curious attempts at 'cracking the code' and, alongside that, Egypt crept into almost every aspect of European consciousness and art. It was never to disappear, only at times to diminish and then to find a potent revival as concepts changed, not least seen in public architecture and funerary monuments which, even if not

wholly in the Egyptian taste, often fused Egyptian with Classical motifs. In more recent times, the discovery of the tomb of Tutankhamun in 1922 sparked off a widespread European revival, and repercussions of it in smaller vein when objects from the tomb were featured in Paris, and, most potently, in the British Museum in 1972 to mark the fiftieth anniversary of the discovery.

It is all these aspects of Ancient Egypt reflected in taste and style in Europe and America that Professor Curl has drawn superbly together. The value of his study can be immediately recognised and gauged when it is realised that the first edition was more than two decades ago, a second followed in 1994, and now, revised and brought fully up to date, charting the ever-present influence of the Land of the Pharaohs on Europe, comes this third edition. It is to be heartily welcomed and recommended to all with an interest in Ancient Egypt, Egyptology, and Egyptian themes in art, including their influence on so much of our lives in both their physical presence and their place in human consciousness.

PETER A. CLAYTON, FSA:

author of *The Rediscovery of Ancient Egypt: Artists and Travellers in the 19th Century* and *Chronicle of the Pharaohs* (*see* Select Bibliography).

Preface

Δεινοὶ πλέκειν τοι μηχανὰς Αἰγύπτιοι

(Truly at weaving wiles the Egyptians are clever).

ÆSCHYLUS (525–456 BC):
Fragments, Frag. 206 in the *Loeb Classical Library* edition,
translated by HERBERT WEIR SMYTH
(Cambridge, MA: Harvard University Press, 1926).

Introduction

Many architectural styles have been the subjects of studies in recent years.[1] The Gothic Revival has spawned a not inconsiderable literature,[2] for example, and other aspects of Historicism (e.g. Neo-Classicism, the Greek Revival,[3] the Italianate style, the Domestic Revival, and the so-called Queen Anne style[4]) have provided architectural historians with rich quarries from which to fashion their studies. There have also been forays into exoticism and the influence of the East on Western taste with studies of *Chinoiserie*[5] and the craze for 'Hindoo' or Indian styles.[6] Curiously, despite its widespread manifestations and longevity, the Egyptian Revival did not receive the attention it deserved until relatively recent times, when there was a tremendous surge of interest, further prompted by several important exhibitions and the publication of various books and papers.[7] This study will attempt to outline the history of that Revival, tracing its origins in Antiquity, and chronicling its oddly stubborn and surprising persistence throughout the centuries.

It is a commonly held belief that the Egyptian Revival was a short-lived aberration in a period of eclectic revivals following the Napoleonic Campaigns in Egypt (1798–1801). Whilst it is true that there was indeed a marked increase of interest in the architecture and art of Ancient Egypt in the first decades of the nineteenth century (sparked partly by French publications, and partly by a desire in both England and France to allude to naval and military successes in Egypt and Egyptian waters), the history of the Revival spans a much greater swathe of time, and leads the student from the present age back to the

1 CROOK (1987).
2 *See*, for example, BROOKS (1999), EASTLAKE (1970), GERMANN (1972), MACAULAY (1975), and MCCARTHY (1987).
3 CROOK (1972).
4 GIROUARD (1977).
5 HONOUR (1961).
6 CONNER (1979).
7 *See* for example, CARROTT (1978), CLAYTON (1982), CONNER (*Ed.*) (1983), CURL (1994*a*), HUMBERT (1989*a*, 1998), HUMBERT (*Ed.*) (1996), HUMBERT, PANTAZZI, and ZIEGLER (*Eds*) (1994), SIEVERNICH and BUDDE (*Eds*) (1989), and other works cited in the Select Bibliography.

centuries that saw the rise of Hellenistic culture in the lands of the pharaohs and in those of Asia Minor.

The singular importance of the Alexandrian cults within the Roman Empire has been noted by many distinguished historians.[8] No student of Taste acquainted with the great collections of antiquities in European museums (especially those of Rome itself) can fail to be aware of and impressed by the immense amount of material with an Egyptian flavour that survives today,[9] although that must represent only part of what must have existed in the first three or four centuries of our era. Whilst many Egyptian antiquities first arrived in Europe because they were associated with the growing cults of the Nilotic deities, that was not the only reason why they were so prized. By Cicero's time (106–43 BC) many fabulous villas[10] had been built in the landscape around the Bay of Naples, and several sumptuous interiors were decorated with mural paintings, some showing Nilotic landscapes, Isiac ceremonies, and Egyptian Mysteries. However, it would be dangerous to assume that such interior décor meant the fortunate owners of such villas were devotees of Isis, Serapis, or Nilotic religions, for Roman Egyptomania had a secular side, an equivalent, perhaps, of the eighteenth-century European fascination for *Chinoiserie*. Like Cathay to the gentry of Rococo Europe,[11] Egypt was exotic to Romans of the Late Republic, but perhaps a more accurate comparison would be that of India in relation to late eighteenth- and nineteenth-century Britain,[12] for Egypt lay within Rome's sphere of influence, and was to become part of the Roman Empire after Octavian's victories in 30 BC.

Certainly, by the first century BC, Egypt, and allusions to Egypt, were implied in Roman art, and symbols and attributes connected with Egyptian cults were depicted to suggest things Nilotic and exotic without being in any way associated with worship or religious devotions. Some scholars have pointed out that not all inhabitants or owners of villas in which Isiac symbols were used decoratively could have been adherents of that religion themselves, just as those who lived in or owned houses in which Bacchic motifs decorated the walls were not necessarily devoted to Bacchus/Dionysus[13] any more than a Georgian gentleman, whose dwelling contained rooms featuring

8 For example DUNAND (1973, 1979), ENGELMANN (1975), GRANDJEAN (1975), HORNBOSTEL (1973), KATER-SIBBES and VERMASEREN (1975), LECLANT (1969), ROULLET (1972), TAKÁCS (1995), TRAN TAM TINH (1971, 1972, 1973), DE VOS (1980), and many others listed in the Select Bibliography.
9 *See* ROULLET (1972).
10 ARMS (1970), vii.
11 HONOUR (1961).
12 CONNER (1979), 113–53.
13 SCHEFOLD (1952), 58.

pagodas, magots,[14] bamboo, and other motifs associated with China, would have been a follower of Confucius or The Buddha.

After the battle of Actium (31 BC) and the incorporation of Egypt as a province within the Roman Empire, Nilotic motifs in Roman decorative schemes became more common. In the *Aula Isiaca*, a room in the imperial palace on the Palatine in Rome, the décor was Egyptianising Roman work, featuring Egyptian motifs such as the *atef* crown, the sun-disc, *uræi*, lotuses, and so on,[15] but it should be remembered that Augustus (64 BC–AD 14, Emperor effectively from 27 BC), distrusted 'oriental' cults, so the Egyptianising themes were probably more associated with the absorption of Egypt than with any religious or quasi-religious rites. After all, the Romans, and Augustus in particular (**Plate 3**), were conquerors of Egypt and thus heirs of Egypt and all its rich associations.

Many Ancient Egyptian objects, such as obelisks, were also brought to Europe partly because they demonstrated that Egypt had been subdued by Rome, and partly because they were admired for their æsthetic, monumental, mysterious, and exotic qualities.[16] It should be remembered that obelisks were foreign to Græco-Roman art and architecture, so the importation of Egyptian obelisks and their re-erection in Rome by order of Augustus was clearly a political act. Obelisks, set up and newly adorned with inscriptions in Latin, visibly alluded to Roman conquest and the Emperor's claims to power. Once obelisks (and other Egyptian artefacts such as lions and sphinxes) had been placed in the Roman context they became familiar objects, and took on new associations. Obelisks were erected in other cities besides Rome, so gradually they became part of the language of Classical architecture and decoration. Egypt had entered the Roman public landscape.[17]

It would seem that the cult of Isis was brought to Campania[18] from Delos, which was an important point of connection between Italy and Alexandria,[19] and by the first century BC was well established. The Roman tendency to absorb ideas created an eclecticism in many fields, not least in religion, architecture, and decoration: this assimilation of foreign intellectual and cultural themes after the defeat of Antony and Cleopatra and the consequent annexation of Egypt encouraged the cults of Isis and Serapis, and by the middle of the first century AD they were

14 Small grotesque figures of porcelain, ivory, etc.
15 ROULLET (1972), 47.
16 *See* HABACHI (1978, 1984) and IVERSEN (1968).
17 TAKÁCS (1995), 80.
18 The region of west central Italy bounded by the Apennines, the Sorrentine peninsula, and the River Liris (now Garigliano).
19 TRAN TAM TINH (1964 and 1972), MALAISE (1972*a* and *b* and 1984), and DEWANDEL (1941/2).

firmly established in the Roman pantheon. Isis's cult was advanced to the status of *sacrum publicum*[20] and was granted a site in the *Campus Martius* which eventually became the huge *Isæum Campense*. As certain Roman emperors began to adopt the ruling styles of the Ptolemies, Isis and Serapis increased in importance, eventually becoming imperial deities.

With Publius Ælius Hadrianus (Emperor Hadrian [reigned AD 117–38]), Egypt played a more important rôle in the Roman Empire, and it shows in the many Egyptianising artefacts of that time that have survived. Hadrian was genuinely interested in Egypt,[21] although his intellectual curiosity was fired initially by his philhellenism. It should be remembered that to the second-century Roman, Alexandria was the place where the books, ideas, knowledge, and treasures of the cultural past still existed and could be studied, much as, to the early Renaissance mind, Constantinople was the city where Classical civilisation was still alive and could be rediscovered anew.[22] Hadrian's[23] great complex at Tibur (the *Villa Adriana* at Tivoli) was a mnemonic of much, but it was especially a mnemonic of Alexandria and of Græco-Egyptian culture. The deification and Egyptianisation of Hadrian's companion, Antinoüs (*c*. AD 110–130), after the latter's death by drowning in the Nile, identified the Bithynian youth with Osiris, and, through his cult, helped to promote an Egyptianisation of taste throughout the Empire. Hadrian's interest in things Egyptian created a vogue for collecting Egyptian *objets d'art* or artefacts made in the Egyptian style[24] among the population as a whole, and stimulated a second-century Egyptomania as remarkable as was that of the early nineteenth century.[25]

Thus the worship of Isis, of Serapis, and of other gods and goddesses, together with an undoubted fashion for collecting Egyptian ornaments, statues, and other things, ensured not only a steady export of Egyptian antiquities to the cities of the Roman Empire, but that such antiquities would be copied by artisans working in Europe. Egyptian forms, such as the statues of deities, obelisks, lions, sphinxes, pyramids, and so on, entered into the language of Roman imperial architecture and decoration to an extent that was largely unacknowledged until nineteenth- and twentieth-century scholarship[26] redressed the balance. It should be remembered that, after the decline of the Empire in the West, many such Egyptian or Egyptianising motifs ceased to be

20 An officially recognised cult permitted to have its ceremonies in Rome.
21 BIRLEY (1997).
22 TAKÁCS (1995), 105.
23 BOATWRIGHT (1987) and HANNESTAD (1988).
24 Throughout, objects made to look like Egyptian artefacts, but manufactured outside Egypt, will be referred to as 'Egyptianising'.
25 VERMASEREN (*Ed.*) (1981). *See also* VIDMAN (1970).
26 *See* Select Bibliography.

recognised as having Egyptian connotations at all, so that by the time artists of the Middle Ages saw them, their origins were obscure, to say the least. Only with the Renaissance did large numbers of antiquities with an Egyptian ancestry reappear to be exhibited with other Classical objects in the collections of the period. They were greatly prized, for the appreciation of ancient works of art grew apace at that time, and attempts were made to decipher the mysterious hieroglyphs, which nobody in Western Europe could read any more.[27]

It is clear that Egyptian elements were of immense importance during the Roman Empire.[28] The many obelisks that grace the squares and open spaces of Rome itself, for example, provide evidence of the esteem in which these Egyptian objects were held in imperial times (although they have only stood on their present sites from the Renaissance and Baroque periods).[29] The collections of Egyptian pieces and of Roman works in the Egyptian style in the Vatican and Capitoline Museums indicate how widespread were such objects during the Roman Empire, and study of the literature dealing with the sites where ancient artefacts were discovered reveals that Egyptian cults had a powerful influence in imperial Rome. Many of the most spectacular discoveries were made on or near the sites of Isiac temples.[30] Some statuary, such as that depicting the god Bes, or the representations of the 'many-breasted' Diana (or Artemis) of Ephesus, startle with their bizarre Asiatic imagery. We are often brought up to consider Ancient Rome in the light of a pure Classicism, but such a view is unbalanced because the Rome of the Emperors was embellished with many items from Egypt and elsewhere, and in matters of art and architecture the motifs used became more and more eclectic, drawn from every corner of the Empire.

The impact of Egypt on Renaissance art was very considerable, and some notion of the interest generated by Egyptian and Egyptianising objects may be gained by a study of collections of drawings (notably the *Codex Ursinianus* in the *Biblioteca Vaticana* in Rome and the *Codex Pighianus* [drawings by Stephanus Vinandus Pighius (1520–1604)] in the *Staatsbibliothek* in Berlin), whilst statuary from Hadrian's Villa at Tivoli, especially the Egyptianising *telamones* now in the *Sala a Croce Greca* in the *Museo Vaticano*, provided inspiration for many artists, including Raphael (Raffaello Sanzio [1483–1520]) and Giulio Romano (*c*.1499–1546).[31]

27 *See* REYNOLDS (*Ed.*) (1989), Chapters III, IV, V, VI, VII, and VIII.
28 For example ROULLET (1972), HORNBOSTEL (1973), and the series *Études Préliminaires aux Religions Orientales dans l'Empire Romain*.
29 IVERSEN (1968).
30 *See* ROULLET (1972), *passim*.
31 PEVSNER and LANG (1956).

The threads of Egyptian influences that run through Western European civilisation are many and varied. The continuity of an Egyptian religion and the revival of the Hermetic Tradition have been admirably chronicled by Dr Frances Yates (1899–1981), Dr Reginald Eldred Witt (1903–80), Theodor Hopfner (1886–1946), M. Münster, N. Martin Persson Nilsson (1874–1967), and others. Particularly interesting in the illumination of the Marian *cultus* and its connections with Antiquity are the works of Theodor Trede (1833–after 1889), Serafino Montorio (d. 1729), St Alfonso Maria de' Liguori (1696–1787), and Hippolytus Marraccius (Ippolito Marracci [1604–75]).[32] Dr Witt's magisterial *Isis in the Græco-Roman World*[33] covers the early influence of Egyptian cults with enviable erudition and style, and is especially useful for its sources: it draws attention to the persistence of an Egyptianising religion, and has reminded us of the antiquity of elements in Christian liturgies and beliefs that connect our own European civilisation with something infinitely older that developed by the banks of the Nile.[34]

Anne Roullet's *Egyptian and Egyptianizing Monuments of Imperial Rome*[35] records systematically in a *Catalogue Raisonné* those objects that once adorned the capital of the Western world, and is essential reading for those who wish to pursue the subject. Scholars including Adolf Rusch (born 1883), Pierre Saintyves (1870–1935), Frances Yates, Carlos Sommervogel (1834–1902), and René Taylor have discussed the importance of the Hermetic Tradition, especially in relation to the period of the Counter-Reformation.[36] The significance attached to Hermetic philosophy by Renaissance thinkers is now generally recognised, and Dr Frances Yates has shed light on the byways of sixteenth- and seventeenth-century intellectual life in her *Giordano Bruno and the Hermetic Tradition* and *The Rosicrucian Enlightenment*.[37] The Hermetic-Egyptianising elements that recurred from the Renaissance period in writings and in illustrations produced an iconography becoming more overtly Egyptian after the triumph of the Counter Reformation in Central and Southern Europe. A list for further reading is included in the Select Bibliography which, though extensive, is by no means exhaustive. However, the general reader should find there sufficient material to facilitate further pursuit of aspects discussed in the text. Eighteenth- and early nineteenth-century stage-design, for example, is a subject in itself, and can only be touched on by selected pictures and descriptions.

32 *See* Select Bibliography.
33 WITT (1971).
34 *Ibid., passim.*
35 Published by Brill of Leiden in 1972, it is the most thorough investigation of Egyptian and Egyptianising objects known to have existed in Rome at one time or another, and is an indispensable work for any student of the subject.
36 *See* Select Bibliography.
37 *See* list of works under YATES in the Select Bibliography.

As far as scope is concerned, this book will discuss the Egyptian Revival in Western Europe within the last two millennia, but will not dwell in detail on the history of the Revival in America, which has been admirably covered by the late Professor Richard G. Carrott in his *The Egyptian Revival. Its Sources, Monuments, and Meaning. 1808–1858*.[38] In certain instances there will be an inevitable overlap as sources are identical. The courteous help given by Professor Carrott is here acknowledged.

Coherent and consistent threads run through the story of the Egyptian Revival from Classical times to the present day and this is an attempt to trace them and to demonstrate the manifestations of Egyptian art, architecture, and forms in the West. All the known examples will not be named, for this is not a catalogue. Furthermore, the work is not concerned with the wider aspects of social conditions of each period covered. Economic considerations preclude the inclusion of illustrations of every item mentioned: it is hoped that the pictures finally selected will serve to enhance and explain points in the text.

The Argument

This study begins with an outline of how important aspects of Egyptian religion were absorbed into Græco-Roman culture and later into European civilisation as a whole. Early manifestations of a vogue for Egyptian objects from the time of the Roman Empire will be discussed, together with descriptions of the most important forms and images associated with the Nilotic religions. The interpretation of Egyptianising objects during the proto-Renaissance of the thirteenth century in Italy will be mentioned, especially in relation to Cosmati[39] sphinxes and lions. The rediscovery of Egyptian and Egyptianising[40] motifs in the Renaissance period will be described, together with the great interest in Hermes Trismegistus and the mysteries of Nilotic culture that developed in the time of the Humanists.[41] The significance of sixteenth- and seventeenth-century attitudes to occultism, alchemy,

38 CARROTT (1978).
39 Roman workers of marble in the twelfth and thirteenth centuries were known as the *Cosmati*, from the name *Cosma*, or *Cosmas*, which recurs in families of craftsmen working with the material at the time.
40 *See* footnote 24.
41 Term much used but rarely explained. It can mean **1.** belief in the mere humanity of Christ; **2.** devotion to human interests, or the character and quality of being human; **3.** system of thought concerned with purely human (rather than divine or supernatural) interests; **4.** devotion to the study of Græco-Roman languages, antiquities, and literature that came into vogue during the Renaissance; **5.** pragmatic devotion to studies promoting human culture, putting human interests and the mind of humans first, rejecting beliefs in the supernatural or in deities. In art-history terms, **4** is the usual meaning.

and the Hermetic Tradition will be outlined. The richness of Marian symbolism clearly owes much to that associated with the Egyptian goddess Isis. Apparently Baroque inventions, like the celebrated *Honigschlecker*[42] on the altar of St Bernhard in the basilica of Neu-Birnau[43] on the northern shore of Lake Constance (the *Bodensee*) in Germany, are similar to Græco-Roman images of Egyptianising deities such as Harpocrates to be found in many European collections. Egyptianising elements in the works of Robert Fludd (1574–1637), Athanasius Kircher (1602–80), Michael Maier (1569–1622), Free-masonic writers,[44] and in iconography will be mentioned. The use of Egyptian forms within the Rococo and Neo-Classical periods will be sketched in, while the importance of archæological and scholarly correctness after Egyptian buildings and artefacts had been studied in detail and published will be stressed.

An acquaintance with funerary architecture cannot leave the Egyptian Revival unnoted, for many mausolea, catacombs, cemetery gates and lodges, and designs for tombs owed much to the style.[45] Even the pyramidal form of funerary monument that will be familiar from the time of Giovanni Lorenzo Bernini (1598–1680) owes its origins to Egyptian prototypes.[46] Egyptian motifs in art and architecture were favoured in Renaissance designs: Raphael used Egyptianising figures, whilst sphinxes and obelisks were commonly found in doorcases and in funerary architecture.[47] Egyptian elements recur during the sixteenth and seventeenth centuries, but the rediscovery of Egyptian architecture, correctly observed (as in the case of the architecture of Ancient Greece), dates from the eighteenth and (especially) nineteenth centuries. Yet even before an archæological approach was adopted, Giovanni Battista Piranesi (1720–78) had a complete Egyptianising interior built in Rome as a *capriccio*.[48] The French Academy in Rome produced architects of genius who used Egyptian forms in exotic combinations, with a severe Classicism (much inflated in scale), and their works abound with references to pyramids, obelisks, sphinxes, Egyptian cornices, columns, and details.[49]

The Egyptian Revival in the last two centuries of our era[50] was an international movement, and was part of the final phase of Romantic

42 Honey-sucker. A *putto* licking his fingers.
43 *See* BOURKE (1961), 124–5 and 263. It was by Josef Anton Feuchtmayr (1696–1770).
44 *See* CURL (2002*b*).
45 CURL (2002*c*).
46 REYNOLDS (*Ed.*) (1989), Chapter III.
47 *Ibid.*
48 Illustrated in PIRANESI (1769).
49 ACADEMIE DE FRANCE À ROME (1976), ACADÉMIE DES BEAUX-ARTS (1787–96. 1806, and 1818–34), and ROSENAU (1953, 1960, and 1976).
50 That is, within the last two hundred years.

Neo-Classicism.[51] The æsthetic ideals of Neo-Classicism tended to strive for greater simplicity, grandeur, and massiveness, first by returning to the architecture of Ancient Greece, especially the Doric Order,[52] and then going back even further to the buildings of Ancient Egypt, just as, in the Gothic Revival, the first style to be resurrected was late Perpendicular, then Second Pointed, then Middle and First Pointed, and finally a synthesis of many styles.[53] Many designers working with Neo-Classical forms became fascinated by the problems of designing for commemoration (possibly the purest type of architecture as there is no problem of daily and changing use with which to contend). The 'visionary' architects of eighteenth-century France[54] employed simple geometry, huge blank walls to emphasise the terror and finality of death, and Egyptianising motifs for their schemes for cemeteries, mausolea, cenotaphs, and memorials.[55] The Egyptian Revival from the eighteenth century was partially associated with a funerary tradition and with the search for what Étienne-Louis Boullée (1728–99)[56] called *architecture parlante* (architecture expressive of its purpose, capable of arousing a powerful emotional response in all who beheld it). It was also important in the search for an architectural expression of the Sublime (the eighteenth-century æsthetic category associated with terror, power, vastness, ruggedness, and the ability to stimulate imagination and the emotions. The Sublime is associated with limitlessness, storms, waterfalls, a raging sea, mighty mountains, and huge, powerful stereometrically pure buildings. In architecture, an exaggerated scale, powerful unadorned fabric, and gloomy cavernous structures could be classed as Sublime).[57] Perhaps the most lasting legacy of the Revival has been the value given to simple, clear, blocky elements by architects and architectural critics. It is certain that Otto Wagner (1841–1918), Karl Friedrich Schinkel (1781–1841), Willem Marinus Dudok (1884–1974), and even the young Frank Lloyd Wright (1869–1959) could not have designed many of their buildings (where solid, cubic blocks play such an important part) without the precedent of the Egyptian Revival and its influence on Neo-Classicism as a whole.[58] The memorable images produced by Friedrich Gilly (1772–1800),[59] Boullée,

51 *See* especially ARTS COUNCIL OF GREAT BRITAIN (1972), CLAY (1980), HONOUR (1977), MEEKS (1966), and TURNER (*Ed.*) (1996), **xxvi**, 735–44
52 PEVSNER (1968), **i**, 197–211.
53 CURL (1999 and 2000), 283–4, and (2002*d*).
54 *See* KAUFMANN (1952). *See also* KAUFMANN (1933 and 1968).
55 *See* ETLIN (1984), and CURL (2002*c*).
56 *See* ROSENAU (1953, 1960, 1976).
57 BURKE (1757), TURNER (*Ed.*) (1996), **xxix**, 889–91.
58 *See* PEHNT (1987): a perceptive paper on the subject.
59 WATKIN and MELLINGHOFF (1987), 66–70 and *passim*.

Schinkel,[60] Claude-Nicolas Ledoux (1736–1806),[61] and others have been admired by architects of the twentieth century, and Schinkel especially has had a considerable following. The last's sets for Mozart's *Die Zauberflöte*[62] are masterpieces in the Egyptian Revival style,[63] appropriately enough for this partially Freemasonry-inspired *Singspiel*.[64] Many pamphlets, frontispieces, and illustrations associated with Freemasonry are not guiltless of Egyptian elements.[65] The iconography of European Freemasonry, that potent force in the Enlightenment, was steeped in Egyptianising design, for Ancient Egypt provided a main source of Freemasonic legend and wisdom.[66] Napoleonic discoveries brought accurate pictures of Ancient Egyptian art and architecture to Europe, and soon a revival of Egyptian styles in architecture made its appearance in halls, showrooms, exhibition buildings, factories, cemetery lodges, and mausolea.[67] Augustus Welby Northmore Pugin (1812–52) lampooned the style in his *An Apology for the Revival of Christian Architecture in England*,[68] for it was used in some of the early commercial cemeteries because of its associations with death, and incurred the wrath and scorn of that skilled polemicist.[69]

The nineteenth century produced many examples of the Egyptian Revival. Buildings, furniture, jewellery, paintings, ornaments, and even chimney-pots offer thousands of variations in the style. Egyptianising motifs became fashionable in the Victorian period largely through the drawings, writings, and photographs of travellers who ventured to the Nile. Egypt was a popular goal for the Thomas Cook (1808–92) tours, and artists, photographers, and collectors made Egypt familiar.[70] Victorian jewellery in the Egyptian style, some of it designed by May Morris (1862–1938), was sought after, whilst furniture in the Egyptian Taste by Liberty, Holman Hunt, and others became popular. Sir Lawrence Alma-Tadema (1836–1912) used Egyptianising furniture in his paintings, and there are strong Egyptian elements in paintings by Edwin Long (1829–91), Sir Edward John Poynter (1836–1919), the Hon. John Collier (1850–1934), David Roberts (1796–1864) (mostly

60 BERGDOLL (1994), and SNODIN (*Ed.*) (1991).
61 VIDLER (1990).
62 K.620 of 1791.
63 THIELE (1823).
64 Like an opera, but with spoken German dialogue between musical numbers instead of *recitative*.
65 *See* CURL (2002*b*).
66 *See* TERNER (2001).
67 CARROTT (1978), CONNER (*Ed.*) (1983), HUMBERT, PANTAZZI, and ZIEGLER (*Eds*) (1994), HUMBERT (*Ed.*) (1996), HUMBERT (1989*a* and 1998), and *see* Select Bibliography.
68 PUGIN (1843).
69 CURL (2000*d*), 103–7.
70 CLAYTON (1982).

fine topographical work),[71] and William Holman Hunt (1827–1910). Ceramics and glass in the Egyptian Taste proliferated, and fakes and forgeries of 'original' Ancient Egyptian work were produced on a massive scale. At the end of the century the pictures by Arnold Böcklin (1827–1901)[72] and his circle contain several Egyptian Revival elements, notably in the variations on the *Toteninsel*[73] theme.

In the twentieth century there have been further outbreaks of Egyptomania, the most spectacular occurring after the discovery of the tomb of the Pharaoh Tutankhamun in 1922. The famous *Exposition des Arts Décoratifs et Industriels Modernes* in Paris in 1924–5 stimulated more Egyptianising themes in architecture, furniture design, interiors, jewellery, ceramics, and ornament, and gave its name to the style known as *Art Déco*, which exploited stepped forms, the chevron, bright primary colours, and rich materials, prompted by the discovery of Tutankhamun's treasures.[74] Cinemas, and even factories, acquired exotic plumage in the 1920s and 1930s,[75] and films featuring Cleopatra and Ancient Egypt, culminating in the massive movie with Elizabeth Taylor as the Queen in the 1960s, encouraged revivals of the Revival.[76] The success of the Tutankhamun travelling exhibition in Europe and America aroused further interest in the Nile style.

The Egyptian Revival has had a longer life than most people suppose. This study will discuss a recurring theme in the history of Taste, how Ancient Egypt was the inspiration for design motifs in the West, and will describe the sources of the Revival, its influences, and its physical manifestations. The inspiration[77] of Egyptian art and architecture is not yet dissipated: the ways in which Egyptianisms have permeated the West are many, and this study will attempt to show that Egypt provided some of the most important influences that are central, rather than peripheral to our culture. The book has been written in the belief that Ancient Egyptian religion, art, and architecture have profoundly affected Græco-Roman and Christian civilisations in ways that, to a very great extent, have been grossly underestimated by historians and commentators: it will outline some of the most important examples of such influences, and will trace an extraordinary and persistent thread that leads back to the ancient cultures of the Nile.

71 CLAYTON (1982), and GUITERMAN and LLEWELLYN (1986).
72 PALMA and NUZZI (*Eds*) (1980).
73 The Isle of the Dead of 1880.
74 DUNCAN (1988), HILLIER and ESCRITT (1997), and BENTON, BENTON, and WOOD (*Eds*) (2003).
75 ATWELL (1981), HITCHMOUGH (1992).
76 HUMBERT (1989*a*).
77 *See* CONNER (*Ed.*) (1983).

Acknowledgements

. . . the land of Egypt, when we sat by the flesh pots,
and when we did eat bread to the full

THE OLD TESTAMENT: *Exodus*, **xvi**, 3

The seed of the idea that eventually became *The Egyptian Revival* was sown in 1960 when I visited Mozart's birthplace in Salzburg and there saw an exhibition of Karl Friedrich Schinkel's designs for *Die Zauberflöte* and other theatrical and operatic productions: those designs, with their Egyptianising allusions, made an overwhelming impact, and they have remained embedded in my mind ever since. That seed, planted so long ago, prompted an obsession, and I began to note Egyptiana during my frequent travels at home and abroad. Gradually, the idea grew into an ambition to write a book, and this volume, written in my seventh decade, is the result. Even as I look up from my desk, I can see, high on a hill across the waters of the Lough, a tall obelisk-memorial. Egyptianising motifs are never far away.

I have been greatly helped by many people to assemble the great mass of material that forms the basis of this book. First of all, I am grateful to my original publishers, George Allen & Unwin, and especially to Mr Rayner Unwin and Mr John Newth for so quickly seeing the possibilities in my first ideas. Mr Merlin Unwin subsequently became closely involved at the formative stage, and took the process through to publication in 1982.[1] The book went out of print shortly after my publishers became Unwin Hyman, and the rights reverted to me: this reversion was confirmed when Unwin Hyman was taken over by HarperCollins Publishers Ltd Subsequently, Miss Katharine Reeve, of Manchester University Press, was equally speedy in determining to bring out a new version of the book in 1994, revised, corrected, up-dated, and retitled *Egyptomania*,[2] to coincide with a major exhibition of that name in Paris, Ottawa, and Vienna.[3] That book, in turn, went out of print and again rights returned to me. Through the good offices of Mr Peter Clayton I was introduced to Mr Robin Page, of Rubicon Press, who, in 2002, agreed to publish a new edition: it was agreed that we should revert to the original title, with a new subtitle reflecting more accurately the contents of the book, and were determined to include some colour-plates (some taken specially for the purpose) in order to do better justice to some of the beautiful artefacts created as a

1 CURL (1982).
2 CURL (1994*a*).
3 *See* HUMBERT, PANTAZZI, and ZIEGLER (*Eds*) (1994).

result of this Revival. I delivered the book at the end of 2002, and worked with Mr Page and Mr Peter Phillips until by the Autumn of that year the book was almost ready for publication. Unfortunately, Mr Page died just as our labours neared their end, and the whole project went into a legal limbo. Mr Clayton again came to the rescue, and introduced the book to Mr Richard Stoneman of Routledge, who indicated his interest in publishing the work, but we had to wait for many months until Probate was granted and it became possible to purchase rights from the legal representatives of Rubicon. Thereafter, through the good offices of Mr Stoneman and Miss Katherine Davey (Production Editor) work proceeded at last, and the book was prepared for publication.

Even new editions cost money to produce, involving some new illustrations, re-use of old ones, and re-working of the text and bibliography to take modern scholarship into account. It was therefore useful to receive a modest grant from the Marc Fitch Fund towards the costs of obtaining the illustrations, and so I acknowledge with thanks this grant, the support of my referees, and the advice of Mr Roy Stephens when making my application.

Research for the book ranged far and wide, and involved extensive use of every possible moment not devoted to academic duties. Without the help and advice of numerous scholars, librarians, and others, it would have been impossible. So I record here the names of those to whom I owe an especial debt of gratitude. Mr John Harris, former Curator of the RIBA Library Drawings Collection, was more than helpful, and made several useful suggestions. I should also like to thank Herr Ulf Cederlöf of the *Teckning och Grafik* department, *Statens Konstmuseer*, Stockholm; Frau Karla Camara, *Sachbearbeiterin*, of the *Stiftung Preussische Schlösser und Gärten Berlin-Brandenburg*; the staff of the *Kupferstichkabinett und Sammlung der Zeichnungen, Staatliche Museen zu Berlin*; Dr Claudia Balk, Frau Babette Angelaeas and the staff of the *Deutsches Theatermuseum*, Munich; Dr Gerald Heres and the staff of the *Grünes Gewölbe, Staatliche Kunstsammlungen*, Dresden; Dr Manfred Boetzkes of the *Theatermuseum*, Köln; Mr Nicholas Thomas, Director of the City of Bristol Museums; Miss M. V. Gordon; the staff of the *Historisches Archiv* of the *Fried. Krupp GmbH*, Villa Hügel, Essen; the staff (especially Miss Claudia Mernick and Mr Trevor Todd) of the RIBA Library; Mr C. A. McLaren, Keeper of Manuscripts at Aberdeen University Library; the *Caisse Nationale des Monuments Historiques et des Sites*; Dr Štefan Krivuš and the staff of the *Matica Slovenská*; Miss Ursula McMullan of the Mansell Collection; Ms Sherry Picker of TimePix, New York (where the Mansell Collection is now); Ms Jill Bloomer, Image Rights and Reproductions, Cooper-Hewitt, National Design

Museum, Smithsonian Institution, New York; Ms Piriya Vongkasemsiri and other staff of the Chicago Historical Society; Dr sc. K.-H. Priese, *Abteilungsleiter*, and Frau Ute Wolf of the *Ägyptisches Museum und Papyrussammlung, Staatliche Museen zu Berlin*; Mr John Hopkins, Mr Bernard Nurse, and the staff of the Society of Antiquaries of London; Mr Iain J. Harrison of the Birmingham Museums and Art Gallery; Miss Elisabeth Stacey of the Photographic Library, The National Trust; the staff of the Bodleian Library, University of Oxford; Mr D. J. Hall, Mr Lucas Elkin, and the staff of Cambridge University Library; the staff of the British Library (especially Miss Pam Taylor); Mr Bryan Hucker and the Director of Greenwich Hospital; the staff of the Victoria and Albert Museum (particularly Ms Helen Dobson, Ms Rachel Lloyd, and Mr Nicholas Wise); the staff of Saffron Walden Public Library, Essex (notably Mrs Jill Palmer, Mr Martyn Everett, and Mr Alan Stevens); the staffs of the Lincolnshire Library Service at Boston and Lincoln; the staff of the *Bibliothèque Nationale* in Paris; Madame Caroline Wyss of the Photothèque des Musées de la Ville de Paris; the *Direzione Generale Musei Vaticani*; the staff of the *Biblioteca Apostolica, Città del Vaticano*; the staff of the library of The Queen's University of Belfast (especially Mr Dan Holden, Mrs Karen Latimer, and Mr Michael Smallman); Miss Jan Ruhrmund of the Morrab Library, Penzance, Cornwall; and the staff of the Courtauld Institute of Art. I owe special thanks to the staff of the Guildhall Library, City of London (including Mr Ralph Hyde [formerly Keeper of Prints and Maps], Mr John Fisher, and Mr Jeremy Smith); to the late Mr John Morley, former Director of the Art Gallery and Museums and the Royal Pavilion at Brighton; and to Mr Peter Clayton. Mr Hyde has been a tower of strength in providing notes, references, and pictures of Egyptianising material; Mr Morley gave up much time to show me items in the Brighton collections and to discuss them with me; whilst Mr Clayton's expertise and generosity have made the task of writing this book very much less onerous than would have been the case without his help. Not only did Mr Clayton introduce me to Mr Page and Mr Stoneman, but he made available items from his own exhaustive collection of illustrations, and wrote the Foreword to the present book: without his help it is doubtful if the book would ever have appeared at all.

I am very grateful to the late Mr F. H. Thompson, former General Secretary of the Society of Antiquaries of London, and to the Society itself for practical help from the Research Fund. Other persons who very kindly assisted in the project with advice, information, and time, were Mr Harold Allen, Mr David Atwell, Ms Stella Beddoe (Keeper of Decorative Art, The Royal Pavilion, Libraries, & Museums, Brighton),

Sir Geoffrey de Bellaigue, Miss Eileen M. Bennett, Mr I. L. Bradley (Unit Administrator of the former Biddulph Grange Orthopædic Hospital), the late Professor Richard G. Carrott (whose own work on the Revival in the United States of America has been an inspiration), Mrs Bridget Cherry, Mrs Diane Clements (Director, The Library and Museum of Freemasonry, Freemasons' Hall, London), Mr Giles Clotworthy, Sir Howard Colvin (doyen of British architectural historians), Mrs Elizabeth Conran (former Curator) and Mr Howard Coutts (Keeper of Ceramics, The Bowes Museum, Co Durham), the late Mr H. G. Conway, Dr Maurice Craig, Miss C. H. Cruft, Miss Ingrid Curl, Mr John McK. Curl, Mr Martin R. Davies, Mr John Davis (Curator, Design Council Slide Collection, Manchester Metropolitan University), Mr Richard Day (Curator, The Bugatti Trust), Mr T. Dimmick, Mrs Michael Drew, Frau Eva Eissmann, the late Mr Edmund Esdaile, Dr Marianne Fischer, Mr Geoffrey Fisher (Conway Library, Courtauld Institute of Art), Mr John A. Gamble, Heer Jan Geeraerts (of the *Koninklijke Maatschappij voor Dierkunde van Antwerpen*), Mr P. C. Gibbling (of the Faringdon Collection Trust), the late Mr John Gloag, Mr Michael Goldmark, Mr Richard Gray and Ms Rachel Marks (of the Cinema Theatre Association), Mr John Greenacombe (my former colleague at *The Survey of London*), Mr Rhys Griffith (Principal Archivist, The London Metropolitan Archives, Corporation of London), the late Mr Leslie V. Grinsell, Herr Helmut Grosse, the late Mr K. T. Groves, Mr Raymond Hall, Miss Mary Harvey, Mr T. O. Haunch (former Librarian and Curator of The Freemasons' Hall in London), Professor Dr. M. S. H. G. Heerma van Voss, Miss Hermione Hobhouse, Mr Ian Hodgson, Professor Mátyás Horányi, Dr Jean-Marcel Humbert, Dr Bertrand Jæger, Dr Astrid James, the late Dame Penelope Jessel, Mr Ian Johnson (who was particularly supportive), Miss Sylvia Katz (of the Design Council), the late Mr Kenneth Kettle, the late Dr Hans Knappertsbusch, Dr Susan Lang, M. Jean Leclant, Mr Gilbert Lewis, Professor Göran Lindahl, Herr Björn Linn, Mevr Petra Maclot, Mr Peter O. Marlow, Miss Glenise Matheson (of the John Rylands University Library of Manchester), Mr Willem A. Meeuws, Mr Geoffrey Middleton, Mr Denis F. McCoy, Miss Marianne McElwee (Picture Library Assistant, Royal Collection Enterprises), Miss Helen O'Neill (of the Glyndebourne Festival Opera), the late Prof. Arno W. Oppermann, Dr Wolfgang Pehnt, the late Professor Sir Nikolaus Pevsner, Mr L. A. Porri, Miss Anne Riches, Madam Edith Róth, Ms Jessica Rutherford (Head of Division, The Royal Pavilion, Libraries, & Museums, Brighton), the late Mr John Sambrook, Dr Hans Schneider, Dr Melanie Simo, Mr Alan Spencer, Dr Elisabeth Stæhelin, Mr

Malcolm Starr, Miss Nicola Stevens, Professor Peter Swallow, Mr Roger Towe, Professor David Walker, Dr Eugène Warmenbol, Professor David Watkin, Mr Theon Wilkinson and the British Association for Cemeteries in South Asia (BACSA), the late Dr R. E. Witt, Mr Kevin Smith Wheelan, the late Mr Arnold Whittick, Mr Christopher Wood, and Mrs Kay Woollen.

I am greatly in debt to my old friend Mr Rodney C. Roach of Oxford who has done a splendid job processing the pictures. Other illustrations were supplied by Addys (Boston), Mr James Austin, Herr Klaus Broszat, Geremy Butler Photography, Mr Martin Charles, Mr Peter Clayton, A. C. Cooper, Carreras Rothmans, Godfrey New Photographics, Giraudon of Paris, the late Mr Guy Gravett (founder of the Guy Gravett Picture Index), Dr Štefan Krivuš, Herr Willy Meyer, Messrs A. G. Porri & Partners, Mr Alan Spencer, and TimePix. Mr H. J. Malyon, formerly of the General Cemetery Company, allowed me to photograph monuments in the General Cemetery of All Souls, Kensal Green, as well as to inspect documents, and further research was carried out in the archives of the Company in 2000–2001, facilitated by the Directors, especially Mr Michael Nodes (Chairman) and Mr Michael Ford, and by the Secretary, Mr David Burkett, and the staff of the Company. This research culminated in the publication of a monograph in 2001 (*Kensal Green Cemetery: the Origins & Development of the General Cemetery of All Souls, Kensal Green, London, 1824–2001*[4]). The late Mr Gilbert Rumbold, who originally discussed the *Art-Déco* period with me in Guernsey in 1957, was most helpful when I talked further with him in Belfast in 1958. Mr Rumbold contributed a number of designs to *The Savoy Cocktail Book 1930* and to many other publications. I shall always remember his amusing company. I was greatly helped by Signora Luciana Valentini and by the staff of the British School at Rome during the research stages, and I acknowledge the kind assistance of the Assistant Director of the School. Mr Peter Bezodis very kindly provided much information in correspondence and conversation, and I am most grateful to him for his help over the years. The late Sir John Summerson most courteously gave access to material in Sir John Soane's Museum, and discussed aspects of the Revival with me: later, I was helped by Mrs Susan Palmer, Archivist, and other staff at that most enchanting of Museums. Mr Stanley Baron, of Thames & Hudson Ltd, civilly permitted the quotations from Dr Witt's work to appear. The late Professor Richard G. Carrott granted permission to quote from his admirable book on the Egyptian Revival. Dr Susan Lang and the late

4 CURL (*Ed.*) (2001*b*).

Sir Nikolaus Pevsner graciously allowed me to quote from their pioneering essay on the Revival, and have my warmest thanks. Their work provided a valuable skeleton on which part of the present study is based. My younger daughter, Ingrid, very kindly told me about, and photographed, various Egyptianisms in France, and my brother, John, helped to track down Egyptianising mausolea with me in Ireland. My wife, Professor Dorota Iwaniec, gave me moral support while I was working on the complicated and frequently overwhelming task of revising and re-writing the book: I have dedicated the finished volume to her as a small acknowledgement of my great debt.

Miss Pamela McIntyre transformed my chaotic notebooks and much scribbled-over manuscripts into respectable typescript, and has my gratitude and admiration. Mrs Margaret Reed of Starword prepared what survived of the material submitted to Manchester University Press for this new book, a particularly arduous task, as she inherited much that was incomplete and had deteriorated: I am very grateful to her for her continuing collaboration. The Index was compiled by Miss Francis Mather, who patiently took on board my many suggestions, and produced what I believe adds greatly to the usefulness of this volume. She has my warmest thanks.

The Governing Body of Peterhouse, University of Cambridge, granted me a Visiting Fellowship in 2002 which enabled me to work on the book in the peaceful surroundings of the College: I record my thanks due to the Master, Fellows, and Governing Body of that august College, and express my appreciation of the many kindnesses of the Fellows who became friends and of the College staff who made my period of residence so pleasant. I am also grateful to the Universities where I have been Professor of Architectural History for making it possible for me to have the time to research and write this book.

If I have inadvertently omitted anyone from these notes of thanks I hope that a sincere expression of my indebtedness to everyone who helped me will suffice. Without the assistance of friends, colleagues past and present, and a great many people I only know slightly or in correspondence, the task of writing this book would have been impossible.

JAMES STEVENS CURL

Winchester; Leicester; Rathmullan, County Donegal; Burley-on-the Hill, Rutland; Peterhouse, University of Cambridge; Broadfans, Dunmow, Essex; and Holywood, County Down: 1978–2003

CHAPTER I

Egypt and Europe

The Idea of Egypt in the European Mind; The Isiac Religion; The Absorption of Egyptian Religion into the Græco-Roman World; Obelisks; The Isæum *Campense; Pyramids; Epilogue*

It flows through old hushed Egypt and its sands,
Like some grave mighty thought threading a dream,
And times and things, as in that vision, seem
Keeping along it their eternal stands, –
Caves, pillars, pyramids, the shepherd bands
That roamed through the young earth, the glory extreme
Of high Sesostris, and that southern beam,
The laughing queen that caught the world's great hands.

JAMES HENRY LEIGH HUNT (1784–1859): Sonnet – *A Thought of* [sic] *the Nile*, lines 1–8, from *The Poetical Works of Leigh Hunt* (London: Edward Moxon, 1832), 211.

I am She that is the natural Mother of all things, Mistress and Governess of all the Elements, the Initial Progeny of Worlds, Chief of the Powers Divine, Queen of Heaven, the Principal of the Gods Celestial, the Light of the Goddesses. At My Will the Planets of the Air, the wholesome Winds of the Seas, and the Silences of Hell be disposed. My Name, My Divinity, is adored throughout all the World, in divers manners, in variable Customs, and in Many Names, for the Phrygians call me the Mother of the Gods; the Athenians, Minerva; the Cyprians, Venus; the Candians, Diana; the Sicilians, Proserpina; the Eleusians, Ceres; some Juno, others Bellona, others Hecate; and principally the Ethiopians who dwell in the Orient, and the Egyptians, who are excellent in all kinds of ancient Doctrine, and by their proper Ceremonies accustom to worship Me, do call Me Queen Isis. Behold, I am come to take pity on thy Fortune and Tribulation! Behold, I am present to favour and aid thee! Leave off thy weeping and lamentation, put away all thy sorrow, for behold the healthful day which is ordained by my Providence. Therefore be ready and attentive to My Commandment . . .

And know thou this of certainty, that the residue of thy Life until the Hour of thy Death shall be bound and subject to Me . . . Thou shalt live Blessed in this World, thou shalt live, glorious by My Guidance and Protection . . . And know thou that I will prolong thy days above the time that the Fates have appointed and the Celestial Planets ordained.

LUCIUS APULEIUS: (c.AD 125–c.170): *Metamorphoses*, Book XI.
Based on the translation by WILLIAM ADLINGTON of 1566.

1

The Idea of Egypt in the European Mind

Egyptological collections in museums throughout the Western world have made artefacts of Ancient Egypt familiar to us all. Mummified bodies, coffins, sculptures, hieroglyphic inscriptions, and stylised paintings are immediately recognisable as having derived from the lands of the Nile. Nowadays, with instant communication, ease of travel, and an immense treasury of published works, photographic images, and archæological discoveries readily available, it might be thought that mysterious Egypt — the land of the pharaohs, where strange deities presided over a theology of immense complexity — has become less remote. Yet we find those dried bodies, the staring eyes of the painted masks, the 'Canopic' jars with their grisly contents, fascinating and rather terrible, as they await the call to a Resurrection that has never happened. The plundered tombs, the mighty pyramids, the ruined temples, and the weather-beaten Sphinx move us with their antiquity, their curious aura, their gigantic scale, and their brooding, massive solemnity. A realisation that a rich and powerful civilisation, with an enormous legacy of architecture, art, and artefacts, has vanished, and that its meaning and beliefs have ceased, apparently, to impinge on contemporary life, is food for gloomy thoughts.

And yet all is not as it seems. The civilisation of the West that developed from the Græco-Roman world, from the elaborate organisation of the Christian Church and its close connections with secular power and the legitimising of that power, and from the vast cultural stew of the lands around the Mediterranean Sea, drew heavily on the religion of Ancient Egypt, a fact that is often ignored, glossed over, or claimed as 'exaggerated' by commentators. Throughout the Græco-Roman world Egyptian deities were worshipped, and they exercised an enormous influence on other faiths, notably Christianity. It may be this that has led historians (who ought to be objective) to shy away from the obvious.

It is well known that trading relations between Egypt and the Greek world were established from the second half of the second millennium BC. Homer (*fl.* eighth century BC), in the *Odyssey*, tells us of the visit to Egypt of Menelaus,[1] and Greeks secured settlements in Egypt from around the seventh century BC. Herodotus (*c.*490–*c.*425 BC) travelled in Egypt and left us an extremely valuable account in his *Histories*, which were subsequently regarded as prime sources by later writers, including Diodorus Siculus (*fl.* *c.*60–30 BC) and Strabo (64 BC–after AD 24). The Greeks were aware of the antiquity of Egyptian civilisation, and were impressed by its religion,

1 The Legend of 'The Egyptian Helen', the subject of *Die ägyptische Helena*, an opera (premiered at Dresden in 1928) by Hugo von Hofmannsthal (1874–29), with music by Richard Strauss (1864–1949).

buildings, and customs: even more important, however, was the awe with which Egypt was regarded, for it was seen as the repository of all ancient wisdom. Greek intellectuals visited Egypt at least as early as the seventh century BC: Thales of Miletus (*fl. c.*600 BC), the famous astronomer and scientist, has been credited with the organisation of geometry after studying Egyptian methods of land-measurement; there were Greek settlements in Egypt, notably at Naukratis; and it is clear from numerous Greek and Latin *graffiti* that tourists were no strangers to Egypt in Classical Antiquity.

Egyptian architecture developed very early, and evolved certain forms that remained more or less constant in their basic elements throughout the millennia. It was a massive columnar and trabeated architecture, with a limited range of capitals (bud, papyrus, palm-leaf, volute, etc.[2]), and a simple entablature, usually consisting of a lintel (architrave), torus-moulding, and gorge-cornice[3]. Ornament featured stylised versions of the lotus (both bud and flower),[4] papyrus (bud and plant),[5] and palm (which influenced Greek ornament in turn),[6] whilst there are columns at Beni-Hasan and Deïr-el-Bahari that suggest a prototypical Greek Doric Order (associated, in the case of the Beni-Hasan tombs, with rock-cut segmental ceilings).[7] The Ancient Egyptian rock-cut tombs at Beni-Hasan have sixteen-sided columns *in antis*, slightly tapering towards the top and separated from the lintels by *abaci*: projecting cornices over have representations of beam-ends carved out of the solid rock. In basic arrangement, rock-cut tombs in Lycia, Arcadia, and Macedonia have similarities to those of Beni-Hasan,[8] and it is not unlikely that there was some transportation of architectural ideas, although the geometry of formal spaces sheltering a dead body would appear to have been arrived at independently by a number of civilisations.[9] Perhaps more intriguing is the appearance of Egyptian decorative motifs in Greek art and architecture. Palm-motifs occur in the capitals of the Tower of the Winds in Athens;[10] the Egyptian decorated bell-capital suggests an archaic Corinthian capital; Egyptian wall-paintings and capitals featuring the lotus suggest the essential form of the Ionic capital; the anthemion as a design is not all that far removed from the stylised lotus-flower; *antefixa*, in Greek architecture, recall some Egyptian painted work; whilst sphinxes and other composite creatures are not uncommon in Hellenistic and Roman designs.[11]

2 *See* Select Glossary, under **capital**. *See also* PHILLIPS (2002).
3 *See* Select Glossary for descriptions and illustrations.
4 *Ibid. See also* PHILLIPS (2002).
5 *Ibid.*
6 *Ibid.*
7 *See* CLAYTON (1982), for illustrations.
8 *See* KURTZ and BOARDMAN (1971), *passim*, for descriptions of Greek tombs.
9 *See* DINSMOOR (1950), 58–9, 124–216, 328 and STATHAM (1950), 10–16, 43, 46, 55, 56.
10 *See* Select Glossary, under **capital**.
11 For descriptions and explanations of the Classical Orders see CURL (1999, 2000) and CURL (2001a).

If some consider Egypt to be the possible source of the Doric Order, the origins of the Ionic Order are more markedly from the Southern Mediterranean area.[12] The characteristic volute or scroll-capital may have been derived from the Egyptian lotus, and there are similarities to Mycenæan scroll-work. Early capitals of the proto-Ionic type in Cyprus, Lesbos, Naukratis, and Neandria[13] have volutes that are probably derived from vegetation, with palmettes interposed. The Ionic Order was particularly favoured in Asia Minor, and the most celebrated buildings in which it was used were the temples of Artemis at Ephesus and the Mausoleum at Halicarnassus.[14] Henry Heathcote Statham (1839–1924) pointed out that there is a quasi-Asiatic stamp[15] about the Ionic Order. It might also be observed that the slight batter of the doorway of the north portico of the *Erechtheion* in Athens and in other Ionic buildings also recalls Egyptian architecture, especially the pylon-tower form. In Egyptian temples, capitals, decorated with papyrus, lotus, bud, or combinations of these, are usual. In some cases, however, the capitals are replaced by the face of the goddess Hathor with drooping sacerdotal hood repeated four times at the top of each column.[16]

The Egyptians themselves demonstrated an archæological approach to their own past, notably in the Saïte period (664–525 BC), when there was a conscious revival of earlier art-forms, and much restoration of existing artefacts and buildings.[17] From 332 BC, following the overthrow of the Persian monarchy by Alexander III, 'the Great' (356–323 BC), Macedonian Greeks known as the Ptolemies[18] ruled Egypt, and Alexandria became the most important centre of Greek culture. The key to the remarkable early spread of the Egyptianising cults was Alexander, who was closely identified with Zeus-Ammon (**Colour Plate I**), with Osiris, and with Dionysus, as well as himself becoming heir to the pharaohs.[19] When Alexander conquered Egypt, the ancient deities gained a new and potent influence throughout the Hellenistic world. Unlike many conquerors, Alexander did not attempt to superimpose his own culture or to obliterate the indigenous civilisation. Like Napoléon, Alexander brought scholars with him to study and interpret the riches of the Nile Valley, and, as a result, Egypt was to contribute an enormous amount to Hellenistic culture. The founding of the great city of Alexandria was to be associated with a harbour presided over by *Isis Pharia*, and the new capital was to become a fountain-head from which an Egyptianised Hellenistic civilisation would flow.

12 DINSMOOR (1950), *passim.*
13 *See also* Select Glossary of the present work, under **capital**.
14 Two of the Seven Wonders of the Ancient World.
15 STATHAM (1950), 65.
16 *See* Select Glossary under **capital**, and *see* CLAYTON (1982), for illustrations.
17 CLAYTON (1982), 7–8.
18 HORNBLOWER and SPAWFORTH (1996), 1271–3.
19 *Ibid.,* 57–9.

The early death of the god-like Alexander caused the elevation of Ptolemy I Soter (323–282 BC), who transformed Alexandria into a splendid metropolis, and encouraged the cult of the Græco-Egyptian hybrid god Serapis (or Sarapis), probably in order to help unify the country after the disruptions of conquest. It was during his reign that the cult of Isis began to spread outside Egypt, and spread in spectacular fashion. Ptolemy's son, by Berenice, Ptolemy II Philadelphus (282–246 BC), who ruled jointly with his father from 285 to 282 BC, followed the precedents of pharaonic Egypt and married his own sister, Arsinoë, who was closely identified with Isis.[20] Under this Pharaoh, Nilotic culture and religion were exported to Italy, Asia Minor, and Greece, and fine new temples were built at Philæ dedicated to Isis and Osiris.[21] Significantly, the architecture at Philæ was Egyptian, not Greek, and, in any case, as has been mentioned above, there had been a long history of the revival of Ancient Egyptian architecture in Egypt itself (notably under Psammeticus I [664–610 BC] of XXVI Dynasty) in which Greeks had been involved, for many Greek mercenaries joined forces with the Egyptians to restore the independence and power of Egypt, and close connections with Greece were forged. Traditional art, architecture, and religion were revived to emphasise cultural continuity as well as national identity. The Greek colony of Naukratis was founded in the reign of Psammeticus I, and some strange mixtures of Greek and Egyptian art have been found at Saqqara and elsewhere. A Carian grave-*stele* of 550–530 BC, for example, has a segmental head, and is decorated with incised carvings: at the top of the *stele*, following the line of the segmental head, are the vulture's wings with sun-disc and *uræi* above images of a man taking leave of a woman that are entirely East Greek in style (**Plate 1**). This *stele* is one of the earliest surviving instances in which a purely Egyptian motif appears with a representation of figures that are purely Greek.[22]

Egyptian art and architecture were certainly conservative, but the conscious Egyptian Revival of the Saïte period set the precedent for what was to follow. Philæ acquired buildings in the reigns of the native Pharaohs of XXX Dynasty (380–343 BC), Nectanebo I and II, in the Ptolemaïc (Hellenistic) period (332–30 BC, notably in the reign of Ptolemy XII Neos Dionysus [80–51 BC]), and in the reigns of the Roman Emperors Augustus (27 BC-AD 14) and Trajan (AD 98–117). At Philæ additions made by the Romans showed Augustus and Tiberius (AD 14–37) offering myrrh, incense, and other gifts to Isis and her family. To a certain extent the whole group of buildings erected at Philæ must be regarded as Revivalist.

20 HORNBLOWER and SPAWFORTH (1996), 1272 and WITT (1971), 46–8.
21 WITT (1971), 46–8.
22 MASSON, MARTIN, and NICHOLLS (1978). The Author is grateful to Dr Nicholls for discussing this stele in the Fitzwilliam Museum, Cambridge, with him.

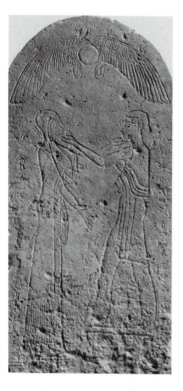

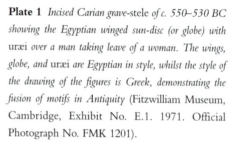

Plate 1 *Incised Carian grave-stele of c. 550–530 BC showing the Egyptian winged sun-disc (or globe) with* uræi *over a man taking leave of a woman. The wings, globe, and* uræi *are Egyptian in style, whilst the style of the drawing of the figures is Greek, demonstrating the fusion of motifs in Antiquity* (Fitzwilliam Museum, Cambridge, Exhibit No. E.1. 1971. Official Photograph No. FMK 1201).

The temple complex of Horus at Edfu (237–57 BC) was begun by Ptolemy III Euergetes I (246–221 BC); the main temple was completed by Ptolemy IV Philopater (221–205 BC) in 212; the hypostyle hall was built under Ptolemy VIII Euergetes II (ruled jointly [170–164 BC] with Ptolemy VI Philometor and Cleopatra II, then alone [164–163 and 145–124 BC], and finally with Cleopatras II and III [124–116 BC]); and the pylon-towers were added by Ptolemy XII in 57 BC. Dendera, dedicated to the cow-goddess Hathor, acquired its splendid temple (110 BC-AD 68) from the reign of Ptolemy IX Soter II (116–107 and 88–80 BC), and was added to by his successors, including Cleopatra VII (51–30 BC) (**Plate 2**).[23] Subsequently, the Roman Emperors Tiberius, Caligula (37–41), Claudius (41–54), and Nero (54–68) added to the embellishment of the complex, whilst Domitian (81–96), Nerva (96–98), and Trajan are celebrated in hieroglyphs in the entrance-pylon.[24] Augustus himself was depicted in his *Mammisæum* (Birth- or Incarnation-House) at Dendera as a completely Egyptianising figure (**Plate 3**), and at Kôm Ombo Tiberius is shown with bowls containing the crowns[25] of Upper and Lower Egypt (**Plate 4**).

23 For a brief résumé of the Ptolemies, see HORNBLOWER and SPAWFORTH (*Eds*) (1996), 1271–3.
24 LEPSIUS (1849–59) illustrates and describes these.
25 *See* Select Glossary.

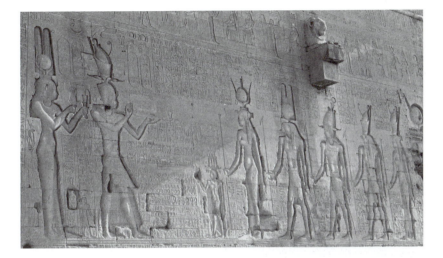

Plate 2 *Cleopatra VII (51–30 BC) presenting her son 'Cæsarion' (Ptolemy XV Cæsar [44–30 BC]) (the two figures on the left) to some Egyptian deities, including Isis, Re-Herakhte, Osiris, Horus, and Mut. Cleopatra shakes a sistrum and holds a menat, whilst Cæsarion offers incense. This carving is on the rear wall of the Ptolemaïc temple at Dendera, and dates from the fourth decade BC. The graceful and sensuous figures of the queen and the goddess should be compared. It is clear from this and other carvings that the identification of Ptolemaic royalty with Ancient Egyptian deities was complete. The process was to continue when Egypt fell to Rome (PAC).*

Plate 3 *The Roman Emperor Augustus (27 BC- AD 14) in his Birth- or Incarnation House (Mammisæum) at Dendera presenting the sun on its horizon to Hathor. He wears the nemes head- dress with additional ornaments including the ram's horns of Khnum with uræi, the crown of Lower Egypt, and a triple arrangement of discs, plumes, etc., so his complete Egyptianisation is clear, but not surprising, given that, once Egypt nominally became part of the Roman Empire when Octavian became Augustus in 27 BC, it had a peculiar status: it was governed from Rome, yet was regarded as part of the Emperor's personal estates. It was the single most important granary of the Empire, and no member of the imperial family or of the Senate could visit Egypt without the personal permission of the Emperor. Furthermore, the deification of Roman Emperors was closely associated with Egyptian precedent (PAC).*

Plate 4 *The Emperor Tiberius (AD 14–37), wearing the* atef *crown further embellished with ram's horns and* uræi, *presenting two small bowls containing the white crown of Upper Egypt* (right) *and the red crown of Lower Egypt to a deity. From a column at the temple of Kôm Ombo* (PAC).

Now Ptolemaïc Egyptian architecture such as that mentioned above, although still in a recognisable traditional Egyptian style, had a refinement and elegance that had affinities with Classical Græco-Roman designs. At Elephantine, for example, there was an unusual type of building consisting of a *cella* with seven columns square on plan on either side, and two columns circular on plan set between the square columns at each end: the whole was placed on a high podium, and was crowned with a simple coved cornice (**Plate 5**). At some time in the 1820s the Elephantine temple appears to have been destroyed, but fortunately it was recorded by the French surveyors preparing plates for the great *Description de l'Égypte*, which will be described later.[26]

The simple, square column was also used at the huge mortuary-temple of Queen Hatshepsut (1479 BC-1458 BC) at Deïr-el-Bahari (*c.*1473 BC-*c.*1458 BC), designed by Senmut (or Senenmut). The composition has long ranges of these square columns, massive ramps joining the main levels, and is symmetrical (**Colour Plate III**). It had a considerable influence on the stripped Classicism of the twentieth century, notably some of the works of Albert Speer (1905–81 – e.g. the Party Congress Grounds at Nürnberg [from 1934]), and on the Neo-Classical architects K. F. Schinkel and Alexander 'Greek' Thomson.

26 COMMISSION DES SCIENCES ET ARTS D'ÉGYPTE (1809–28).

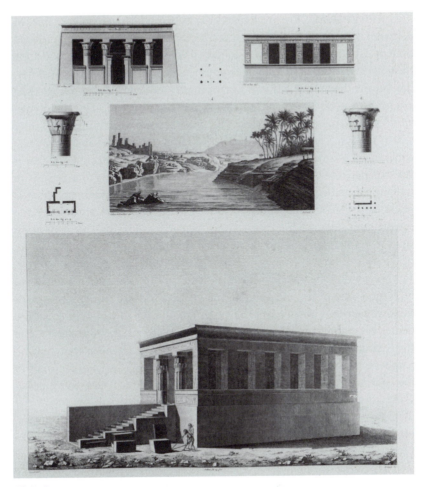

Plate 5

(**Top left**) *Plan, elevation, and two papyrus capitals (one is on the* right*) from the temple at Syene (Aswan), showing a typical Ptolemaïc arrangement of battered walls, coved cornice (or gorge-cornice) with winged globe and uræi, and four columns with papyrus capitals arranged almost in antis, with pluteus.*

(**Centre**) *View of the Isle of Elephantine and its environs. The small plan above the view is that of 'a ruined edifice' at Syene.*

(**Bottom**) *Perspective view of the southern temple at Elephantine showing the peripteral square columns set on a high podium on the long sides, with in antis arrangement of circular columns with bud capitals, all supporting a simple coved cornice. Repetitive square columns with Græcianised detail based on those of the choragic monument of Thrasyllus in Athens (see Select Glossary) became elements more favoured by certain architects of the Neo-Classical period, notably Karl Friedrich Schinkel and Alexander 'Greek' Thomson, and so demonstrated how Egyptian and Greek motifs fused and became one.*

(**Top right**) *Plan and elevation of the northern temple at Elephantine showing the peripteral arrangement of square columns along the flanks with circular columns at each end in antis, high podium, and coved cornice (From* Description, *A, Vol. 1, pl. 38, GB/SM).*

The Ptolemaïc Empire forged links over a wide geographical area. In Alexandria cultural life flourished, and a great museum and library, presided over by Isis and Serapis, were established. Egyptian deities were accorded the same status as that of the Greek gods and goddesses. Gradually, however, the Greeks themselves became Egyptianised, and many deities mingled by a curious process of syncretism that was a feature of the Græco-Roman world. Greek rule came to a close after the Battle of Actium in 31 BC, after which the last Queen, Cleopatra VII, committed suicide, and Egypt was annexed by Rome in 30 BC, although its status was rather odd in that it was retained as a favoured province by Augustus, who began a process of moving monuments within Egypt, and also removing monuments (such as obelisks) to beautify Alexandria and Rome itself. Even Augustus became Egyptianised (despite his antipathy to 'oriental' cults), and his deification was yet another aspect of how potent was the theology of the ancient deities of the Nile (**Plate 3**).

Not only obelisks, jewellery, statuary, and *objets d'art* were imported by Rome: one of the most significant catalysts for Roman enthusiasm for things Egyptian was to be the Egyptian religion when the worship of the deities Isis and Serapis was publicly sanctioned among the *sacra publica*, and the deities were recognised as denizens of the Roman polytheistic pantheon.[27] This momentous event only became possible when the lands of the eastern Mediterranean became politically integrated with the Empire. Once that occurred, Roman artists began to manufacture objects in the manner of Egyptian artefacts, and a Classical Egyptian Revival began. However, there had been a major catastrophe earlier when Gaius Julius Cæsar (100–44 BC) took Alexandria in 47 BC, for the great library attached to the huge temple of Serapis (Osiris) there was burned, and many works were destroyed, including the mighty *History of Egypt* by Manetho (*fl.* 280 BC) which Ptolemy I Soter had commissioned. A further disaster occurred when the Emperor Theodosius I (AD 388–95) ordered the closure (389) of all non-Christian temples through the Roman Empire and two years later the Christian prelate of Alexandria, Theophilus (Patriarch AD 385–412), vigorously suppressed Egyptian paganism and was instrumental in destroying the great temple of Serapis at Alexandria, marking the end of religious toleration in the Empire (and incidentally also destroying many ancient texts stored in the library of the *Serapeion*). Earlier, Theophilus had ordered the Serapeion at Menouthis, north-east of Alexandria, to be destroyed, but, interestingly, the nearby temple of Isis Medica was temporarily spared. However, despite the destruction of the

27 TAKÁCS (1995), 127.

Alexandrian *Serapeion*, part of the library (Sarapiana) building, which formed part of the temple structure, seems to have survived for a time, and was still used by pagan scholars such as Hypatia, the woman learned in astronomy, mathematics, and philosophy, and an important teacher of Neoplatonist philosophy. Hypatia was torn to pieces in AD 415 by an infuriated mob of Christian zealots at the instigation of their leader, Cyril (Bishop of Alexandria from 412 to 444), whose polemics point to a continuing vitality of the pagan cults in Egypt in the fifth century of our era. He suppressed the cult of Isis at Menouthis by translating thither the supposed relics of Sts Cyrus and John, but, as we shall see, Isis was not that easy to obliterate.[28] After all, the Gnostics argued that Isis and the Virgin Mary shared the same characteristics, and Cyril would have been all too aware of that when he was vigorously promoting the official adoption of the Church of the dogma of *Panagia-Theotokos*, the All-Holy Virgin Mother of God, at the Council of Ephesus in 431.[29]

Eventually, the Christian zealots had their odious way, and literary works that had survived the tragedy of 47 BC were consumed by fire. Thus a vast legacy of pharaonic and Ptolemaïc Egypt was lost to the world, and the hieroglyphic script, still understood and used by certain cults, quickly became mysterious and unreadable, although we know that as early as the reign of Claudius hieroglyphs were being used to *suggest* Egypt, but meant nothing, so they were bogus or pseudo-hieroglyphs. By around AD 450 it would seem that virtually nobody could read the Ancient Egyptian texts, while an immense amount written in Greek about Ancient Egypt was lost. Egypt began to become infinitely remote, mysterious, and elusive.

Once Egypt fell to the Arabs in AD 640, the land and its buildings became even more mysterious and inaccessible: it was a legendary place, the seat of ancient mysteries lost in time, with important Biblical associations evident in the tales of Moses, Joseph, and, of course, the Flight to Egypt. A few intrepid pilgrims ventured into Egypt, but the difficulties were immense, and such was the extortion practised by the new masters there that hardly anybody bothered to travel in the lands of the Nile for many centuries.

Hieroglyphs were known from the obelisks that could still be seen in Rome, but it appears their meaning was quickly forgotten, even in the first decades of our era. So Egypt entered into the European mind as an inaccessible land, where ancient esoteric knowledge once could be tapped, and where legend and Biblical stories mingled in a heady brew. It was an enticing subject for speculation, mythology, and scholarship.

28 *See* WITT (1971), 185–97, for further illumination.
29 *Ibid.*, 185.

The Isiac Religion

No consideration of Egyptian influences in Europe can afford to ignore Isis, the Great Goddess, Mother of the God, Queen of Heaven, who was wise and cunning, infinitely patient, and life-giving, able even to resurrect the dead. Her legacy to European civilisation is immense, and her presence, in attributes and symbols, in religion and philosophy, in architecture, art, and design, and in the Christian Church, is very real. She helped to remove the particularist[30] aspects that had survived in the Christian Church, and, by her femininity and œcumenical appeal, she became loved and revered. The devotion she inspired in ancient times throughout the Græco-Roman world was enormous, and that devotion is still obvious, even in parts of Western Europe. She is the key to an understanding of the thread that joins our own time to the distant past, and which explains a great deal within the cultural heritage of the Western European tradition.

The rôle that the culture of Ancient Egypt played in the development of Western civilisation is not often recognised, even though the importance of the cult of Isis in Alexandria and in Italy has long been known.[31] There are probably two main reasons for this: first, the images of Egyptian deities look very foreign to European eyes; and, second, an acknowledgement of how remarkably complete was the absorption of the Isiac religion in the Roman Empire would seriously weaken the unique claims of Christianity. Yet, as will be seen, there were countless objects made in Europe in an Egyptianising style, while the Great Goddess herself was Europeanised in her imagery. Furthermore, the resemblances between Isis and the Virgin Mary are far too close and numerous to be accidental. There can, in fact, be no question that the Isiac cult was a profound influence on other religions, not least Christianity. As Dr Witt has noted,[32] the more we probe the mysterious cult of the goddess Isis, the greater that goddess appears in historical terms: Isis was a familiar deity in the cosmopolitan cities of Rome and Alexandria, in the towns of Pompeii and Herculaneum, in the city-states of the Hellenistic period (c.323–end of the first century BC) in Asia Minor, and throughout Gaul, whilst there was an important Isiac temple in Roman Londinium. She cannot be ignored or wished out of existence, nor can it be assumed that one day in the fifth century of our era she simply vanished from the hearts and minds of men.

30 Particularism was the doctrine that Divine Grace is provided for or offered to a selected part of humanity, or an élite.

31 The Author records his gratitude to Mr Peter A. Clayton for his help with many things Egyptian.

32 WITT (1971), 11. Dr Witt's monograph offers a conspectus of the Isiac religion in its entirety in one scholarly volume, and builds upon the early foundations set down by BERGMAN, GRIFFITHS, GRIMM, HOPFNER, LAFAYE, MERKELBACH, MÜNSTER, and TRAN TAM TINH, and others whose works are cited in the Select Bibliography of the present work. The Author acknowledges his debt to Dr Witt, as well as to the studies mentioned above: he is also grateful to Mr Stanley Baron and Thames & Hudson Ltd for permission to quote from Dr Witt's copyright work.

Isis was the ruler of shelter, of heaven, of life: her mighty powers included a unique knowledge of the eternal wisdom of the gods, and she was well-versed in guile. Her tears shed for her murdered brother and consort, Osiris, caused the waters of the Nile to flood, so she was associated with rebirth and with the resurrection of the dead,[33] for the river that seemed to die, like Osiris, was 'reborn as the living water'.[34] Every pharaoh was understood to be a reincarnation of Horus,[35] and was therefore the offspring of Isis, the mother-goddess, who could not die, was incorruptible, and was closely involved in the resurrection and re-assembly of the dead.[36] She was the sacred embodiment of motherhood, yet was known as the Great Virgin,[37] an apparent contradiction that will be familiar to Christians. Isis, as the goddess of procreation, had many symbols, the most startling of which (the cow) she shared with Hathor.[38] Enthusiasts who have pursued the Marian *cultus* of the Christian Church, and who are familiar with the works of Hippolytus Marraccius and St Alfonso Maria de' Liguori,[39] will recognise the young heifer as a symbol of the Virgin Mary, whose crescent-moon on many paintings of the post-Counter Reformation period recalls the lunar symbol of the great Egyptian. In imagery Isis is often represented as a comely young woman with cows' horns on her head-dress,[40] the horns usually framing the globe (**Plate 2** and *see* Select Glossary). The goddess often held in her hands a sceptre of flowers, or one of her breasts and her son, Horus.

To Plato (*c.*429–347 BC) and others, Egyptian culture was already very ancient.[41] Indeed, Plato mentions the so-called *Lamentations of Isis*[42] as being of considerable antiquity in his own day.[43] Herodotus of Halicarnassus suggested that the deities of Egypt had been adopted by the Greek city-states,[44] and that, specifically, Demeter and Isis were one and the same.[45] Symbols, such as the *sistrum*, or rattle, occur in Greek statues that can be identified as Isiac, and Herodotus noted clear similarities between Hellenic and Egyptian deities.[46] Others[47] have noted the occurrence of Isiac symbols in Cretan art,

33 HOPFNER (1922–25) and WITT (1971) discuss these matters at length. Although HOPFNER's work is over eighty years old, it is still a classic, and the present study owes it a considerable debt.
34 WITT (1971), 15.
35 *Ibid.*
36 *Ibid.*
37 *See also* STEINER (1980).
38 SEYFFERT(1899), 324–5. *See also* Select Glossary.
39 *See* Select Bibliography.
40 SEYFFERT (1899), 324–5.
41 *See especially Timæus.* WITT (1971), 15–16. *See also* HOPFNER (1922–5), *passim.*
42 The *Lamentations* consisted of a dialogue between Isis and her sister Nephthys during the Passion of Osiris, and were probably first written down in the third millennium BC.
43 WITT (1971), 16.
44 *Histories,* Book II, 49–51. *See also* NILSSON (1925), 10–11, and the later edition of 1949. *See also* the same scholar's *La Religion populaire dans la Grèce* (Paris: Plon, 1954), *passim.*
45 SEYFFERT (1899), 324–5.
46 *Histories,* II, 59.
47 NILSSON (1925), 10–11.

13

suggesting cross-currents between Crete and Egypt: the importance of the sea-routes in spreading cultural influences cannot be overstressed.

Realities of life in Egypt produced their own symbolism. The fruitful Nile Valley, renewed in its fecundity each year, was in stark contrast to the deserts that bordered it. The Valley was the beloved land of Isis, but the deserts were the domains of the appalling Seth (otherwise Typhœus or Typhon), Lord of Foreigners, enemy of Isis, and killer of Osiris. From the realms of Seth came death, disease, blight, eclipses of the sun and moon, and evil itself. That disagreeably oppressive hot South Wind, called the *Sirocco* or the *Mistral*, was sent from Seth's country to spread its menace over the fair lands by the northern shores of the Mediterranean Sea. According to Hesiod (*fl. c.*700 BC),[48] Seth or Typhon was a giant of enormous strength, with a hundred snake-heads. Seth represented the fire and smoke within the earth, and was master of destructive forces: he was the source of hurricanes, and was the father of the fearsome dogs Orthos and Cerberus, as well as the progenitor of the Lernæan Hydra. His abode lay beneath the earth, in dark and dreadful places.[49]

For millennia the Nile watered the lands that bore corn, palms, flax, and papyrus. The last, used for making boats and rolls on which texts could be written, was closely associated with Isis, who invented the skills of weaving and spinning,[50] who guarded boats and their crews from all perils, and who hovered protectively over those about to die.[51] After death, the overseer of the embalming ritual and the guardian of the dead was Anubis,[52] the transporter of souls, the friend and messenger of Isis. In that other Kingdom Justice was dispensed with infinite wisdom by Osiris, the god and consort-brother of Isis, just as was to be the case with the Hellenistic successor of Osiris, named Serapis.[53]

Osiris, with his sister-wife, enjoyed the most general worship of all the Ancient Egyptian gods.[54] His colour, as that of the god associated with life, was green,[55] and his sacred tree was the evergreen tamarisk.[56] The Greeks identified Osiris with Dionysus.[57] Legend has it that Osiris had ruled as a King, and introduced agriculture, morality, and religion to the world, until

48 *Theogony*, 869.
49 SEYFFERT (1899), 663.
50 GAIUS PLINIUS SECUNDUS (AD 23/4–79): *Naturalis Historia*, Books 11, 13, etc., for descriptions of the use of papyrus for decorating images.
51 WITT (1971), 16–17.
52 SEYFFERT (1899), 38.
53 WITT (1971), 17; SEYFFERT (1899), 38, 324–5, 438–9. *See also* LURKER (1984), 28 and HART (1986), 21–26.
54 SEYFFERT (1899), 438–9.
55 *Ibid.*
56 *Ibid. See also* PLUTARCH: *De Iside et Osiride*.
57 ÆLIANUS (1864–66), *passim. See also* SEYFFERT (1899), 439.

his brother Seth cruelly murdered him in a wooden chest,[58] which then was cast into the Nile. The grief-stricken Isis retrieved the chest, but Seth retaliated by cutting the body into small pieces which he then scattered.[59] These parts were collected by Isis, and his body was duly resurrected by her, although the phallus was missing.[60] This obliged the goddess to resort to parthenogenesis in order to conceive and bring forth Horus, avenger of Osiris, and mighty cosmic deity. Another version of the story involves Isis as a kite, fanning the breath of life into Osiris and being impregnated by her ithyphallic but dead brother.[61] In either version the conception of Horus, like that of Jesus, was miraculous. Osiris the Resurrected, the Invincible, possessor of the All-Seeing Eye, was also Ptah, God of Fire and Architect of the Universe, identified with Amun (Ammon), Apollo, Dionysus, the real architect Imhotep, the Apis-Bull, and finally the powerful Græco-Roman Serapis.

Worship of Serapis-Osiris was first developed at Memphis, and combined in an anthropomorphic deity Egyptian and Hellenistic attributes of Osiris and Apis (Osorapis = Serapis or Sarapis). From the time of Ptolemy I Soter the centre of the cult became Alexandria, where the *Serapeion* mentioned above, a temple of unparalleled beauty and splendour,[62] was erected by Ptolemy III Euergetes I. At the celebrated *Serapeion* not only was there a centre of scientific and medical research of an empirical nature, but 'incubation' cures (where the patient remained within the temple precincts, even sleeping therein) were also sought, similar to those chronicled at Lourdes in recent times. The transformation of the Ptolemies into deities was not only inevitable given the longevity and potency of the Isiac religion, but in turn it assisted in the spread of the Egyptian cults. Later, when the Roman Emperors became gods (nothing less would do after Egypt and its god-like monarchs had been conquered), the precedent of Egypt was powerful, and Isis enjoyed much imperial favour.

The conception of Serapis was extended in due course to include Osiris, Apis, Dionysus, Hades (Pluto), Asclepius, Zeus, and Helios.[63] Worship of Serapis, with the cult of Isis, spread rapidly from Egypt to the coast of Asia Minor, to the islands and mainland Greece itself, and finally to Rome and Italy: by imperial times, especially during the reign of Hadrian, the cults of Serapis and Isis extended throughout the Roman world.[64] Incorporation of the character and attributes of Æsculapius

58 SEYFFERT (1899), 439.
59 *See* HART (1986), 151–67.
60 PLUTARCH: *De Iside et Osiride,* 12, and *passim.*
61 HART (1986), 160.
62 SEYFFERT (1899), 578.
63 *Ibid.*
64 SEYFFERT (1899). *See also* WITT (1971), *passim.*

(Asclepius) within Serapis ensured his veneration as the god of healing,[65] and indeed serpents were particularly associated with Serapis as a beneficent deity.[66] As Zeus-Serapis, the deity is to be seen in the celebrated and colossal bust in the Vatican, with a *modius* or corn-measure, as a symbol of the abode of the dead (or of fertility in nature) on his head.[67] Images of Serapis, Isis, and Harpocrates once occurred on the abaci of the ornate Antique Ionic capitals in the church of Santa Maria in Trastévere in Rome (**Plate 31**): R. Lanciani, in *Bulletino della Commissione archeologica comunale di Roma* of 1883,[68] suggested these ornate capitals originated in the *Isæum Campense* in Rome, or from the *Thermæ* of Caracalla, and indeed their opulent style would perhaps indicate they were made in the reigns of Caracalla (Emperor AD 198–217) or Domitian (Emperor AD 81–96).[69] The strong association with Egyptian deities would point to the *Isæum Campense* as the more likely source.

The Absorption of Egyptian Religion into the Græco-Roman World

During the extraordinary fusion of religions in the Ptolemaïc period, Isis and Osiris became further merged with many deities.[70] In particular, Isis, through the range of her powers, grew in stature to be the 'most universal of all goddesses',[71] and held sway over the dominions of heaven, earth, the sea, and (with Serapis) mistress of the Other World beyond. She was the arbiter of life and death, deciding the fate of mortals, and she was the dispenser of 'rewards and punishments'.[72] During the first four centuries of our era Isiac cults became established in all parts of the Roman Empire.[73]

Ritual worship of Isis consisted of morning and evening services; of annual festivals to celebrate the spring and the beginning of the navigation season; and of autumnal rites to prepare for winter. The spring festival was held on 5 March, and involved the *Navigium Isidis*, during which a sailing-vessel, built on Egyptian lines, and decorated in the Egyptian style, was laden with spices and cast upon the sea.[74] This festival was partly in recognition of

65 SEYFFERT (1899), 75–6.
66 *Ibid.*, 578.
67 *Ibid.*, 578–9, and *see* Select Glossary.
68 LANCIANI (1883), 35, 56.
69 NIBBY (1818–20), **ii, 674.**
70 SEYFFERT (1899), 324.
71 *Ibid.*
72 *Ibid.*
73 *Ibid.*, 325.
74 APULEIUS: *Metamorphoses*, **xi**, 8–17. *See also* FIRMICUS MATERNUS (1938), 2. Apuleius gave descriptions of Isiac services, although he was coy about the Mysteries.

the goddess being patroness of navigation, inventress of sail, and protector of sailors and ships. The autumnal festival commemorated the grief of Isis and her subsequent joy on finding Osiris again.[75] Attributes of the goddess include the serpent, the *cornucopia*, the *hydreion* (vase for holy water), ears of corn, lotus, moon with horns, crescent-moon, segmental pediment, *sistrum* (rattle), and garment with knot beneath the breast (*see* Select Glossary).

Development of the cults of Isis and Serapis[76] was helped by trade, and there were certainly Isiac shrines in Rome by the beginning of the first century BC. Greek began to be used in the service of Isis from the third century BC, and cult-statues became Hellenised. Apart from the identification with Demeter (noted by Herodotus), Isis later became associated with Aphrodite, and was closely associated with the Ptolemaïc Queens (**Plate 2**). The best-preserved shrine of Isis in Italy is in Pompeii, where wall-paintings show sphinxes, Nilotic flora and fauna, the Adoration of the ithyphallic mummy of Osiris, Isis as Fortuna, Isiac ritual, dance, and legend, and the sacred symbols of the goddess. Pedimented *ædiculæ* tombstones from Greece and Italy have survived showing priestesses of Isis holding the *sistrum* and *situla* (or *hydreion*), whilst in a Roman relief Isis herself is depicted with Serapis, a bull, Jupiter, Dolichenus, Juno, the Dioscuri, and a phoenix:[77] the mixing of Egyptian elements with Roman motifs emphasises the syncretism of the Isiac cults.

The spread of Egyptian religions brought an Egyptianisation of sculpture and architecture.[78] Classical statues identified with Egyptian deities sometimes had strongly Egyptian features and head-dresses, while the left foot placed before the right (the *pharaonic* stance) was common to both Egyptian and Greek statuary. Other representations of Isis seem almost completely Hellenistic, save for the Isiac attributes of *sistrum*, *hydreion*, and head-dress with lotus (*see* Select Glossary). The fine Roman marble statue of Isis found at Pozzuoli has the *sistrum* in the right hand, the *hydreion* in the left, a fertility-knot at the breast, and a vestigial lotus-bud on the head. The Egyptian head-dress is suggested by the ringlets and drapes (**Plate 6**). Vestigial lotus-buds are often found as a form of crowning feature above the forehead (**Plate 7**), not unlike the upper *acroterion* supporting an ornament at the apex of Greek pediments. There is a head from the *Villa Adriana* at Tivoli, now in the Vatican (the features of which are entirely Græco-Roman), that has a head-dress closely derived from Egyptian prototypes, and a lotus-crown (**Plate 8**). The iconography became fixed.[79]

75 WITT (1971), *passim.*
76 TAKÁCS (1995), *passim.*
77 Illustrated in WITT (1971), plates 31–33.
78 *See* ROULLET (1972), *passim.*
79 *See* ROULLET (1972), 93.

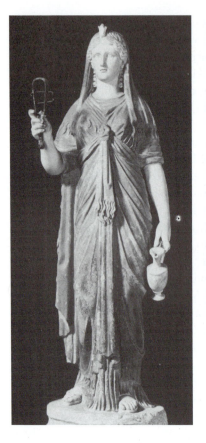
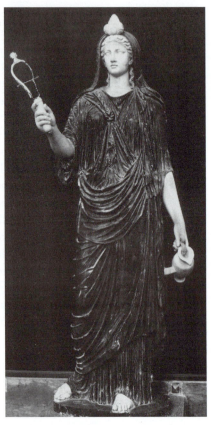

Plate 6 *A Roman marble representation of the Egyptian goddess Isis, found at Pozzuoli. In the right hand is the* sistrum *(rattle), and in the left is the* hydreion, situla, *or vase, for holy water. Fertility is represented by the knot on the breast of the goddess. An Egyptian head-dress is suggested by the ringlets of hair and the drapes, and the connections with Egypt are made overt by the vestigial lotus-bud set above the forehead. Now in the* Museo Nazionale, Naples (MC, Mansell/TimePix).

Plate 7 *Another Roman representation of Isis with her attributes of* sistrum, hydreion, *and* lotus-crown (MC, Mansell/TimePix).

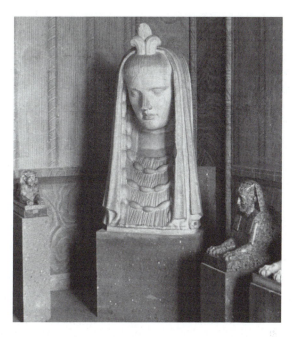

Plate 8 *The goddess Isis re-interpreted. The face is completely Græco-Roman, but the head-dress still suggests the Egyptian prototypes, whilst the lotus-bud growing from the head emphasises the Nilotic origins. This fine head, now in the* Museo Greg. Egizio *(No. 73), is of white marble, came from the* palæstra *of the* Villa Adriana *at Tivoli (discovered in the sixteenth century), is a Roman or Alexandrian creation, and was drawn by Étienne Dupérac (c.1525–1601), Pighius van Campen (1520–1604), and Cassiano dal Pozzo (c.1588–1657), among others. The sphinxes on either side are Roman, and are of granite. Photograph of 1980 (JSC).*

Isis and Osiris were usually worshipped near each other,[80] and the same was true of Isis and Serapis. There were the celebrated Ptolemaïc temples of Isis and Osiris at Philæ, and there was a temple of Isis in the *Serapeion* at Delos, built by the Athenians in about 150 BC. Dedications are known to 'Isis, Mother of the God'.[81] The Egyptian goddess, in spite of being identified with Greek deities, was refreshingly different compared with the Olympians, and her qualities appealed to civilised Greeks and Romans who were no longer enamoured of the barbarities and licentiousness of their more traditional deities. She became associated in her capacity as Mistress of the Heavens with the moon, and so became identified with Artemis/Diana. Isis was seen as Pallas Athene, as Persephone, as Demeter, as

80 WITT (1971), 18.
81 *Ibid. See also* MÜNSTER (1968), 158.

Aphrodite/Venus, and as Hera.[82] The Egyptian goddess was Queen of earth, of heaven, and of hell.[83] As a moon-goddess she was Artemis/Diana,[84] goddess of chastity, and ruler of the mysteries of childbirth and/or procreative cycles.[85] Her son, Horus, became Apollo himself. Isis, in her catholicity, was astonishing.

In terms of imagery, however, the statues of Artemis of Ephesus are rather more startling, for they incorporate a curious necklace-like assemblage of egg-like objects that have been thought to suggest motherhood and fecundity, or even breasts. Anatomically, the many breasts are impossible, and are represented on some coins as eggs, although they reappear as breasts in Renaissance and later imagery. Breasts, fountains, and eggs have iconographical significance as symbols of rebirth and fecundity, and Artemis/Diana was identified with Isis as a mother-goddess. The cult-statues of Artemis of Ephesus were sculpted with the suggestion of a wrapping of the body, rather like the binding of an Egyptian mummified corpse, whilst the wrappings were decorated with the heads of horned animals, suggesting both the hunt and the cows' horns of Isis (later symbolised by the lotus-flower or -bud). Heads of such cult-statues had either wide-spread drapes or decorated moon-like discs suggesting halos. One of the finest surviving examples of such strange images was made in the second century AD for the Emperor Hadrian's villa at Tivoli, and is now in the Vatican (**Plate 9**).

We know that there were Oriental architects such as Apollodorus of Damascus (*fl.* AD 98–123) in Rome from Trajan's time, and Hadrian, it would appear, had both Asiatic and Egyptian artists in his service. In the early years of the Empire there seems to have been a ferment of intellectual activity as well as a widespread eclecticism in artistic matters stimulated, no doubt, by the geographical and cultural diversity under the rule of Rome. Egyptian portraits showing faces with great dark eyes painted on wooden panels and set in the mummy-wrappings during the Roman period are familiar images to haunters of museums where there are Egyptian collections: the fact that the style of these portraits is also found in primitive Christian paintings as well as in decorative themes that passed from Egypt to Rome cannot be overlooked. Oriental and Egyptian religions exerted such a powerful influence on Rome that even the appearance of the deities altered: Jupiter became horned Ammon, and Diana became the Syrian of Ephesus with her many 'breasts', now thought to be either eggs on threads, or the testicles of sacrificed animals.

82 SEYFFERT (1899), 325.
83 WITT (1971), 20.
84 *Ibid.*
85 *See* XENOPHON of Ephesus's novel (*c.* AD 100–150), *The Ephesian Story of Anthia and Habrocomes.*

Plate 9 *Artemis/Diana of Ephesus, mixing Græco-Roman and other traditions. This deity was identified with Isis as a mother-goddess, goddess of the Moon and Night. The horned animals around the body suggest the cows' horns of Isis, whilst the wrappings suggest the bindings of an Egyptian mummified body. The disc behind the crowned head suggests a halo. This replica of the celebrated cult-statue in Ephesus, with its symbols of fecundity, dates from the second century AD, and came from the* Villa Adriana at Tivoli. *The egg-like forms gave the statue the name* multimammiam, *or many-breasted, but they are not breasts, and are clearly shown hooked on to a necklace: they are probably the testicles of sacrificed animals, although another interpretation is that they are eggs. Now in the* Galleria dei Candelabri *in the Vatican, Inv. 2505. Photograph of 1980* (JSC).

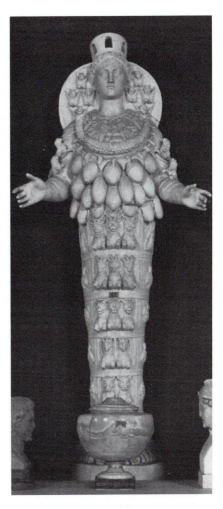

During the Roman Republic there appears to have been a *Serapæum* in the third century BC at Ostia (which was only a few days' sail from Alexandria), and there was an important cult-centre for Isiac worship in the *Campus Martius* in Rome for the last two centuries before the establishment of the Empire, so the cult of Isis was by no means confined to Egypt even then: there had been shrines of Isis in Rome at the time of Sulla (*c.*138–79 BC), and Isiac altars had existed on the Capitoline hill during the first century BC. When the Roman Empire established its ascendancy over the ancient land of Egypt, and Roman Emperors followed Hellenistic precedent by identifying with deities, Egyptian custom was absorbed and continued. The apotheosis of the Emperors to the status of gods is clearly linked with the Isiac religion, and when Octavian established the Empire Isis was already well entrenched in Italy.

Life, all life, was sacred in Ancient Egypt. Isis herself, by her reconstitution and resurrection of Osiris, and through her instructions for his worship, was the founder-teacher of Egyptian religion, and revered as such in Italy. Her association with Artemis/Diana (see the tondo of a silver *patera* from the Boscoreale treasure in which emblems of Diana and Isis appear)[86] was strengthened by the idea that Artemis became Bast (Bastet), the cat-goddess, when she fled to Egypt.[87] Bast was an important deity, with her chief temple at Bubastis, and, most significantly, her symbol and musical instrument was the *sistrum*. The route for pilgrimage to her shrine was the Nile itself. When Isis became Hellenised, the attributes of Bast-Artemis were taken over by her. Many Roman *sistra* are decorated with representations of cats, and many such examples have been found at Pompeii. Isiac temples in Italy were embellished with paintings and mosaics representing flora and fauna associated with Egypt, so that they, as well as architectural features associated with the Alexandrian deities, became familiar to worshippers. The *sistrum*, of course, was well-known, as was another Egyptian symbol, the *ankh*: the Christian symbol of the Cross would seem to owe much to the *ankh* sign, with the horns on top of the *ankh* anticipating the halo around the head of Christ. Indeed, when Christian mobs destroyed the *Serapeion* at Alexandria this Isiac symbol was recognised as a Crucifixion sign, and as a prophetic emblem that looked forward to the triumph of Christianity.[88]

Obelisks

Augustus removed the first obelisk by sea to Rome. From that time further Egyptian obelisks were either shipped to Rome, or made by Romans in the Egyptian style, using Egyptian granite. Fourteen obelisks still stand in Rome alone, re-erected on their present sites from Renaissance times.

The visitor to Rome can hardly fail to notice the presence of so many Ancient Egyptian obelisks (some inscribed with hieroglyphs, and some plain) that grace major public spaces of the city. Connected symbolically both with the sun and with notions of a ruler's temporal power, monolith-obelisks, brought to Rome from the Delta area of Lower Egypt, served as expressions of divine radiance and political clout, and were re-erected on the *spinæ* of circuses, in front of temples or tombs, or used as the gnomons of giant sundials.[89]

86 WITT (1971), plate 36, and *passim*.
87 *See* HOPFNER (1922–5), 81, 23.
88 BRADY (1935), discusses this matter.
89 IVERSEN (1968) and HABACHI (1978, 1984). *See also* CURL (2000a and b).

One of the first Egyptian obelisks to be brought to Rome under Augustus was that of Sethos or Seti I (1290–1279 BC) (XIX Dynasty) which stood at Heliopolis. It was re-erected in 10 BC, with a dedication to the sun, at the eastern end of the *spina* of the Circus Maximus (which had close connections with the sun cult: the passage of chariots around the *spina* was likened to the movement of planets around the sun, a point emphasised by the Romans who fixed gilded globes at the tops of the pyramidions that capped obelisks). This red-granite obelisk was rediscovered in 1471, excavated in 1587, and re-erected in the Piazza del Pòpolo in 1589 by order of Pope Sixtus V (1585–90) under the direction of Domenico Fontana (1543–1607). The present elliptical form of the Piazza, and its embellishment with sphinxes and Egyptianising lions, was designed by Giuseppe Valadier (1762–1839)[90] (**Plates 10 and 11**).

Fontana is more celebrated for having organised the re-erection of the huge obelisk of red granite in the Piazza di San Pietro in 1586. Dating from the time of Nectanebo II (360–343 BC), and erected by Ptolemy II at Alexandria, this monument had been brought to Rome by order of Gaius Julius Cæsar Germanicus (AD 12–41), known as Emperor (from AD 37) Caligula, and was set up in the *Circus Gai et Neronis* where many Christians, according to legend, were martyred. The obelisk was still standing to the south of the Basilica of San Pietro during the Middle Ages, and so, as a 'witness' to so much suffering, was even associated with the crucifixion of St Peter (and thus was known as *Pyramis Beati Petri*). Its importance is emphasised by its prominent new position in front of the huge new church.[91]

Another large inscribed obelisk (again of red granite), this time from Karnak, dates from the time of Tuthmosis III (1479–1425 BC – XVIII Dynasty), and was moved first to Alexandria in AD 337 under Flavius Valerius Constantinus (*c.*AD 272/3–337, Emperor Constantine I [the Great] from 323). In 357 it was moved again to Rome under Constantius II (ruled 337–61), where it was put up on the *spina* of the Circus Maximus. It appears to have been toppled and broken in the sixth century, and lay under a deep layer of earth throughout the Middle Ages (though its existence was known). Disinterred in 1587, it was re-erected under the direction of Fontana in 1588 in the Piazza di San Giovanni in Laterano (**Plate 12**), where it stands today.[92]

At the top of the Spanish Steps (*Scala di Spagna*), in front of the church of Santissima Trinità de' Monti, stands an obelisk of red granite (**Plate 13**). It was brought to Rome uninscribed, and acquired its hieroglyphs in Italy,

90 DEBENEDETTI (1979) and MEEKS (1966). *See also* CURL (1999, 2000), 695–6.
91 ROULLET (1972), 68.
92 IVERSEN (1968), 128–141, ROULLET (1972), 70–71, and CURL (2000*a* and *b*).

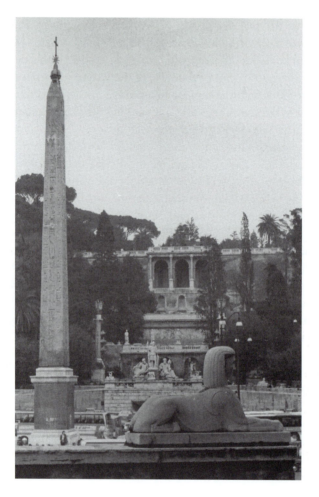

Plate 10 *Egyptian red-granite obelisk in the Piazza del Pòpolo, Rome, originally brought to the city from Heliopolis by Augustus in 10 BC to commemorate the subjugation of Egypt, and erected, with a dedication to the sun, at the eastern end of the* spina *of the Circus Maximus. The obelisk was still upright in the early mediæval period, but fell before Leon Battista Alberti rediscovered it in 1471. It was excavated in 1587, and was removed to its present position in 1589 by order of Pope Sixtus V (1585–90). On the west and east sides of the Piazza are curved walls with groups of Neptunes and Tritons, and of Roma between the Tiber and the Anio: sphinxes decorate these walls. The Egyptianising features and ramps were designed by Giuseppe Valadier in 1816, and completed in 1818. Photograph of 1980 (JSC).*

copied from those of the obelisk now in the Piazza del Pòpolo. It appears to have been set up in the Gardens of Sallust at some time between AD 79 and 360 (it was mentioned by Ammianus Marcellinus [c.AD 330–95], the last great historian of the Roman Empire), and still stood in the eighth

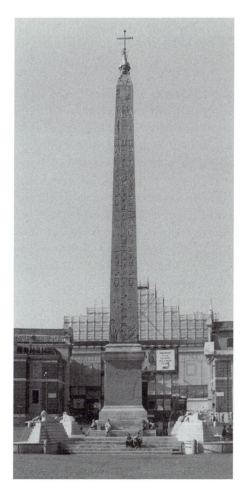

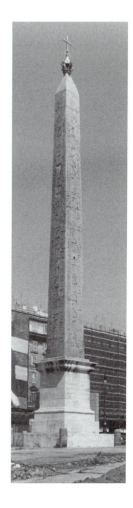

Plate 11 *The obelisk in the Piazza del Pòpolo, Rome, showing its Egyptianising base. Photograph of 1999* (JSC).

Plate 12 *Ancient Egyptian inscribed red granite obelisk re-erected in 1588 in the Piazza di San Giovanni in Laterano, Rome. Photograph of 1999* (JSC).

century. It was re-erected on its present site in 1786–9 under the ægis of Pope Pius VI (1775–99) by Giovanni Antinori (1734–92), who had to site it taking into account a complicated system of vanishing-lines of perspective in relation to the church, the Spanish Steps, and the axes of streets that converge on the space in front of the church. By rotating the pedestal on which the obelisk stands, Antinori successfully incorporated the monument into a complex geometrical network, and achieved a solution visually comfortable from just about every angle.

Now the copied (or 'spurious') hieroglyphs are significant, for they demonstrate that there was a desire to *suggest* Egyptianising 'authenticity' by adding inscriptions to unadorned objects. Given that to copy the hieroglyphs, however crudely, from the obelisk brought to Rome under Augustus and re-erected in the Circus Maximus would have been more difficult once that object had been set up vertically, the possibility exists that the text was cut shortly after the obelisk now in the Piazza del Pòpolo had arrived in Rome (i.e. 10 BC),[93] that is *before* it was placed in position.

The case of the 'Sallustian' obelisk is interesting, since Pius VI was fully cognisant of the importance of antiquities, not only for propaganda as expressions of power and prestige (in this he followed Sixtus V and the Roman Emperors from Augustus himself), but also as objects of study (he founded the Vatican's first public museum of antiquities, the Museo Pio-Clementino). As we shall see, Pius VI added three antique obelisks to the seven that already stood in Rome, and he played a vital part in reviving interest in obelisks throughout the Western world.[94]

Other obelisks include the uninscribed red-granite examples, of Roman workmanship, originally erected on the façade of the Mausoleum of Augustus, one of which now stands (since 1587) in the Piazza del' Esquilino to the north-west of the Basilica of Santa Maria Maggiore (where it was placed by Fontana on the orders of Sixtus V), and the other (discovered in 1781 and re-erected 1783–86) in the Piazza del Quirinale between the Antique marble Horse-Tamers (**Plate 14**). Mention should also be made of the red-granite inscribed obelisk from Heliopolis (XXVI Dynasty – Psammeticus I), brought to Rome in 10 BC, and erected as the gnomon for a sundial in the Campus Martius: it was put up on its present site in the Piazza di Montecitorio in 1790–2 (**Plate 15**).[95] These last two obelisks were erected by Antinori for Pius VI: the Quirinale group is both the centrepiece of the Piazza and the culmination of a long vista (thus demonstrating Antinori's mastery of urban scenic composition); and the Montecitorio obelisk was erected near the spot where it was excavated, so in the latter case archæological reasons prevailed over scenic considerations in the choice of site.

Mention will be made below of the great *Isæum Campense* which once stood near the Pantheon in Rome.[96] Numerous objects have been recovered from its site, including obelisks. The red-granite obelisk from the entrance-court of the *Isæum* was later (in the fourth century) removed to the Circus

93 ROULLET (1972), 71–2.
94 For Pius VI and obelisks, *see* COLLINS, J. (2000): I am grateful to Mr Howard Cattermole for this reference. *See also* CORBO (1972) and CURL (2000a and b).
95 IVERSEN (1968), ONOFRIO (1967).
96 *See* Select Glossary.

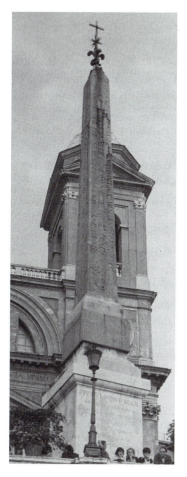

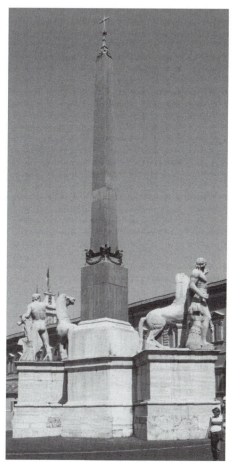

Plate 13 *Red granite obelisk in front of the church of Santissima Trinità de' Monti, inscribed with its hieroglyphs in Italy. Photograph of 1980 (JSC).*

Plate 14 *Roman obelisk from the Mausoleum of Augustus erected between the Antique Horse-Tamers in the Piazza del Quirinale in 1786. Photograph of 1999 (JSC).*

Maxentius, but now stands in the Piazza Navona (once, as its shape suggests, a circus[97]). It is Roman work with a hieroglyphic inscription in honour of Domitian (81–96), and the obelisk was re-erected in 1649 (**Colour Plate IV**) as part of the *Fontana dei Fiumi* (fountain of the rivers) (1648–51), designed by Giovanni Lorenzo Bernini (1598–1680), who, in 1667, set up

97 Called the *Circus Agonale*, or Circus or Stadium of Domitian. The name 'Navona' is said to be derived from the *agones* or contests which took place in the Circus. The great church of Sant' Agnese in Agone (from 1652), by Girolamo (1578–1655) and Carlo (1611–91) Rainaldi and Francesco Borromini (1599–1667), stands on the western side of the Piazza. St Agnes was the virgin martyr who died in *c.*305 by being pinned through the throat with a sword, but the *in Agone* simply refers to the location of the church, and not to her martyrdom or pain.

another inscribed red-granite obelisk (this time an Egyptian piece of the XXVI Dynasty, originally from Saïs, which stood on the *dromos*[98] of the *Isæum Campense* after it was brought to Rome), found in 1655, on the back of a carved elephant in the Piazza della Minerva outside the main door of the church of Santa Maria sopra Minerva (**Plate 50**). This very curious design is derived from an illustration in the *Hypnerotomachia Poliphili* of Francesco Colonna (1433–1527), published in Venice in 1499 by Aldus Manutius (1450–1515), an important book that includes descriptions of hieroglyphs and of many buildings of Classical Antiquity: although a work of imagination, it drew on Antique literature, and the woodcuts remained influential for long afterwards (**Plates 40** and **41**). Not far from Santa Maria sopra Minerva stands yet another red-granite obelisk, also from the *dromos* of the *Isæum Campense*, but originally from Heliopolis (XIX Dynasty). It now embellishes the fountain of 1575 in the Piazza della Rotonda in front of the Pantheon, where it was placed in 1711 by order of Pope Clement XI (1700–21) (**Plate 16**).

The following obelisks also deserve mention: that in the Giardino del Lago, Borghese Gardens (1790) – of red granite, uninscribed, of Roman workmanship, provenance not known; the specimen at the Villa Cælimontana (1817) – of red granite, inscribed, XIX Dynasty, from Heliopolis, once erected on the *dromos* of the *Isæum Campense*; that in the Viale dell' Obelisco in the gardens on the Pincio (1822) – of red granite, of Roman workmanship, with a hieroglyphic text in honour of Hadrian and Antinoüs, originally set up on the tomb of Antinoüs between AD 130 and 138; and the example in the Viale delle Terme (1925) – of red granite, inscribed, XIX Dynasty, from Heliopolis, erected on the *dromos* of the *Isæum Campense*.[99] Thus seven surviving standing obelisks have pharaonic inscriptions, two have inscriptions of Roman emperors (one with pseudo-hieroglyphic texts), and the remaining ones are uninscribed.[100] These large objects and the number of them demonstrate how they were prized by the emperors, while the great numbers of Egyptian items that were collected and transported to imperial Rome testify to a widespread interest in things Egyptian.[101] Of course there were many more obelisks standing in Rome of which only a few can be mentioned here: two red-granite obelisks of the time of Rameses II (XIX

98 Straight, formal avenue of great magnificence, lined on either side with columns, sphinxes, statues, obelisks, etc., leading to a holy of holies, and associated with courts, porticoes, and colonnades on both sides. At the *Isæum Campense* (which Apuleius mentions in *Metamorphoses*) the *dromos* provided the formal axis linking the *Isæum* to the *Serapeum*, Isis the Great Goddess with Osiris the Resurrected, the Invincible. For Serapis (or Sarapis) *see* ENGELMANN (1975) and HORNBOSTEL (1973), the latter an especially comprehensive study of artefacts associated with that deity.

99 CLAYTON (1982), 9.

100 *Ibid.*

101 *See* ROULLET (1972).

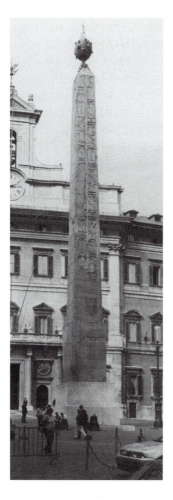

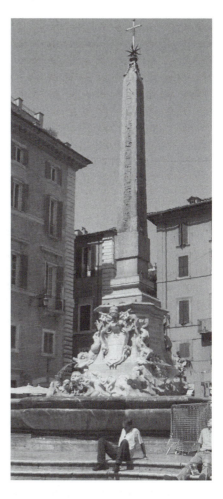

Plate 15 *Ancient Egyptian obelisk from Heliopolis now in the Piazza di Montecitorio. Photograph of 1999 (JSC).*

Plate 16 *Obelisk from the* dromos *of the* Isæum Campense *set up in 1711 over the sixteenth-century fountain in the Piazza della Rotonda. Photograph of 1999 (JSC).*

Dynasty) from Heliopolis set up on the *dromos* of the *Isæum Campense,* one from 1790 in the Bóboli Gardens, Florence, and the other from 1739 in the Piazza del Duomo in Urbino; a red-granite obelisk with Roman imitation hieroglyphs, originally set up in front of the temple of Æsculapius, erected in the third century AD on Tiber Island, and now in fragments in the *Museo Nationale,* Naples, the Louvre in Paris, and Munich; and a black-granite Roman creation in the Egyptianising style, inscribed with a copy of linear New Kingdom or later hieroglyphs, which does not taper like a real obelisk – it is now in the *Museo Archeologico* in

Florence. All in all there seem to have been at least eight large and some forty-two smaller obelisks in imperial Rome.[102]

The *Isæum Campense*

Once Egypt had been subjugated and incorporated within the Roman Empire, Egyptian religious cults and artefacts began to be fashionable, and temples of deities such as Isis and Serapis were built in numbers. This was also prompted by the embarrassing fact that the emperor, having defeated divinities in the form of the Egyptian rulers (even though these were Greek by then), could hardly remain a mere mortal, so the emperors were deified thereafter. Isis, in the words of Dr Witt, became the 'goddess darling of Roman Emperors'.[103] Augustus was the Beloved of Isis and Ptah, and offered the Egyptian goddess wine and myrrh in the Isiac holy of holies at Philæ. Tiberius, too, is depicted in Egypt sacrificing to Horus, Hathor, and Isis, whilst Caligula encouraged the cult of Isis, imported a large obelisk to beautify Rome,[104] erected an Egyptianising building on the Palatine, rebuilt part of the *Isæum Campense,* and emphasised his Egyptian sympathies by deifying his own sister.[105] Under Claudius Isiac cults grew in importance, and many funerary monuments of the period record priests and priestesses of Isis. In the reigns of Galba (AD 68–69), Otho (69), Vitellius (69), and Vespasian (69–79) Isis appeared on the coins of Alexandria. Vespasian and Titus (Emperor 79–81) spent the night before their Triumph in the *Isæum* in Rome, and Otho, among other emperors, publicly worshipped the Egyptian goddess.[106] By the time of Vespasian (who performed miraculous cures in the name of Serapis) the imperial and Isiac cults had become intimately associated, and both he and his son Titus (who had participated in the consecration of the Apis-Bull at Memphis) were familiar with Egyptian architecture and cults. Domitian (AD 81–96) owed his life to the goddess, and in thanksgiving comprehensively reconstructed the huge *Isæum Campense* in Rome, enlarged and beautified during the next century, and further restored and embellished under Marcus Aurelius Severus Alexander Cæsar (222–35). This vast complex (some 220 by 70 m) consisted of a huge court (35 by 65 m), entered from the east and west, in the centre of which was an obelisk. To the south of this court was a semicircular construction leading to a *Serapæum* (where Serapis was venerated), and at the north end

102 ROULLET (1972), 43–5.
103 WITT (1971), Chapter XVII. *See also* TAKÁCS (1995), 71–129.
104 Described by GAIUS SUETONIUS TRANQUILLUS: *De Vita Cæsarum, Claud. 20.*
105 WITT (1971), 223–4. *See also* TAKÁCS (1995), 71–129. The building was probably the *Hermæum.*
106 SUETONIUS.

of the long *dromos* was the *Isæum* (*see* plans in the Select Glossary). The semicircular southern ambulatory leading to the *Serapæum* (now under the church of San Stefano del Cacco) was an arrangement not unlike the ambulatory with radiating chapels in larger mediæval churches. Part of the complex lies beneath the sanctuary of the church of Santa Maria sopra Minerva (itself an amazing association with a goddess identified with Isis), and there were large triumphal arches leading to the court of the *Isæum* from what is now the Via di Santa Caterina da Siena and the Piazza del Collegio Romano. One of these monumental entrances is shown on a coin of the Emperor Vespasian, and the pediment is segmental: the entrance also appears on a funerary relief from the tomb of the Haterii, now in the Vatican, and was in the form of a triumphal arch inscribed *Arcus Ad Isis* in the pediment of which Isis-Sothis was seated side-saddle on the back of a dog (Anubis?).

Now the segmental (rather than triangular) form of the pediment is unknown in Classical architecture before the first century of our era. It is particularly associated with Isiac cults partly because of its resemblance to the crescent-moon of Isis, Queen of Heaven, and the bow of Artemis/Diana, the Virgin Goddess, with whom Isis was closely identified. In the celebrated mosaic from the Roman temple of *Fortuna Primigenia* (also closely identified with Isis) at Palestrina (the Roman *Præneste*), one of the most ancient towns in Italy, the theme of the segmental pediment recurs. Although much of this temple now lies beneath the cathedral, the mosaic was removed, and is now in the museum there. Isis was identified in Greece with Tyche, Goddess of Chance, often represented with a *cornucopia*, with a rudder as the pilot of destiny, and with wings and ball as emblems of her variability. Thus Roman *Fortuna* was also Isis, and the mosaic features Nilotic scenes, with Egyptian animals and plants shown in their natural habitat. The date of this mosaic (**Plate 17**) has not been established, but it appears to have been made some time during the first century AD. In it, the Nile is depicted flowing from the mountains to the Delta lands, inundating Egypt, and there are three structures (clearly temples or shrines) with *segmental* pediments (**Colour Plates V** and **VI**).[107]

This segmental shape appears to have had a particularly exotic significance for the Romans, and can be traced back to Egyptian sarcophagi-lids and to the symbolic shape of the moon, and must be interpreted as having Isiac connotations. The buildings shown in the mosaic with segmental pediments are similar to mausolea near Ostia which was a known centre for the Alexandrian cults: segmental pediments clearly were associated with the Isiac cult, and are among the most lasting legacies of an

107 GILBERT (1942), CURL (1994a), 18–36, and VOS (1980).

Plate 17 *The celebrated mosaic from the temple of* Fortuna Primigenia *at Palestrina, showing the inundation of Egypt by the Nile. Animals include a sphinx, a camel, a rhinoceros, serpents, various apes, hippopotami, and other Nilotic creatures. An Egyptian temple (Thebes?) with pylons and statues of Osiris, is shown on the right, while other temples and shrines have segmental un-Egyptian pediments, and these segmental forms suggest the crescent-moon of Isis: they are unknown in Classical architecture before the first century AD. The segmental-pedimented temple on the left has a crescent-moon set on the top, and there are two obelisks set up before the portico. A cult-statue is carried on a litter beneath the segmental pediment on the bottom right.* Fortuna Primigenia *was closely identified with Isis* (MC, Mansell/TimePix)

Egyptianising religion and culture in the Græco-Roman world. However, it was not only symbolism that promoted segmental pediments, for we know that the curved roofs and segmental pediments shown in the mosaic belong to an old tradition in Ancient Egyptian wood-and-reed buildings which entered the Classical language of architecture via Ptolemaïc Egypt.[108] The allusion is also made in certain other first-century AD Roman wall-paintings such as that at Pompeii recorded by Charles Heath (1785–1848) and

108 MEYBOOM (1995), 248, Note 83.

published as Plate LX in the 1852 edition[109] of *Pompeiana: the Topography, Edifices, and Ornaments of Pompeii* by Sir William Gell (1777–1836) and John Peter Gandy (later Deering [1787–1850]), first published in 1817–19, which was, for many years, the standard work on the excavations then in progress. As the Gell-Gandy text states, the pediment of the temple (which they erroneously associated with Bacchus) was 'singular, from having a curved pediment', and the building (a prostyle tetrastyle[110] Ionic temple similar to those depicted in the Palestrina mosaic) was 'guarded in the Egyptian manner, by sphinges'. Quite so, but what they failed to notice was the crescent-moon above the pediment and the fact that the crocodile devouring a *putto* fixes the site as Nilotic (**Plate 18**). As Pompeii was overwhelmed by the Vesuvian eruption of AD 79, it is clear that the association of the segmental pediment with Nilotic, Egyptian, and Isiac subjects occurred slightly earlier than thought by, for example, Pierre Gilbert.[111]

The segmental pediment, because of its clear Egyptian allusions, unsurprisingly was a common feature in Isiac temples (**Colour Plates V** and **VI** and **Plates 17, 18, 19**): the *Isæum Campense* not only had a segmental pediment over its main entrance, but the form was repeated on the pediments over *ædiculæ* (**Plate 19a and b**). Gilbert[112] has pointed out the frequent use of the segmental pediment in shrines of the early-imperial period, and that this form of pediment was increasingly used in Classical architecture from the second century AD. Later, of course, segmental alternating with triangular pediments became common architectural motifs (**Plate 43**).

The cemetery of *Isola Sacra* that served the town of *Portus Augusti* during the second and third centuries AD contains a number of mausolea, usually constructed of *opus reticulatum*, or of brick, or of combinations of these, with vaulted roofs expressed by segmental pediments over the façades.[113] Significantly these date from a period during which the worship of Isis and Serapis flourished. Surviving mosaics from the cemetery feature the *Pharos* (lighthouse) and other Isiac attributes. Isis was not infrequently found in Pompeian *lararia* with the household gods, and, in particular, she appeared in the guise of *Fortuna* to watch over daily life. There cannot be any doubt that, of the 'mystery' religions in Italy before the destruction of Pompeii in the reign of Titus, the most popular were those of Isis and Serapis. Roman artists and architects regarded the segmental pediment as an appropriate form to use in association with the Egyptian mysteries, and the bow-like segment was seen as specifically Isiac.

109 GELL and GANDY (1852), 171–2. *See also* TRAN TAM TINH (1971), *passim.*
110 With four Ionic columns forming a portico at the front. *See* CURL (1999, 2000), 157, 522, 661–2.
111 GILBERT (1942).
112 *Ibid.*
113 TOYNBEE (1971), 82–7 and 134–8.

Plate 18 *Engraving by Charles Heath showing 'paintings at the Temple of Bacchus', Pompeii,* *published in* Pompeiana. The Topography, Edifices, and Ornaments of Pompeii *(1852) by Sir* *William Gell and J. P. Gandy. The temple is 'singular, from having a curved pediment. It is guarded* *in the Egyptian manner, by sphinges', and the pediment is crowned by an Isiac crescent-moon: the* *temple is Ionic prostyle tetrastyle, just like those shown in the Palestrina mosaic. A crocodile devours* *the figure in the centre and there is a palm-tree to the left, so the scene is deliberately Nilotic, and the* *temple is that of Isis. It is therefore quite clear (since Pompeii was overwhelmed by the eruption of* *Vesuvius in AD 79) that the association of segmental pediments with Egypt and with Egyptian deities* *is earlier than Pierre Gilbert's hypothesis that the segmental pediment was first used in Classical* *architecture in the second century AD by Roman imperial builders (JSC).*

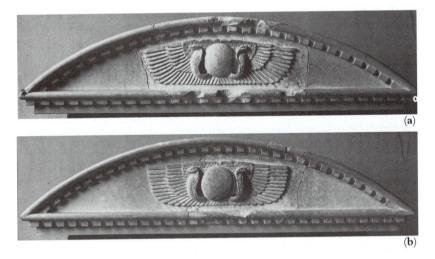

Plate 19 (a, b) *Segmental pediments with winged globe and* uræi, *and dentils, probably the crowning* *features of ædicules or niches. They are Roman work in the Egyptianising style from the* Isæum *Campense in Rome. Segmental pediments were intended to suggest Egypt because of their resemblance* *to the crescent-moon of Isis, and they were also associated with Diana (crescent-moon and the hunting-* *bow): they appear in Classical architecture for the first time in the first century AD (ÄM, SMB,* 16785–16786).

Plate 20 *Marble* antefixa *of Roman design and workmanship. That on the* left *was probably from the temple of Demeter-Isis at Ostia, and is now in the* Museo Greg. Egizio *(No. 94) in the Vatican. That on the* right *probably came from the* Isæum Campense *in Rome, and is also in the* Museo Greg. Egizio *(No. 96) in the Vatican. Both have rearing* uræi *on either side of a lotus-bud over which is a disc. An* antefixum *very similar to these was found by Athanasius Kircher in the seventeenth century among the remains of the* Isæum Campense *in Rome, was exhibited in his celebrated Museum, and was illustrated in his* Œd. Æg., III, p. 61: *it was also drawn by Cassiano dal Pozzo, and has been described by Vermeule in* The dal Pozzo-Albani drawings of Classical Antiquities in the Royal Library at Windsor Castle *(see Select Bibliography).* Antefixa *are architectural elements set over cornices to cover the ends of the junctions of roof-tiles, and are found in Greek and Roman architecture, but never occur in Ancient Egyptian architecture. Egyptianising* antefixa *were embellished with* uræi, *crowns, lotuses, papyrus, and other* Echt-Egyptian *motifs to adorn Hellenistic and Roman temples dedicated to Isis, Serapis, and various Egyptian deities (ME, Inv. 22860–22861, MV, Nos 94 and 96, AF.XXXII.8.6).*

The architecture of the *Isæum Campense* alluded to Egypt in a deliberate way. Even the *antefixa* (architectural components unknown in Ancient Egyptian buildings) were embellished with *uræi* and other Egyptian motifs (**Plate 20**), and once crowned the cornices of the great *Isæum*. Similar *antefixa* adorned the temple of Isis at Ostia.

Sculptural and pictorial representations of rivers recur in imperial times. The allegorical Nile group, now in the Vatican (**Plate 21**), may be inspired by a Hellenistic original, but it is Roman work of the second century AD. It was discovered under the church of Santa Maria sopra Minerva in 1513, and originally stood in the *Isæum Campense* near a statue of the Tiber and one of the obelisks. Many fragments and objects from the

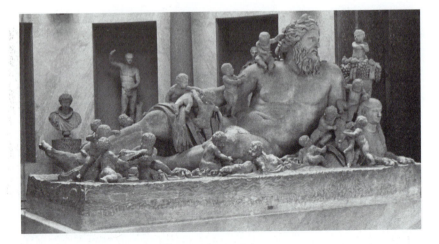

Plate 21 *Colossal statue of the Nile, discovered in 1513 under the church of Santa Maria sopra Minerva in Rome, which is built over part of the* Isæum Campense: *the statue was probably set up in the great temple of Isis, one of the grandest of all Roman imperial temples. The river-god is shown with a Romanised sphinx by his left elbow and a crocodile at his feet. The sixteen* putti *playing around the god represent the sixteen cubits associated with the level of flooding of the river, and the cornucopia (a symbol of fruitfulness and plenty) shows the harvests made possible by the waters of the Nile (and therefore by the copious tears of the Great Goddess Isis). The base has stylised waves carved upon it, and there are some lively reliefs of Nilotic flora and fauna. The work is Roman of the second century AD, perhaps inspired by a lost Hellenistic original, and is in the* Braccio Nuovo *in the Vatican. Photograph of 1980 (JSC).*

Isæum Campense survive, including the segmental pediments with *uræi* (**Plate 19a** and **b**), part of a frieze or cornice of rearing *uræi* (**Plate 22**), a marble capital in the Egyptianising style (**Plate 23**), and the spectacular grey-granite columns now in the *Museo Capitolino*, Rome, and in the *Museo Archeologica* in Florence. These columns are of several types, but the most interesting are those creations in the Egyptianising style that depict Isiac processions around the bases, with figures on pylon-like pedestals carrying Canopic vases and other objects. The *Isæum* was adorned with obelisks, statues of Horus, Isis, and Serapis, sculptures of the Hathor-cow, *naöphorus* figures, sphinxes, baboons, and much else recorded by Anne Roullet in her *Catalogue Raisonné*.[114] There can be little doubt that the *Isæum Campense* was one of the richest repositories of Egyptian and Egyptianising elements in Rome, if not in Italy, and it has provided an incomparable legacy of beautiful and curious examples of how the Egyptian style influenced design in imperial times. It was still a place celebrated for its beauty and grandeur as late as 410.

114 ROULLET (1972).

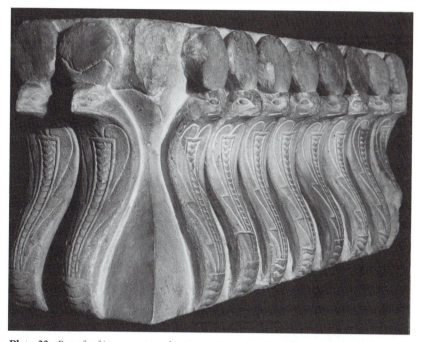

Plate 22 *Part of a frieze or cornice of rearing* uræi *carrying discs from the* Isæum Campense *in Rome: it is Roman work of white marble in the Egyptianising style, and owes nothing to Classicism* (ÄM, SMB, 16784).

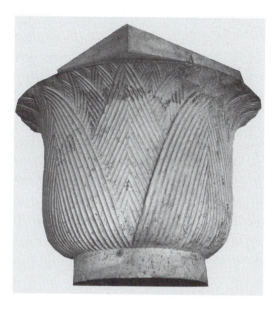

Plate 23 *Luna marble capital from the* Isæum Campense *in Rome. A Roman version of a papyrus capital, found near the church of Santa Maria sopra Minerva in 1852, and now in the* Museo Greg. Egizio, Rome (ME, No. 77, MV, AF.XXX.II.18).

Like Egyptian temples, the *Isœum*[115] was surrounded by walls, and the architecture was a synthesis of Hellenistic, Egyptian, and Roman styles. The closest model for the complex appears to have been the *Serapeion* at Memphis, which consisted, basically, of two temples linked by a straight *dromos* embellished with obelisks and Egyptianising statuary, including lions, crocodiles, and sphinxes. Something of the extraordinary richness of the *Isœum* can be understood from the array of artefacts from it that are now in collections in Rome and elsewhere,[116] or form parts of churches and other buildings. Unquestionably, this *Isœum* was of world importance, and made Rome a centre of Isiac religion just as it was later to be a centre for the Christian religion. Lucius Apuleius, in the eleventh book of his *Metamorphoses*, has left us one of the most remarkable and moving accounts of religious experience to survive from Classical Antiquity, and made it quite clear how kind and beneficent was Isis. Lucius arrived at Rome with the greatest desire to make his prayers to the 'Sovereign Goddess Isis' whose temple was called after the place where it was built (that is, *Campensis*), and 'continually adored of the people of Rome'. Lucius frequented the sacrifices of Serapis, which were carried out by night, and in due course the Great God Osiris appeared in his own form: at midnight the sun shone with unparalleled radiance; gods celestial and gods infernal became visible; and things fell into an ordered and beauteous whole.

Thus the huge *Isœum* was a temple of singular richness, and its array of Egyptian and Egyptianising sculptures would have encouraged a familiarity with the Nile style.[117] Furthermore, the Alexandrian deities were worshipped in temples that were readily accessible from the market-place: Vitruvius commented upon this fact that perhaps partly explains the popularity of Isis among the common people.[118]

While Christianity was being established in the Roman Empire, the cult of Isis was claiming many converts, and in Italy exerted a powerful influence. There are tombs in the *Via Appia Antica*[119] that can be positively identified as Isiac, and Egyptianising religion became established in the holiest of places: from being a powerful goddess in the Egyptian pantheon, Isis became a deity of world stature.[120] The widespread honour in which Isis was held ensured that images of the goddess and of her attributes proliferated. An Isiac altar of Roman workmanship, now in the British Museum,[121] shows the Apis-Bull with the Isiac crescent-moon on his side

115 *See* CURL (2000a), 56–61.
116 ROULLET (1972), *passim.*
117 WITT (1971), 87.
118 VITRUVIUS: *De Architectura*, **i**, VII. However, Isis was by no means the goddess of the underdog: she was adored by all classes, and both sexes.
119 CURL (2002c), 48, 50. Some have *sistra* and other attributes on them.
120 WITT (1971), *passim.*
121 *Ibid.*, plates 47–50.

repeating the shape of his horns, an Egyptianising offerant flanked by Nilistic fauna and holding a *naos* (the offerant is probably a *naöphorus*), a worshipper crowning himself with roses (very Isiac), and two priests, one with a scroll, and the other with a *flambeau*. It is abundantly clear from altars, statuettes, mosaics, ornament, *cippi*, coins, and other artefacts that Isis, Horus-Harpocrates, Serapis, Nilotic flora and fauna, and Isiac emblems such as the serpent, crescent-moon, cows' horns, and *sistrum* were familiar throughout the Græco-Roman world.

Pyramids

Obelisks and many Egyptian and Egyptianising artefacts and architectural details have been mentioned above. One of the most instantly recognisable and powerful of Egyptian forms to be adopted in Europe was the pyramid, and pyramidal tombs were known in the Græco-Roman world, although many have been destroyed. Small pyramids of steep pitch were built in Egypt at Abydos, and, during the New Kingdom, sharply pointed pyramids were placed on top of tombs. In late-pharaonic times, and during the Ptolemaïc and Roman periods, even as late as AD 300 or so, pyramidal tombs were built in the Sudan, especially at Napata and Meroe in Nubia. These late pyramids are quite small and have steeply-pitched sides at 65°- 70°, quite unlike the earlier gigantic pyramids of the Gizeh type, and it would appear that Nubian temples and pyramids were of more significance to Classical architecture than is generally realised. During the Ptolemaïc period there was a renaissance of pharaonic art in which traditional motifs were revived, notably the pyramidal tombs, and new Egyptian temples were built more as free-standing objects set in their own precincts, like Græco-Roman temples.

Of course mausolea with stepped pyramidal roofs were erected by the Greeks: examples are the Lion Tomb at Cnidos and the great Mausoleum at Halicarnassus.[122] However, the tower-tomb at Hermel in the Lebanon (first century BC) consists of three stages: the lower has angle-pilasters; the second has four pilasters on each face; and the third is a pyramid with steeply pitched sides.[123] The best-known of the pyramidal Roman tombs, of course, is that of Caius Cestius, of the time of Augustus, which stands on the line of the Aurelian Wall near the *Porta Ostiensis* (**Plate 24**): it is of the steeply-pitched type, very similar to Nubian pyramids in pitch and size. There was another Roman pyramid in the necropolis on the Vatican Hill, known as the *Meta Romuli* during the mediæval period: it was larger than the pyramid of

122 CURL (2002*c*), 28–32.
123 *Ibid.*, 60, 62.

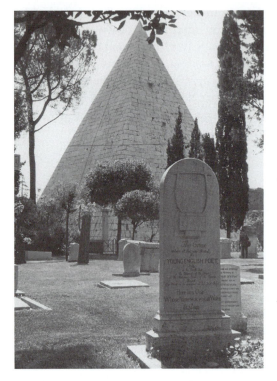

Plate 24 *The pyramidal tomb of Caius Cestius, of the time of Augustus (c.12 BC), standing outside the Aurelian Wall near the Porta San Páolo, formerly the* Porta Ostiensis. *It was known in the mediæval period as the* Meta Remi, *and was restored in 1663: it was one of several Antique pyramids erected in Rome. This structure is of brick-faced concrete covered with marble blocks, and it stands, a 'stranger among strangers', like a sentinel, by the Protestant Cemetery, Rome. The grave of John Keats (1795–1821) is in the foreground. Photograph of 1977* (JSC).

Cestius, and stood until it was destroyed in the sixteenth century. It is shown in a view of Rome in *Cronica cronicarum ab initio mundi usque ad annum 1493* (the *Nürnberg Chronicle*) sited between the basilica of San Pietro and the Mausoleum of Hadrian (*Castel Sant' Angelo*),[124] and it also appears (with the Cestius pyramid) in a miniature by Pol de Limbourg in *Les Très Riches Heures du Duc de Berry*.[125] Some writers[126] have shed doubts on whether or not Roman pyramids were designed in imitation of Egyptian types, as the Roman varieties are more slender and 'stand midway between an obelisk and a pyramid',[127] which is not really accurate: Egyptian pyramids were known to travellers, after all, and a pyramid is a strong architectural form, easily described and recorded. Pyramids at Jebel Barkel near Meroe and other late examples in Egypt and Nubia could have been more pleasing to Græco-Roman sensibilities than the squatter proportions of the Gizeh type, and, in any case, the steeper pyramid of the Cestius pattern was favoured by the Ptolemies. Pyramidal tombs and monuments were erected in places throughout the Roman Empire: there is a fine example in Vienne in France.

124 Illustrated in ROULLET (1972), plate LXXXV.
125 Fol. 141 v., in the *Musée Condé*, Chantilly, illustrated in ROULLET (1972), plate LXXXIII.
126 PEVSNER and LANG (1956), for example.
127 *Ibid.*, 218.

Epilogue

Pyramids and obelisks, then, were familiar in the Rome of the emperors, many of whom were devoted Isiacs. It has been noted above that Domitian rebuilt the great *Isæum* in the *Campus Martius*, but he also reconstructed and enlarged the *Isæum* at Beneventum in *c*.88, where he was depicted in pharaonic garments: obelisks at Beneventum were described with acclamations affirming Domitian's immortality, and the Emperor was identified with Serapis/Osiris incarnate. Indeed, Domitian built generously for the Egyptian deities, and he was clearly inclined to the Nilotic religions.[128] At his villa at Monte Circeo Domitian created an Egyptianising setting: an Osiris Canopus and a pharaonic statue have been found on the site.

It is clear that, even by the end of the first century AD, Egyptian religion and artefacts permeated the Roman Empire, and were familiar throughout that Empire. The numbers of Egyptian and Egyptianising artefacts that survive attest to this, even today, and the obelisks (mentioned above) that grace public spaces in Rome emphasise the all-pervading presence of Egypt outside Egypt and in the heart of the Empire itself. A few hours spent in the Vatican and other great European collections will be sufficient to persuade the most sceptical of how singularly important was Nilotic culture and religion in Antiquity. The memorable and beautiful statues of Isis and Antinoüs are reassuringly Classical, but on occasion the sensibilities can be subjected to some images that can shock: the god Bes, for example, could never be regarded as attractive, despite his undoubted popularity, yet he recurs, and images of him were made in quantity in the Egyptianising style in Italy and elsewhere. For the present writer, the most extraordinary statue to survive from Antiquity has to be that of the Egyptian deity Anubis, completely Classical in every respect, including the drapery, but with the head of a jackal, the disc on a crescent-moon placed between his ears: the figure (which represents either the deity or a priest) carries on its left arm the Wand of Hermes or *caduceus* of Hermes/Mercury with whom Anubis was identified, so represents *Hermanubis*, the complete assimilation of Anubis within the Græco-Roman pantheon (**Colour Plate VII**). This, somehow, is a profoundly unsettling artefact and demonstrates that the Roman Empire was not that pure Classical realm many believe, for the Egyptian religion permeated it to an extraordinary degree.

That inescapable fact, to a very large extent, has been partially suppressed until modern scholarship started to reveal the astounding and

128 WITT (1971), 234. Nevertheless, some scholars (e.g. TAKÁCS [1995], 101) have declared that this does not mean Domitian was an Isiac.

widespread prevalence of the devotion to the Nilotic deities that existed at least until the end of the fifth century of our era and, by a process of osmosis, or something very like it, survived, though transmogrified, in ways that are only now beginning to make sense.

CHAPTER II

Some Manifestations of Egyptianisms from the Time of Trajan to the Early Renaissance Period

Introduction; The Villa Adriana *at Tivoli; Egypt, Rome, and the Emperors; The Reality of Egypt in Recession; The Transformation of Isis; The Proto-Revival and The Survival of Egyptian and Egyptianising Artefacts*

Canes currentes bibere in Nilo flumine,
A crocodilis ne rapiantur, traditum est
(Tradition holds that dogs run when they drink in the River Nile,
lest they should be seized by crocodiles).

GAIUS JULIUS PHÆDRUS (*c*.15 BC–*c*.AD 50):
Fables, Book 1, Fable 25, lines 4–5.

Concerning Egypt itself I shall extend my remarks to a great length, because there is no country that possesses so many wonders, nor any that has such a number of works which defy description.

HERODOTUS (*c*.90–*c*.425 BC) translated by GEORGE RAWLINSON:
The Histories, Book II, 35.

Introduction

The Egyptianisation of Rome under the Principate proceeded apace. The *Isæum Campense* sheltered Vespasian[1] and Titus on their return to Rome, and they and their immediate successors paid due regard to Isis and Serapis. It should be remembered that any monarch claiming the highest position in Egypt, and passing through Alexandria, would be seen as the heir of the godlike Alexander the Great.[2] Domitian was the beloved of Isis and Ptah, as is made clear by the inscription on the obelisk[3] he caused to be erected during his enhancement of the *Isæum Campense*, and which is now in the Piazza Navona (**Colour Plate IV**).

Marcus Ulpius Traianus (*c.*53–117), Emperor Trajan from 98, admired Alexander the Great,[4] and was himself given the epithet *invictus*. He is known to have consulted the Oracle at Heliopolis and is shown on sculpture presenting Isis and Horus with offerings of wine.[5] The so-called 'Kiosk' at Philæ, also known as 'Pharaoh's Bed', is largely Trajanic, of *c.*AD 96, has four columns at the ends and five on the flanks, and the large stone *abaci* were presumably intended to be carved with Isis- or Hathor-heads (**Plate 25**). Indeed, the architecture of the 'Kiosk' is almost Classical, in spite of the Egyptianising detail. Philæ is not far from Elephantine, where the architecture has pronounced Classical elements in its composition (**Plate 5**). With Trajan's successor, however, Egyptianising tendencies multiplied, and evolved into true Egyptomania, for reasons that will become apparent.

Publius Ælius Hadrianus (AD 76–138, Emperor Hadrian from 117) was a remarkable man in many ways. Having stabilised the defences of the Empire, he was able to familiarise himself with his realms through his many and extensive travels, thus gaining knowledge of the topography, government, and security in the provinces. His progress through far-flung parts, accompanied by the imperial retinue, would not only impress provincials and bring the realities of central power home to them, but would enable the Emperor to become acquainted with the local elite.[6]

Hadrian, as noted elsewhere, was enormously interested in Greek culture,[7] and although that culture had been absorbed by Rome, its intellectual centre was still at Alexandria, where many of the great treasures of learning survived in the libraries.[8] Alexandria, therefore, was of singular

1 NICHOLS (1978), *passim*
2 HENRICHS (1968).
3 ERMANN (1893), 213.
4 SYME (1958), **ii**, 770–1.
5 WITT (1971) 235. *See also* SUETONIUS (1923).
6 HALFMANN (1986).
7 PIGANIOL (*Ed.*) (1965).
8 RITSCHL (1838).

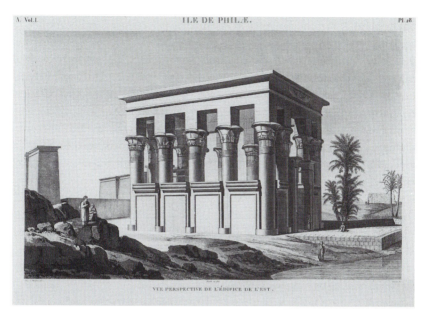

Plate 25 *The so-called 'Kiosk' of Trajan, also known as 'Pharaoh's Bed', on the Island of Philæ, an essay in Romano-Egyptian architecture, begun under the Emperor Trajan (AD 98–117), and left unfinished. The capitals are of the papyrus type, and the spaces between the columns are filled to about half the height of the shafts with walls (plutei), a motif that was employed by many Neo-Classical architects (St George's Hall, Liverpool [1839–54], by Harvey Lonsdale Elmes [1814–47], Charles Robert Cockerell [1788–1863], and Robert Rawlinson [1810–98], has plutei). The abaci above the capitals have become enlarged blocks, presumably intended to be carved with Hathor- or Isis-heads. On the left are the pylon-towers of the temple of Isis (From Description, A, Vol. 1, pl. 28, GB/SM).*

importance as a link between the Hadrianic present and a Greek cultural past: indeed, it was a metropolis in which a great and rich past could be understood, studied, and assimilated.

Just as eighteenth-century European gardens of allusion[9] drew on a vast range of styles and eclectic motifs to suggest variety and stimulate ideas about different countries, periods, and cultures, so Hadrian, fully aware of the diversity of the Roman Empire and the significance of Alexandria as a means by which so much that was of value in the study of Antiquity in his own day, saw possibilities in gardens and architecture to create mnemonics that would bring the past and certain places to mind.

Hadrian also understood the importance of conserving and restoring ancient buildings and sites of cultural significance: in this respect, it was

9 CURL (1997).

under his ægis that the *Serapeion* in Alexandria was restored and beautified,[10] but that was not the only project of restoration and beautification he instigated and encouraged. So Hadrian was intellectually curious, with a mind that was open and wide-ranging: he was, in many respects, a Prince of the Enlightenment many centuries before the eighteenth-century phenomenon of the Europe of the *philosophes*. And just as eclecticism was regarded as indicative of an open mind during the Enlightenment, Hadrian's interest in mystery religions, exotic artefacts, astrology, and, especially, things Egyptian, was an essential part of his tolerant, civilised, cultured, and intelligent personality.[11]

That Hadrian wanted to know how the world worked, understood that civilisation cannot be created on a *tabula rasa*, and recognised that the richness of the past can inform the present, are facts that are beyond dispute. What is also clear is that, as Emperor, his example could prompt fashions, and that his interest in Egypt encouraged a general enthusiasm for things Egyptian as well as a demand for objects made in the Egyptianising style.[12] However, fashion alone, and aping Hadrian in particular, can hardly explain why the whole of Western Europe and the Roman colonies in the East were flooded[13] with a predilection for things Egyptian. Vidman[14] claimed that this phenomenon was because of Hadrian's special liking for the Egyptian religion[15] but others have disputed this, and have denied that depictions of Hadrian and his wife (from 100), Sabina Augusta (died *c.*136 or 137), as Serapis and Isis would indicate that the imperial couple were cult initiates: rather, they have suggested, this merely provides evidence of the continuation of a Ptolemaïc tradition in which the monarchs were identified with Egyptian divinities.[16]

Be that as it may, it is arguable that the vast Empire governed by Hadrian was less Roman, more Græco-Roman, and Græco-Roman with a strong Egyptian flavouring: it was really a mélange of Hellenistic, Roman, Greek, Ptolemaïc, Egyptian, and Middle-Eastern cultures, more a variety of Eastern Mediterranean cultural soup that the Classical Roman civilisation so simplistically believed for so long.

And the Egyptianising tendencies of Hadrian, despite those in denial of reality, were obvious in one of the most stupendous creations of his reign. It is time to consider that wonderful complex.

10 BEAUJEU (1955), 230 and *passim*.
11 *See* BOATWRIGHT (1987) and HANNESTAD (1988) for discussions on Hadrian, imperial policy, Roman art, and the city of Rome. *See also* SYME (1965).
12 VIDMAN (1970).
13 '*überschwemmte*'.
14 VIDMAN (1970), III.
15 '*Vorliebe für die ägyptische Religion*'.
16 TAKÁCS (1995), 107.

The *Villa Adriana* at Tivoli

As was indicated above, the *Isæum Campense* provided a great many of the Egyptian and Egyptianising artefacts that grace the collections of numerous museums today, although the Vatican Museum had the pick. However, as Anne Roullet has pointed out,[17] it is 'hardly possible to write about Egyptian monuments of Imperial Rome without mentioning' the *Villa Adriana* at Tibur (Tivoli) near Rome,[18] for the Egyptian and Egyptianising artefacts which Hadrian collected to adorn the huge complex of his 'villa' (a misnomer if ever there was one) are among the most important examples of the Roman 'vision of Egypt' in imperial times. Hadrian had visited Egypt in 117 and had seen the great city of Alexandria, the important town of Canopus, and Saïs, among other places, which must have played some part in prompting his ambitious scheme to create an Egyptianising element in the grounds of the vast pleasure-palace at Tibur (the term *villa*[19] does not really conjure up what this enormous and exotic series of buildings and gardens actually was). Indeed, the *Villa Adriana* was really a series of episodes (most of great grandeur) within a 'garden of allusions'.[20]

The Egyptian Canopus was a town situated on the same tongue of land as Alexandria, about fifteen miles distant, as Strabo noted, at the mouth of the Canopic (or Canobic) branch of the Nile, adjacent to the Canopic canal. Before the foundation of Alexandria, it was the principal harbour of the delta, and the ancients placed it at the boundary between the Continents of Africa and Asia. It was the seat of the important cult of Zeus-Canopus, and the much-frequented shrine and oracle of Serapis was situated there, revered equally by Egyptians and Greeks.[21] The canal of Canopus was supposed to have been spectacularly beautiful, and at one end of it was the celebrated temple of Serapis and Isis.

At the *Villa Adriana* the Canopus *Serapæum* was commenced in 118, intended to evoke the Egyptian original. It was designed as a long, straight canal (*Euripus*)[22] and was clearly intended to allude to both the sacred and the profane. At one end of this canal was a vast semicircular sanctuary with a *Serapæum*, an arrangement very similar in its geometry to the *Isæum Campense*. Around the canal was a colonnade carrying an entablature[23] that

17 ROULLET (1972), 49.
18 WINNEFELD (1895), *passim*.
19 The Latin word *villa* suggests a rural dwelling associated with an estate, varying in character from a working farm to a luxurious country-house, often built solely for pleasure. *See* HORNBLOWER and SPAWFORTH (*Eds*) (1996), 1599, and RUFFINIÈRE DU PREY (1994), *passim*.
20 CURL (1997), 325–42.
21 WILLIAM SMITH (*Ed.*) (1870), **i**, 561. *See also* TAKÁCS (1995), *passim*.
22 *See* plan in the Select Glossary.
23 Entire horizontal mass of material, carried on columns, pilasters, or statues (essentially a lintel spanning a gap between supports). *See* Select Glossary.

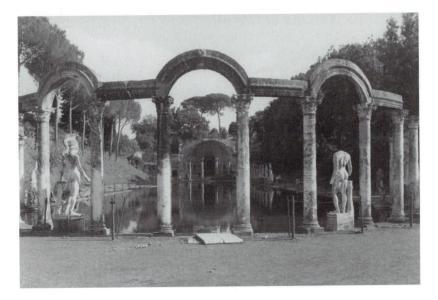

Plate 26 *The* Canopus *at Tivoli, looking towards the* Serapæum. *Photograph of 1999* (JSC).

was sometimes horizontal and sometimes in the form of a semicircular arch, carried on columns, *caryatids*,[24] and *telamones*[25] (**Plate 26**).

As the Emperor's biographer, Spartian, relates,[26] Hadrian created 'in his villa . . . a marvel of architecture and landscape-gardening; to the different parts he assigned the names of . . . buildings and localities, such as the *Lycæum*, the *Academy* . . ., the *Canopus*, and *Temple*, while in order that nothing should be wanting he even constructed a representation of *Tartarus*'. At Tivoli Hadrian indulged his eclectic tastes by building copies of admired architecture in the Empire, for, as noted above, he was well travelled and came to know Egypt well.

Along the sides of the Tivoli canal, in niches within the *Serapæum*, and in sundry *ædiculæ*,[27] were numerous Egyptian and Egyptianising statues and ornaments, some in execrable taste, but others exceptionally fine in workmanship and design.[28] A Nilotic theme was suggested by the sculpted crocodiles and other fauna placed along the canal: other sculptures included representations of baboons, falcons, sphinxes, pharaonic figures, Egyptian

24 Carved, draped, straight, standing, whole female figures, carrying on their heads supports for an entablature (*see* note 23), used instead of columns.

25 Carved, straight, unbowed, standing, whole male figures, carrying on their heads supports for an entablature (*see* note 23), used instead of columns.

26 ÆLIANUS SPARTIANUS: *Scriptores Historiæ, Augustæ.*

27 Architectural frame around an opening, consisting of two columns or pilasters over which is an entablature (*see* note 23) with pediment. *See* CURL (1999, 2000), 8.

28 ROULLET (1972), 51.

queens, Ptah, Artemis of Ephesus (**Plate 9**), *naöphori*,[29] the colossal bust of Isis (**Plate 8**), canopic jars,[30] and an Osiris Canopus.[31]

However, the Canopus at Tivoli was not completed in its final form until 134–38, when it seems to have been lavishly beautified as a memorial to the Emperor's 'favourite' (as he has been coyly known), Antinoüs (*c.*110–30), who was drowned in the Nile during Hadrian's second visit to Egypt. The Bithynian youth's death has been claimed as a ritual sacrifice, as an accident, as suicide, and even as an act of self-worship (the Narcissus myth hovers near). Whatever the reasons for his premature death, he was extravagantly mourned by the Emperor, deified, and commemorated by means of statues, cults, shrines, temples, and festivals. He even had a new town in Egypt, Antinoöpolis, created in his memory[32] by the banks of the Nile, opposite Hermopolis Magna.

But there is a dark side to all this. It seems that, like many before and after him, Hadrian sought enlightenment in Egypt. The imperial flotilla sailed upstream to Hermopolis, the city of Hermes/Thoth,[33] who interpreted all secrets and revealed unlimited knowledge. Antinoüs's death occurred on or near the date of the commemoration of the death of Osiris, and the youth's cult was explicitly merged with that of Osiris in the city named after him. Some (e.g. Cassio Dio [*c.*164 - after 229]) have even hinted that Antinoüs's death was a substitute for that of Hadrian, intended to prolong the Emperor's life, but, again, Antinoüs had reached the age when his relationship with the older man was no longer honourable, and Hadrian's desire to maintain his ties with his youthful lover therefore would have made his position intolerable. Nevertheless, suicide, whilst a way out of an impossible situation, could also have been a last, supreme, voluntary self-sacrifice for the Emperor.

Antinoüs, deified, was commemorated in various guises,[34] but his Egyptian persona as Osiris is clear from the celebrated Hadrianic statue made for the *Villa Adriana* shortly after his death. Made of Parian marble, the statue was rediscovered in 1740 and restored. It is Græco-Roman in style, but the pharaonic stance (with left leg slightly before the right, and arms held rigidly at the sides) is Egyptian, as is the characteristic *nemes*[35] head-dress and the *shendyt*[36] kilt-like garment around the figure's middle (**Plate 27**).

29 *See* Select Glossary.
30 *Ibid.*
31 *Ibid.*
32 These events are described in BIRLEY (1998), 235–58.
33 *See* Select Glossary
34 *Ibid.*
35 *Ibid.*
36 *Ibid.*

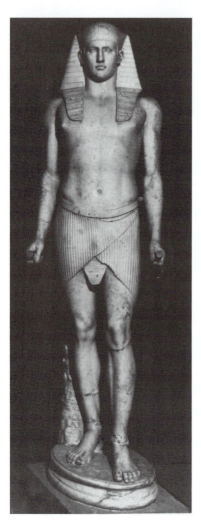

Plate 27 *Antinoüs from the* Villa Adriana, *Tivoli, a Hadrianic Roman sculpture of Parian marble in the Egyptianising style, 2.41 metres high. Note the* nemes *head-dress, clenched fists around cylinders, and positioning of the feet with left foot before the right* (pharaonic stance). *Apart from the pose,* shendyt *kilt, and head-dress, the features of the figure are entirely Græco-Roman and Classical. Antinoüs was the beloved (euphemistically referred to in most sources as 'favourite') of the Emperor Hadrian (AD 117–138), and was drowned in the Nile on a trip to Egypt in AD 129–130, allegedly in an act of self-worship. The bereaved Emperor had Antinoüs deified, founded a new city named after him, and promoted the cult of the dead youth throughout the Empire: indeed, there is evidence that Antinoüs was worshipped inside the precincts of the mighty* Isæum Campense *in Rome. Antinoüs was identified after his death with Dionysus and Osiris, and this statue was probably set up in a shrine in the* Canopus at Tivoli. *It was discovered in 1740, restored, and became a much-admired model for Neo-Classical sculpture. Now in the* Museo Greg. Egizio, No. 99 (ME, MV, AF.XXX.11.37).

Stylistically similar are the two red-granite *telamones* from the Canopus of the *Villa Adriana* at Tivoli, found in the middle of the fifteenth century, and now in a prominent position framing a doorway in the *Sala a Croce Greca* in the Vatican Museums.[37] They have lotus-flower capitals on top of their *nemes* head-dresses, and they originally functioned as columns (the male version of *caryatids*). These figures were probably derived from other Egyptianising *telamones* from the *Isæum Campense*, and very likely flanked a portal (as they do now), because they comprise a symmetrical pair, one with left foot planted before the right, and the other with right foot before the left (**Plate 28a** and **b**).

37 Inv. 196–7. *See* PAPAFAVA *(Ed.)* (1979), 45.

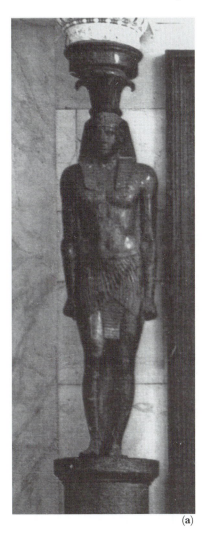
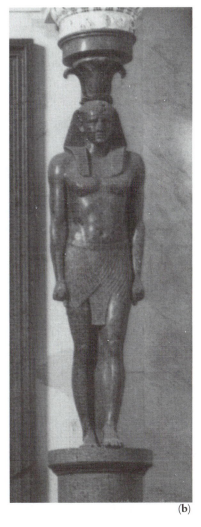

(a) (b)

Plate 28a and **b** *The two polished red-granite 'Antinoüs telamones' from the* Canopus *at the* Villa Adriana *at Tivoli, both Roman (Hadrianic) creations in the Egyptianising style. The figures are very similar to the Antinoüs type illustrated in* **Plate 27**, *except that they are crowned with large lotus-flower capitals, and they served as* telamones *(straight male figures used instead of columns, the male version of* caryatides*). They were probably derived from Egyptianising telamones in the* Isæum Campense, *and very likely flanked a portal, as they are symmetrical, one with left foot before the right and the other with right foot before the left. They were rediscovered in the middle of the fifteenth century, and were set up at the entrance to the Bishop's palace at Tivoli, where they were drawn by Giuliano da Sangallo and Baldassare Peruzzi, among others. Thereafter, they were copied very frequently. They are now in the* Sala a Croce Greca *in the* Museo Vaticano, *Nos 196–197 (MC, Mansell/TimePix).*

When these fine Antique statues re-emerged from the débris of the *Villa Adriana* they were eagerly (if not always accurately) drawn by anti-quarians and artists, including Giuliano da Sangallo (1445–1516),[38] whose version shows incorrect cushion-capitals and *shendyt* kilt-like cloths so loose they appear about to drop off. The da Sangallo drawing is doubly interest-ing because it also shows a Roman city-gate on which triangular and seg-mental pediments alternate over *ædiculæ* (**Plate 43**).

As has been noted above, the segmental pediment is a form associat-ed with Isiac shrines and temples, and appears to have been unknown in Classical architecture before the first century AD. Thus it seems to have entered the Classical language of architecture almost by stealth, and became so common that it lost all associations with Egypt, Isis, and the Nile.[39]

It is known that the Egyptianising Antinoüs figure (**Plate 27**) with *nemes* head-dress, *shendyt* kilt, and pose was copied by sculptors in Antiquity, especially after the dead youth was elevated to the status of a god: the *telamones* (**Plate 28**) aroused great interest when they were rediscovered in the fifteenth century, and the Antinoüs spawned many copies when it was found in 1740. Imperial taste doubtless encouraged a fashion that other connoisseurs followed, and Roman collectors vied with each other to build up comprehensive shows of Egyptian and Egyptianising *objets d'art*. Antinoüs recurs in mosaics, complete with Nilotic flora and fauna (**Plate 29**), and as the column-substitutes in the form of symmetrically balanced red-granite *telamones* mentioned above (**Plate 28**): the latter may have been suggested by *Echt*-Egyptian Osiride-piers, and by Egyptianising versions of these in Rome. At the *Villa Adriana* there were many eclectic elements: in the *Canopus* Hadrian created a Revival idea, and the Villa and its environs embraced a catholic selection from all corners of the Empire, something of which the œcumenically-minded Isis would no doubt have approved.[40] From the sixteenth century a profitable search for works of Antique art was instituted at Tivoli, and the ruins yielded many of the principal treasures of the Vatican, Capitoline, and other museums, including several Egyptian and Egyptianising pieces.

Some commentators[41] have tended to play down Hadrian's religious interest in Egypt, emphasising his 'intellectual curiosity'[42] and insisting that it 'was not so much his attachment' to Antinoüs, 'who happened to drown in the Nile, that made Egypt interesting to him as it was his profound inter-

38 HÜLSEN (1910a), fol. 41 d-e, 57.
39 GILBERT (1942). *See also* CURL (1994a), 18–36.
40 PARIBENI (1930).
41 Such as TAKÁCS (1995), 104–7.
42 *Ibid.*, 106.

Plate 29 *A Roman mosaic, probably copied from a Hellenistic original, featuring Nilotic flora and fauna and an Egyptianising figure similar to the* Villa Adriana *Antinoüs* (**Plate 27**). *It dates from the second century AD, and is now in the* Museo Gregoriana Profana, Rome (MC, Mansell/TimePix).

est in Greek culture'.[43] Similarly, the deification of Antinoüs and the 'naming of a newly founded city in Egypt as Antinoöpolis were products of Hellenistic modes of thinking'.[44] Others have proposed that the deification of Antinoüs was more 'a motif of artistic inspiration than an object of adoration'.[45]

There seems to be a commonly held resistance to any acceptance of the idea of Ancient Egyptian religious cults having been not only widespread in the Roman Empire, but that they were adopted by many members of the Principate. It is simply not true to assume that the Nilotic deities were adored only by the οἱ πολλοί, slaves, and women,[46] for it emerges that participants of the cult of Isis (for example) were 'from all levels of society'.[47] However, the literature is very considerable, and those who wish to pursue the matter should consult the sources listed in the Select Bibliography.[48]

There is another curious misinterpretation that seems to have coloured just about every consideration of the importance of the Egyptian

43 *Ibid.*, 105.
44 TAKÁCS (1995), 105.
45 BEAUJEU (1955), 256, quoted also in TAKÁCS (1995), 105.
46 *See*, for example, HEYOB (1975), who attempted (not convincingly) to show that women were the majority adherents of Isis. *See also* KRAEMER (1992).
47 TAKÁCS (1995), 6.
48 See especially VIDMAN (1965, 1966, 1969, 1970, 1981).

cults within the Roman Empire, and that is an assumption of the superior-
ity of Christianity as a religious and moral force. The whole point about
religion in the Empire was that it was tolerant and all-embracing, whereas
Christianity claimed to be exclusive, was essentially intolerant of all other
cults, and could not be treated in the same way as, say, the Egyptian cults,
because of its peculiar stance. The intransigence of Christians prompted
persecution, because it was perceived that there was no possibility of their
sect being advanced to a *sacrum publicum*[49] as a component of Roman votive
religion: Christians regarded themselves as superior to all other sects, and
refused to countenance any position where it would be on a par with other
cults. In short, Christianity could not and would not accommodate itself to
the pagan religious system.

The appalling destruction carried out by Christians, especially from
the fifth century, is indicative of an essential lack of tolerance and of a
fundamentalist belief in their own rightness. A comparison with the
cultural vandalism of the Taleban, or with sixteenth- and seventeenth-
century European iconoclasts, may not be absolutely off the mark. The
towering figure of Hadrian is a welcome contrast to such disagreeable
goings-on.

If Hadrian had only been interested in Egypt as a sort of intellectual
dilettante, it is very odd that he encouraged Isiac cults, erected a temple of
Isis at Petra, and established a *Serapæum* in Samaria. It is also unusual to have
one's drowned lover deified, identified with Osiris, and represented in
pharaonic stance complete with *nemes* head-dress and *shendyt* garment.
However, a connoisseur, a collector, an intellectual might amass hordes of
Egyptian objects and cause artefacts to be manufactured in the Egyptian
Taste, for, after all, there were to be many such instances of Egyptomania in
the years following the Napoleonic invasion of Egypt (1798–1801).

The *Villa Adriana* was certainly eclectic, and provided mnemonics for
parts of the Empire, but it was especially associated with Egypt (notably
with Alexandria), and Egyptian deities were represented there. If Hadrian's
interests in Egypt were purely cultural, intellectual, commemorative of
Antinoüs, and so on, why did the complex include not only a *Serapæum* but
a temple for the worship of Egyptian deities, discovered only in 2002?
Whilst the jury is still out on this one, it seems likely that, like other
emperors, Hadrian actively worshipped Egyptian gods and goddesses, and
probably his own deified lover, by then transformed into Osiris.

49 For an intelligent discussion of *superstitio* and *sacrum publicum see* TAKÁCS (1995), *passim*.

Egypt, Rome, and the Emperors

Even before the *Canopus* was constructed at Tivoli, gardens with an Egyptianising flavour had been known in Italy, and Nilotic scenes and Egyptianising statues enlivened walls and gardens in many places, notably Pompeii. Nilotic gardens of the *Euripus* type (that is with gardens, statues, and architectural features disposed along the sides of an artificial canal) had been created in the time of Marcus Tullius Cicero (106–43 BC), when they seem to have been regarded in much the same way as Gothick and *Chinoiserie* fripperies were viewed in eighteenth-century England. Such Roman gardens, for profane rather than sacred purposes, nevertheless suggested the Alexandrian deities, and appropriate high-quality images were created. The Gardens of Sallust on the Pincio in Rome were pleasure-gardens created by the historian about forty years before Christ: in the reign of Tiberius they became imperial gardens, and under Domitian and Hadrian acquired statues, an Egyptianising pavilion, and an obelisk (mentioned above).

Nearly all the Egyptian antiquities that were taken to Rome are late in date, and nearly all come from Lower Egypt. Most were removed from religious buildings, and consist of obelisks, sphinxes, lions, animal-headed deities, and other familiar motifs. As has been mentioned above, a few plain imported obelisks appear to have acquired their rather coarsely-carved hieroglyphs in Rome, possibly suggesting there were Egyptian artists, or sculptors trained in the Egyptian style, working in the imperial capital.[50]

However, Egyptianising rather than genuine Egyptian works occur in great numbers in Italy, pointing to the growing importance of the Egyptian cults and to the Egyptomania among fashionable Romans for a suitably exotic décor in private houses. It is clear that exact, or semi-exact, copies were made of real Egyptian pieces, but there were also many imitations in the Egyptian style, intended to suggest a Nilotic setting. Egyptian granites were imported for certain artefacts, but imitation stone to suggest Egyptian origins was developed to a considerable extent under the Julio-Claudians. *Postiche*, emulating the close-grained Egyptian granites, was used: the oleaginous quartzes and scintillating mica aggregates helped to produce the desired effects. *Scagliola*, imitating marble with great cunning, was an equivalent development in the Baroque period in Western and Central Europe. If anything, the imperial *postiche* was even more remarkable for its realism and hardness. Marble was used for architectural features, and could be obtained readily in Italy, but there was a considerable trade in imported Egyptian stones, including red and black granites from Aswan, for statuary, and these came by sea direct to Rome. Egyptian red porphyry was also used: and onyx

50 ROULLET (1972), *passim*.

(not used for this purpose by the Egyptians themselves) provided the eyes of statues and was exploited to add detail to real Egyptian statues undergoing refurbishment to make them more acceptable to European tastes. Coloured marbles were prized for statuary from the time of Hadrian because it was cheap and easy to cut, as well as being decorative. The *rosso antico*, as it is known (actually Greek red marble), was in particular favour, for it could be brought to a high polish, and the material would then look like a dark Egyptian stone. At least one of the Antinoüs figures from the *Villa Adriana* (now in Munich) and many other works, were made of this material. The *Villa Adriana telamones*, however, as noted above, were of red granite.[51]

Mention of Egyptianising pyramidal tombs has been made above. The Eastern part of the Roman Empire contained many ambitious tombs, some of which, like their Egyptian counterparts, were rock-cut: as was the case at Beni-Hasan and derivative Persian examples, façades were cut into the vertical faces of the cliffs, with burial-chambers behind. Græco-Roman, Semitic, and Egyptian traditions mixed on occasion, as in the Kedron Valley complex and at Petra. An architectural phantasy of the nineteenth century shows this synthesis, and includes Egyptianising cornices, pyramids, and a segmental-lidded Egyptian sarcophagus (**Plate 30**).

Numismatists cognisant with Roman coins will realise the importance of Isis and her cult.[52] The goddess appears on a coin of Antoninus Pius (138–161) with *sistrum* and dog, and on the coinage of Marcus Aurelius (161–180) she is depicted as *Navigatrix*.[53] With the reign of Lucius Ælius Aurelius Commodus (180–192), the Isiac cults achieved enhanced status, and the Emperor himself was identified with *Sol Invictus*, Hercules, and Osiris/Serapis. It is as a synthesis of Hercules and Osiris that he is represented as an ithyphallic giant at Cerne Abbas, Dorset.[54] The Emperor took the title 'Invincible' as a deliberate association with Osiris/Serapis, and his ithyphallic image recalls the magical impregnation of Isis.

Lucius Septimius Severus, Emperor 193–211, was devoted to Egypt, and was identified with Serapis, whilst his successor, Aurelius Antoninus, nicknamed Caracalla (211–217), gave the rites of Isis and Serapis enormous importance in Rome, and Isis herself enjoyed imperial patronage. Caracalla is welcomed by Isis to Egypt on coins, and identified iconographically with Harpocrates. The *thermæ* that bear Caracalla's name contained a *Serapæum* embellished with rich Ionic capitals decorated with the heads of Serapis, Isis,

51 ROULLET (1972), *passim*.
52 Some commentators have played down the significance of this.
53 On the reverse of some coins of Marcus Aurelius is an image of an Egyptianising temple with statues of Hermes/Thoth. *See* TÓTH (1976), WEBER (1910), and FOWDEN (1993).
54 *See* JOHN NEWMAN and NIKOLAUS PEVSNER (1972): *Dorset* in *The Buildings of England* series (Harmondsworth: Penguin Books Ltd).

Plate 30 *An architectural phantasy of the early-nineteenth century, showing sarcophagi in the foreground: the sarcophagus on the left has a segmental lid, and the segmental form was closely associated with Egypt in Græco-Roman Antiquity. The large mausoleum in the centre with an in antis arrangement of columns, Egyptianising coved cornice, and pyramid on top, is the so-called 'Tomb of Zechariah', whilst behind it is the 'Tomb of Absalom'. Other rock-cut tombs are shown, and the pyramids (perhaps an attempt to show the structures erected by Helena, Queen of Adiabene, in the first century AD) add a further Egyptianising touch. In the eastern parts of the Roman Empire there were many elaborate tombs where Egyptianising elements, such as coved cornices, pyramids, segmental shapes and powerful stereometrically pure forms could be found* (JSC).

and other Egyptian deities: these may be the capitals now in the church of Santa Maria in Trastévere, or they may have come from the *Iseum Campense* (**Plate 31**). In any case the heads were deliberately hacked off, apparently during a somewhat drastic renovation in 1870 under Pius IX (Pope 1846–78), which suggests, perhaps, that the Egyptianising deities were still feared for their powers, or that there may have been some other reason for such vandalism. Caracalla is represented with the *nemes* head-dress in Egyptianising statuary now in the *Museo Nazionale* in Rome and in the *Museo del Sannio* at Benevento. Caracalla also caused a temple of Serapis to be erected on the Quirinal, and its magnificence and importance made it clear that Serapis (or Sarapis) was to be given equal status to Jupiter.[55]

55 TAKÁCS (1995), 117. Takács discusses the Egyptian connections of many Emperors in her excellent book.

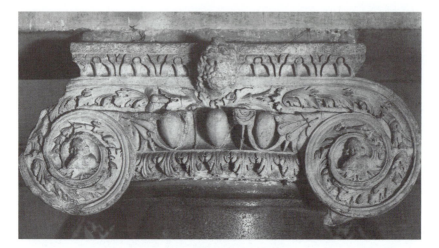

Plate 31 *Head of Serapis (with* modius *on his head) in the centre of the abacus of one of the ornate Antique Roman Ionic marble capitals on brown granite shafts now in the church of Santa Maria in Trastévere, Rome, and re-erected there when the church was rebuilt 1139–40 under Innocent II (Pope 1130–43). They probably came from the* Isæeum Campense *(sacked as late as 1084), or from the* thermæ *of Caracalla, and stylistically they would appear to date from the time of Domitian (Emperor AD 81–96), or Caracalla (Emperor 211–217). The photograph dates from before 1870, when the heads (which included Serapis, Isis, and Harpocrates) were hacked off during the Pontificate of Pius IX (1846–78), which indicates the persistence of the Ancient Egyptian deities was regarded as undesirable, and to be feared, to say the least (JSC).*

Heliogabalus (properly Elagabalus, but in reality Varius Avitus Bassianus [218–222]) imported serpents to Rome, the symbols of Horus-Harpocrates, and also collected hippopotami, a rhinoceros, and a crocodile, but his devotion to the Syrian sun-god Elah-Gabel[56] led to trouble, for the Roman Pantheon could not, at that time, be subjected to drastic change: it could *absorb* cults, but it could not be undermined or supplanted. Alexander Severus embellished Rome with statues of Isis and Serapis, and under Gaius Aurelius Valerius Diocletianus (Emperor Diocletian [284–305]) – who knew Egypt well – Roman and Egyptian deities were worshipped at Philæ, and the Nilotic gods were accorded status equal to that of the old Olympians. During the Tetrarchy Isis and Serapis adorned public buildings and monuments as well as coins, and under Constantine (306–337) – despite the adoption of Christianity as the State Religion – Isis remained on the coins, even though the Nile Cubit was removed from the *Serapeion* at Alexandria and placed in a church. Under Julian the Apostate (361–363) Isis, Horus, and

56 For discussions relating to this rather curious Emperor, who was high-priest of the sun-god, *see* BALDUS (1991), FREY (1989), PIETRZYKOWSKI (1986), and TURCAN (1985).

Anubis appeared on coins, the Cubit was returned to the Alexandrian *Serapeion*, and it seemed for a while that Christianity would be eclipsed by a revival of the status of the Nilotic deities: the Empress Helena was identified with Isis, and Julian with Serapis. The effects of Julian's short reign[57] were reversed by subsequent developments when the supremacy of Christianity was reaffirmed, and the *Serapeion* with its incomparable library and museum suffered much damage in 391, and virtually complete destruction a few years later. Yet after the Theodosian closure of all pagan temples throughout the Empire, Isis and her attributes nevertheless remained on coins long afterwards, and her connection with navigation was overtly shown,[58] emphasising her association with harbours, lighthouses, and the safety of sailors: the goddess with billowing sail and ships was a common image. Even after the demotion of Isiac festivals in favour of Christian practice, the Isiac hold on the affections of men did not perish, for celebrations connected with the sea and with navigation continued.[59]

To the worshippers of Isis, life was a journey over the seas of life, with frequent pauses in harbours, and final rest. The mediæval pilgrim, noting the labyrinth patterns on the floors of cathedrals,[60] the signs of the Zodiac, and the symbolic aspects of the journey in a large place of worship, would not have found the idea unfamiliar. Frequent pauses by images, side-altars, and reliquaries were experienced by Christian pilgrims, in much the same way in which devotees of Isis paused during their worship, although we do not know much about the existence of possible wayside shrines similar to those of the Madonna in Roman Catholic countries today. It is not improbable, however, that little *ædiculæ*, containing images of the goddess, graced corners of buildings, crossroads, and roadsides in the heyday of the Roman Empire. Processions, carnivals, and the like, with floats, are probably successors of Isiac festivals: men dressed as women (signifying the hermaphrodite and magical-sexual sides of the Isiac cults), as animals, or as grotesque monsters are survivals of the Ancient Egyptian religion. Some commentators have suggested that even the term 'carnival' may be derived from the procession of the Isiac ship-float to the harbour for the *Navigium Isidis*.[61] Quite apart from the revelry that precedes Lent in certain countries (usually where the Roman Catholic religion has a long, unbroken tradition), there appear to be many aspects of Isiac custom that survive in the Orthodox Church, including the Blessing of the Waters of the Nile, in which the river is actually named[62] and asked to rise. The Nilotic religions

57 AMMIANUS MARCELLINUS (c.330–95) is illuminating on this subject.
58 WITT (1971), plates 54–67, 240–2.
59 See WITT (1971), *passim*.
60 CURL (2002b).
61 *Carrus Navalis*, but probably from *Carnem Levare*, the putting away of flesh as food.
62 WITT (1971), 183–4 and notes, 310.

were securely established in Europe in the fourth century, and they did not simply disappear: many of their aspects were absorbed by the new religion of Christianity.[63]

Egyptian art, architecture, and religion permeated the very fabric of the Roman Empire. Some of the grandest buildings in Rome were dedicated to Egyptian deities, and Nilotic statuary, mosaics, and even buildings were known to the cosmopolitan citizens of the capital of the Western world. Manufacture of objects in the Egyptian style was widespread, and the Alexandrian deities were of immense importance.[64] Egyptianisms were on all sides, and in almost every aspect of life: Egyptian ideas entered deep into the consciousness of Romans. Such a remarkable phenomenon could hardly vanish overnight, and indeed much that derived from the Nile Valley survived long after Christianity had apparently triumphed.[65]

The Reality of Egypt in Recession

Græco-Roman writers drew much inspiration from Egypt, especially after it became part of the Roman Empire: Herodotus tells us a great deal about Egypt in his *Histories* of the fifth century BC; Diodorus Siculus (of the time of Julius Cæsar) devotes a whole book to Egypt; Strabo visited Egypt *c.*30 BC and dedicated a book of his *Geographica* to an account of his travels; Plutarch of Chæronea (*c.*AD 46–*c.*120) studied the workings of the Egyptian High-Priest Manetho of Heliopolis (*fl.* 280 BC) from which he drew the material for his important work on Isis and Osiris; Gaius Plinius Secundus (AD 23/4–79) recorded much about Egypt; and Ammianus Marcellinus of Antioch (*c.*AD 330–395) included interesting information about Egypt in his works. These writings survived the collapse of the Empire in the West, and knowledge of Egypt was preserved in written form throughout the so-called Dark and Middle Ages: during the Renaissance period they were studied anew, and given piquancy by the inaccessibility of Egypt under Islam. Indeed, Europeans who succeeded in getting into Egypt rarely got beyond Cairo, so travellers during the late-Mediæval and early-Renaissance periods mention Rosetta, Damietta, and the Pyramids of Gizeh (which were identified as the Granaries of Joseph by the Anglo-Irish Franciscan monk, Symon Simeonis [*fl.* 1322],[66] who left an account[67] of his

63 Dr Witt's remarkably interesting book has much to say on this fascinating subject.
64 *See*, for example, DUNAND (1973).
65 The Author acknowledges the generous help of Mr Peter Clayton, whose knowledge of coins and much else was of considerable help in the preparation of this Chapter.
66 Or Simeonis, sometimes *called* Simon FitzSimon.
67 It contains the first datable reference to gypsies in Europe.

journey,[68] including a description of the famous lighthouse at Alexandria, in *Itinerarium Symonis Semeonis Ab Hybernia Ad Terram Sanctam*, some five centuries before the birth of Thomas Cook [1808–92]). It is clear that the Egypt of the pharaohs had little attraction for the mediæval mind (which was only interested in allusions to Old Testament and Christian traces). To the educated Roman of the late-imperial period the Holy City was Memphis or Alexandria, and the Pyramids, the Sphinx, the *Serapeion*, and the Nile were as important as the Temple, the Holy Sepulchre, and Jerusalem were to mediæval Europeans (who thought of Jerusalem and sometimes Constantinople as the Celestial City).

Eusebius (*c*.AD 260–339), the father of ecclesiastical history, tells us much about Egypt, and Isidore, Bishop of Seville (*c*.600–636), in his *Originum seu Etymologiarum Libri* (probably the most influential encyclopædia of the Middle Ages), writes of obelisks, pyramids, and other Egyptian structures, specifically referring to pyramids as a type of tomb. Descriptions of architecture are notorious for their problems of interpretation, and mediæval ideas about Egypt were hazy in the extreme. The capture of Egypt by the Arabs in the seventh century made the country largely inaccessible to Western Christians, and consequently the architecture and art of Egypt entered into the realms of the fabulous, while the importance of Rome as a place where early-Christian Martyrdoms were witnessed grew apace. Surviving Egyptian monuments in Rome remained on view, and the obelisk near the basilica of San Pietro must have aroused considerable curiosity among those who visited the Mother Church of Christendom. This great obelisk was known as *Pyramis Beati Petri* from the tradition that it had witnessed the Apostle's Martyrdom and the torments and deaths of many Christians killed in the Circus under Nero and other Emperors.[69] A confusion between what was an obelisk and what constituted a pyramid is apparent in the title, and in the mediæval period, apparently from the eleventh century, the obelisk was thought to be the mausoleum of Julius Cæsar, whose ashes were supposed to repose in the bronze ball set on the tip of the pyramidion: in 1587 the ball was found to be empty. This was the obelisk identified by Pliny as having been erected by Ptolemy II at Alexandria,[70] and it stood throughout the mediæval period at a point east of the chapels on the south side of the basilica.[71] Other obelisks stood, but many had fallen and

68 Symon was accompanied by another Franciscan, Hugh le Luminour or Hugh Limner (the Illuminator), but the latter died in Egypt, and Symon proceeded to Jerusalem, at which point his manuscript breaks off. His *Itinerarium* was published by James Nasmith as *Itineraria Symonis Simeonis et Willelmi de Worcestre* in Cambridge (1778).

69 TACITUS: *Annals* (*c*. 116), XV, XLIV.

70 *Historia Naturalis*, XXXVI, XIV, 67–69.

71 ROULLET (1972), 67–9.

broken, many became submerged beneath rubble and vegetation, and some were built into later structures. However, enough Egyptian artefacts and descriptions of Egyptian work, with their now incomprehensible hieroglyphs, survived to keep simmering the curiosity of observers.[72]

The Transformation of Isis

Art and architecture in the Eastern Empire seem to have become transmogrified into what we now call the Byzantine style with remarkable speed, in spite of the wholesale re-cycling of Classical columns and entablatures. Paradoxically, Byzantine art kept alive many aspects of Egyptian culture, and nowhere is this more clear than in the grief-stricken *Panagia-Theotokos*, or All-Holy Mother of God, the procession of whose ikon today recalls Isiac processions at Philæ and elsewhere.[73] The Blessed Virgin, Mother of Jesus, Queen of Heaven, is abundantly merciful to those in distress, a benevolent presence in the hour of death, helper of women in childbirth, and an image of infinite compassion, pity, and love. The *Panagia-Theotokos* resembles the Græco-Roman Isis-Sophia in many ways, and it is no accident that the great church of *Hagia Sophia* in Constantinople was entrusted to the care of the Blessed Virgin.

There was a time in the history of the Church when the expressions in the Book of Canticles (*Canticum Canticorum*, the Song of Songs) were applied to the Mother of God, while in *Revelation* 'there appeared a great wonder in heaven; a woman clothed with the sun, and the moon under her feet, and upon her head a crown of twelve stars'.[74] Mary was seen as *Stella Maris*, as was Isis; Rose of Sharon[75] (roses were important in Isiac ritual, as Lucius Apuleius makes clear); the Lily among Thorns;[76] the Tower of David (Isis was a Tower, a lighthouse, as *Isis-Pharia*);[77] the Mountain of Myrrh and the Hill of Frankincense (both significantly Isiac in that they are associated with the rites of the dead, and with embalming);[78] the Garden enclosed, the Spring shut up, the Fountain sealed (springs, fountains, and gardens were also Isiac);[79] the Palm-Tree (a significantly Egyptianising motif);[80] and much else as well. She was Queen of Mercy, Mother of Mankind, our Life, Hope

72 PEVSNER and LANG (1956).
73 WITT (1971), 276–7.
74 *The Revelation of St John the Divine*, XII, 1; *Canticles*, VI, 10. These are also emblems of Isis.
75 *Canticles*, II, 1.
76 *Ibid.*, II, 2.
77 *Ibid.*, IV, 4.
78 *Ibid.*, IV, 6.
79 *Ibid.*, IV, 12.
80 *Ibid.*, VII, 7.

of All, Refuge, Help and Asylum, Propitiatory of the World, Queen of Heaven and of Hell, Dispenser of Graces, City of Refuge, Patroness, Protectress in Death (particularly Egyptian, and reminiscent of the connection between Seth and Isis), Ladder of Paradise, Gate of Heaven, Mediatrix, Omnipotent, Peacemaker, Intercessor, Advocate, Redeemer, and Saviour. Among the authorities for this catholicity of titles is none other than St Alfonso (or Alphonso) Maria de' Liguori (1696–1787), founder of the Redemptorists,[81] whose *Glories of Mary*[82] should satisfy the most curious of students of Mariolatry. St Alfonso, it seems, could resurrect the dead (as could Isis), create rain (Isis caused the Nile to flood), and fly (Isis had wings).[83] *Maria Myrionymos* is also amply discussed in the aretalogy of Hippolytus Marraccius (Ippolito Marracci [1604–75]), whose *Polyanthea Mariana* appeared in no less than eighteen books in Cologne.[84] Like Isis, *Maria Myrionymos* was *Augusta*, *Primigenia* (connected with *Fortuna* and *Tyche*), *Gubernatrix*, *Aurora*, *Exorcista*, and much else. Marraccius's *Bibliotheca Mariana alphabetico ordine digesta* is also illuminating reading for Northerners unversed in Counter-Reformation literature. Serafino Montorio's *Zodiaco di Maria*, published in 1715, tells us of a couple of hundred varieties of Madonna to be found in Southern Italy alone, a region that is arranged on the principles of the Zodiac.[85] Montorio's work is dedicated to the *Gran Madre di Dio*, who could equally well have been the *Magna Mater*, Isis, or Artemis/Diana of Ephesus herself. Quite clearly, Isis, the Great Goddess, was alive and well in Counter-Reformation Europe. Another curiosity is *Vita del Venerabile Servo di Dio Fra Egidio da S. Giuseppe Laico Professo Alcontarino*, published in Naples in 1876, which reveals that the Venerable Fra Egidio resurrected a slaughtered and dismembered cow in a butcher's shop by the simple expedient of making the Sign of the Cross with his monkish cord: this act recalls the Isiac resurrection of the parts of Osiris, and the cow, it will be remembered, is closely associated with Isis.

There are many other obscure pamphlets dealing with the lives of various Southern Saints, clerics, monks, and nuns that were published during the last two centuries, and nearly all contain Isiac overtones, or suggest most obviously survivals of an Egyptianising religion nearly fourteen centuries after Christianity officially supplanted Isis and Serapis. Flying monks and nuns, abilities to conjure and perform good magic, the creation of rain or springs, a facility to perform the resurrection of the dead, successful battles with demons in the shape of composite zoömorphic and anthropomorphic

81 Or College of The Most Holy Redeemer.
82 LIGUORI (1834–43 and 1837). He was declared a Doctor of the Church in 1871.
83 *See* CAPECELATRO'S two-volume *Life* published in Rome in 1893.
84 *See* MARRACCIUS (1648, 1710).
85 For an entertaining account, *see* DOUGLAS (1915), 256–60.

creatures (very Egyptian), and other remarkable happenings, recur. Miraculous images of the Madonna and Child with powers as impressive as those of Isis and Horus suggest a continuation of Egyptian ideas, while the association of the Madonna with grottoes, caves, and fountains recalls the cavernous *Serapæum* at Tivoli and many Isiac legends. For those who wish to pursue the literature, the sober Lutheran Theodor Trede's *Das Heidentum in der römischen Kirche*[86] is a mine of information with copious scholarly notes and references (his sources are impeccable) to support his relentless account of improbable and mysterious happenings, intelligence of which he gathered while serving as a pastor in Naples.

The veneration of Mary in the early history of the Church seems to have been regarded as heretical, or at least was discouraged, but it appears that from the fifth century her status changed, and a degree of veneration within churches seems to have been tolerated.[87] Now this is most significant. The Blessed Virgin Mary is the Sister and Spouse of God and Sister of Christ, both of which suggest Osiris/Isis/Horus; she was the Wearer of Diadems, the Fresh Tuft, and was associated with agricultural fertility as the Cornucopia of All Our Goods, all clearly Isiac in origin. She was symbolised by a young heifer (*iuvencula*), which suggests the Apis-Bull, Hathor, and the cows' horns of Isis-Hathor, and was *Medicina Mundi*, associating her most obviously with Isiac powers of healing. She was, like Isis, *Pelagus*, or the *Pharos*, shedding light in the darkness and leading us safely to harbour. She was the *Salvatrix* of sailors, like Isis, and, like her Egyptian predecessor, was an inventress and a powerful dispenser of justice. She was associated with the swallow, horned animals, and the crescent-moon, all of which are connected with Isis/Artemis of Ephesus, whose image (**Plate 9**) includes horned animals, mummy-like wrappings, a halo-like disc, and allusions to the moon, as well as the symbols of fecundity in her 'many breasts', eggs, or necklaces of testicles. She is *Nympha Dei*, and is identified with Juno, Aphrodite/Venus, Minerva, and even with Hermes/Mercury.[88] Christian writers have seen Serapis as St Joseph and Isis as the Wife of Joseph. St Jerome (Eusebius Hieronymus [*c*.347–420]) refers to the *multimammia* of the Ephesian Diana in his Preface to the *Epistle to the Ephesians*, and some commentators have naïvely (or perhaps primly) supposed that this refers to the fountains over which Diana presided, but the more correct view is undoubtedly that which treats the multiplication of 'breasts' or eggs as a symbol of the productive and nutritive powers of the goddess (and, of course, of Isis). In some contexts, however, fountains and

86 TREDE (1889–91).
87 *See* SMITH, SIR WILLIAM (Ed.) (1863), ii, 268.
88 *See* USENER (1879), XXIV, BRIFFAULT (1927), III, 184, and ROSCHER (1884–1937).

breasts appear to be symbolically interchangeable, and some fountains have water spouting from the nipples (**Plate 47**). In due course the *Mater Dei* was installed in Ephesus in the place of *Magna Mater*.

An absorption of the cult of Isis within the Christian Church seems to have begun around the time when the destruction of the great pagan temples (including the Alexandrian *Serapeion*) began under Theodosius. The fourth-century *Songs of Paulinus* do not appear to include references to the Madonna, whose *cultus* only begins to emerge after the time of Theodosius. An officially approved Christianity could hardly change the widespread worship of Isis that was already of considerable antiquity in the Græco-Roman world, but it could gradually ingest that worship, so that Isis became associated with Jesus, and her status as a great forerunner would be recognised. Yet we must beware of assuming some sudden change, some cataclysmic overthrow, some major alteration of sensibility and age-old custom. Over several centuries, the blending of religions took place very slowly, almost imperceptibly, so that images of Isis became to be regarded as those of the Madonna (the names of whom were identical to those of the great Egyptian), for after all the diadem, the palm, the infant, the moon, the rose, and much else were common to both. It is submitted that it is simply beyond the bounds of reason or possibility that a goddess so universally revered as Mistress of the World, whose awesome praises were beyond number, who was the goddess of goddesses, who was the first principle in which the elements were contained, who was the source of grace, truth, and life, who could resurrect the dead, who could bring forth a child by miraculous means without the agency of a living male, who was a supreme deity, who was the mother of God, and who was the Queen undisputed of Heaven, could have vanished overnight by some act of world-wide rejection.[89] The revered figure of Isis, the greatly loved, the most universal of all goddesses, could not have been wished out of existence. Her catholicity and her essential syncretism were absorbed within the Church, and *Maria Myrionymos*[90] appeared in the place of her Isiac forerunner. An official ending of Isiac worship did not mean that the cult of the goddess died, for, quite apart from the iconography of the Eastern Church, mediæval legend in the West included references to Isis as the Planter or Divine Engrafter, in which rôle she was identified with the conception of Christ by the Virgin Mary by, for example, Christine de Pisan (*n.* 1364), whose version of the legend was published as *Les Cent Histoires le Troye* in Paris in 1499.[91]

89 *See* WITT (1971), 269–81.
90 HOPFNER (1922–25).
91 PISAN (1499).

It was the policy of the Early Church to purify existing places of pagan worship and to re-dedicate them: the great number of churches dedicated to St Mary that stand on the sites of *Isæa* point to a deliberate containment and adaption of Isiac worship. St Augustine (354–430) advocated the Christianisation of holy sites, for he was aware of the danger of destroying hallowed shrines, and this policy must have permitted numbers of images of Isis to survive in churches. The merging of the Isiac cults with Christian veneration of the Virgin was a long and subtle process that enabled Isiac pictures and statues to remain *in situ* for a long time without causing eyebrows to be raised.[92] Isiac images could become Madonnas by stealth. The *Madonna Achiropita*,[93] as we learn from the appropriately named St Nilus, favoured purple as the colour of her garment, and was a rescuer of Mankind from plague and invasion: unlike many ikons, hers were *not* painted by St Luke (whose enormous output in this genre was miraculous), and had a strong resemblance to the ancient *Magna Mater*, whose image also had a divine origin in that it was not painted by any human agency. Byzantine images of Mary and so-called 'Black Madonnas' (signed *Lukas me pinxit* or not) are probably variations on images of Isis.[94] It also appears that a Roman statue of Isis survived in the church of St Germain-des-Près in Paris until it was destroyed in the sixteenth century, suggesting a fear of the continuing power of the goddess, and a desire to purify the church of 'non-Christian' elements. There was an Isæum on the Cælian hill in Rome on the site of which was built the church of Santa Maria della Navicella: the association of Mary with navigation is Isiac, of course, and the marble votive boat (a sixteenth-century copy) that now stands before the church makes the connection overt.[95]

The eternal renewal of the Eucharist had its parallels too in the everlasting tears of Isis, bringing constant rebirth by the banks of the Nile. The Christian religion, it might be proposed, owes as much to the Nile as it does to the Jordan, and for the Church Alexandria should be at least as important as Jerusalem (whereas Rome absorbed influences from both cities). In both Western and Eastern iconography the attributes of Isis survived. Coptic *stelai* show the Mother and Child, identified as Christian by the Greek crosses on either side of the head, but the basic iconography of the image is that of Isis and Horus, translated into Mary and Jesus. Byzantine images owe much to Ptolemaïc and Romano-Egyptianising art. In Isiac temples holy

92 WITT (1971). Dr Witt is particularly illuminating on the merging of Isis with the Blessed Virgin Mary (*see especially* his pp. 269–81 and Notes). *See also* JAMESON (1907), 1–69.

93 *Acheiropietoi* images were supposed to have been erected by angels, and so were 'untouched by human hand' (*acheiropoieton*).

94 *See* WARNER (1976).

95 ROULLET (1972), 37–8. *See also* ONOFRIO (1962), 176.

water was familiar, and the rattle of the *sistrum* was heard:[96] indeed the *crotalus*, descendant of the *sistrum*, was used in Christian churches, especially on Maundy Thursday, and was commonly heard in the Ethiopian rites. Orthodox Christianity, it must be said, lacked a female element before the time of Theodosius, and consequently must have seemed somewhat bleak and forbidding: the Madonna supplied Christianity with an important and kindly aspect it had lacked hitherto – Isis was essential as a benevolent and gentle influence, and could take many forms and adopt many names.

Artists of the mediæval period created extraordinary beasts to adorn churches, cathedrals, sculptures, and illuminated texts. Exactly how many of these fanciful monsters were influenced by Egyptian or Egyptianising exemplars is difficult to assess, but images of composite creatures were common in imperial Rome, and many survived the end of the Empire. Yet, in St Paul's *Epistle to the Romans*, Egyptian religions were denounced for giving deities zoömorphic shapes: Paul noted that pagans professed themselves to be wise, but that they became fools because they changed the glory of 'the incorruptible God into an image made like to corruptible man, and to birds, and fourfooted beasts, and creeping things'.[97] Paul could hardly have avoided knowing something of the Egyptian religions, and often used words and terms associated with the Mystery Religions. Even Tarsus, Paul's birthplace, had shrines for Isiac cults, and it is perhaps worth noting that Paul's blindness and conversion have Isiac associations in that Isis could blind those who offended her with her *sistrum*, and yet could also restore sight. Decimus Junius Juvenalis (*fl.* first half of the second century AD), according to Plutarch, mentions the wrath of Isis which could cause the goddess to induce blindness by means of a blow from the *sistrum*. Both Isis and Serapis were renowned for their powers to cure blindness.

Paul's journeyings took him to places where Isiac cults were well-established: Isis-Artemis ruled in the great Ionic temple at Ephesus (one of the Wonders of the Ancient World), and devotion to her was intense; Antioch had thriving Hellenistic religions; and Philippi was not guiltless of a devotion to Isis the Great Queen. Clearly the worship of Isis (by whatever name) was widespread, and, as the goddess of a Myriad Names, Isis was dangerous to Christianity by her œcumenical and catholic nature. In the *Acts of the Apostles* the names of many personages have Isiac overtones, as might be expected in a narrative partially concerned with the conversion of followers of other faiths to Christianity. As the Christian Church developed its rituals, terms such as *eucharistia* and *ecclesiæ* would have been familiar to devotees of Isis and Serapis, so the move from the Nilotic religions to that

96 WITT (171), 269–81, is especially interesting on the parallels, and this admirable study is recommended to those wishing to pursue the topic. *See also* FORTESCUE (1948), 308, and STEINER (1980).
97 *The Epistle of Paul the Apostle to the Romans:* I, 23.

of Christ would not have been a huge jump for an Isiac in the Græco-Roman world. With the acceptance of Egyptian deities into the Roman religious systems, a certain blurring of identities occurred (the association of Isis with Diana of Ephesus is just one example), and it was nothing extraordinary to see Isis/Diana/Hathor/Aphrodite as a prototypical Madonna. There were precedents in plenty.

This blurring continued after Christianity had become the State Religion, and the fact that Isis shares so many titles and attribute with the Madonna[98] cannot be overlooked. Isis continued to attract her devotees, and her symbols, including the lily and the fountain, proliferated, as did her names. Significantly, the cult of the Virgin Mary dates from a time very near the period of the destruction of the Alexandrian *Serapeion* and other Nilotic shrines. The Gnostics held that Isis and the Virgin Mary shared attributes, and when the dogma of the All-Holy Virgin Mother of God[99] was adopted in 431 at Ephesus (of all places), the theologians could not have been unaware of the importance of Isis and of Diana, the Great Goddess. Indeed, the Council of Ephesus, anxious to resolve the Nestorian controversy,[100] first gave official recognition to the elevation of Christ's mother, and in so doing acknowledged the position of Isis throughout the civilised world, for such an œcumenical goddess was a challenge to Christianity and its ascetic philosophies that were repugnant to many in the Empire.

The grimness of the Crucifixion and the male-dominated religion cannot have held much appeal for the devotees of Isis, and it would appear that the absorption of so many aspects of the Isiac religion by Christianity was deliberate policy, and necessary, after the closing and destruction of so many temples devoted to the Nilotic deities Christians hated so much. Isiac symbolism was taken over by the Marian *cultus*, and was to become overt on several occasions, notably in the Counter-Reformation period. It appears that the rival claims of Isis and Christ caused some friction and many difficulties that had to be resolved: in this respect the Flight into Egypt is not insignificant, for the healing powers of Jesus were ascribed to His stay in that country, the inference being that He learned his techniques from Isis herself. Indeed, so powerful was Isis that even nominal Christians were to be seen at the altar of *Isis Medica*[101] at Menouthis, near Canopus and Alexandria, when ill, rather than rely on the less accredited (and presumably derivative, therefore weaker) powers of Christ. Such a state of affairs could not be per-

98 HOPFNER (1922–25), and ROSCHER (1884–1937). *See also* the extraordinary work by MARRACCIUS (1710) on Marian attributes.
99 SMITH (*Ed.*) (1863), 259–70.
100 Pertaining to Nestorius, Patriarch of Constantinople (428–431), and to his teaching that the divinity and humanity of Christ were *not* united in a single personality.
101 WITT (1971), 186.

mitted to continue, so the *Isæum* was duly Christianised, and the relics of Christian Saints were interred within a new church that was to become important (significantly) for sailors.[102] The properties of the hallowed place as a beacon and as a source of healing could not remain in the control of the dangerous idol of female form and many guises: *Isis Myrionymos* was a mighty goddess, and had to be absorbed by the Christian religion or she would pose a permanent threat. The Neoplatonist Eunapius (*fl.* second half of the fourth century) remained unconvinced by it all, and in his *Lives of the Sophists*[103] defended the old traditions against upstart Christianity: one can imagine the ill-concealed scorn with which a cultivated pagan mind of Classical Antiquity viewed attempts to give legitimacy and a spurious historical continuity to sites recently claimed for Christianity. The church of Santa Maria sopra Minerva in Rome stands partly over the site of the once magnificent and hugely important *Isæum Campense*, and there are many examples where Christian churches were erected on sites sanctified for use by Egyptian cults. Significantly, Christian sources often cite 'dark Egyptian devils' assuming female form, and an 'odious demon' who led astray those who were ill and sought an 'incubation cure' but they are silent about the identity of the 'idol', the feared goddess. The great Egyptian, the all-powerful protean deity, the majestic, awesome, œcumenical Isis, could not even be mentioned by any of her myriad names.[104] Isis was she who arose in the Beginning, and was the greatest of magicians, after all.[105]

As Isis was the most potent source of power and wisdom in the whole Græco-Roman world, her transformation, the re-consecration of her sacred sites to Christianity, and the absorption of her best qualities by the new religion were essential to the survival and growth of the Church. In some instances Egyptian deities are depicted with Christian angels, notably in Græco-Roman jewellery (where Thoth and Anubis associate with Sts Michael and Gabriel), and John, the Messenger, the Bearer of Glad Tidings, was sometimes identified with Hermes and Anubis.[106] Horus-Harpocrates is occasionally shown as a warrior on horseback, attacking Seth-Typhon, who has been transformed into a crocodile: such images obviously affected Christian iconography, with particular reference to Sts Michael and George. Horus is also depicted in catacombs in Alexandria trampling on crocodiles,[107] and it will be remembered that both Sts Michael and George are held to have fought dragons identified with the Devil. Michael waged

102 HOPFNER (1922–3), 306, 32; 733, 18.
103 *See* EUNAPIUS, *Lives of the Sophists*, 45, in the Loeb Edition of 1922.
104 VIDMAN (1969), 403, 556a, and HOPFNER (1922–25), 732, 28.
105 BERGMAN (1968), 283, and MÜNSTER (1968), 207–8.
106 CURL (2002b) discusses this connection.
107 ROSCHER (*Ed.*) (1884–1937), WITT (1971), 214–17.

war against the dragon-serpent persecutor (who is clearly Seth) of a pregnant woman who fled to the wildernesses (as did Isis). A curious pamphlet, *Novena in Onore di S. Michele Arcangelo*, published in 1910, contains a Litany giving many titles of the Archangel Michael: these include Secretary of God, Liberator from Infernal Chains, Defender in the Hour of Death, Custodian of the Pope, Spirit of Light, Terror of Demons, Lash of Heresies, Wisest of Magistrates, Commander-in-Chief of the Armies of the Lord, Conductor of Mortals, and Custodian of the Holy Family. Here is a catholicity of titles with clear Egyptianising connotations: the idea of a sort of armed guard for the Holy Family might startle, but those familiar with the veneration shown to the oddest of objects in Southern Europe will scarcely be surprised. Abstractions are foreign there: attitudes to deities are positive and direct. An Isiac family is easier to comprehend than the Trinity, after all, and there are obvious parallels between Isis-Horus representations and those of the Madonna and Child.[108] Furthermore, Ptolemaïc Egypt exerted considerable influences on Byzantine religious imagery, for representations of the Mother and Son had been known for centuries before Christianity.[109] A merging of aspects of the Nilotic cults with official Christianity ensured a longevity of Isiac emblems.

In the Græco-Roman world Isis and other Nilotic deities were familiar from temples, private houses, public buildings, and gardens. Many *Isæa* survived, and the *Navigium Isidis* processions could still be seen, even at the end of the fourth century. Until the dawning of the fifth century many Græco-Roman families remained faithful to the Egyptian deities (especially Isis and Serapis), in spite of the advances of the new religion. Some Roman Emperors, including Caracalla, had been depicted wearing the Egyptian *nemes* head-dress, and sphinxes in pairs guarded the mausoleum of Diocletian at Spalato (Split). The great *Isæum* in Rome was probably not wholly destroyed until 1084 when the area was wrecked by Norman and Saracen invaders, but parts of the site, like other *Isæa*, were Christianised from the twelfth century, when the cults of female Saints (especially that of the Virgin Mary) expanded on an awesome scale. In Southern Europe the Holy Family (and especially the Mother) became revered. One is not aware in Italy of the adult Christ in the iconography of the period to nearly the same extent as one is of the Infant in His Mother's arms. Many early Saints were Byzantines or North Africans, even in Italy, and they replaced the local Classical pagan deities, a state of affairs that was fraught with problems. The Marian *cultus* provided means of providing an attractive universal figure who would be more powerful than local male Saints, although the latter could be useful as fight-

108 *See* JAMESON (1907), and WARNER (1976).
109 WITT (1971), 198–221.

ers and protectors. However, the cults that had developed after the upheavals of the fourth century, and especially from the sixth century, carried forward Isiac tradition, and the image of the Virgin and Child, the tradition of Horus-Harpocrates, and the Roman *Lars Familiaris* survived and prospered. Gradually, a host of Saints was replaced by a multitude of Madonnas, especially in Southern Italy: some (like Santa Maria della Libera and Santa Maria di Constantinopoli – two war-like Madonnas of clear Egypto-Byzantine origins) were notably pugnacious, but Madonnas could multiply with bacteriological ease, yet in the process would not lose power or credibility. The very catholicity of the Madonna ensured that anything could be attributed to her, and that her histories, with their mythopœic ramifications, could embrace a vast range of iconography and legend. Clearly Isis of the myriad names and countless forms remained alive and well.

When Egypt and so much of the old Hellenistic and Roman world fell to Islam, knowledge of Egypt, its arts, and monuments became confused and speculative. Apart from surviving Egyptian and Egyptianising artefacts in Christian Europe, and apart from descriptions in literature, Egyptian architecture and culture became inaccessible, remote, and infinitely mysterious. This fact, and the curiosity-value of obelisks and other items on view in Rome gave much food for thought.

Many early-Christian churches were constructed of materials looted from Roman temples and public buildings: pieces of the entablatures often came from several different buildings, so the continuous entablatures of, say, colonnades between the aisles and the nave can seem coarse and disjointed. Columns were quite frequently of different heights, so bases and capitals vary. The architectural results of such re-use of elements from older buildings are often uncomfortable, and the archæological and historical interest can exceed the æsthetic effects. The original church of Santa Maria in Trastévere was probably founded before the reign of Constantine, and completed in the fourth century. It was rebuilt by Innocent II (1130–43) in 1139–40, and consecrated by Innocent III (1198–1216) in 1198. Some fifty years after the sack of the mighty *Isæum Campense* in Rome, twenty-eight columns of dark reddish-brown granite, with Ionic capitals carved in marble (and decorated with heads of Nilotic deities), were set up in the nave of the basilica of Santa Maria in Trastévere (**Plate 31**). The re-use of capitals is commonplace in Rome, and the fact that these splendid capitals and shafts have been recycled does not point to a survival of interest in Isiac religion in the twelfth century: in fact it is quite possible that the Egyptianising elements were no longer recognised as such by the builders of the church, just as it appears the Cosmati sculptors referred to below did not recognise the sphinxes and lions they saw in Rome as having Egyptian origins at all. If the Trastévere capitals and columns did indeed come from the *Isæum*

Plate 32 *Capital and abacus of a pier in Malmesbury Abbey, Wiltshire. The repetitive palmette motif, almost identical to similar designs found in Ancient Egyptian and Greek work, decorates the abacus. This pier was associated with a statue of the Virgin Mary and dates from c.1170. Photograph of 1981* (JSC).

Campense,[110] they were only a small part of a large number of Egyptian and Egyptianising antiquities that could be seen in Rome, including obelisks, statues, Canopic jars, lions, sphinxes, at least two pyramidal tombs, Nilotic scenes in gardens, temples, and mosaics, pavilions in the Egyptian style, and much else.

There can be no doubt that the imagery of Egyptian artefacts remained an important element during the Romanesque period. Greek terracotta *antefixa,* with elementary volutes and crowned with palmettes, have their origins in archaic capitals from Larissa in Æolis (*see* Select Glossary). Similar compositions prepare us for the capital from the *tholos* in the precinct of Athena Pronaia at Delphi, with volutes and central anthemion motif, while early capitals from Neandria have volutes on either side of a motif derived from the stylised lotus (*see* Select Glossary), and similar capitals from Cyprus, Lesbos, Naukratis, and elsewhere have volutes flanking palmettes or anthemion motifs. An almost precise miniature version of this theme is repeated as a continuous frieze around the abacus of the capital of the third pier from the west in the southern nave arcade at Malmesbury Abbey in Wiltshire (**Plate 32**), where a repetitive motif

110 Santa Maria in Trastévere is discussed in *Architektonische Studien des Kais. Dtsch. Archæol. Inst.,* **iii** (1889), 77. *See also* LANCIANI, R. A. (1883): *Bulletino della Commissione Archeologica Comunale di Roma,* 35 and 56. *See also* NIBBY (1818) and GIEHLOW (1915).

featuring the palmette (here interpreted as the *fleur-de-lis*) held between two primitive volutes is continued all round the abacus. This remarkable decoration of a Romanesque building, dating from *c*.1170, is an exact derivative of an ancient Græco-Egyptian design, and, significantly, the pier was associated with a statue of the Virgin Mary that attracted great devotion until the iconoclasm that followed the Reformation: it is probably one of the earliest examples of an Egyptianising motif in England that dates from the Middle Ages.

By the twelfth century the Virgin Mary had become a figure of universal devotion throughout Christendom. One particular image recurs frequently from the thirteenth century, especially in Central European wood-carving: it is of the Virgin of Mercy, depicted with her mantle (usually coloured blue) as a shield against disasters, notably plague, famine, and war (often shown as arrows shot by God at humanity as punishments for threefold concupiscence). This sheltering cloak suggests the outstretched protective wings of Isis herself.[111]

The Proto-Revival and the Survival of Egyptian and Egyptianising Artefacts

In the thirteenth century an Egyptian Revival of limited extent took place, although it was of brief duration. The monument to Rolandino de' Passeggeri at Bologna, for example, had a pyramidal roof on an arcaded version of a tower-tomb, and although it is essentially a canopy, like a gigantic reliquary, and is Gothic, it is still basically Classical in form: a resemblance to tombs of the imperial period is obvious. The cloisters (*chiostro*) of San Giovanni in Laterano, constructed in 1222–24 by members of the Vassalletus family, are of peculiar interest in the context of this study, as there is little other Romanesque architecture in Rome because the Classical tradition survived in part, and because there was an enormous quantity of Roman work that could be quarried for use in new buildings. The oddity about these cloisters can be found in the central area of one side, where access to the *cortile* can be gained: there are four openings, one in the centre of each side, framed by double columns standing on bases that are set on wide slabs forming the top of a die or continuous pedestal. On each side of one of these openings, and carrying the stone top of the die, are two sphinxes, facing inwards: one is bearded, male, and serious; the other is female and is smiling; and both have *nemes* head-dresses (**Plates 33a** and **b**).

111 *See* WARNER (1976) on this subject.

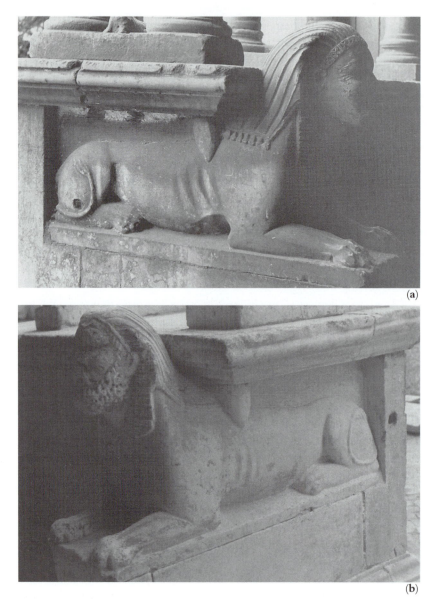

(a)

(b)

Plate 33a and **b** *Sphinxes in the* chiostro *of the basilica of San Giovanni in Laterano, Rome, of 1222–24. These were modelled by the Cosmati, and were based upon Egyptian and Egyptianising sphinxes extant at the time. The Cosmati female sphinx (**a**) has a broad smile and wrinkles of laughter around the eyes, while the male (**b**) is serious and bearded. Similar laughing sphinxes occur at the choir-screen at Civìta Castellana and at the door of the sacristy in the Cathedral at Ferentino. The Lateran pair is probably the first example of a couple of male and female Egyptianising sphinxes, a theme which does not seem to have been found in Egyptian Antiquity, but which certainly developed from Renaissance times. Photograph of 1999 (JSC).*

Egyptian and Egyptianising lions and sphinxes surviving in Rome (mostly late works from Egypt or Roman versions of Egyptian originals) were used as exemplars by Cosmati artists, who emphasised the slight and mysterious smiles on the Antique versions, so that the thirteenth-century sphinxes (and sometimes lions as well) acquired wide smiles and wrinkles of laughter around the eyes. Pairs of male and female sphinxes (as in the Lateran examples) are Revivalist rather than *Echt*-Egyptian, and were to recur with increasing frequency from the Renaissance period. Two earnest sphinxes, apparently also by Vassalletus, and of indeterminate sex, support a Paschal candelabrum in the Cathedral of Santa Maria in Anagni.[112] All these thirteenth-century Cosmati sphinxes have chests at right-angles to the bases, or lean forwards, while real Egyptian sphinxes appear relaxed, and are less likely-looking to spring out at the beholder. The somewhat primitive appearance of Cosmati sphinxes seems to be due to the difficulty of placing a human head on a lion's body, and making the sphinx seem to carry a column or a pair of columns on a slab on its back.[113] In the *Museo Civico* in Viterbo is a thirteenth-century sphinx with an Egyptianesque body, but the head is turned sideways to the left, and has a head-dress that looks like a clumsy attempt to suggest the *nemes* type: along the base (where an Antique Egyptian or Egyptianising sphinx would have hieroglyphs) is an inscription.[114] Two mutilated sphinx-bodies minus heads survive in the *chiostro* of San Paolo fuori le Mura in Rome.

In the thirteenth century the famous lions (**Plate 34**)[115] of the time of Nectanebo I could still be seen in front of the Pantheon in Rome, as a certain Magister Gregorius[116] noted in the previous century: these lions provided models for Cosmati sculptors, who fashioned a lion under the porch of the church of Santi Apostoli near the site of the *Isæum Campense*. This Cosmati lion has its head turned to the right, a round beard, crossed forepaws, and tail along the base (which is signed BASSALECTVS). The beard, ears and chin, and the rounded profile are derived from Egyptian or Egyptianising originals, and are also marked in the derivative Cosmati lions, such as those at the entrance of the church of San Lorenzo in Lucina, in the choir of the church of San Lorenzo fuori le Mura (both in Rome), at the sacristy door of the Cathedral of Ferentino, and in the Bishop's throne at Anagni.[117] Now all these lions have heads turned sideways, and have paws parallel to the main axis of the body: they derive from Antique lions in Rome, and indeed there were several Egyptian or Egyptianising lions

112 Illustrated in ROULLET (1972), plate III.
113 ROULLET (1972), 8–9 and notes.
114 ROULLET (1972), 8, and plate III, and NOEHLES (1966), 17–38, and plates.
115 Now in *Museo Greg. Egizio*, Rome, Nos 21–23.
116 G. McN. RUSHFORTH (1919): *Journal of Roman Studies*, **ix**, 14–58.
117 Illustrated in ROULLET (1972), plates IV–VII.

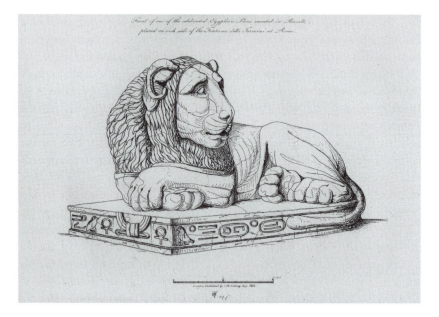

Plate 34 *One of a pair of XXX Dynasty grey granite lions from the time of Nectanebo I from either the temple of Serapis at Memphis or the temple of Thoth at Hermopolis Parva. They stood in front of the Pantheon in the twelfth century, and in the following century were models for some lions made by the Cosmati in Rome, including that in the porch of the church of SS. Apostoli. Rediscovered in 1435, they were set on pedestals in front of the Pantheon in the 1530s, and in 1586 were moved to the Acqua Felice, Piazza di San Bernardo, where they functioned as water-spouts until they were removed to the Vatican Museum and replaced by copies. Charles Heathcote Tatham drew them when he was in Rome (1794–6), and published them. From TATHAM (1826) (JSC).*

known in the mediæval period that could be copied. The Cosmati were also engaged to erect an obelisk on the Capitol during the thirteenth century: they took the upper part of an obelisk from the *Isæum Campense*, added part of a renovated granite column, and placed the whole on a pedestal incorporating four lions modelled on Hellenistic originals. Of course the lions and sphinxes copied with such obvious delight by the Cosmati were not necessarily identified by them with Egypt, but rather were more likely to have been associated with the past in general, and with Antique Roman architecture and sculpture in particular.

Now the real Egyptian lions mentioned above (**Plate 34**) came either from Memphis or Hermopolis Parva, and were shipped to Rome at some time to beautify the *Isæum Campense*. By the twelfth century they were set in front of the Pantheon, but appear to have disappeared for a time until they were rediscovered in 1435, and subsequently placed on pedestals again before the Pantheon where they were drawn by Francisco d'Ollanda (or de

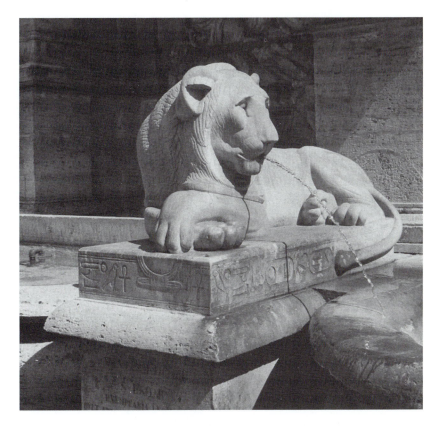

Plate 35 *Copy of the Antique Egyptian lion* (see **Plate 34**), *made when the originals were moved to the Vatican Museum in the nineteenth century. They form part of the Acqua Felice of 1583–7, designed by Domenico Fontana. Photograph of 1999* (JSC).

Holanda [1517–84]). In 1586 they were moved to decorate the Acqua Felice (1583–7), designed by Domenico Fontana, where they functioned as water-spouts, and in the nineteenth century they were moved to the Vatican Museum and replaced by copies (**Plate 35**). These very beautiful recumbent lions, with crossed forepaws and heads turned sideways, are among the most appealing of Egyptian and Egyptianising objects in Rome.

These were not the only celebrated Egyptian lions to emerge in fifteenth-century Rome, for two handsome recumbent early-Ptolemaïc lions from the *Isæum Campense* were found in 1435 and set up in front of the church of San Stefano del Cacco, but under Pope Pius IV (1559–66) were moved to the Piazza del Campidoglio. In 1588 Giacomo della Porta (1532–1602) converted them into *fontanelle*, or water-spouts, at the foot of the great flight of steps leading to the Capitol (**Plates 36** and **37**). There they may be seen today.

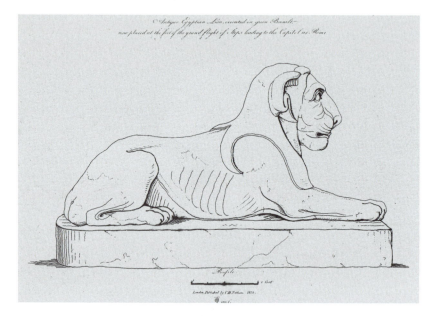

Plate 36 *'Antique Egyptian Lion . . . now placed at the foot of the grand flight of Steps leading to the Capitol at Rome'. C. H. Tatham's drawing of the early-Ptolemaïc lion from the Isæum Campense. Some authorities call them lionesses, but the* nemes *type of head-dress hides any mane. From TATHAM (1826) (JSC).*

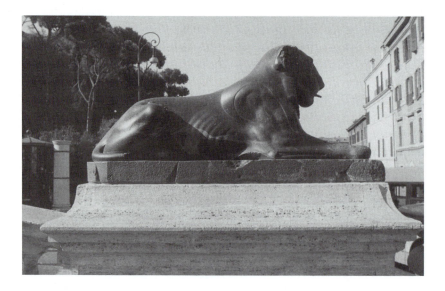

Plate 37 *Lion shown in* **Plate 36** *in 1999. It is at the foot of the steps leading to the Capitol in Rome, and was converted into a water-spout in 1588 by Giacomo della Porta (JSC).*

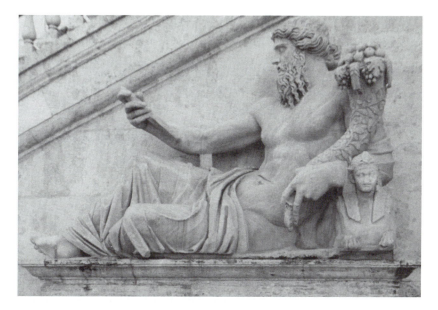

Plate 38 *Statue of the Nile river-god from the great flight of steps leading to the Piazza del Campidoglio in Rome. A later interpretation of the Antique (see* **Plate 21**). *Photograph of 1999* (JSC).

It is also interesting, in the context of this study, to consider the statuary personifying the rivers Nile and Tiber associated with these steps. The great statue of the Nile (**Plate 21**) from the *Isæum Campense* had been found in 1513, and was alluded to in the sculpture representing the Nile set on a landing at the steps leading up to the Piazza del Campidoglio, for the sphinx and cornucopia are quotations from the Antique statue, but the *putti* were omitted (**Plate 38**).

Anne Roullet reminds us that there were known Egyptian and Egyptianising remains visible in and near Rome in the mediæval period, including obelisks, the two pyramids, several lions and sphinxes, and much else.[118] An immense amount must have been lost, however, for Flavius Magnus Aurelius Cassiodorus Senator (*c.*490–583), who held high office under Theodoric, King of the Goths, tells us in his *Variæ Epistulæ*[119] that marble was being burned for quicklime, buildings were being looted for materials, and sculpture was vanishing even in his time (*c.*550): Cassiodorus is of historical importance, not least for his topographical remarks, and it seems that travellers of the time would have been able to see many of the monuments of imperial Rome (including the *Isæum Campense*) virtually intact, although others were being vandalised or destroyed.

118 ROULLET (1972), Appendix II, 150–2.
119 *Var.* VII, 13.

From the tenth century there was a marked increase of interest in the historical remains of Rome:[120] both the *Mirabilia* and the *Graphia Aurea Urbis Romæ*, containing notes on the monuments of Rome, were composed then. By the following century writers expressed the view that pyramids and obelisks (frequently confused with each other and called *pyramis*) were ancient tombs, and in the twelfth century, perhaps because of the damage done by invaders a few years earlier, antiquities and architecture became the subject of serious consideration. This proto-Renaissance encouraged archæological excavation and even restoration of Roman monuments, but a further two centuries were to pass before Rome awakened fully to its great heritage of antiquities.

A revival of interest in Egypt was triggered partly by the rebuilding of the chief church of the Dominicans in Rome, Santa Maria sopra Minerva, in 1280–85: part of this church stood on the site of the temple of Minerva, and part stood on the site of the *Isæum Campense*. These considerable building operations (and others in 1347) unearthed a number of Egyptian and Egyptianising objects that had graced the Isiac buildings: one discovery was a *cynocephalus*, possibly representing Anubis, guide of the dead and guard of Osiris.

A few intrepid voyagers ventured into Egypt, and some noted the existence of the Pyramids, identifying them correctly as sepulchres (although the 'Joseph's Granaries' myth died hard). The Sphinx was associated with Isis, and the enormous scale of these monuments caused comment.[121] Even before the Sack of Constantinople in 1453 brought scholars and books to the West, interest in Greek texts and in Egypt had been aroused. The connection between Apollo and Horus was once more revealed[122] when Greek texts known as *Horapollo* dealing with Egyptian matters were rediscovered by Cristofero Buondelmonte of Florence (*c*.1375–*c*.1435) in 1419: what had actually been found was a mediæval version of the Greek original called *Hori Apollonis Hieroglyphica*, and the writings were attributed to Hermes Mercurius Trismegistus, who was thought to be a contemporary of Moses. Their translation into Latin and Italian in the fifteenth century brought Neo-Platonist ideas current in the third and fourth centuries in Alexandria to early-Renaissance Europe. These texts became important to scholars throughout the civilised world, and were seen as links between Christian doctrine and the philosophical and magical practices going back to Ancient Egypt. This Hermes, the Thrice-Greatest or Thrice-Wise, was identified with Thoth, who again was identified with the

120 ULRICHS, L. (1871): *Codex Urbis Romæ Topographicus* (1871), *see* ROULLET (1972), 7.
121 CARRÉ (1932, 1935).
122 SBORDONE (*Ed*.) (1940).

Greek Hermes, supposed to be the author of the collection of Greek and Latin religious and philosophical works. The 'Hermetic' texts, however, appear to have been by various Alexandrian authors between the first and third centuries of our era: Hermes was certainly not *Contemporaneus Moisi* (as he is described in the celebrated *sgraffito* decoration in Siena Cathedral).

The world of the Renaissance Humanists was greatly influenced by pagan philosophy, but Christianity was not rejected as a result: rather, it was reinterpreted in the light of the wisdom of ancient texts, and the basic similarities of all religions and philosophies were explored. Marsilio Ficino (1433–99) was a follower of Platonic ideas, and indeed saw in the works of 'Hermes Trismegistus' much that was Christian (which is not surprising as they date from after the foundation of the Christian religion): he translated the texts into Italian, and these were published in 1471. The works were seen as profound truths that predicted Christian belief, and that established a thread of wisdom from Ancient Egypt to the Jews, the Greeks, and the Romans: the 'Hermetic' truths, regarded as going back to the time of Moses, or even Abraham, were a source of spiritual and intellectual stimulation that cannot be overestimated, and had a profound effect on the study of Egyptian artefacts.

Lorenzo Valla (1407–57) revealed the *Histories* of Herodotus in his Latin translation, and interest in things Egyptian was thus further stimulated, for Herodotus was a mine of information about Ancient Egypt. Many works dealing with ancient architectural remains were produced in the course of the fifteenth century, notably by Flavio Biondo of Forlì, otherwise known as Blondus of Forlì, (1392–1463) – who described Egyptian items such as hieroglyphs, pyramids, and obelisks in his *Roma Instaurata* of 1446 – and Ciriaco d'Ancona (1391–1455): the latter's sketches of *c*.1450 are of considerable importance, because Ciriaco went twice to Egypt itself in 1412–14 at the behest of the Florentine intelligentsia, as well as recording Egyptian and Egyptianising artefacts in Rome,[123] but his work was not as methodical as it might have been. Nevertheless, his collections of inscriptions and sketches of antiquities made throughout Italy and other countries were important, and he recorded inscriptions near the Pyramids of Gizeh. Blondus of Forlì also described the *Villa Adriana* at Tivoli (probably one of the earliest occasions on which the building was mentioned in the Renaissance period)[124] and it is arguable that he, with Poggio, invented the discipline of historical geography. Blondus's *Roma Instaurata* owed much to the works of Sextus Julius Frontinus (*c*.30–101) who had written a comprehensive work on the aqueducts of Rome that was much admired by

123 *See* HÜLSEN (1907) and BODNAR (1960). *See also* BURCKHARDT (1937), 94–5.
124 PEVSNER and LANG (1956, 1968 edition), 246, note 46.

Renaissance antiquaries. Blondus set out to describe what existed, and attempted to recover what had been lost: his *Roma Triumphans* was one of the first comprehensive efforts to provide a complete exposition of Roman Antiquity. Between *c.*1485 and 1510 there were other significant sketches produced by Cronaca and Giuliano da Sangallo,[125] but, apart from obelisks, Egyptianising Roman antiquities did not attract specific attention, and they were lumped with antiquities in general. This is odd, for interest in Egypt, mysteries, and hieroglyphs was widespread, but investigations concentrated on literary sources.[126]

Giovanni Pico della Mirandola (1463–94) evoked Egypt, evolving a mystical system in which the truth of Christianity was shown through Cabbalistic-Hermetic texts. Burckhardt[127] noted that Antique civilisations exerted an influence in the so-called Dark Ages and in the mediæval period: indeed, Romanesque architecture had remarkable allusions to Antique forms, and, later, with the development of civic life in Italy from the fourteenth century, studies of Antiquity flourished. Poggio Bracciolini (1380–1459) began his walks in Rome,[128] noting visible obelisks: his works prompted studies of architectural remains which, for the first time, were associated with investigations of ancient literature. Poggio discovered the manuscript by Ammianus Marcellinus containing descriptions of Egyptian hieroglyphs in a library in Germany,[129] and he and Guarino were the two great book-finders: the former acted as agent for Niccolò Niccoli (*c.*1364–1437), and scoured the abbeys of Central Europe for ancient texts, discovering the complete works of Quintillian (*c.*35–*c.*100) at St Gallen in Switzerland, and much else besides. Largely through Poggio's diligence Niccoli (Florentine bibliophile and member of the elder Cosimo de' Medici's circle) managed to collect the surviving works of Ammianus Marcellinus, one of the major sources of the Egyptian Revival. Poggio was one of the first to record systematically the inscriptions of Ancient Rome, and he removed vegetation that had obscured carvings and even the forms of buildings:[130] his *De Varietate Fortunæ* (1488), however, set new standards, and methodically described the remains of the ancient city of Rome. It is unfortunate that Poggio's works were not more complete and not illustrated, for very much more of Ancient Rome survived in his day than during the lifetime of Raphael (who was fascinated by Antique remains). Many of the artefacts Poggio discussed have long since disappeared, since not only

125 For CRONACA *see* MS. Christ Church, Oxford, Inv. 0814 r. and v.
126 ROULLET (1972), 11.
127 BURCKHARDT (1937), 90.
128 *Poggii Opera:* fol. 50, 'Ruinarum urbis Romæ descriptio', written *c.*1430. *See also* BRACCIOLINI (1996).
129 BURCKHARDT (1937), 98. *See also* PEVSNER and LANG (1956, 1968 edition), 218. *See also* THOMPSON, E. A. (1947).
130 *Vita Poggii. See* BURCKHARDT (1937), 93, 311.

were the ancient buildings quarried for materials to be used elsewhere, but vast amounts of marble were burned to make quicklime: paradoxically, a Renaissance desire to emulate the architecture of the past hastened the destruction of Antique fabric. Poggio was to translate sections of the works of Diodorus Siculus whose *Bibliotheca* included six books dealing with the history and mythology of the Egyptians. During the fifteenth century the discoveries led to the systematic creation of libraries: ancient books were copied by armies of scribes (Poggio himself was an accurate and speedy copier), and there was a rapid multiplication of translations from Ancient Greek texts. Cardinal Bessarion (1403–72) collected works by Christian and pagan authors, and his library became the heart of the *Biblioteca Marciana*, while the great library of Federico II da Montefeltro (1422–82), Count and 1st Duke of Urbino, established with the help of the bibliophile Vespasiano da Bisticci (c.1421–98), later passed to the Vatican collections.

Poggio's descriptions of remains in Rome in *De Varietate Fortunæ* stimulated some archæological activity, and the enthusiastic antiquarian and cosmographer, Pius II (1458–64), caused the resurrection of several buried obelisks and promoted the recording of Antique remains. Pius II was particularly attached to Viterbo, and therefore probably familiar with the thirteenth-century Cosmati sphinx and the Etruscan representations of wingless sphinxes on vases held there. Yet an elegiac melancholy begins to pervade the literature, induced, no doubt, by the realisation of what had been lost and by the knowledge of how vulnerable were existing remains. Petrarch and Boccaccio also suggest a similar sense of sadness on occasion: Giovanni Boccaccio (1313–75), in *Fiammetta*, described the ruins of Baiæ near Naples (which had been a fashionable Roman spa, and where Lucullus, Pompey, and Cæsar all had villas), and his work was not untinged with regret.

Soon, collections of antiquities of all kinds (including books, sculptures, and artefacts) became the vogue, while, from the time of Pope Nicholas V (1447–55), came a new passion for embellishing Rome bringing, as Burckhardt[131] noted, new dangers for the ruins as well as a new respect for Antiquity. It is a sobering thought that the roads leading from Rome were lined with over a quarter of a million tombs built with architectural pretensions in Antiquity, and that many of these were known in the fifteenth century. The pitiful numbers of mutilated tombs that still stand are an indictment of the vandalism that has occurred since Renaissance times: a comparison of the state of the tombs by the *Via Appia Antica* today with those photographed by J. H. Parker (1806–84)[132] is enough to demonstrate the shocking rate of destruction even in living memory.

131 BURCKHARDT (1937), 94.
132 A fine set survives in the *Accademia Britannica* in Rome.

The architect Antonio Averlino, called Filarete (*c*.1400–69), produced his *Trattato di architettura* (1461–4) which circulated in manuscript form, but was not printed until the nineteenth century, and it included details of the ideal city of Sforzinda which was to contain a House of Vice and Virtue surmounted by an Isiac Egyptianesque statue of Virtue. The facilities in this House included lecture-rooms, a whore-house, and a university (an ambitious œcumenical programme worthy of Isis herself). Sforzinda was to have sixteen subsidiary squares linked by roads and canals to the gates: the connection with the sixteen Cubits of the Nile may be circumstantial, yet Filarete describes obelisks, decorated with hieroglyphs suggestive of an Egyptian character, that were to be erected.[133] In spite of the fact that Sforzinda was never realised, Filarete's influence extended throughout the High Renaissance and Mannerist periods. Filarete was probably influenced by Boccaccio, and indeed used Boccaccio's ideas as the skeleton on which he constructed his architectural and sculptural theories.[134]

A curious feature of the recording of antiquities in Renaissance times was that hieroglyphs (the key to the meaning of which had long been lost) were treated in an extraordinary and cavalier fashion. They were inaccurately noted, and often 'records' of them were not records at all, but owed more to wishful thinking or to the imagination of artists. Leon-Battista Alberti (1404–72), perhaps the most important of Humanist architect-theoreticians, described Egyptian remains in Book VIII of his celebrated *De Re Ædificatoria* of 1452 (fully published 1485): he stated that pyramids were generally of four sides, that their height was most commonly equal to their breadth so that they gave a monolithic impression, although sometimes they were constructed of brick. As for the 'columns' erected as monuments, some were used in other structures, but others were so large that they stood on their own for posterity. In other words obelisks and pyramids are confused. Obelisks are frequently referred to by Renaissance writers by the term *guglia* or *Julia*. Alberti noted that the 'Ægyptians' employed symbols, and his interpretation of hieroglyphs[135] seems to have relied on Ammianus Marcellinus and on Ambrosius Theodosius Macrobius (*fl. c*.400): the latter's compilation of seven books treating of a number of historical, mythological, and antiquarian subjects in the form of table-talk was known as *Convivia Saturnalia*. Like his contemporaries, Alberti appears not to have compared the corrupt interpretations of hieroglyphs in the printed sources of the period with the real hieroglyphs on surviving obelisks and sculptures in Rome. The *Horapollo* texts were also corrupt in that they

133 FILARETE (1965), 152 ff., LAZZARONI and MUNOZ (1908), and ONIANS, J. (1971): *Journal of the Warburg and Courtauld Institutes*, **xxxiv** (1971), 96 ff.
134 ROSENAU (1974), 48–70 and *passim*.
135 Book VIII, Ch. IV.

gave imaginary versions of the meaning of hieroglyphs, and in any case dated from the time when the key to an interpretation was being lost.[136] Even Alberti's motif of the winged eye, used as a trademark, was derived from European interpretations of hieroglyphs, and later turns up as an emblem of the French architect Claude-Nicolas Ledoux (1736–1806): in Ledoux's case the eye expresses the architect's involvement with mystical and Freemasonic ideas that had, supposedly, Antique Egyptian origins.[137]

Egyptian elements began to appear in the work of *Quattrocento* artists. Lorenzo Ghiberti (1378–1455) made the set of gilded bronze doors (1425–52) for the Baptistry to the west of the Cathedral in Florence: these doors have panels with remarkable perspectives showing scenes from the Old Testament, and were planned by 1437, so the Pyramid (based on the Gizeh instead of Cestius-Meroe model) in the second panel from the top of the left-hand door must be one of the most advanced and earliest accurate depictions of an Egyptian pyramid.[138] Obelisks also began to be featured from this time, notably on medals. Pisanello (Antonio Pisano [*c*.1395–*c*.1455]) produced a medal of John VIII Palæologus in *c*.1438 which was one of the first to show obelisks: the portrait-medallion, as perfected by Pisanello, was itself a revival of Antique Roman practice. Pyramids based on the Cestius (**Plate 24**) model appeared in art during the fifteenth century: the fresco of the Martyrdom of St Sebastian on the west wall of the interior of *La Collegiata* in San Gimignano by Benozzo Gozzoli (*c*.1421–97) – who had worked with Ghiberti on the doors in Florence – features pyramids of this type flanking the central picture of the Martyrdom.

Pope Sixtus IV (1471–81) caused items of Egyptian sculpture to be exhibited in the 1470s when the Capitoline Museum was founded, but even before that, as has been noted above, Pius II had busied himself with antiquities, and was responsible for erecting the two Egyptianising *telamones* from the *Villa Adriana* (**Plate 28**) at the Bishop's residence at Tivoli, where they were later drawn (rather crudely) by Giulano da Sangallo (*c*.1443–1516) (**Plate 43**), an ardent student of the Antique. These *telamones* were among the most important Roman works in the Egyptianising style, and were drawn by many artists as well as being copied by designers who used Egyptian and Egyptianising motifs.

A series of discoveries of Antique objects was made in Rome, including one that captured the contemporary imagination: on 18 April 1485 the corpse of a young Roman woman of the Classical period was found by Lombard masons who were digging out a tomb in the gardens of the Convent of Santa Maria Nuovo on the Appian Way beyond the tomb

136 PEVSNER and LANG (1956, 1968 edition), 219.
137 CURL (2002*b*).
138 CURL (1982), 47.

of Cæcilia Metella. The body was in a wondrous state of preservation, and was seen by a great number of people until it was buried by night by order of Pope Innocent VIII (1484–92). This body was connected with the Egyptian custom of mummifying corpses, and, significantly, was thought to be far more beautiful than anything known in modern times. Under Julius II (1503–13) followed the astounding discoveries of the Laocoön, the Vatican Venus, and much else. Pius II's *Commentarii* wax almost sentimental about antiquities. The respectability of the past began to be assured, as artefacts from Antiquity were admired: ancient things were to be revered and emulated as exemplars. A curious by-product of all this was that family trees and ancestral roots began to be valued too, and the further back pedigrees went, and the grander they appeared, so much the better.

Ancestor-worship took on bizarre forms from the *Quattrocento*: Pius II drew attention to the antiquity of his own family, the Piccolomini, and there appears to have been a great desire among many illustrious houses to establish long and distinguished pedigrees[139] as Renaissance Man sought to find his roots in Classical Antiquity. Paul II (1464–71) claimed descent from Ahenobarbus; the Massimi from Quintus Fabius Maximus Verrocosus; and the Cornaro from the Cornelii.[140] One of the oddest manifestations of ancestor-worship, going back to the Egyptian period, occurred in the *Appartamento Borgia* in the Vatican itself. These papal rooms were decorated by Bernardo Pintoricchio (or Pinturicchio) (*c*.1454–1513) for Rodrigo Borgia, Pope Alexander VI (1492–1503), and the Room of the Lives of the Saints there shows on the vaulting the legend of Isis and Osiris (including the discovery of Osiris's limbs) with the Apis-Bull. The Medallion of the Madonna is over the door; St Catherine of Siena (bearing the features of Lucrezia Borgia) disputes with Maximian on the back wall; hermits in Ancient Thebes are shown; and Hermes Trismegistus, Moses, and Isis face the Apis-Bull.[141] Now the Apis-Bull is shown, not as an heraldic device, but in full procession: an effigy of the bull is also depicted, carried within an *ædicule* by figures, behind which are Nilotic flora; in the tympanum of the *ædicule* is Hermes (also associated with Anubis); and under the *ædicule* is a winged sphinx with horned head (**Plate 39**).

The connection between the Borgias and Egypt was suggested by the Dominican Annius of Viterbo (died 1502), who was involved in an elaborate deception to demonstrate the descent of the Borgias from none other than Osiris: Annius took as the basis of his flimsy structure the Apis-Bull on the Arms of the Borgias. This bull, of course, is associated with

139 BURCKHARDT (1937), 95.
140 *Ibid.*
141 WITT (1971), 267 ff. See also YATES (1964), 115–16, 259.

Plate 39 *The Apis-Bull carried in procession within an ædicule, with the head of Hermes in the tympanum, a winged sphinx below, and below that another horned bull's head. Note the Nilotic palms carried in the procession. Part of Pintoricchio's decoration of the* Appartamento Borgia *in the Vatican for Pope Alexander VI, it emphasises the Pontiff's 'Egyptianism'. Such a procession would also have been familiar in Rome during the first century AD, so the Egyptian deities were welcomed back to Rome at the very beginning of the sixteenth century (JSC).*

Serapis, but Annius went further: by producing Egyptian artefacts, allegedly excavated in Italy, the idea was to demonstrate a close connection between Roman, Etruscan, Greek, and Egyptian art, and hence the descent of the Pope from Osiris. There was even a *Borgiad* that celebrated the family in heroic terms. By the last decades of the fifteenth century, magnificent processions, recalling imperial Triumphs, formed part of the Roman Carnival, and were encouraged by Popes Paul II, Sixtus IV (1471–84), and Alexander VI. These processions included Isiac allusions and Egyptianising motifs, as depicted in *The Triumph of Cæsar* (*c.*1480–95) by Andrea Mantegna (1431–1506): the latter work contains hieroglyphs of the bogus decorative type intended to suggest Egypt without any serious attempt to portray them accurately, although another view is that Renaissance 'hieroglyphs', notably those planned by Donato Bramante (1444–1514) for the Belvedere in the Vatican, were supposed to mean something, as certain allegorical ideas were suggested by objects such as rudders (guidance), circles (eternity), vases (life), or palms (victory).[142] In Bramante's case, the intention was to commemorate himself and Pope Julius II,[143] and Mantegna's *St James led to Execution* has an inscription in pseudo-hieroglyphs commenting on Martyrdom.

Antiquities, especially those that had been witness to Christian Martyrdom, acquired an especial reverence in the *Quattrocento*. The great obelisk that had stood near the basilica of San Pietro since imperial times was regarded as particularly important, so that when Bramante was engaged to redesign the church, he considered swinging the axis round so that the obelisk would be in front of the basilica.[144] In the event, Domenico Fontana (1543–1607) transported and re-erected the obelisk on its present site in the piazza in 1585–86, as, ever since the Pontificate of Pope Nicholas V (1447–55), it had been the intention (probably first suggested by Alberti) to have the obelisk (as witness to the Martyrdom of St Peter) in front of the basilica. Raffaello Sanzio (Raphael [1483–1520]) proposed the re-erection of another obelisk from the mausoleum of Augustus to stand before St Peter's so that the larger obelisk would remain where it was, but he was over-ruled.[145]

The Pintoricchio frescoes in the *Appartamento Borgia* were unquestionably partly the result of the influence of Pico della Mirandola, who refuted astrology by analysing the weather-forecasts of astrologers and showing that, over a given period, seventy-five per cent of the time they were hopelessly wrong, which is even worse than the statistics of guesswork would suggest. Pico's notion of freedom of will and the essential logic

142 See MURRAY (1962), 31.
143 PEVSNER and LANG (1956, 1968 edition), 220 and note 50.
144 *Ibid.*, note 51.
145 GOLZIO (1936), 101.

of the universe made a considerable impression in his day, and his arguments led to a realisation that Christianity was not unique: in fact much of Christian orthodoxy was much older than reactionaries were prepared to admit, and the key lay in Alexandria and in the Nilotic religions. Egyptianising décor was therefore an indication of advanced, logical, clear thinking, and indicative of a new spirit of enquiry. The almost unthinkable occurred: Pope Alexander VI installed Isis in the Vatican itself, with the Apis-Bull and other allusions to the Nile.[146] Pico, as Burckhardt noted, was 'the only man who loudly and vigorously defended the truth and science of all ages' against the one-sided worship of Classical Antiquity.[147] He knew Hebrew, the Cabbala, the Talmud, and the mediæval mystics, and was far more catholic in his views than orthodoxy (especially Counter-Reformation orthodoxy) could smile upon.[148] Pico insisted that God made Man to *know* the laws of the Universe, to love its logic and its beauty, and to admire its Sublime immensity: Man was not bound to a fixed place, to slavery in his work, but had the will to be, to know, to move, to understand, and was neither heavenly nor earthly, neither mortal nor immortal only, for he was free to shape and to overcome his own limitations. Pico's proto-enlightenment contained much that derived from Egypt.

Pintoricchio and his pupils also adorned the *Libraria Piccolomini* in Siena (built by Cardinal Francesco Piccolomini [the future Pope Pius III] to house the collection formed by his uncle, Pius II) with the brilliant frescoes of 1505–09. Decorations feature the crescent-moons of the Piccolomini crest in the window-reveals and in the floor, and there are sphinxes in number on the enrichments between the panels. Siena Cathedral also contains a celebrated sequence of marble pavements enriched with *sgraffito* decorations: at the west end of the nave is a figure of Hermes Trismegistus, with Moses and other Oriental figures, of 1482–83, with winged sphinxes in the inscriptive panel. Also in Siena, in the Palazzo Saracini, is a vaulted ceiling in the rear *cortile* adorned with pretty paintings: these include Egyptian *telamones*, sphinxes on plinths, and a Diana of Ephesus, heavy with 'many breasts'. These startlingly brilliant Renaissance paintings and *sgraffito* decorations point to a considerable awareness of Egyptianising motifs in the Siena of the fifteenth and sixteenth centuries, and indicate the increasing awareness of Antiquity, even Egyptian Antiquity, as the source of much that was held to be important.

Further interest in Egypt was aroused by the Dominican Friar Felix Fabri of Ulm who went on pilgrimage in 1480, returning via Sinai and

146 SAXL (1957), 174 ff., especially 184, held that Alexander VI was 'within the limits of orthodoxy'. *See also* YATES (1964), 115–16.
147 BURCKHARDT (1937), 102.
148 *Ibid.*

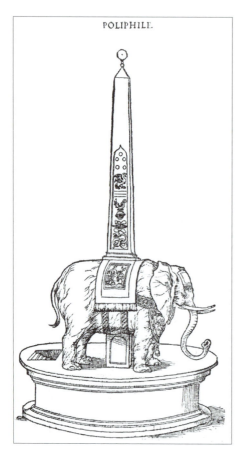

POLIPHILE.

Plate 40 *An obelisk on an elephant's back, from* Hypnerotomachie, *the French version (Paris: 1561) of* Hypnerotomachia Poliphili. *Such an image owes little to Classical Antiquity, yet was of singular importance from the Renaissance period* (GN/SM).

Egypt in 1483. He left an account (*Evagortium in Terram Sanctam*) in which he mentioned the Pyramids at Gizeh and the great obelisk in Alexandria which is now in Central Park, New York.[149] Nevertheless, the *Hori Apollonis Hieroglyphica* remained one of the most important influences, and the original Greek texts were published by Aldus Manutius (1450–1515) in 1505. Renaissance Humanism became permeated by a desire to grasp the key to the mysteries of Antiquity, especially the supposed wisdom enshrined in hieroglyphs and in Hermetic philosophies. The importance given to Hermetic ideas is stressed by the figures of Hermes Trismegistus in Siena and in the *Appartamento Borgia*, visual representations that can be traced to the rediscovery of the texts, the published translation of 1471, and the increasing Egyptianisation of the Bishop of Rome himself. It must be remembered that the notion that all magic, all knowledge, all skills, and all basic architectural wisdom came from Egypt was powerful, and much

149 CLAYTON (1982), 10.

Plate 41 *Illustration from* Hypnerotomachie, *the French version (Paris: 1561) of* Hypnerotomachia Poliphili, *which attempts to show the Mausoleum at Halicarnassus based on the description in Pliny's (AD 23/24–79) books. The obelisk set on top of the stepped pyramid, like the obelisk on the elephant, owes little to Antiquity, but had a profound effect on Renaissance and later imagery. In a sense the image is a hedging of bets, since obelisks were confused with pyramids, and so both are shown. Obelisks resting on balls, skulls, or elephants, are also inventions of the time* (GN/SM).

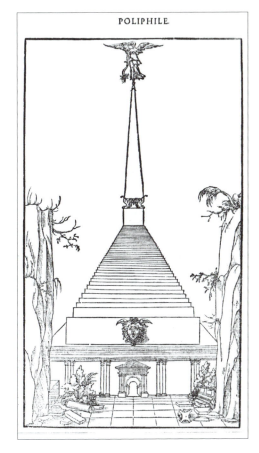

intellectual effort was expended on trying to reveal the mysteries of Egypt by deciphering hieroglyphs. Egyptian religion, architecture, and sculpture took on new significance as products of a great culture from which all skills had come: the craft of building, and especially the techniques of quarrying, cutting, dressing, and carving stone, were associated with Egypt. The mason's craft had come from Egypt, Hermes had invented principles of geometry essential to architecture, and the stone buildings of Egypt became symbols of excellence and causes for wonder in European minds.

The work of Filarete seems to have influenced Francesco Colonna's *Hypnerotomachia Poliphili*, published in Venice by Aldus Manutius in 1499, one of the most important Renaissance books relating to the Egyptian Revival. The work is a phantasy, written in Latin and Italian, with some passages in Hebrew and Greek, and took its final shape in 1467. The Manutius edition was illustrated with woodcuts (**Plates 40** and **41**) that often depict Classical architectural and sculptural remains: huge colonnades and avenues, partly submerged in woods and undergrowth, figure in the

pages of this strange book, and are among the first published illustrations of Classical ruins, although a pupil of Domenico Ghirlandaio (1449–94) made some fine topographical drawings of Rome around 1480.[150] *Hypnerotomachia Poliphili* contains Egyptianising motifs, including what appear to be fake hieroglyphs,[151] as well as two important images: the first is an elephant with an obelisk on its back (**Plate 40**), and the second is supposed to be the celebrated Mausoleum at Halicarnassus (**Plate 41**). Both these images were to spawn many progeny in the years to come.[152]

150 *Codex Escurialensis*, fol. 40.

151 GOMBRICH (1951), 120. *See also* GODWIN (1999).

152 Themes touched upon in this Chapter may be further explored in ROULLET (1972), BURCKHARDT (1937), WITT (1971), and PEVSNER and LANG (1956).

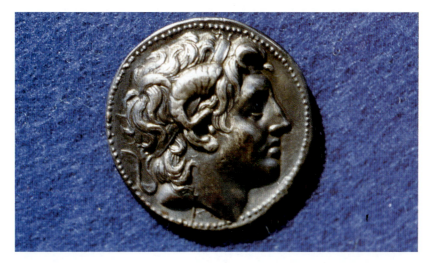

Plate i *Posthumous portrait of Alexander the Great on the obverse of a silver tetradrachm of his erstwhile general, Lysimachus (c.355–281 BC), showing the ram's horn of Amon featured as part of his head-dress, an allusion to the identification of Alexander as the deity's son (PAC).*

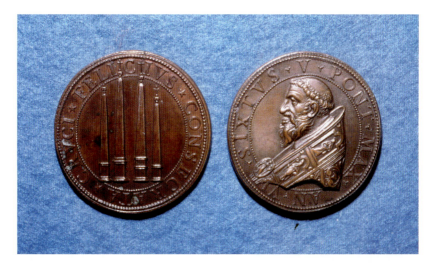

Plate ii *Bronze medal struck in the sixth and final year of the pontificate of Felice Peretti, Cardinal Montalto (1520–90 – Pope Sixtus V [1585–90]), showing on the reverse the four obelisks he caused to be re-erected in prominent positions in Rome (i.e. from left to right, that in the Piazza del Pòpolo [1589], that beside San Giovanni in Laterano [1587–8], that in front of the basilica of San Pietro [1586], and, finally, that by Santa Maria Maggiore [1587]) under the direction of Domenico Fontana (1543–1607). It should be noted that the Lateran obelisk is correctly shown as the tallest of the four erected under Sixtus's ægis. These obelisks were celebrations of the triumph of Christianity over paganism, and each was surmounted by a cross, indicative of the Pontiff's desire to subsume ancient monuments to the glorification of the Faith (PAC).*

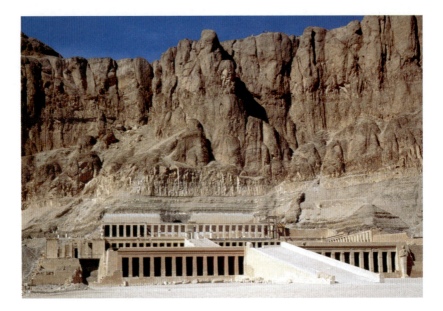

Plate iii *Mortuary-temple of Queen Hatshepsut at Deïr-el-Bahari, Egypt (c.1473–c.1458 BC), designed by Senmut. Note the long ranges of square columns, which influenced Western European Neo-Classicism* (Michael Wright).

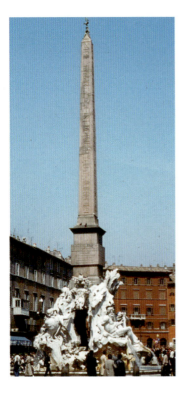

Plate iv *Bernini's* Fontana dei Fiumi *in the Piazza Navona, Rome, with the obelisk from the entrance-court of the* Isæum Campense *inscribed with hieroglyhs in honour of Domitian. Photograph of 1980* (JSC).

94

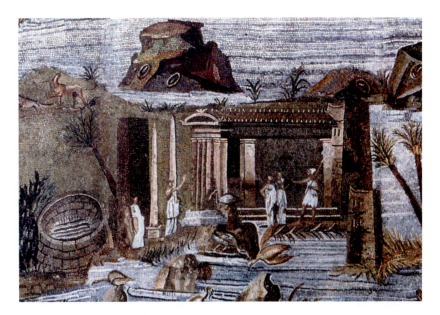

Plate v *Detail from the Palestrina mosaic (see* **Plate 17**) *showing a building with segmental pediment and crescent-moon on top* (PAC).

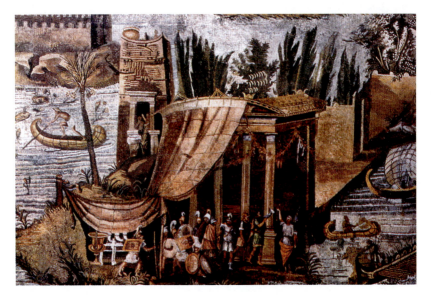

Plate vi *Detail from the Palestrina mosaic (see* **Plate 17**) *showing a building with segmental pediment* (PAC).

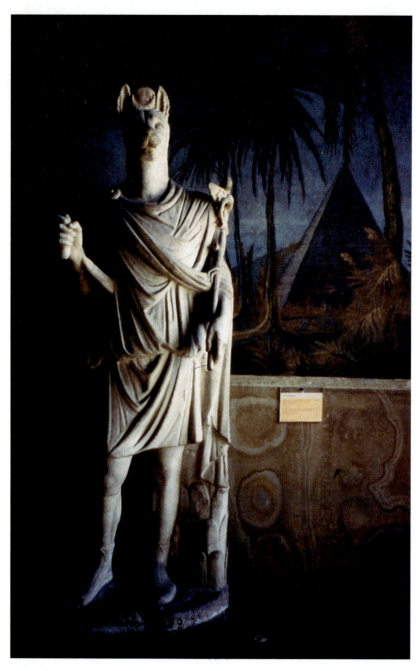

Plate vii *Antique (probably second century AD) statue of Anubis, with the* kyrekeion, caduceus, *or herald's wand of Hermes, held on the left arm, and with a jackal's head between the ears of which is a disc on a crescent-moon. Now in the Altemps Musuem, Rome, it may represent the deity, as* Hermanubis, *a composite of Hermes/Mercury and Anubis, or it may represent a priest of Anubis, wearing on his head the jackal's mask* (PAC).

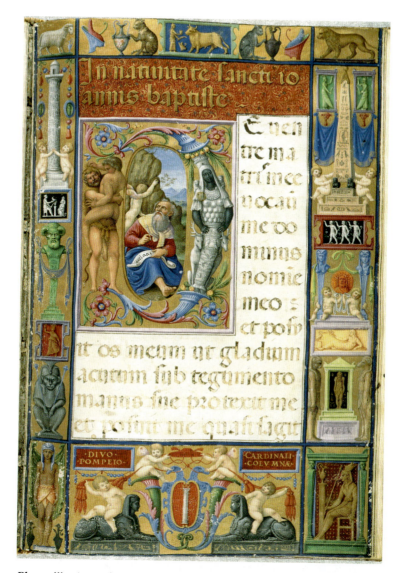

Plate viii *A page from the Colonna Missal (probably after 1537) showing some extraordinary Egyptianising motifs. At the top (centre) is the Apis-bull, flanked by cats (Bast) with vases, and by a lion and a ram in the corners. The rest of the border quotes Egyptianising and other Antique motifs: on the left is a Trajanic column with* putti *while balancing it, on the right, is an obelisk resting on sphinxes, again with* putti. *On either side of the obelisk are figures derived from winged figures on the* Mensa Isiaca. *The baboon on the left is based on an actual find, and animal-headed gods flank the* ædicule *in which is an Egyptianising* telamon *(based on drawings made by Pirro Ligorio). On the bottom left is a* telamon *based on those from the Villa Adriana, whilst at the base are two Roman Egyptianising sphinxes (based on finds in Rome) with* cornucopiæ, putti, *and cherubs. On the bottom right is a seated pharaonic figure in an* ædicule, *and the capital illumination features a cornucopia with an Artemis of Ephesus (with many breasts instead of testicles or eggs) flanked by harts (Rylands Latin MS. 32, fol. 79r, JRULM).*

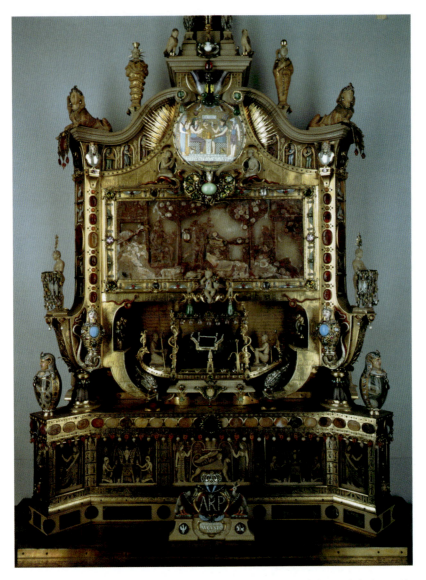

Plate ix *The Apis-Altar of 1731 by Johann Melchior Dinglinger, made for Friedrich August 'the Strong' (1670–1733), Elector of Saxony (from 1694) and King of Poland (from 1697 to 1702, and again from 1709 [recognised 1719] until his death). It has Canopic figures, the Apis-bull on a boat propelled by Egyptianising sailors (one of whom wears the Isiac crescent on his head), sphinxes, mummies, and a crowning obelisk (only the base of which can be seen). The ARP monogram stands for* Augustus Rex Poloniae. *Many of the elements of the design are derived from the* Mensa Isiaca, *and the Altar is embellished with gold, silver, enamel, and precious stones* (Grünes Gewölbe, Staatliche Kunstsammlungen, Dresden, VIII, 202).

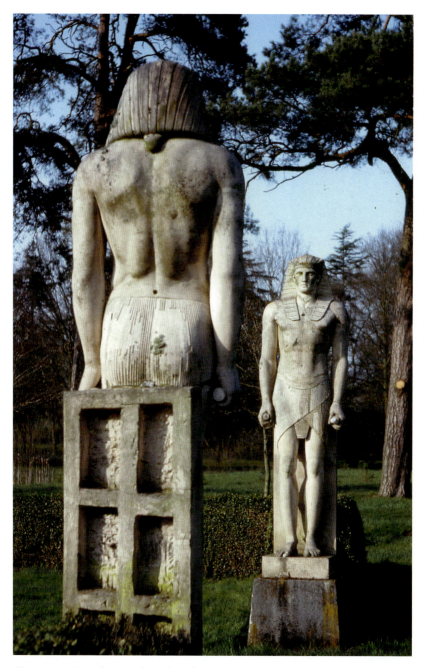

Plate x *Antinoüs figures in the gardens of Buscot Park, Faringdon, Berkshire (now Oxfordshire), made of Coade Stone. One of these may be the figure in Thomas Hope's interior at Duchess Street* (**Plate 99**). *Photographed in 1982 (JSC).*

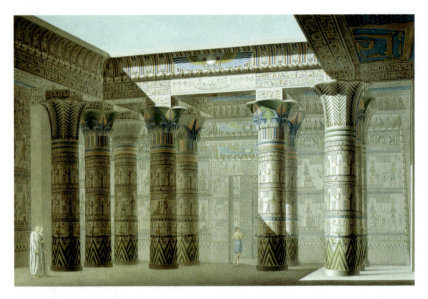

Plate xi *Perspective view of the painted interior under the portico of the large temple on the Island of Philæ, showing palm-leaf, bell, and papyrus capitals. It is typical of the superb standards applied to this sumptuous scholarly publication. From* Description, *A, Vol. I, pl. 18* (GB/SM).

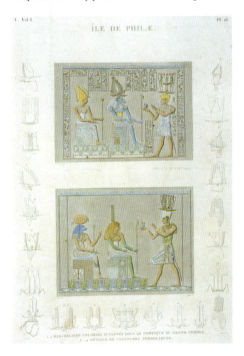

Plate xii *Fine Colour-plate from* Description, *A, Vol. 1, pl. 16, showing the coloured bas-reliefs under the portico of the 'Grand Temple' at Philæ, typical of the accurate and exacting standards of this great work* (GB/SM).

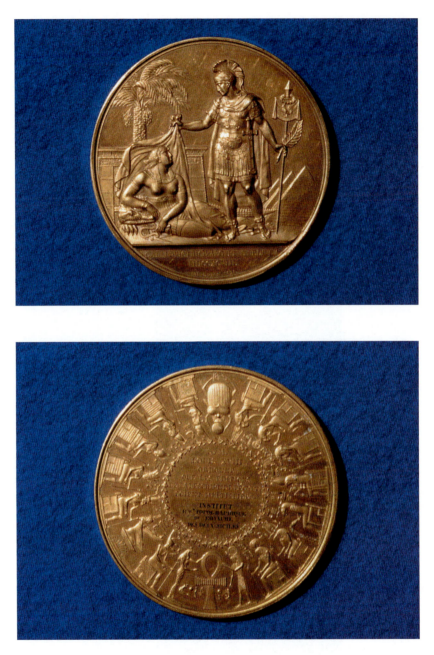

Plate xiii *Gilt-bronze medallion commemorating the order by King Louis XVIII to complete the publication of* Description, *dated 1826, designed by Jean-Jacques Barré (1793–1855). The obverse* (**a**) *portrays the rediscovery of Egypt, as an Egyptian Queen is unveiled by a standing figure of Gallia (represented as a triumphant General) in 1798. The identification of France with Græco-Roman Antiquity is made overt. The reverse (**b**) shows a series of Egyptian deities with the* ankh *at the bottom and the scarab-beetle, Khepri, at the top (PAC).*

Plate xiv *General view of the Sèvres biscuit porcelain surtout of the Service Égyptien, made in 1810–12 by Jean-Baptiste Lepère, following an earlier set of 1808, and now in Apsley House, London. It is over 6.5 metres long. In the middle is a model of the 'Kiosk' at Philae, flanked by obelisks from Luxor, with other elements modelled on the pylon-towers of the Temple at Edfu, the temple of Hathor at Dendera, the colonnades from Philae, and avenues of sacred ram-headed lions (criosphinxes) based on those at Karnak. The elements of the surtout are set on plinths of imitation porphyry. Denon was in overall control of the design, and the models were based on the drawings done for the Description de l'Ègypte (V & A Picture Library transparency number CT 10068, Museum Number C–132–1979).*

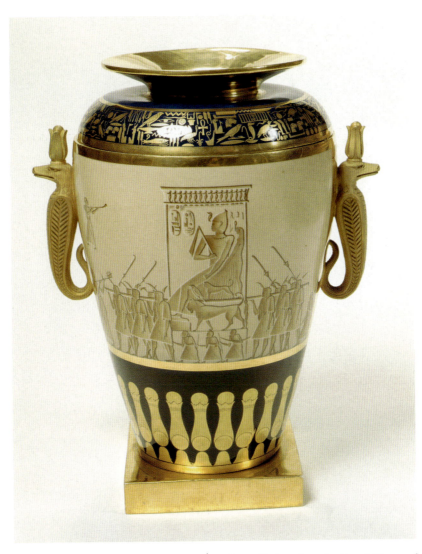

Plate xv *Ice-cream bucket from the* Service Ègyptien, *with decorations after Denon's* Voyage of 1802 (V & A Picture Library CT 7321, Object C128–1979. Photograph by Ken Jackson).

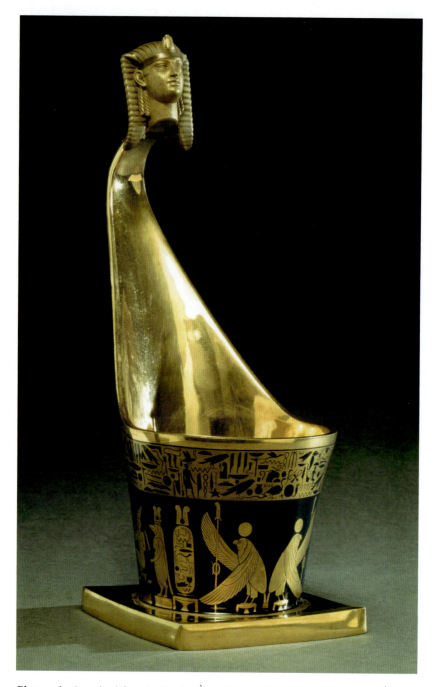

Plate xvi *Sugar-bowl from the* Service Ègyptien, *based on the* Description de l'Ègypte, Antiquités, ***iii***., *pl. 66, no. 15, and on Denon's* Voyage *(1802)* (V & A Picture Library CT 7320, C127–1979).

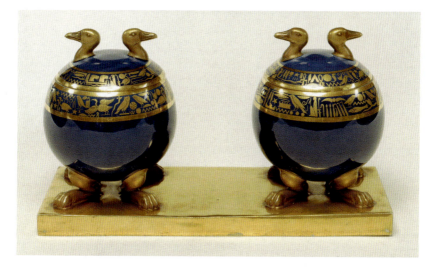

Plate xvii *Pair of jam-jars from the* Service Ègyptien, *now in Apsley House, London, after Denon (1802)* (V & A Picture Library CT 7303, C131–1979).

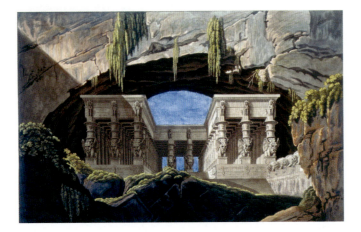

Plate xviii *Design by Karl Friedrich Schinkel for Act I, Scene 1 of* Die Zauberflöte *made for the 1816 production of the* Singspiel *at the* Königliche Schauspiele-Opernhaus, *Berlin, and showing a fantastic Egyptianising portico in a rocky grotto: the cavetto cornice and small figures (with stars) at cornice level have a Piranesian flavour. Note the triangular pseudo-arch at the bottom. C. F. Thiele's published version, based on Schinkel's original project* (THIELE/BL.1899.c.5).

Plate xix *Schinkel's gouache design for Act 1, Scene 6, of Mozart's* Die Zauberflöte, *for the 1816 Berlin production at the Königliche Schauspiele-Opernhaus. It shows a dark vault in the form of a hemi-dome, indicated by stars that follow the lines of 'ribs' terminating in an 'oculus' like that of the Pantheon in Rome. In the centre is the Queen of the Night standing on her crescent-moon, an extraordinary image that recalls the* Immaculata *from Baroque and Rococo church ceilings; the Isiac and Marian allusions are clear. Sarastro, the High Priest of the Temple in the* Singspiel *says of the Queen: 'This woman thinks much of herself, and hopes by trickery and superstition to ensnare the people and to destroy our safe and strongly-built temple', a Freemasonic allusion. C. F. Thiele's published version, based on Schinkel's original project (see Schinkel Museum, SMB, KuSdZ, No. XXII c. 121 .x)* (THIELE/BL.1899.c.5).

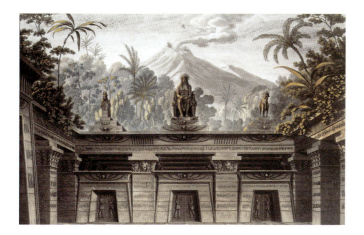

Plate xx *Schinkel's design for Act I, Scene 15, of* Die Zauberflöte *the 1816 Berlin production at the* Königliche Schauspiele-Opernhaus, *showing the Egyptianising forecourt to Sarastro's palace with a tropical landscape in the background. The three portals lead to Wisdom, Reason, and Nature, but are contained within a unified building in which Osiris presides over the central portal (Wisdom); a priest with hieroglyphical tablet (derived from designs by Piranesi) is set over the portal of Reason; and what appears to be a bull is set over the portal of Nature. The sources for the design appear to be Piranesi's* Diverse maniere . . ., *Denon's* Voyage . . ., *and Alexander von Humboldt's account of his journey to South America. 'Hieroglyphs' are of the bogus kind, as at that time they could not be understood. C. F. Thiele's version of Schinkel's original project (Schinkel Museum, SMB, XXII c.ll8)* (THIELE/BL.1899.c.5).

Plate xxi *Schinkel's design for Act II, Scene 1, of* Die Zauberflöte *in the 1816 Berlin production at the* Königliche Schauspiele-Opernhaus, *showing the luxuriantly tropical flavour of the* Palmenwalde *(palm forest). In the centre is a distant view of a Philæ-like complex of Egyptian temples dedicated to Isis. The 'Nilotic' aspects of the landscape are somewhat transformed by the mountainous background, probably suggested by Humboldt's travels. C. F. Thiele's version of Schinkel's original project (Schinkel Museum, SMB, Th XX)* (THIELE/BL.1899.c.5).

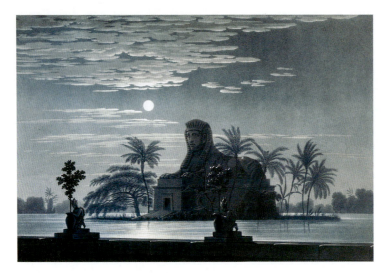

Plate xxii *Schinkel's design for Act II, Scene 8, of* Die Zauberflöte, *in the 1816 Berlin production at the* Königliche Schauspiele-Opernhaus, *showing Sarastro's garden, with lake and island on which is a mausoleum consisting of a massive sphinx on a battered base, with palm trees. A noble evocation of a Nilotic style, the figures in the foreground somewhat incongruously seem to owe something to Piranesi (see* Schinkel Museum, SMB, KuSdZ, No. XXIIc, 102. Pass.) (THIELE/ BL.1899.c.5).

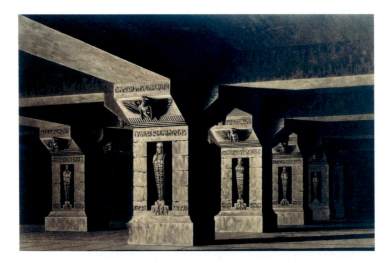

Plate xxiii *Schinkel's design for Act II, Scene 20, of* Die Zauberflöte *the 1816 Berlin production at the* Königliche Schauspiele-Opernhaus, *showing the interior of a 'strange vault' with massive piers and a primitive structure of enormous unadorned beams. Statues representing mummified bodies are set in niches on stepped bases. Sources would appear to have been descriptions of the 1791 Vienna production, Denon' s study of the temple of Apollonopolis, and certain creations of Piranesi. Friedrich Jügel's version of Schinkel's original project (*Schinkel Museum, SMB, Th. XXIII*) (THIELE/ BL.1899.c.5).

CHAPTER III

Further Manifestations with Egyptian Connotations in Europe from the Renaissance to the Beginning of the Eighteenth Century

The Mensa Isaica; *Records and Drawings; Egyptianisms in Design; The Hermetic Tradition; Some Manifestations of Egyptiana; Travellers and Speculators; Bernini; The French Connection*

Mysterious Flood, – that through the silent sands,
Hast wandered, century on century,
Watering the length of great Egyptian lands,
Which were not, but for thee.

> BAYARD TAYLOR (1825–78): *To the Nile.*

The tapering pyramid! th'Egyptian's pride,
And wonder of the world! whose spiky top
Has wounded the thick cloud, and long outliv'd
The angry shaking of the winter's storm;
Yet spent at last by th'injuries of heaven,
Shatter'd with age, and furrow'd o'er with years,
The mystic cone, with hieroglyphics crusted,
Gives way .. .

> ROBERT BLAIR (1699–1746): *The Grave* (1743), lines 190–197.

The *Mensa Isiaca*

By the beginning of the sixteenth century appreciation of Antiquity grew apace, more discoveries were made, and artists attempted to emulate the creations of the Classical past. In addition, an Egyptianising tendency became more marked, and may have been influenced by events in 1515 when the *Madonna dell'Arbore* in Milan Cathedral wept: Prato recorded this as well as the discovery of a dragon during excavations of a mortuary-chapel near the church of San Nazaro. It will be remembered that Isis shed tears which caused the Nile to flood each year: the re-Egyptianisation of the Virgin was proceeding.

In the Age of the Humanists an excellence in epistolography was deemed essential, and competent Latinists were in demand from Popes, Princes, and Republics for the writing of speeches and for taking on correspondence. The letters of Cicero and Pliny were regarded as models of style, and at the beginning of the sixteenth century the letters of the librarian of the Vatican, Pietro Bembo (1470–1547) – Humanist, friend of Raphael, and later Cardinal – set new standards, and were prized as stylistic masterpieces: with a growing appreciation of excellence in Latin also came the development of a mature use of Italian in correspondence, the models for which were again produced by Bembo. The Italian Classical style was thoroughly imbued with the ideas of Classical Antiquity.

Interest in Egyptian themes and objects seems to have increased during the sixteenth century, especially after the spectacular *Mensa Isiaca*[1] (also known as the *Tabula Bembina*, or Bembine Tablet of Isis) was unearthed before 1520 (**Plate 42**). Cardinal Bembo acquired this bronze tablet with its incised designs inlaid with silver: it may have come from the *Isæum Campense* in Rome, and features hieroglyphs, Egyptianising figures, and Nilotic flora and fauna. It is an authentic work of Antiquity, but it is not pharaonic: it is an Egyptianising Roman or Alexandrian piece, perhaps by a Greek named Neilos, and probably dates from the reign of the Emperor Claudius (41–54), whose name, inscribed in hieroglyphs, is the only part of the text that seems to have any meaning.[2] In the centre of the design is Isis in an *ædicule*, flanked by attributes, including serpents: there are Apis-Bulls, Thoth, various deities, and much else. Clearly the maker or makers of the *Mensa Isiaca* knew his or their Egyptian gods and goddesses, the Egyptian style, and Egyptianising detail. According to Giehlow,[3] Bembo sent drawings of the tablet to friends before he left Rome in 1520, but the artefact became an important source for Egyptianising designs after Enea Vico de

1 *Museo Egizio*, Turin, No. 7155. *See* VALERIANO BOLZANI (1556).
2 ROULLET (1972), 143–4. *See also* GRIMM (1963).
3 GIEHLOW (1915), 111.

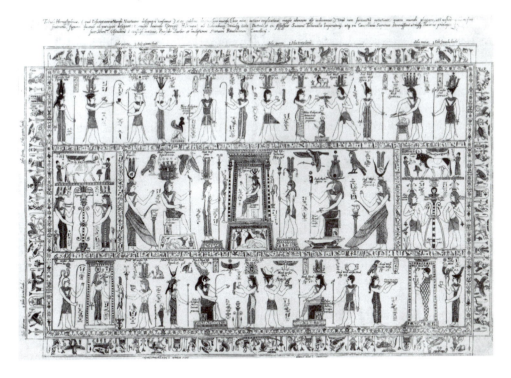

Plate 42 *The* Mensa Isiaca, *or* Bembine Tablet *(Tabula Bembina) of Isis, of bronze inlaid with silver, is Roman or Alexandrian work of the early imperial period, and is in an Egyptianising style, featuring deities and fake hieroglyphs. It was probably made for a Roman sanctuary dedicated to the Egyptian deities, and dates from the time of the Emperor Claudius (AD 41–54), whose name, inscribed in hieroglyphic form, is the only part of the text which makes sense. The table was re-discovered at the beginning of the sixteenth century, and bought by Cardinal Bembo for his collection at Padua. It was first published by Enea Vico de Parma in 1559, and from the start of the seventeenth century it was used as a source for Egyptological studies, until in the nineteenth century it was shown to be Roman Egyptianising work. From J. G. Herwart von Hohenburg's* Thesaurus Hieroglyphicorum *(1608) (BL 559 ★f25 Fig. 1 8076081 3, TAB. 62).*

Parma (1523–67) first published it in his *Vetustissimæ Tabulæ, Æneæ Hieroglyphicis . . . literis cœlatæ* in 1559, although Stephanus Vinandus Pighius (1520–1604) had also made drawings of it around 1555.[4] Piero Valeriano[5] mentions the tablet in his *Hieroglyphica* of 1556 (a vast collection), G. Franco made an engraving of it in 1600, L. Pignorius (1571–1631) published it in his *Vetustissimæ, Tabulæ Æneæ* in 1605,[6] and Johann Georg Herwart von

4 *Codex Pighianus*, Tübingen, fol. 50v., 51r. Also *Staatsbibliothek d. Stiftung Preuss. Kulturbesitz, Handschriftenabteilung, Lat. Fol. 61.*
5 VALERIANO BOLZANI (1556), 105 v., 124 v., 144 r., 167 v., 233 r. *See also* his 1592 publication.
6 Published in Venice by Giacomo Franco. *See* PIGNORIA (1608 and 1669).

Hohenburg[7] included it in his *Thesaurus Hieroglyphicorum* of 1608 (the illustrations were collected in Rome by N. van Aelst). Athanasius Kircher (1602–80), the German Jesuit who became regarded as a leading light in all things Egyptian, drew heavily on the *Mensa Isiaca* for his sources.[8] Certainly from the seventeenth century the *Mensa Isiaca* was used as a major reference work and plundered for motifs until, in the nineteenth century, it was at last correctly identified as Roman or Alexandrian work. Anne Roullet[9] suggests it may have been made for a sanctuary in the reign of Claudius, but most of the hieroglyphs are of the bogus but decorative kind. There is an extensive Bibliography on the *Mensa Isiaca* in *Jahrbuch d. Römisch-Germanischen Zentralmuseums Mainz.*[10]

Illustrations of this celebrated tablet fascinated many artists: Giovanni Battista Piranesi (1720–78) was certainly familiar with the tablet, which, as previously noted, was one of the richest sources for Athanasius Kircher, who made important collections of Egyptianising objects and published much on the subject.[11] The *Mensa Isiaca* provided motifs for artists to copy and interpret for the best part of two hundred and fifty years. The design may be related to the letters of the Hebrew alphabet and to Tarot cards, or, as Kircher thought in his *Œdipus Ægyptiacus* (1652–54), it may be a representation of a cosmic scheme.[12]

Records and Drawings

Interest in Egyptian Antiquities developed further, and many designs incorporated Egyptianisms. Sebastiano Serlio (1475–1554) produced a number of stage-designs with fine perspective effects: his set for a tragedy, illustrated in a woodcut in *L'Architettura* (1584), shows an obelisk and stumpy pyramid in the background. Pirro Ligorio (*c*.1510–83), the Neapolitan painter, architect, and antiquarian, produced several collections of drawings of monuments from Antiquity,[13] and recorded the collections from the *Villa Adriana*, including the *telamones*. His drawings, and copies of them by others, were well-known to Renaissance artists.[14] Copies of real hieroglyphs were made in plenty, and there are records of many pieces of Egyptian and Egyptianising work by several sixteenth-century artists, not all of them Italian. Baldassare Peruzzi (1481–1536), the Sienese painter, architect, and

7 Fig. 1 f.
8 KIRCHER (1652–4), **iii**, 80–160 and plate.
9 ROULLET (1972), 144.
10 **x** (1963), 214.
11 *See* Select Bibliography.
12 The tablet is discussed and illustrated in HALL (1928–75).
13 MANDOWSKY and MITCHELL (*Eds*) (1963).
14 *Codex Ursinianus*, Biblioteca Vaticana, Vat. Lat. 3439.

stage-designer (who worked with Pintoricchio and later with Bramante and Raphael), has been credited with drawings of Egyptian objects in the surviving sketches that bear his name, but some authorities consider them not to be by him:[15] the Sienese Sketch-Book includes the *Villa Adriana telamones* and a head with *nemes* head-dress. Among other artists who recorded Egyptian and Egyptianising motifs were Maerten van Heemskerck (1498–1574), who stayed in Rome from 1532 to 1535, and drew a sarcophagus resting on sphinxes as well as sundry other obelisks and sphinxes: he also produced a picture of the Pyramids of Egypt almost a century after *Hypnerotomachia Poliphili* which shows obelisks on top of stepped pyramids and obelisks resting on balls set on podia, demonstrating how very vague was the understanding of real Egyptian architecture even in the latter part of the sixteenth century.[16] Some commentators thought Poliphilus's pyramid with the obelisk on top was *Echt*-Egyptian, and it is likely that the stepped roof of the Mausoleum at Halicarnassus (**Plate 41**) was confused with the Pyramids of Gizeh in Renaissance minds, for the Pyramids, having lost their outer casing, were then stepped like the roof of the Mausoleum. Obelisks and pyramids were often jumbled images in the Renaissance and Mannerist periods, and do not appear to be properly categorised until several eighteenth-century publications clarified matters.

The *Codex Ursinianus*[17] contains many records of hieroglyphs, done in the 1560s, and drawings of various Egyptian artefacts, including the lions in front of the Pantheon and various *telamones*.[18] Gradually the city of Rome awoke to its great past. The period saw the rediscovery of several Egyptian and Egyptianising monuments of imperial times, most of which were recorded by artists and antiquaries. These documents really begin, as has been mentioned above, with Ciriaco d'Ancona's work of about 1450.[19] Cronaca[20] and Giuliano da Sangallo[21] produced many interesting and influential records of Egyptianising remains between around 1485 and 1510 (**Plate 43**); Giovanni Colonna, whose work survives in the *Biblioteca Vaticana*,[22] recorded his impressions in the 1520s; Maerten van Heemskerck[23] made his drawings in the 1530s; Amico Aspertini (*c*.1475–1552),[24] Francesco d'Ollanda,[25] and Lambert Lombard (*c*.1505–66)[26] made theirs in

15 *See* the Peruzzi Sketch-Book in Siena and EGGER (1902).
16 For Heemskerck *see* HÜLSEN and EGGER (1913–16).
17 Vat. Lat. 3439.
18 Illustrated in PEVSNER and LANG (1956, 1968 Edition), 221.
19 HÜLSEN (1907), *passim.*
20 MS. Christ Church, Oxford, Inv. 0814 r. and v., and Bayonne, *Collection Bonnat*, Inv. 1352 v.
21 HÜLSEN (1910*a*).
22 Vat. Lat. 7721.
23 HÜLSEN and EGGER (1913–16).
24 Now in the British Museum.
25 TORMO Y MONZÓ (1940).
26 Liège: Cabinet des Dessins (Aremberg Collection), Musée des Beaux-Arts.

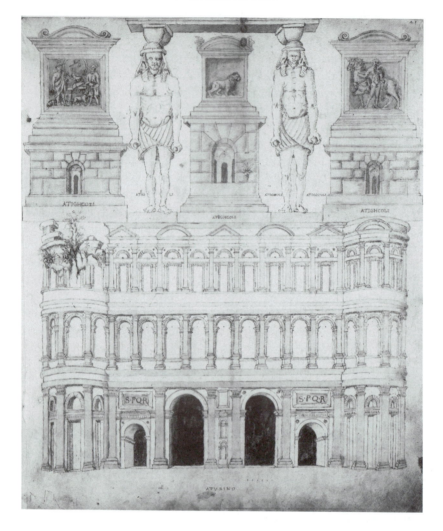

Plate 43 *Drawing by Giuliano da Sangallo recording various Antique remains. At the top are the two* telamones *from the* Villa Adriana *at Tivoli, now in the* Sala a Croce Greca, Museo Vaticano *(Nos 196–197). They are similar to the Egyptianising images of Antinoüs, and were originally in the* Canopus *at the* Villa Adriana*: they were probably inspired by similar figures set up in the* Isæum Campense*, and were derived from Osiris-columns found in Egypt itself.* Telamones *also recur in the so-called* Ariccia *relief, from a tomb on the* Via Appia Antica*, and now in the* Museo Nazionale, Rome*: this features the Apis-Bull, the god Bes, and baboons. The da Sangallo drawing also features a Roman city-gate in which the segmental and triangular pediments alternate over* ædicules*: thus an Isiac pediment form entered into the language of Roman Classical architecture, almost by stealth* (BAV, AF, Barb.Lat.4424, 43R [fol. 41R]).

the late 1530s (although Aspertini also made drawings in 1500–03); Stephan Vinand Pighius[27] and Pirro Ligorio[28] in around the mid-1550s produced their important sketches and studies of Egyptianising and other Antique objects; Jean-Jacques Boissard[29] did his work c.1559; Pighius produced more drawings c.1560–70 in the *Codex Ursinianus*;[30] Giovannantonio Dosio (1533–1609),[31] Pierre Jacques,[32] and Baldassare Peruzzi[33] followed suit; and around the turn of the century Étienne Dupérac (c.1525–1601)[34] drew a number of works, or copied them from other sketch-books by other hands. After 1612 Cassiano dal Pozzo (c.1588–1657)[35] spent much time investigating rare monuments in Rome and making himself thoroughly conversant with the wisdom, customs, and works of the ancients. From 1623 he was employed by the Barberini household after the election of Matteo Barberini as Pope Urban VIII (1623–44), and was able to pursue his antiquarian interests (which the Pope shared). Many of his discoveries and ideas were made known to the antiquarian and scholar Nicolas-Claude Fabri de Peiresc (1580–1637).[36]

Now all the sketch-books included Egyptian antiquities in Rome, but, with the exception of the obelisks (which had aroused considerable interest anyway), most of the artists seem to have recorded the Egyptian or Egyptianising artefacts incidentally, without according them especial significance (that is, until Kircher's influence began to be felt). The exceptions are the sketch-books of Pirro Ligorio, the *Codex Ursinianus* (Pighius), and the drawings of Dupérac, all of which appear to offer some kind of organisation of the visual evidence of Egyptian or Egyptianising antiquity as they were unearthed. It was then that the publications started to come out: Mercati's book on obelisks, *De Gli Obelischi di Roma*, was published in 1589; J. G. Herwart von Hohenburg's *Thesaurus Hieroglyphicorum* appeared c.1608; and L. Pignorius brought out his work on Egyptian antiquities, *Characteres Ægyptii*, in 1608. The collections of sketches by the artists mentioned above contain drawings of the *Villa Adriana telamones*, sphinxes, lions, obelisks, and other Egyptianising objects:[37] these, with the publications, are the major sources for Renaissance Egyptiana. Among the illustrations are several details of the *Mensa Isiaca* and

27 MATZ, FRIEDRICH (1871): *Monats berichte d. Kgl. Preuss. Akad. d. Wissenschaften zu Berlin* (Sept.-Oct.), 445– 99.
28 MANDOWSKY and MITCHELL (*Eds*) (1963).
29 Stockholm MS. S. 68. *See also* BOISSARD (1597).
30 Biblioteca Vaticana, Vat. Lat. 3439.
31 HÜLSEN (1933).
32 REINACH (1897).
33 EGGER (1902).
34 Paris, Bibliothèque Nationale, MS. *Fonds Français* 382.
35 VERMEULE (1960, 1966).
36 TURNER (*Ed.*) (1996), **xxv**, 412.
37 Mentioned earlier in the present text.

a much-admired *cynocephalus* discovered in the Middle Ages. The collections made by non-Italian artists led to Egyptian forms becoming familiar to artists and patrons throughout Western Europe, although it must be emphasised that these were records of existing known pieces, and were not original designs.

Egyptianisms in Design

The next step, having noted the sources, was to use Egyptian and Egyptianising features creatively in new designs. When Raphael decorated four State-Rooms in the Vatican (known as Raphael's *Stanze*) in 1514–17, he worked with Giulio Romano (*c*.1499–1546), who is also credited with aspects of the design.[38] On two walls of the *Stanza dell'Incendio* are Egyptianising *telamones* (**Plate 44**) clearly derived from those found at the *Villa Adriana* (**Plates 28** and **43**), and in the *Stanza della Segnatura* (painted during the Pontificate of Julius II) Raphael joined with his contemporaries in an enthusiasm for the Antique, for in the paintings we can find Diana of Ephesus as well as Ptolemy and other Egyptianesque features. The term 'Egyptianesque' is used deliberately here, since, as Pevsner and Lang have pointed out,[39] the Tivoli *telamones* were of Roman provenance and were nearer the spirit of the times than were many Ancient Egyptian artefacts, with the exception of sphinxes, lions, obelisks, and pyramids. Giulio Romano incorporated Egyptianising elements in his *Triumph of Scipio* at the Louvre in Paris, completed later. These works by Raphael and Romano move away from the mere recording of Egyptian and Egyptianising features to a creative interpretation of Nilotic and Isiac elements and this tendency became more marked as time went on. A further step in this direction is indicated by the extraordinary illumination of the Missal of Pompeo Colonna (**Colour Plate VIII**) which displays a good array of Egyptian and Egyptianising forms and decorations known to Renaissance artists. The Missal is a *creative arrangement* of motifs found in collections like the *Codex Ursinianus*: its date is uncertain, but is given as 1520 in M. R. James's *A Descriptive Catalogue of the Manuscripts in the John Rylands Library*[40] in Manchester (where the Missal can be found today). Pevsner and Lang,[41] however, drew attention to the fact that Pompeo Colonna was created a Cardinal in 1517, and since he is described as *Divo Pompeio Cardinali Columnæ* in the Missal, the illuminations probably date

38 HARTT (1958).
39 PEVSNER and LANG (1956, 1968 edition), 222. For more detailed discussion *see* ROULLET (1972), *passim*.
40 JAMES (1921), nos. 32–7, 87 ff.
41 PEVSNER AND LANG (1956, 1968 edition), 247, note 58.

Plate 44 *Painted Egyptianising figure (based on the* telamones *from the* Villa Adriana*), part of the* Stanza dell'Incendio di Borgo *of 1514–17 in the* Palazzo Vaticano, *designed by Raphael, and painted by Giulio Romano* (MV. AF, No. XVIII.40.9).

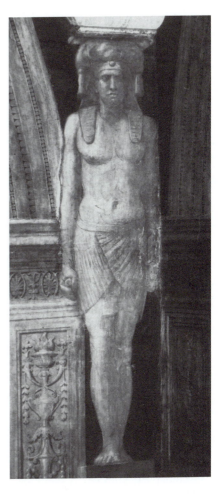

from after his death in 1532. Pevsner and Lang also quote the authority of Anne Roullet for suggesting a later date, as the details of the Missal that are derived from the *Mensa Isiaca* appear to be more like those published by Enea Vico in 1559 rather than those of the original drawings of the *Tabula*. Yet Giehlow[42] has shown that Pietro Bembo distributed several drawings of the tablet and details of it in his lifetime before 1520, and those may just possibly be the sources. Roullet has also argued that the hieroglyphs are too well observed and correct to have been painted at the beginning of the century, so on balance, given that the Vico published version seems to have a close resemblance to the details of the Missal, the date would appear to be some time in the second half of the sixteenth century.

42 GIEHLOW (1915), 111. *See* ROULLET (1972), no. 324.

The paintings of Pintoricchio in the *Appartamento Borgia* (**Plate 39**) suggested Isiac and other Egyptianising ideas without being overtly Egyptian in manner: the style was firmly Classical and Roman. Egyptianising motifs *were* used in the Missal, however, despite the strongly Renaissance features of some of the items, and it is a strange and unsettling piece of work. Unlikely though it may seem, the reasons for these Egyptianising decorations in the Missal appear to be similar to those behind the creation of the Pintoricchio works for the Borgias. According to Mugnos,[43] Colonna and his family claimed descent, not from mere Roman ancestors, but from something more mysterious, much older, and therefore better: it must be remembered that the worship of Antiquity created a desire for exotic and extremely long pedigrees. Apis, that is, Osiris, was once again the illustrious ancestor claimed by the Colonna clan.[44]

During the sixteenth century Egyptian motifs found in architecture are usually confined to obelisks, sphinxes, lions, and *telamones* based on the pair from the *Villa Adriana*. Sphinxes became relatively popular, usually as supports for sarcophagi, although they can also be found supporting columns, as in the porch of Sant' Antonio Abbáte in Rome (1269), where wingless Cosmati sphinxes support an Order, and recall an obelisk set on sphinxes on the right of the page from the Colonna Missal (**Colour Plate VIII**). This porch was noted by Thomas Hope (1769–1831) in his Sketch-Book, now in the Royal Institute of British Architects Drawings Collection. It must have appealed to him as a trigger for some of his furniture designs, as must the lion *monopodia* from the Bishop's throne in Santa Maria in Cosmedin, also drawn by him.[45]

In the church of Santa Maria della Pace (erected by Sixtus IV in 1480 and rebuilt by Pietro da Cortona [1596–1669] during the Pontificate of Alexander VII [1655–67]) there are several tombs of the Cesi family. Two sphinxes of remarkably refined design support the mid-sixteenth-century monument of Angelo Cesi: the bodies are visible from the front, and the heads and shoulders are turned round to face outwards (a more usual arrangement was to be for the spine of each sphinx to lie at right-angles to the length of the sarcophagus), so the Cesi sphinxes are a composite of the Egyptian lion type with turned humanoid head. The sculptor was Vincenzo di Raffaello de' Rossi (1525–87). The more usual type of straight symmetrical sphinx-supports can be found carrying the sarcophagus at the

43 *See* Select Bibliography.
44 PEVSNER and LANG (1956, 1968 edition), 222. They also refer (note 59) to A. LHOTSKY's 'Apis Colonna. Fabeln und Theorien über die Abkunft der Habsburger', in *Mitteilungen des Österreichischen Instituts für Geschichtsforschung*, **lv** (1942), 187. MUGNOS (1658) is essential on the Colonnas, while BURCKHARDT(1937) is also illuminating on ancestor-searches and on the Egyptianising of forebears of great Renaissance families. *See also* GIEHLOW (1915). The ramifications are mind-boggling.
45 WATKIN and LEVER (1980), 55–9 and plate 38b. The Author is indebted to Mr John Harris for first drawing his attention to the sketch-book, and to Professor Watkin for discussing it with him.

monument of Guillaume du Bellay (1491–1543 – soldier, historian, diplomat, and humanist) of 1557 in Le Mans Cathedral. This form of Renaissance tomb seems to have been invented by Andrea Sansovino (*c*.1467–1529) in 1505 for the tomb of Ascanio Sforza in Santa Maria del Pòpolo in Rome, although the sphinx-like forms have only tenuous resemblances to Egyptianising elements.[46] However, sarcophagi resting on sphinxes had not been unknown in Antiquity, and various artists, including Heemskerck, had recorded them, so the du Bellay monument may have been derived from Sansovino's design or from drawings of Antique fragments themselves. It is clear that a regard for the Antique had become fashionable in France as well, for du Bellay is depicted in Classical armour. Pevsner and Lang[47] have pointed out that Joachim du Bellay (*c*.1522–60) (Guillaume's cousin) was a member of a group of writers known as *La Pléiade*,[48] which was animated by a common veneration for the writers and sculptors of Antiquity. The title of the group was first given to a group of seven in the reign of Ptolemy Philadelphus that included Theocritus, Lycophron, and Aratus.[49] Joachim du Bellay wrote verses in praise of Diana, and was a friend of Pierre Belon (1517–64), one of the first Frenchmen of relatively recent times to visit Egypt and publish his impressions: his book came out in 1553 and included descriptions of the Pyramids and the Sphinx.

Pierre Bontemps (*c*.1505–68) has been credited with the sculpture of the du Bellay monument, and he was associated with Francesco Primaticcio (1504–70) (who had worked under Giulio Romano in Mantua, and who was called in by François Ier in 1532 to work at Fontainebleau with Giovanni Battista di Jacopo Rosso [1494–1540], called Rosso Fiorentino). Fontainebleau became the focus for the cultural ambitions of the King (who collected *objets d'art*, and employed Rosso, Primaticcio, and Benvenuto Cellini [1500–71] – the latter from 1540 to 1545), and gave its name to the School of artists which developed French Mannerism there (Rosso invented strapwork decoration at Fontainebleau). In 1540 Sebastiano Serlio (1475–1554) was also called to France by the King, and advised on building operations at Fontainebleau until he was succeeded by Philibert de L'Orme (1500–70). Serlio was certainly acquainted with Egyptianising motifs, and published a book on portals called *Livre Extraordinaire* of 1551 which enjoyed a considerable vogue. Primaticcio used sphinxes and other Antique motifs including obelisks in his decorations for the *Galerie d'Ulysse*, and Giulio Romano had incorporated Egyptian motifs in his *Triumph of Scipio*, which the King owned by 1534.

46 DAVIES (1910), 9, 146, 171, and 179. *See also* STREET (1883).
47 PEVSNER and LANG (1956, 1968 edition), 224.
48 HAY (*Ed.*) (1967), 187–91, and 341.
49 *Ibid.*, 224. *See also* HARVEY (1969), 652.

The first true piece of *architectural* Egyptiana in France can be found at Fontainebleau, in the *Pavillon des Armes*, or *Pavillon d'Horloge*, called Porte des Aumonières, facing the Jardin de Diane (**Plate 45**). It is an extraordinary concoction, with an entablature over the doorway carried by two female Egyptianising terms (pedestals like inverted obelisks supporting, or merging with, busts). Now the obvious source for the idea comes from the *Villa Adriana telamones* (**Plate 28**) which were well-known, and which had been recorded by numerous artists (**Plate 43**). Furthermore, Raphael and Giulio Romano had quoted the *telamon* motif in the *Stanza*, as has been noted (**Plate 44**).

Sune Schéle[50] has noted the resemblances of the Fontainebleau terms to Egyptianising terms by Cornelis Bos (otherwise Sylvius Bosch, or Bus [*c*.1510–*c*.1566]), who was in Paris in the 1530s, and it is possible the designer of the Porte knew Bos's work. Jacques Androuet the Elder (*c*.1520–*c*.1585) – known as Du Cerceau – published engravings of Egyptianising terms in 1559 which have baskets on their heads (so they are varieties of *canephoræ*,[51] albeit *terms*). One of these figures is almost identical to the Fontainebleau stone terms, but Schéle says that the Du Cerceau work is probably derived from Bos.[52] However, Du Cerceau's love of phantasy may suggest that he could have had some influence on the designs at Fontainebleau. A more likely source for the Fontainebleau figures is quite simply the *telamones* from Tivoli, made female, and incorporated with inverted obelisks: the *telamones*, after all, were much admired, and it would have been no great feat of imagination to make them female: indeed some drawings of them by Peruzzi and others make the breasts female.

There may be a reason for the change of sex that lies in the presence at Court of Diane de Poitiers (1499–1566), mistress (from 1536) of the Dauphin (the future King Henri II [reigned 1547–59]), and created Duchesse de Valentinois in 1548: it will be remembered that the Porte faces the Jardin de Diane. Stucco terms in the Chambre du Roi are in the form of Dianas of Ephesus, while the Chambre de la Reine was designed with sphinxes on the chimney-piece. Egyptianising elements were carried by the followers of the Fontainebleau School to other parts of France. At the Château of Bourdeilles in the Dordogne there are sumptuous painted

50 SCHÉLE (1965), 24, plate 27, no. 71.

51 *Canephoræ* (from the Greek, κανηφόρος *lit.* 'bearing a basket' with baskets on their heads) must not be confused with *caryatid(e)s, atlantes,* or *telamones. Atlantes* are male figures used instead of columns or pilasters to support an entablature, and are usually shown bent and straining against an immense load. *Telamones* are straight male figures, unbent, and showing no sign of strain, used instead of columns, and so are male versions of *caryatid(e)s,* which are female figures used instead of columns, and have astragals, ovolos, and abaci on top of their heads. *Canephoræ* have baskets instead of the astragals, ovolos, and abaci, and may be used as columns or not. PEVSNER and LANG (1956, 1968 edition) confuse the terminology. *See* CURL (1999, 2000) for precise definitions.

52 *See* SCHÉLE (1965), 24, 145, ROULLET (1972), and PEVSNER and LANG (1956).

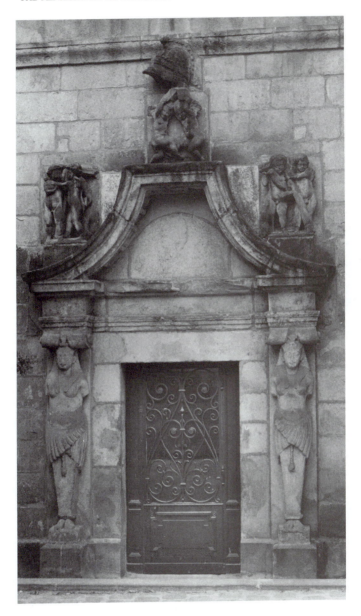

Plate 45 *Egyptianising doorway to the* Pavillon des Armes, *at the Château of Fontainebleau, facing the* Jardin de Diane, *by Giovanni Battista Rosso Fiorentino of c.1530, or possibly by Primaticcio or Serlio, of c.1540. The two figures on either side are female versions of the* Villa Adriana telamones, *but with inverted obelisks instead of legs, their feet protruding from the 'bases' of the obelisks. It seems to be the earliest piece of Egyptianising architecture in France. Photograph of 1979 (JSC).*

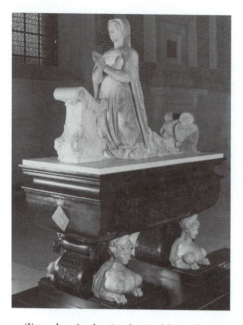

Plate 46 *Tomb of Diane de Poitiers (1499–1566), Château d'Anet, Eure-et-Loire, France. Note the sphinxes supporting the sarcophagus* (BAL GIR 192990).

ceilings by Ambroise le Noble and sphinx-motifs with wings of birds and insects (very Egyptian) on the beams. The Gold Room at Bourdeilles also contains a tapestry after a cartoon by Primaticcio showing François Iᵉʳ and his falconers.[53] A *Diane Chasseresse* by Primaticcio also enlivened the room of François Iᵉʳ at the Château of Chenonceaux, where there is a painted sphinx over the fireplace in the Chambre De César de Vendôme. Indeed, allusions to Egyptianising features, especially sphinxes, *telamones*, and various Isiac symbols (such as the crescent-moon on Diana's forehead), recur in French Renaissance interiors. Diana as Huntress also occurs in the Camera di San Paolo in the Convent of San Paolo in Parma, where the celebrated frescoes were painted by Antonio Allegri of Correggio (*c.*1489–1534) from 1518: over the fireplace is Diana with crescent-moon on her forehead, the entire composition set on a truncated, steeply-pitched pyramid – a very early example of this type of composition. In the gardens at Fontainebleau are sixteenth-century sphinxes with massive breasts, their tails set towards the long canal. Massive breasts also recur on the sphinxes supporting the sarcophagus on the tomb of Diane de Poitiers at the Château of Anet (**Plate 46**), and the sphinxes have crescent-moons on their heads.[54] Breasts and crescent-moons of course, are related to the Diana of the Ephesus-Isis theme. Dr Yates has reminded us that the Château of Diane de Poitiers was depicted as an Isiac temple in pictures created for the house.[55]

53 The Author owes this to Dr Eileen Blackstock.
54 For Diane de Poitiers *see* ORLIAC (1930), 312 and *passim*.
55 YATES (1947), 135.

Frontispieces and painted devices of the sixteenth and early-seventeenth centuries often incorporate Egyptianising motifs. Pevsner and Lang[56] have drawn attention to a design for a device of Henri II published in Venice in 1566 which features two female Egyptianising terms flanking a crescent-moon, complete with strapwork.[57] The Isiac-Egyptian connections with Diana would not have escaped an age that was much more alive than our own to symbol, allegory, and attribute. All of which could mean that the Fontainebleau Porte is connected with Diane de Poitiers, or that it is simply associated with François Ier's love of hunting. There is another association, which is that the fleur-de-lis is an emblem particularly associated with France and with French Royalty: it is a motif frequently found on finials and on other terminal features, and is, as the name suggests, derived from the lily. As an heraldic lily, the fleur-de-lis is closely associated with the Virgin Mary (and also with Isis-Diana): its basic form also suggests the lotus-bud that is often found on the forehead of Isis in Græco-Roman work.

One further problem remains concerning the terms of the Porte, and that is the date. Humbert[58] suggests c.1530 and that Rosso was the designer, but Pevsner and Lang proposed c.1540 and Primaticcio as the designer (on the grounds that the concave-sided pediment is less likely to have been designed by Rosso). If c.1540 is right then Serlio *might* be a candidate in the light of his *Livre Extraordinaire*.

Giulio Romano was mentioned above in connection with the Vatican *Stanze*, but the work he carried out at Mantua for Federico II Gonzaga (1500–40), 5th Marchese and 1st Duke, is also of considerable interest. The extraordinary Palazzo del Tè (1525–32) is regarded as a masterpiece of Mannerism, with its triglyphs appearing to drop from the entablature, giving a disturbing feeling of instability, and many other quirky details. But Giulio drew on Roman ruins (in which friezes had broken up) for the Palazzo del Tè, which is a clever mixture of an Antique villa and Raphael's Villa Madama (itself influenced by surviving parts of Roman *thermæ*). However, the Loggia delle Muse at the Palazzo del Tè is truly astonishing for its quotations from Antiquity, especially those with an Egyptianising flavour. The head of Alexander the Great, complete with horns of Amon (**Colour Plate I**), recurs in a medallion on the ceiling, and other medallions are copies taken from Antique coins. Coffers on the ceiling are decorated with frescoes of the Nectanebo lions (**Plates 34** and **35**), sphinxes discovered in Rome, and other motifs, but, even more surprising,

56 PEVSNER and LANG (1956, 1968 edition), 225 and notes 64–66. *See also* HAY (*Ed.*) (1967), 164–84.

57 The *Impresa* is inscribed *Enrico Secondo Re di Francia* and was published by H. Ruscelli.

58 HUMBERT (1989*a*), 35.

are hieroglyphs decorating the frames of the coffers. This Loggia is fully discussed in a brilliant paper by Bertrand Jaeger.[59]

Probably one of the finest of all Italian Renaissance gardens is that created for Cardinal Ippolito II d'Este (1509–72) between 1550 and 1572 by Pirro Ligorio[60] and others. Now Ligorio was an antiquarian of some distinction, and carried out major archæological investigations at the site of the vast *Villa Adriana* at Tivoli and studied the extraordinary antiquities that were being or had been excavated there.[61] He also wrote the *Libri del' Antichità*, which covers a huge range of topics and which, it if had been published in good time, would have undoubtedly assured his fame. As has been mentioned above, he recorded the artefacts recovered from the *Villa Adriana* as well as many of the Egyptian and Egyptianising pieces that had surfaced or were known in Rome itself.[62] Steeped in history, myth, and legend,[63] he interwove allusions to Antique Tiburtine cults into the complicated iconography he devised to honour d'Este at the gardens he designed for land the Cardinal had purchased below the governor's palace in 1550.

Memory is a major theme of these gardens of the Villa d'Este at Tivoli, for historical understanding of any part could be jogged by a series of triggers. The fountains for which the gardens are celebrated were intended not only to beautify the place and delight the beholder, but to contain meanings suggesting the nature and deities of the region. Those meanings are not at all obvious to the unprepared visitor of today, for they derive from the placing of the principal fountains on a system of alignments with various Antique sites in the surrounding landscape.[64]

In short, the gardens of the Villa d'Este at Tivoli are not only extraordinary and wonderful in themselves, but have formal relationships with the countryside beyond them, and especially with the principal sites of Classical Antiquity. The subject is of immense complexity and can only be touched upon here, but certain scholars have begun investigations that point to rewarding interpretations.[65] What is clear from an examination of sixteenth-century attitudes among the intellectuals of the day is that pagan deities were given Christian associations in a process of syncretism worthy of anything that occurred in the Græco-Roman world in the early years of the Empire.

59 JAEGER (1994). *See also* JAEGER (1991). *See also* GOVI ET AL. (*Eds*) (1991).
60 TURNER (*Eds*) (1996), **xix**, 370–3.
61 *Descriptio superbæ et magnificentissimæ villæ Tiburtinæ Hadrianeæ*, MS. Paris, Bibliothèque Nationale, MS. ital. 1129).
62 *See* MANDOWSKY and MITCHELL (*Eds*) (1963).
63 COFFIN (1964).
64 DERNIE (1996), 20–25.
65 For example COFFIN (1960 and 1964), and DERNIE (1996), 20–25.

Plate 47 *Artemis of Ephesus transformed at the Villa d'Este, Tivoli (compare with* **Plate 9***). Photograph of 1999* (JSC).

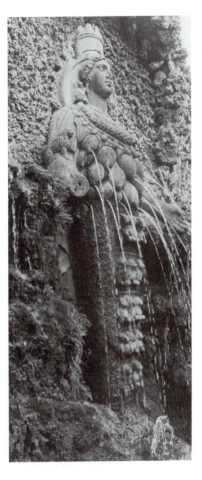

In 1567–8 Ligorio designed various statues for the gardens, but he also used ancient sculptures, some excavated from the *Villa Adriana*, to embellish the place. The Antique statue of Hercules that stood above the fountain of the many-headed dragon identified the gardens with the Garden of the Hesperides, but also alluded to the ancient deity of Tibur and to the supposed ancestor of the d'Este family who, like other grandees in Italy at the time, were not to be satisfied with descent from mere mortals.

Connections with Artemis/Diana, the *Villa Adriana*, St Paul, the Virgin Mother, the Generative Earth, and Egypt, among other allusions, are made by the fountain-statue of Artemis of Ephesus transformed. This time the curious necklaces of eggs/testicles have indeed become 'many breasts' complete with nipples spouting water (**Plate 47**), but the statue is not, apparently, in its original position (it was located at the Water Organ, in which context it was placed inside the shrine-like element in the central part of what was essentially a Mannerist triumphal arch, and was identified

125

with the Sybil of legend, who was to become *Mater Matuta*, the Goddess of the Dawn).

Then occurred one of the grandest, most public, and spectacular resurrections of Egyptian artefacts in Rome, already referred to in Chapter I. This was the re-erection of several large obelisks as part of a major town-planning improvement carried out under the ægis of Felice Peretti, Pope Sixtus V, who saw Rome as the seat of all spiritual and temporal power on earth. On the very day he became Pope (25 April 1585) he instructed the architects Domenico Fontana and Matteo Castello (1525–1616) to commence the reconstruction of the Acqua Alessandrina, renamed the Acqua Felice in his honour. It was the great fountain of the Acqua Felice at the end of the aqueduct which was decorated with the famous lions of Nectanebo (**Plates 34** and **35**). Sixtus's insistence on plentiful supplies of water regained the higher ground for habitation, for ever since the beginning of the Middle Ages the hills had been largely abandoned, and new buildings were concentrated in the low-lying areas by the River Tiber. Provision of water-supplies enabled the planning of Rome to proceed on a huge scale within the Aurelian walls, and Sixtus's vision transformed the city more radically than had been achieved by any Pope before or after him.[66]

Domenico Fontana created a scheme of straight roads, beginning (1587) with the Via Felice, linking the basilica of Santa Maria Maggiore and the Trinità dei Monti. Thereafter new thoroughfares were constructed, joining Santa Maria Maggiore to San Giovanni in Laterano, Santa Croce in Gerusalemme, San Lorenzo fuori le Mura, Santa Maria del Pòpolo, and also linking the Laterano to San Paolo fuori le Mura and the Colosseum. It was at the focal points of these roads that obelisks surmounted by crosses were erected: at Santa Maria Maggiore in the Piazza dell' Esquilino (1587), in the Piazza di San Giovanni in Laterano (1587), and in the Piazza del Pòpolo (1589). Earlier, of course, the huge obelisk had been put up in front of the basilica of San Pietro itself (1586).

The vast public works of Sixtus V's short Pontificate were celebrated in frescoes by Cesare Nebbia (*c.*1536–1614) and Giovanni Guerra (1544–1618) in the Salona Sisto of the new Library (1585–9) which was built under Fontana's direction across the Belvedere Court designed by Bramante. These frescoes have an iconographic programme glorifying Sixtus's achievements, including his transformation of Rome.[67]

It is hardly surprising that, as the obelisks in Rome were disinterred, studied, re-erected, or moved to positions of prominence, they aroused considerable interest. The great number of engravings of obelisks and columns in the *Cinquecento* testifies to the importance given to those

66 TURNER (*Ed.*) (1966), **xxiv**, 398.
67 GIEDION (1967), 75–100.

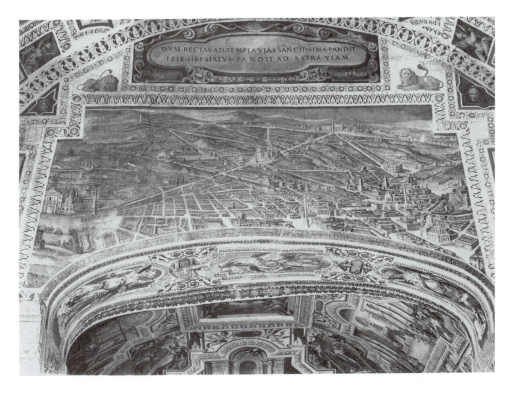

Plate 48 *The great fresco of Pope Sixtus V's master-plan for Rome in the Vatican Library showing the positions of the re-erected ancient obelisks. On the left is the obelisk in the Piazza del Pòpolo, and at the top is that in front of San Giovanni in Laterano. Between the Lateran and the Piazza del Pòpolo is the obelisk in front of Santa Maria Maggiore in the Piazza dell'Esquilino, and at the extreme top right corner is the pyramid of Cestius* (BAV.AF).

Antique objects, and the fine fresco in the Vatican Library shows how those obelisks dominate the plan (**Plate 48**). Sixtus and his architects placed obelisks at points where splendid urban spaces would be developed, so the centrepieces of important civic areas, as well as the focal-points of streets, were Egyptian or Egyptianising artefacts. This fact should not be underestimated: in Rome, where the Roman Catholic Church had its nerve-centre, obelisks,[68] with their mysterious hieroglyphs, could be seen by countless visitors, pilgrims, *cognoscenti*, and the like.

It was Sixtus's policy (very much in line with Counter-Reformation thinking) to preserve all ancient monuments that he could alter to serve the Faith or that could be used for some practical purpose (such as aqueducts). The process of 'Christianising' obelisks began with the exorcising of the

68 *See* ROULLET (1972), nos. 68–93. *See also* ONOFRIO (1967), 69–202.

huge obelisk that had stood to the south of the sacristy of San Pietro all through the Middle Ages (one of very few still upright by then), and replacing the ancient sphere on top by the papal *monti*, a sunburst of ten prongs and a cross. Other obelisks were given similar treatment by being surmounted by crosses, and the columns of Trajan and Marcus Aurelius acquired statues of St Peter and St Paul in 1587 and 1588 respectively. It is hardly surprising that a medal was struck to celebrate the Pope's achievements: the reverse is inscribed

CRVCI FELICIVS CONSECRATA

around the four obelisks shown with their new pedestals and crosses on top (**Colour Plate II**). It should be noted that the Lateran obelisk is actually even bigger than that in front of St Peter's, is 32·18 metres high, and weighs about 455 tons. It was found buried very deep and broken into three pieces, so it was quite a feat to put it together, transport it, and re-erect it. Sixtus had intended re-erecting three more obelisks, but Death intervened, and it was left to his successors to carry on the work.

The Hermetic Tradition

So it was that drawings, paintings, publications and an enormous interest in Antiquity brought Egyptian motifs to a wider public throughout Europe. The *Mensa Isiaca*, as we have seen, was published in 1559; Celio Calcagnini brought out his *De Rebus Ægyptiacis* in Basel in 1544; and Piero Valeriano (also known as Giovanni Pietro delle Fosse) published his *Hieroglyphica sive de Sacris Ægyptiorum Literis Commentarii*, also in Basel, in 1556. The last is a particularly full collection of hieroglyphic material.

As has been mentioned earlier, the Renaissance-Hermetic tradition was developed from the work of Marsilio Ficino and Pico della Mirandola, but it enjoyed a revival in the seventeenth century.[69] Ideas which had an 'Egyptian' origin, and which were connected with 'Hermes Trismegistus', also involved the Cabbala, and achieved expansion in the Rosicrucian Manifestos.[70] Robert Fludd (1574–1637)[71] was an adherent of Hermeticism, and an apologist for Rosicrucianism, as is clear from his *Tractatus Apologeticus* and *Apologia Compendiaria*. His *Utriusqui Cosmi . . . Historia* set out the basic scheme developed by Pico della Mirandola when he added Cabbalistic elements to the revival of Hermetic philosophy encouraged by Ficino's interpretation of the recovered Hermetic texts. Prominent in this proto-

69 YATES (1964), 209.
70 YATES (1972). Dr Yates's work has helped to clarify the muddy waters of fact and fiction in the seventeenth-century context.
71 GODWIN (1979b).

Enlightenment were Giordano Bruno (1548–1600) – philosopher, Dominican friar, intellectual, and admirer of 'Egyptian' wisdom – and Michael Maier – author of *Arcana Arcanissima* and *Symbola Aureæ*, – both of whom contributed to what Dr Yates has called 'the Rosicrucian Enlightenment'. Maier was close to the Court of Kaiser Rudolf II (1552–1612)[72] who was devoted to chemistry, alchemy, magic, astronomy, and astrology, and was the patron of Tycho Brahe (1546–1601) and Johann Kepler (1571–1630). The title-page of Maier's *Arcana Arcanissima, Hoc est Hieroglyphica Ægyptio-Græca* (1614) has two obelisks, each set on four balls on pedestals, with figures of Osiris, Typhon, Isis, Hercules, Dionysus, and representations of an ibis, a *cynocephalus*, and the Apis-Bull, while his *Symbola Aureæ, Mensæ Duodecim Nationum* is a volume not entirely innocent of Egyptian or Egyptianising ideas, containing material on *Hermetis Ægyptiorum Regis et Antesignani Symbolum*.[73] Both Maier and Fludd were published in Oppenheim, and both had connections with Great Britain, the Netherlands, the Court of the Elector Palatine, and the Court of the Empire itself. Maier, like Fludd and John Dee (1527–1608), did much to promote 'Egyptian Hermetic' truth: his *Symbola* contains praise of the wisdom of Hermes, celebrates the sacredness of the Virgin Queen Chemia,[74] and ends with a hymn of regeneration.[75] Chemia is obviously a variant on Isis, fount of wisdom, and the notion of the Virgin Queen is also found in Elizabethan times as Queen Elizabeth (reigned 1558–1603) became an ikon to replace the Papist Virgin Mary. Hermetic-Egyptian ideas can also be found in the works of Edmund Spenser (*c*.1552–99), and Dee was a key figure in Dr Yates's 'Rosicrucian Enlightenment'.

Interest in the occult was a feature of the period, and many looked to Egypt as the source of all knowledge. Considerable impetus was given to the study of things Egyptian by the influence of Giordano Bruno, who believed that the ancient wisdoms of Egyptian religion were of great significance to Christianity: he held that Egyptian theology was not only acceptable, but demonstrated that Christianity was hardly unique, and there is evidence he may have influenced certain Hermetic developments in Protestantism and Rosicrucianism.[76] Bruno probed the possibility of returning to some of the principles of the Egyptian religion, and Dr Yates has suggested influences on Elizabethan England, Lutheran Germany, and Freemasonry:[77] he preached a reformation of

72 YATES (1972).
73 The Council of Europe Exhibition in Florence in 1980 featured works of an occult and magical nature in which designs that included Egyptianising motifs were much in evidence.
74 YATES (1972), 85.
75 *Ibid.*
76 *Ibid.*
77 YATES (1972), 216.

the world[78] based on Hermetic-Egyptian wisdom in order to overcome religious differences. Yet Bruno was to die at the stake for his conviction that the wisdom, mysteries, and magic of Ancient Egyptian beliefs were superior to the dogmas of a repressive orthodoxy that burned dissidents. His denial of the unique nature of Christianity brought about a reaction from the authorities and a painful death in February 1600. The man who said that even the Cross was a symbol invented by the Egyptians, and who saw clearly the debt that Christian belief and practice owed to the ancient cults of Isis and Osiris, must have smiled a wryly cynical smile when considering that the powers demanding his life had ignored the presence of Isis and other Egyptian deities in the Borgia apartments in the Vatican, while the Vicar of Christ had claimed descent from Osiris (in whose divinity orthodoxy did not believe) through the dubious researches of Annius of Viterbo. The infamous burning of Bruno was one of the most extraordinary of double standards ever demonstrated by a powerful organisation.

It will be recalled that the title of *Theotokos* (meaning 'God-Bearer', therefore 'Mother of God') was confirmed at the Councils of Ephesus (431) and Chalcedon (451). The Doctrine that Christ was born of the Virgin Mary, without a human father, is based on *Isaiah* 7: 14, but it and various other constructs, such as The Perpetual Virginity of Mary, clearly owe debts to Egypt. Isiac symbols, such as the lily, the garden, the fountain and the rose had long been associated with the Virgin Mary, and can be found in plenty. In the Lady Chapel of the Collegiate church of St Mary in Warwick the gilt effigy of Richard Beauchamp gazes in adoration at the figure of the Virgin on the ceiling: she is shown as Queen of Heaven, standing on a crescent-moon; her head is crowned, and the arrangement of the decorative elements of the crown suggests the crescent-moon on her head as well.[79] She carries the orb and a sceptre decorated with the fleur-de-lis. So Isiac attributes were associated with the cult of the Blessed Virgin Mary: one of the more startling of Renaissance images of the Virgin and Child was produced by Francesco Vanni of Siena (1563–1610), and shows the Virgin standing with a crescent-moon at her feet, flanked by lilies and roses, with fountains in the background. From the time of Pope Paul V (1605–21) an image of the *Immacolata* as a young woman supported on a crescent-moon and crowned with stars became usual (**Plate 49**): a fine example of this typology occurs in the celebrated fresco in Paul V's chapel in the Palazzo del Quirinale by Guido Reni (1573–1642). It is perhaps significant that the crescent-moon should appear in images of the Virgin with increasing

78 For the reformation of the world and gardens *see* PATTERSON (1981), an interesting and wide-ranging paper.

79 The Author owes this item to Miss Eileen Bennett.

Plate 49 *Ceiling of the* Stiftskirche, *Lindau-am-Bodensee, Germany, showing the Assumption of the Blessed Virgin Mary, with the figure surrounded by stars and a sunburst, angels, cherubs, and the crescent-moon. It was painted by Andrea Appiani (1754–1817). Photograph of 1980 (JSC).*

frequency at precisely the same time when Egyptianisms were becoming more common in art and architecture, and in the following century-and-a-half artists of the Baroque and Rococo periods were to depict the Virgin with her Isiac attributes on ceilings and altarpieces throughout Roman Catholic Europe.

Renaissance Hermetic speculations were not confined to areas where Roman Catholicism remained strong, however. Protestant countries, notably Scotland, seem to have developed Hermetic notions which had an important influence on the development of Freemasonry.[80] Legends of the Craft hold that Freemasonry is as old as the art and science of architecture, and so there are debts to Ancient Egypt, to great works such as the Temple of Solomon in Jerusalem, and to mediæval European cathedrals.[81] The transition from Craft Guilds of Operative Masons to organisations concerned with what Dr Yates has called 'the moral and mystical interpretation of building'[82] and thence to 'a secret society with esoteric rites and teaching'[83]

80 CURL (2002b). *See also* DE QUINCEY, THOMAS (1824) 'Historico-Critical Inquiry into the Origins of the Rosicrucians and the Freemasons', in *The London Magazine*, which reappeared in his *Collected Writings (see* QUINCEY [1889–90]). *See also* YATES (1972), *passim.*
81 CURL (2002b).
82 *See* YATES (1964), 274, 414–16, 423, and YATES (1972), 209. *See also* CURL (2002b), and the bibliography in the last work.
83 YATES (1972), 209.

seems to have occurred in the sixteenth century. Freemasonic lore stresses the antiquity of geometry, even suggesting that Abraham taught the subject to the Egyptians, while other sources derived from the works of Diodorus Siculus state that geometry was invented by the Egyptians to work out the inundations of the Nile and that it was developed by Thoth-Hermes, otherwise Hermes Trismegistus, in connection with land-measurement and surveying, and hence the setting-out of monumental architecture. Thus the beginnings of architecture, and therefore of Freemasonry, are traced to Egypt,[84] the mysterious land from which all wisdom sprang. Abraham brought knowledge to Egypt, the Jews learned skills from Egypt when in captivity, then brought these skills to Jerusalem, where the Temple was the most perfect expression of architecture, so the legends go. From Jerusalem architecture was exported to the Greeks, and then to Rome, where Augustus was Grand Master of Freemasonry and Patron of Vitruvius, 'Father of all true Architects to this day'.[85] Roman expertise in Europe, according to *The Constitutions of Free-Masons*, declined until King James I and VI (1603–25) revived the Lodges in Great Britain and caused Roman architecture to be rediscovered, largely through the expertise of 'our great Master-Mason, Inigo Jones'[86] (1573–1652). But these arcane matters fall into the category of legend. However, it is beyond dispute that the great organisation that became Freemasonry developed rituals and codes that connect it with the Mysteries of Antiquity and, apparently, with the rites of Isis and Osiris (alluded to in Mozart's *Singspiel Die Zauberflöte* [K.620 of 1791]).

Yet, as we have seen, it was not only in Protestant Europe, in Freemasonry, and in Rosicrucianism that Egyptianisms occur: Hermeticism had produced some startling manifestations of Egyptianising motifs in Roman Catholic Europe, even in the Vatican itself. Indeed, the Hermetic tradition played a not inconsiderable rôle in the development of the Society of Jesus (of which Kircher was a distinguished member), and, as René Taylor has pointed out,[87] Hermeticism and mystical architecture became closely associated with the Counter Reformation. Thus Isiac attributes became overtly part of Marian imagery, and the crescent-moon became particularly associated with the Blessed Virgin Mary from the seventeenth century.[88] Relationships between alchemy, geometry, Freemasonry, Hermeticism, Rosicrucianism, Protestantism, Roman Catholicism, architecture, and Egyptianising tendencies are emphasised.

84 YATES (1972), 212.
85 ANDERSON, (1723). *See also* W. J. HUGHAN'S *Introduction* to the 1890 facsimile edition in *Quatuor Coronatorum Antigrapha*, **vii**. *See* CURL (2002*b*), 17–78.
86 ANDERSON (1923 edition), 39.
87 *See* WITTKOWER and JAFFÉ (*Eds*) (1972).
88 *See* SEZNEC (1953) and SOMMERVOGEL (from 1890).

Some Manifestations of Egyptiana

Northern European funerary monuments, frontispieces, and decorative arches (for masques, processions, and the like) acquired arrays of obelisks from the second half of the sixteenth century. The obelisk will be familiar to all those who visit parish churches or cathedrals in England, for they promiscuously feature in monumental design of the sixteenth and seventeenth centuries (which was not noted for its reticence). These obelisks are frequently confused with pyramids, but were intended to signify Eternity: they were known 'Antiques' or 'Anticks'. A fashion for obelisk 'Anticks' cannot be explained entirely by the rediscovery of Egyptian obelisks and their re-erection in Rome starting with the mighty town-planning scheme of Sixtus V described above. Small obelisks are not features associated with Italian funerary art, but are very common in Northern Europe, especially in the commemorative monumental architecture of the Netherlands, Northern Germany, and England. It seems likely that the obelisk as a symbol of eternity may have achieved fashionable status through the iconography on printed sources (many of these in the Hermetic tradition derived from Pico della Mirandola). Inigo Jones used obelisks as part of his architectural vocabulary, it is true, but those powerful forms also enjoyed a symbolic significance and association with Freemasonry, Rosicrucianism, and alchemical-Hermetic-Cabbalistic currents. It is particularly interesting that the widespread use of an Egyptian element as individual and recognisable as the obelisk should have been so common in Northern, largely Protestant, countries, where Freemasonry (the guardian of knowledge and Ancient Egyptian wisdom) and a Rosicrucian search for Enlightenment (derived partly from the questioning of orthodoxy by Bruno) were influential. Obelisks were also used (especially in the Netherlands and in Germany) to provide crowning embellishments for gables and parapets in important buildings: the Town Hall at Leiden (*c.*1579) has crowning obelisks and features with Ionic capitals that look oddly like the Fontainebleau terms when seen from a distance, while the *Stadtweinhaus* in Münster was crowned with spectacular banded obelisks.

Religious upheavals in Europe (notably the massacre of St Bartholomew's Day in 1572) led to a migration of artisans, and so obelisks, ribbon-like decorations loosely draped around vertical arrows or shafts (suggestive of the serpent twined around a vertical object), *putto*-heads with wings (recalling the outstretched wings on either side of the solar globe), and other motifs having affinities with Egyptian prototypes, became widespread. At the same time certain Egyptian or Egyptianising motifs continued to occur in printed sources, including Ruscelli's *Imprese* (already

noted above) and Giovanni Antonio Dosio's (1533–1609) record of Roman antiquities, both published in the 1560s.

Travellers and Speculators

Then came a few travellers to venture into Egypt to see Egyptian antiquities for themselves. One of the first was George Sandys (1578–1644) who recorded his impressions in *Relation of a Journey, begun . . . 1610* (1615): the Pyramids were monuments to 'prodigality and vainglory', and he described crocodiles and other creatures and plants unfamiliar to early-Stuart England. Next on the scene was Nicolas-Claude Fabri de Peiresc, French *savant*, patron, and collector of antiques, who included Egyptology among his many interests, speculating about hieroglyphs and attempting to unravel their meanings by diligent research into the Coptic language. Pevsner and Lang[89] have noted correspondence between Peiresc and (Sir) Peter Paul Rubens (1577–1640) about a mummy (there was a considerable trade in mummies, which were pulverised and used by apothecaries for their concoctions), and between Peiresc and William Camden (1551–1623) about a figure of Isis: regarding the image of the goddess, Peiresc also corresponded with Lorenzo Pignorius (who brought out a new edition of descriptions and illustrations of the *Mensa Isiaca* in 1669, entitled *Pignorii Mensa Isiaca*, with a frontispiece featuring a pyramid, obelisks, sphinxes, a *cynocephalus* holding an *ankh*, a term with an inverted-obelisk base, and a hawk-headed figure), and with Girolamo Aleandro, secretary to Cardinal Barberini, which clan had a taste for Egyptian objects. Peiresc also knew the Jesuit Athanasius Kircher, who consulted the Frenchman when he started to work on hieroglyphs. It seems to have been Peiresc who prompted Kircher to approach Barberini, and from the 1630s on, Kircher was to remain in Rome where, in the words of Pevsner and Lang, he 'succeeded in establishing himself' as the recognised 'authority on Egyptian matters' on 'thoroughly unsound foundations'.[90] Peiresc, however, was an indefatigable correspondent, was an important link between intellectuals all over Europe, and his significance as a disseminator of knowledge cannot be overestimated. His scholarship was also impressive.[91]

89 PEVSNER and LANG (1956, 1968 edition), 227.
90 *Ibid.*, 228. Perhaps the remark is a little unfair: Kircher recorded hieroglyphs accurately (and was almost alone in doing so at the time), and he was on to a theory about them which, had he had the information available to scholars in the early nineteenth century, might have enabled him to solve their mystery. He also built up a remarkable collection of Antique Egyptiana, and had a good eye for what was Egyptian or Egyptianising and what was not.
91 TURNER (*Ed.*) (1996), **xxiv**, 329–30.

As the speculative fringes of theology embraced a somewhat distorted notion of Egypt, and the idea that the Ancient Egyptians were the possessors of true wisdom gained ground (not a new idea, but one that had some currency in imperial Rome), Hermetic publications became reputable, and alchemical and magical aspects gained prestige. A by-product of all this was that Egyptian and Egyptianising motifs were integrated with Christian iconography. Isaac Casaubon (1559–1614) demonstrated that the so-called 'Hermetic' writings were not Ancient Egyptian at all, but post-Christian in date, whereupon the wrath of Jesuit critics fell upon him. Many ignored Casaubon's critique, including Fludd and Sir Walter Raleigh (c.1552–1618) – both convinced Hermeticists – and the Jesuit Athanasius Kircher (who mingled his brand of Hermeticism with doses from the Cabbala, with Mexican and Oriental spice added to his synthesis).

Considerable impetus was given to the study of Egyptian antiquities and Hermeticism by the appearance of various works by Kircher, who not only established a museum of Egyptian and Egyptianising antiquities in Rome, but used the ideas of the Pythagoreans, of Plato, of Pico della Mirandola, and those in Hermetic writings to set up systems to explain the cosmos. Kircher's use of light and dark pyramids in diagrams is derived from the work of Fludd, and owes a considerable debt to the system of numbers adopted by the Sage of Croton, Pythagoras (fl. sixth century BC). Kircher sought to explain pagan cultures to his own Counter-Reformation world, but his many publications[92] include works of pseudo-Egyptology purporting to deal with sphinxes, obelisks, and hieroglyphs, and a great deal of his œuvre is speculative. If the written contents of his books are inaccurate and fantastic, the same flavours pervade the illustrations: the frontispiece of his *Sphinx Mystagoga* of 1676, for example, shows an array of pyramids of the excessively spiky variety owing more to the Cestius model and to obelisks than to the Gizeh type, while his improbable Pyramid of Cheops looks forward to Fischer von Erlach and Boullée described below. A flavour of the occult and the improbable is strong in Kircher's publications and illustrations. His enormous collection of material, however, included statues, inscriptions, sphinxes, and other items, and the museum he established was the first to be solely devoted to Egyptian and Egyptianising artefacts, although there was much Egyptiana in other great collections, notably those of the Farnese family and of the reigning House of Tuscany.

The volume that had first stimulated Kircher's Egyptological studies was Johann Georg Herwart von Hohenburg's *Thesaurus Hieroglyphicorum* (c.1608, the same year in which Pignorius's *Characteres* came out). Now

92 *See* Select Bibliography.

Herwart treated hieroglyphs as decorations, a view Kircher held was incorrect, so he began to study the Coptic language using material provided by Peiresc, including the collection and glossary of Pietro della Valle (1586–1652) which became the basis of Kircher's work. *Prodromus Coptus sive Ægyptiacus* (1636) and *Lingua Ægyptiaca Restituta* (1643) provided bases for all subsequent studies of Coptic: although Kircher believed Coptic was closely related to the tongue of pharaonic Egypt, he failed to decipher the hieroglyphs correctly as he regarded them as symbolic rather than linguistic, and the phonetic system eluded him. It must be remembered, however, that Hermes Trismegistus was credited with the invention of hieroglyphs, and that the mysterious signs were thought to enshrine the highest mysteries of divinity itself.

The re-erection of an obelisk to stand before the Palazzo Pamphili in the 1640s provided Kircher with a chance to study the hieroglyphs, and to suggest designs for the worn and lost pieces of the inscription. The broken obelisk from the Gardens of Sallust, found in 1666, and with only three sides visible, gave Kircher the opportunity of suggesting what might be carried on the hidden face: he produced a drawing of the likely appearance of the fourth side, and when the obelisk was raised he was found to be correct. His success with the fourth side can be ascribed to his accurate observations of the other three sides and his recognition of the similarity to another obelisk. In this respect Kircher was unusual in that he was among the first to copy hieroglyphs with accuracy: most observers simply did not bother. He illustrated the *Mensa Isiaca* correctly: for him and for many others it was a rich source of Egyptian motifs. Kircher's work was subsequently proved to be unsound, for his interpretation was inductive, and he tended to read into hieroglyphs what he had gleaned from writers on philosophy, wisdom, theology, astrology, the Cabbala, Hermetic texts, and magic.

William Warburton, Bishop of Gloucester (1698–1779), did not approve of the Neo-Platonic mysticism of Kircher and others. In his *The Divine Legation of Moses* (1741), Warburton mentions Egypt and hieroglyphs, and specifically denounces the 'late Greek Platonists, and forged Book of Hermes'. Kircher's approach, to Warburton, was a futile journey through the 'fantastic regions of Pythagorean Platonism', and English Georgian rationalism was not impressed by the murky occultism of Renaissance Egyptology: nevertheless the Hermetic tradition, and the belief that Egypt was the source of all wisdom, took a long time to be discredited.

The late Anthony Blunt[93] has described a drawing by Stefano della Bella (1610–64) which shows the Pyramids and the Sphinx: it has been suggested

93 BLUNT (1954).

that this picture was intended to illustrate Pietro della Valle's work, *Viaggi*,[94] which duly appeared in 1650. Stefano della Bella had spent some time in Paris, where he worked for Cardinal Richelieu (1585–1642), and in Italy he had worked mostly for the Duke of Tuscany: his convincing drawing is very likely based not on della Valle's written description, but on the writings of Tito Livio Burattini who had known Egypt around the end of the 1630s. Burattini was more accurate as an observer than some of his contemporaries, and had travelled in Egypt with John Greaves (1602–52) of Oxford, with whom he had investigated the Great Pyramid at Gizeh. Greaves made accurate surveys, later published in his important *Pyramidographia* (1646), the first objective and truly thorough accurate work on the pyramids, which, by virtue of its unsensational and balanced descriptions, stands out as a model of clarity in fields where obfuscation was usual.[95]

Bernini

A growing taste for Egyptianising ornaments in gardens perhaps begins with the Villa d'Este at Tivoli and other sixteenth-century creations, and received additional impetus after the re-erection of obelisks in Rome. That process continued long after the Pontificate of Sixtus V, and in 1647 the Fountain of the Four Rivers (*Fontana dei Fiumi*) in the Piazza Navona, Rome, was commenced to designs by Gian Lorenzo Bernini (1598–1680), and completed in 1652: it consists of a rocky, grotto-like travertine base representing the four corners of the earth, round which are grouped the river-deities of the Danube, Ganges, Nile, and Rio de la Plata (**Colour Plate IV**).[96] Over the massive and heroic base, pierced on all four sides, Bernini placed the obelisk (which therefore seems to be carried over the void) first erected in the central court of the *Iseum Campense* in AD 81 shortly after Domitian's accession, then moved by Maxentius at the beginning of the fourth century to grace the Circus on the Appian Way. During the mediæval period the obelisk lay broken but visible: it was noted by the Anonymous Magliabecchianus in the 1410s, and Poggio Bracciolini saw it later; it was drawn by several artists in the sixteenth century (including da Sangallo, Ligorio, Dupérac, *et al.*), and in 1648 Pope Innocent X (1644–55) had it moved to the Piazza Navona, probably at the instigation

94 PEVSNER and LANG (1956, 1968 edition), 228. *See also* the Select Bibliography of the present work.
95 This Chapter has drawn on ROULLET (1972), PEVSNER and LANG (1956), KIRCHER (1636, 1643, 1647, 1650, 1652–4, 1666, 1676, and 1679), GODWIN (1979*a* and *b*), 1981, and 1999), CONNER (*Ed.*) (1983), and YATES (1947, 1964, 1966, and 1972), to which authors and works acknowledgement is given.
96 TURNER (*Ed.*) (1996), 832.

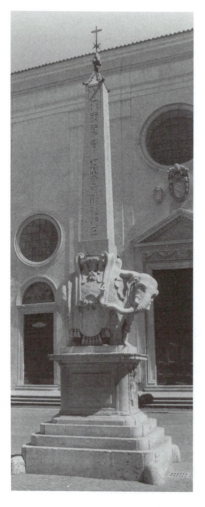

Plate 50 *Egyptian obelisk of red granite from Saïs, originally brought to Rome and set up on the dromos of the Isæum Campense. It was rediscovered in the garden of the Dominican Convent near the church of Santa Maria sopra Minerva in 1655 during the Pontificate of Alexander VII. In 1666–67 it was re-erected on a specially sculptured elephant to designs by Gian Lorenzo Bernini in the Piazza della Minerva, but the image of an obelisk on an elephant derives from the celebrated illustration of 1499 in* Hypnerotomachia Poliphili. *Photograph of 1999 (JSC).*

of Kircher.[97] This stunning composition represents the triumph of Christianity, the power of the Pope, and the influence of the Roman Catholic Church throughout the whole world: the obelisk too, associated with the sun's rays and with supernatural force, is given additional symbolism by appearing to be weightless, carried aloft over the void.

Bernini also designed a base for the small obelisk found in the gardens of Santa Maria sopra Minerva, deriving his composition from the woodcut of the elephant carrying an obelisk on its back in *Hypnerotomachia Poliphili* of 1499 (**Plate 40**): the obelisk was set up on Bernini's base (**Plate 50**) in the Piazza della Minerva during the Pontificate of Alexander VII, who was particularly interested in Egyptology, and who knew Kircher. The

97 ROULLET (1972) no. 72.

re-erected obelisk was intended as a special memorial to Alexander's Pontificate, and the symbolism suggests the bringing of the sun's rays on the back of Wisdom.[98]

Other re-erected obelisks have been mentioned earlier, but obelisks also featured in architectural compositions and in capricci, especially when Antiquity was to be suggested. Nevertheless, despite so many obelisks having been re-erected or made for specific architectural reasons, they could still be confused with pyramids, and nowhere is this more obvious than in a type of funerary monument in which figures are composed against a tapering element in turn set against a wall: often that element has a pyramidal top, so it is like a fat obelisk. Such designs derive from Bernini's pyramidal compositions as in the papal funerary monuments in Rome: these were prototypes for a type of Baroque memorial that can be found in considerable numbers (**Plate 58**).

The French Connection

A taste for Egyptianising garden-ornaments in France may have derived from Roman precedent. As early as 1632 Egyptian statues arrived in France, where they were acquired by Nicolas Fouquet (1615–80), builder of Vaux-le-Vicomte, then they passed to André Le Nôtre (1613–1700). After Fouquet's arrest, King Louis XIV (1643–1715) acquired the services of Fouquet's architect, Louis Le Vau (1612–70), his painter Charles Le Brun (1619–90), and his gardener, Le Nôtre. The trio was asked to outdo its achievements at Vaux-le-Vicomte for the King at Versailles, where even the plan of the town owes its origin to the layout of the Piazza del Pòpolo in Rome, with its radiating axes meeting at the obelisk. Louis XIV was identified with Apollo (the 'Sun-King'), and there are certain affinities between the château and gardens of Versailles and the *Villa Adriana* at Tivoli: just as Hadrian's villa contained a great number of Egyptian and Egyptianising objects, so the gardens of Versailles were embellished with Egyptianising sculptures, including sphinxes and obelisks. Certain Egyptianising tendencies of the French monarchy from the time of François Ier have already been noted, but from the reign of Louis XIV Egyptianisms began to recur with greater frequency. The King and Jean-Baptiste Colbert (1619–83) established the French Academy in Rome to excavate and study antiquities and to record paintings and monuments, and thus helped to encourage an appreciation of Egyptian motifs in French design. The desire to emulate Versailles brought Egyptianising garden-ornaments to every corner of civilised Europe.

98 HIBBARD (1966), 118–23.

Thus close connections between Italy and France in cultural matters developed. Nicolas Poussin (1593–1665) used Egyptianising elements, including some from the Palestrina mosaic, in *The Flight into Egypt*, and there are Egyptianising motifs in some of his other compositions. Furthermore, there was considerable missionary activity, and certain religious Orders had established more-or-less permanent centres in Cairo and other places from the early-seventeenth century.[99] In 1672 Colbert entrusted a German Dominican, Father Vansleb, with the task of acquiring manuscripts and ancient coins: Vansleb travelled as far as Upper Egypt, and took a lively interest in the monuments – he was among the first to describe the ruins of Hadrianic Antinoöpolis.[100] Jean de Thévenot (1633–67) visited the Delta area, Cairo, and its environs in 1652: whilst there he measured the Great Pyramid at Gizeh and described the interior; he also was the first European to suggest that Memphis was near Saqqara, and published his account of his journeys in the Levant in 1664. Father Claude Sicard (1677–1726), a French Jesuit, discovered and identified Thebes, and appears to have been one of the first European travellers since Antiquity to discover the temples of Kôm Ombo, Elephantine, and Philæ. By 1722 he had located twenty principal pyramids, twenty-four complete temples, and over fifty decorated tombs.[101] Sicard had been entrusted by the Regent, Philippe d'Orléans, with the task of recording Egypt's ancient monuments, and he drew the first map of Egypt from the Mediterranean Sea to Aswan. Before he died he had written a geographical comparison of Ancient and Modern Egypt.

Benoît de Maillet (1656–1738), French Consul-General in Egypt under Louis XIV, was the first of many European diplomats who used their influence to acquire Egyptian antiquities for European collections: he supplied Anne-Claude-Philippe de Thubières, Comte de Caylus, Marquis d'Esternay (1692–1765), archæologist and man of letters, with Egyptian artefacts. Maillet published his *Description de l'Égypte* in 1735, the first attempt to describe all of Egypt, with antiquities given pre-eminence.[102] Maillet included a section of the Great Pyramid, and seems to have been the first to promote the idea of transporting some of the Luxor obelisks to Paris.

Information gathered by Sicard and Maillet shed much light: no longer was Egypt regarded with superstitious awe as a mysterious land peopled by monsters and dæmons. Another Frenchman, Paul Lucas (1664–1737), explored Saqqara and published his *Voyage fait en 1714* in 1720. Thomas Greenhill published a picture of the Saqqara catacombs in 1705 in his book on embalming. Middle and Upper Egypt were further explored by Dr N.

99 VERCOUTTER (1992), 30.
100 *Ibid.*, 31.
101 CLAYTON (1982), 12.
102 VERCOUTTER (1992), 33.

Plate 51 *A plate from the English edition of BERNARD DE MONTFAUCON (1721–22). At the top* (right) *is the central ædicule from the* Mensa Isiaca, *and at the bottom* (left, No. 8) *is an Egyptianising* telamon *statue. Many items are identified as 'found at Rome', while others were in private collections in France* (MC, Mansell/TimePix).

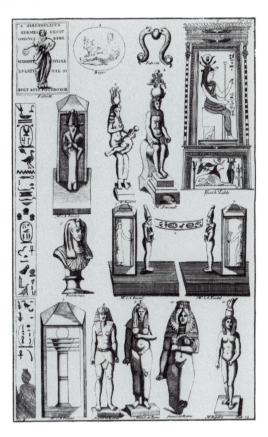

Granger of Dijon (died 1733), who discovered the temple of Seti I at Abydos.[103] The French contribution to an understanding of Ancient Egypt cannot be overstressed. Especially important in this respect is Bernard de Montfaucon (1655–1741), whose *L'Antiquité expliquée et représentée en figures* was published in ten volumes in Paris between 1719 and 1724. This mighty work is a comprehensive archæological study, and discusses Egyptian as well as Classical antiquities, based on Montfaucon's travels in Italy (he did not visit Egypt): it includes pyramids, sphinxes, and other items, including mummies (**Plates 51** and **52**). The diligent Benedictine systematically set out his examples of Egyptian artefacts with some skill, and he gives the impression of being critical of some earlier research, which he regarded as speculative and undisciplined: he rejected far-fetched interpretations of hieroglyphs, despised admiration for 'Egyptian Wisdom', and denounced Egyptian art and religion. Here was the mind of the Enlightenment at work: sober, discriminating, rational, unemotive, and sceptical. Montfaucon shared with

103 CLAYTON (1982), 12–13, and VERCOUTTER (1992), 30–7.

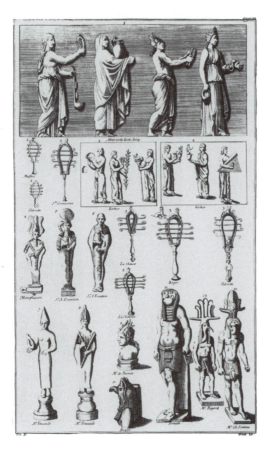

Plate 52 *A plate from the English edition of MONTFAUCON (II, 2, pl. CXVI, No. 2), including many examples of the* sistrum *(rattle), and various objects from the collections of Kircher, Claude-Nicolas Fabri de Peiresc (1580–1637), and others. At the top is an Isiac procession, and below it is another Isiac procession featuring a harp, a sistrum, a tambourine, and other objects. These processions were carved on a grey-granite column formerly in the* Isæum Campense *in Rome, and now in the* Museo Archeologico, Florence. *These Roman creations in an Egyptianising style were drawn by dal Pozzo at the beginning of the seventeenth century, and Kircher mentions the column as standing in the Medici Gardens in Rome (MC, Mansell/TimePix).*

Bishop Warburton a deep distrust for the mysticism of Kircher and others. Pythagorean Platonism was relegated to a shadow of a dream in the fantastic world of occultism, for a new scientific rationalism was abroad. Yet, despite a rejection of Alexandrian Neo-Platonism, Egyptian art became the subject of serious study, and later archæological investigations were to reveal it as a definitive style, worthy of respect.

CHAPTER IV

Egyptian Elements in Eighteenth-Century Europe to the Time of Piranesi

Explorers of the Eighteenth Century; Further Baroque Themes; The Search for Stereometrical Purity; The Individual Contribution of Giovanni Battista Piranesi; The Legacy of Piranesi

Pygmies are Pygmies still, tho'percht on Alps,
And Pyramids are Pyramids in Vales.
Each man makes his own Stature, builds himself:
Virtue alone out-builds the *Pyramids*;
Her Monuments shall last, when *Egypt's* fall.

<div align="right">

EDWARD YOUNG (1683–1765):
Night Thoughts, Night the Sixth (1744), lines 309–313.

</div>

Nimrod is lost in *Orion*, and *Osyris* in the Dogge-starre.

<div align="right">

SIR THOMAS BROWNE (1605–82):
Hydriotaphia (1658), Ch. V.

</div>

Explorers of the Eighteenth Century

In 1720 the clergyman Thomas Shaw (1694–1751) took up the position of Chaplain to the English Factory in Algiers, and over the next decade travelled in North Africa, including Egypt. His *Travels, or Observations relating to Several Parts of Barbary and the Levant* came out in 1738 (a second edition was published in 1757), and included an engraving of the Palestrina mosaic in a mirror-image of the original. However, until the 1730s no British travellers had gone further south than Saqqara. Then the Rev. Richard Pococke (1704–65), later Bishop of Ossory and Meath, compiled detailed descriptions and measurements of several monuments as far upstream as Aswan, and published his work in his *A Description of the East and Some Other Countries* (1743–45). Pococke was a founder-member of a club called The Egyptian Society in London, as was Frederik Ludvig Norden (1708–42), who had been sent to Egypt in 1737 by King Christian VI of Denmark to study the country. Norden got as far as Derr in Nubia, and his *Travels in Egypt and Nubia* came out in 1757: the latter was of considerable importance in the history of the Egyptian Revival, for it had clear illustrations by Marcus Tuscher (1705–51) (**Plates 53** and **54**), and

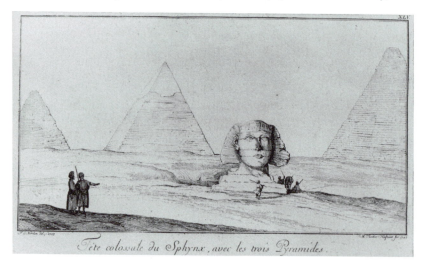

Tête colossale du Sphynx, avec les trois Pyramides.

Plate 53 *A more accurate version of the Gizeh pyramids and Sphinx from plate XLV in F. L. NORDEN of 1757. Norden was a Captain in the Danish Navy, and was the first European to to travel so far up the Nile and have an account of his journey posthumously published. He subsequently served in the British Navy, and lived in London, where he was elected to several learned societies. Even though Norden knew Egypt, his pyramids are too steep compared with the reality. It is as though, to eyes accustomed to the 'Classical' pitch of the Cestius pyramid, the more squat Egyptian pyramids were unacceptable, and had to be made to appear more elegant (GN/SM).*

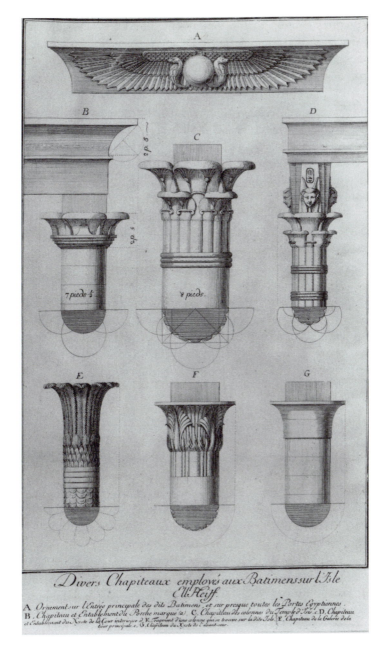

Plate 54 *Plate CXLIV from NORDEN showing reasonably accurately-observed Egyptian details: (A) coved cornice with winged globe and uræi; (B) an 'Order' with coved cornice; (C) papyrus-capital; (D) papyrus-capital with heads on the abacus; (E) palm-capital; (F) enriched bell-capital; (G) unadorned capital. Norden's work remained a standard Egyptological source-book from the time of its publication until the Napoleonic studies came out in the early-nineteenth century (GN/SM).*

those pictures relating to the monuments of Middle and Upper Egypt revealed something of the glories of Dendera, Karnak, Luxor, Esne, Edfu, Kôm Ombo, and Philæ to the public. Norden was to enthuse about Egyptian architecture, and saw it as superior to Greek and Roman work.[1]

Dr Charles Perry (1698–1780) also reached Aswan, and published his *A View of the Levant* in 1743. Norden's and Pococke's books were the standard Egyptological sources from the time of their publication until the Napoleonic studies superseded them. Many travellers followed, including James Caulfeild, 4th Viscount and 1st Earl of Charlemont (1728–99) (who was accompanied by Richard Dalton [*c*.1715–91], the first British professional artist to visit Egypt) in 1749, and John Montagu, 4th Earl of Sandwich (1718–92) (whose *A Voyage Performed . . . in the Years 1738 and 1739* was not published until 1799).[2] Then came a Danish expedition in the 1760s, one of the members of which was the German Carsten Niebuhr (1733–1815), the only survivor of a gruelling voyage, who published an account in 1772. These intrepid explorers were followed by James Bruce (1730–94), who went to Egypt and Abyssinia from 1768 to 1773: his *Travels to Discover the Source of the Nile* came out in 1790, with subsequent editions. Bruce was accompanied by Luigi Antonio Melchiorre Balugani (1737–71), who tended to refine and Classicise artefacts he drew,[3] but whose contributions Bruce caddishly dismissed claiming Balugani's drawings were his own.

Further Baroque Themes

In 1712 Johann Bernhard Fischer von Erlach (1656–1723) completed a series of illustrations with texts, based on his drawings and observations made over the years, and these were published (with texts in German and French) as *Entwurff einer Historischen Architektur . . .*, in Vienna in 1721 and in Leipzig in 1725. The book was translated into English by Thomas Lediard (1685–1743) and published in London in 1730 as *A Plan of Civil and Historical Architecture*. The illustrations are extraordinary: many show eclectic compositions that purport to be 'historical' buildings, but often the scale is grossly inflated, as in his vision of the Temple of Solomon,[4] from which building Fischer believed all Classical architecture derived (a peculiarly Freemasonic concept). His engraving of the Gizeh Pyramids (IV) shows them too steeply pitched (**Plate 55**), whilst his ramped pyramids piercing the clouds (No. XI) anticipate the work of Boullée (**Plate 56**).

1 NORDEN (1757), **ii**, xxiii.
2 It has been suggested that this book was largely written or heavily corrected by his tutor.
3 CLAYTON (1982), 12–14, and VERCOUTTER (1992), *passim.*
4 CURL (2002*b*), 94–103.

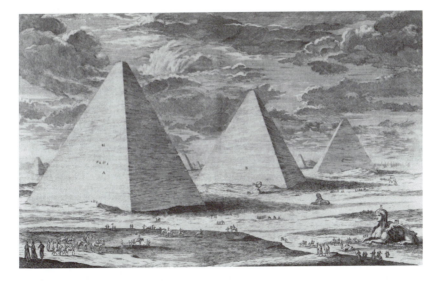

Plate 55 *Gizeh pyramids (which appear to have acquired numerous progeny) and Sphinx, as interpreted by FISCHER VON ERLACH in plate IV of his* Entwurff einer Historischen Architektur *(1721). This gives an idea of the Egypt of the European imagination, as the pyramids owe more to the steeply-pitched Roman Cestius type than to true Egyptian exemplars* (GN/SM).

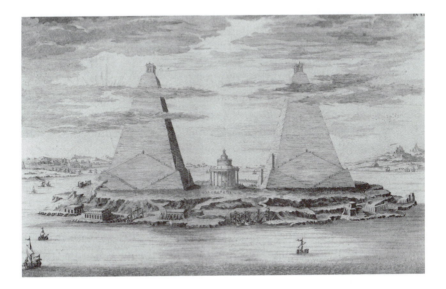

Plate 56 *FISCHER VON ERLACH's improbable vision of ramped pyramids piercing the clouds (plate XI from his* Entwurff einer Historischen Architektur*). This book was much admired during the eighteenth century, and the images of the ramped pyramids had a profound influence on later Neo-Classical designs, such as those by Boullée (**Plate 81**) (GN/SM).*

147

Fischer knew the work of the Roman archæologists and antiquaries, notably Kircher and Giovanni Pietro Bellori (1613–96 – who published distinguished antiquarian studies),[5] and there is a curiously Kircherian quality to his illustrations.

Fischer was clearly familiar with the published sources, and quotes Thévenot, Lucas, and Ausonius, among others. In Vienna Fischer had incorporated an obelisk in his design for the *Castrum Doloris*[6] of Kaiser Joseph I in St Stephen's Cathedral (1711), and used full-breasted reclining sphinxes in the staircase of the *Gartenpalais* Trautson in 1710. In his extra-ordinary (but unrealised) designs for Schloss Schönbrunn Fischer also repeated the obelisk theme to add imperial *gravitas*. His great rival, Johann Lukas von Hildebrandt (1668–1745), incorporated sphinxes in the terraces of Schloss Belvedere in Vienna, but they are alert, sit up, and are more Rococo in manner. Egyptianisms recur in profusion throughout Europe in the eighteenth century. The spectacular *Haus zum Cavazzen* in the Markt-platz, Lindau-am-Bodensee, of 1729 (now the *Städtische Kunstsammlungen*), has a marvellously inventive Baroque façade that features painted sphinxes on the stucco. Near by, the Isiac crescent-moon can be seen on the ceiling in the *Stiftskirche*, on which (as mentioned above) the Virgin Mary is carried aloft in glory (**Plate 49**).

Throughout Baroque Central Europe can be found many instances where the Marian symbolism is clearly derived from that of Isis. Quite apart from the crescent-moon (a common attribute of the Virgin), Baroque ceil-ings in which the Blessed Virgin is celebrated often depict a wide range of symbols. At *Wallfahrtskirche* Steinhausen, for example, Johann Baptist Zimmermann's (1680–1758) enchantingly beautiful ceiling of 1730–31 shows the Marian fountain, among other attributes. The *Fons Signatus*, the *Rosa Mystica*, the *Stella Maris*, the *Oliva Speciosa*, the *Hortus Conclusus*, the *Stella Matutina*, and the *Salus Infirmorum* (which recur in numbers in South German Rococo decorative schemes) are all Marian, and, ultimately, Isiac. The Lily among Thorns, the Chalice and the Host, and the Healer of the Sick are familiar motifs in the context of Central European Counter-Reformation Baroque architecture.[7] *Maria Pulchræ Dilectionis* is also the *Cedra Exsaltata*, and the *Mater Dolorosa*,[8] with her everlasting tears, reminds us irresistibly of Isis. Panels of Græco-Roman mosaics from Antioch show initiation ceremonies in the House of the Mysteries of Isis in which the goddess has emblems of stars and moon, and she is draped in robes similar

5 AURENHAMMER (1973), 153.
6 Obelisks were commonly found in ephemeral funerary architecture. *See* POPELKA (1994) and a review of the book (CURL [1996*b*]).
7 *See* BOURKE (1961) for an excellent introduction to this subject.
8 For attributes *see* POWELL (1959).

to those worn by the Virgin in Baroque and Rococo ceilings. In Altenburg in Austria, the frescoes by Paul Troger (1698–1762) and Johann Jakob Zeiller (1708–83) of 1732–34 show an interpretation of *Revelation*, Chapters 4, 12, and 18, featuring the Woman in Heaven with a crown of stars and the moon under her feet: she is in travail, and is carried aloft out of the reach of a fearsome dragon that is waiting to devour the new-born child. God the Father in Majesty is carried on a throne of clouds borne by angels and surrounded by blinding light, while the Archangel Michael swoops down with blazing sword to attack the many-headed monster, and angels defeat the forces of Hell . . . *And there was War in Heaven*[9] . . . Parallels with Seth-Typhon, Horus-Harpocrates, and the pregnant Isis are stunningly obvious in this remarkable and vivid work. Representations of Horus-Harpocrates in the Græco-Roman world often show a *putto*-like figure with his fingers to his lips: a parallel may be found in *Wallfahrtskirche* Neu-Birnau, designed by Peter Thumb (1681–1766), on the northern side of the Bodensee. In this wondrously light and elegant church, a vision of Heaven indeed, is the celebrated figure by Joseph Anton Feuchtmayr (1696–1770) of the *Honigschlecker*, a *putto*, caught with his finger still sweet with honey, in a gesture that could only come from the Græco-Roman-Egyptian Horus-Harpocrates.[10]

Such overt identification of the Madonna with Isiac emblems, and the use of the Horus-Harpocrates image in an eighteenth-century basilica, seem startling, yet even from the mediæval period, as has been noted above, there had been allusions to Isis: as Divine Engrafter, Isis was concerned with bringing plants to life, so was identified with the Virgin Mary, who is also noted for her powers of encouraging agricultural fertility. As *Iuvencula*, Mary is the young heifer (Isis-Hathor), *Nympha Dei*, a deer, the moon, a swallow (again crescent-moon symbolism), and a figure on whom innumerable praises were showered. The Blessed Virgin's myriad names may be studied in this colossal work of Marraccius, and her *cultus* is further discussed in Antonio Cuomó's *Saggio apologetico della bellezza celeste e devina di Maria SS. Madre di Dio*, published in Castellamare in 1863, a weird concoction of quotations that will satisfy the most fervent enthusiast.

A fashion for Egyptianising motifs (usually bogus hieroglyphs, sphinxes, obelisks, and pyramids in its earliest manifestations) blossomed in the eighteenth century. The sphinxes used by two of Austria's greatest architects, Fischer von Erlach and Lukas von Hildebrandt, have been noted above, but there are other outstanding instances where Egyptianisms appear in Baroque

9 *Es erhub sich ein Streit*, a text often set by musicians of the Baroque period. The most splendid setting is that of Johann Sebastian Bach (1685–1750), BWV 19.

10 BOURKE (1961), 18, 19, 21, 23, 64, 70, 74, 119, 120, 124–5, 212, 263, 277.

architecture of the first rank. The parish-church (formerly a house of the Augustinians) at Dürnstein has an elegant tower with large obelisks at the corners of the third stage, and obelisks are also used as terminating features to the attic storey of the elaborate portal in the courtyard.

Perhaps one of the first examples where a large range of Egyptianising motifs appeared in one three-dimensional work of the eighteenth century was the *Apis-Altar*, made in 1731 by Johann Melchior Dinglinger (1664–1731), Court Jeweller to Friedrich August I (1670–1733), Elector of Saxony from 1694, King Augustus II of Poland from 1697 to 1702, and again from 1709 until his death). This extraordinary piece of jewel-encrusted *Égyptiennerie* is decorated with themes derived from the *Mensa Isiaca*, and is surmounted by an obelisk adorned with bogus hieroglyphs: it is probably the finest of the early Egyptian Revival pieces in Baroque Europe (**Colour Plate IX**).[11]

Sphinxes in gardens, as Pevsner and Lang have said, 'are so common and often look so frankly Rococo that one tends to forget their Egyptian ancestry'.[12] Rococo sphinxes at the Belvedere in Vienna have been mentioned above, but the charming sphinxes (more like courtesans from a Rococo *Salon*) in the gardens of Veitshöchheim (1763–75), near Würzburg, are even more Rococo (although their Egyptian origins are clear): sculptors were Johann Wolfgang von der Auwera (1708–56), Ferdinand Tietz (1708–56), and Johann Peter Alexander Wagner (1730–1809) (**Plate 57**). Big-breasted Rococo sphinxes recur at Stift Altenburg, the Benedictine monastery Baroqueised by Josef Munggenast (1680–1741) in 1730–33: they recline on plinths in the courts of the monastery buildings. Sphinxes at Versailles are more on the Græco-Roman-Egyptian pattern, owing more perhaps to Roman versions of the Hadrianic period than to *Echt*-sphinxes from Egypt itself, and sphinxes at Chenonceaux are also more overtly Egyptianesque. Chenonceaux was presented by Henri II to Diane de Poitiers, but the sphinxes there appear to be of late seventeenth- or early-eighteenth-century date. The sixteenth-century sphinxes at Fontainebleau are more animated, and possess many of the characteristics of the sphinxes that adorn the tombs of Guillaume du Bellay and Diane de Poitiers. Sphinxes are often found depicted as garden-furniture in eighteenth-century paintings.

Lord Burlington's villa at Chiswick had grounds embellished with sphinxes on plinths, and with obelisks, designed by William Kent (1684–1748), and there are handsome sphinxes at Blickling in Norfolk. The

11 WATZDORF (1962).
12 PEVSNER and LANG (1956, 1968 edition), 230. The Author is grateful to the late Sir Nikolaus Pevsner and to Dr Lang for permission to quote. Sir Nikolaus also kindly suggested some further lines of enquiry which have proved rewarding.

Plate 57 *Rococo sphinx in the gardens at Veitshöchheim, near Würzburg, Germany. Photograph of 1977 (JSC).*

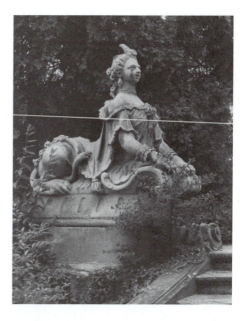

chimneys at Chiswick are obelisks, but then obelisks had been familiar in England since Elizabethan times. Pyramids are not so common, as noted above, but very steep pyramids were often confused with obelisks. Sir John Vanbrugh (1664–1726) designed a pyramid for the elaborate gardens of allusion at Stowe in Buckinghamshire, and at Castle Howard, Yorkshire, he erected the Great Obelisk of 1714 and the Pyramid Gate (1719) to embellish the grounds of that great house. Kent had used a stepped pyramid with Egyptianising proportions at the Temple of British Worthies at Stowe in *c.*1735, and pyramids (usually of the Cestius type) as well as obelisks and thin spiky pyramids are found in South Park Street Cemetery, Calcutta, founded in 1767.[13] A monumental obelisk had stood until 1682 at Nonsuch (the great Palace in Surrey, begun in 1538 by King Henry VIII, completed by the Earl of Arundel in 1556, and demolished 1682–88), and a free-standing obelisk was erected in 1702 to designs by Nicholas Hawksmoor (*c.*1661–1736) in the Market-Place at Ripon, Yorkshire.[14] Hawksmoor also employed an obelisk instead of a spire at St Luke's Church, Old Street, London. There is a pyramid-tomb commemorating Olof Adlerberg at Järäfalla in Sweden of 1757; an elongated pyramid of about the same period in the churchyard of St Anne, Limehouse, London; and a mausoleum in Chiddingstone, Kent, with a pyramidal stone roof of 1736. It should also be remembered that funerary monuments had long been designed in a

13 CURL (2002*d*), 141–5.
14 HEWLINGS, RICHARD (1981): 'Ripon's Forum Populi', in *Architectural History*, **xxiv** (1981), 40.

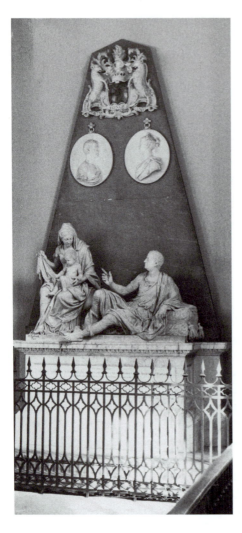

Plate 58 *Pyramidal composition of a typical Baroque funerary monument, distantly derived from the triangular forms of Bernini's tombs of the popes in the Basilica of San Pietro in Rome. Such compositions invariably employ a background which is, in effect, a fat obelisk. The example is the monument of the 1st Earl of Harborough (died 1732) by John Michael Rysbrack (1684–1770) in the church of St Mary Magdalen, Stapleford, Leicestershire. Photograph of 1990 (JSC).*

pyramidal form, the most celebrated being the papal tombs in the Basilica of San Pietro in Rome by Bernini, already referred to above: the pyramidal type of composition dominated the design of funerary monuments throughout the Baroque period (**Plate 58**).

However, obelisks were invariably placed on pedestals,[15] and owed more to Roman precedent than to any conscious emulation of Egypt. The use of Egyptian elements (usually in gardens) was often regarded in much the same way as Chinese, Gothick, and other styles were employed: that is, Egyptianisms were playful, entertaining, and exotic, and tend to be in the

15 *See* **Plates 10–16** and **Colour Plate II**.

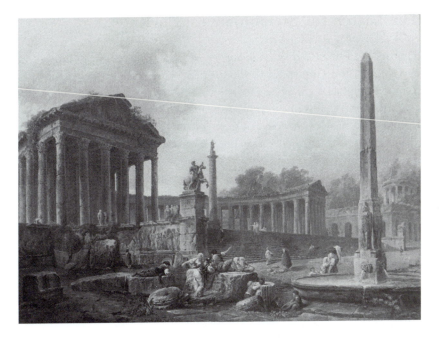

Plate 59 *Architectural composition by Hubert Robert (1733–1808) featuring a repaired Egyptian obelisk and a base incorporating the* Villa Adriana telamones. *This is one of a number of* capricci *that show Egyptian and Egyptianising elements as part of imaginary architectural compositions* (Photograph by JSC, 1980, reproduced by permission of The Bowes Museum, Barnard Castle, Co. Durham).

spirit of the Rococo. Hautecœur, in his monumental *Histoire de l'architecture classique en France*, quotes many instances where Egyptian motifs occur, and his work is useful to students of Egyptiana.

Hubert Robert (1733–1808) painted a number of *capricci* in which Egyptianising elements can be found: in the Bowes Museum (Barnard Castle, Co Durham), for example, there are two of his architectural compositions, one of which shows a massive Piranesian bridge adorned with Egyptianising lions, whilst the other shows a colonnade and an obelisk, the pedestal of which is supported by four *Villa Adriana telamones* (**Plate 59**). Thus Robert took Egyptianising themes and placed them within compositions in which more conventionally Classical elements featured in his *capricci*. Various artists also produced designs with Egyptianising flavours in the course of the eighteenth century, including Jean-Louis Desprez (1743–1804), who designed an Egyptianesque funerary temple as early as 1766.

The Search for Stereometrical Purity

The publication of *Recueil d'Antiquités Égyptiennes, Étrusques, Grecques, et Romaines* by the Comte de Caylus in 1752–67[16] brought new light to a study of Egyptian architecture, for the volumes were crammed with details, and the text expressed an appreciation of the æsthetic possibilities of Egyptian art. Caylus argued that from Egypt passed the basic artistic and architectural language that created the Classical works of Greece and Rome, but he also wrote persuasively of the qualities of grandeur, primitiveness, simplicity, and massiveness, and saw these as virtues. Like Marc-Antoine Laugier (1713–69)[17] and Jacques-François Blondel (1705–74), Caylus was looking at simple, unadorned forms without prejudice, for basic geometries were gradually beginning to be appreciated in their own right, and nothing could be more stark, simple, massive, or stereometrically pure than the forms used in Ancient Egyptian architecture.

During the second half of the eighteenth century an interest in simplicity and primitiveness in architecture developed, manifest in the growing appreciation for Greek-Doric (virtually ignored hitherto)[18] and Ancient Egyptian motifs. Such architecture was not regarded as 'primitive' in any pejorative sense: starkness and boldness came to be valued for themselves, for they were stripped of unnecessary ornament and fripperies. In France, particularly, the younger generation of architects took to basic geometrical forms and stark effects with enthusiasm: the atmosphere in the Academies in Paris and Rome encouraged this tendency, and a taste for monumentality, megalomaniac scale, blank walls, and powerful, massive, gloomy compositions developed apace.

In short, it is clear that not a little of this interest in reviving Egyptian architecture can be traced to Edmund Burke (1729–97), whose *Philosophical Inquiry into the Origin of our Ideas on the Sublime and Beautiful* appeared in 1756. Sublime works of art could induce emotional reactions like terror, awe, dread, amazement, fear, passion, and gloom, and there is no doubt that the mighty, massive, brooding architecture of Ancient Egypt had the power to arouse those emotional reactions, so it had certain Sublime qualities. Étienne-Louis Boullée (1728–99) realised this, and, in his vast schemes featuring blank walls, a stupendous scale, and Egyptianising elements, suggested the desolation and terror of death. In designs for cemeteries, monuments, and the like, Boullée created *architecture parlante*, or architecture that expressed itself and its purpose. Egypt was a land associated

16 In seven volumes.
17 *See* CURL (2001*a* and 2002*a*) for a discussion of Neo-Classicism, simplicity, and stripped Classicism.
18 *See* PEVSNER and LANG (1968), **i**, 197–211, for a very thorough preliminary investigation of the Doric Revival.

with wisdom and mystery, where the mightiest architecture was associated with death, a Sublime association indeed. Sir John Soane (1753–1837) was aware of the immense grandeur of Egyptian architecture, and its 'colossal', 'awful', and 'majestic' properties.[19] Soane's contemporaries also made similar remarks about Egyptian architecture, so its grandeur, massiveness, and ponderous qualities, conveying awe, gloom, and a sense of permanence began to be valued. Hubert Robert conveyed the idea of the Sublime possibilities of Egyptian architecture in some of his paintings, whilst Louis-François Cassas (1756–1827) also produced Sublime images of Egyptian temples of pyramids 'restored'. Such characteristic French approaches contrasted with those of eighteenth-century England, where there were very few architects who were to explore the realms of the Sublime in anything like the way in which French architects were to experiment. Only Vanbrugh and Hawksmoor at the beginning of the century used Egyptianising forms in a Sublime way reminiscent of the French Academic approach in the period 1770 to 1795. During the second half of the eighteenth century a full-blooded and inventive Egyptian Revival got underway, prompted by the genius of Piranesi. It is to this period that we now turn.

The Individual Contribution of Giovanni Battista Piranesi

The inventor of a fashion for Egyptianising forms used in an eclectic manner was Giovanni Battista Piranesi: his published works often include Egyptian or Egyptianising objects, and promiscuous arrays of exotica can be found in *Le Antichità Romane* (1756) (**Plate 60**). His engraving of an ancient burial-chamber in *Prima Parte di Architetture e Prospettive* (1743) includes a sphinx and a pyramid, and his drawings of Antique ruins provided the basic material for his later imaginary schemes. One important element in Piranesi's engravings of Roman subjects (such as those in *Le Antichità Romane* and *Della Magnificenza ed Architettura de'Romane* [1761]) was the scale of the buildings, for Piranesi inflated scale to make the buildings and ruins far more impressive, overwhelming, and grander than they actually were in reality: thus Piranesi emphasised the Sublime in Roman Antique architecture, and, in his images of imaginary prison interiors (*Carceri d'Invenzione* [begun c.1745 and reworked in 1761]) the overwhelming scale, brooding terror, and powerful effects were the epitome of the Sublime.

19 SOANE (1929), 20–1.

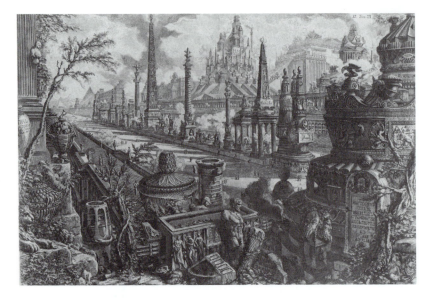

Plate 60 *Second frontispiece of Volume III of PIRANESI's* Antichità Romane, *with several Egyptianising forms in evidence. Note the pyramids, obelisks, and fantastical pyramidal compositions. The array of obelisks, columns, etc., represents the* spina *of a great Roman circus, greatly inflated in scale* (SAL).

It is clear that Piranesi had studied the plates in Fischer von Erlach's *Entwurff* (his sketches of Fischer's Egyptianising plates [*c.*1743] are now in the Pierpont Morgan Library, New York), and in his own Egyptianising designs can be found a new approach to 'Egyptian' forms that was to influence European designs well after the Napoleonic invasion of Egypt, even into the twentieth century.[20] The most important work by Piranesi that affected the Egyptian Revival was his *Diverse Maniere d'adornare i Cammini* (Various ways of decorating fire-surrounds of 1769), a considerable proportion of which was devoted to inventions in what purported to be the Egyptian style (**Plate 61**). As Professor John Wilton-Ely has pointed out, Piranesi's interest in a style rather than the 'use of random motifs such as obelisks and pyramids in his imaginary compositions'[21] is demonstrated in an architectural invention showing an ancient school in the Egyptian style in Piranesi's *Opere Varie*: the Egyptianising portal and frieze clearly were to influence James Playfair (1755–94) in his designs for Cairness House, Aberdeenshire, of 1791–97. In a letter of 18 November 1768 to Thomas Hollis (1720–74) accompanying a copy of the plates of *Diverse Maniere,*

20 CONNER (*Ed.*) (1983), 17.
21 WILTON-ELY (1978b), 107.

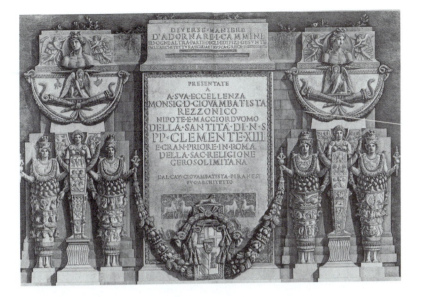

Plate 61 *Title-page of G. B. PIRANESI (1769):* Diverse Maniere d'adornare i Cammini, *with no fewer than four figures of Artemis of Ephesus (who was identified with Isis in Græco-Roman Antiquity)* (SAL).

Piranesi emphasised his originality as a pioneer of the Egyptian Taste, and stated that 'Egyptian architecture appears here for the first time; I want to stress that because people always believed that there was nothing more than pyramids, obelisks, and giants, neglecting the parts that would be adequate to adorn and support this architectural style'.[22] Piranesi saw the possibilities for new designs in the austerity and monumentality of Egyptian architecture, and broadened his Egyptian architectural vocabulary by studying printed sources and the objects on view in Rome itself: gradually he evolved a fusion of elements that led to a synthesis in which Græco-Roman, Egyptian, and other styles can be detected, yet the result is a satisfactory whole.

During the 1760s he was one of the first designers to apply Egyptianising motifs to contemporary interiors, and he produced a complete Egyptianising interior (*c.*1768) for the *Caffè degl'Inglesi* in the Piazza di Spagna in Rome (**Plate 62a** and **b**). This *Caffè* does not survive, and it seems to have attracted mixed comment from observers. It was described in 1776 by the painter Thomas Jones (1743–1803) as a 'filthy vaulted room the walls of which were painted with Sphinxes, Obelisks and

22 Piranesi sent a proof-copy of *Diverse Maniere* with 57 plates, and the letter accompanying the plates is in the possession of The Society of Antiquaries of London to which body the Author is indebted for permission to quote.

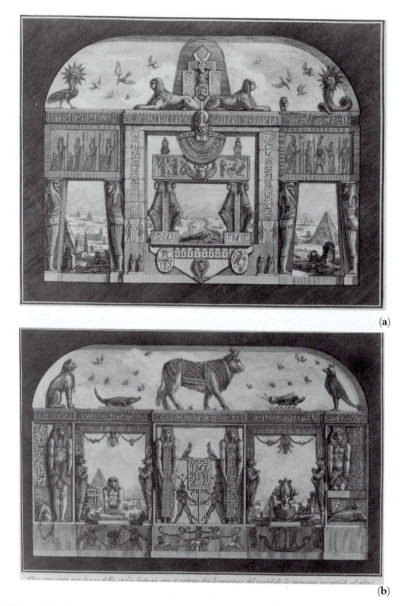

(a)

(b)

Plate 62 (a, b) *Two designs for walls in the* Caffè degli Inglesi, *Rome, designed by Piranesi. From* DM *(1769). There are plenty of Nilotic flora and fauna, including crocodiles, locusts, and the Apis-Bull. The longer wall* (**b**) *incorporates the* telamones *from the* Villa Adriana, *and two other Antinoüs-telamon figures support obelisks emblazoned with hieroglyphs. The shorter wall* (**a**) *features two sphinxes from the collections in Rome, as well as sundry other Egyptianising figures that were part invention and partly based on a vast range of sources. These designs show Piranesi to have been a pioneer in the creation of an Egyptian Taste, and indeed the Caffè degli Inglesi seems to have been one of the very first contrived interiors with an Egyptian flavour created since Antiquity* (SAL).

Pyramids from capricious designs by Piranesi, and fitter to adorn the inside of an Egyptian Sepulchre, than a room for social conversation'.[23] (Sir) John Soane did not approve either, and accused Piranesi of mistaking 'Confusion for Intricacy, and undefined lines and forms for Classical Variety'.[24] Two plates in the *Diverse Maniere* show two walls from this curious interior (**62a** and **b**), and there are also several designs for Egyptianising chimney-pieces that were completed by November 1767 (**Plates 63–72**).

Now the title-page (**Plate 61**) of *Diverse Maniere* depicts four Dianas of Ephesus, each pair flanking a variety of term with a form of inverted obelisk-like body. It would seem that the *Mensa Isiaca*, or, more probably, published descriptions and illustrations of it, influenced Piranesi when he was preparing the designs for chimney-pieces, but other influences are the Antinoüs, the Antinoüs-*telamones*, *naöphori*, and other motifs referred to above. One of the most long-lasting themes culled from *Diverse Maniere* was the variation on the stepped pyramid: Piranesi quoted this (**Plate 64**), and then inverted it, so that a stepped corbel-form appeared (**Plate 65**). The next stage was to convert the inverted stepped pyramid into a corbelled pseudo-arch (**Plate 66**), and this element became a common theme in designs that had supposedly Egyptianising pretensions. Stepped corbelling does actually occur in the Grand Gallery in the Great Pyramid, but illustrations of this were few and far between, and had nothing like the circulation of Piranesi's designs, so Piranesi must be seen as the inventor of this important motif in Egyptianising and Art-Déco work.

As for the *Mensa Isiaca*, it had been thoroughly published, as previously noted, and there is a detailed account of it in the Comte de Caylus's *Recueil*, of 1752–67,[25] but Piranesi selected images from the tablet in a freely eclectic manner. His designs for the chimney-pieces do not have any pretensions to authenticity or to archæological correctness, for he deployed his Egyptian, Etruscan, Greek, and Roman motifs in combinations and positions that took his fancy. In the case of the Egyptianising designs in *Diverse Maniere*, the result, in the words of Dr Conner, is a 'psychedelic extravaganza of sphinxes and statuettes, jackals and crocodiles, mummies, star-patterns, and hieroglyphs'.[26]

In 1769 James Barry (1741–1806) wrote to Edmund Burke to say that Piranesi would go down to posterity with a deserved reputation, 'in spite of his Egyptian and other whimsies, and his gusto of architecture flowing out of the same cloacus as Borromini's and other hairbrained moderns'.[27] Piranesi

23 FORD (1946–8), 54, also quoted in WILTON-ELY (1978*b*), 107.
24 SOANE (1929).
25 CAYLUS (1752–67), **vii**, 34–119, plate xii.
26 CONNER (*Ed.*) (1983), 17.
27 BARRY (1809), **i**, 163.

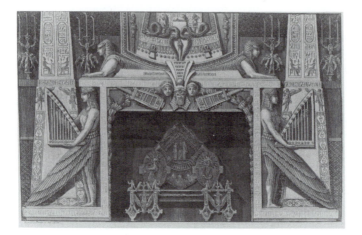

Plate 63 *Fireplace design by G. B. Piranesi, from* DM. *The two winged figures with harps are derived from those featured on the* Mensa Isiaca, *except that Piranesi makes them male (with* nemes *head-dress) instead of female. Two* sistra *are placed immediately over the opening. Also featured are dog-faced baboons* (at the top), *an Apis-Bull, sphinxes, serpents, and parts of obelisks* (SAL).

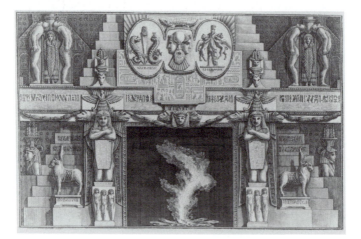

Plate 64 *Fireplace design by Piranesi from* DM, *featuring part of a stepped pyramid and two kneeling Egyptianising male figures with* nemes *head-dresses, arms folded on truncated inverted obelisk fragments. Such a kneeling figure was known as a* naöphorus, *and was a late Egyptian, Ptolemaïc, or Roman imitation of Ptolemaïc or earlier models. Kircher had examples in his collection, as it was from those that Piranesi derived his design, although he transformed the battered form of the pylon-shaped shrine (or* naos) *into an inverted obelisk-like fragment. Also featured are Apis-Bulls, falcons, busts of telamones, uræi, and* (at the top), *a crocodile* (SAL).

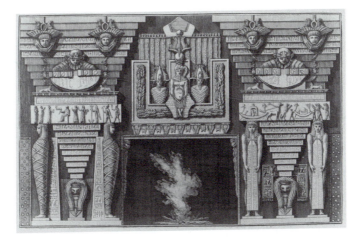

Plate 65 *Fireplace design by Piranesi from* DM, *featuring two inverted stepped pyramids, mummies, and two* telamones *supporting obelisks. The inverted step-pyramid was the forerunner of the corbelled arch* (SAL).

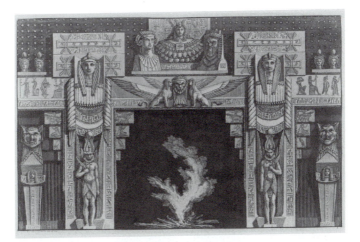

Plate 66 *Fireplace design by Piranesi from* DM, *featuring corbelled pseudo-arches derived from the inverted stepped-pyramid motif, with an Artemis of Ephesus over the fireplace, and supporting figures derived from the Antinoüs-telamones figures from the* Villa Adriana, *mixed with other Egyptianising themes derived from Antique fragments, freely interpreted. The corbelled pseudo-arch became a common theme in later designs which purported to be Egyptian or Egyptianising work (although it is true that the Grand Gallery in the Great Pyramid at Gizeh had corbelled stepped sides), and recurs in Art-Déco designs of the 1920s and 1930s. The next step was to shave off the steps to provide a canted arch, another common theme of the Egyptian Revival in the early nineteenth century and during the twentieth-century revival of such motifs* (SAL).

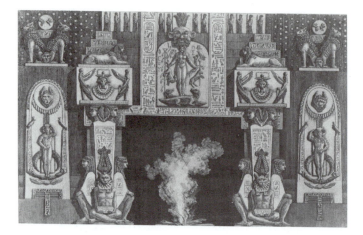

Plate 67 *Fireplace design by Piranesi from DM showing his imaginative use of Egyptianising motifs including sphinxes, seated figures with* nemes *head-dresses, crocodiles, an Isiac procession (at the top), bees, inverted obelisks, seated lioness- or cat-headed male figures, and sundry other freely treated elements* (SAL).

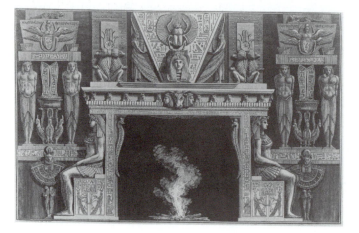

Plate 68 *Fireplace design by Piranesi from DM, showing seated Egyptianising figures, four long-kilted versions of the Antinoüs-telamon type, dog-headed baboons, a scarab-beetle, and other motifs, including two versions of the ægis (to the right and left of the seated figures) with cats supporting them,* uræi, *and the Apis-Bull* (SAL).

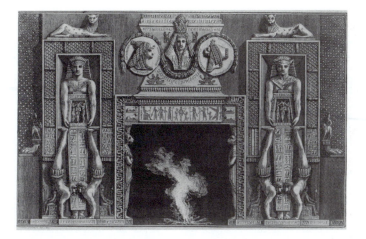

Plate 69 *Fireplace design by Piranesi from* DM, *showing two Antinoüs-telamon figures with inverted obelisks instead of legs (the feet appear at the bases), and holding pylon-shaped shrines modelled on those in the* Mensa Isiaca *and on other Antique fragments, freely interpreted. Such shrines were referred to by the name* naos, *and occur in late Egyptian, Ptolemaïc, and Roman examples, held in the laps of crouching figures* (naöphori), *of which there were several examples in Kircher's collection* (SAL).

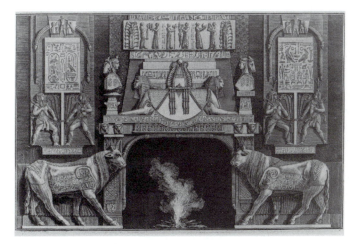

Plate 70 *Fireplace design by Piranesi from* DM, *showing Apis-Bulls, two heads of Isis backed by bulls' (or Hathor-cow) heads, sphinxes, a frieze of Isiac worshippers, figures tying lotus and papyrus (symbolising unity), and other motifs based on objects from Antiquity* (SAL).

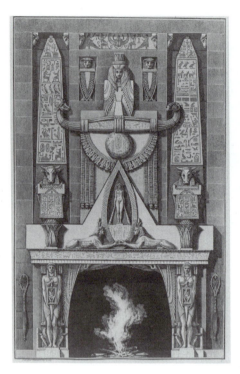

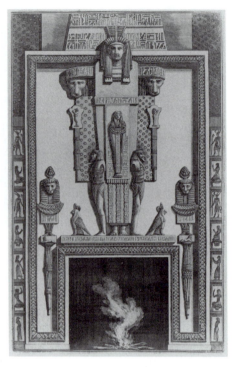

Plate 71 *Fireplace design by Piranesi from DM, showing two Antinoüs-telamon figures holding* naos shrines, *so they are really standing versions of the* naöphorus *type based on late-Egyptian, Ptolemaïc, and Roman Egyptianising work. The bulls' heads on battered panels suggest the* naöphorus *form, and there are Roman Egyptianising sphinxes and two obelisks to complete the composition* (SAL).

Plate 72 *Fireplace design by Piranesi from DM, showing an array of Egyptianising elements ingeniously composed* (SAL).

printed an *Apologetical Essay in Defence of the Egyptian and Tuscan Architecture* (with parallel texts in Italian, French, and English) as part of his *Diverse Maniere*, clearly aimed at potential clients as well as designers, and he wrote at length on the variety of Egyptian ornament, for its eclectic possibilities had not escaped him, and he used Egyptian motifs in the book in the manner of *capricci*. The designs are in a Rococoesque spirit that was to be found in Strawberry Hill Gothick or in aspects of *Chinee*-work: a certain chilliness in Antique Classicism led to a reaction in which the spirit of *Rocaille* was caught up by the *bissarrerie* of *Chinoiserie* and Egyptianising ornamentation.

Gothic Revival was anticipated as a further attraction for jaded æsthetic palates, and the post-Piranesian phase of the Egyptian Revival can be seen as part of the Picturesque movement which was to lead to an amazing

diversity, even a free-for-all in matters of style. Blondel, in his *Cours d'Architecture*,[28] of 1771–77, saw the connection between the Piranesian use of Egyptianisms and a Rococo style he (Blondel) had thought *passé*: there was already something in the air which saw nothing odd about mixing themes from Memphis, Pekin, and other *savantes productions* from other peoples and nations, but Blondel did not altogether approve.

Sir William Chambers (1723–96) used the example of the *Villa Adriana* as a precedent for the use of *Chinoiserie* elements in his *Designs of Chinese Buildings* (1757), while Cornelius Pauw, in his *Recherches Philosophiques sur les Égyptiens et les Chinois* (1773), also linked Egypt and China. Now the use of ornament from any source – Gothic architecture, Chinese forms, Egyptian art, 'Hindoo' styles, Moresque buildings, and other exotica – creates problems for the purist, but it must be remembered that the second half of the eighteenth century saw the decline of Palladianism, the use of archæology, and a wide appreciation of styles as part of the Picturesque revolution. The bizarre possibilities of Egyptianising motifs were quickly spotted by designers of Piranesi's calibre, and Piranesi himself defended his eclectic Egyptian inventions on the grounds that Ancient Egyptian wall-paintings were decorative rather than symbolic. He also stated that there was much to admire in the Egyptian lions and sphinxes that survived in Rome, for the Antique sculptors 'had a perfect knowledge of all that is good and beautiful in nature. I am certain that an understanding eye will see ... not only the grand and the majestic, which no one denies to the Egyptians, but likewise that delicacy, that fleshiness, and that palpableness, which is supposed to have been known only to the Greeks, and never to the Egyptians'.[29]

By Piranesi's time, Egyptian architecture was recognised as imposing, massive, and a repository of mysterious lost knowledge, but it was not perceived as embracing works with any decorative beauty.[30] Then words such as 'beautiful', 'exquisite', 'stupendous', and 'majestick' began to be applied to reliefs and decorative features in Ancient Egyptian architecture by Norden and Pococke, and Norden described the Trajanic 'Kiosk' at Philæ (**Plate 25**) as of 'great beauty', with ornaments and capitals of the 'utmost delicacy'.[31] Thus Norden and Piranesi flew in the face of received opinion, and opened a debate on the qualities of Egyptian forms: shortly these were to be seen as adaptable not only for garden-ornaments and funerary architecture, but for furniture design and interior decoration as well.

28 BLONDEL (1771–7), **iii**, LVIII.
29 PIRANESI (1769), 14.
30 CONNER (*Ed.*) (1983), 18.
31 NORDEN (1757), **ii**, 84. *See also* POCOCKE (1743–5), **i**, 86 and 218.

Piranesi can be identified as the architectural theorist who provided the arguments later used by designers, including Robert Adam (1728–92), who, like many architects since, have sought to justify a philosophy relating to modern design that would be respectable. Adam's use of a wide variety of motifs derived from archæological investigations lent his designs an integrity. Horace Walpole (1717–97) recognised the genius of Piranesi when he wrote that the 'delicate redundance growing into our architecture' would be stopped if only 'the sublime dreams of Piranesi' were universally studied: he saw that Piranesi had 'imagined scenes that would startle geometry, and exhaust the Indies to realize'.[32]

Then an idea gained currency that the Ancient Egyptians were the progenitors of most of the world's great civilisations, and, following Kircher's work, this included China. Some writers argued that India, with its zoömorphic deities, pyramidal temples, and decorative motifs (such as the lotus) had derived its religion and architecture from Egypt.[33] A readiness to consider Egyptian, Oriental, Eastern, European, and exotic cultures as inter-related, having offshoots of one another, had an 'indirect effect on the practice of Regency architects and designers, who seem to have delighted in combining near-eastern with far-eastern, or Indian with Egyptian or Chinese, within a single building, room or artefact, and who employed forms (such as ribbed columns, lotus leaves, or star patterns) which refer to no exotic culture exclusively, but rather to a generalised Orient'.[34]

Mention has been made of the influence of Fischer von Erlach's *Entwurff* on Piranesi, but there may be yet another important precursor of Piranesi's Egyptianising designs. Filippo Juvarra (1678–1736) produced a number of sketches including imaginary scenes with Egyptianising motifs: they include a sarcophagus resting on the backs of reclining sphinxes with heads turned to one side, and a reclining statue of Nilus, with sphinx and tall obelisk-pyramids embellished with bogus hieroglyphs.[35] Juvarra's drawings pre-date Piranesi's work, and were once in Lord Burlington's collection: they contain elements of the *capriccio* as well as of stage-sets in Juvarra's work, but the scale is less fearsome than in the drawings of Piranesi.

Gradually, thanks to Piranesi's championship of Egyptian architecture, it became accepted that the hardness and 'simplicity' of Egyptian buildings were not due to ignorance, but were deliberate. Taste of the day had tended to view non-naturalistic styles as primitive or

32 In the Advertisement to the Fourth Edition of WALPOLE (1786), 398. *See also* WILTON-ELY (1978*b*), 8, 47, 67, 76–80, 88, 107–9, 116.
33 MAURICE (1800–1), **iv**, 228.
34 CONNER (*Ed.*) (1983), 19.
35 Fols 21 and 22 in the Devonshire Collections at Chatsworth House, Derbyshire.

inferior: Piranesi insisted that Egyptian art, though stylised, was highly sophisticated. A bridge between what might be described as the 'Rococo' attitude to design-forms and that of a later, Romantic and Picturesque stance, was partly provided by nuances and changes in philosophy, and that bridge, spanning the gap that separated the Enlightenment from Romanticism, was partially the construction of Johann Gottfried von Herder (1744–1803), who was one of the first in the eighteenth century to point out what Egyptian art might contribute to late eighteenth-century taste. Herder reminded his readers that the first great architectural monuments the world had ever seen were those of Ancient Egypt, and that permanent buildings in which squares and other significant geometrical forms were exploited led to the creation of powerful and instantly recognisable elements such as pyramids and obelisks. A simple geometry, giving an impression of permanence, and stripped of unnecessary ornament, was achieved by the Ancient Egyptians. Herder realised the possibilities of stark, simple architecture, and a severe expression of basic forms, based on Ancient Egyptian models: the 'primitiveness' of so much late eighteenth-century architectural experiment stemmed from philosophical ideas of Burke and Herder, and the stripped-down, Sublime images derive from Piranesi, whose gigantic, overpowering prisons, over-scaled views, improbably magnificent megalomaniac tombs, and Egyptianising eclecticism were to mingle with a growing demand for simplicity by the German Herder and the Frenchman Laugier. French architects of the last quarter of the eighteenth century were not slow to connect Laugier's call for simplicity with the potent ideas of Herder, the images of Piranesi, and the Sublime of Burke and Immanuel Kant (1724–1804).[36]

Piranesi also made a collection of eleven plates as early as 1750 that included six of his own works under the title *Camere Sepolcrali degli Antichi Romani le quali esistono dentro a di fuori di Roma*: these plates are much more than archæological records; they convey something of a theatrical atmosphere. Somewhat different was Mauro Tesi's (1730–66) etching *Camera Sepolcrale Egiziana* (see **Plate 89**), which is not based upon archæological investigation, but is a theatrical interpretation, with something of the atmosphere of Piranesi's *Camere*, and with a domed chamber superimposed on Egyptianising engaged columns – a most unhistorical notion – for the circular form of the building is not Egyptian. Only the columns, figures, and bogus hieroglyphs betray an intention to suggest Egypt.

36 The key works are HERDER's *Älteste Urkunde des Menschengeschlechtes* (1774) and KANT's *Observations on the Feeling of the Beautiful and Sublime* (1764) and *The Critique of Judgement* (1790).

The Legacy of Piranesi

One of the earliest (and finest) Egyptianising interiors immediately influenced by Piranesi is the *Sala dei Papiri*, decorated for Pope Pius VI (1775–99) by Anton Raphaël Mengs (1728–79) around 1776, but possibly commissioned by Pope Clement XIV (1769–74) in 1772 (**Plate 73**). Whilst Mengs unquestionably drew upon Piranesi's work, his most important mentor was Johann Joachim Winckelmann (1717–68), who from 1764 was Commissioner for Antiquities for Rome and its environs, who instituted a more systematic exploration by means of excavation, and who was one of the first to appreciate the powerful, primitive Doric of the Greek temples at Pæstum.[37] Mengs had met Winckelmann in 1755, and painted a fine portrait of him which now hangs in the Metropolitan Museum of Art in New York. The painter had studied the works of Michelangelo and Raphael, and, thanks to Winckelmann, was to win European renown as one of the leading exponents of Neo-Classicism. The *Allegory of History* that is the subject of the main decorations of the *Camera dei Papiri* has an interesting iconography relating to the function of the room: Genius carrying manuscripts is heralded by Fame, and advances towards History, who is attended by Time and by Janus. The latter points to a picture of the Museo Pio-Clementino. From our point of view the most interesting parts of the decorations are the Egyptianising figures in the corners of the ceiling, which owe much to Antinoüs (**Plate 27**) and to the Antinoüs-*telamones* (**Plate 28**) (and also to the figures in the *Stanza dell'Incendio* by Raphael and Giulio Romano [**Plate 44**]): but the idea of the inverted obelisk instead of legs comes from Piranesi's *Diverse Maniere* (**Plate 69**), although the Piranesian figures hold a *naos*. On either side of the Mengs figure (**Plate 73**) are sphinxes and *couchant* lions based on Egyptianising pieces discovered in Rome.

An unexecuted design for an entrance-gateway to Sherborne Castle, Dorset, by Sir William Chambers (1723–96), of the second half of the eighteenth century is of interest because the figures in the niches in either side are seated, Egyptianising, and holding *naos*-shrines (**Plate 74**): the figures are of the Antinoüs type, but are very like the *Diverse Maniere* figures by Piranesi (**Plates 64**, **65**, **69**, and **71**). Mr John Harris dates the Chambers designs as *c*.1758, but as the figures are so close to those in *Diverse Maniere*, a later date seems more than likely,[38] probably some time in the 1770s.

[37] For a discussion of the Doric Revival *see* PEVSNER and LANG (1968), **i**, 197–211, and CURL (2002*a*), 74–6.

[38] Personal communication. *See also* HARRIS (1957). The drawing was exhibited in the Neo-Classical Exhibition at the RIBA Heinz Gallery in 1980. *See also* CONNER (*Ed.*) (1983), 24, and HARRIS (1970), 246 and plate 79.

Plate 73 *Corner of the ceiling of the* Sala dei Papiri *in the Vatican by Anton Raphaël Mengs, of 1772–76. The Egyptianising figure is based on the Antinoüs from the* Villa Adriana, *but with inverted obelisk instead of legs, and feet protruding from the 'base'. The source is Piranesi, notably the DM (see* **Plate 69***), possibly influenced by earlier examples of the type (see* **Plate 45***). The lion and sphinx are based on examples that were well-known in Rome from Antiquity. The lion is modelled on the lions from the* Isæum Campense, *found in 1435, and later converted by Giacomo della Porta (c.1533–1602) into* fontanelle *at the foot of the great stairs leading to the Roman Capitol, whilst the sphinx resembles many Egyptianising pieces of the Hadrianic period. Photograph of 1980 (JSC).*

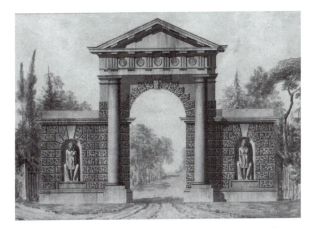

Plate 74 *Entrance-gateway for Sherborne Castle, Dorset, designed by Sir William Chambers, supposedly in c.1758. Although the gate is a conventional essay in rusticated vermiculated masonry, with a Roman Doric Order and Tuscan columns, the figures in the niches are Egyptianising seated versions of Antinoüs, similar to Piranesi's designs in DM. If Chambers's design really is earlier than the DM, then it is a remarkable anticipation (see* **Plates 44**, **45**, **64**, **65**, **69**, *and* **71***) (RIBADC).*

Thus, by the second half of the eighteenth century Egyptianisms were quite well established within the vocabulary of Neo-Classical design, and by the 1790s were not at all unusual. From 1798, however, they became increasingly common, and, in the spectacular outburst of Egyptomania that occurred during the first decades of the nineteenth century, the Egyptian Revival proceeded in a flood of invention prompted by new knowledge gained from the Land of the Pharaohs rather than from second- or third-hand sources, or from Egyptianising motifs and artefacts made in Europe.

CHAPTER V

The Egyptian Revival from the Time of Piranesi until the Napoleonic Campaigns in Egypt

Introduction; The Tomb and Egyptianising Forms; Egyptianisms in Design before the Impact of Denon and the Description; *The Invasion*

Nile pater, quanam possim te dicere causa
aut quibus in terris occuluisse caput?
te propter nullos tellus tua postulat imbres,
arida nec pluvio supplicat herba Iovi,
Te canit utque suum pubes miratur Osirim
barbara, Memphitem plangere docta bovem.

(For what cause, Father Nile, or in what lands hast thou hid thy head? Thanks to thee, thy country never sues for showers, nor withered grass petitions Jupiter, the Rain-Giver. Thy peoples, in barbarous weepings for the Memphis Bull, praise and worship thee as their Osiris).

ALBIUS TIBULLUS (*c*.54–*c*.18 BC):
Elegies, Book I, Elegy 7, lines 23–28.

The lunatic, the lover, and the poet,
Are of imagination all compact:
One sees more devils than vast hell can hold,
That is, the madman; the lover, all as frantic,
Sees Helen's beauty in a brow of Egypt . . .

WILLIAM SHAKESPEARE (1564–1616):
A Midsummer Night's Dream, Act V, Scene 1, lines 7–11.

Introduction

The gradual search for an architectural expression freed from Rococo orna-
ment, and with clear geometrical shapes exposed, was encouraged by the
theories of Laugier and Herder, while the fecund imagination of Piranesi,
together with the last's drawings of ancient buildings at Pæstum[1] and Rome,
led to an appreciation of the possibilities of Greek Doric and Egyptian archi-
tecture. Not least in such appreciation was the enormous scale suggested by
Piranesi, and a realisation of the grandeur and primitivism of both Greek
Doric and Egyptian design. The eighteenth century discovered Greek Doric
forms through Winckelmann, Mengs, Piranesi, the Society of Dilettanti, and
finally through the ambitious project by James 'Athenian' Stuart (1713–88)
and Nicholas Revett (1720–1804) that gave birth to *The Antiquities of Athens*
(1762–1830). That momentous and handsome publication was intended as
an accurate survey of Ancient Greek buildings, and, like Piranesi's *Diverse
Maniere*, was aimed at patrons as well as at architects. Here was a splendid
source-book for the Greek Revival, and Greek Doric began to be regarded
as noble, severe, Picturesque, and even Sublime. The dawning respectability
of tough Greek Doric[2] pushed the frontiers of Taste further towards even
greater ruggedness, massiveness, and the primitive. Egyptian architecture
would be even more desirable, up-to-date, and fashionable as the search for
simplicity and for purity of form gained momentum.

The Tomb and Egyptianising Forms

Between 1773 and 1778 Carmontelle (Louis Carrogis [1717–1806]) laid
out the garden of allusions[3] at the Parc Monceau, Paris, for the Anglophile
Duc de Chartres, later the Duc d'Orléans, and Grand Master of the Grand
Orient of Freemasonry.[4] This curious garden has a *Bois des Tombeaux*, or
series of tomb-like structures set in woods, and includes a steeply-pitched
pyramid of the Cestius type, but with primitivist Egyptianesque terms
acting as *telamones* (**Plate 75**). The transformation of the English landscape
garden with monuments (such as William Shenstone's gardens at The
Leashowes, and the gardens at Stowe) into Continental gardens with
cenotaphs and, later, with real tombs, is a complicated story, and cannot be
developed here. Nevertheless, it led to the formation of the first garden-

1 A superb set of his original drawings of the Greek Doric temples at Pæstum can be seen in Sir John Soane's
 Museum, London.
2 *See* the essay on 'The Doric Revival' in PEVSNER and LANG (1968), **i**, 196–211.
3 CURL (1997).
4 CURL (2002b). This was Louis-Philippe-Joseph (1747–93), called *Égalité*.

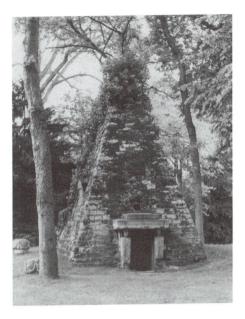

Plate 75 *Pyramid in the* Bois des Tombeaux *in the Parc Monceau, Paris, conceived by Louis Carrogis, called Carmontelle, for the Duc de Chartres (Philippe-Égalité, 1747–93), between 1773 and 1778. The entrance has primitive Egyptianesque terms acting as telamones. Photograph of 1987 (JSC).*

cemeteries, and was closely associated with a change of sensibility regarding the burial of the dead.[5]

Of course a taste for melancholy, and for tombs, had come to the fore with Robert Blair's didactic poem, *The Grave* (1743), while Edward Young's *Night Thoughts* (1742–45) and Thomas Gray's (1716–71) *Elegy in a Country Churchyard* (1750) contributed to notions of solitary watchers by tombs, and to a fashionable cult of sepulchral gloom. Monuments (and, later, graves) in an Arcadian landscape began to occur, emulating Virgil and, of course, Poussin's celebrated *Et in Arcadia Ego*, where a Classical tomb is depicted in an Antique landscape, complete with shepherds.[6] This taste coincided with the *architectural* search for purity of form, with a growing awareness of Egypt as a source from which stereometrically pure forms derived, and as the fount of the primitive. Furthermore, Egypt was perceived as once having been peopled by wise and clear-sighted *philosophes*, for the Hermetic notions had not really died, and in the 1760s Freemasonry was a growing force (especially on the Continent), so the Egyptian origins of the art of architecture were further emphasised in legends of the Craft.[7]

A younger generation of French architects based on the Academies in Paris and Rome responded to all this with a stunning series of designs in which a growing Egyptianisation was clear. Marie-Joseph Peyre (1730–85) brought out his *Œuvres d'Architecture* in 1765, a work which demonstrates

5 CURL (2000c and 2001b). *See also* CURL (1994b).
6 *Ibid.*, especially (1994b).
7 CURL (2002b).

Piranesian influences in the overblown scale and repetition of Neo-Classical motifs, and also shows many works with Egyptianising features. Prominent among these younger architects was Louis-Jean Desprez (1743–1804), who went to Rome in 1776 as winner of the Grand Prix: during the 1760s he had designed a funerary temple with a domed interior set within a Cestius-type pyramid, and set about with plenty of obelisks. Once in Rome he caught the Piranesian obsessions with gloomy, cavernous interiors, Egyptianising detail and vastness of scale. Whilst in Italy Desprez studied painting and drawing as well as architecture, contributed illustrations to Jean-Claude Richard, Abbé de Saint-Non's (1727–91) *Voyage Pittoresque, ou Description des Royaumes de Naples et Sicile* (1781–86), became interested in stage-design, and, as a theatrical designer, was employed by King Gustavus III of Sweden (1771–92) in 1784, living in that country until his death. The works of Desprez have an intensely dramatic character with strongly Romantic effects despite the apparently Classical nature of the drawings. During his stay in Rome, Desprez produced a number of water-colours of imaginary tombs that incorporate Egyptianising ideas; the sombre funereal character is enhanced by the semicircular and segmental arches of ashlar beneath which the tombs are set (**Plates 76–78**). In one design (**Plate 76**), a crouching lion (suggestive of those Egyptian and Egyptianising lions in Rome that Desprez must have known) lies beneath a severe monolithic sarcophagus carried on stumpy primitivist columns. Instead of a formal effigy on top of the sarcophagus, the form is a naked figure, lying as though on a mortuary-slab or in the anatomy lecture-theatre. In these extraordinary images Desprez was starting to move away from the Piranesian use of Egyptian motifs, although the gloomy, dungeonesque scenes suggest Piranesi's *Carceri d'Invenzione* (inventions of prison interiors) of 1745, and other designs. In 1788 Desprez was to design with Egyptianising elements at Haga Castle in Sweden, and certainly used Egyptianising motifs in his stage-sets.[8] He also designed Egyptianesque capitals for the Botanic Institute at Uppsala.

The work of Carl August Ehrensvärd (1745–1800) was more severe than that of Desprez (though the latter probably influenced the Swede): in a water-colour which he entitled 'Egyptian Architecture in a Nordic Landscape' (**Plate 79**), now in the *Nationalmuseum*, Stockholm, Ehrensvärd showed buildings with stumpy, primitive, Greek Doric columns that were far more 'deformed' than any Pæstum Doric exemplars. Robert Rosenblum[9] has pointed out the 'squat and earthbound' colonnades that 'seemed more appropriate to a pre-Greek architecture and were hence

8 WOLLIN (1933, 1935, and 1939).
9 ROSENBLUM (1970).

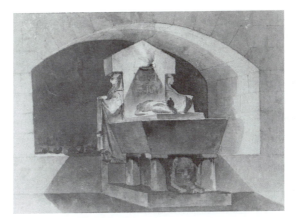

Plate 76 *Sepulchre in Egyptian style with Egyptianising figures and a lion (c.1779–84) by the French designer, active in Sweden, Louis-Jean Desprez (1743–1804). Pen and black ink; brush and brown, grey, blue-grey wash; traces of graphite on off-white laid paper sheet: 5¹¹/₁₆ x 11³/₈ inches (145 x 289 mm); image: 5⁹/₁₆ x 7⁷/₈ inches (142 x 200 mm). Note the segmental arch, which was associated with primitivism and with Egyptian architecture among Neo-Classical designers. The lion, stumpy primitivist Doric columns, blocky tomb-slab, and shrouded Egyptianising figures with nemes head-dresses complete the ensemble (SI, No. 1938–88–3950).*

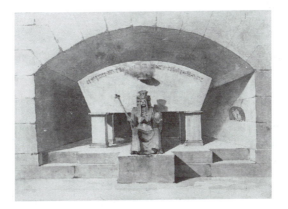

Plate 77 *Imaginary sepulchre design in the Egyptian style showing Death seated and crowned (c.1779–84) by Desprez. Pen and black ink; brown, grey, blue-grey wash; traces of graphite on off-white paper sheet: 7¹/₁₆ x 11⁵/₁₆ inches (180 x 287 mm); image: 5¹¹/₁₆ x 7¹³/₁₆ inches (145 x 198 mm). Note the bogus hieroglyphs in segmental form on the segmental sarcophagus (compare with*
Plate 30) *under the massive segmental masonry vault. Segmental shapes were regarded since Roman Antiquity as having Egyptian connotations (crescent-moon, bow of Diana, and segmental pediments on Isiac temples, shrines, and ædicules). Note the semicircular loculus on the right with projecting cadaver's feet. The crowned skeletal figure with sceptre, orb and nemes head-dress reigns over a dark kingdom: here is Sublime Terror (SI, No. 1938–88–3951).*

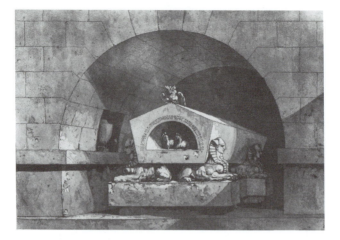

Plate 78 *Design for an Egyptian tomb by Louis-Jean Desprez. Pen-and-ink and water-colour. The sarcophagus rests on sphinxes with large breasts, and hieroglyphs follow the semicircular form of the loculus set in the sarcophagus, and in which the body rests. A funerary urn sits in the niche on the left, and an owl, harbinger of death, perches on the sarcophagus* (BN, HA 52 fo.)

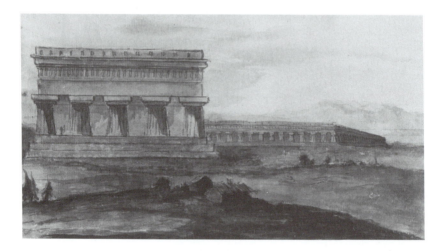

Plate 79 *'Egyptian Architecture in a Nordic Landscape' by Carl August Ehrensvärd, showing how very primitive, stumpy Doric (a deformed and shortened version of the Pæstum Doric) was thought to be 'Egyptian', even in the 1780s. The 'Egyptian' architecture is very similar to that proposed by Ehrensvärd for his 'Egyptian Temple' in Gustav Adolf Square, Stockholm, of 1782. He also used primitive Doric for his entrance to the dockyard at Karlskrona of 1785, which obviously influenced James Stirling in the design for the primitive Doric centrepiece within the circular courtyard of the Staatsgalerie in Stuttgart (Statens Konstmuseer, Stockholm, Teckning och Grafik, No. NMH 179/1866).*

considered Egyptian'. Early Doric temples, like those of Corinth and Pæstum, were much admired by Ehrensvärd and by other late-eighteenth-century artists – Soane acquired the original Piranesi drawings of the Pæstum temples. Ehrensvärd proposed stumpy Doric for the Karlskrona dockyard in 1785. The 1780s were important for the development of Neo-Classicism in Scandinavia. In common with architects from France, Germany, and England, many Scandinavians made their ways south to Italy where they came into contact with the international revival of Classical Antiquity. The Swedes Eric Palmstedt (1741–1803) – designer of the Royal Theatre at Gripsholm (1782) – and Carl August Ehrensvärd were among the most important of the Scandinavians to travel to France and Italy at the time. In 1779–80 Palmstedt copied a design for a mausoleum by Claude-Thomas Lussault of about 1770: it consists of a pyramid of the 'ideal' type (that is with the section of an equilateral triangle), with a domed Pantheon-like interior, four hexastyle Doric porticoes, four cupolas at the corners, and a subterranean vault – it is one of the earliest designs for ideal pyramid-mausolea that were to become so popular in the next decade.[10] The Dane Peter Meyn also designed several funerary projects using the pyramid as a main component in 1780.[11] Meyn's designs were influenced by Peyre's publication, and by the works of Nicolas-Henri Jardin (1720–99), Professor at the Academy in Copenhagen: Jardin had designed a pyramidal *Castrum Doloris*[12] for King Frederik V (1746–66) which appears to be the first stereometrically pure pyramid of Neo-Classicism of the ideal type. Eighteenth-century designs for pyramids, however, generally follow the Cestius proportions because that form was more in accordance with Neo-Classical Taste than was the Gizeh type. Geometrical logic and purity were potent forces in the eighteenth century, and their importance should not be overlooked. Ehrensvärd designed his 'Egyptian' (i.e. stumpy squat Greek-Doric) temple with a *Castrum Doloris* in the centre for the funeral of the Dowager Queen Louisa Ulrika in 1782, but later placed the *Castrum Doloris* within a huge black pyramid to stand in front of the Royal Palace: its interior was to be fitted out in primitive stumpy Doric. Ehrensvärd's pyramid design was far more revolutionary than those of his contemporaries, for it was an ideal stereometrically pure form sitting directly on the paving of the square, with no podium, plinth, or base (**Plate 80**).[13]

At the French Academies public buildings, monuments, cemeteries, and vast civic structures were the subjects studied by the young architects

10 Palmstedt's drawing is in the *Konstakademien*, Stockholm.

11 Five of which are preserved in the *Kunstakademietssamling*, Charlottenburg, Copenhagen.

12 For this subject *see* POPELKA (1994), and *see* CURL (1996*b*).

13 NILSSON (1964). Information also kindly provided by Herr Ulf Cederlöf of the *Statens Konstmuseer*, Stockholm. *See also* collections in the Uppsala *Universitetsbibliotek*.

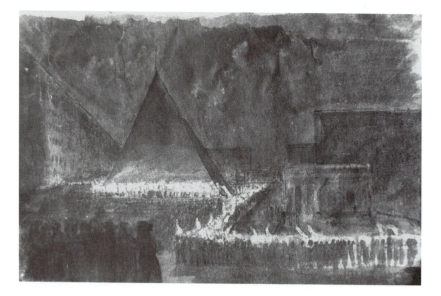

Plate 80 *Visionary design by C. A. Ehrensvärd for a black pyramid in Gustav Adolf Square, Stockholm, for the funeral and lying-in-state of the Dowager Queen Louisa Ulrika of Sweden (1720–82) (a sister of King Friedrich II [the Great] of Prussia [1712–86]) in 1782, and shows an 'ideal' pyramid of stereometrically pure shape resting directly on the ground, and based on the Cestius model (*Ulf Cederlöf: Uppsala Universitetsbibliotek).

who exploited the possibilities of huge size, massing of simple stereometrically pure forms, and symmetry. Étienne-Louis Boullée's drawings in the *Cabinet des Estampes* of the *Bibliothèque Nationale* in Paris provide an array of designs, many of which are projects associated with death. His cenotaphs and cemeteries are schemes in which Egyptian motifs play no small part, and in which the influence of Piranesi is clear. Huge blank walls emphasise the terror and finality of death, and have a powerful image that could be easily read. Boullée visualised funerary monuments, cenotaphs, and cemeteries as temples of death, designed to chill the heart: he insisted that such structures should be built to withstand the ravages of time, while incorporating what he called the 'Poetry of Architecture'.[14] Boullée's cemeteries incorporate surrounding walls with the main monument in the centre, for he sought 'perfect symmetry' and included features such as gigantic Neo-Classical sarcophagi (which themselves became huge buildings), enormous pyramids, and 'funerary triumphant arches'. By cutting decoration to the minimum, Boullée gave his buildings a 'character of immutability'. His cone-shaped cenotaphs incorporate ideas based on both domes and

14 CURL (2002*c*), 190.

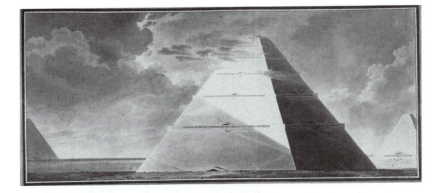

Plate 81 *A design (c.1785) for a gigantic pyramid-cemetery by Étienne-Louis Boullée which he called* Cénotaphe dans le Genre Égyptien. *Note the ramps rising up the faces of the pyramid to low, sinister, triangular openings. The vast scale is clearly influenced by Piranesi, while the design, though clearly showing an angle of batter more like real Egyptian pyramids, owes much to Fischer von Erlach (see* **Plate 56**) *(BN, HA 55, No. 26).*

pyramids, and have obelisks and the funereal cypress associated with them. He could conceive of nothing more appropriate or melancholy than a monument consisting of a flat surface, bare and unadorned, 'absolutely stripped of detail, its decoration consisting of a play of shadows, outlined by still deeper shadows'.[15] 'No gloomer images exist', Boullée asserted, 'and if we make abstraction of all the beauty of art, it would be impossible not to appreciate, in such a construction, the mournful effect of the architecture'.[16] To Boullée, the Egyptians had very grand ideas, and he could admire with reason their pyramids, the order and composition of the architecture of the temples, and the splendour of Egyptian images.

Boullée's design for a gigantic pyramid-cemetery combines themes from Fischer von Erlach and Piranesi (**Plate 81**), while his project for a cenotaph[17] to be erected in memory of a national military hero shows an enormous building in the form of a huge sarcophagus set on a podium (**Plate 82**), with a frieze consisting of a repeated Egyptianising figure in relief clearly derived from the Egyptianising figure of Antinoüs and the *telamones* from the *Villa Adriana*. Boullée probably drew them from one of the many sources that illustrated these Egyptianising sculptures. Another cenotaph[18] is like a gigantic funerary triumphal arch set in a truncated

15 ROSENAU (1976), 106. The quotations are from Boullée's Essay on 'Architecture', *tr.* SHEILA DE VALLÉE, *ed.* HELEN ROSENAU. *See* BOULLÉE (1968). The Author is grateful to Dr Rosenau-Carmi for her invaluable help in the past.
16 *Ibid.*
17 *BN*, HA, 57, No. 27.
18 *BN*, HA, 57, No. 13.

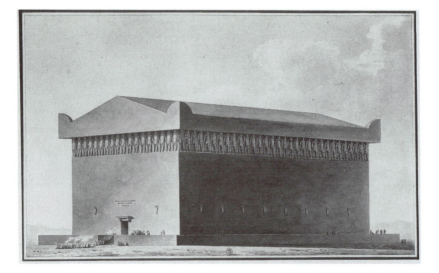

Plate 82 *A project by Boullée for a cenotaph erected in memory of a national military hero. The building is in the shape of a huge sarcophagus, imitating those of Antiquity (see* **Plate 30**), *with a lid with plain horns, and the frieze consists of repeated Egyptianising* telamones *based on those in the* Sala a Croce Greca *in the* Museo Vaticano *from the* Villa Adriana *at* Tivoli *(see* **Plate 28**), *and on the Antinoüs, also from the* Villa Adriana *(see* **Plate 27**) *(BN, HA 57, No. 27).*

pyramid: the 'arch' is actually a huge coffered hemi-dome, and there are massive steps up the sides of the pyramid, while obelisks on bases add further Egyptianising flavours to the design. In one scheme[19] by Boullée for a mortuary chapel set in the wall of a cemetery, a raised hemi-dome functions as the entrance: in this design the terror and desolation of death are expressed in the blank walls that are devoid of all features save narrow vertical slit-windows (**Plate 83**).

The qualities of Egyptian architecture were certainly being exploited by the 1760s. Antiquity was not being slavishly copied, for the Neo-Classical architects were to use Antique forms and motifs with eclectic verve. Plain walls, a careful selection of elements, and a daring stripped-down approach to decoration were characteristics of the greatest Neo-Classical architects, including Boullée and Ledoux in France, Soane in England, and Gilly and Karl Friedrich Schinkel in Prussia. As the engravings of the *Grands Prix* show,[20] the Neo-Classicists adapted eclectic motifs from Antiquity: their use of obelisks, pyramids, and blank walls

19 *BN*, HA, 55, No. 28.
20 *See* ACADÉMIE DE FRANCE À ROME (1976) and ACADÉMIE DES BEAUX-ARTS (1787–96, 1806, and 1818–34).

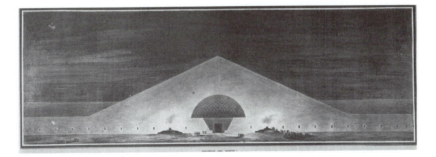

Plate 83 *Design by Boullée for a* Chapelle des Morts. *Note the blank walls emphasising the terror and desolation of death, and the very low pyramidal form, the opposite extreme compared with the Cestius type of pyramid* (BN, HA 55, No. 28).

created a suitably funereal image for much of the monumental work. Egyptianising forms were used to achieve a noble and solemn appearance. The *Grands Prix* drawings also contain an extraordinary *Chapelle Sépulchrale* by la Barre[21] which demonstrates many of the characteristics of eclectic design of the period: Pantheon-domes, pyramids, Greek Doric porticoes, sphinxes, sarcophagi, and urns were drawn from the familiar architectural vocabulary of Egyptianising designs for death.

Another influence on these young French architects was Antoine-Chrysostôme Quatremère de Quincy (1755–1849), whose prize essay submitted to the Académie des Inscriptions et Belles-Lettres in 1785 is likely to have been known to Boullée and others, although it was not published until 1803. The Egyptians had grandiose ideas, Boullée tells us in his *Essai*: the architectural order of their temples gave an impression of greatness. Their pyramids were rightly admired as characteristic of monuments designed to withstand the ravages of time, and conjured up the melancholy image of arid mountains and immutability. Quatremère de Quincy analysed Egyptian architecture and compared it with that of Ancient Greece (a common preoccupation of the time). His work dwells on the massiveness and brooding grandeur of Egyptian architecture, and it grants that it contained much that was admirable. The views expressed in his *De l'architecture Égyptienne* coincide very closely with those of Boullée and other architects of the last quarter of the eighteenth century, so it would seem reasonable to suppose that Quatremère's influence was felt in architectural circles long before publication, or that he imbibed influences and opinions current in the 1770s and 1780s. The illustrations by Gaitte in Quatremère de Quincy's book show considerable detail (**Plate 84**).

21 Illustrated in CURL (1994*a*), 105. The reference is *BN*, HA 75, *fol*. Pl. 119).

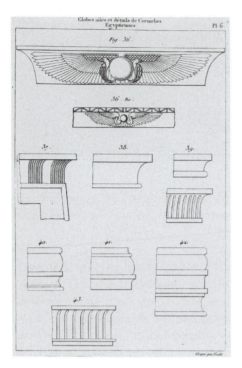

Plate 84 *Engraving* (Planche 6) *by Antoine-Joseph Gaitte (b. 1753) in* QUATREMÈRE DE QUINCY's De L'architecture Égyptienne *showing* (top) *coved cornice with winged globe and* uræi; (left) *top of a battered pylon-like form with torus moulding and coved cornice; several types of coved cornices; and other details* (GN/SM).

James Playfair (1755–94) visited France in 1787, and whilst there took on board much of what was happening in the Continent: when he designed Cairness House, Aberdeenshire, for Charles Gordon in 1789–97, he incorporated primitivist unfluted stumpy Greek-Doric columns and an entablature set within a semicircular arch as a variety of Diocletian Window. He also designed an Egyptianising tomb-like billiard-room in 1793 for the same house, a drawing of which survives (**Plate 85**). This extraordinary and advanced primitivist room anticipates Thomas Hope's house in Duchess Street, London, in its use of Egyptianising motifs, segmental ceiling, hieroglyphic friezes, and other elements. Playfair is known to have visited Rome in 1792–93, and the design may have developed from a sight of material there: it is probably the first true Egyptian Revival interior in Britain. Playfair also met Antonio Canova (1757–1822) in Italy, and his interest in Neo-Classicism, and especially in the French Neo-Classicism of the Peyre-Boullée-Ledoux schools, is brought out by the contents of his library revealed in the sale catalogue.

Now the powerful French designs outlined above were a reaction to the delicate Rococo adopted by the previous generation: such architectural dreams need not necessarily have any chance of realisation, but it was certainly with these Egyptianising designs for buildings associated with death that French architects achieved the Sublime. The

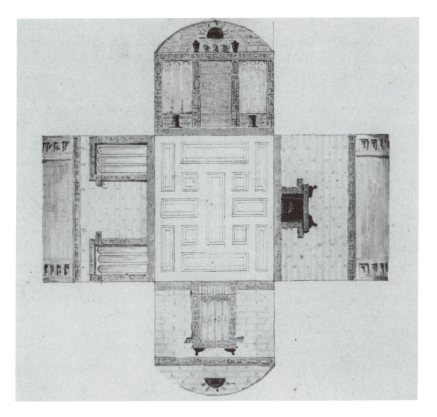

Plate 85 *Billiard-room in Cairness House, Aberdeenshire, by James Playfair, of 1793. An essay in the primitive Egyptianising style, with bogus hieroglyphs on the frieze, architraves, and chimney-piece. The ceiling is a segmental section, which was thought to be specifically Egyptian, and was supposed to be based on 'Nero's Baths at Baia' (but, as was noted earlier, the Romans also associated segmental forms with Egypt). Note the semicircular funereal loculi in the segmental shapes at each end of the vault, the Canopic urns, and sphinxes. The room had pale-yellow masonry walls with painted granite architraves* (Miss M.V. Gordon and The University of Aberdeen. Reproduced by permission of the University of Aberdeen, Special Libraries and Archives, AU MS. 1160/28/6/12).

importance of Piranesi's work in these developments cannot be overstressed, and it was his influence that drew young architects away from the delicacies of Rococo: the Venetian was obsessed by ash-chests, urns, vases, tombs, columbaria,[22] and powerful, massive structures, all of which he deliberately over-sized in his drawings. Piranesi's exaggerated sense of scale and his powerful images started something of a cult among students at the French Academies.

22 Soane, too, was obsessed by the architectural furniture of death. *See* JOHN SUMMERSON (1978): 'Sir John Soane and the Furniture of Death', in *The Architectural Review*, **clxiii**/973 (March), 147–55.

Pyramids, with their simple elemental geometry, were felt to indicate progressiveness in architecture. The Pyramid of Cestius in Rome was well-known, and publications from the end of the Middle Ages had indicated that pyramids fascinated Western commentators. By the eighteenth century architects not only began to exploit the iconographical suggestions of pyramids, but saw the expressive possibilities of these starkly pure forms. Boullée, Ledoux, Desprez, Ehrensvärd, and others certainly did this, and both the Comte de Caylus and Quatremère de Quincy commented upon the 'expressive power' of simplicity, grandeur, solidity, massiveness, and uniformity found in Ancient Egyptian architecture. Hawksmoor and Vanbrugh used pyramids, and the form had funereal connections, so was ideally suited to monuments and even individual mausolea, alone, complete, and stark in the landscape. Mr John Harris has drawn attention to the pyramidal 'sepulchral temple' by Jardin (noted above) of 1748,[23] and the Carmontelle pyramid in the Parc Monceau has already been mentioned.[24] In 1777 John Carter (1748–1817) published a design for a pyramidal Egyptianising dairy in the *Builder's Magazine or Monthly Companion for Architects*,[25] and, according to Emil Kaufmann, 'found pleasure in putting sphinxes on top of the classic entablature of a temple'.[26] In 1778 the young John Soane published a pyramidal design for a garden-temple with a simplified Doric distyle *in antis* portico and flanking sphinxes in his *Designs in Architecture*, a work he subsequently tried to suppress. Soane also exhibited a design for a 'Mausoleum to the Memory of James King' at the Royal Academy in 1777: it consists of a central domed building set on a heavily rusticated podium joined by diagonal wings to four pyramids.[27]

James Wyatt (1746–1813) designed a mausoleum for the 4th Earl of Darnley at Cobham Park, Kent, in 1783–84, which incorporates a Roman Doric Order, sarcophagi at the corners, an attic storey above the entablature with segmental openings, and a pyramid-roof: his designs were exhibited at the Royal Academy in 1783, and survive in Sir John Soane's Museum in London.[28] Boullée's gigantic ramped pyramid of *c*.1785 has already been mentioned **(Plate 81)**.[29] Friedrich Gilly (1771–1800 – the gifted friend and teacher of Schinkel, who was one of the young architects to introduce French Neo-Classicism to Prussia) projected a pyramid with a Greek Doric portico on each face flanked by sphinxes, and with a band of bogus hieroglyphs around the pyramid itself:[30] this project is a logical extension of the sym-

23 FRASER, HIBBARD, and LEWINE (*Eds*) (1967), fig. 30.
24 SIRÉN (1950), 125.
25 London (1774–78).
26 KAUFMANN (1968), 50. But in this pleasure he was not alone.
27 Also illustrated in SOANE (1778).
28 COLVIN (1978 edition), 952, and CURL (2002c), 180.
29 *BN, HA*, 55, No. 26.
30 HORN-ONCKEN (1935).

Plate 86 *Mausoleum at Blickling, Norfolk, designed by Joseph Bonomi Senior for the Earl and Countess of Buckinghamshire, 1794. Simple Neo-Classical doorcases are set into the pure form of the pyramid. Photograph of 1980 (JSC).*

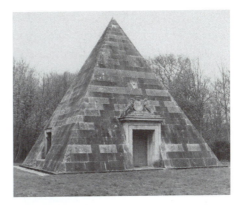

metrical planning of the Villa Capra at Vicenza by Andrea Palladio (1518–80), also used by Vanbrugh at the Temple at Castle Howard (1725–28), and by Colen Campbell (1676–1729) at Mereworth Castle, Kent (*c.*1722–25).

The Palladian exercise in formal geometry was influential throughout Europe in the eighteenth century, and it is easy to see why its symmetry appealed to Neo-Classical architects experimenting with purity of form. Joseph Bonomi (1739–1808) built a pyramidal mausoleum with domed interior and recesses at Blickling, Norfolk, for John Hobart, 2nd Earl of Buckinghamshire (1723–93) in 1794 (**Plate 86**): the designs for this important pyramid were exhibited at the Royal Academy in that year, and survive at Blickling.[31] Pyramids appear with frequency in a funereal connection, and other examples include Peter Joseph Krahe's (1758–1840) design for General François Severin Desgraviers Marceau's (1769–96) monument at Koblenz of 1799, in which the pyramidal composition is surrounded by cypresses in the manner of the Boullée monuments.[32] Funereal in appearance, but not in purpose, is the ice-house at the Désert de Retz at Yvelines, near Paris, built between 1774 and 1784 by François de Monville and François Barbier, and based on the form of the Pyramid of Cestius.[33]

The obelisk, too, was much used. Mention has already been made of the impact of obelisks in Renaissance town-planning in Rome, and this established a fashion for the erection of obelisks as eye-catchers and monuments (examples by Vanbrugh and Hawksmoor have been mentioned above). There is an extraordinary obelisk set on a formally-conceived grotto-like base (reminiscent of Bernini's design for the Piazza Navona

31 COLVIN (1978 edition), 125.
32 VOGEL (1928–9), 160–65. Marceau was killed after receiving a mortal wound at Altenkirchen when he and his forces were covering the French retreat over the Rhine: his body was burned and his calcined bone-fragments entombed in a pyramid, designed by J.-B. Kléber, where they lay until transferred to the Panthéon in 1889.
33 Illustrated in HUMBERT (1989*a*), 39.

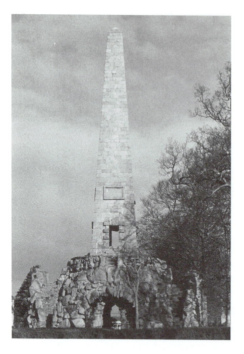

Plate 87 *Obelisk at Stillorgan, Co. Dublin, designed by Sir Edward Lovett Pearce. Set on a formally-conceived rockwork base, it is reminiscent of Bernini's* Fontana dei Fiumi (**Colour Plate IV**) *in the Piazza Navona, Rome. Photograph of 1977 (JSC).*

fountain in Rome) at Stillorgan, Co. Dublin, designed by Sir Edward Lovett Pearce (1699–1733)[34] (**Plate 87**). Obelisks a-plenty survive in the South Park Street Cemetery in Calcutta,[35] some of which are, in fact, very steeply-pointed pyramids.[36] In Ancient Egypt obelisks were usually placed in pairs flanking the axis of processional ways in temple complexes, but their use in Europe (even in Antiquity) was rarely similar, for they were employed as eye-catchers in parkland, as monuments alone in cemeteries, as central *foci* of urban spaces, as crowning features of buildings or monuments, or as backgrounds to funerary monuments. Boullée and others used obelisks to embellish their buildings, and the form was widely used in Franco-Prussian architectural design.

When Friedrich II (the 'Great') of Prussia died in 1786 the Berlin *Akademie der Wissenschaften* proposed that a monument should be erected in his memory. To this end Karl Ludwig Fernow designed a pyramid without decorations, but inscribed with the word FREDERICO: clearly the proto-type of the Cestius Pyramid is suggested. Heinrich Gentz (1766–1811) pro-posed a rotunda on a podium, with obelisks, which suggested he was acquainted with French designs, possibly from Peyre's *Œuvres*. The design by Friedrich Gilly outshone them all, however, consisting of a Greek Doric

34 The Author is indebted to Dr Maurice Craig for showing him this and discussing it.
35 CURL (1993), 141–5.
36 The Author is indebted to Mr Theon Wilkinson for telling him about these.

temple set on a high podium within an enclosure (a 'sanctuary') entered through a triumphal arch of stunning primitive stripped form. Several pairs of obelisks were to stand within the enclosure, and sarcophagi-lids were also to adorn the bleak, bare, chilly space.[37] So powerful was this image that it determined the young Karl Friedrich Schinkel to become an architect.

The qualities of the Egyptian style appealed to Romantic Classicists, for massiveness and bareness could contribute to the required Sublime effects. Simple geometry, bare unadorned walls, and a cold severity could be combined with a megalomaniac scale to produce what was desired. Both Herder and Kant understood this, and Kant, in his *Critique of Judgement*, mentions the Gizeh pyramids as mathematically Sublime. Gentz was to seek Sublime effects in his proposals for a huge obelisk set on a rocky base as a monument to Martin Luther (1804).

The student of funerary monuments will be familiar with the pyramidal composition and with the obelisk. Crowning obelisks on tombs of the sixteenth and seventeenth centuries have already been mentioned, and the large, widened, fat obelisk as a background to sculptural groups became commonly employed from the seventeenth century, largely as a result of the exemplars in composition provided by Bernini for the papal tombs in Rome. Markland[38] tells us that:

> descending to later days, we approach that favourite ornament, the pyramid, which, for a series of years, was the prevailing characteristic. This appears to have originated with Bernini, and, for this violation of taste and judgement, Flaxman[39] has bestowed upon him a well merited censure. The representation of a building, intended from its immense size, and its solid base, to last thousands of years, indicated by a little slab of marble, an inch thick, 'to be the back ground of sculpture, belonging to none of the ancient classes, foisted into architecture, with which it has neither connection nor harmony',[40] does appear to be the very climax of absurdity, were it not heightened by making the pyramid rest upon four round balls, or, as we have already seen, upon four skulls.

Markland, of course, was confusing his 'pyramid' with an obelisk, although the obelisk was always much less steeply battered, and the composition was basically pyramidal.

An early use of the stepped pyramid as part of a tomb structure is found at the Contarini monument, *Il Santo*, in Padua, of 1544–48, designed by Michele Sanmicheli (c.1484–1559). After Bernini made the pyramidal form famous, examples became many. In England the white-marble tomb of the Earl of Exeter (1704) in the church of St Martin in Stamford,

37 NEUMEYER (1938–9). *See also* RIETDORF (1940).
38 MARKLAND (1843), 59 ff.
39 John Flaxman (1755–1826), the foremost English sculptor of the Neo-Classical period.
40 Quoted from Flaxman's address on the death of Banks. *See* FLAXMAN (1865) which contains Flaxman's address on the death of Thomas Banks (275–99).

Lincolnshire, by Peter Stephen Monnot (1657–1733) of Rome, is a fine example of a group of figures set against a fattish obelisk. This type of monument was much favoured by John Michael Rysbrack (1694–1770): good representatives of his work can be found in the church of St Michael, Great Witley, Worcestershire,[41] and in the church of St Mary Magdalen, Stapleford, Leicestershire (**Plate 58**). Similar compositions can be found in the tombs of ex-King Stanisław I Leszczynski of Poland (1704–9 and again 1733–5) and his consort Catherine Opalinska in the church of Bon Secours, Nancy, by Louis-Claude Vassé (1716–72) assisted by Félix Lecomte (1737–1817), and Nicolas-Sébastien Adam (1705–78) respectively, and in the monument of John, Duke of Argyll and Greenwich, of 1748–49, by Louis-François Roubiliac (1705–62).[42] This pyramidal form of monument also appealed to designers like Jean-Baptiste Tuby, René Michel (known as Michelange) Slodtz (1705–64), and Jean-Baptiste Pigalle (1714–85). The last's monument to the Maréchal de Saxe (1696–1750 – illegitimate son of August the Strong, Elector of Saxony and King of Poland) in the church of St Thomas, Strasbourg, includes a steeply-pitched pyramid, almost an obelisk, as the background. In fact the pyramid motif in funerary design varied from the obelisk to the Cestius Pyramid in shape, and from the Cestius model to the very flattened, wide-angled cemetery-entrances of Boullée.[43] Slodtz's pyramidal monument in the church of St Maurice, Vienne, of 1740–47, is another example.

One of the last British architects to make a pilgrimage to Rome, before the study of Egyptian antiquities was systematised after the Napoleonic Campaign in Egypt, was Charles Heathcote Tatham (1772–1842). He arrived in Rome in 1794, and stayed for two years during which he made many drawings of architectural details, including much Egyptianising material in the Vatican and elsewhere[44] (**Plates 34** and **36**). His travelling-companion was Joseph Michael Gandy (1771–1843), who returned from Italy to employ various Egyptianisms in his designs. In Rome he met Canova, Angelika Kauffmann (1741–1807), Sir William Hamilton (1730–1803), and the eccentric Earl-Bishop of Derry (1730–1803).[45] However, Tatham's chief œuvre was in his provision of exemplars for Neo-Classical furniture and décor. His *Etchings of Ancient Ornamental Architecture drawn from the Originals in Rome and other Parts of Italy during the years 1794, 1795, and 1797* was published in 1799–1800, and was indeed a major

41 Illustrated in CURL (1993), 129.
42 *Ibid.*, 131. The last is in Westminster Abbey.
43 *Ibid.*, 193. *BN*, HA, 55, No. 28.
44 Later published as *Etchings, representing the best examples of Grecian and Roman Architectural Ornament* (London: 1826).
45 COLVIN (1978 edition), 808.

source-book of the Egyptian Revival and of Neo-Classicism as a whole, based on the discoveries made at the archæological investigations of Pompeii, Tivoli, Herculaneum, and Rome itself: it went into further editions, and a German translation appeared in Weimar in 1805. The clear line-engravings derived from the style of illustration employed by Flaxman and by Johann Heinrich Wilhelm Tischbein (1751–1829) – the latter is of singular importance for his engravings of Classical antiquities, although he is largely known today for his famous portrait of Goethe (1786–87) – and influenced Thomas Hope, Charles Percier (1764–1838), and Pierre-François-Léonard Fontaine (1762–1853). Tatham's *Etchings, representing the best examples of Grecian and Roman Architectural Ornament* contains a tribute to the influence of Piranesi, but also notes that the Venetian 'rejected with disdain the restraints of minute observation', and that he 'sacrificed accuracy' to conceptions that were the 'richer products of a more fertile and exuberant mind'.

Tatham designed candelabra and other ornaments of fine quality that incorporated Egyptianisms, and through the leading cabinet-makers John Linnell (1729–96) and Thomas Tatham (both relations) he had a profound effect on the design of contemporary furniture.[46] The Drawings Collection of the RIBA contains two books of drawings by Tatham which include a beautiful sketch (**Plate 88**) of an Egyptian 'Therm of a french Chimney-piece statuary marble with gilt or-moulu ornaments – at Carleton (*sic*) House, Pall Mall'.[47] Two Tatham sketches, dated Rome 1796, show an 'Egyptian Sepulchre' and an 'Egyptian Temple dedicated to the God Anubis' that are copied from theatrical designs by Mauro Antonio Tesi (1730–66) (**Plate 89**).[48] Another drawing shows a *Monument projeté pour le centre de la place des Victoires, à Paris*,[49] and is obviously the design by Jean-Nicolas Sobre (a pupil of Ledoux, active 1785–*c*.1805) of 1795: it shows a large obelisk (adorned with Neo-Classical motifs) resting on the backs of elephants (**Plate 90** – clearly a variant derived from the *Hypnerotomachia Poliphili*[50] and Bernini images [**Plates 40** and **50**]). Tatham also illustrated an 'ideal' pyramid-mausoleum (set on a massive rusticated base with tetrastyle Doric *in antis* entrances and heavy segmental sarcophagi-lids capping the battered corner-pavilions [themselves flanked by sphinxes]) (**Plate 91**).[51] The collection also contains original designs by Tatham, including a 'Table executed for the Earl of Carlisle at Castle

46 COLVIN (1978 edition), 808–10.
47 The Author is indebted to Mr John Harris for showing him these drawings.
48 TATHAM (1794–*c*.1808), 15.
49 *Ibid.*, 13, illustrated in CURL (1982), 104.
50 *See* GODWIN (1999).
51 TATHAM (1794–*c*.1808), page not numbered. Illustrated in CURL (1982), 105.

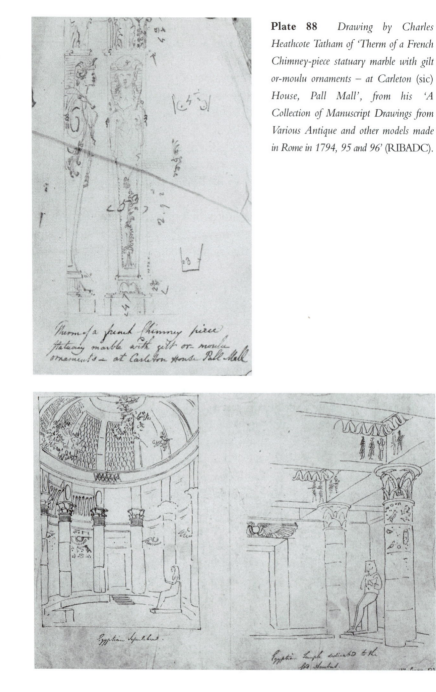

Plate 88 *Drawing by Charles Heathcote Tatham of 'Therm of a French Chimney-piece statuary marble with gilt or-moulu ornaments – at Carleton (sic) House, Pall Mall', from his 'A Collection of Manuscript Drawings from Various Antique and other models made in Rome in 1794, 95 and 96' (RIBADC).*

Plate 89 *Two drawings by Charles Heathcote Tatham from his 'Collection of Manuscript Drawings from Various Antique and other Models', showing an 'Egyptian Sepulchre' and an 'Egyptian Temple dedicated to the God Anubis' based on theatrical designs by Mauro Antonio Tesi (RIBADC).*

Plate 90 *Drawing by C. H. Tatham of 'Monument projeté pour le centre de la place des Victoires, à Paris', from his 'Collection of Manuscript Drawings'. The design is by J.-N. Sobre of 1795 (RIBADC).*

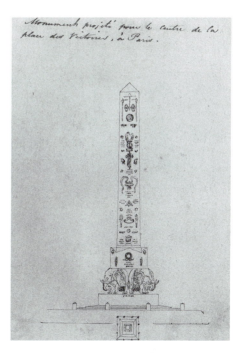

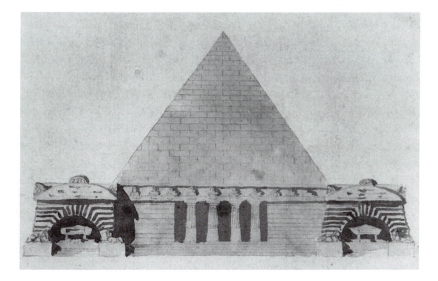

Plate 91 *Pyramidal mausoleum drawn by C. H. Tatham and in his 'Collection of Manuscript Drawings'. Note the sphinxes flanking the corner pavilions in which the sarcophagi rest. Note also the segmental tops to the pavilions. This may be an original design or it may be influenced by the work of the French Academy in Rome (RIBADC).*

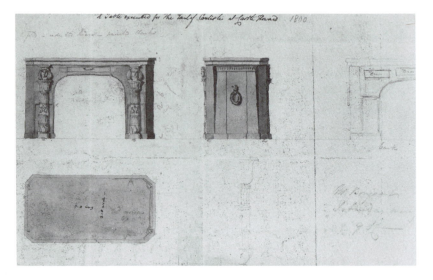

Plate 92 *'Table executed for The Earl of Carlisle at Castle Howard', from C. H. Tatham's 'Collection of Manuscript Drawings', dated 1800* (RIBADC).

Howard' of 1800[52] (which has several Egyptianising features [**Plate 92**]) and an Egyptian temple proposed to be used as a greenhouse for Trentham Hall, Staffordshire, dated 1804 (**Plate 111**),[53] which was probably derived from Vivant Denon's illustrations published in 1802.[54] This Egyptian temple is ingeniously adapted for use as a greenhouse, and is more self-consciously Egyptian than is the well-known mausoleum at Trentham Park which Tatham designed and built in 1807–08 in a more severe Neo-Classical style, yet Egyptianising pylons are suggested in the battered forms (**Plate 171**).[55]

Some of the last eighteenth-century manifestations of the steeply-pointed pyramid (almost an obelisk, but with continuous battered sides meeting at the apex rather than with a pyramidion on top) occur in the parish churchyard of Knockbreda in Co. Down, near Belfast.[56] Similar 'cheese-wedge' pyramids recur at Downpatrick Anglican Cathedral, Co. Down, and in other late-Georgian Ulster churches, and can also be found in South Park Street Cemetery in Calcutta: the form may owe not a little to Freemasonic iconography.[57]

52 CURL (1982), 106. This was Frederick Howard (1748–1825), 5th Earl (from 1758) of Carlisle, who succeeded John Hobart, 2nd Earl of Buckinghamshire (*see above*) as Lord Lieutenant of Ireland in 1780.
53 TATHAM (1794–c.1808), 11.
54 DENON (1802).
55 CURL (2002c), 183.
56 *Ibid.*, 169–76.
57 CURL (2002b).

There is an interesting painting of 1791 in the Musée Municipal in Brest by Jacob-Henri Sablet (1749–1803) entitled *Double Portrait dans le Cimetière des Protestants à Rome*: it shows a new Neo-Classical monument, the Cestius Pyramid, and several Freemasonic allusions, including the acacia-branches covering the Pyramid (which had then, and has now, no covering vegetation) and lightning in the storm-tossed sky. The acacia signifies hope in the afterlife, and the storm refers to the trials of Initiation.

Egyptianisms in Design before the Impact of Denon and the *Description*

French Taste and scholarship were to stimulate the next and most concentrated phase of the Egyptian Revival, but there were important Italian publications before the French led the field, including *Dell' Architettura Egiziana* (1786), by Count Jacopo Belgrado, and *Monumens Égyptiens* which, despite its language, was published in Rome in 1791. The significance of these two books has been largely overshadowed by the huge (and beautifully illustrated) works of Denon and of the Commission des Sciences et Arts d'Égypte[58] that followed in the next century, but their impact on design is obvious from their contents: *Monumens Égyptiens* is one of the most interesting source-books of the Revival before the monumental achievements of the French scholars who recorded Nilotic buildings during the Napoleonic campaigns were made available. Werner Oechslin has provided some interesting comments on these and on other influences on Neo-Classical architecture.[59] Although Boullée, Ledoux, and the younger generation of French architects associated with primitive forms and with Egyptianising themes are often described as 'Revolutionary', the term is somewhat misleading, as many of the designers were servants of the Ancien Régime, and flourished in the reign of King Louis XVI (1774–92 [guillotined 1793]).

Of these architects, perhaps one of the most interesting was Claude-Nicolas Ledoux (1735–1806), whose work is best-known through his own book, *L'Architecture considerée sous le rapport de l'art, des mœurs et de la législation* (1804). Ledoux was deeply interested in Freemasonic and mystical ideas:[60] William Beckford (1759–1844) met Ledoux in 1784, and even that eccentric was somewhat put out by an occultist meeting at the French architect's house.[61] A drawing of an eye (in which Ledoux's theatre at Besançon is reflected) can be found in Ledoux's book, and recalls the device

58 *See* Select Bibliography of the present work.
59 OECHSLIN (1971), 201–38.
60 CURL (2002*b*), 12, 94, 117, 120, 129, 142, and *passim*.
61 BRAHAM (1980), 160. *See also* VIDLER (1976, 1987, 1990).

of the winged eye used by Alberti. Ledoux used blank walls, removed ornament (even functional mouldings), and simplified architectural form: he exploited the possibilities of Egyptian architecture, as in his celebrated gun-foundry, where the pyramid is used as the casing for the furnaces (**Plate 112**). After Ledoux had remodelled the château at Maupertuis for the Marquis de Montesquiou-Fézansac, Alexandre-Théodore Brongniart (1739–1813) designed the celebrated 'ruined' pyramid by the lake in the *Élysée* of the gardens, where the Marquis held Freemasonic meetings: this pyramid (representing Antiquity) was contrived with a recess on one side containing a primitive Doric portico with segmental pediment (an allusion to Ancient Greece, Ancient Egypt, and Isiac rites), and is unquestionably Freemasonic.[62] Brongniart was also to design a massive ideal pyramid as the centrepiece (**Plate 167**) for Père-Lachaise Cemetery in Paris (*c*.1804), but this was not realised.[63]

A use of Ancient Egyptian or Egyptianising elements, therefore, was intended to indicate a 'progressive' approach in architectural design. Two terracotta statuettes, dated 1804, by Claude-François-Michel Clodion (1738–1814), now in a private collection,[64] may be modelled from the large Egyptianising figures made for the mortuary chapel of the Comte d'Orsay in the church at d'Orsay (Chevreuse) in 1773 which was destroyed during the Revolution. One of the figures is quite clearly derived from one of the Piranesi designs in *Diverse Maniere*. A relief from the d'Orsay chapel was exhibited by Clodion in the Paris *Salon* of 1773 (item 250 in the *Catalogue*), and a drawing survives in the French National Archives.[65]

Josiah Wedgwood (1730–95) started to use Egyptianising motifs as early as 1770, and the Etruria factory in Staffordshire continued to do so until *c*.1810, with later re-issues. Designs fall into three distinct phases: those produced during the Wedgwood and Bentley partnership and later (i.e. *c*.1768–80); those developed by Josiah Wedgwood II in the early part of the nineteenth century incorporating hieroglyphic designs; and the later re-issues and revivals. The Wedgwood/Bentley Egyptian Wares include sphinxes, Egyptian deities, a Cleopatra, Canopic jars, candle-sticks, and cameos made in black basalt or blue-and-white jasper-ware. Wedgwood himself felt black basalt was very effective as it was similar in appearance to the 'Basaltes of the Ægyptians'.[66] The second group consists mostly of wares decorated with bogus hieroglyphs and various Egyptianesque motifs in black 'basalt' on a *rosso-antico* ground. An odd feature of the Wedgwood

62 CURL (2002*b*), 132. *See also* BRAHAM (1980), 160, 216.
63 Illustrated in CURL (2002*c*).
64 The Author is indebted to Mr John Harris for these items. Illustrated in CURL (1982), 96.
65 GALLET (1964).
66 Wedgwood/Bentley *Catalogue* (1779).

Plate 93 *'Canopic' figure (probably French) of red, grey, and black marble, dating from the early nineteenth century. It is carved with ornament in relief. A heart-shaped motif is suspended between two birds whose feet rest on an ædicule within which is the Apis-Bull. Below, the solar-disc with uræi is supported by a scarab-beetle backed by a ribbed crescent. On either side of the central ornament are Egyptianising figures* (Photograph by JSC, 1981. Reproduced by permission of The Bowes Museum, Barnard Castle, Co Durham).

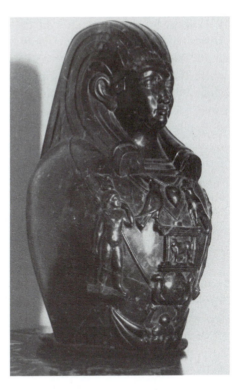

productions is that the designs were not taken from works of those who had visited Egypt, but were culled from Montfaucon, Fischer von Erlach, and, apparently, Kircher. Wedgwood Canopic jars generally did not have removable lids, although later Canopic jars, including one of 1868 of blue 'jasper-dip' with white reliefs, has a removable lid in the form of a head of Imsety. Another possible source for Wedgwood could have been Michel-Ange de la Chausse's *Museum Romanum*, published in Rome in 1746.[67] Wedgwood often mixed Græco-Roman elements with his Egyptian motifs in a free Neo-Classical style. Other 'Canopic' figures carved in marble and other materials were produced as ornaments in several countries, notably France, and usually did not have lids (**Plate 93**). Wedgwood also began to manufacture a greater range of Egyptianising ornaments after the Napoleonic campaigns in Egypt itself. An ink-stand of 1805 of black basalt with red decorations in relief nevertheless has elements derived from Moutfaucon, and a teapot, cover, and stand set, also of 1805, made of unglazed red stoneware (known as *rosso antico*), and now in the Victoria & Albert Museum, has sitting sphinxes and other motifs derived from the *Mensa Isiaca* and from Montfaucon.

67 CONNER (*Ed.*) (1983), 21–2. *See also* ALLEN (1962).

Thus, by the last quarter of the eighteenth century the Egyptian Revival embraced three distinct attitudes: the first was essentially playful, almost Rococoesque, where effects were sought not unlike in those cases where Romantic ruins, *Chinoiserie*, 'Hindoo', and Gothick themes were employed; the second was a more severe view of Romantic Classicism, where Picturesque effects were evident, but where the Egyptianisms were becoming more fully integrated with the eclectic language of Neo-Classicism; and the last phase was archæological, where correctly observed, measured, and recorded detail formed the bases of design-work. This archæological approach was further strengthened from 1802 when the works of Denon came out, followed a few years later by the *Description de l'Égypte*, which provided accurate source-books for Egyptian architecture in much the same way that Stuart and Revett's *Antiquities of Athens* was a source-book for the Greek Revival.

However, before then, there were many instances where Egyptianisms recurred in design. Johann Heinrich Müntz (1727–98) designed an 'Egyptian' Room (actually Gothick with Egyptianising figures – an odd and unnerving mixture) for James Caulfeild, 1st Earl of Charlemont (1728–99), at Marino, near Dublin, in 1762. It will be recalled that Caulfeild visited Egypt in 1749 with Richard Dalton, the artist. In 1773 Robert Adam built the entrance-screen for Syon House, Middlesex, with sphinxes as terminal features of the flanking walls. Egyptianising motifs appeared in numbers in later eighteenth- and early nineteenth-century furniture,[68] notably in the work of Thomas Sheraton (1751–1806), as is apparent from his publications. Something of an archæological approach to furniture-design appears in Sheraton's *The Cabinet Dictionary* of 1803, although his designs do not demonstrate a convincing comprehension of the Egyptian style. In *The Cabinet-Maker, Upholsterer, and General Artist's Encyclopædia* of 1804–06, Sheraton illustrated Egyptianisms in sphinx-heads and feet used as capitals and bases on pilasters, motifs which were to be developed by Henry Holland (1745–1806), who employed C. H. Tatham as his draughtsman in *c*.1789.

A delightful Egyptianising marble bust of 'Mrs Freeman as Isis' was carved in *c*.1789 by Anne Seymour Damer (1748–1828), and shows the subject with a lotus-bud sprouting from her forehead, with a *sistrum* motif on the pedestal, and with a hair-style based on Hathor-heads (**Plate 94**).[69] George Dance Jr (1741–1825) designed an Egyptianesque chimney-piece for the 1st Marquis of Lansdowne in 1788–91, and was later commissioned by Benjamin West (1738–1820) to design a monument to George Washington (1732–99) in 1800 to consist of a low central pavilion with flanking pyramids recalling

68 READE (1953) and JOHNSON (1966).
69 NOBLE (1908), 78–82. The bust is in the Victoria & Albert Museum.

Plate 94 *'Mrs Freeman as Isis' by Anne Seymour Damer. Note the lotus-bud sprouting from Mrs Freeman's forehead, and the sistrum on the base* (V&A Neg. No. E708).

the work of Ledoux. Dance had met Piranesi in Rome, and obviously was another architect influenced by the Venetian master.[70]

Overtly Egyptianesque, and doubtless also influenced by Piranesi was the *Théâtre Feydeau*, with its entrance and foyer decorated in the Egyptian Taste, by Amant-Parfait Prieur of 1789. The use of Egyptianising elements for novelty became part of *le style Louis Seize* and derived from Piranesian prototypes. There was a salon in the Place Vendôme decorated with Egyptianising motifs in 1786, but rather more important was the series of garden-pavilions and Egyptianesque ornaments in the park at Étupes, designed by Jean-Baptiste Kléber (1753–1800)[71] for the Prince de Montbéliard in 1787. In the garden at Étupes Kléber designed an Egyptian Island, perhaps suggested by the Isiac buildings at Philæ, approached by a bridge. On this island were a swing, benches, ornaments, and a bath-house, all in the Egyptian manner: the swing, bridge, and ornaments were delightfully eclectic examples where motifs (culled from Montfaucon and Caylus) were used in the manner of Piranesi's *Diverse Maniere* designs, but the bath-house was more correctly based on archæological observation, and had

70 COLVIN (1978 edition), 249–52; PEVSNER (1976), 21; STROUD (1971), 245.

71 KRAFFT with DUBOIS (1809–10), 17 and 31–5. *See also* CARROTT (1978), plates 3 and 5, and HUMBERT (1989*a*), 40.

a battered podium on which sat a temple structure, distyle *in antis* at both ends, with eight square piers down each of the longer sides. Symmetrical flights of steps at each end led up to the top of the podium, and those steps were supported on segmental arches. Now this building is reminiscent of the temple on the Island of Elephantine (**Plate 5**) that had not been adequately recorded in 1787, so Kléber must have developed his design from studies of a variety of sources, one probably being Norden, published in a French edition in 1755. Norden and Pococke were standard source-books at the time, and Quatremère de Quincy used plates from both in his *De l'Architecture Égyptienne*. Kléber's work at Étupes was greatly admired as being in the true Egyptian manner, with a richness of decoration arrayed in harmonious fashion.[72] As Major-General Kléber, Military Governor of Alexandria, this gifted architect was assassinated in Egypt during the aftermath of the Napoleonic campaign, and has many avenues, boulevards, and places named after him in France today: for example, a bronze statue of him, as an heroic General standing in front of a reclining sphinx, in the Place Kléber in Strasbourg, was sculpted (1838) by Philippe Grass (1801–76).

P.-F.-L. Dubois designed an ice-house and a bridge for M. Davelouis at Soisy-sous-Étoile, described as a *temple égyptien*, and had a distyle *in antis* Egyptianising portico with two obelisks standing before it, an unusual instance where obelisks flank an axis in the *Echt*-Egyptian manner rather than stand on the axes themselves as *foci* (**Plate 95**). Both obelisks and the temple façade were decorated with bogus hieroglyphs, and there was a winged globe in the tympanum of the pediment. At that time, these buildings were praised for their 'novel' and 'picturesque' forms,[73] yet the designs were not really scholarly works of archæological correctness: they were illustrated in Krafft's *Recueil d'architecture civile* (1812).[74]

John Nash (1752–1835) set a sphinx on the centre of the attic storey of Southgate Grove, Middlesex, in 1797, illustrated in George Richardson's *New Vitruvius Britannicus* (1802–08 and 1808–10), but Egyptianisms are rare in Nash's work, although he used Egyptianesque detail in the chimney-pieces in the Gallery at Attingham Park, Shropshire (1807); and he appears to have been responsible for the Egyptianising library at Barnsley Park, Gloucestershire. Many of the designs of Jean-Jacques Lequeu (1757–1825), however, were Egyptianising in an overt way, for he used bogus hieroglyphs, canted and corbelled arches, and themes owing more to Piranesi than to archæology (**Plate 109**):[75] his work was intimately connected with Freemasonry.

72 KRAFFT with DUBOIS (1809–10, 33.
73 REED, CHARLES (1836): 'A few remarks on ancient foundations and modern concrete', in *The Architectural Magazine*, **iii**, 80. *See also* DOWSON, J. (1836): 'Essay on the metaphysics of architecture', in *The Architectural Magazine*, **iii**, 245–9.
74 CURL (1982), 112. *See also* KRAFFT (1812a).
75 CURL (2002b), 156–68. *See also* DUBOY (1986).

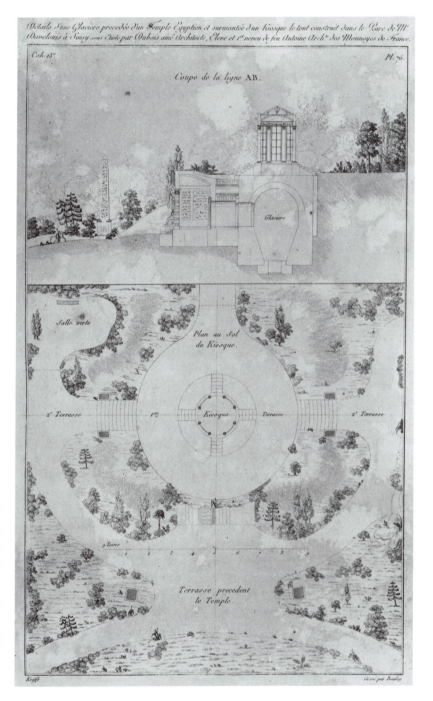

Plate 95 *P.-F.-L. Dubois' design for an ice-house at Soisy-sur-Étoile, with Egyptian obelisks and portico, from KRAFFT's* Recueil d'architecture *(1812), 76 (GN/SM).*

199

The Invasion

On 19 May 1798, shortly after dawn, a huge French fleet sailed from Toulon with an army of 34,000 men as well as guns, ammunition, and animals: the flagship was the 120–gun *L'Orient*, and on board was Napoléon Bonaparte. The invasion of Egypt was planned in the greatest secrecy, and the supposed aim was to liberate Egypt from Ottoman rule and thereby menace British India and threaten British notions of the balance of power. Furthermore, it was proposed that French engineers would cut a huge canal through the isthmus of Suez, and thus spread French influence to Asia and Africa. Almost immediately Napoléon was compared with Alexander and Octavian.[76] Those in the know about where the French expedition was heading had read Claude-Étienne Savary's (1750–88) *Letters Written from Egypt*, and Napoléon himself had a copy of Constantin-François Chasseboeuf, Comte de Volney's (1757–1820) *Voyage en Égypte et en Syrie* (1787), in which the monuments of Upper Egypt, largely buried in the sands, were mentioned as ready for discovery.

By any standards the concept of the campaign was extraordinary, grandiose, and breathtaking in its audacity and scope: furthermore, a learned Commission on the Sciences and Arts consisting of 167 eminent intellectuals under the leadership of Baron Dominique Vivant Denon (1747–1825) was to accompany the army. Under Denon's command were sixteen cartographers and surveyors who were to record the land and the fabric, and who were to herald the birth of modern Egyptology.

Having taken Malta, the fleet sailed on, and troops were landed near Alexandria on 1 July: Alexandria fell on 3 July, and Kléber was appointed Military Governor. The army marched towards Cairo, and on 21 July was fought the Battle of the Pyramids, after which the French army entered Cairo on 24 July. Meanwhile, the French ships had anchored at Aboukir Bay, where they were caught by a British fleet under the command of Horatio Nelson: on 2 August 1798 it was all over, *L'Orient* had blown up (and with it the Treasure of the Knights of Malta), and the French army was cut off in Egypt. Lady Hamilton (*c*.1765–1815) said that if she were King of England she would make the Admiral 'Duke Nelson, Marquis Nile, Earl Alexandria, Viscount Pyramid, Baron Crocodile, and Prince Victory'.[77]

Meanwhile, the *savants* had set up their printing-presses, an administrative system, and the work of surveying and recording had begun.

76 HEROLD (1962), Chapter I. The immense efforts to record Egyptian antiquities, facts about Egypt, Ancient Egyptian architecture and artefacts, etc., however, had very little to do with military strategy. The sub-plot was to find the secrets of the Ancients (especially those concerning power) and to elevate Napoléon as a modern Alexander, a modern Augustus.

77 WARNER (1960), 145. *See also* CLAYTON (1982), 14–26, and CONNER (*Ed.*) (1983), 28–31.

Laboratories, a museum, and a library were formed, and the *Institut d'Égypte* was founded. Denon's enthusiasm was unbounded, and in a remarkably short time a vast amount of material had been gathered, accurate surveys had been made, and the foundations laid for the two great monuments of the campaign: Denon's *Voyage*, and the gigantic *Description*. On 22 August 1799 Denon, some of the *savants*, and Napoléon managed to run the British blockade and escaped in French frigates along the North African coast. Kléber was then Commander-in-Chief, but was assassinated on 14 June 1800. In the Spring of 1801 a British expedition under Admiral George Keith Elphinstone, Viscount Keith (1746–1823), arrived at Alexandria, and an army under Lieutenant-General Sir Ralph Abercromby (1734–1801) landed on 8 March, defeating the French on 21 March. Under the terms of the Treaty of Alexandria and its subsequent implementation the French *savants* kept all the notes, drawings, and surveys, but all antiquities passed to the British. Among the last was a piece of carved basalt found by an officer of engineers, P.-F.-X. Bouchard, at Fort Julien on the Rosetta mouth of the River Nile in 1799, but before the Stone was shipped to England the French scholars were permitted to copy the ancient inscriptions in hieroglyphs, in a cursive script that looked something like Arabic, and in Greek, that were cut on the *stele*. From the Greek, the Stone was dated (196 BC) from the reign of Ptolemy V Epiphanes (205–180 BC), and it seemed possible that the Greek text was a translation or version of the other two texts, so the Stone might provide the key to the understanding of hieroglyphs. In due course the Rosetta Stone was accompanied by Colonel (later General Sir) Tomkyns Hilgrove Turner (*c.*1766–1843) on the frigate *Égyptienne*, and on 11 March 1802 placed in the Library of the Society of Antiquaries of London: later that year it was deposited in the British Museum with other Egyptian antiquities taken from the French.

Several scholars quickly established that certain hieroglyphs were rather like letters of an alphabet, and Dr Thomas Young (1773–1829) seems to have been the first to realise that hieroglyphs included both phonetic and pictorial signs.[78] Young sent his conclusions to the French scholar Jean-François Champollion (1790–1829) in 1814, and published his findings in a Supplement to the *Encyclopædia Britannica* in 1819. When Giovanni Belzoni (1778–1823) discovered an obelisk with base-block (both of which had inscriptions in hieroglyphs and Greek in 1815), and brought it to England for the antiquary William John Bankes (1786–1855) (it was the first Ancient Egyptian obelisk of any size to reach Britain), Champollion (who knew Coptic) realised Young was right, and began to enlarge Young's

78 YOUNG (1823).

list of correctly identified hieroglyphs. Also working on the copies of the texts on the Stone at the same time were Baron Antoine-Isaac Silvestre de Sacy (1758–1838) and Johan David Åkerblad (1763–1819). On 14 September 1822 Champollion concluded that hieroglyphs were partly ideographic and partly phonetic, and in 1828, in company with Nestor L'Hôte (1804–42)[79] and an Italian team led by Ippolito Rosellini (1800–43),[80] Champollion visited Egypt collecting and copying texts. He also found he was able to read the hieroglyphs having devised an Alphabet of Hieroglyphs. A centuries-old mystery had been solved.[81]

79 L'HÔTE (1836, 1840).
80 ROSELLINI (1832–44 and 1925).
81 CHAMPOLLION (1822, 1824a, 1824b, 1824–6, 1833, 1835–45, 1841, 1909).

CHAPTER VI

The Egyptian Revival after the Napoleonic Campaigns in Egypt

Introduction; Denon; Thomas Hope and the Neo-Classical Use of Egyptianisms; The Description *and the Glorification of Napoléon; Freemasonry; Furniture Design, and Other Egyptianising Manifestations*

Soldats! du haut de ces Pyramides
quarante siècles vous contemplent
(Soldiers! from the top of these Pyramids
forty centuries look upon you).

NAPOLÉON BONAPARTE (1769–1821):
Proclamation to His Army before the Battle of the Pyramids, 21 July 1798.

But the iniquity of oblivion blindely scattereth her poppy, and deals with the memory of men without distinction to merit of perpetuity. Who can but pity the founder of the Pyramids? *Herostratus* lives that burnt the Temple of *Diana*, he is almost lost that built it; Time hath spared the Epitaph of *Adrians* horse, confounded that of himself.

SIR THOMAS BROWNE (1605–82):
Hydriotaphia (1658), Ch. V.

Introduction

Egypt was impressed on the popular imagination by various means following the Napoleonic Campaigns. First there were various medals struck in both France and England to celebrate aspects of success on both sides,[1] and there were great numbers of satirical prints produced in which crocodiles, pyramids, mummies, sphinxes, and other motifs appeared in various combinations and permutations. There was an Egyptian operatic festival in 1800 at Drury Lane, London, with Egyptianising sets and costumes, and other spectacular Egypt-inspired entertainments were mounted. William Capon (1757–1827) proposed a design for a gigantic pyramid to be erected on Shooter's Hill as a National Monument, and George Smith (1783–1869) produced a design for a mausoleum in the Egyptian style to be erected in Alexandria in memory of Ralph Abercromby.

Denon

On his return to France, Denon was appointed Director-General of Museums, and he founded the *Musée Napoléon*, now the Louvre. In 1802 he published his *Voyage dans la Basse et la Haute Égypte pendant les campagnes du général Bonaparte* which came out in Paris and in London.[2] The book was translated into English, and later into German. The French edition consisted of two elephant folio volumes (one of text and one of plates), and the English edition of two quarto volumes (with integrated plates). The book was an instantaneous success, and few publications have enjoyed such an extensive circulation so quickly. Not only did Denon write a readable and extremely interesting account of the expedition, but provided a series of reasonably accurate views of the great buildings of Egypt which brought Egyptian architecture to a much greater readership than Norden, Pococke, or Perry had ever reached. Some forty editions of *Voyage* were published (including an abridged version in New York), and the plates were magnificent examples of French engraving at its best. Here, at last, was a reliable source-book for Ancient Egyptian architecture (**Plate 96**). Several editions of Denon's book in English were available by the end of the first decade of the nineteenth century, most of them American.[3] The *Voyage*, published some years before the colossal *Description de l'Égypte* began to appear, can be said to be the first attempt to provide comprehensive and accurate

1 *See* CLAYTON (1982) for illustrations of these.
2 DENON (1802). *See* Select Bibliography.
3 CARROTT (1978). A very useful account.

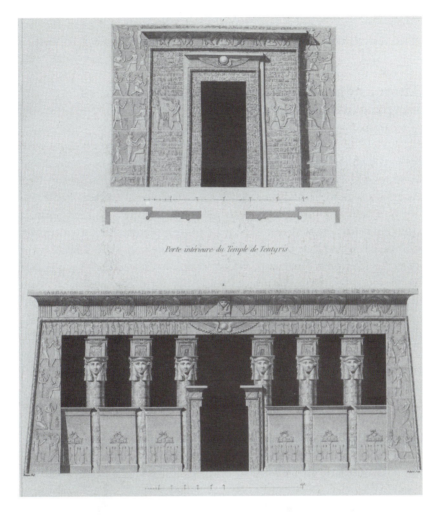

Porte intérieure du Temple de Tentyris.

Plate 96 *Portico of the ancient temple at Dendera from DENON's* Voyage *(Planche 39). The superb engravings offered accurate exemplars of real Egyptian buildings, and the work became an important source-book for the Egyptian Revival. Note the Hathor-headed capitals and* abaci *treated as* naos-*shrines (GB/SM).*

descriptions of Ancient Egyptian architecture, and it had an extraordinary impact. With its publication the nineteenth-century Egyptian Revival began in earnest. It is clear that Napoléon's Egyptian Campaign, and the exact archæological surveys of buildings carried out as part of that Campaign, began the serious, scholarly side of the Revival, as well as focusing attention on Egypt in a scientific, rather than a speculative, manner. With the later unravelling of hieroglyphs began more than a Revival: Egyptomania had arrived. Denon's *Voyage* and the painstaking work of the

Commission des Sciences et Arts d'Égypte became for the Egyptian Revival what Stuart and Revett's *Antiquities of Athens* was to the Greek Revival.

Thomas Hope and the Neo-Classical Use of Egyptianisms

Meanwhile, under the Consulate, the architects Percier and Fontaine were busy redesigning the furnishings of the old royal palaces of France,[4] and incorporated Egyptianisms in their designs. They began to issue their *Recueil de Décorations Intérieures*[5] in 1801, an influential work which came out in a later edition of 1812 with twice the number of illustrations: it contains plates showing several Egyptianising pieces. An Egyptianising *secrétaire* has seated Isiac figures, hieroglyphs on the lion-headed herms, and other Egyptianising ornaments, whilst a clock has seated male figures (not unlike those in *Diverse Maniere*), a pylon-like form crowned by a coved cornice (with winged globe), winged sphinxes, an Isiac crescent-moon, and lots of Piranesian stars (**Plates 97** and **98**). Percier and Fontaine also illustrated a Canopic *Bonne Déesse* with four breasts on Plate 14 of *Recueil*: they were prominent in the creation of the *Empire* style, in which Graeco-Roman themes merged with Egyptian elements in a magnificently rich brew. Their *Recueil* was to be a profound influence on Thomas Hope (1769–1831)[6] who began remodelling the interiors of his house in Duchess Street, London, in 1799, and completed them in 1804. It must be emphasised, nevertheless, that the overall style adopted by Hope at Duchess Street differs considerably from that favoured by French designers, and the late John Edwards Gloag (1896–1981) also noted that Hope's work and English Regency styles can be seen as independent developments when compared with French work, although there are clear cross-currents and common influences.[7] There is, however, a connection with Percier that should be mentioned in addition: Percier knew Flaxman in Rome during the 1790s, and Flaxman was also friendly with Hope. Letters in the Fitzwilliam Museum in Cambridge demonstrate that Flaxman's friendship with one of Napoléon's chief architects was long-lasting.[8]

Hope took Piranesi's ideas and merged them with archæologically-based designs for furniture. In his *Household Furniture and Interior Decoration*[9]

4 WATKIN (1968), 209.
5 *See* Select Bibliography.
6 WATKIN (1968), 209–10.
7 Personal discussions between Mr Gloag and the present writer. *See also* WATKIN (1968), 292.
8 WATKIN (1968), 210 and 292.
9 London, 1807.

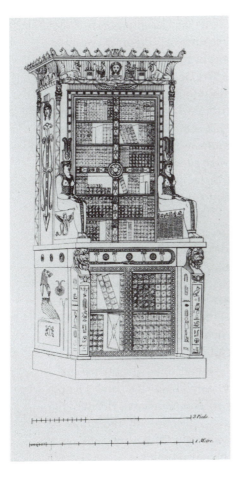

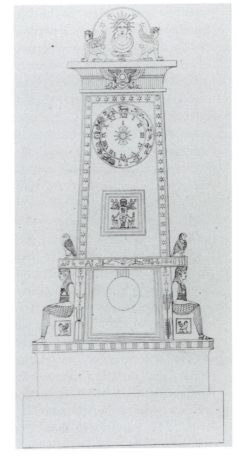

Plate 97 *Plate 28 from C. PERCIER and P.-F.-L. FONTAINE's* Recueil de Décorations Intérieures *(1801), showing an Egyptianising* secrétaire *and bookcase of c.1800 (GN/SM).*

Plate 98 *Plate 8 from PERCIER and FONTAINE's* Recueil de Décorations Intérieures, *showing an Egyptianising clock designed by them. Seated figures on each side come straight from Piranesi's designs for fireplaces in* Diverse Maniere. *Note the pylon-like form, winged globe with* uræi, *and Isiac crescent-moon at the top (GN/SM).*

Hope states that his sources for Egyptianising objects were from his own collection, and from those in the Vatican, in the Capitoline Museum, and in the Egyptian Institute at Bologna. For his writings on the Egyptian Taste Hope used Norden, Piranesi, and Denon, yet he had himself visited Egypt and had made extensive drawings while there in the 1790s. Hope's 'Egyptian Room' in Duchess Street, the most spectacular example of the Egyptian style of the time, would probably have been much the same if

207

Napoléon and Denon had never crossed the Mediterranean,[10] but nevertheless his illustration is of considerable interest[11] (**Plate 99**): materials used in the ornaments were granite, porphyry, basalt, and serpentine; between the double doors was a table carrying two Canopic vases on battered bases; and two Antinoüs statuettes stood on a table opposite the black-marble chimney-piece. Hope was critical of imitations using inferior materials,[12] and sought to suggest permanence. On the chimney-piece were *couchant* lions on battered bases flanking an Egyptianising statuette. Furniture was of some splendour: chairs were adorned with a Hathor-cow on a panel at the back, and two seated Piranesian Egyptianising figures supported the arm-rests (**Plate 100**), whilst Canopic figures surmounted the back-rails. The couch had panels with representations of Anubis and Horus, and the feet had panels with scarabs: a scorpion-motif appeared on the sides beneath the lions that graced the terminal-blocks (**Plate 101**). Black and gilt are dominant finishes. Indeed, the black rail decorated with gilt rosettes and the brackets beneath tend to suggest Greek forms, and recall Piranesi's eclecticism in *Diverse Maniere*. Chairs, couch, Isis-clock (**Plate 108**), torchères, and other items can be seen today at Buscot Park, near Faringdon, in the grounds of which are other Egyptianisms, including two Coade-Stone Antinoüs figures (**Colour Plate X**)[13] and several sphinxes. The room at Duchess Street also contained a mummy and a cinerary urn: owning a mummy was certainly fashionable, and Thomas Rowlandson (1756–1827), in his drawing of 'The Antiquary', ridiculed the curiosity aroused by the mummy in the collection of the Duke of Richmond – the drawing shows a hideously ugly 'Antiquary' quizzing a smiling mummy at the feet of which is a bemused sphinx.

The *Lararium* of Hope's house had a segmental ceiling, whilst the chimney-piece was derived from temple-pylons, had a coved cornice, and had a stepped upper section for the display of statuettes taken from the stepped forms employed in *Diverse Maniere*. This chimney-piece was set against a mirror (**Plate 102**), and the rich colouring must have made it extremely effective, even startling. Hope also illustrated several items of an Egyptianising nature in his book (**Plates 103–107**).

Hope described the Egyptianising clock in his otherwise Classical 'Flaxman Room' (**Plate 103**) as 'carried by a patinated bronze figure of Isis, or the moon, adorned with her crescent', but surviving versions of the clock (at the Royal Pavilion, Brighton, at Buscot Park, Faringdon, and in private collections) do not have any sign of the cow's horns and moon-disc

10 CONNER (*Ed.*) (1983), 38.
11 WESTMACOTT (1824), 214.
12 WATKIN (1968), 115–16.
13 The larger Antinoüs figure in Plate 99 may be one of the Coade Stone figures now at Buscot Park: if not, it is probably from the same batch manufactured at the time in the Lambeth works.

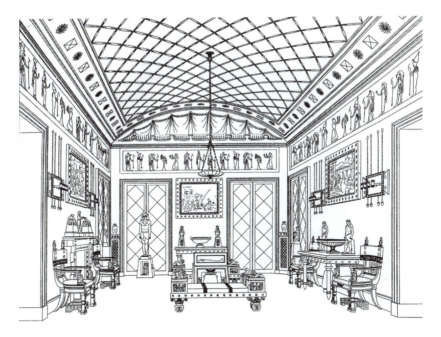

Plate 99 *Thomas Hope's 'Egyptian Room', or 'Little Canopus', of 1799–1804, in his house in Duchess Street, London, from HOPE (1807), plate VIII. Note that the Neo-Classical chairs (part Greek, part Egyptian) have seated Piranesian Egyptianising figures supporting the arm-rests, and that there are Canopic figures (copied from an example in the Vatican) surmounting the back-rails. These arm-chairs mix elements of the* klismos *(in the shapes of the backs and legs) with Græco-Roman Throne-Chairs illustrated by CAYLUS (1752–67 – iv, 286, plate LXXXIII), DURAND (Recueil [1802–05]), and REALE ACCADEMIA ERCOLANESE DI ARCHEOLOGIA:* Le Antichità di Ercolano esposte *(Naples: 1757–92). The crouching Egyptianising figures Hope claimed to have copied from an 'Egyptian idol in the Vatican' (probably a combination of the* naöphorus *and baboon statues). Other Egyptianisms on the chairs were the winged globes on the front rail (copied from a mummy-case in Bologna) and various ornaments copied from Thebes and Dendera. The segmental form of the ceiling should be noted (copied from mummy-cases, with a hint, in the detail, of Antique drapery, which also occurs in schemes of Roman decoration), as should the statue of Antinoüs (probably of Coade Stone [see* **Colour Plate X**]*) on the left. Between the doors, against the back wall, are two Canopic vases on battered bases, and in front of them is a mummy in a glass case. In the foreground (centre), is a couch with Egyptianising lions based on Antique exemplars on the pedestals, and with figures of Anubis, Horus, and scorpions. On the right, against the wall, are two more Antinoüs figures, and above them are wall-lights of carved, ebonised, gilded woods, in the form of a door-bolt. All the decorations were painted, and the frieze was derived from papyrus scrolls. Prevailing colours of walls, ceiling, and furniture were pale yellow and blue-green, with masses of black and gold. Paintings on the walls were set in plain frames embellished with Piranesian stars, which were associated with Egyptianising tendencies (JSC).*

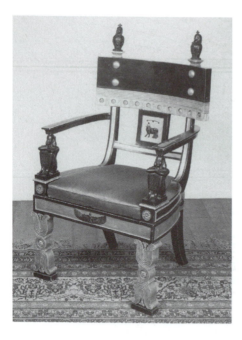

Plate 100 *Armchair shown in* **Plate 99**. *Note the seated figures, the Canopic figures with lotus head-dresses, and out-stretched wings* (The National Trust, Buscot Park, A. C. Cooper).

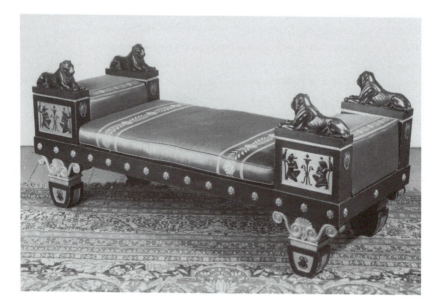

Plate 101 *Egyptianising couch shown in* **Plate 99**. *Note the reclining lions based on Antique models, Egyptianising deities, and scarab-beetles* (The National Trust, Buscot Park, A. C. Cooper).

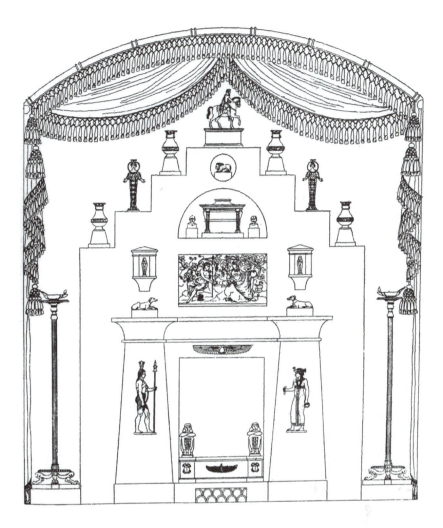

Plate 102 *'The closet or boudoir fitted up for the reception of a few Egyptian, Hindoo, and Chinese idols and curiosities. The sides of this Lararium are formed of pillars, and the top of laths, of bamboo. Over these hangs a cotton drapery, in the form of a tent. One end of the tabernacle is open, and displays a mantle-piece in the shape of an Egyptian portico, which, by being placed against a background of looking-glass, appears entirely insulated. On the steps of this portico are placed idols, and in its surface are inserted bas-reliefs'. The fireplace is flanked by two thin pylons, whilst the seated figures on the fire-guard are derived from Piranesian themes. Note the loculus in the centre. The said steps (themselves clearly derived from Piranesi) support statues of Artemis of Ephesus, and, at the top, is the equestrian statue of Marcus Aurelius. Colours were strong, featuring yellow drapes, and red and black for the Egyptian fireplace, with gilded figures. Note again the segmental ceiling form (1799–1804). Plate X from HOPE (1807) (JSC).*

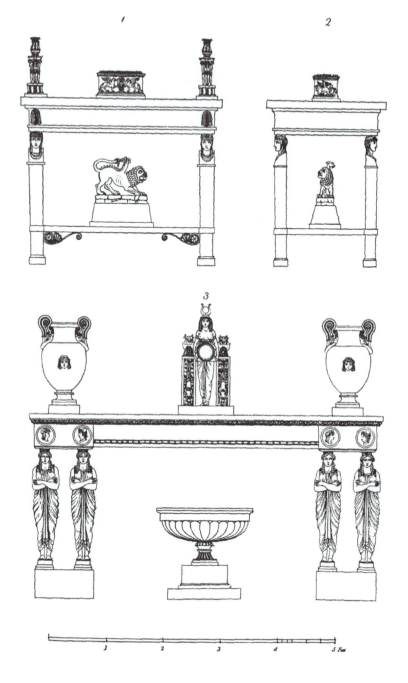

Plate 103 *Tables from Hope's* Lararium *(1 and 2), with (3) a 'table dedicated to Aurora' on which is the 'Isis clock', supposedly designed by Hope, which incorporates a statue of Isis adorned with cows' horns and lunar disc. Plate XIII from* HOPE *(1807) (JSC).*

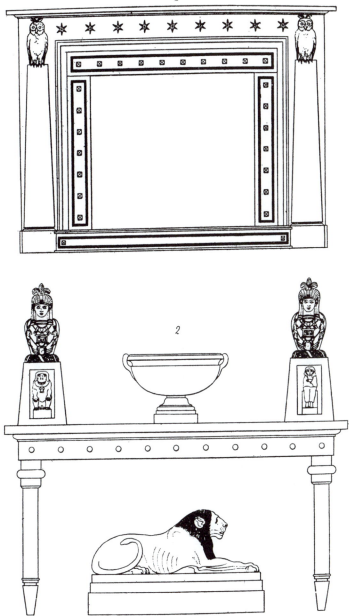

Plate 104 *Black marble chimney-piece from the Aurora room (1), with (2) a table in the Egyptian room, with lion and cup of basalt. On either side of the cup are Egyptian naos shrines, with 'idols', supporting 'Canopuses'. Both the lion and 'Canopuses' are based on Antique originals. Plate XVI from HOPE (1807) (JSC).*

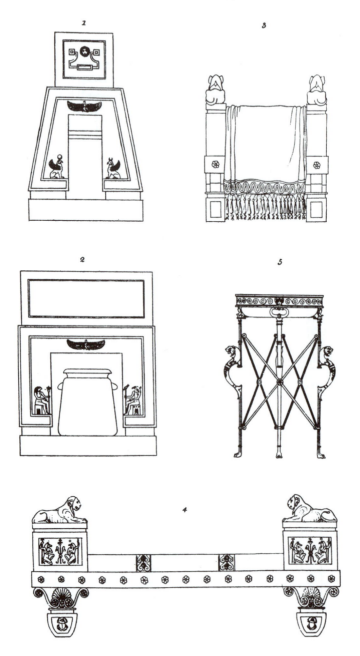

Plate 105 *Front and end of a glazed case containing a mummy (1 and 2). The case stands on a battered base under which is an alabaster urn. Illustrations 3 and 4 show the front and end of the couch in the Egyptian style shown in* **Plates 99** *and* **101**. *5 shows a bronze tripod. Plate XVII from* HOPE *(1807)* (JSC).

214

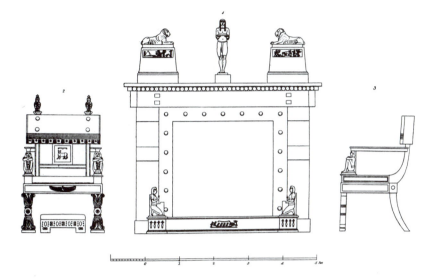

Plate 106 *'Mantle-piece of black marble, copied from the façade of a sepulchral chamber' shown in plate XLVI from HOPE (1807). Hope claimed that the ornaments on the shelf and fender were copied from Egyptian items in the Capitol in Rome, the Vatican, and DENON (1802). The chair (see* **Plates 99** *and* **100***) has arm-supports in the form of 'crouching priests', and the 'winged Isis' placed on the rail at the front of the chair was supposed to be 'borrowed from an Egyptian mummy-case in Bologna'. 'The Canopuses on the back rail' were copied from the one in the Capitol, and 'other ornaments' were 'taken from Thebes, Tentyris, &c.' (JSC).*

head-dress illustrated by Hope. The base and frames for the panels are of *rosso antico* marble, and the clock-face, inset panels of bogus hieroglyphs, and bulls' heads are of gilt-bronze (**Plate 108**). Now this clock has been attributed to designs by Hope, but there are problems here, because Hope deplored the 'Rococo' use of pseudo-hieroglyphs, and favoured a more scholarly use of coherent iconographic programmes: the bulls'-heads and battered elements on which they rest are straight from Piranesi's *Diverse Maniere*, and the fake hieroglyphs make the attribution to Hope questionable. Hope's *Household Furniture* has fine illustrations showing a wide range of Egyptianising motifs, and his main sources have been noted above. He was familiar with the Egyptianising material from the *Villa Adriana*, and he knew Denon's work, taking certain themes from Denon's account of Thebes and Dendera (which Denon called Tentyris).[14] As has been indicated, Playfair's Egyptian Room at Cairness House (**Plate 85**) looked forward to Hope's Duchess Street rooms, but Percier and Fontaine undoubtedly had some influence on Hope, whose interiors in the Egyptian

14 HOPE (1807).

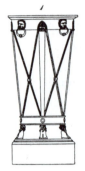

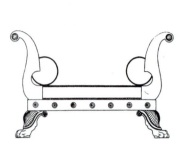

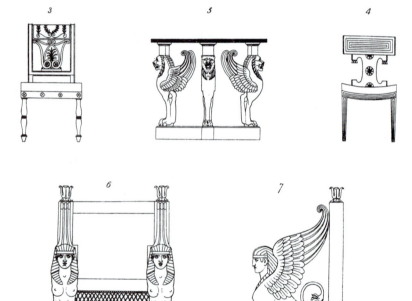

Plate 107 *Various items of Græco-Egyptian-inspired furniture from* HOPE *(1807), plate XIX. The bottom pictures (6 and 7) show the elevations of a Coade Stone seat or throne adorned with sphinxes and lotus-flowers* (JSC).

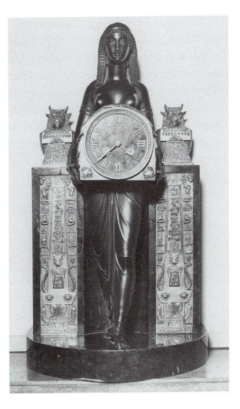

Plate 108 *Egyptianising 'Isis' clock of c.1805, supposedly designed by Thomas Hope for his house in Duchess Street. The original scheme was for the goddess to have cows' horns and a moon-disc on her head, but there is no sign of such horns or their fixing on this specimen: the horns and disc are clearly shown on 'the table dedicated to Aurora', plate XIII of* HOPE *(1807)* (**Plate 103**). *The hieroglyphs are bogus, the bulls' heads are ill-defined versions of one of* PIRANESI's *fireplace designs in* Diverse Maniere *(see* **Plate 71***), and the colours are dark red, gold, and bronze. Several versions of this clock were made, some in France and others in England* (RPAGMB).

Taste were far more refined than Piranesi's efforts at the *Caffè degl'Inglesi* in Rome. Hope's displays of vases, urns, and statuary in a series of tomb-like interiors emphasise his narrative approach to the settings of art and artefacts.

Sir John Soane was to achieve certain resemblances to Duchess Street in his house at Lincoln's Inn Fields: his use of mirrors, segmental sections for ceilings, and other devices recall Hope's designs, although there are few overt Egyptianisms in Soane's own work. Soane was to acquire one of the great prizes of real Ancient Egyptian art, however – the sarcophagus of Seti I, which Belzoni discovered in 1817. Henry Salt (1780–1827) had visited Egypt in 1806 with Arthur, 10th Viscount Valentia (1785–1863), and published his *Twenty-Four Views* of Egypt in 1809: he later became British Consul-General in 1815, and between 1816 and 1827 financed several expeditions, including those of Belzoni, and formed collections of antiquities, many of which were sold to the British Museum. However, the Trustees refused to buy Seti's sarcophagus, and Soane bought the sarcophagus for his collection of antiquities in Lincoln's Inn Fields. As the material of which the sarcophagus is made is translucent (it is a form of alabaster), Soane sometimes placed lamps within the sarcophagus to give extraordinary and Sublime lighting effects when entertaining guests.

Thomas Hope's Egyptianisms were robust yet refined, scholarly yet imaginative, bold yet delicate: they represent a high point in Neo-Classical design, and were beautifully realised. Hope emphasised the need for good craftsmanship to encourage the manufacture of objects that would last, and indeed was particularly keen to promote the use of long-lasting materials, for Egyptian architecture was associated with permanence. Certainly the flavour of Hope's creations differed from that of the designs of his French contemporaries, among whom Lequeu[15] was probably the oddest (**Plate 109**). Wyatt Angelicus Van Sandau Papworth (1822–94), founder of the Architectural Publication Society, and the Editor of its *Dictionary of Architecture*, states that the extraordinary influence of Percier and Fontaine in France 'was paralleled' in England by that of Charles Heathcote Tatham to whom, 'perhaps more than to any other person, may be attributed the use of the "Anglo-Greek style"'.[16]

The Egyptian Revival in England sprang from an archæological interest and from the popularity of Egyptian motifs after Nelson's spectacular victory at Aboukir Bay. Yet, as has been indicated above, the vogue for things Egyptian went back much further, and many Egyptian features were familiar in the vocabulary of Classical Taste. The opening of the Gallery (which included Egyptian antiquities) in the Capitoline Museum in Rome in 1748 stimulated further interest, and Tatham's drawings which he sent to Henry Holland from Rome quite clearly influenced design in England. At Southill House, Bedfordshire, which Holland remodelled in 1799–1800, Egyptianising elements, including lotus-pedestals and a chimney-piece, were incorporated.[17] The English edition of Denon's *Voyage* stimulated further interest, Sheraton's publications attempted to include some of the new trends, and Chippendale the Younger (1749–1822) made two writing-tables for Stourhead in 1804 that featured Egyptianising heads.[18] A more scholarly use of Egyptianising features in English furniture was encouraged by Thomas Hope: with his designs, 'Canopic' vases, winged globes, Egyptianising figures, monopodia, leopards' heads and paws, lotus-plants, *couchant* lions, Egyptian deities, hieroglyphs, rosettes, palms, and, of course, Antinoüs and Isis, became established and clarified. Hope's Egyptianising furniture indicates the tendency towards simplicity of form, robustness of construction, and the 'emphasis on unbroken surfaces marked by straight lines, which distinguishes the best Regency furniture'.[19] Indeed the importance of the Egyptian Taste in furniture design cannot be exaggerated. Rudolf Ackermann (1764–1834) published his *Repository* in monthly

15 *See* DUBOY (1986).
16 PAPWORTH (*Ed.*) (1853–92), iii, E–G.
17 RICHARDSON *ET AL.* (1951) and STROUD (1966).
18 JOY (1977), 88. *See also* HUSSEY (1955–6), **ii**, 238.
19 JOY (1977), 90.

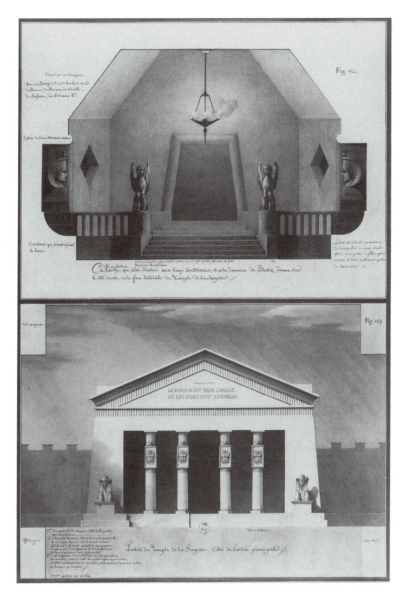

Plate 109 (Top) *Porch or vestibule which leads to the underground chambers and Pluto's dwelling, facing the right-hand side wall of the Temple of Wisdom, and* (bottom) *main entrance of the Temple of Wisdom. Both these drawings by Jean-Jacques Lequeu of c.1800 show pronounced Egyptianesque leanings. The canted section of the vestibule, which was a favourite 'Egyptian' motif adopted by designers of the time, follows Piranesi rather than true Egyptian prototypes. The Temple tympanum celebrates the statement that happiness, welfare, or prosperity lie in the angle, quoin, or corner where the wise are assembled: it is therefore unquestionably Freemasonic* (BN, HA, from LEQUEU's *Architecture Civile*, plate 67, figs. 164 and 165).

instalments from 1809, most numbers of which include plates showing furniture and interior decorations, some of which are in the French Empire style, based on Percier and Fontaine's *Recueil* – one plate shows a *secrétaire*-bookcase, described as being 'after the style so exquisitely perfected by M. Persée (*sic*), the French Architect to Bonaparte'.[20] Tatham's publications inspired many pieces of furniture as well as the details, including monopo-dia, lions' masks, leopards' heads, and terminal figures, that became features of the Neo-Classical style, and which included many items based on Egyptian and Egyptianising antiquities. Nevertheless, Greek and Egyptian motifs were merging, and what was Greek and what was Egyptian could still cause confusion. Denon had praised the 'order' and 'simplicity' in Egyptian architecture, and, like Herder and Kant, understood its Sublime possibilities: Soane and his contemporaries noted how Egyptian elements could be used to induce Sublime effects. Yet Charles Kelsall (1782–1857) could mention a 'specimen from Egyptian Tombs' in his design for the College of Mathematics: the 'Egyptian' elements were capital-less Greek Doric columns and heavily battered openings, demonstrating that the search by Neo-Classicists for a 'primitive' style led them to Egyptian and sturdy Greek Doric architecture, frequently confusing and merging them.[21]

However, in the first decade of the nineteenth century the dominant influence in 'Egyptian' design was still Piranesi. George Dance Jr. (1741–1825) designed some Egyptianising features at Lansdowne House in London (1788–91) and Stratton Park, Hampshire (1803–06),[22] and his brother Nathaniel appears to have designed Egyptianising terms for Lansdowne House in 1794.[23] Egyptianising chimney-pieces occur in numbers in England, but most of these designs are really attempts to give variety: the conscious iconography of Hope is absent. The military and naval campaigns in Egypt, however, created a popular fashion for Egyptianising decoration. Robert Southey (1774–1843) commented that, as the soldiers came home with their broken limbs and ophthalmia, everything had to be Egyptian, for 'the ladies wear crocodile ornaments, and you sit upon a sphinx in a room hung round with mummies, and the long black lean-armed long-nosed hieroglyphical men . . . are enough to make the children afraid to go to bed. The very shopboards must be metamorphosed into the mode, and painted in Egyptian letters, which, as the Egyptians had no letters, you will doubtless conceive must be curious'.[24] Soane was to denounce 'Egyptian mania' and the decoration of furniture

20 April 1822. *See also The Cabinet-Maker and Upholsterer's Drawing Book* of 1802.
21 WATKIN, DAVID (1966): 'Charles Kelsall: the Quintessence of Neo-Classicism', in *The Architectural Review*, **cxl**/834 (August), 109–12, and the same author's *Thomas Hope* (1968).
22 SUMMERSON (1952).
23 CARROTT (1978), 32.
24 SOUTHEY (1807): *Letters from England*, LXXI.

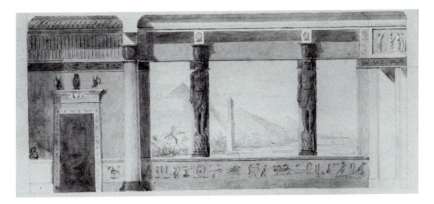

Plate 110 *Robert Smirke saw the Palazzo Borghese on his visit to Rome in 1802, and would not have missed the celebrated* Sala Egizia *there by Tommaso Conca (1734–1822) of c.1788. This, plus the Piranesi interiors of the* Caffè degl'Inglesi *in the* Piazza di Spagna *in Rome, must have influenced his first design for an interior in the Egyptian Style of c.1802. The two telamones are clearly based on those from the* Villa Adriana, *and now in the Vatican (***Plate 28***). The lighter colour was to be a pinkish-yellow, and the darker a rich blue-grey. However, some authorities have suggested it might have been a drawing of an existing artefact (RIBADC CC 12/72, No. 2).*

with Egyptianising motifs.[25] An Egyptian Hall was created under the north portico at Stowe in 1805, with a segmental-vaulted ceiling and decorations based on Denon's records of the temples of Dendera at Thebes: in the same year an Egyptianising bedroom was also created at Stowe.[26] Denon also seems to have provided the inspiration for the dining-room at Goodwood, which had chairs decorated with crocodiles.

Between 1801 and 1805 Robert Smirke (1780–1867) and his brother Richard visited Italy and Greece, and while in Italy produced a drawing in pencil and water-colour of a delightful room in the Egyptian Taste quoting the Antinoüs-*telamones* (**Plate 110**). Then in 1802 and 1803 came the important publications of Denon's *Voyage* which were to provide rich pickings for designers (**Plate 96**). An immediate and recognisable derivative from Denon is C. H. Tatham's Greenhouse for Trentham Hall, Staffordshire, which seems to date from 1804, though not realised until 1807–08 (**Plate 111**). Ledoux's *Forge à Canons*, complete with its pyramids, was published in his *L'architecture considerée*, also in 1804, but the design is probably of late-eighteenth-century date (**Plate 112**). Thomas Hopper (1776–1856) produced the Egyptian Hall at Craven Cottage, Fulham, in *c.*1805, again influenced by Denon: it was pictured in a pencil drawing by Frederick William Fairholt (1814–66) in an extra-illustrated copy of

25 SOANE (1929), 21.
26 CONNER (*Ed.*) (1983), 52–3.

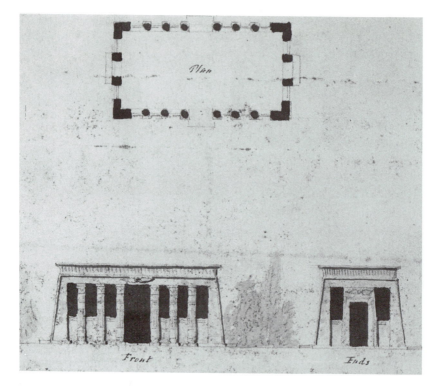

Plate 111 *'A Design for an Egyptian Temple proposed to be used as a Greenhouse' for Trentham Hall, Staffordshire, from a Collection of Manuscript Drawings by Charles Heathcote Tatham of 1804, probably based on Denon* (RIBADC).

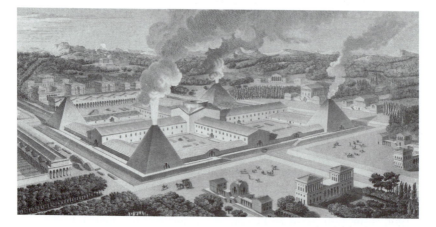

Plate 112 *The* Forge à Canons *(planche 125) from C.-N. LEDOUX's* L'architecture considerée, *showing the use of pyramidal forms as corner-pavilions (in this case used as furnaces)* (GN/SM).

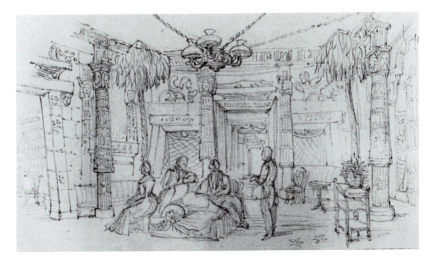

Plate 113 *The 'Egyptian Hall' of c.1805 by Thomas Hopper for Walsh Porter at Craven Cottage, Fulham, supposedly copied from plates in Denon's* Voyage, *with rich painted decorations in the Egyptian Taste, Hathor-headed columns covered with hieroglyphs, and with palm-trees in each corner. Doors were of iron, with plate-glass panes. This exotic chamber was composed of walls derived from the outside, rather than the inside, of an Egyptian building, so it was more like a courtyard than a room, with its columns, palm-trees, a camel, and the attempts to re-create the effect of roughly cut masonry. A lion-skin hearth-rug, a tiger-skin for the sofa, and twisted serpents which supported the tables completed the Oriental effect, while a mummy and a sphinx were added for good measure. Repton admired certain aspects of the room, but Porter's scheme attracted a certain amount of ridicule (GLCL).*

Thomas Crofton Croker's (1798–1854) *A Walk from London to Fulham* (1856) in Guildhall Library, City of London (**Plate 113**).[27] In 1806 James Randall (*c.*1778–1820) published a design for a country mansion in the Egyptian style in his *Architectural Designs:*[28] it was to have battered corner-piers, Hathor-headed, palm- and bud-capitals, and hieroglyphic decorations, all supposedly derived from Denon. In 1805, Joseph Michael Gandy (who, as has been recalled above, visited Italy with Tatham, and became a draughtsman in Soane's office in 1797), published *The Rural Architect* which included designs for 'Lodges after the model of the Egyptian entrances to their temples': one pair was set as inhabitable pyramids, and the other as pylon-towers, though in miniature, with obelisks (**Plates 114 and 115**). In his *Designs for Cottages*, which he dedicated to Thomas Hope, Gandy shows a design (plate XXXIX) that incorporates a circular pavilion with a long and short obelisk as gate-posts.

27 Mr Ralph Hyde kindly drew attention to this item.
28 RANDALL (1806), plate XXIV.

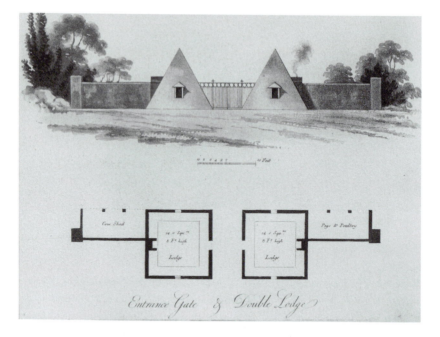

Plate 114 *A design for an 'Entrance Gate and Double Lodge' from* GANDY *(1805b), plate XXXIX, showing pyramidal gate-lodges* (RIBA).

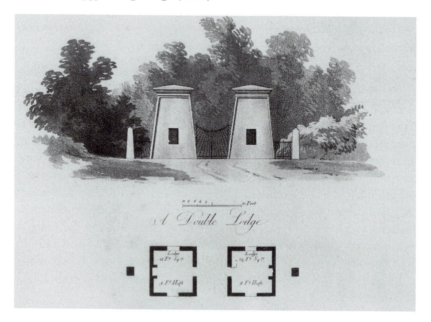

Plate 115 *A design for a 'Double Lodge' from* GANDY *(1805b), plate XLII, showing the pylon-shaped lodges and miniature obelisks as gate-posts* (RIBA).

Plate 116 *Metal door-knocker in the form of an Egyptianising male head with nemes head-dress, with suspended knocker. Such objects were made in countless numbers, in both brass and cast-iron. This example was photographed in Rathmullan, Co. Donegal, in 1978 (JSC).*

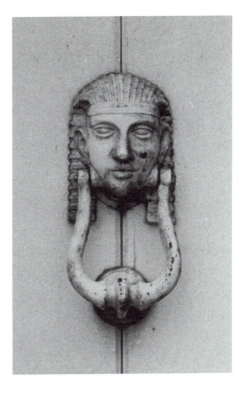

It is clear that Egyptianisms entered into design in a major way from the first years of the nineteenth century, and found their ways into furniture-design, countless artefacts, architecture, interior-design, stage-design, and much else. Even door-knockers became overtly Egyptian, and great ingenuity was displayed, bringing Nilotic allusions to everyday life (**Plate 116**). The influence of Egyptian and Egyptianising design on the West was enormous, and cannot be over-estimated.

The *Description* and the Glorification of Napoléon

J.-A. Renard (1744–1807) built a garden-room for the Prince de Bénévant at Valançay in 1805: it was in the form of a small Egyptian temple, square in plan, that did not derive from Denon at all. Then, in 1806–09, François-Jean Bralle (1750–*c.*1832), and Pierre-Nicolas Beauvallet (1750–1818) built the Fellah or Fountain of the Incurables against the outside wall of the Hospice des Incurables (now Hôpital Laënnec) in the rue de Sèvres. It consists of a sealed Egyptian gate forming a recess in which is a male Egyptian figure based on the Antinoüs from the *Villa Adriana* which Napoléon removed from the Capitoline

225

Museum in 1798, and which was exhibited in a prominent position in the Louvre for the opening of the museum on 8 Brumaire Year IX. It was returned to Rome by the Allies in 1815. The sealed gateway is derived from Denon and other sources, but the winged globe is replaced by the imperial eagle with outstretched wings (**Plate 117**). Bralle substituted pitchers for the two cylinders held in Antinoüs's tightly-clenched fists, but the *nemes* head-dress is wholly inappropriate for a *fellah*, or water-carrying servant. This fountain was one of several erected in Paris by order of Napoléon. By a decree of 2 May 1806, fifteen handsome new fountains were ordered, six of which were in an Egyptianising style (Fellah, Apport-Paris [Place du Châtelet], Paix et Arts, Palais des Beaux-Arts, Château d'Eau, and Boulevard Montmartre).[29]

Bralle was also responsible for the *Fontaine de la Victoire* in the Place du Châtelet, Paris: these fountains doubled as memorials to the Egyptian Campaign and as glorifications of Napoléon (**Plate 132**). Nicolas Bataille added a handsome Egyptianising porch to the Hôtel de Beauharnais, 78 rue de Lille, Paris, in *c*.1807, complete with palm-capitals on columns set *in antis*, gorge-cornice, winged globe with *uræi*, battered walls with torus-moulding, and incised figures of Mut.[30] The source is probably Denon's view of the Esna temple, but lightened by the wide spacing of the columns.

If Denon's work had been an important source since its first appearance in 1802 (and indeed we owe Denon much even today for his records of monuments that do not exist any more), the *Description de l'Égypte, ou, Recueil des observations et des recherches qui ont été faites en Égypte pendant l'expédition de l'armée français, publié par les ordres de Sa Majesté l'empereur Napoléon le Grand* outshone everything that had gone before as a major source of Ancient Egyptian architecture and artefacts. It came out between 1809 and 1828, in twenty-one volumes (nine of text and twelve of plates), and the second edition of 1820–30, published by C.-L.-F. Panckoucke, includes atlases, and ran to twenty-four volumes.[31] On the elaborate frontispiece (**Plate 118**) is an Egyptian portal decorated with trophies and the names of places which frames a montage of some of the finest buildings and artefacts. This colossal work was based on the scientifically exact measurements of remaining buildings of Egyptian Antiquity, and on the detailed notes made by the surveyors regarding condition, detail, and so on. Scholarly reconstructions, full records of surveys, and precise descriptions by artists, architects, scientists, and historians were commissioned by Napoléon. The books include details of

29 *See* HUMBERT (1998).
30 Illustrated in HUMBERT (1989*a*).
31 Scholars dispute the precise number of volumes, but this is because of the methods of binding and the various sizes of the folios. *See* Select Bibliography for explanatory notes.

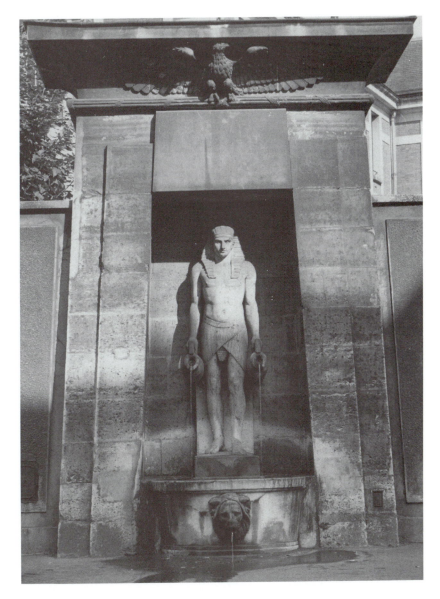

Plate 117 *Egyptianising fountain in the rue de Sèvres, Paris, designed by François-Jean Bralle (1750–c.1835), with decoration and sculpture by Pierre-Nicolas Beauvallet (1750–1818) of 1806–09, based on the figure of Antinoüs (***Plate 27***) from the Villa Adriana, which had been brought to Paris in 1798 and returned to the Vatican in 1815. Bralle transformed Hadrian's deified favourite into an Egyptian water-bearer (fellah) by converting the two cylinders the Roman original holds in clenched fists into the handles of the two vessels from which water flows. The present figure is a replacement of the original by Gechter of 1844. The Napoleonic eagle replaces the winged globe with uræi (James Austin).*

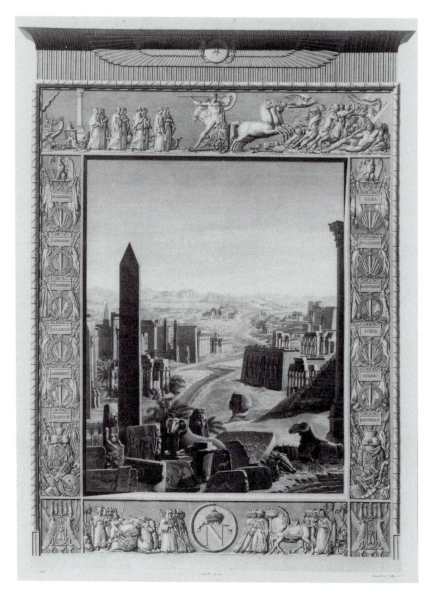

Plate 118 *Frontispiece of* Description *of 1809, A, Vol. I. This wonderful and monumental compilation was a great achievement, and provided a rich selection of real Egyptian exemplars and sources for designers (GN/SM).*

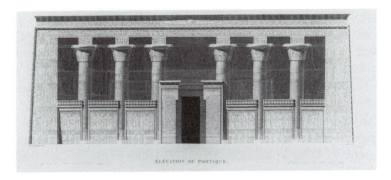

ÉLÉVATION DU PORTIQUE.

Plate 119 *Plate from* Description, *A, Vol. I, showing the elevation of the portico of the temple at Esna (Latopolis) with its papyrus capitals,* pluteus, *and gorge-cornice* (GB/SM).

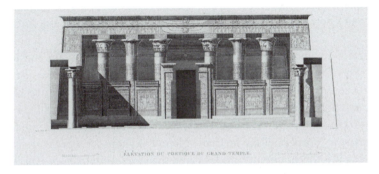

ÉLÉVATION DU PORTIQUE DU GRAND TEMPLE.

Plate 120 *Plate from* Description, *A, Vol. I, showing the elevation of the portico of the great temple at Edfu (otherwise known as Apollonopolis Magna). Note the three types of capital and the* pluteus (GB/SM).

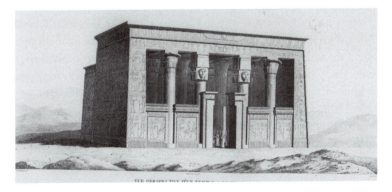

VUE PERSPECTIVE D'UN TEMPLE

Plate 121 *Plate from* Description, *A, Vol. I, showing a perspective view of the 'Contralato' temple in the environs of Esna. Note the papyrus and Hathor-headed capitals (the latter have naos–abaci), and the gorge-cornice* (GB/SM).

the topography, natural history, geography, and antiquities of Egypt. The precise measurements and the beautiful, accurate engravings were of the highest quality (**Plates 118–121**) and in the best traditions of scholarship: texts were edited by Edmé-François Jomard (1777–1862), an engineer who had been with Denon in Egypt, and who contributed six volumes of commentaries.[32] Other illustrations were based on drawings by Balzac, Cécile, Chabrol, and Dutertre, whilst Baron René-Edouard Devilliers du Terrage (1780–1855), *savant* and civil engineer, produced various scholarly reconstructions in collaboration with J. Jollois.[33] The book included perspective views (**Colour Plate XI**) as well as orthographic projections, and several illustrations were coloured (**Colour Plate XII**).

A very fine bronze medallion by J.-J. Barré was struck to celebrate the order given in 1826 by King Louis XVIII (1814–24) to complete the publication of the *Description*. Apart from the Romano-Gallic General, the Egyptian Queen being unveiled, and the crocodile, the medal also features the Gizeh Pyramids and the temple at Dendera. Hieroglyphs are not bogus, but give the names of the deities correctly (**Colour Plate XIIIa and b**).

The *Description* is the greatest achievement of the *Commission des Sciences et Arts d'Égypte*, but the glorification of Napoléon was one of its aims, and the Egyptianisation of French Taste proceeded apace. In 1811 the Isiac origins of Paris were officially 'proved', and there were sundry proposals to erect obelisks in Paris. Napoléon signed a decree in 1809 ordering the construction of an obelisk to the glory of the *Grande Armée* on the Pont Neuf.

Freemasonry

The importance of Freemasonry in the history of the Egyptian Revival is considerable: the idea of Egypt as the source of all knowledge of architecture and of all wisdom as enshrined in the Hermetic Mysteries was potent. The Craft was traced to Egypt, and the Israelites were supposed to have learned the skills of architecture from the Egyptians. Freemasonry in the latter half of the eighteenth century reflected many of the philosophical, moral, political, and artistic currents of the Enlightenment. Liberalism was implicit in Freemasonic ideals of the Brotherhood of Man, and Continental Freemasons seem to have held little brief for Clericalism in its more reactionary and obscurantist forms. A full discussion of the art and architecture of Freemasonry cannot be attempted here, but the present

32 *See* JOMARD (1812, 1819, 1822, 1825, 1828, 1829).
33 CLAYTON (1982), 27.

writer has published on the subject.[34] What does seem significant is that Continental European Lodges often had Egyptianising décor, and Lequeu alludes to this in many of his drawings (**Plate 109**).[35] There was a close connection between the story of the Captivity in Egypt, the use of the Cubit as a unit of measurement, and the Solomonic Temple. The main influences in the Egyptianisation of Continental Lodges seem to have been Count Alessandro Cagliostro (1743–95) and Karl Friedrich Köppen (author of *Crata Repoa* [1778]). Cagliostro became Grand Master of a Parisian Lodge to which a temple of Isis was attached, and his rituals were speedily adopted in some French and Central European Lodges. In any case it is clear from standard designs for Masonic Certificates on the Continent that the Egyptian elements were well to the fore. Pyramids, Egyptian columns, palm-trees, sphinxes, and Egyptian Isis- or Hathor-headed capitals are much in evidence. A surviving French Master-Mason's apron glorifies Napoléon and Freemasonry (**Plates 122–124**).[36]

From the description of the 'Egyptian' rites it seems that they were supposed to have been derived from Isiac ceremonies in Ancient Egypt and the Græco-Roman world. Justine Wynne, Countess Rosenberg-Orsini, described in *Alticchiero* (1787)[37] the villa of that name which had a Canopus as well as other exotic features: she had been the mistress of the prominent Freemasons Giovanni Giacomo Casanova de Seingalt (1725–98) and Andrea Memmo (1729–93). In 1731 the Abbé Jean Terrasson (1670–1750) published his *Séthos, histoire ou vie tirée des monumens anecdotes de l'ancienne Égypte. Traduite d'un manuscrit grec.* This very prolix book, by a translator of Diodorus Siculus, concerns Séthos, an Egyptian Prince, who is initiated into ancient mysteries, and who, after many travels and adventures, retires to a temple of initiates. The book was much read, and was often cited as if it were a standard work on Ancient Egyptian matters, for it contains a very long and detailed description of the Isiac Mysteries: throughout Terrasson's text the idea of Egypt as the fount of wisdom and of the Hermetic tradition is stressed. The playwright Tobias Philipp Freiherr von Gebler (1726–86), also a Freemason, who knew Lessing and Wieland, wrote the text of *Thamos, König in Ägypten*, given in 1773 with specially composed music (K. 345) by the young Wolfgang Amadeus Mozart (1756–91), who thus came into contact with mystical ideas of initiation, Hermetic notions, and Freemasonry. Mozart's impressive and solemn music was later re-cast and expanded for a new production (with Egyptianising sets) given by the troupe of Emanuel Schikaneder (1751–1812). Otto Jahn observed of the

34 CURL (2002*b*).
35 DUBOY (1986).
36 The Author is indebted to Mr Terence Haunch for introducing him to these items.
37 *See* Select Bibliography.

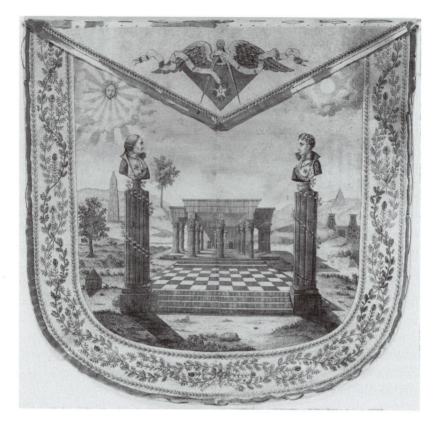

Plate 122 *French Master-Mason's apron of the Napoleonic period, printed from an engraved plate. The busts on the two pedestals are those of Napoléon (right) and Jean-Jacques Régis Cambacérès (1753–1824), Duc de Parme, Second Consul of France, Pro-Grand-Master of the Grand Orient. The pedestals are entwined with spirals of flowers, supporting the Solomonic Columns of the Temple in Jerusalem, and therefore Jachin and Boaz. On the right are pylons behind which is a pyramid, and in the centre is a curious building somewhat influenced by the 'Kiosk' at Philæ, but with un-Egyptian columns. To the left is an obelisk. The squared floor is also Freemasonic (UGLE).*

choral writing in *Thamos* that it is grander, more free, and more imposing than any of the Masses of the period, that a 'solemn act of worship' was represented on the stage, and that the 'expression of reverence to the Supreme Being was heightened in effect by the Egyptian surroundings'.[38]

Egyptianising theatrical sets, designed with varying attention to historical accuracy, became fashionable in the last third of the eighteenth century, a fact not unconnected with the influence of Freemasonry. With

38 CURL (2002*b*).

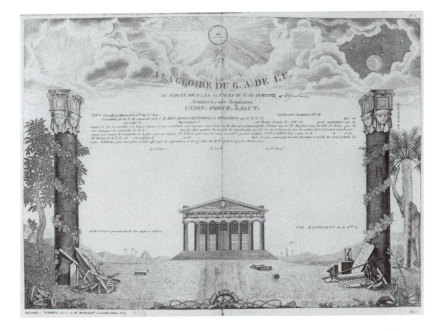

Plate 123 *Typical design for a Freemasonic certificate for Lodges under the Grand Orient of France, from a nineteenth-century printer's sample-book. In the centre is a Greek Doric temple with winged globe in the tympanum, and there are pyramids, obelisks, and palm-trees in the distance. On either side are two Hathor-headed columns with garlands around the shafts, recreating the 'Solomonic' twisted columns associated with the Temple in Jerusalem, and therefore with Jachin and Boaz* (UGLE).

Thamos Egyptianising stage-sets were designed for a production north of the Alps, probably influenced by the stage-designs of Tesi of the previous decade. Mozart's *Die Zauberflöte* of 1791 (K. 620) shows that the authors were very well acquainted with Terrasson's *Séthos*, and indeed large sections of the libretto of *Die Zauberflöte* are lifted from the Frenchman's work: the setting of the *Singspiel* is Egyptian, and there are references of solemn beauty to Isis and Osiris in it. We know that when Mozart visited Vienna he became acquainted with many intellectuals, including Franz Anton Mesmer (1734–1815), and later he was to meet Ignaz von Born, one of the leading scientists of his day (and an important Freemason), who wrote interestingly about Ancient Egyptian mysteries in *Physikalische Arbeiten*, later quoted in Bremer's *Symbolische Weisheit der Ägypter* (1793).

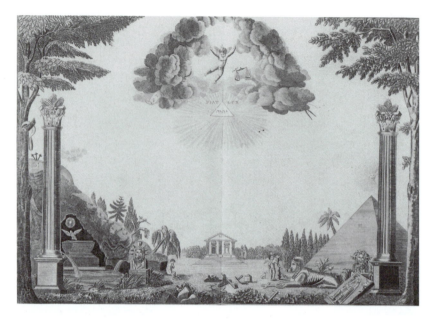

Plate 124 *Typical design for a Freemasonic certificate for Lodges under the Grand Orient of France, from a nineteenth-century printer's sample-book. Note the sphinx, Egyptianising deity (Serapis), serpents, pyramid, palm, and features (recalling the lotus-crown on Roman statues of Isis) on top of the columns (UGLE).*

Furniture Design, and Other Egyptianising Manifestations

George Smith (*fl.* 1780–1828) popularised the Egyptian-Hopeian style in his *Collections of Designs for Household Furniture* (1808), in which work considerable numbers of the designs are for libraries. This appears to be an architectural association with the library of the *Serapeion* at Alexandria, and with Egypt as the fount of wisdom and learning. Smith's *The Cabinet-Maker's and Upholsterer's Guide* (1826) contains a design for a complete library in the Egyptian Taste,[39] and, although his pattern-books lack Hope's scholarly approach (in spite of Smith's claim that his examples were 'studied from the best examples of Egyptian, Greek, and Roman styles'), they had a considerable influence on the furniture trade.

The Royal Pavilion at Brighton contains a number of items with Egyptianising motifs well to the fore, although most of these have been introduced in recent years, and were not originally there at all. There was, however, a room described as 'An Egyptian Gallery' in the Pavilion, dating

39 SMITH (1826), plate CXLVII.

probably from the 1802 reconstruction, but no accurate or adequate descriptions of this room appear to have survived: Attree's *Topography of Brighton* (1809) described the room as an 'Egyptian Gallery . . . the walls of which are covered with a historical paper'. It occupied the site of the present North Drawing-Room. Some of the Egyptianising furniture at present in the Royal Pavilion deserves mention here. The Saloon contains a couch in the form of a papyrus river-boat, on crocodile feet, in green-painted wood with carved-gilt reeding and enrichments featuring reeds, shells, and dolphins (**Plate 125**): it dates from *c.*1806–10.[40] Mary Russell Mitford (1787–1855) described the Egyptian Library in Rosedale Cottage as 'swarming with furniture crocodiles and sphynxes . . . Only think of a crocodile couch and a sphynx sofa',[41] and it appears there were several versions of this couch made. Smith himself designed the elbow-chair (painted black and parcel-gilt with cane side-panels) in *c.*1804, and made in 1806 from his design published in *Household Furniture* in 1808. This chair combines conventional Egyptianising motifs (winged stars, sheathing around the vertical members, and the rows of stars) with Greek anthemion and Medusa-mask ornament. The stars were often used by Percier and Fontaine, and ultimately derive from Piranesi (**Plate 126**).

Curiously, the lull in hostilities between Britain and France led many travellers to the latter country to visit museums and galleries and buy artefacts in the latest taste. One of the most fashionable shops was that of Martin-Eloy Lignereux (*fl.* 1789–96), whose partner, Dominique Daguerre, had had a shop in London until his death in 1796.[42] Items purchased by the Prince of Wales (later King George IV) – a leader of fashion and taste – included *une paire de girandoles avec figure de femme Égyptienne* and two cabinets with gilt-bronze Egyptianising figure-enrichments set on inverted obelisks, the whole in *la forme antique*.[43] The use of the phrase *forme antique* was usually applied to Greek and Roman artefacts, but by 1803 the respectability of Egypt as a source of Antique art was becoming established, especially after the Napoleonic Campaign and the publication of Denon's beautiful and influential book.

Georges Jacob (1739–1814) was the most celebrated of all Parisian furniture-makers of the Louis Seize period, and he made Neo-Classical furniture in the Antique style for the painter Jacques-Louis David (1748–1825): his furniture appears in David's celebrated *Paris and Helen* and *The Lictors bringing Brutus the Bodies of his Sons* (both 1789). The firm of Jacob

40 HIGGINBOTTOM (1976), Item 116. The Author is grateful to the late Mr John Morley for showing him these items and discussing them with him.

41 *Our Village* (1830), Series IV, 240.

42 BELLAIGUE (1968), *passim*. The Author is indebted to Sir Geoffrey de Bellaigue for advice and information.

43 *Ibid.*

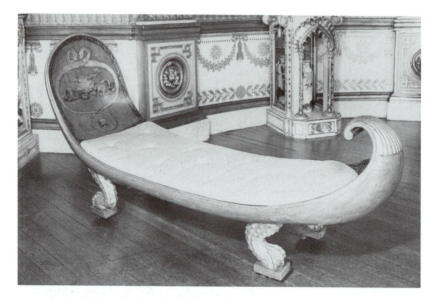

Plate 125 *Egyptianising couch (c.1806–10) in the form of a river-boat, on crocodile feet, of green-painted wood with carved-gilt reeding and gilded enrichments featuring reeds, serpents, and other motifs, now in the Royal Pavilion, Brighton* (RPAGMB).

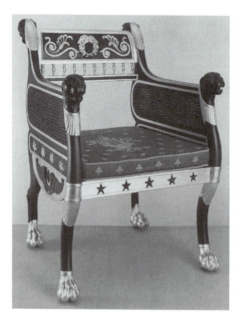

Plate 126 *Chair based on a design found in George Smith's* Collection of Designs for Household Furniture. *On the back-rail is a Medusa mask, but the legs and arm-rests are based upon Egyptian leopard monopodia, whilst further Egyptianising flavours are given by the winged motifs on the sides and by the Piranesian stars* (RPAGMB).

Frères (Georges II Jacob [1768–1803] and François-Honoré-Georges Jacob [known as Jacob-Desmalter, 1770–1841]) was the leading furniture-maker in Paris, producing large numbers of fine artefacts in the *Directoire* and *Empire* styles, many of which were embellished with Egyptianising detail. Clients included King Gustavus III of Sweden and the Prince of Wales.

As has been indicated above, Denon became Director of the Musée Napoléon around the time his *Voyage* first came out, and in 1803 was appointed Director of the *Monnaie des Medailles*.[44] In 1805 he became artistic adviser to the porcelain factory at Sèvres, where Alexandre Brongniart (1770–1847) was the Administrator of the *Manufacture Impériale* (as it became once Napoléon was Emperor), and had improved the processes of manufacture and glazing. Brongniart built up the *Musée Céramique* at Sèvres, and developed an interest in design as well as in the technicalities. Denon proposed that an Egyptian Service should be manufactured at Sèvres, to designs derived from illustrations in his *Voyage*. Denon was to have control of the design of the whole project, while Brongniart dealt with the problems of manufacture.[45] This *Service Égyptien*, when complete, consisted of *66 assiettes avec vues, 12 assiettes à monter, 12 compotiers, 2 sucriers à figure égyptienne, 2 glacières forme égyptienne, 4 figures avec vasques, 2 corbeilles à palmes,* and *2 confituriers à boules-griffes,*[46] and a magnificent architectural centrepiece, or *surtout de table* (**Colour Plate XIV**), featuring in the centre the Trajanic 'Kiosk' (**Plate 25**) at Philæ, four obelisks from Luxor, the pylons from Edfu (with elements from Dendera), seated figures with *nemes* head-dresses, and avenues of *criosphinxes* from Karnak (**Plate 127**). This *surtout* of biscuit porcelain was designed by Jean-Baptiste Lepère (or Le Peyre) – who had been on the Nile expedition with Denon – and made by Jean-Nicolas-Alexandre Brachard (1775–*c.*1830) and others. Plates had rich dark-blue borders with gold ornament designed by Alexandre-Théodore Brongniart (1739–1813), and the views of Egypt from Denon were painted in a sepia monochrome by Jacques-François-Joseph Swebach-Desfontaines (1769–1823). Claude-Antoine Depérais (1777–*c.*1825) painted the Signs of the Zodiac. One version of this stunningly beautiful *Service* was made by 1808, intended for Napoléon's use at the Tuileries, but was presented to Tsar Alexander I of Russia (1801–25). The second version was made in 1811–12 for the Empress Josephine (1804–14), but she refused it, finding it *trop sevère*: it was presented to the Duke of Wellington (1769–1852) by King Louis XVIII in 1818, and was bought for the nation in 1979. It is now in the Victoria & Albert Museum (**Colour Plates XIV-XVII**).[47]

44 TRUMAN (1982), *passim.*
45 *Ibid. See also* the Exhibition *Catalogue* of the Sèvres *Manufacture Nationale* (1951); VERLET, GRANDJEAN, and BRUNET (1953), esp. 226–7; GRANDJEAN (1955), 99–104; *Connaissance des Arts,* **cxviii** (1961), 124–33; and GRANDJEAN (1959), 223–30.
46 ARTS COUNCIL OF GREAT BRITAIN (1972), no. 1420.
47 *Ibid. See also* CONNER (*Ed.*) (1983), 42. *Surtout* details came from *Description . . .*

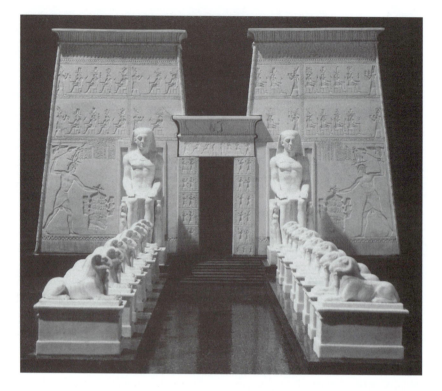

Plate 127 *One of the ends of the* surtout *of the* Service Égyptien *by Lepère, modelled on the pylon-towers of the temple at Edfu, with seated male figures (with* nemes *head-dresses), and avenues of sacred ram-headed lions* (criosphinxes), *all of biscuit porcelain on imitation porphyry* (V & A Neg. No. SJ.10307).

Also associated with Denon is the furniture made by Jacob-Desmalter, including the beautiful medal-cabinet, probably designed by Percier, with mounts by Martin-Guillaume Biennais (1764–1843) (**Plate 128**): decorations included the scarab motif, the crescent-moon of Isis, and serpents on lotus-stalks.[48] Biennais and Jean-Baptiste-Claude Odiot (1763–1850) made the silver-gilt Borghese table-service of 1794–1814, which includes crescent-moon handles on a samovar: Odiot made a similar urn that rested on sphinx-supports for the Russian Court.[49]

In 1777 Laurent Pecheux (1729–1821) painted a portrait of the Marchesa Gentili Boccapaduli in her Cabinet of Curiosities which shows a table in the Egyptian Taste[50] similar to a late-eighteenth-century Italian

48 Now in the Metropolitan Museum of Art, New York. *See* HUMBERT, PANTAZZI, AND ZIEGLER (*Eds*) (1994) for details of this and other items.
49 ARTS COUNCIL OF GREAT BRITAIN (1972), no. 1719d, and p. 816.
50 PRAZ (1964), fig. 134. ARTS COUNCIL OF GREAT BRITAIN (1972), no. 208.

Plate 128 *Medal- or coin-cabinet in the form of a pylon: part of various items of furniture in the Egyptian Taste which once belonged to Denon. It is of mahogany with silver inlay and added silver enrichments, 35½ x 19¾ x 14¾ in. (90.2 x 50.2 x 37.5 cm.),* was probably designed by Percier and made (c.1805) by François-Honoré-Georges Jacob-Desmalter (1770–1841), with mounts by Martin-Guillaume Biennais (1764–1843). (The Metropolitan Museum of Art, New York: Bequest of Collis P. Huntingdon, 1900 [No. 26.168.77]. Photograph ©1926 The Metropolitan Museum of Art Neg. No. 64218 LS B).

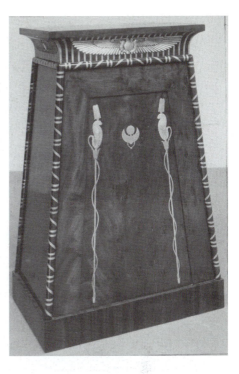

table, painted red and mottled green and black (to look like Egyptian granite), with a black-marble top.[51] The latter has corner-*telamones*, and the frieze is decorated with bogus hieroglyphs. Similar tables by Giovanni Socci are now in the Palazzo Pitti in Florence, a building which also contains a marble chimney-piece flanked by *telamones* similar to those on French and Italian furniture of the period.[52] Even as early as 1782, chairs adorned with gilt ornaments (freely adapted from Egyptian exemplars, including serpents, scarabs, and scorpions) were being made in Italy: a late-eighteenth-century chest, probably intended for the *Sala Egizia* in the Villa Borghese in Rome, is derived from the decorations of the *Caffè degl'Inglesi* and from other illustrations in *Diverse Maniere*.[53]

Centrepieces for tables of the time seem to have attracted Egyptian elements to their design. In 1811 the Prince Regent bought a fine centrepiece for £504 19s. 0d. (**Plate 129**), described as large 'Egyptian Temple or incense burner with figures supporting branches for eight lights'. Egyptianising motifs include the Canopic figure capped with an Isiac lotus-bud, figures with head-dresses carrying the canopy (the frieze of which is

51 Now in the Metropolitan Museum of Art, Robert Lehman Collection, 41. 188.
52 For example the console-table in the Palazzo Pitti of *c.* 1810, noted by the Author. *See I mobile neo-classico italiano*, plate CLXXXIII, and JOHNSON (1966).
53 No. 1647 in the ARTS COUNCIL OF GREAT BRITAIN (1972).

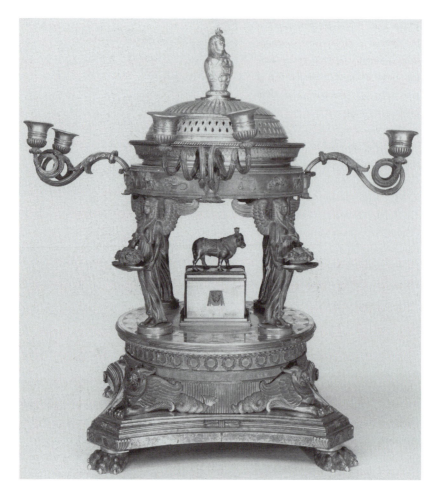

Plate 129 *Table centrepiece of gold, silver, and gilt-bronze, decorated with the Apis-Bull, and a Canopic jar with lotus on the head. The canopy is supported by winged female Egyptianising figures with* nemes *head-dresses* (The Royal Collection ©2005, Her Majesty Queen Elizabeth II, R. 508144, 50419 A–C).

embellished with scorpions and Nilotic fauna), and, under the canopy, an Apis-Bull on a podium decorated with Egyptianising masks.[54]

One of the most interesting examples of Regency furniture in England was intended for ceremonial use at Greenwich Hospital.[55] This is the remarkable centrepiece of the Dolphin Furniture, a gilt-wood tripod

54 The Author is indebted to the late Mr John Morley and to Sir Geoffrey de Bellaigue for drawing his attention to this splendid piece. No. 724 in the *Catalogue* of the Royal Pavilion at Brighton (HIGGINBOTTOM [1976]).

55 HIGGINBOTTOM (1976), no. 100, and CONNER (*Ed.*) (1983), 96.

Plate 130 *Gilt-bronze centrepiece of the Dolphin Furniture, Brighton, presented to Greenwich Hospital in 1813 by the widow of Mr John Fish in memory of Lord Nelson, and signed by William Collins of London. The winged sphinxes and crocodile allude to Nelson's campaign in Egyptian waters* (Reproduced by kind permission of Greenwich Hospital).

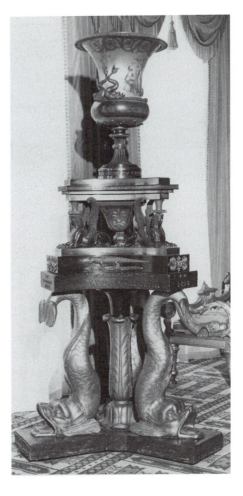

stand of inverted dolphins, with two composite tiers in parcel-gilt bronze separated by a tripod support of winged sphinxes carrying baskets on their heads, the lower tier decorated with crocodiles. This centrepiece is inscribed 'To the Memory of Lord Viscount Nelson the Gift of the Late John Fish Esqr. of Kempton Park Presented by his Widow and Executrix A.D. 1813', and was made by William Collins (perhaps a relation of the cabinet-maker Collins of Tothill Fields [died 1793]). Scenes of the Battle of Trafalgar and of the Apotheosis of Nelson are painted in the glass lamp supported by this centrepiece, which is actually an elaborate torchère (**Plate 130**). Other variants of this type of centrepiece can be found in Sheraton's *Cabinet Dictionary* (1803).

Sphinxes, of course, were commonly found in the vocabulary of designers in the early part of the nineteenth century. Large council-chairs incorporating winged sphinxes were made by Tatham and Bailey in 1813,

241

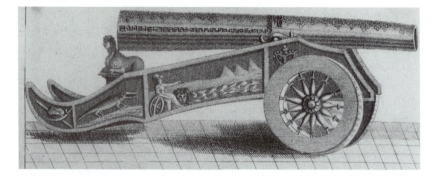

Plate 131 *'The Great Egyptian Gun in St James Park 16 feet 1 In. long' from R. S. Kirby:* Kirby's Wonderful and Eccentric Museum, *originally published in 1803 in Vol. 1, p. 173. The gun was captured during the campaign against Napoléon in Egypt and in Egyptian waters, and a special Egyptianising carriage, with sphinx, crocodile, and Britannia pointing to the pyramids, was made for its display in London* (GLCL).

and are recorded as having graced the Throne-Room in Carlton House:[56] these sphinxes are based on the throne in San Gregorio Magno and on seats in the Vatican, recorded by Tatham when in Rome.[57] Winged sphinxes are not especially Egyptian, however, but the winged variety often occurs with Egyptianising heads in early-nineteenth-century Neo-Classical designs (**Plates 107** and **130**). Winged sphinxes appear on state-chairs designed by Schinkel for Prince Karl of Prussia in 1828, and based on the model in a wall-painting from Herculaneum.[58] Similar sphinxes, but this time without wings, and sitting up in an alert position, support the circular backs of chairs designed for the Queen's Throne-Room in the *Residenz* in Munich, designed by Leo von Klenze (1784–1864).[59]

A rare and strange piece of Egyptiana found its way to St James's Park in 1803 after the Egyptian Campaigns: this was the Great Egyptian Gun, apparently a Turkish cannon (captured at Alexandria in 1803) of fluted make, with raised work of hieroglyphs. A new carriage was made for it (carved by one Ponsonby) which had panels on the side featuring Britannia pointing towards the Pyramids, with a lion and a crocodile: the barrel of the cannon rested on a sphinx (**Plate 131**).[60]

There were also parallels in architecture, where Egyptianising elements were used: obelisks, sphinxes, and other motifs appeared in stone and stucco

56 PYNE (1819).
57 TATHAM (1826), plates 81–85.
58 STAATLICHE SCHLÖSSER UND GÄRTEN, BERLIN: HM 7725 1–2.
59 RESIDENZMUSEUM, MUNICH: M. 932, 933. *See* THOMA (1937).
60 KIRBY (*Ed.*) (1820). Mr Ralph Hyde kindly provided this item.

just as they appeared in wood, silver, bronze, and gold. William Henry Playfair (1790–1857) included sphinxes over pediments of his severely Greek Doric Royal Institution (now the Royal Scottish Academy) in Edinburgh, of 1822–26 (enlarged and altered 1832–35). Obelisks, too, enjoyed a long life. Vincenzo Coacci (1756–94) made an ink-stand modelled on the Quirinal Monument in 1792 of silver, silver-gilt, and lapis-lazuli on a base of *rosso antico*, and incorporates sphinxes, the head-dresses of which conceal candle-sockets. This fine Neo-Classical piece influenced many nineteenth-century designs for centrepieces and similar ornaments.[61] The obelisk can be found in one of the longest-lived pieces of Egyptianising furniture, and still in use today: this is the Metronome, invented by a Dutchman named Winkler, but patented by Johann Nepomuk Mælzel (1772–1838), who placed the clockwork mechanism inside a stumpy obelisk, rather like a steeply-pitched pyramid with an obelisk-top. Thus an Egyptianising form of the Neo-Classical period was familiar in all musically-inclined households, whilst pylon-shaped chimney-pots became extremely common (as did chimney-pieces with pylon-shaped uprights), lotuses and palm-leaves recurred on street-furniture, and door-knockers in the form of Egyptianising heads with *nemes* head-dresses were made by the thousand.

The German-speaking lands also embraced Egyptianisms with enthusiasm. The bridge at Monbijou by Carl Gotthard Langhans (1732–1808) and Johann Gottfried Schadow (1764–1850) had paired sphinxes, and Schadow also used sphinxes to embellish the entrance to Steinhöfel Park, both in Berlin.[62] The Schloss at Kassel acquired a fine Egyptian Room in 1830, and Friedrich Weinbrenner (1766–1826) designed a synagogue for Karlsruhe in 1798 which had pylons at the gate.[63] The same architect built a pyramid of black stone near the intersection of the Karl-Friedrich Strasse and the Kaiser-Strasse as the monument of Margrave Karl-Wilhelm of 1823. Pyramids were also used in designs for Prince zu Schwarzenberg at Leipzig, of 1815,[64] and a pyramid was erected in honour of Napoléon's coronation near the Moravian settlement of Zeist between Arnhem and Utrecht.[65] Gilly's design for a monument to King Friedrich of Prussia was essentially pyramidal in composition, and incorporated obelisks and sarcophagi. More overtly and daringly Egyptianising were Karl Freiherr Haller von Hallerstein's (1774–1817) first designs of 1814–15 for Walhalla near Regensburg in Bavaria which included a propylæum with pylons, the

61 The Minneapolis Institute of Art, Minnesota. Morse Foundation, 69. 80a. *See also* IVERSEN (1968), 125.
62 SCHMITZ (1914), 166–81.
63 WISCHNITZER (1951), also quoted by CARROTT (1978), 43. For Weinbrenner *see* BROWNLEE (*Ed.*) (1986), and ELBERT (1988).
64 VOGEL (1928–9), 160–5.
65 BÆDEKER, KARL (1910): *Belgium and Holland including the Grand-Duchy of Luxembourg* (Leipzig and London: Bædeker), 444.

central pylon being higher than those on either side: the pyramidal composition was achieved by a series of mighty platforms with battered sides, like several superimposed Egyptian *mastaba* tombs, and was capped by a Greek temple. Gilly's design was the inspiration for this marvellous vision, but Haller was the most Egyptian-minded of the great German Romantic-Classicists in his architectural works, as can be seen from his Walhalla project and in the designs for the Munich Glyptothek of 1814, which is probably derived from Denon, and based on the Dendera temples, though it combines both Greek and Egyptian elements.[66]

Mention of the series of Egyptianising fountains erected in Paris as part of the glorification of Napoléon and commemoration of the Egyptian Campaigns has already been made. The rue de Sèvres *Fellah* fountain, with its Antinoüs-based water-bearer, is a splendid example (**Plate 117**), and the Fontaine de la Victoire in the Place du Châtelet is another (**Plate 132**). One cannot avoid coming across Egyptianisms in Paris: sphinxes perch on gate-piers near Saint-Sulpice, and there are many others (2 Quai des Célestins [*c.*1680], and 6 rue Férou [*c.*1780], for example).[67] Such Egyptianisms in the townscape helped to popularise the style. A spectacular Egyptianising piece of civic design was carried out under Giuseppe Valadier (1762–1839) at the Piazza del Pòpolo in Rome from 1816 to 1820 for Pope Pius VII. Valadier took as his centrepiece the Antique obelisk (**Plates 10 and 11**), and, with the twin churches (Santa Maria in Monte Santo and Santa Maria de' Miracoli [1662–79]) by Carlo Rainaldi (1611–91), the church of Santa Maria del Pòpolo, and the city gate as his points of reference, created an elliptical space with ramps to give access to the higher ground, fusing the park and the buildings in a wonderfully confident work of urban planning. Ramps were crowned with sphinxes, which had interested Valadier for a considerable period, as his sketch-books from before 1800 contain Egyptianising elements.[68]

As has been made clear, Egyptianisms often occurred mixed with other Neo-Classical motifs. For example, Elim Chapel in Brighton, of 1810, has Egyptianising architraves, but a correct Doric pediment.[69] Yet Thomas Harrison's (1744–1829) unexecuted design for a monumental pyramid with four symmetrical hexastyle *in-antis* pylon-shaped porticoes (each flanked by a pair of sphinxes) is the most Egyptian version of such a common Neo-Classical scheme, only retaining its Classical-Palladian ancestry in its basic composition. Designs by Giuseppe Martelli (1792–1876) dating from the second decade of the nineteenth century

66 NERDINGER (*Ed.*) (2000), *passim*, for von Klenze.
67 CURL (1984*a* and 1986); HUMBERT (1998).
68 BRÜES (1965).
69 The Author owes this to the late Mr John Morley.

Plate 132 (a) Fontaine de la Victoire *in the Place du Châtelet, Paris, with its* Colonne du Palmier *inscribed with the names of fifteen battles won by Napoléon. It was designed by François-Jean Bralle (1750–c.1832), with sculptures by Simon-Louis Boizot (1743–1809). Erected between 1806 and 1808, the Egyptianising palm-capital was intended (like the Antinoüs fountain in the rue du Sèvres) to evoke the Nile campaign of Napoléon. The handsome sphinxes* (**b**) *with the double basins were added in 1858 to a design by Gabriel-Jean-Antoine Davioud (1824–81) and sculpted by Alfred Jacquemart, giving an extra Egyptian flavour to the more subtly Egyptian shaft. Similar sphinxes were erected around the obelisk in the Place de la Concorde in 1850 by Charpentier to celebrate the second anniversary of the Proclamation of the Second Republic under Louis-Napoléon Bonaparte. Photographs of 1983* (JSC).

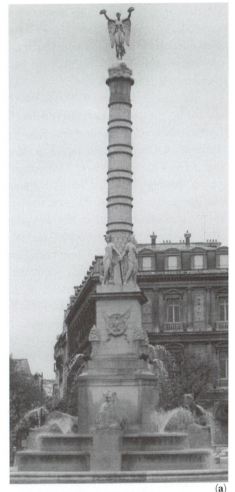

(a)

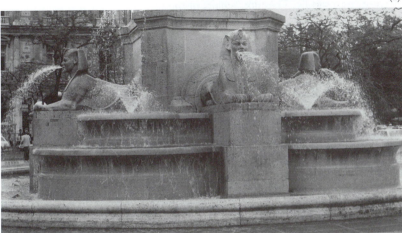

(b)

contain some Egyptianising elements: his *Tempio* of 1815 has a massive pylon-like centrepiece with a coved cornice and winged globe over the distyle *in-antis* entrance.[70] Luigi Cagnola (1762–1833) designed *La Rotonda* at Inverigo near Milan in 1813: Egyptian figures and a *caryatid*-porch are found in this eclectic design.[71]

As has been seen, George Smith and Nathaniel Whittock were advocating the use of Egyptianisms in libraries[72] and Whittock later noted the Egyptian style was ideal for shop-fronts.[73] In Barbara (Wreaks) Hoole Hofland's *A Descriptive Account of the Mansion & Gardens of White-Knights, a Seat of His Grace the Duke of Marlborough*[74] there is a reference to 'The Anti Room' having 'Egyptian Idols', while the drawing-room chimney-piece was also in the Egyptian Taste: it also appears that the second room of the library was ornamented in the Egyptian manner. The designer of these elements (including hieroglyphs, murals, and statuettes) at White-Knights, Reading, Berkshire, could have been Samuel Pepys Cockerell (1753–1827), or, possibly, John Buonarotti Papworth (1775–1847) – who designed a railway-station and a monument in Alexandria in 1835–37. Papworth worked at White-Knights in 1815–16, but the creator of the Egyptianising elements may have been Francesco Bernasconi, who worked with Cockerell at White-Knights in 1810.[75] Barnsley Park, Gloucestershire, also acquired an Egyptianising library by John Nash in 1806–10. Now the association with the library at the Alexandria *Serapeion* may be the reason for such décor, but equally well battered pylon-like forms can be adapted for use in bookcases and drawing-cabinets.[76]

Gaetano Landi (of whom little is known), in his *Architectural Decorations* (1810), included an original design for a 'Grand Egyptian Hall' (**Plate 133**) that perhaps owes more to Piranesi than to Hope for its inspiration, although there are segmental lunettes and friezes of Egyptianising figures derived from scrolls. The 'lion' chairs in the illustration are probably quotes from Denon, and the fireplace is a somewhat ham-fisted and unscholarly concoction (**Plate 134**) that also looks back to Piranesi, and falls into Professor Carrott's category of 'Commercial Picturesque'.[77]

One of the oddities of the Egyptian Revival was that, even though there were modern, accurate, archæologically-based source-books such as Denon and the *Description*, many designers persisted in using inaccurate and

70 WOLFERS and MAZZONI (1980).
71 MEEKS (1966), 149.
72 WHITTOCK (1827), 152.
73 WHITTOCK (1840), plate XII.
74 *See* Select Bibliography.
75 PAPWORTH (1879), HOFLAND (1819), and WATKIN (1968), 211, 293 (note 50).
76 CONNER (*Ed.*) (1983), 84.
77 CARROTT (1978), 35.

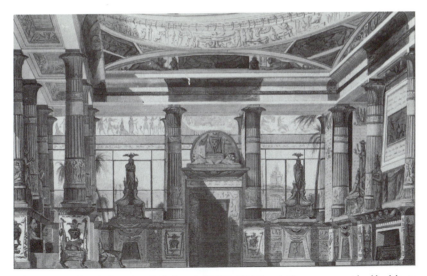

Plate 133 *Grand Egyptian Hall from LANDI (1810), which owes a considerable debt to Piranesi's DM. Columns were reddish-brown, with green capitals and bases, and other colours were light green, cream, and buff* (GN/SM).

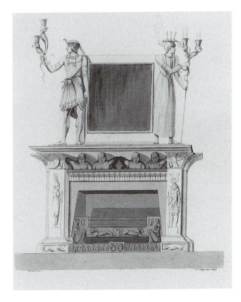

Plate 134 *Fireplace in the Egyptian taste from LANDI (1810)* (GN/SM).

old-fashioned 'sources' such as the works of Piranesi, Montfaucon, and even Kircher. Old habits and tired images died hard.

However, one realised work of the post-Napoleonic period stands out for its sheer exuberance. This is the *Caffè Pedrocchi* in Padua (1816–31), reckoned by Henry-Russell Hitchcock to be the 'handsomest nineteenth-century café in the world', and the 'finest Romantic Classical edifice in

Italy'.[78] It is an essay in Neo-Classicism with Greek Doric, Corinthian Empire, Palladian, Gothic, Moorish, and Egyptianesque themes by a pupil of Selva, Giuseppe Jappelli (1783–1852),[79] probably in collaboration with Antonio Gradenigo (1806–84). In one of the corner projecting wings facing the piazza is a handsome room (apparently used for Freemasonic meetings) in the Egyptian Revival style, and it is reasonably scholarly too.

The *Caffè*, in short, is a masterpiece of historicism, handled with great verve, imagination, and scholarship.[80]

78 HITCHCOCK (1977).
79 *See* ROBERTO C. MANTIGLIA (1955): 'Giuseppe Jappelli architetto', in *L'Architettura*, **i** (November–December), 538–52.
80 *See* MEEKS (1966), 124–9.

CHAPTER VII

Applications of the Egyptian Style

Introduction: Die Zauberflöte; *Stage-Designs and Mozart; The Commercial Picturesque and the Adoption of Egyptian Forms; Other Egyptianising Designs*

Primus aratra manu sollerti fecit Osiris
et teneram ferro sollicitavit humum.
Primus inexpertæ commisit semina terræ
pomaque non notis legit ab arboribus.

(The first plough was made by the skilled hands of Osiris,
who solicited the virgin soil with iron.
The first seed committed he to the inexperienced earth,
and gathered fruit from strange trees).

ALBIUS TIBULLUS (c.54–c.18 BC):
Elegies, Book I, Elegy 7, lines 29–32.

O Isis und Osiris, schenket
Der Weisheit Geist dem neuen Paar!
Die ihr der Wand'rer Schritte lenket,
Stärkt mit Geduld sie in Gefahr.
Lasst sie der Prüfung Früchte sehen;
Doch sollten sie zu Grabe gehen,
So lohnt der Tugend kühnen Lauf,
Nehmt sie in euren Wohnsitz auf.

(O Isis and Osiris, bestow
the Spirit of Wisdom on the young couple!
You, who guide the traveller's footsteps,
grant strength with patience in time of danger.
Give them the rewards of their Trial,
Yet should they be entombed,
grant honour to Virtue's bravery,
and accept them in your dwelling-place).

WOLFGANG AMADEUS MOZART (1756–91),
EMANUEL SCHIKANEDER (1751–1812),
and CARL LUDWIG GIESECKE (1761–1833):
Die Zauberflöte (*The Magic Flute*), Act II, Scene I.

Introduction: *Die Zauberflöte*

Among the most imaginative schemes where Egyptian Revival forms were used, stage-designs must take pride of place, especially in the German-speaking countries, and, perhaps of all inspirations where Egyptianising stage-sets were concerned, Mozart's *Singspiel*, *Die Zauberflöte* (K.620), proved to be the most potent. *Die Zauberflöte* is based on *Séthos*,[1] and it is clear that the authors[2] of the libretto were familiar not only with Terrasson's work but with the writings of Apuleius, Diodorus Siculus, and Lucian (*c*.AD 115–*c*.180). A detailed discussion of the work cannot be entered into here, but the present writer's *Art and Architecture of Freemasonry* goes into the tangled web at some length.[3] It will be sufficient to say that *Die Zauberflöte* owes debts to many other works, including *Thamos, König in Ägypten*, by Gebler, and sundry works of Rococo exotica popular at the time.

Illustrations for the printed libretto of *Die Zauberflöte* were engraved by Ignaz Alberti, a Freemason and Brother of Mozart's Lodge: one of these decorations[4] contains much bogus 'Egyptian' allusion in the tall pyramid (or is it a fat obelisk?) with *ankh* and other ill-observed details, as well as Freemasonic references in the mattock, pick, hourglass, and fragments of carved masonry. The overall gloom of the dark, cavernous scene, however, recalls images from Piranesi, and indeed the grotesque crouching figures suggest elements from *Diverse Maniere*, while the larger vase could also have been derived from Piranesi's studies of vases and urns (**Plate 135**). In *Die Zauberflöte* settings include dark vaults, scenes with pyramids, temples of Wisdom, Isis, and Osiris, and many other Egyptianising tendencies. There are many parallels with the Isiac religion in *Die Zauberflöte*: Isis transformed herself into an old hag, and then into a beautiful girl, just as happens to Papagena, while Papageno the bird-catcher might have stepped with his reed-pipes from the banks of the Nile; magic bells may be a reference to the sacred *sistrum* and timbrels used in Isiac ceremonies; and the references to roses, bells, transformations, and so on may have Isiac-Egyptian connotations. Monostatos, whose black visage and singular name pick him out as anti-social (his heart is as black as his face), could loosely identify him with Seth of the South Wind, the murderer and dismemberer of Osiris, especially since he hates the temple and the High Priest Sarastro, and therefore hates Isis and Osiris as well. His chains and irons represent repression that can only be lifted when his intended victims are initiated to Enlightenment.

1 TERRASSON (1731).
2 Schikaneder is usually credited with this, but there seems to be some evidence that both Giesecke and Mozart contributed to it.
3 CURL (2002*b*).
4 It is often referred to as the 'frontispiece' (e.g. by PEVSNER and LANG [1956]): it is nothing of the kind.

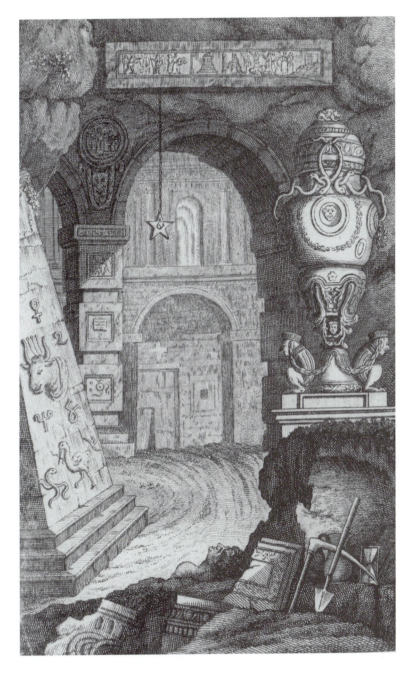

Plate 135 *Engraving by Ignaz Alberti of Vienna showing an evocation of an 'Egyptian' scene to illustrate the first edition of the libretto of Wolfgang Amadeus Mozart's* Die Zauberflöte *(K. 620) of 1791. The large vase with crouching figures is derived from Piranesi's works* (BL, Music Library, Hirsch IV, 1395).

That memorable scene in Act II with the *Zwei schwarzgeharnischte Männer* (two men in black armour),[5] who sing of the paths of trials and of those trials through Fire, Water, Earth, and Air, of conquering the fear of death, of rising from earth to the sphere of heaven, of illumination, of consecration, and of the mysteries of Isis, do so to a Lutheran chorale, *Ach Gott, vom Himmel sieh darein.*[6] The solemn, Antique flavour of this scene is emphasised by the two figures, who could almost be the two *telamones* from the *Villa Adriana*, or even Jachin and Boaz. Roses were used in Isiac rites, and roses play no small part in *Die Zauberflöte*. Furthermore, Tamino with the flute is an Orpheus, able even to charm wild animals: that flute was carved in a magic hour by Pamina's father (even the names Tamino and Pamina seem to have a quasi-Egyptian origin) from a thousand-year-old oak-tree during lightning, thunder, storm, and uproar. So her father, too, like her mother (the Queen of the Night, a quasi-Isis), was a supernatural being. Hermes invented the lyre and was the guide to the dead in Hades, so if the flute is substituted for the lyre (Hermes also invented the shepherd's pipe), that gives Pamina an Hermetic-Egyptian connection too. However, the priestly race of the Kerykes (of the Eleusinian Mysteries) claimed Hermes as the head of their family (that is, father), and, of course, those mysteries were festivals of Demeter, identified as Isis, and her daughter Persephone.[7] These matters are very complicated, and deserve discussion at greater length. The Egyptianising content of the *Singspiel*, however, prompted designers to experiment with sundry Egyptian-inspired stage-sets, and it is worth mentioning a few of these below.

Stage-Designs and Mozart

Only three years after the death of Mozart, Giulio Quaglio III (1764–1801) designed stage-sets for a production of *Die Zauberflöte* at the *Nationaltheater*, Mannheim, in 1794, that were a considerable improvement on the designs used in the original Viennese and other very early productions.[8] The set,

5 Not, as tediously usual in theatre-programmes and the portentous effusions of BBC announcers, 'Two Armed Men'.

6 *Ach Gott, vom Himmel sieh darein/Und lass dich's doch erbarmen!* (Ah, God, from heaven look on them and yet grant to them thy mercy!), a paraphrase by Martin Luther (1483–1546) of Psalm XI in the Vulgate version, which first was published in 1524. *See* DENT (1960), 248. *See also* J. S. BACH's Cantata BWV2. Mozart's score and other evidence in the National Library, Vienna, demonstrate that the extraordinary passage in *Die Zauberflöte* was meticulously worked on: Mozart probably saw the tune in *Kunst des reinen Satzes*, published in Berlin in 1771–6, by Johann Philipp Kirnberger (1721–83). *See* JAHN (1856), **iv**, 617.

7 *Die Zauberflöte* is always given with massive cuts to the spoken dialogue, both in the theatre and in recordings (in the latter it is sometimes omitted altogether). This may explain why many commentators find the libretto nonsensical: they have never heard it. *See Die Zauberflöte. Oper in zwei Aufzügen von W. A. Mozart. Dichtung nach Ludwig Gisecke* (sic) *von Emanuel Schikaneder* (Zürich/Wien: Apollo-Verlag, n.d.).

8 *See*, for example, *Allgemeines Europäisches Journal*, published in Brünn (now Brno) in 1795, which pictured six rather crudely drawn scenes.

probably by Giuseppe Quaglio, for the *seltsames Gewölbe* (or strange vault) in Act II has sphinxes, obelisks set on balls, semicircular *loculi* with corpses *à la Desprez*, and cinerary urns.[9] In 1804 *Die Zauberflöte* was given at Kismarton,[10] with sets by Carl Maurer, who was engaged as *Hofkammermaler* in 1802 by Prince Miklós II (1765–1833). Maurer's somewhat ungainly designs are preserved in a sketch-book, *Handzeichnungen zum Theater Gebrauch von Carl Maurer, Fürstlich Esterhazycher Hof Theater Decorateur*, dated Eisenstadt, 1812, and now in the Čaplovič Library: these sets attempted to suggest Egypt, but had inauthentic and ill-observed details,[11] including sphinxes, bogus hieroglyphs, obelisks, a Bernini-Poliphilus elephant with obelisk on its back, a Piranesian prison-like interior, a term with six breasts over a fountain (presumably supposed to be Artemis of Ephesus), and corbelled openings with stepped and canted arches (**Plates 136–138**).[12] What makes Maurer's sets so interesting is that they not only prolonged a non-historical phase of Egyptianising design two to ten years after the publication of Denon's great work, but looked forward to aspects of *Art-Déco*.

Far more professional, and of a quality that is outstanding, are the sets by Karl Friedrich Schinkel, designed in 1815, when Schinkel became responsible for stage-design at the *Königliche Schauspiele-Opernhaus*, Berlin, under the management of Count Brühl. *Die Zauberflöte* was given with these sets on 16 January 1816 to celebrate the centenary of the coronation of the first King of Prussia in Königsberg and the victory (1815) after the Wars of Liberation against the French: it set a new standard of excellence. Schinkel selected the Egyptian style for historical correctness as well as for the grandeur and solemnity of the occasion, and he produced a masterpiece of Neo-Classical theatre decoration in which architectural and historical accuracy were achieved without being slavish to pedantic correctness in every detail. These stunning designs were much admired at the time: Ernst Theodor Wilhelm (later Amadeus) Hoffmann (1776–1822), in the *Dramaturgischen Wochenblatt* of 2 March 1816, waxed lyrical about them, praising the starry skies, dark vaults full of Sublime Terror, supernatural atmosphere, noble sphinxes, colossal scale of the great temple, and the contrast between light and

9 Illustrated in CURL (1982), 135. *See Clara Ziegler-Stiftung, Theatermuseum,* Munich, No. S. Qu. 44/11.

10 Known in German as Eisenstadt, the capital of the Burgenland, where the Esterházy princes had a fine *Schloss*, designed by Carl(o) Martin(o) Carlone (1616–79), and built 1663–72. Kismarton passed from Hungary to Austria in 1921: it should not be confused with the huge Esterháza Palace in Hungary proper (it is now called Fertöd), built 1764–84 by Prince Miklós (Jószsef) Esterházy I (1714–90) to designs perhaps by himself and Melchior Hefele (1716–94).

11 Prince Miklós incurred very heavy expenditure during the Napoleonic Wars, when he raised a regiment, and his grandson, Prince Miklós III (1817–94), was forced to sell part of the huge Esterházy collections. Maurer could, therefore, have been an economy.

12 HORÁNYI (1962). The Author is indebted to Madame Edith Róth of the *Académiai Kiadó,* Budapest, to Professor Mátyás Horányi, and to Dr Štefan Krivuš, Director of *Matica Slovenská,* for help with Maurer's sketch-book in the Čaplovič Library, Dolny Kubín. He is also indebted to Miss Milena Michalková for assistance with correspondence.

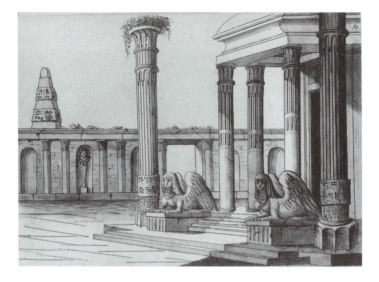

Plate 136 *Stage-design by Carl Maurer for Mozart's* Die Zauberflöte *(page 10 of Maurer's sketch-book, dated 1812), showing decorations for the theatre at Kismarton (Eisenstadt). This, and the following two designs, appear to have been used for a production of the* Singspiel *first given at Kismarton on 10 August 1804 under the direction of Johann Nepomuk Hummel (1778–1837). There are winged, breasted sphinxes, fake hieroglyphs, a steeply pitched banded pyramid, and a temple-front with, significantly, segmental top to the portico* (MAURER).

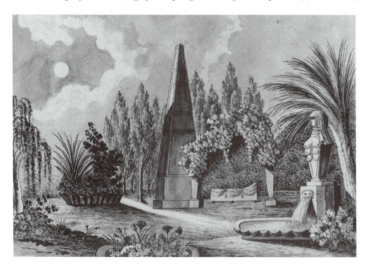

Plate 137 *Carl Maurer's design (page 15 from his sketch-book) for the moonlit garden (Act II, Scene 8) in* Die Zauberflöte. *In the centre is an obelisk divided into five panels on each face, and on the right is a crudely represented Artemis of Ephesus with breasts instead of necklaces of eggs or testicles* (MAURER).

254

dark (**Colour Plates XVIII–XXV**). Schinkel's memorable images include the Queen of the Night on her crescent-moon under a Pantheon-like hemi-dome of stars in the form of the ribs of a vault (**Colour Plate XIX**); the distant Philæ-like view of Sarastro's temple (**Colour Plate XXI**); the Garden with massive sphinx in the moonlight (**Colour Plate XXII**); the underground vault (**Colour Plate XXIII**); and the mighty Closing-Scene with Osiris in the centre and the Great Pyramid (**Colour Plate XXV**).[13]

There is also an extraordinary design by Schinkel for the interior of the Temple in Jerusalem made for the 1817 production of the opera *Athalia* by Johann Nepomuk, Freiherr von Poissl (1783–1865), to a text (after Racine) by J. G. Wohlbrück. Schinkel's Temple had coved Egyptian cornices over columns with palm-capitals set *in antis*, while the rest of the decorations derived from Assyrian, Persian, and other styles. The massive room was illuminated by a clearstorey supported on squat Egyptianising columns.[14]

Plate 138 *Carl Maurer's design (page 16 from his sketch-book) for the entrance to the Trials by Fire and Water (Act II, Scene 32) in* Die Zauberflöte. *Maurer uses the corbelled pseudo-arches which derive from Piranesi's* DM, *and also shows primitive unfluted Doric columns (to suggest Egypt) and the canted arch (which derives from the corbelled arch). The canted and corbelled arch-forms, seen here together, were to become common features in the Egyptian Revival of the nineteenth and twentieth centuries, and were popular in* Art-Déco *work. The angled 'arch', for example, recurs in bridges associated with the M1 Motorway designed in the 1930s* (MAURER).

13 *See Kupferstichkabinett und Sammlung der Zeichnungen*, Berlin, Nos 22C/12 IX Pass, 22C/102 Pass, and the published reviews of Schinkel's designs by CARL FRIEDRICH THIELE (1823).

14 SM 22b. 104, numbered 131 in the *Catalogue* of the 1981 Schinkel Exhibition in Berlin, now in the *Kupferstichkabinett und Sammlung der Zeichnungen* in Berlin.

Other interesting designs for *Die Zauberflöte* include those of Simon Quaglio (1795–1878). Dr Manfred Boetzkes has said[15] that 'Quaglio's stage-sets are fully equal in authority to those of Schinkel'. Quaglio, like Schinkel, 'seeks inspiration from Egyptian architecture, and his success in doing so may be seen from impressive studies like the Temple Forecourt and imaginative works like the Egyptian Interior' (**Plates 139–141**).[16] Norbert Bittner (1786–1851), the Viennese architectural painter and etcher, produced illustrations of stage-designs after Josef Platzer and Antonio di Pian for *Die Zauberflöte* (**Plates 142–143**),[17] and Friedrich Christian Beuther (1777–1856) – who was interested in an archæologically correct Classicism – designed sets for Mozart's *Singspiel* including a fine garden with sphinx at night, and an Egyptian room of some grandeur (**Plates 144–145**).[18]

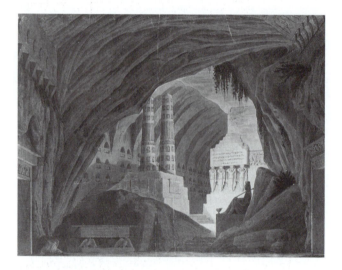

Plate 139 *Pen-and-water-colour design by Simon Quaglio for Act II, Scene 20, for the 1818 production of* Die Zauberflöte *at the* Nationaltheater, Munich. *This 'strange vault' combines built forms with natural rocks, and incorporates familiar motifs such as funerary* loculi, *Egyptian doorcases, two pillars like circular obelisks with collars set around their outside, stepped Piranesian forms,* caryatids *with Egyptianesque head-dresses, hieroglyphs, and a seated figure* (DTMFCZ-S, IK: IX Slg. Q., Inv. No. 530, Neg. No. 2253).

15 *See* ARTS COUNCIL OF GREAT BRITAIN (1972), 943.
16 In ARTS COUNCIL OF GREAT BRITAIN (1972), 943, item 755. *See* S. Qu. 503, S. Qu. 532, and S. Qu. 525 of the *Clara Ziegler-Stiftung, Theatermuseum,* Munich. *See also MASKE UND KOTHURN* (1956), **ii**.
17 *See* No. G. 16939 a and b, *Institut für Theaterwissenschaft der Universität Köln,* and *Theater-dekorationen nach den Original Skizzen des K.K. Hoftheater Mahlers Anton de Pian. Radiert und verlegt von Norbert Bittner* (Vienna: 1818). *See also* ROSENBERG (1972): *passim.*
18 G. 16928a, G. 16927, *Institut für Theaterwissenschaft der Universität Köln.*

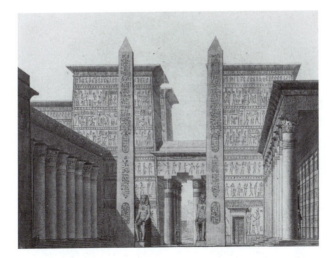

Plate 140 *Pen-and-water-colour design by Simon Quaglio for Act II, Scene 2, for the 1818 production of* Die Zauberflöte *at the* Nationaltheater, Munich. *The forecourt to the temple is shown, with massive pylons, obelisks, colonnades, and colossal seated Egyptian figures. Quaglio's slightly off-axis approach should be compared with Schinkel's deliberately balanced symmetry. The two massive obelisks are allusions to Jachin and Boaz, while looking suitably Egyptian in their context. The stepped corbelled 'arch' over the entrance should be noted* (DTMFCZ-S, IK: IX Slg. Q., Inv. No. 532, Neg. No. 2251).

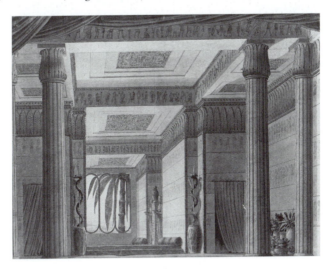

Plate 141 *Pen-and-water-colour design by Simon Quaglio for Act I, Scene 13, for the 1818 production of* Die Zauberflöte *at the* Nationaltheater, Munich. *This room in Sarastro's palace combines Greek and Egyptian features (note the palm-capitals and frieze, Egyptian figures, coffering, and glazing-bars to the window)* (DTMFCZ-S, IK: IX Slg. Q., Inv. No. 525, Neg. No. 2252).

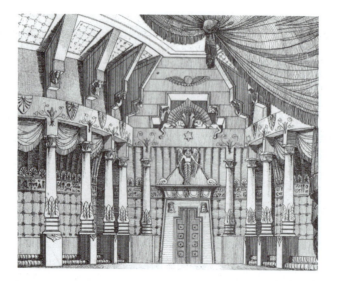

Plate 142 *Etching after Josef Platzer and Antonio di Pian by Norbert Bittner of the Egyptian room (*Prächtiges Zimmer in Sarastros Palast*) in Act I, Scene 13, for the 1818 production of* Die Zauberflöte *at the* Kärntnertortheater, *Vienna. Note the stepped corbelled form from Piranesi* (TMK, No. G. 16939a).

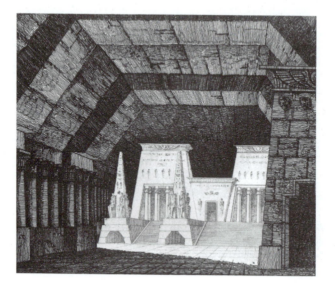

Plate 143 *Etching after Josef Platzer and Antonio di Pian by Bittner, showing the vaults between the pyramids in Act II, Scene 20, for the 1818 production of* Die Zauberflöte *at the* Kärntnertortheater, *Vienna. Note the canted arches derived from Piranesi over the vault and in the podium of the temple* (TMK, No. G. 169396).

258

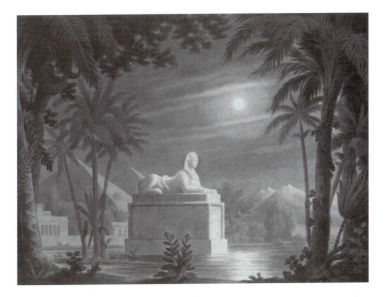

Plate 144 *Tempera-and-water-colour design by Friedrich Christian Beuther showing the garden with Sphinx at night for Act II, Scene 8, of* Die Zauberflöte *at the* Kurfürstliches Hoftheater, *Kassel, in 1821* (TMK, No. G. 16928a).

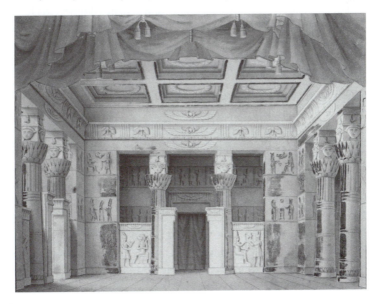

Plate 145 *Tempera-and-water-colour design by Beuther for the Egyptian room in Act I, Scene 13, for the 1817 production of* Die Zauberflöte *at the* Grossherzogliches Hoftheater, Weimar, *and for the 1821 production at the* Kurfürstliches Hoftheater, *Kassel* (TMK, No. G. 16927).

The Commercial Picturesque and the Adoption of Egyptian Forms

William Bullock (*fl.*1808–27) opened his Egyptian Hall at what is now 170–173 Piccadilly, London, in 1812 as the London Museum. The building was intended to house his collection of curiosities, and was designed by Peter Frederick Robinson (1776–1858), who had a reputation as a connoisseur of styles, and who had advised the Prince of Wales on Chinese furnishings for the Royal Pavilion at Brighton. This was an early design alleged to be based on archæological investigations of the Egyptian style, and was supposed to be 'taken from Denon's celebrated work', and 'principally from the great temple' at Dendera.[19] The façade was framed within a torus moulding and crowned by a massive cavetto cornice: on the ground floor two bud-capitaled columns set *in antis* framed the entrance; on either side were windows with stepped corbelled heads *à la Piranesi*; and the ground-floor storey was crowned by a smaller cavetto cornice embellished with the winged globe. Above, the second storey was illuminated by three windows, all held within battered pylon-like torus-frames each crowned with a cavetto cornice embellished with winged globes, but the central window was taller than the other two and had a stepped corbel-arched head supported on two figures, one male and one female. These Coade Stone figures, described by James Elmes (1782–1862) as 'sturdy Ethiopians', were supposed to represent Isis and Osiris, but managed to look more like rather incontinent and embarrassed 'Red Indians': they were carved by the Irish sculptor Sebastian Gahagan (*fl.* 1800–35) (**Plate 146**). Above the cornice of the central window were two sphinxes tail-to-tail. Architraves were liberally decorated with bogus hieroglyphs. Elmes, master of John Haviland (1792–1852) (who, according to Professor Carrott's estimation, was the 'greatest of the American Egyptian Revival architects'),[20] was impressed by Robinson's efforts, supposing the Ancient Egyptians built their houses in storeys, and found Gahagan's figures 'novel in idea and application', Picturesque in effect, and adding variety to the composition, while 'the robust columns beneath them seem built exactly for pedestals'.[21] The large projection of the crowning cornice was 'grand and imposing'.

However, Mr Hugh Honour has pointed out that the claim of the Egyptian Hall to derive from Dendera has no foundation in truth, for the temple of Hathor at Dendera bears no resemblance at all to Robinson's confection. The late Professor Carrott has amusingly (and accurately) referred to buildings like the Egyptian Hall (probably erected for advertising

19 ALTICK (1978), 235–252, and ELMES (1827), 157.
20 CARROTT (1978), 34.
21 ELMES (1827), 157. *See also* HONOUR (1955), 243, 245. *See also* HONOUR (1954).

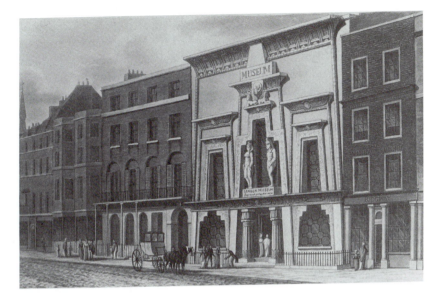

Plate 146 *The Egyptian Hall at 170–173 Piccadilly, London, built to designs of Peter Robinson in 1811–12 for William Bullock. The two figures looked more like Red Indians than Egyptian deities, but the façade, which was one of the very first examples in the Egyptian style in England, had a considerable influence on subsequent developments. From a print by Ackermann of 1815 (GLCL).*

purposes to appear novel, Picturesque, and different) as belonging to a genre that might be described as 'Commercial Picturesque'.[22] James Henry Leigh Hunt (1784–1859) said of the Egyptian Hall that 'Egyptian architecture will do nowhere but in Egypt. There, its cold and gloomy ponderosity ('weight' is too pretty a word) befits the hot, burning atmosphere and shifting sands. But in such a climate as this, it is worth nothing but an uncouth assembly. The absurdity, however, renders it a good advertisement. There is no missing its great lumpish face as you go along. It gives a blow to the mind, like a heavy practical joke'.[23]

In 1821 a curious twist of fate determined that the Egyptian Hall should house a magnificent exhibition of Egyptian art and artefacts brought to London by Giovanni Battista Belzoni (1778–1823). The Italian appealed to British patriotism to support explorations in Egypt (**Colour Plate XXVI**) in reply to the stream of scholarly publications being produced in France, notably the *Description*, and his achievements in Egypt from 1815 to

22 CARROTT (1978), 35. The late Professor Carrott's work on the Revival deserves respect, and some of his pithier observations have stood the test of time. His category of 'Commercial Picturesque' is little short of brilliant.
23 HUNT (1861), 43. *Quoted in* ALTICK (1978), 237.

1819 caught the imagination of the public to an extent not known again until over a century later when Tutankhamun's tomb was found. Thanks to Belzoni and Salt many of the finest Ancient Egyptian sculptures ever seen outside Egypt found permanent homes in London from 1818 to 1821, and the impact of these works on the public was compounded by the big exhibition in Bullock's Hall in 1821–22. Belzoni's *Narrative of the Operations and Recent discoveries within the Pyramids, Temples, Tombs and Excavations, in Egypt and Nubia* was published in London by John Murray in 1820, and is one of the most fascinating and lively accounts of Egypt ever written. Although the book was intended to extol his discoveries, it stands as something of a masterpiece.[24] The exhibition which followed in the Hall was an immediate success: it featured replicas of two of the finest chambers in the tomb of Seti I (whose sarcophagus Belzoni also brought to London), and it enabled enormous numbers of people to see the first major exhibition of Ancient Egyptian artefacts in London, so interest in Egypt was quickened.

The setting for Belzoni's exhibition was appropriate, for J. B. Papworth had re-styled the 'great apartment' into an Egyptian Hall in 1819. Papworth had been commissioned by Bullock to lay out *Hygeia*, a model town, for his estates in America, and his connections with the showman clearly were cordial. The Egyptian Hall (**Plate 147**) had Hathor-headed columns carrying a gallery, and was top-lit: Papworth also covered much of the interior with somewhat unscholarly, even uncouth (if the drawing is to be believed) Egyptianising ornament.[25]

Rudolf Ackermann (1764–1834), whose *Repository of Arts, Literature, Commerce* . . . (a monthly journal until 1828) published the Papworth design in September 1819, also published an extraordinary set of designs for Egyptianising playing-cards in 1819 (**Plate 148**). 'The figures', Ackermann observed, 'are beautifully drawn, the architecture well imagined, and the *accessories* of every description are introduced with a peculiarly tasteful feeling. The Nine of Diamonds is made to form an Egyptian sepulchre; two obelisks form the entrance, leading to a massive pyramid, which composes the background of the picture, and the diamonds are converted into characteristic embellishments'.[26] Bogus hieroglyphs and winged globes complete the picture. The Six of Hearts has two seated Egyptianising figures holding inverted obelisks (so they look rather like terms) on either side of a portal leading to a darkly menacing route: the sources are derived from *Diverse Maniere*, much modified, with bogus hieroglyphs. The Four of Spades features a canopy carried on four columns sheltering a pyramid and

24 BELZONI (1820, 1821, 1822).
25 *See The Survey of London*, **xxix**, 266–70.
26 Mr Ralph Hyde kindly drew the Author's attention to these curious designs.

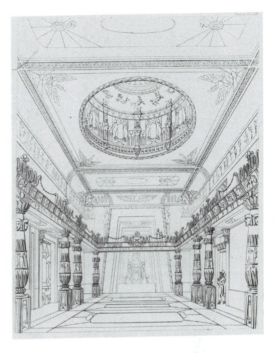

Plate 147 *Interior of the Great Room of the Egyptian Hall, Piccadilly, London, as modified by John Buonarotti Papworth in 1819. No. 45 of R. Ackermann's* Repository of Arts &c., *published 1 September 1819* (GLCL).

a globe, and the Two of Diamonds features pyramids and a fountain (very Isiac). This odd series of designs contains many allusions to funerary architecture, to tombs and temples, to Egypt and to Neo-Classical subterraneous vaults. Freemasonic stars, crescent-moon, tripod, square, two pillars, and other emblems can be found in these strange cards.

Bullock's Egyptian Hall, despite its shortcomings in terms of scholarship and taste, had an enormous influence in England and around the world. Its fame gave publicity to all things Egyptian, and advanced the evolution of Egyptomania in all branches of the decorative arts.[27] One of its architectural progeny was the former Classical and Mathematical School, which became the Civil and Military Library, Ker Street, Devonport, Plymouth, built to designs by John Foulston (1772–1842) in 1823. This was part of a group of buildings by the same architect, but all in different styles: a range of Classical houses; a Greek Doric town-house and column; an Oriental 'Hindoo'-Gothick chapel; and the Egyptian Library (which also contained an impressive display of minerals presented by Sir John St Aubyn Bart.[1758–1839]). This eclectic historicism, giving a wide stylistic choice, was justified by Foulston himself. He said that if 'edifices, exhibiting the various features of the architectural world, were erected in conjunction, and skilfully grouped, a happy result might be obtained . . .'. Foulston was

27 HUMBERT, PANTAZZI, and ZIEGLER (*Eds.*) (1994), 275.

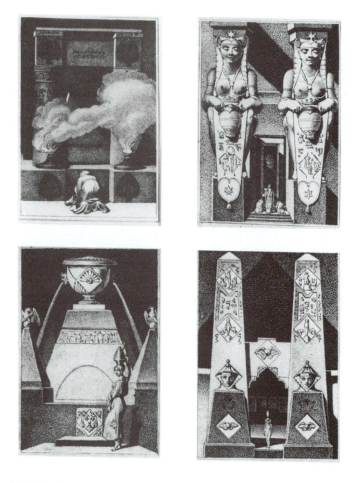

Plate 148 *Four designs from R. Ackermann's* Pictorial Cards, in Thirteen Plates *(1819). These odd concoctions, 'by an artist of Vienna', have a strong Freemasonic flavour similar to Alberti's decorations for the libretto of* Die Zauberflöte *of 1791* (**Plate 135**). *Top left is the Four of Spades, top right (with female Egyptianising terms) is the Six of Hearts,* bottom left *is the Two of Diamonds, and* bottom right *is the Nine of Diamonds (note the Antinoüs-like figure under the arch)* (GLCL and The Worshipful Company of Makers of Playing Cards).

'induced to try an experiment (not before attempted) for producing' a Picturesque effect, 'by combining in one view, the Grecian, Egyptian, and a variety of the Oriental . . .'.[28] Foulston was therefore working within the Picturesque tradition, the consequences of which were to broaden the stylistic palette. However, his library (**Plates 149–150**) reminded critics more of Bullock's Hall in Piccadilly than anything in Egypt, and it certainly

28 FOULSTON (1838), *passim.*

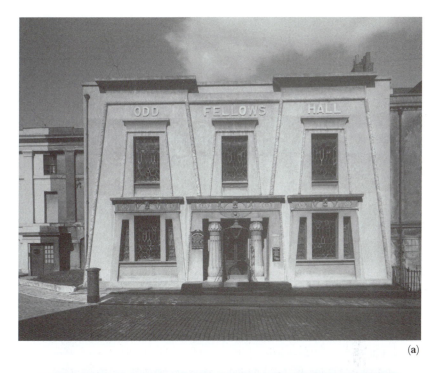

(a)

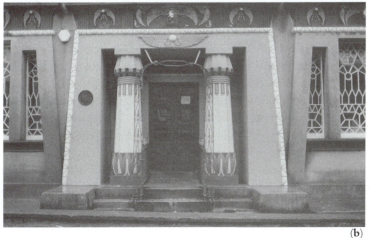

(b)

Plate 149 (a) *Front elevation of the Civil and Military (or Public) Library (now Odd Fellows Hall) in Ker Street, Devonport, Plymouth, Devon, by John Foulston, of 1823, photographed in 1957. The Egyptian style was associated with learning, curiosities, and the Great Library at Alexandria, and Foulston's building has features in common with Robinson's Museum, including the tripartite composition, the pylon-shapes with roll-mouldings and cavetto cornices, the stumpy columns at the entrance (probably derived from Denon), and the elaborate glazing-bars* (NMR. AA58/44). (b) *Detail of the main entrance. Photograph of 2002* (JSC).

265

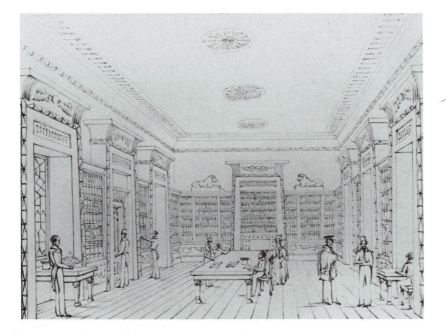

Plate 150 *Interior of Foulston's 'Civil and Military Library, Devonport', from* Public Buildings erected in the West of England, *showing the Egyptianising interior* (JSC).

can be compared unfavourably with Regency Greek Revival designs, which were far more scholarly. The interior had cavetto cornices, torus mouldings, winged discs, and other Egyptianising features, whilst the main façade was basically composed of two torus-edged pylons, a two-storey arrangement of window-openings (with elaborate glazing-bars), and had an entrance flanked by bud-capitaled columns. In 2002 the building was in a poor state of repair, and although some details survive in what was the library on the first floor, the interior of the ground floor has been virtually gutted. Ker Street was redeveloped after the 1939–45 war, and Foulston's remaining buildings (the Doric town-house, the column, and the former Library) now have a dismal setting of grey apartments that could easily have strayed from Stalinist Eastern Europe.

Egyptian Revival obelisks are more usually found as single monuments, following the trend established in sixteenth-century Rome, and the impressive obelisk on its Egyptianising base at Rostrevor, Co. Down, of 1826, is no exception: it was erected in 1826 to the memory of Major-General Robert Ross, who had seen service in Egypt from July 1801 until the end of that year (**Plate 151**). Indeed, the nineteenth century saw a growing popularity of this Egyptian form as a commemorative object, either as an eyecatcher, individual monument, or grave-marker in

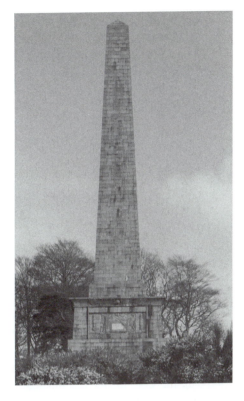

Plate 151 *Massive granite obelisk at Rostrevor, Co. Down, with Egyptianising pedestal incorporating a steeply battered die, a large cavetto cornice decorated with winged orbs and uræi, and a relief showing a draped sarcophagus with flags and military trophies flanked by inverted torches. It was erected in memory of Major-General Robert Ross (1766–1814) in 1826, and was designed by William Vitruvius Morrison (1794–1838). Photograph of 1990 (JSC).*

cemeteries. Obelisks are so common in cemeteries they cannot be listed here, but among rather fine individual commemorative obelisks standing alone in the landscape can be mentioned (Sir) Robert Smirke's massive Wellington Testimonial in Phœnix Park, Dublin, of 1817–22 (**Plate 152**),[29] and the War Memorial to the men of Co. Antrim who died in the Great War of 1914–18 that stands on the Knockagh Hill at Greenisland, overlooking Belfast Lough: the latter was designed by Henry Seaver (1860–1941),[30] and is a scaled-down version of the Wellington Testimonial.

Parisian Hathor-heads and other Egyptianisms can be found (appropriately) in the Place du Caire in a building (No. 2) of 1828, sculpted by J.-G. Garraud, but the detail is somewhat clumsy and bucolic (**Plate 153**). Much more scholarly is Luigi Canina's Egyptian Gate in the Borghese Gardens in Rome, also completed 1828 (**Plate 154**). The Gardens were originally an attempt to encapture something of the atmosphere of the *Villa Adriana* at Tivoli: Canina bridged a road, using stone from Tivoli, and gave grandeur to his work by adding a superstructure in the Egyptian style. He

29 The Author is indebted to Dr Maurice Craig for this item. Smirke was knighted in 1832.
30 *See* obituary in *The Builder*, **clx**/5133 (20 June 1941), 588.

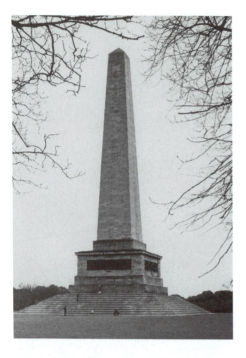

Plate 152 *The Wellington Testimonial, Phoenix Park, Dublin (1817–22), designed by (Sir) Robert Smirke. Photograph of 1977 (JSC).*

built the great pylons (with stairs inside) flanking the axis, with on one side Egyptianising colonnades terminating in lower pylon-forms guarded by lions, and on the other a pair of obelisks (without pedestals) decorated with hieroglyphs. Canina used brick covered in dark red stucco[31] to imitate Egyptian granite (Hope would not have approved). A Picturesque technique combined with some archæological expertise thus engendered architectural associations and some identifications with Tivoli. As an evocative and memorable work the gate succeeds, but it is not a slavish copy: elements from an ancient architectural vocabulary were used, but new purposes and ideas were expressed. This is a case where obelisks were used in a true Egyptian manner, that is in pairs on either side, marking a route. The cast-iron Egyptian gates (1827–30) to the Park of Alexander at Tsarskoe Selo, near St Petersburg in Russia, are even more splendid and spectacular:[32] the pylons are covered with Egyptianising figures in reliefs, and the gate-piers are herms (rather than terms) with *nemes* head-dresses. They were designed by the Scots architect Adam Menelaws (*c.*1749–1831) and the figures were designed by Vasily Ivanovich Demuth-Malinovsky (1779–1846).

There was another source for the popularisation of the Egyptian style in the pictures and engravings of John Martin (1789–1854), the English

31 In 1999 it was being *painted* cream, and was already a target for Roman *graffiti*.
32 Illustrated in HUMBERT (1989*a*), 65.

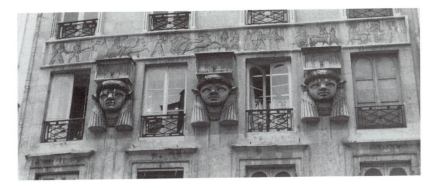

Plate 153 *Hathor-heads on No. 2 Place du Caire, Paris, sculpted by J.-G. Garraud in 1828, and based on figures at Dendera, Philæ, and Deïr-el-Medineh. The façade has other Egyptianesque elements such as the gorge-cornice with fake hieroglyphs and the columns on the ground floor. Photograph of 1983 (JSC).*

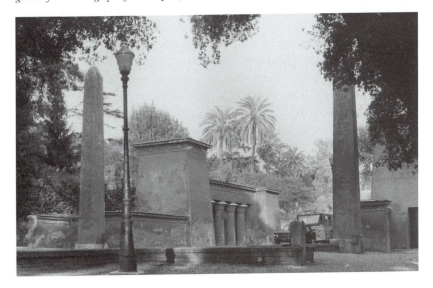

Plate 154 *Egyptian Gate by Luigi Canina (1795–1856) at the Villa Borghese, Rome, of c. 1825–28. This is a symmetrical composition with an obelisk, two pylons, and a colonnade on each side of the axis formed by the road. Obelisks are decorated with hieroglyphs, and Egyptianising lions complete the composition. Photograph of 1980 (JSC).*

painter of large visionary and apocalyptic scenes with Biblical and Oriental settings: these images exerted a very great influence on Romantic taste in Europe and America. Martin became famous in 1816 with *Joshua Commanding the Sun to Stand Still*, and followed this with a series of enormous canvases, the most Egyptianising of which were *The Destroying Angel*,

The Death of the First Born, and *The Seventh Plague of Egypt*. Prints were made of Martin's work by Ackermann, Le Keux, and others, and many were pirated, so these visionary compositions became familiar to a wide public. Martin was greatly admired in France: he was honoured by both Charles X and Louis-Philippe, and his work attracted the attention of Charles Augustin Sainte-Beuve (1804–69), Victor Marie Hugo (1802–85), and Théophile Gautier (1811–72). Gustave Planche (1808–57) described Martin in 1834 as the 'poet's painter', and Willem Bürger (pseudonym of Étienne-Joseph-Théophile Thoré [1807–69]) said in 1863 that of all painters Martin had the highest reputation in Europe. Martin, in short, was the master of Sublime Terror. Jules Michelet (1798–1874) was reminded of Martin's visions by the opulence of John Nash's developments in London.[33] The creations of Alexander 'Greek' Thomson in Glasgow[34] also have a certain affinity with the grandeurs of Sublime compositions in Martin's paintings.

There seems to have been a considerable interest in the Egyptianising style in the provinces, especially in the West of England. Foulston's work in Plymouth has been mentioned above, but his partner, George Wightwick (1802–72), produced several Egyptianising designs, some of which are in the RIBA Drawings Collection: there are shop-fronts with Egyptianising cast-iron columns, and designs for fireplaces of some refinement (**Plate 155**) by him. Wightwick wrote an account of Foulston that is entertaining and informative, and contributed to E. Nettleton's *Guide to Plymouth, Stonehouse, Devonport, and the Neighbouring County* of 1836. In the West of England he designed many houses, shops, terraces, public buildings, and often used Egyptianisms in his details.[35]

Also in the 'Commercial Picturesque' category of Professor Carrott is the Egyptian House in Chapel Street, Penzance, Cornwall (**Plate 156**), a design slightly closer to Bullock's Hall in Piccadilly than to Foulston's Devonport library, created in *c*.1835–6, and, like the London building, was erected as a museum, although it also functioned as a shop. It was built for John Lavin, bookseller and dealer in minerals,[36] who collected geological specimens, but who was also an agent for the sale of various artefacts, including chimney-pieces and obelisks, manufactured by the Lizard Serpentine Company.[37] Therefore, like the Devonport library and Museum, it had a connection with the display of minerals. With the fireplace and Devonian connections it is possible that Wightwick could have been the

33 OSBORNE (1970), 695–6.
34 *See* STAMP and MCKINSTRY (*Eds.*) (1994) and STAMP (*Ed.*) (1999). *See also* McFADZEAN (1979).
35 COLVIN (1978 edition), and information provided by Mr John Harris, who helpfully suggested an examination of Wightwick's work.
36 Information kindly provided by the Morrab Library, Penzance: the Author is indebted to Miss Jan Ruhrmund.
37 CONNER (*Ed.*) (1983), 55.

Plate 155 *Two chimney-pieces in the Egyptian style by George Wightwick, probably dating from the 1830s. Wightwick settled in Plymouth in 1829 and began practice on his own behalf before joining John Foulston in partnership prior to Foulston's retirement in c. 1836. Thereafter, until 1851, Wightwick was the leading architect in the South-West of England (RIBADC).*

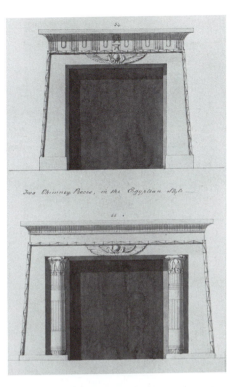

designer, but, infuriatingly, documentary evidence for the involvement of either him or Foulston has eluded all searches. The design of the Royal Arms on the building suggests it was completed before 1837 (the Accession of Queen Victoria), and we know Lavin bought the two cottages on the site in 1835, so the building can be dated with some accuracy. During the restoration of the building in the early 1970s (carried out under the direction of Mr Paul Pearn), it was discovered that the two herms flanking the central window on the first floor were of Coade Stone.[38]

No. 144 Fore Street, Exeter, Devon, acquired some vaguely Egyptianesque features in *c.* 1830,[39] and, strangely enough, No. 42 Fore Street, Hertford, Hertfordshire, also acquired a stucco front of Egyptianising type in *c.*1822 (**Plate 157**), having battered architraves with winged globes over the first-floor windows, and a torus-moulding framing the façade which is capped by a cavetto cornice suggesting a pylon. The shop-front is

38 KELLY (1990), 134, and n. 61, 144.
39 NIKOLAUS PEVSNER (1952): *South Devon* (Harmondsworth: Penguin Books Ltd), 158. Holloway Street, Exeter, has a few surviving houses with Egyptianising window surrounds and doorcases, and Professor CARROTT (1978), 35, mentions the 'Heavitree Brewery at Exeter, Devon, of about 1833, by R. Ford'. The brewery was demolished in the 1980s, but, in the words of PEVSNER's *Devon* (1989), 433, was 'slightly Gothic'. Mr Ford has eluded discovery.

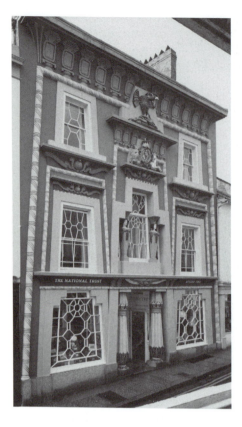

Plate 156 *Egyptian House in Chapel Street, Penzance, Cornwall, of c.1835. Note the remarkable pattern of glazing-bars, the zig-zag pattern all over the torus mouldings, and the stepped corbelled arches derived from Piranesi's* DM. *Could Foulston and/or Wightwick have been involved?* (The National Trust).

Plate 157 *No. 42 Fore Street, Hertford: a remarkable survival, with shop-front in the Egyptian style, and a street-front above with battered Egyptianising architraves. Photograph of 1978* (JSC).

Egyptianesque as well, and it is a remarkable survival, but the basic façade is simply Egyptianising detail applied to a standard late-Georgian façade. Egyptianisms were not all that rare in the domestic architecture of the first half of the nineteenth century, but full-blooded Egyptianising façades such as Bullock's Museum, Chapel Street, Penzance, and Fore Street, Hertford, are not common. In Richmond Avenue, Islington, London, for example, there is a handsome terrace (Nos 46–72) that is of a conventional London early-Victorian type, except for the severe Greek detail of the ground-floor façade and the Egyptianising sphinxes and obelisks flanking the entrances (**Plate 158**).

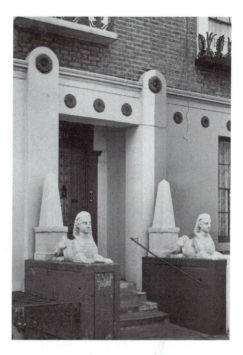

Other Egyptianising Designs

The idea that Egyptian architecture could suggest strength, solidarity, and durability led to its being seen as appropriate for structures such as mills, railway-stations, bridges, retaining-walls, prisons, and so on. Some early suspension-bridges with Egyptianising features in the designs have been identified: they include Brighton Chain Pier of 1823 by Captain (later Sir) Samuel Brown (1776–1852) and the Clifton Suspension Bridge, designed in 1831 (but started on site in 1836) by Isambard Kingdom Brunel (1806–59) (**Plate 159**). The pylons were ready by 1840, and work was only resumed in 1861 under John Hawkshaw (1811–91) and William Henry Barlow (1812–1902), to be completed in 1864. The original scheme had pylons with coved cornices, winged globes, sphinxes on top, hieroglyphs, and much else, and the bridge was quite extravagantly admired by all,[40] although it was not built as designed. The pylon-form was thought to be ideally suited for suspension-bridges, and several such bridges incorporated Egyptianising elements, such as that at Anzio with lotus-columns and sphinxes,[41] and the bridge near St Petersburg in Russia mentioned by Henry-Russell Hitchcock.[42]

40 MARÉ (1954), 174.
41 BAEDEKER (1896): *Southern Italy and Sicily* (Leipzig: Bædeker), 18.
42 HITCHCOCK (1958), 58.

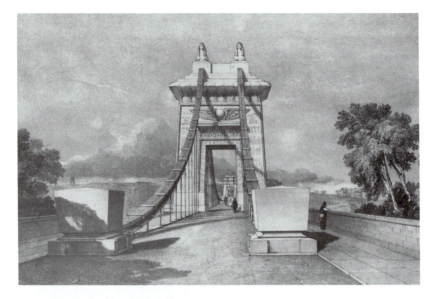

Plate 159 *Gateway (actually the pylon-tower from which the structure is suspended) to Clifton Suspension Bridge, 1831. Lithograph after the unrealised design by Isambard Kingdom Brunel. The pylon was derived from that at Dendera, but the pylon-form is admirably suited to suspension-bridges, while, extended, the battered form is ideal for retaining-walls, dams, and the like, so similar shapes are found in many structures of the nineteenth century. Note the pylon-piers with winged globes, sphinxes on top, battered opening and sides, and the cables anchored in massive sarcophagi-like blocks* (City of Bristol Museum and Art Gallery).

Indeed, one of the earliest, grandest, and most ambitious of designs for a bridge in the Egyptian style was prepared (*c.*1826–7) by Pierre-Dominique Bazaine (1786–1838) to connect Vasilevskyi Island and the northern quay at St Petersburg: it consisted of two massive pylon-towers from which the chains were suspended, with the ends of the chains anchored beneath blocks on which were Egyptianising lions. The pylons were adapted from the great south gate at Karnak, but decorated with an impressive series of reliefs to celebrate Alexander I's victories over Napoléon. In a further iconographical twist, the winged globe became the double-headed imperial Russian eagle with outstretched wings. The design, however, was never realised.[43]

There were other proposals, some built, some not, which exploited the pylon-tower form for suspension-bridges,[44] and the battered profile of

43 Bazaine's drawings are now in the Canadian Centre for Architecture, Montréal (DR 1980.019:3–5), to which institution the Author is indebted, as he is to Madame Michèle Picard for being his *cicerone* in Montréal. *See also* HUMBERT, PANTAZZI, and ZIEGLER (*Eds.*) (1994), 322–5.

44 HUMBERT, PANTAZZI and ZIEGLER (*Eds.*) (1994), *passim.*

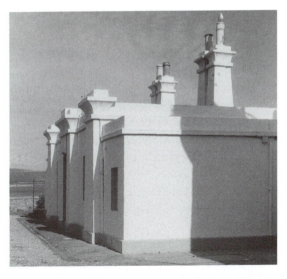

Plate 160 *Egyptianising details on the lighthouse-keeper's cottages at Cromarty, Scotland, designed by Alan Stevenson (1846). Photograph of 1985 (JSC).*

Egyptian walls was appropriate for use in retaining-walls (as in the Croton Distributing Reservoir [1842] in New York[45]) as well as to suggest enormous strength, holding in something behind, be it water (as in reservoirs), earth (as in retaining-walls), or social transgressors (as in prisons).[46]

An association with strength, durability, and so on also rendered the Egyptian style suitable for buildings connected with safety, such as lighthouses. A remarkable series of Egyptianising lighthouses and ancillary buildings was erected in Scotland to designs by Alan Stevenson (1807–65): examples include those at Cromarty (1846) (**Plate 160**), Fortrose (1846 – Ross and Cromarty), and Noss Head (1849 – Caithness). Stevenson also added two ranges of Græco-Egyptian houses to the lighthouse complex at Eilean Glas, Scalpay, in *c*.1845.[47] Painted white, these charming buildings sit beautifully in the Highland landscapes.

It is curious (given the recommendation by Thomas Hope that young artists should never adopt the Egyptian style save from notions more 'weighty' than novelty, and his observation that hieroglyphs 'can afford us little pleasure on account of their meaning, since this is seldom intelligible') that pseudo-hieroglyphs and Egyptianisms not based on available accurate sources should have been employed by designers well into the nineteenth century. Hope opined that hieroglyphs could 'afford us still less gratification

45 *See* CARROTT (1978), plates 86 and 87.
46 For example, the 'Tombs', New York (1835–8). *See* CARROTT (1978), plates 111–14, 116, 118, 121–5, etc.
47 *See* JOHN GIFFORD (1992): *Highlands and Islands* in *The Buildings of Scotland* series (London: Penguin Books Ltd, in association with The Buildings of Scotland Trust), 62, 124, 347, 399, 418, 626, 629, and plate 122.

on account of their outline, since this is never agreeable . . . Real Egyptian monuments, built of the hardest materials, in the most prodigious blocks, even where they please not the eye, through the elegance of their shapes, still amaze the intellect, through the immensity of their size, and the indestructibility of their nature. Modern imitations of these wonders of antiquity, composed of lath and plaster, of callico and of paper, offer no one attribute of solidity or grandeur to compensate for their want of elegance, and grace, and can only excite ridicule and contempt'.[48] This interesting passage is also quoted in John Claudius Loudon's (1783–1843) *An Encyclopædia of Cottage, Farm, and Villa Architecture and Furniture*,[49] one of the most influential publications of its day. Loudon dwelt at some length on the massiveness, gloom, magnitude, solidity, and permanence of Egyptian architecture in *The Architectural Magazine*,[50] and took considerable pains to stress fitness of purpose to legitimise style as appropriate to use.[51]

In France, however, the Egyptianising Taste continued to have patriotic and Napoleonic associations, not least because of the distinguished designs that stood in Paris. A *Fontaine du Déo* was erected in Mauvages (Meuse) in 1831 to designs by Théodore Oudet inspired by the *Fontaine du Fellah*, the water-carrier's fountain in the rue de Sèvres in Paris, which, as previously noted, incorporated the Antinoüs figure as a 'Fellah' (**Plate 117**). A monument by Claude Dejoux (1732–1816) to General Louis-Charles-Antoine Desaix de Veygoux (1768–1800), Commander of the French army in Egypt, was erected by the Place des Victoires, Paris, on an Egyptianising pedestal designed by Le Peyre, in 1810, complete with the little obelisk from the Albani Collections in Rome.[52] Enthusiasm for things Egyptian in France gained further momentum when the Napoleonic dream of erecting an Ancient Egyptian obelisk in Paris was realised: one of the obelisks from Luxor was carefully dismantled and shipped to France (in the appropriately-named *Louxor* towed by the *Sphinx*), where it was re-erected in the Place de la Concorde under the direction of the engineer Apollinaire Lebas in 1836 (**Plates 161 [a, b,** and **c]**). The pedestal and foundations were designed by Jakob Ignaz Hittorff (1792–1867), who was in charge of the alterations to the Place de la Concorde from 1832 to 1840. A special medal was struck to mark the occasion (**Colour Plate XXVII**).[53]

48 HOPE (1807), 27.
49 London: 1834, 1016.
50 **iv**, (1837), 278.
51 *Ibid.*
52 The obelisk was sold in 1815 to avoid the expense of having to return it to Rome. Purchased by Prince Ludwig of Bavaria (the future King Ludwig I), it was installed in von Klenze's *Glyptothek* in Munich, damaged in the 1939–45 war, and then restored and re-erected (1972) in the Hofgarten at the entrance to the Egyptian collections in the Bavarian capital's *Residenz*.
53 HUMBERT (1998), 153–163.

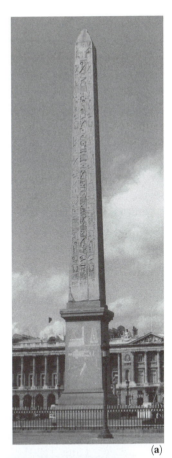

(a)

Plate 161 (a) *The great obelisk from Luxor as re-erected in the Place de la Concorde, Paris, in 1836 under the direction of the naval engineer Apollinaire Lebas. It was given to King Charles X (1824–30) by Mohammed Ali, Viceroy of Egypt, in 1829, and was re-erected during the reign of King Louis-Philippe.* (b) *The pedestal of the Place de la Concorde obelisk:* (i) *The obelisk being taken down at Luxor and barged;* and (ii) *being re-erected on its new pedestal in Paris. Photographs of 1990 (JSC).*

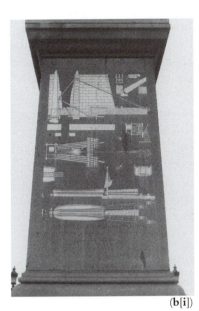

(b[i])

(b[ii])

European and Egyptian connections developed quickly, and with them the number of travellers and artists who went to study Ancient Egyptian remains. Owen Jones (1809–74) went to Egypt in 1832–33, where his observations of the decorative colour on buildings were to stand him in good stead years later. David Roberts (1796–1864) was to produce the most familiar of all images of Egypt produced in the nineteenth century in the published views of his beautiful *Egypt and Nubia* (1846–49),[54] based on his travels in Egypt in 1838–39. Roberts felt that the French publications conveyed 'no idea' of the 'splendid remains' of Ancient Egypt, but his own images embraced aspects of Egypt that appealed to early-Victorian Britain – the associations with the Bible, antiquities, and the exotic scenes associated with Islamic Egypt. Louis Haghe (1806–85) was responsible for the fine lithographs from Roberts's original drawings, and these became very popular after they were published in *Egypt and Nubia*: Queen Victoria and the Archbishops of Canterbury and York were among the distinguished subscribers to the book. Whilst Roberts himself produced Sublime inventions of imaginary scenes in Ancient Egypt perhaps even finer than those of Martin (his *Departure of the Israelites from Egypt* [exhibited 1829] is a memorable example [**Colour Plate XXVIII**]), his views for the published work were fresh, realistic, pellucid, and beautifully composed, with a marvellous sense of colour.

Joseph Bonomi Jr (1796–1878) worked in Egypt as a draughtsman (mostly for Robert Hay of Linplum [1799–1863], who began his expeditions up the Nile in 1824 – he was to employ Francis Vyvyan Jago Arundale [1807–53], Bonomi, Frederick Catherwood [1799–1854], Edward W. Lane [1801–76], and Charles Laver, and published his *Illustrations of Cairo* in 1840), and made three visits to that country in all.[55] He was involved in several Anglo-Egyptian projects, notably the illustrations for Sir John Gardner Wilkinson's (1797–1875) *The Manners and Customs of the Ancient Egyptians*, which came out in three volumes in 1837.[56] This Bonomi was the son of the Bonomi who designed the pyramidal mausoleum at Blickling in Norfolk (**Plate 86**) and who married a cousin of Angelika Kauffmann (1741–1807).[57] The younger Bonomi was a distinguished Egyptologist, was the second Curator of Sir John Soane's Museum, and married John Martin's daughter in 1845.

Roberts was invited by John Marshall of Leeds to make designs for a proposed flax-spinning mill because Marshall wished the building to advertise his products, and the Egyptians made linen out of flax, so he

54 *See* Select Bibliography.
55 *See* British Museum Add. MSS. 29812–60 an Add. MS. 31054).
56 *See* Select Bibliography.
57 Angelika Kauffmann and Maria Cosway, *née* Hadfield (1759–1838), were sponsors at Bonomi's baptism in Rome.

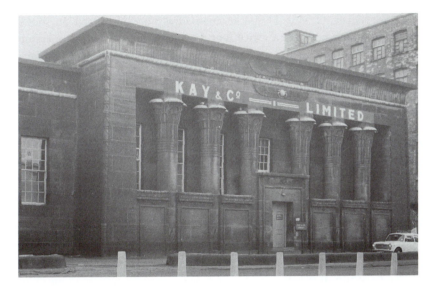

Plate 162 *Temple Mills, Marshall Street, Leeds (1842), by Joseph Bonomi Jr and James Combe of Leeds. This was the most coherent attempt to adapt an Egyptian temple to a commercial building. John Marshall of Leeds, keen to advertise his new flax-spinning mill, commissioned David Roberts to make designs, and Roberts contacted Bonomi for help. The main influences are Edfu and Dendera, and the chimney was an obelisk. Even the machinery inside was in the Egyptian style, chosen no doubt because the Ancient Egyptians used flax for the production of linen. Photograph of 1979 (JSC).*

stipulated an Egyptian Revival style. At first, Marshall employed a local engineer, James Combe (of whom very little appears to be known), but it seems his work did not satisfy the client, so Roberts was called in as an adviser, but he, in turn (not being an architect), contacted Bonomi for help. As finalised in 1842 the mill consists of an office-block and the factory: sources for the office-block are the temple at Antæopolis, as recorded in the *Description*, and the temple of Horus at Edfu, whilst the factory is clearly derived from the 'Typhonium' at Dendera, published in the *Description* (**Plate 162**).[58] Details of both blocks are scholarly, and it is quite clear they came from respectable archæological sources, such as the *Description*, and from first-hand observations by Bonomi and Roberts. Originally there was a chimney-stack shaped like an obelisk, whilst the double beam-engine of *c*.1840 by Benjamin Hick of Bolton had Egyptianising details and a regulator in the form of a winged solar-disc.[59]

58 CARROTT (1978), plates 17–20. Professor Carrott erroneously attributed the complex to Ignatius Bonomi.
59 Illustrated in CONNER (*Ed.*) (1983), 90. The model of this engine was exhibited at the Great Exhibition in London in 1851, and is now in The Science Museum, London.

So Marshall's Mill, Holbeck, Leeds, was not only based on sound scholarly source-books, but was also in the 'Commercial Picturesque' camp through its self-advertising aspects. It should be noted that the Mills were *not* designed by Bonomi's brother, Ignatius (1787–1870).[60] Again, like libraries and learning, there was an association with Ancient Egypt. Bonomi also produced another piece of associationism, this time with Isiac healing and water, when he designed an Egyptian *ædicula* over a spring at Hartwell House, Buckinghamshire, in 1851.[61] This commission stemmed from Dr John Fiott (1783–1866), who changed his name to Lee, and was a collector of Egyptian antiquities (many of which were acquired in Egypt in 1807–10): the inscription of hieroglyphs was composed by Samuel Birch (1813–85).[62]

Joseph Bonomi Jr's sandstone memorial in the West London and Westminster Cemetery at Brompton, London, has pretty, incised Egyptianising details co-existing (somewhat incongruously) with the *Chi-Rho* monogram. It is, however, a sombre piece, commemorating four of his children who died in 1852.[63] Not surprisingly, it was in the design of funerary monuments, mausolea, and the like, that the Egyptian style found widespread favour. Not only was so much Egyptian architecture associated with death, but its simple geometrical form appealed to designers searching for greater simplicity of expression as part of the movement we now term Neo-Classicism. Paradoxically, however, it was in funerary architecture that the Egyptian Revival came to grief at the hands of a vitriolic and obsessed polemicist who did immeasurable damage by equating morality and architecture, and blackening the style in the minds of generations to come.

60 *See Companion to the Almanac* (1844), 241–2; *Transactions of the Society of Biblical Archæology* (1879), **vi**; *Penny Magazine* (1843); and BONSER (1960). *See also* COLVIN (1978 edition), 124, and CONNER (*Ed.*) (1983), 89–90.

61 *See* SMYTH (1851), 156, 222, and (1851–64), plate 1.

62 CONNER (*Ed.*) (1983), 91.

63 JAMES STEVENS CURL (1989): 'The West of London and Westminster Cemetery at Brompton'. Final Report and Survey (1 September) for English Heritage.

CHAPTER VIII

The Egyptian Revival in Funerary Architecture

Introduction; Funerary Exemplars; The New Cemeteries; Pugin; Commemorative Egyptianisms; Conclusion

Egypt had maimed us,
offered dream for life,
an opiate for a kiss
and death for both.

HILDA DOOLITTLE (MRS RICHARD ALDINGTON [1886–1961]):
Egypt (1921), lines 5–8.

'Tis all one to lye in St *Innocents* Church-yard,
as in the Sands of *Ægypt*.

SIR THOMAS BROWNE (1605–82):
Hydriotaphia (1658), Ch. V.

Introduction

The use of obelisks and pyramidal compositions in funerary and commemorative architecture has already been noted. Pyramidal compositions (**Plate 58**), usually incorporating fat obelisk-shapes set flat against a wall, had been developed since the time of Bernini (and there are earlier instances): eighteenth-century European funerary monuments in churches were often of the pyramidal type of composition, with an obelisk as the main background against which sculptural groups could be set (a convention that, though very common, by no means attracted universal approval, and indeed drew upon it vitriolic abuse, notably in the first six decades of the nineteenth century). As Neo-Classical influences grew stronger, however, such designs for commemorative sculpture and architectural compositions associated with death tended to become more wide-angled, notably in the work of Boullée, whose low, spreading pyramids are particularly awesome in quality (**Plate 83**).

Jean-Nicolas-Louis Durand (1760–1834), probably one of the most influential architectural theorists of the Napoleonic period in France and Germany, trained under Boullée, and experimented with pyramids. His major publication is *Précis des Leçons d'Architecture données à l'École Poly-technique* (1802–5), which included an ideal pyramid with a domed circular interior surrounded by semicircular-headed *loculi* for urns, and Egyptianising *telamones* embellishing the first-floor façade of the *Maison Particulière exécutée à Paris, Rue du Faubourg Poissonière* (garden elevation). The pyramid design owed something to earlier exemplars, notably by Boullée, and variations of it were made by Friedrich Gilly and others.[1] Similar designs to those of Gilly can be found in the work of Giovanni Antonio Selva (1753–1819) (especially the latter's monument to Napoléon of 1813), and in the designs of Thomas Harrison (1744–1829) and of the Russian Alferov (1780–1840) (the last's monument to the defeat of the Tartars at Kazan of 1830 is a case in point, for it had distyle *in-antis* porticoes on each face, the pyramid was truncated, and the sides of the porticoes were battered).[2] The powerfully evocative possibilities of Egyptian architecture were exploited in these remarkable exercises in rigorous geometry. Selva's scheme was the result of his appointment to a Milanese commission to erect a monument to Napoléon on Mount Cenis: the pyramidal design was set on three steps, with octastyle Greek Doric porticoes on each face and the exterior may have been suggested by Antonio Canova's

1 RIETDORF (1940), plates 25, 26, 43, 44, 138, and 139. *See also* CARROTT (1978), plate 28.
2 BASSI (1936), *passim*. *See also* ARTS COUNCIL OF GREAT BRITAIN (1972), nos. 1234–5. For Alferov *see* CARROTT (1978), plate 29 and pp. 43–4, n. 45.

(1757–1822) monument to Titian. Selva may also have known Boullée's designs: the interior was to have been a Pantheon-like coffered dome carried on a vast entablature supported on Doric columns, whilst light was introduced by means of lunettes set above the pediments. By 1814 the project was abandoned as Napoléon's star faded. Selva collaborated with his friend Canova on the Dieden Monument in the Eremitani in Padua, and he was influenced by his studies in France and in England.

Funerary Exemplars

Canova, of course, designed a series of pyramid-tombs that incorporated flat pyramids of low pitch as the main element of the composition. From 1780, when Canova became acquainted with Gavin Hamilton (1723–98) and other members of the international set of Neo-Classical theorists, he developed a revolutionary severity and purity in his designs, and responded to Winckelmann's demands for noble simplicity. He studied Antique works to attain an ideal, and, as he produced his sculptures, many of his contemporaries thought he had excelled the Ancients. Lord Byron opined that Canova was the one heir to Italy's lost greatness, and many agreed with him. Now Canova is known to have seen the very beautiful and refined monument to Provost Richard Baldwin (c.1672–1758) of 1784 in the studios of Christopher Hewetson (c.1739–98) in Rome: it was a tall, obelisk-like pyramid of red oriental granite (the first, apparently, to be made of that material since Antiquity) against which were figures, and the whole was re-assembled in Trinity College, Dublin.[3] Canova's models of the monument to the Archduchess Maria Christina are similar to other funerary monuments of the pyramid-obelisk type in that there are figures in front of it, but he introduced a new severity, and a definite pyramid with primitivist entrance, instead of the obelisk. Canova originally designed a pyramid, with figures entering it, as a monument to Titian in 1790, but this plan failed to come to fruition. In 1798, however, Duke Albert of Sachsen-Teschen asked Canova to design and make a monument to his Duchess, who had died that year. Canova adapted his Titian designs and reversed the composition (**Plate 163**): the monument was erected in the *Augustinerkirche* in Vienna in 1805 as a cenotaph, for the Archduchess's body lies in the *Kaisergruft* of the *Kapuzinerkirche*. A similar design based on the Titian-Archduchess monument was later produced by Canova's pupils for the monument of

3 ALBRIZZI (1824), *passim. See also* POTTERTON (1975) and ARTS COUNCIL OF GREAT BRITAIN (1972), 202.

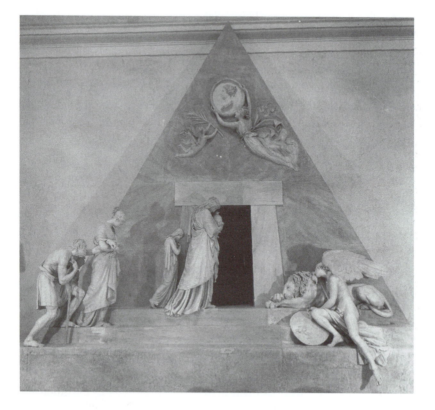

Plate 163 *Model (now in the* Gipsoteca Canoviana *in Possagno [the sculptor's birthplace]) for the tomb of the Archduchess Maria Christina by Antonio Canova: the design was realised in the Augustinerkirche, Vienna, in 1805, and shows the Three Ages of Man moving towards the primitivist door of the pyramidal tomb. The leading figure carries a funerary urn* (Conway Library, Courtauld Institute of Art, Neg. No. B72/2219).

Canova himself in the church of Santa Maria Gloriosa dei Frari in Venice, and was completed in 1827.

Sir Richard Westmacott (1775–1856) was a pupil of Canova and studied in Rome from 1793. His monument to Sir Ralph Abercromby (1734–1801) of 1809 in St Paul's Cathedral in London has overt Egyptianisms in the two sphinxes that flank the heroic central group (**Plate 164**). Other Egyptian allusions can also be found in St Paul's on the monument by Thomas Banks (1735–1805) to George Blagdon Westcott (*c.*1745–98 – who was killed at the naval battle of Aboukir Bay in 1798) (**Plate 165**). Banks knew Italy and stayed in Rome for seven years. Agostino Aglio (*fl.* 1807–38), the painter who exhibited at the Royal Academy in the first four decades of the nineteenth century, produced a design for a monument to Lord Nelson in 1805 incorporating a huge

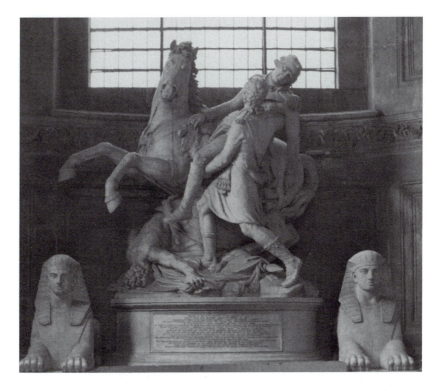

Plate 164 *Monument to Sir Ralph Abercromby in St Paul's Cathedral, London, by Sir Richard Westmacott. The Egyptian references refer to Abercromby's command and death in Egypt. Photograph of 1980 (JSC).*

pyramid with strange beasts in a fantastic landscape,[4] but, strangely, there is no allusion to Egypt whatsoever in Nelson's handsome tomb in St Paul's, although his funeral-car had several Nilotic motifs.[5]

According to Thomas Walker Horsfield (d. 1837), in his *History of Sussex,*[6] (Sir) Robert Smirke designed the pyramidal mausoleum (1812) of 'Mad Jack' Fuller (d. 1834) that stands in the churchyard of St Thomas Becket at Brightling in East Sussex. Unlike the Canova pyramids (which *appear* to be three-dimensional and are not steeply-pitched), the Brightling mausoleum is of the Cestius proportions, and is free-standing. In the churchyard of St Matthew's, Brixton, London, stands the extraordinary monument to Richard Budd (1748–1824) designed by R. Day, erected 1825, and described with glowing hyperbole by Thomas Allen (1803–33)

4 Print Room of The British Art Centre at Yale, no. B. 1977. 14. 4400.
5 Illustrated in JAMES STEVENS CURL (1972): *The Victorian Celebration of Death* (Newton Abbot: David & Charles [Publishers] Ltd), 5.
6 (1835), **i**, 564–5. *See* COLVIN (1978 edition), 744.

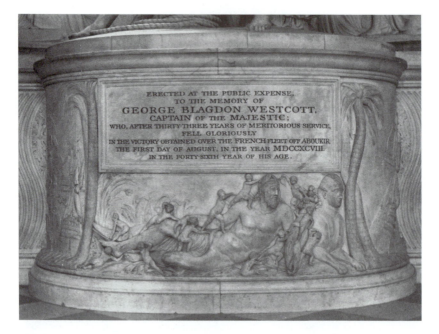

Plate 165 *Monument of 1805 by Thomas Banks (1735–1805) in St Paul's Cathedral, London, to Captain George Blagdon Westcott of the* Majestic *who fell at the Battle of the Nile at Aboukir, 1 August 1798, 'in the forty-sixth year of his age'. Between the strigillated dies is the inscription and a relief showing Father Nile with cornucopia, sphinx, cubits-putti, and palm-trees, clearly derived from the Antique group in the Vatican (***Plate 21***). Photograph of 1980 (JSC).*

in his *History of Lambeth* as 'without doubt the finest sepulchral monument in the open air in the metropolis, and perhaps not equalled by any one in the kingdom'. It is an eclectic mixture of Greek and Egyptianising forms, and is of Portland stone on a granite base (**Plate 166**). The winged globe, the heavy battering, the primitivist entrance (reminiscent of Canova's designs), and the segmental pediments all suggest Egypt.[7]

The New Cemeteries

The associations of Egyptian architecture with death and with monumental celebration ensured that the Egyptian Revival would play no small part in the appearance of the new cemeteries that were laid out in Europe and America from the beginning of the nineteenth century. It is significant that in India and Louisiana, where Europeans found themselves in climates and

7 Also illustrated in CURL (1982), 160.

Plate 166 *Mausoleum in Brixton churchyard of Richard Budd, designed by R. Day. From T. Allen's* History of Lambeth *(GLCL).*

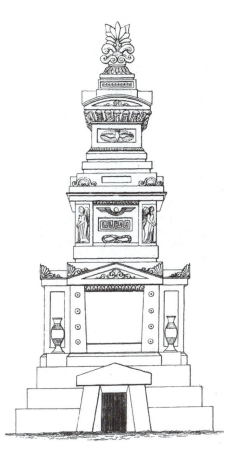

conditions where a customary lack of fastidiousness in matters of hygiene played havoc with lives in a manner much more devastating than in colder zones, cemeteries were formed of necessity in the middle of the eighteenth century. South Park Street Cemetery in Calcutta is one fine example. These cemeteries were in noble contrast to the unsavoury conditions in urban burial-grounds in Europe. In addition, a new sensibility towards the burial of the dead began to develop, influenced to a remarkable extent by the poetry of Robert Blair, Edward Young, and Thomas Gray.[8]

As with so many great modern reforms, however, the aftermath of the French Revolution was the first real occasion on which burial customs were changed in a drastic manner. Under Napoléon, A.-T. Brongniart laid out the great cemetery of Père-Lachaise in Paris, and, as previously noted, proposed as the centrepiece of the entire composition[9] a gigantic pyramid

8 *See* CURL (2000c) and CURL (*Ed.*) (2001b). *See also* CURL (1994b).
9 ETLIN (1984), 312–20.

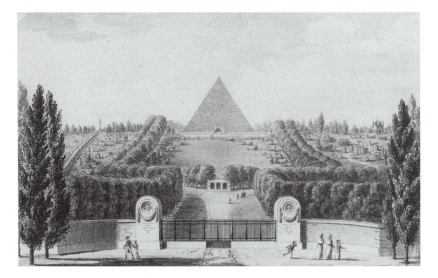

Plate 167 *Brongniart's proposal of c.1810 for a gigantic pyramid as the centrepiece of the new cemetery of Père-Lachaise* (©Photothèque des Musées de la Ville de Paris/Ladet, Inv. No. D96697, Photo No. 86 CAR 0250 [A]).

(**Plate 167**). It is a stupendous design, and, if realised (which it was not), would have been one of the noblest Egyptianising schemes ever conceived. Nonetheless, the cemetery soon became embellished with many distinguished monuments, many of them Egyptianising in style.[10] The beauty of the site, the design of the winding paths, and the first Neo-Classical monuments erected against a background of foliage soon attracted the public to these Elysian Fields. A standard house-tomb was developed for Père-Lachaise which included a subterranean vault with a small chapel above. Many Neo-Classical tombs in the cemetery mix Egyptianising details with otherwise Classical elements. Several of the *savants*[11] who went to Egypt with Napoléon ended up in the cemetery, including Gaspard Monge, whose tomb in the Rond-Point des Peupliers is a spectacular composition in the Egyptianising manner by Clochard (**Plate 168**). Normand tells us that those who erected the structure granted the execution of the monument to Clochard, architect, who, in the chosen style, demonstrated the association of Monge with the *Institut d'Égypte* and with the scientific travels and researches that resulted from its work.[12] Champollion lies near by, celebrated (appropriately) by an obelisk. Typical

10 CURL (2000*c* and 2001*b*).
11 Dr Eugène Warmenbol has informed the Author that they were members of an élite Lodge called the *Ordre des Sophisiens*.
12 NORMAND (1832), 4–9.

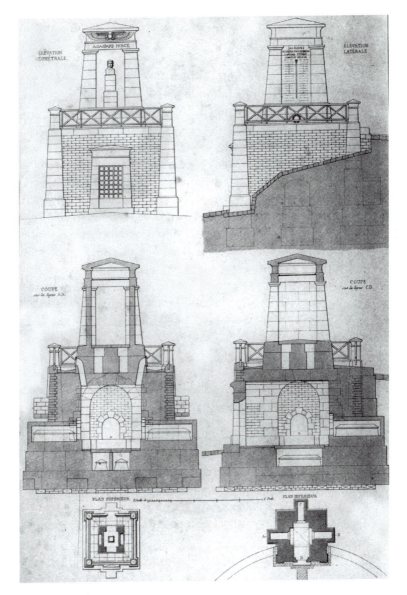

Plate 168 *Tomb of Gaspard Monge, Comte de Peluse (1746–1818), one of the savants who went to Egypt with Bonaparte. Monge was a Professor at the École Polytechnique in Paris, and was a member of the Ordre des Sophisiens, a highly élite Masonic Brotherhood, which seems to have had as members many of those who had been to Egypt and studied the monuments and artefacts. He was the author of Géométrie Descriptive (geometry is central to Freemasonic legend), and was a founder of the École Polytechnique. The designer of the Egyptianising mausoleum in Père-Lachaise Cemetery, Paris, was Pierre Clochard (1774–after 1830), and the tomb was built in 1820. From NORMAND (1832) (JSC).*

of a Græco-Egyptianising Père-Lachaise house-tomb is that of the Moricet family (**Plate 169**).

The fact that Père-Lachaise became the desirable model for those who wished to form public cemeteries laid out on spacious, rational, hygienic lines, is borne out by the vast amount of literature that quotes the Parisian cemetery as *the* exemplar.[13] Not only was the idea of forming cemeteries as opposed to churchyards becoming attractive, but designs for mausolea and funerary monuments in Père-Lachaise were published,[14] and became widely available as source-books for other countries to follow. Architectural ideas were widely published, and the eclectic climate of the period encouraged repetition of and variations on those themes. Augustus Charles Pugin (1769–1832), with C. Heath, brought out *Paris and its Environs* in 1829–31, containing views of tombs in Père-Lachaise, and Normand published a large volume of measured drawings of funerary architecture, with details. As an example of how Père-Lachaise tombs produced progeny elsewhere, the tomb of John Gordon of Newton, Aberdeenshire (1802–40), in the General Cemetery of All Souls, Kensal Green, London, clearly is based on a model in Père-Lachaise published by Pugin, has identical Græco-Egyptianising heads as acroteria, and incorporates the same primitive Doricising of the square columns.[15]

Proposals for the first large cemetery in London to be laid out were first mooted in the 1820s, and Thomas Willson (*c.*1780–*c.*1840) produced a design for a vast pyramid to hold five million bodies, a Sublime notion worthy of Boullée himself: this pyramid was to be constructed of brick, faced with granite, and would occupy an area the size of Russell Square, yet Willson claimed that his idea was 'practicable, economical, and remunerative',[16] and that the pyramid (capped with an obelisk) would 'tower to a height considerably above' that of St Paul's Cathedral (**Plate 170**). The scheme was costed at £2,583,552, and would contain freehold vaults selling at between £100 and £500 each, while other vaults could be let out to the various parishes in London. Willson estimated his pyramid would generate a profit of £10,764,800: this 'Grand Mausoleum', he wrote, 'will go far towards completing the glory of London'. It was to contain ninety-four stages of catacombs, and would be compact, ornamental, vandal-proof, and hygienic. At the base of the pyramid Willson proposed a normal cemetery for earth-burial to surround the pyramid and provide a landscaped setting. In all, there would have been 215,296 vaults. The scheme was

13 For an idea of the extensive bibliography on the subject, *see especially* ETLIN (1984), CURL (2002*c*), and CURL (*Ed.*) (2001*b*).
14 NORMAND (1832), for example.
15 Illustrated in CURL (*Ed.*) (2001*b*), 30 and 186.
16 WILLSON (*c.*1831). The pyramid is fully illustrated in CURL (1993).

Plate 169 *Moricet tomb in Père-Lachaise Cemetery, combining Greek and Egyptian motifs. From* NORMAND *(1832) (JSC).*

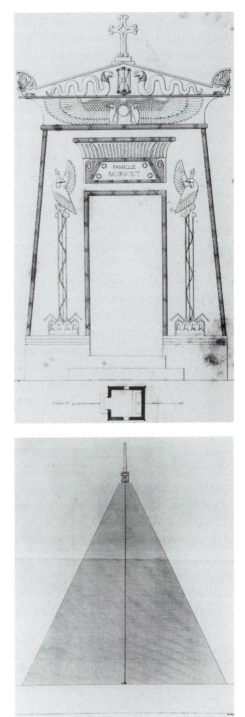

Plate 170 *'The Pyramid to contain Five Millions of Individuals. Designed for the Centre of the General Cemetry (sic) of the Metropolis' by Thomas Willson (c.1780–c.1840), architect, of c.1824 or 1825, published in c.1831. The obelisk on top of the Cestius pyramid inflated to megalomaniac scale, and derived from* Hypnerotomachia Poliphili *of 1499 (see* **Plate 41***) (GLCL).*

exhibited in 1824, one of its attractions being that although it was to cover eighteen acres, the accommodation within the vast structure would provide space for bodies equivalent to a 1000-acre cemetery. An engraved version of this (presumably *c*.1825 or *c*.1831) is in the Royal Library at Windsor Castle, bound with C. H. Tatham's proposals for a National Naval Monument (1802).[17] Yet Willson's design is curiously archaic for its period, for it harks back to *Hypnerotomachia Poliphili* of 1499 and has the proportions of the Cestius pyramid in Rome: it is as though Willson had avoided archæological correctness by ignoring recent publications.

On the other hand, there were designers who drew on aspects of Egyptian architecture for purposes of emphasis, and suggestion, mixing them judiciously with a robust, primitive, elemental Classicism. Tatham, for example, designed and built a powerful Græco-Egyptianising mausoleum for George Granville Leveson-Gower (1758–1833), 2nd Marquess of Stafford and 1st Duke of Sutherland, at Trentham, Staffordshire, in 1807–8, the drawings for which were exhibited at the Royal Academy in 1807: the heavy battering of the walls, of the piers, and of the upper works owes much to French Neo-Classical designs, and the severity of the building suggests an Egyptianising influence (**Plate 171**).[18]

Variations on the French house-tomb with Egyptianising motifs (**Plate 172**) can be found in many places. At Clifton Old Burying-Ground, Belfast (1795, enlarged 1819), is the Luke family vault of *c*.1810 by W. Graham (a local mason), a severe Neo-Classical design capped by a short obelisk (**Plate 173**).[19] More overtly Egyptian in its inspiration is the Greer mausoleum (*c*. 1830) in the tiny parish churchyard at Desertcreat, Co. Tyrone: it has sides with pronounced batters crowned by an Egyptianising cavetto cornice over which is a stepped podium carrying a short, fat obelisk.[20] The Gillow mausoleum in the Roman Catholic burial-ground at Thurnham, Lancashire, by Robert, son of the cabinet-maker and architect, Richard Gillow (1734–1811), is a very grand affair, in a remarkably severe Neo-Classical Egyptianising style, and is said to date from around 1800.[21] If this date is correct, the building is a very early example of a tolerably convincing essay in the Egyptian Taste: the papyrus capitals were clearly derived from a reasonably accurate source, but the column-shafts are ill-observed, and are un-Egyptian, whilst the large stone cross above the gorge-cornice is a

17 COLVIN (1978 edition), 899.
18 Illustrated also in CURL (1993), 183.
19 *See* A.C.W. MERRICK and R.S.J. CLARKE (*Eds*) (1991): *Old Belfast Families and The New Burying Ground from Gravestone Inscriptions, with Wills and Biographical Notes* (Belfast: Ulster Historical Association). *See also* R.W.M. STRAIN (1961): *Belfast and its Charitable Society: a Story of Urban Development* (London: Oxford University Press).
20 CURL (1993), 168–77. *See also* JAMES STEVENS CURL (1978): *Mausolea in Ulster* (Belfast: Ulster Architectural Heritage Society).
21 CONNER (*Ed.*) 1983), 52.

Plate 171 *Tatham's mausoleum for the 2nd Marquess of Stafford at Trentham, Staffordshire, of 1807–8. Photograph of 1978* (JSC).

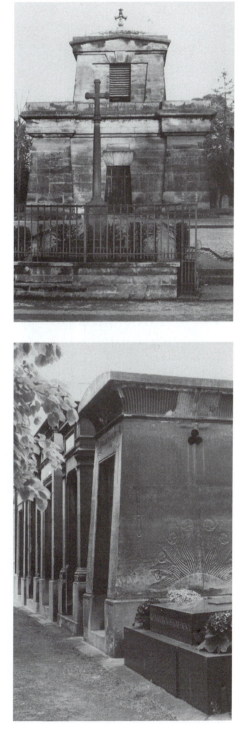

Plate 172 *House-tombs in Montparnasse Cemetery, Paris, with an Egyptianising example (the Mauger tomb) in the foreground. Photograph of 1980* (JSC).

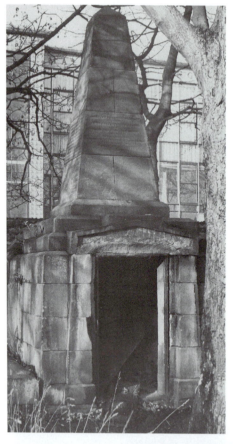

Plate 173 *Luke family vault of c. 1830 in Clifton Old Burying-Ground, Belfast. Photograph of 1960 (JSC).*

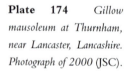

Plate 174 *Gillow mausoleum at Thurnham, near Lancaster, Lancashire. Photograph of 2000 (JSC).*

discordant note. Nevertheless, the Gillow mausoleum is an impressive work of the Egyptian Revival, and deserves to be recorded here (**Plate 174**).[22]

Egyptianising tendencies in funerary architecture, then, began to appear in the design of mausolea, memorials, and other structures in the new cemeteries from the very first decade of the nineteenth century. The fascinating and very grand Parisian cemeteries of Père-Lachaise, Montparnasse (**Plate 172**), and Montmartre have a good range of distinguished designs for individual tombs, and there is a fair collection in London too. The Gordon tomb at Kensal Green has been mentioned above, but in the same cemetery is the Græco-Egyptianising mausoleum of Andrew Ducrow (1793–1842), built for £800 by John Cusworth (1795–1856) to designs by George Danson (1799–1881), and consisting of a pylon form (with torus mouldings at the corners), Egyptianising columns carrying a Græco-Egyptian Doricesque cornice, and many other eclectic elements, including sphinxes guarding the ensemble.[23] It was modestly inscribed as 'erected by genius for the reception of its own remains' in 1837 (**Plate 175**). In the same cemetery is the miniature pylon-tomb of Sir George Farrant (c.1770–1844) (**Plate 176**)[24] and the cenotaph of Major-General the Hon. Sir William Casement (1780–1844), with its Egyptianising canopy supported on four orientalising *telamones*.[25]

The London Cemetery Company was one of the first British Joint-Stock cemetery-companies to employ Egyptianising elements in the architecture of the cemetery buildings themselves (as opposed to individual tombs erected by private interests). Stephen Geary (c.1797–1854) designed and built the Circle of Lebanon Catacombs in the Cemetery of St James at Highgate, London, in 1839 (a range of house-tombs in terrace-form arranged as a circle around an existing mature Cedar of Lebanon) in the Egyptianising style, stucco-faced. James Bunstone Bunning (1802–63) added the straight Egyptian Avenue to these catacombs between 1839 and 1842 in the style of the 'stern and appropriate architecture of Egypt' with an entrance-portal incorporating a canted corbelled arch, flanking engaged Egyptianising columns, and two guardian obelisks, all in stucco-faced brick. This extraordinary and somewhat forbidding portal defied Hope's demands for permanence, to be suggested by tough, long-lasting materials, for Bunning's gimcrack Egyptianising façade was detailed in cheap (and

22 The Author is indebted to Professor James Grimshaw and to Mr Edwin Grimshaw for help with the Thurnham mausoleum.

23 Plentifully illustrated in CURL (*Ed.*) (2001*b*). *See also The Builder*, xiv/725 (27 December 1856), 700, and *The Gentleman's Magazine* (April 1842), 444–5.

24 CURL (*Ed.*) (2001*b*), 189.

25 *Ibid.*, 184. The 'orientalising' of the 'telamones' reflects Casement's connections with India, where his body was buried.

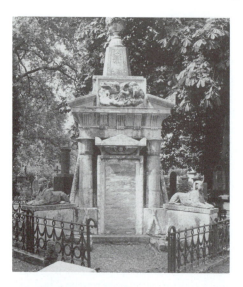

Plate 175 *Mausoleum of Andrew Ducrow in the General Cemetery of All Souls, Kensal Green, London. Photograph of 1997* (JSC).

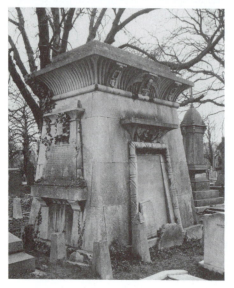

Plate 176 *Farrant tomb in Kensal Green Cemetery, London. Photograph of 1997* (NMR. AA97/1169).

impermanent) stucco (or Roman Cement), whilst his columns appear to have been derived from Bullock's Museum in Piccadilly, so the Egyptian Avenue entrance verges perilously close to Professor Carrott's category of 'Commercial Picturesque' (**Plates 177 and 178**).

A type of wide pyramidal form favoured by Boullée in his 'funerary triumphal arch' also appears in a design (1829) by Axel Nyström for a new cemetery outside the Northern gates of Stockholm.[26] Such stark and simple

26 CURL (2002c), 152.

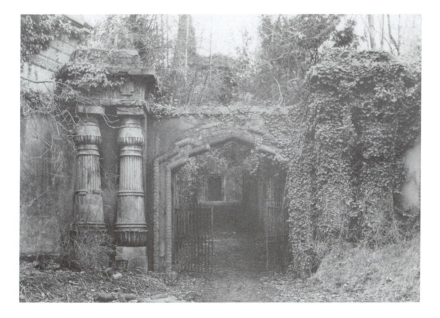

Plate 177 *Entrance to the Egyptian Avenue, Cemetery of St James, Highgate, London (c. 1839–42). Photograph of 1967* (JSC).

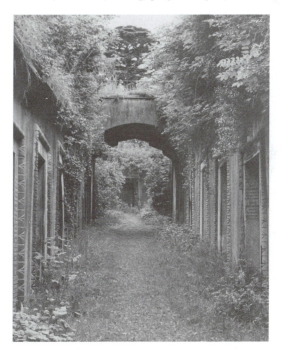

Plate 178 *Egyptian Avenue, Highgate Cemetery. Photograph of 1967* (JSC).

297

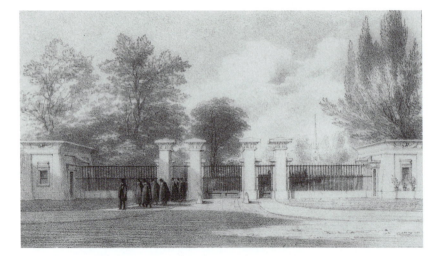

Plate 179 *Entrance-gates and lodges at Abney Park Cemetery, Stoke Newington, London* (London Borough of Hackney Archives Department, No. P. 14908).

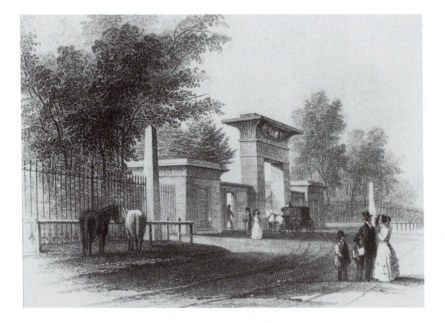

Plate 180 *Entrance-gate and lodges at Mount Auburn Cemetery, Cambridge, Massachusetts, designed by Jacob Bigelow, and erected in the early 1830s* (JSC).

forms suited the fashion for solemn funereal monumental architecture of the Neo-Classical style, and, with the publications of sources, the pyramid and the obelisk (which had long been part of the vocabulary of design) began to be used with more painstakingly archæologically correct attempts to revive Ancient Egyptian design in funerary architecture. The second instance when Egyptian forms were used by a cemetery-company in England was at Abney Park Cemetery, Stoke Newington, in 1840, where Professor William Hosking (1800–61) and Joseph Bonomi Jr. created impressively solid-looking stone gate-lodges and piers in a convincing and scholarly Egyptianising style, complete with a hieroglyphic inscription informing those able to decipher it that these were the 'gates of the abode of the mortal part of Man': even the cast-iron gates incorporated correct Egyptianising motifs (**Plate 179**). The architectural parts of the cemetery at Exeter were also treated with Egyptianising features.[27]

Mount Auburn Cemetery, near Cambridge, Massachusetts,[28] was one of the first large cemeteries to be laid out in the United States on the principle of a landscaped garden, and dates from 1831: it was conceived by Jacob Bigelow (1786–1879), who described the Egyptianising gates and lodges (**Plate 180**) in a guide-book of 1846 as 'in imitation essentially of some of the gateways of Thebes and Denderah', and that his sources were 'mostly taken from some of the best examples in Denderah and Karnac', which probably refers to the North and South portals of the temple at Karnak as published in the *Description de l'Égypte*. Bigelow's structure was originally built of timber in 1831, but was reconstructed in granite in 1842. The relationship of the lodges to the gate at Mount Auburn is reminiscent (in an odd way) of Canina's gate at the Borghese Gardens in Rome (**Plate 154**), and the application of the Egyptian style at Mount Auburn was noted by James Gallier (1798–1866) in 1836,[29] who singled out the cemetery entrance as the 'only remarkable display of (Egyptian) architecture', and indicated that the 'principal portion of the monuments' in the cemetery were in the same style. Gallier doubted if the 'Egyptian style' was the most 'appropriate to a Christian burial-place' because it was reminiscent of 'paganism . . . solid, stupendous, and time-defying', yet he was aware of the powerful associations that a cemetery might bring to mind, recalling that the obelisk was 'by far the most beautiful form of Egyptian architecture, whose stern and severe proportions seem to speak of eternal duration'.[30]

27 The Author is indebted to the late Professor Christopher Brooks for this item.
28 The Author owes this item to Mrs Henry Steiner.
29 JAMES GALLIER (1836): 'American Architecture', in *North American Review*, **xliii**/93, 356–84, and BIGELOW (1860).
30 *Ibid*. Nevertheless, the ensemble is not large, and its scale is anything but stupendous.

However, even before Mount Auburn, the Westminster Cemetery, Baltimore, acquired in 1815 an Egyptian Revival gateway to designs by Maximilian Godefroy (1765–c. 1840),[31] and several other Egyptianising examples followed. Andrew Jackson Downing (1815–52), in his *Cottage Residences* (1842), stated that an expression of purpose should grow out of a quality that is connected in the mind with the use, so he was advocating, in effect, an *architecture parlante*. In the United States the Egyptian Revival style was used for both cemeteries and prisons, and it is easy to see why, for both building types are those from which one does not escape with ease. Obelisk-memorials were fashionable in the United States, so that, by 1833, when the Washington National Monument was originally designed by Robert Mills (1781–1855), the United States could boast several large memorials in the form of obelisks: these include the Columbus Memorial at Baltimore by the Chevalier d'Anmour (1792);[32] the Battle Monument at Lexington (1799);[33] and many others cited by Professor Carrott.[34] Indeed, Carrott has discussed cemetery entrances and obelisks in America very fully, and it would be superfluous to go over the ground again here. It will be sufficient to mention the most important cemetery-gate designs in the Egyptian Revival style: apart from Godefroy's Westminster Cemetery in Baltimore, the most distinguished examples are Mount Auburn (mentioned above); the fine competition entries for Laurel Hill Cemetery, Philadelphia (1836), by William Strickland (1788–1854) and Thomas Ustick Walter (1804–87);[35] Mount Hope Cemetery at Rochester, by John McConnell;[36] Cypress Grove Cemetery, New Orleans, by Frederick Wilkinson;[37] the Old Granary Burial-Ground, Boston (1840), by Isaiah Rogers (1800–69);[38] Touro Cemetery, Newport, Rhode Island (1843 – an identical design to that of the Old Granary at Boston), also by Rogers;[39] proposals for Greenmount Cemetery, Baltimore (1845), by Robert Cary Long (1810–49);[40] the celebrated Grove Street, New Haven (1844–48), by Henry Austin (1804–91), who based his designs on a mixture of the temples of Esna and Ashmunein (*Hermopolis Magna*);[41] the Forest Hills Cemetery, Roxbury, MA (1848), by H. A. S. Dearborn (1783–1851);[42] the Old Burying-Ground, Farmington,

31 CARROTT (1978), 97.
32 ECKELS (1950), 166.
33 HUDSON (1868), 215–19.
34 CARROTT (1978), 139–41.
35 GILCHRIST (1950).
36 CARROTT (1978), 88.
37 WILSON (1959), 48 and NORMAN (1845), 105.
38 LANCASTER (1947), 184.
39 CARROTT (1978), 90.
40 *Ibid.* and HOWLAND (1953), 98, 132.
41 CARROTT (1978), 90–4.
42 *Ibid.*

Connecticut (1850);[43] the Mikveh Israel Burial-Ground, Philadelphia (*c*.1845);[44] and the Odd-Fellows Cemetery, Philadelphia (1849), by Stephen Decatur Button (1803–97), a design of the propylæa type that is not unlike McConnell's work at Mount Hope Cemetery.[45]

A little-known but thrilling piece of Egyptiana was erected in 1840 as the entrance to the cemetery of Terre Cabade at Toulouse to designs by Urbain Vitry (*fl.* 1830–40). Two mighty brick obelisks sitting directly on the ground flank the entrance, and the pavilions are also of brick, stripped, but solidly Egyptianising in a convincing manner. Glasgow Necropolis (founded 1831) acquired an obelisk with inscriptions and Egyptianising vaults (1837) for the temporary storage of bodies pending the erection of permanent tombs: the vaults were probably designed by David Hamilton (1768–1843), and the Necropolis contains several tombs that have Egyptianising features. Other nineteenth-century British cemeteries, including those at Kensal Green, Brompton, Norwood, Bradford, and Brookwood, contain Egyptianising tombs and mausolea. Undercliffe Cemetery, Bradford, for example, contains some fine Egyptian Revival tombs, including the spectacular mausoleum (**Plate 181**) of Daniel Illingworth (*c*.1854).[46] Standard pattern-book Egyptianising mausolea or house-tombs can be found in many cemeteries in Britain, in Continental Europe (notably in Paris), and in the United States of America. One of the most distinguished groups of mausolea in which Greek, Egyptian, and Persian motifs are mingled can be found in the Parsee section of Brookwood Cemetery, near Woking, Surrey.[47] There is also a very fine Egyptianising monument of the 1870s to the Herdman family in Belfast City Cemetery: it is in the form of a pylon-tower with a single column in the centre between the 'antæ'.

Egyptianising tombs may be found in considerable numbers in the United States of America. Graceland Cemetery, Chicago, IL, for example (founded 1860), contains several distinguished mausolea, including the tall pyramid with Egyptianising entrance and guardian sphinx of Peter Schoenhofen (1827–93), designed by Richard Schmidt, the ingenious merging of mastaba and pyramid in the Martin Ryerson (1818–87) mausoleum, designed by Louis Henri Sullivan (1856–1924), and the tombs of John A. Linn (1849–1910), and John K. Stewart (1870–1916).[48]

43 CARROTT (1978), 90–4.
44 *Ibid.*
45 Plates 74 and 79 in CARROTT (1978).
46 POWELL, KEN (1980): 'Vandals in Valhalla', in *Country Life* (27 November), 2011–12, in which the mausoleum is illustrated. The Author is indebted to Mr Don McPhee and Mr C. E. Clark of The Undercliffe Cemetery Charity for help.
47 Illustrated in CURL (1993), 290.
48 *See* BARBARA LANCTOT (1982): *A Walk through Graceland Cemetery* (Chicago, IL: Chicago Architectural Foundation).

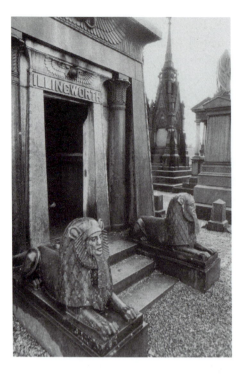

Plate 181 *Egyptianising Illingworth mausoleum* (left) *in Undercliffe Cemetery, Bradford, Yorkshire* (Don McPhee and The Undercliffe Cemetery Charity).

Parisian cemeteries, as noted above, contain several Egyptianising tombs.[49] Père-Lachaise Cemetery has the Boscary, Mollart-Martel, Fourier, Casteja, and Sacchet monuments, to name but a few; Montmartre Cemetery can boast the Minodet mausoleum (complete with two incised guardian *telamones*); and Montparnasse Cemetery is graced with the Mauger house-tomb (*see* **Plate 172**), and a mummiform figure on the grave of Charles Pierre Baudelaire (1821–67).[50]

In the West London and Westminster Cemetery at Brompton stands one very distinguished Egyptianising mausoleum of grey granite, probably by Avis of Putney (1850–2). It contains the mortal remains of a lady named Courtoy, but there is no inscription; the name is recorded in the register of burials held in the cemetery (**Plate 182**). Now this mausoleum has been inaccurately referred to as the Kilmorey tomb,[51] and it is true that Francis 'Black Jack' Needham (1787–1880), 2nd Earl of Kilmorey (from 1832), erected an Egyptianising mausoleum in the cemetery in 1854, but not on the site of the Courtoy tomb. It was designed by 'Kendall and Pope'[52] (which seems to be a reference to Henry Edward Kendall Junior [1805–85],

49 *See* HEALEY, BOWIE, and BOS (1998) and HUMBERT (1998).
50 Illustrated in HUMBERT (1998).
51 In, for example, F.H.W. SHEPPARD (*Ed.*) (1983): *Survey of London*, **xli**, *Southern Kensington: Brompton* (London: The Athlone Press), 247, 251.
52 P.R.O. (Public Records Office), WORK 38/146.

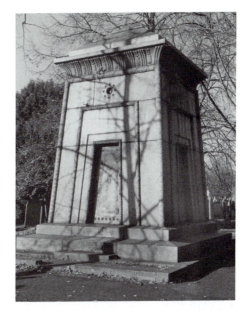

although the identity of Mr Pope has so far eluded discovery), and stood in Brompton Cemetery until 1862, when it was moved in 1862 to Woburn Park, Chertsey, where Kilmorey lived until 1868, and finally translated to the grounds of Kilmorey's residence, Gordon House, Isleworth, Middlesex: it stands today behind a high wall along St Margaret's Road, Twickenham. The massive Egyptianising tomb, of grey and red granite, has battered walls and a doorcase decorated with Egyptian motifs. Inside is a monument to Priscilla Hoste, the Earl's mistress (died 1854), carved in Rome by Lawrence MacDonald (1799–1878): she is shown on her death-bed, with the Earl and their young son, Charles (born 1844), in attendance. The Earl was also entombed there in 1880 (**Colour Plate XXIX**).[53]

Spanish-speaking countries also adopted the Egyptianising style for much funerary architecture as well as for some interiors and other types of building. Spectacular mausolea include those of the García Nieto family in the Cemetery of San Lorenzo, Madrid (1914); of the Bauer family in the Cementerio Británico, Madrid (c.1910); of the Llovera family in the General Cemetery of Valencia (1883); and of the Martínez family in the Cemetery of Nostra Señora de los Remedios, Cartagena (1921).[54] Dr Saguar Quer has chronicled much Spanish Egyptomania, notably in the age

53 BRIDGET CHERRY and NIKOLAUS PEVSNER (1991): *London 3: North West* (London: Penguin Group), 433. The mausoleum is said to have cost some £30,000, and the site in Brompton Cemetery (some 1,963 square feet) cost £1,030 19s. 9d. For the mausoleum *see* DERRICK MERCER (2002): 'The House that "Black Jack" built', in *Newsletter* of *The Mausolea and Monuments Trust*, **iv** (October), 1–2.

54 SAGUAR QUER (1996a and b, and 1997). The Author is indebted to Dr Saguar Quer for much help, courteously and promptly given, when asked.

of Goya and in the period 1840–1940. Latin America, too, notably Argentina, embraced the Egyptian Revival with gusto, as can be seen in the urban cemeteries there, but, in order to chronicle the Egyptianising tombs a far larger tome than this would be necessary.

This book cannot hope to describe and illustrate everything, but it must be stressed that Egyptianising design enjoyed a considerable following in Europe, North and South America, and Australia, notably in commemorative and funerary architecture, despite the efforts of the polemicist to whose works we now turn.

Pugin

Now the problem with such widespread use of Ancient Egyptian forms and detail in architecture was that, although much greater attention was given to archæologically correct 'quotations' in the buildings, the structures were almost invariably tiny compared with the ancient works of architecture in Egypt itself, and often the choice of impermanent materials, such as cement-rendering, did not help. The result was that Egyptianising buildings, and especially cemetery-entrances, excited the ridicule of Augustus Welby Northmore Pugin (1812–52), who, in his *An Apology for the Revival of Christian Architecture in England* (1843), directed a barrage of abuse at Egyptianising cemetery-gates, and caricatured them in one of his most devastating drawings (**Plate 183**). In the text Pugin stated that the 'new Cemetery Companies have perpetrated the grossest absurdities in the buildings they have erected'. He denounced the 'superabundance of inverted torches' (indicative of the extinguishing of life), 'cinerary urns, and pagan emblems, tastefully disposed by the side of neat gravel walks, among cypress trees and weeping willows', and went on to say that 'the entrance gateway is usually selected for the grand display of the company's enterprise and taste, as being well calculated from its position to induce persons to patronise the undertaking by the purchase of shares or graves'. As far as architectural style was concerned, Pugin stated that it was 'generally Egyptian, probably from some associations between the word catacombs, which occurs in the prospectus of the company, and the discoveries of Belzoni on the banks of the Nile; and nearly opposite the Green Man and Dog public-house, in the centre of a dead wall (which serves as a cheap medium of advertisement for blacking and shaving-strop manufacturers), a cement caricature of the entrance to an Egyptian temple, 2½ inches to the foot,[55] is erected with convenient lodges for the policeman and his wife, and a neat pair of cast iron hieroglyphical gates, which would puzzle the most learned to decipher;

55 There can be no quarrel with Pugin's views here: the problem of scale was indeed rather formidable.

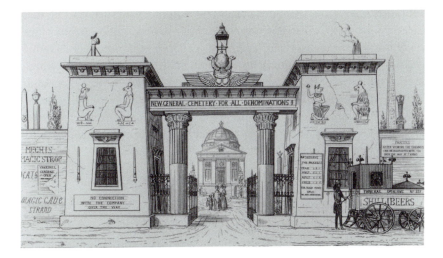

Plate 183 *'Entrance Gateway for a New Cemetery' from A. W. N. Pugin:* An Apology for the Revival of Christian Architecture in England *(1843)* (JSC).

while, to prevent any mistake, some such words as "New Economical Compressed Grave Cemetery Company" are described in *Grecian* capitals along the frieze, interspersed with hawk-headed divinities, and surmounted by a huge representation of the winged Osiris bearing a gas-lamp'.[56]

The architectural profession got a roasting from Pugin too: one architect breathed 'nothing but the Alhambra, - and then the Parthenon', – and another was 'full of lotus cups and pyramids from the banks of the Nile'. He rounded on what he described as a 'Carnival of architecture' … 'tricked out in the guises of all centuries and all nations; the Turk and the Christian, the Egyptian and the Greek'.[57] The illustration (**Plate 183**)[58] Pugin produced to ram his message home was a cruel parody of the Egyptian style, but there was an element of truth in what he said, for scale *was* usually absurd, materials *were* often shoddy, and detail was frequently so ham-fisted it could not be taken seriously.

There can be no question that the damage done by Pugin to Neo-Classicism in general and to the Egyptian Revival in particular was devastating. However, as the late Professor Carrott has shown,[59] the anti-Egyptian arguments of Pugin, although having some parallels in the United States of America, failed to prevail there as they did in Britain: in the United States the enduring character of Egyptian architecture (constructed of good, sound materials such as granite), despite its pagan overtones, was seen as

56 PUGIN (1843), 12.
57 *Ibid.*, 1–2.
58 *Ibid.*, plate IV.
59 CARROTT (1978), 83–96.

appropriate for a Christian cemetery. The reasons for this seem to be that Freemasonic and Odd-Fellow strength, with the powerful Nonconformist tradition, helped to neutralise to a very great extent the shrill pro-Gothic and anti-Neo-Classical arguments of Pugin and the Gothic Revival camp, at least for a while. It also must be remembered that the Gothic Revival in Britain was associated primarily with the Tractarians, with the Oxford Movement, with Ecclesiology, with High-Church Anglicanism,[60] and (after Pugin) with Roman Catholicism: the religious and power-groupings were very different in America, and it shows in the architecture.

Commemorative Egyptianisms

In Southern European countries, where there was less ink being spilled or spleen being displayed concerning stylistic niceties or bogus Puginesque arguments equating morality with architecture, Egyptianising design continued to be used without inhibition.[61] The Cimitero di Staglieno, for example, has an entertaining array of monuments incorporating Egyptianesque themes,[62] and across the Atlantic Ocean Egypt remained a potent inspiration to designers.

A terrible fire in a theatre in Richmond, Virginia, in which seventy-two people were killed in 1798 prompted the design by Benjamin Henry Latrobe (1764–1820) for a 'Theater Memorial' (1812): this was to consist of a square blocky plinth with battered sides and two Greek Doric columns set *in antis* on each face; a stepped base; and a stepped pyramid of Cestius-like proportions to crown the composition. There is a fine water-colour perspective of this design among the Latrobe papers in the Library of Congress in Washington, D.C.[63]

Thomas John Willson (possibly a relative of the projector of the 'Pyramid Cemetery' of 1824 [**Plate 170**]) designed a 'Pyramid Mausoleum' (1882) in honour of the assassinated James Abram Garfield (1831–81), twentieth President of the United States. Willson's object was to 'give expression . . . for all Time . . . to the profound grief' felt as a result of the work of a 'dastardly assassin', and the mausoleum was to contain catacombs 'secure from desecration', over which was to be a Cestius-shaped pyramid surmounted by an obelisk. The form is similar to designs by Gilly and others, but each face was to have had an entrance in the Egyptian style

60 *See* CURL (2002*d*) for a discussion of these matters, putting ecclesiastical architecture in England into its
 contexts.
61 SAGUAR QUER (1996*a* and *b*, and 1997).
62 Illustrated in CURL (1993), 184.
63 CARROTT (1978), 25.

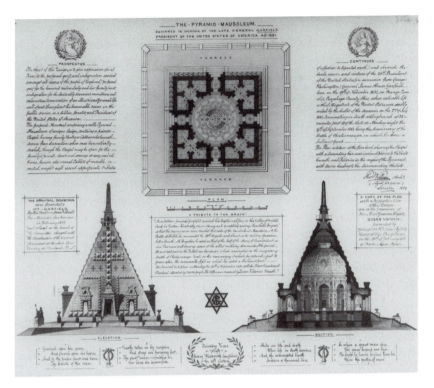

Plate 184 *Pyramidal mausoleum for the assassinated James Abram Garfield (1831–81), 20th President of the United States of America, by Thomas John Willson (1824–1903), of 1882. A variation on the* Hypnerotomachia Poliphili *theme (**Plate 41**), with rows of Egyptianising lions, a domed interior inside the pyramid, and a battered Egyptianesque entrance on each face (RIBA).*

surmounted by a sarcophagus (**Plate 184**). Less overtly Egyptian in inspiration, but still using the basic pyramid with a portico on each face, is the design (1897) for a mausoleum for the Counts of Henckel-Donnersmarck by Julius Karl Raschdorff (1823–1914).[64] The entry by Peter Force for the Washington Memorial Competition in 1837 also relies heavily on the Egyptianising form of the pyramid set on a low podium.[65]

In the south transept of Lichfield Cathedral, Staffordshire, is a handsome Egyptianising monument consisting of a high black base with a white sphinx on top: it commemorates the officers and men of the 80th Regiment of Foot, dates from 1846–50, and is by Peter Hollins (1800–86), whose father, William (1763–1843), designed the 'Egyptian Conduit' in the Bull Ring,

64 In the RIBA Drawings Collection, and illustrated in CURL (2002c), 203. The mausoleum was designed in collaboration with Otto Raschdorff.
65 Reproduced in SKY and STONE (1976).

Birmingham (1807 – demolished 1836).[66] The cathedral of St Mungo[67] in Glasgow also contains an Egyptianising monument, this time in the south aisle: it commemorates the soldiers of the 74th Highlanders killed at Tel-el-Kebir in 1882, and has a relief of the battle-scene with an Egyptianising frame surmounted by a sphinx. It is by Alexander Macdonald & Co.[68]

In funerary architecture and memorials the Egyptianising style had a long life. A memorial tablet to George Edge (died 1901) in St John's Church, Stamford, Lincolnshire, has an Egyptianising cornice and a reclining sphinx set in a panel at the top. However, it would be pointless to attempt to list all the Egyptianising funerary monuments, for most are only variations on what had gone before. Obelisks, Egyptian gorge-cornices, pyramidal forms and compositions, and various other Egyptianisms continued to be used in funerary and commemorative work well into the twentieth century. As will be seen below, there was even to be a proposal (1920) for a massive Egyptianising National War Memorial to the dead of the 1914–18 war by Sir Frank Baines (1877–1933) (**Plate 208**).

Thus, in spite of Pugin, Egyptianisms were retained in favour for commemorative purposes. On the Continent, in Roman Catholic countries such as Belgium, France, or Spain, Egyptian Revival design tended to be employed in the tombs and memorials of Freemasons and free-thinkers, although this was by no means a hard-and-fast rule. The style was employed in the British Isles sometimes for show (as in the Ducrow mausoleum [**Plate 175**] at Kensal Green), but often to underline some connection with Egypt, such as the military campaigns at the beginning and end of the nineteenth century. Occasionally there was a Freemasonic connection, but not invariably. The choice of style for the entrance to Abney Park Cemetery, Stoke Newington, London, is significant for this was the only one of the first large cemeteries laid out by joint-stock companies not to have had any part of its grounds consecrated. In other words, although theoretically open to all who could pay, it was, in reality, a major garden-cemetery for Nonconformists, and, since Gothic (in the early 1840s) was a style associated with mediæval (and therefore Roman Catholic) architecture and with the Gothic Revival (essentially a High Church Anglican and Roman Catholic movement), Dissenters would have tended to opt for some style other than Gothic. With its associations with death and permanence, the architecture of Egypt would have been as acceptable as most styles, untainted with either Roman Catholicism or the Established Church, but, as the century progressed, the links between architectural style and religious sects became much weaker, and in some cases ceased to exist.

66 COLVIN (1995), 506.
67 Or Kentigern.
68 Mevr Petra Maclot kindly drew this to the Author's attention.

Thus the Egyptian Revival *tended* to be a style favoured by those who were not Anglicans, but, even there again, there are no rigid rules as the Egyptianising mausolea in the consecrated portion of the General Cemetery of All Souls at Kensal Green attest. Even in front of the Anglican Chapel is an Egyptianising monument: it commemorates Sir Ernest Joseph Cassel (1852–1921), who, although of German-Jewish descent, was actually a Roman Catholic. The style of his memorial is connected with his history as an early employee of the Anglo-Egyptian bank. In the service of the Franco-Egyptian bank his fortunes were founded. Cassel had long been interested in Egypt: he financed the construction of the great Nile dams at Aswan and Assiut; was a prime mover in the establishment of the National Bank of Egypt; and had many interests in that country, including the irrigation of vast tracts of desert. He set up the Egyptian Travelling Ophthalmic Hospital with a gift of his own money, and his benevolence towards Egypt was immense.[69]

In Cassel's case the Egyptian connections prompted the choice of style for his tall and elegant monument, but in many other instances dealings with 'the East', a vague enough geographical sweep, were sufficient catalysts for the choice of Egyptianising memorials. On occasion an Egyptian style is mixed with orientalising allusions and a Classical base, as in the Casement cenotaph in Kensal Green Cemetery. However, among 'pure' Egyptian Revival tombs may be mentioned the beautiful little Ptolemaïc temple commemorating James Wilson (1831–1906) in Hampstead Cemetery, Fortune Green Road, London: Wilson Pasha, engineer, was in the service of the Egyptian government for forty-three years. Unusually, the temple (which has pylon-tower ends) is tristyle *in antis*.

In Putney Vale Cemetery, Kingston Road, London, is a fine distyle *in antis* Egyptianising mausoleum, the columns having palm-capitals: the door is decorated with lotuses, and rearing *uræi* occur on the door and on the gorge-cornice above the door-surround.[70] There are other funerary monuments to be found with Egyptian influences: some commemorate persons who had connections with Egypt, or, vaguely, 'the East', and a few others commemorate persons of Jewish descent who, again, might be said to have distant connections with Egypt, or who perhaps saw themselves as exiles and used the Egyptian style as the nearest thing to what might have passed as having some kind of relationship with the architecture of Ancient Palestine.

The meaning of the Egyptian style seems to have been protean, and was adopted by various groups with different affiliations: clearly the Egyptianising style could have many and varied resonances for all sorts of

69 *Dictionary of National Biography, 1912–21*, edited by H. W. C. DAVIS and J. R. H. WEAVER (London: Oxford University Press, 1927), 97–100. Biographical note by HUGH CHISHOLM.
70 Illustrated in HUGH MELLER (1981): *London Cemeteries: an Illustrated Guide and Gazetteer* (Amersham: Avebury Publishing Company), 236.

people with vastly constrasting beliefs and backgrounds. It is therefore impossible to lay down precise parameters or links, for Egypt meant different things to one group or another.[71]

Conclusion

Stripped Classicism, in which Græco-Egyptian themes (much simplified) occurred, was not only a feature of the nineteenth century (the works by Schinkel, Thomson, *et al.*), but of the 1920s and 1930s as well. Adolf Hitler (1889–1945) planned to erect gigantic pyramids, smoking cones, enormous obelisks, and mighty two-axis triumphal arches to commemorate his victories throughout Europe. Wilhelm Kreis (1873–1955), the architect of several of these Boullée-esque schemes, was a Neo-Classicist who owed much to the stripped stereometrical purity of many late-eighteenth- and nineteenth-century designs, whilst Albert Speer (1905–81) acknowledged his and his contemporaries' debts to the images of Boullée, Durand, and Ledoux.[72] French Neo-Classical works of architecture, especially the designs of those architects who favoured the utter simplicity of pure forms, including Egyptianising motifs, were admired by Speer and his colleagues. Had the forces of the Axis triumphed, the themes explored by the so-called 'Revolutionary' architects of France might well have acquired a new and more sinister significance than was already apparent when the Enlightenment and the Age of Reason were superseded by the Terror. A chilling totalitarianism suggested by overblown scale and obsessional symmetry would have been well expressed by Kreis's designs.

Simplified Classicism, a return to primitive Doric and Egyptian forms as exemplars, and blank walls enlivened only by the simplest and smallest of openings, had their dark side, suggesting not only the awe and terror of death, previously discussed, and the gloomy and frightening prisons of Piranesi, but the final, irrational, age-old demand for blood-sacrifice. The smoking pyramids of Ledoux's foundry (**Plate 112**) or the vast cones and pyramids (**Plates 81** and **83**) of Boullée had their twentieth-century successors in the flaming monumental Neo-Classical beacons that would have followed the imposition of Hitler's New Order on Europe.[73]

71 These matters are touched upon by several authors, including HUMBERT (*Ed.*) (1996), SAGUAR QUER (1996*a*, 1996*b*, 1997), and (especially relevant to Belgium, where the subject is fraught with passion) WARMENBOL (1992*a* and *b*, 1995*b*, 1996, 1997, 1998, 2001). *See also* DELVAUX and WARMENBOL (1991) and WARMENBOL and MASSEIGE (1990 and 1998).

72 *See* ALBERT SPEER (1970): *Inside the Third Reich* (London: Weidenfeld & Nicolson).

73 One of Kreis's projects for such a monument is illustrated in PEHNT (1987). *See also* GERDY TROOST (1943): *Das Bauen im neuen Reich* (Bayreuth: Gauverlag Bayerische Ostmark), and HANS F. MAYER and GERHARD REHDER (1953): *Wilhelm Kreis* (Essen: Vulkan).

CHAPTER IX

Aspects of the Egyptian Revival in the Later Part of the Nineteenth Century

Introduction; Travellers and Scholars; The Egyptian Revival in the Hands of Serious Egyptologists; The Individual Contribution of Alexander 'Greek' Thomson; The Victorian Vision of Egypt; Eclecticism and Design

Beside the eternal Nile,
The Pyramids have risen.
Nile shall pursue his changeless way:
Those Pyramids shall fall;
Yea! not a stone shall stand to tell
The spot whereon they stood!

<div style="text-align: right">

PERCY BYSSHE SHELLEY (1792–1822):
Queen Mab (1813), Pt. II, lines 126–131.

</div>

Let me . . . urge young artists never to adopt,
except from motives more weighty
than a mere aim at novelty,
the Egyptian style of ornament.

<div style="text-align: right">

THOMAS HOPE (1769–1821):
Household Furniture and Interior Decoration (1807), 27.

</div>

Introduction

As has been outlined above, Nelson's victory at Aboukir Bay made Nilotic motifs popular in all sorts of designs in Britain, whilst the Napoleonic Campaign in Egypt introduced Egyptianising motifs to French design in a powerful and comprehensive way. As previously noted, Nelson's sumptuous funeral-car was decorated appropriately with Nilotic palms for his entombment on 9 January 1806.[1] Thomas Hope, Sheraton, Chippendale the Younger, George Smith, and others helped to make the Egyptian Taste fashionable and familiar.

It is a curious fact that, in spite of the many scholarly publications and accurate depictions of Ancient Egyptian architecture that had appeared by 1840, gimcrack, fairground, 'Commercial Picturesque' Egyptiana was still peddled, not least by architects. Richard Brown (*fl.* 1804–45) published his *Domestic Architecture* in 1842. Again, there was a West Country connection, for Brown appears to have come from Devonshire, and indeed retired there. His published words are, in the appropriate words of Sir Howard Colvin, 'indiscriminately eclectic',[2] and it is possible he was influenced by Foulston. Brown's book contains a most peculiar design for 'An Egyptian Pavilion' that deserves some attention (**Plates 185–7**). Brown states that some 'country houses appear to have been ornamented with propylæ (*sic*) and obelisks, like the temples themselves; it is even possible, that part of the building may have been consecrated to religious purposes like the domestic chapels in other countries; since we find in the sculptures a priest engaged in presenting offerings at the door of the inner chamber . . . The entrances of large pavilions were generally through folding gates, standing between lofty towers, as in the propylæa of temples, with a small door on each side; and others had merely folding-gates with imposts surmounted by a cornice. A circuit wall extended round the premises . . . The walls . . . were sometimes ornamented with panels and grooved lines . . . generally stuccoed, and the summit was crowned either with Egyptian battlements' *(sic!)*, 'the usual cornice, a row of spikes, in imitation of spear-heads, or with some fancy ornament'.[3]

Now much of this stuff is nonsense. Brown's design for 'An Egyptian Pavilion' owes more to Foulston or to Robinson than to Ancient Egypt: it is a spaciously-planned double-fronted house, with the servants' quarters in a distinct wing, and the house could have been part of a terrace of houses, as the side walls of the main block had no apertures, and the servants' wing was set back so that the windows to it would have been illuminated from a

1 Illustrated in RICHARD DAVEY (*c.*1889): *A History of Mourning* (London: printed by McCorquodale & Co. Ltd for Jay's Mourning Warehouse), 76.
2 COLVIN (1995), 167.
3 BROWN (1842), 280–2.

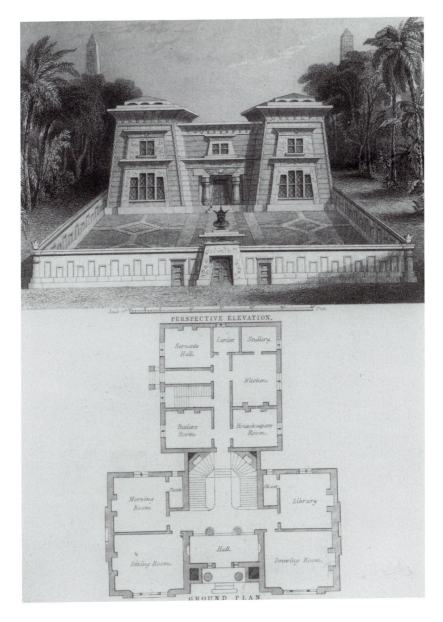

Plate 185 *'An Egyptian Pavilion' from BROWN (1842):* Domestic Architecture, *showing the ground-floor plan and a perspective. This coarse design is curiously old-fashioned for its date, and is very much in the same mould as Robinson's Egyptian Hall or Foulston's Library. Note the obelisks in the background (JSC).*

313

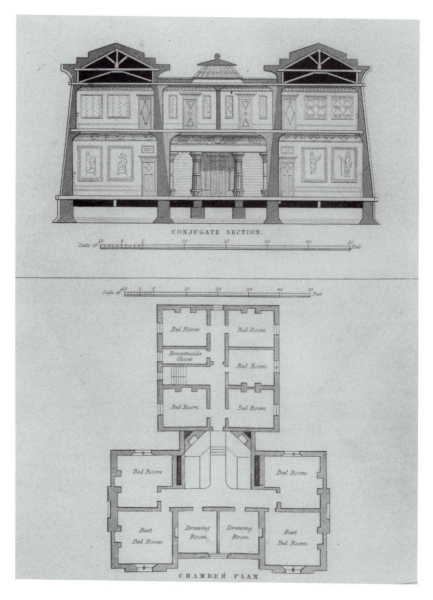

Plate 186 *Section and first-floor plan of Brown's 'Egyptian' House from BROWN (1842):* Domestic Architecture (JSC).

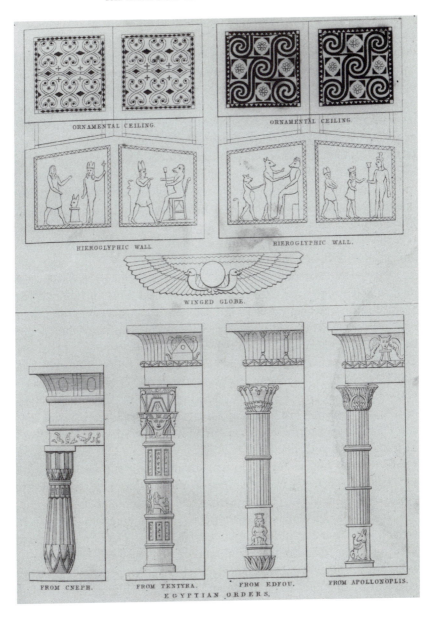

ORNAMENTAL CEILING.

ORNAMENTAL CEILING.

HIEROGLYPHIC WALL.

HIEROGLYPHIC WALL.

WINGED GLOBE.

FROM CNEPH.

FROM TENTYRA.

FROM EDFOU.

FROM APOLLONOPLIS.

EGYPTIAN ORDERS.

Plate 187 *Details of 'Egyptian Orders' and sundry decorations from BROWN (1842):* Domestic Architecture *which he published despite the appearance of scholarly publications that featured accurately surveyed precedents* (JSC).

315

yard or a small garden: indeed, our learned architect stated that Ancient Egyptian 'houses of a small size in the provincial towns were usually connected, and formed the continuous sides of streets; they rarely exceeded two stories, and many of them consisted only of a ground-floor and an upper set of rooms'.[4] Brown also published details of columns, capitals, and decorations for the interior that were ludicrous caricatures of real Egyptian models. So in the West of England there were at least three architects designing in the Egyptianising manner in the first decades of the nineteenth century: Foulston, Wightwick, and Brown. Could Brown be a candidate as the designer of the Egyptian House in Penzance?

More Greek than Egyptian, but with powerful battered pylon-like openings, is the former Stamford Institution building in Stamford, Lincolnshire, by Bryan Browning (1773–1856) of 1842.[5] Browning's work is boldly and confidently Neo-Classical, and of quite a different calibre compared with Brown's ham-fisted designs.

Across the Atlantic many competent and powerful Egyptian Revival designs were realised: the Odd-Fellows' Hall, Philadelphia, of 1846–47, has a vast cavetto crowning cornice, and tall giant pylon-like architraves with their own entablatures rising two storeys above a massive base, whilst above the window-entablatures are corbelled or stepped openings.[6] Massively Egyptianising was the railway-bridge at Harper's Ferry, West Virginia (1835–51), by B. H. Latrobe Jr and Wendel Bollman,[7] as was John B. Jervis's Croton Distributing Reservoir, New York (1842), a tremendous conception, featuring blank walls, massive pylons at the corners and centres, and a plain cavetto cornice: the latter structure was worthy of a New World Ledoux.[8] Synagogues, like halls for the Freemasons and Odd Fellows, were often inspired by Ancient Egyptian architecture, but frequently the Egyptianising elements were confined to the façades. The synagogue at Hobart, Tasmania (1844), was designed with an enormous battered pylon-like façade crowned with a cavetto cornice.[9] Egyptianising synagogues were erected at Launceston in Tasmania, and in Sydney, New South Wales.[10] Mention has been made of Weinbrenner's Egyptianising synagogue at Karlsruhe (1798), and of Strickland's Mikveh Israel synagogue, Philadelphia (1822–25):[11] the Beth Israel synagogue in Philadelphia by T. U. Walter (1849) should also be listed.[12] Other fine Egyptian Revival buildings include

4 BROWN (1842), 281.
5 COLVIN (1995), 172.
6 CARROTT (1978), plate 77.
7 Ibid., plates 79–80.
8 Ibid., plates 86–87.
9 Ibid., plate 89.
10 Ibid., 18, note 4.
11 Ibid., plate 90.
12 CARROTT (1978), plate 91.

the Downtown First Presbyterian church, Nashville, by W. Strickland (1848–51)[13] – a massive concoction with huge pylon-shaped architraves set between a Giant Order of pilasters, and with a distyle *in-antis* porch (the stunning *trompe l'œil* painted Egyptianising interior was redecorated in 1881 and 1937); the First Baptist church, Essex, Connecticut (1845) – Egyptianising and clap-boarded;[14] the Whalers' church, Sag Harbor, New York (1843) – a splendidly robust yet delicately modelled timber building;[15] a project for a church (1845) by Alexander Jackson Davis (1803–92) – an Egyptianising version of Classical churches with a bell-tower set behind a temple-front evolved in England from the time of James Gibbs (1682–1754);[16] the same architect's project for an Athenæum of Natural History, New York – almost 'Greek'-Thomsonesque in its use of large areas of glass set behind the Egyptianising front;[17] Thomas S. Stewart's Medical College of Virginia, Richmond (1844) – one of the grandest and most monolithic of all Egyptian Revival buildings;[18] John Haviland's (1792–1852) New Jersey State Penitentiary, Trenton (1832–36) – massively robust and Sublimely terrifying, with its large areas of blank walls, and sinister portico set between two pylons;[19] the same architect's awesome 'Tombs' Prison, New York (1835–38) – influenced partly by Ledoux's prison at Aix-en-Provence, and partly by the temple at Dendera;[20] the Essex County court-house, Newark (1836–38) – again by Haviland;[21] and the City Jail, Dubuque, Iowa (1857–8), by J. Francis Rague (1799–1877).[22]

Travellers and Scholars

Mention has been made above of the important contributions of Denon, Henry Salt, Giovanni Belzoni, John Gardner Wilkinson, and others. Among nineteenth-century travellers to Egypt were the young architects Charles Barry (1795–1860), Louis-Maurice-Adolphe Linant de Bellefonds (1799–1883), the wealthy antiquarian William John Bankes (1786–1855), Owen Jones (1809–74), George Alexander Hoskins (1802–63), John Frederick Lewis (1805–76), Frederick Goodall (1822–1904), Richard Dadd

13 *Ibid.*, plate 93.
14 *Ibid.*, plate 94.
15 *Ibid.*, plate 95. It has been attributed to Minard Lafever (1798–1854).
16 *Ibid.*, plate 96.
17 *Ibid.*, plate 99.
18 *Ibid.*, plates 102–3.
19 *Ibid.*, plates 107 and 110.
20 *Ibid.*, plates 111, 112, 114, 116, 118, 121–5, 127, 128, and 134. Professor Carrott is particularly good on this building.
21 *Ibid.*, plates 129–31.
22 *Ibid.*, plate 132.

(1817–86), Godfrey Thomas Vigne (1801–63), and many other observant and gifted people who made copious records of what they had seen. European collections of Egyptian antiquities were formed through the activities of adventurers such as Salt, Belzoni, and Bernadino Drovetti (1776–1852),[23] whose discoveries form the core of the Egyptian sections of the London, Paris, Berlin, and Turin museums. Achille-Constant-Théodore-Émile Prisse d'Avennes (1807–79), artist and designer, actually lived at Luxor, and published his two-volume *Histoire de l'Art Égyptien, d'après les Monuments* in 1878–79. Owen Jones's *Views on the Nile, from Cairo to the Second Cataract* (1843) included architectural details, and his interest in the coloured decorations of Ancient Egyptian buildings led to his important reconstructions in the 1850s and to the publication of his *Grammar of Ornament* (1856). Interestingly, Jones travelled in Egypt with the French architect Jules Goury (who had worked with Gottfried Semper [1803–79] on the polychrome decorations of Greek temples), and remained a lifelong friend of Joseph Bonomi Jr.[24]

Then came the greatest work of scholarship dealing with Ancient Egyptian buildings since the publication of *Description*. This was the *Denkmäler aus Ægypten und Æthiopien*, published in Berlin in twelve sumptuous volumes between 1849 and 1859. This was edited by Karl Richard Lepsius (1810–84), a great scholar and linguist from Saxony, who had studied Champollion's works on hieroglyphs, and who had investigated the Egyptian collections in England, Italy, and France. Lepsius led the expedition to Egypt and Nubia in 1842–45 under the ægis of the King of Prussia, Friedrich Wilhelm IV (reigned 1840–61), and the work done at that time was the basis for the *Denkmäler*, which is more detailed than the *Description* in its records of the monuments and inscriptions (**Colour Plates XXX–XXXIV**). Lepsius's discoveries, and the 15,000–odd antiquities and casts he unearthed and made, led to the creation of the celebrated Egyptian Museum in Berlin. The artist with the Prussian expedition was Ernst Weidenbach (1818–82), who later joined the staff of the Berlin Museum. Lepsius was later (1866) to discover the Edict of Canopus at Tanis, a stone inscribed bilingually, which confirmed the accuracy of Champollion's theories and alphabet. The work of Lepsius, and the marvellous *Denkmäler*, were landmarks in the history of Egyptology.

William Henry Bartlett (1809–54), the topographical artist, travelled in Egypt in 1845, and published his *The Nile Boat*, a popular account, in 1850. Then, in 1849, Gustave Flaubert (1821–80) and Maxime du Camp (1822–94) travelled in Egypt, making paper moulds of inscriptions, and

23 *See* RIDLEY (1998).
24 For travellers *see* CLAYTON (1982).

using a camera. Photography, of course, was a cumbersome business then, and drawings were still essential. Edward Lear (1812–88) visited Egypt several times in the 1850s and 1860s, and Amelia Ann Blanford Edwards (1831–92) visited Egypt and Syria in the 1870s, publishing *A Thousand Miles Up the Nile* in 1877. She was later to be a leading-light in the foundation of the Egypt Exploration Fund, and endowed the first Chair of Egyptology in England - that at University College, London.[25]

When Auguste-Ferdinand-François Mariette (1821–81) was sifting through the papers of his recently-dead cousin, Nestor L'Hôte (who had been Champollion's draughtsman), he came across the beautiful drawings, and became infected with the Egyptomania bug. Mariette was to do for archæology in Egypt what Champollion had done for the study of hieroglyphs, and it was he who discovered in 1851 the long-lost *Serapeion* at Memphis, the underground burial-chamber of the Apis-Bulls, one of the greatest of all Egyptological finds, comparable with the tracking-down of the Royal mummies at Deïr-el-Bahari, the finding of the Royal tombs at Tanis, and the opening of the tomb of Tutankhamun. Mariette then helped to organise the projected expedition to Egypt of Prince Napoléon (cousin of the Emperor Napoléon III), and, with the assistance of Saïd Pasha, Viceroy of Egypt, assembled a fine collection of antiquities. In 1858 Mariette was appointed Director of the Egyptian Antiquities Service, with all the powers and resources required for the job: he established the outstanding museum in Cairo.

Ferdinand de Lesseps (1805–94), who constructed the Suez Canal (1859–69), was a friend of Mariette, and was responsible for enhancing the prestige of France. The opening of the canal on 17 November 1869 was marked by a procession of ships led by the French imperial yacht, *Aigle*, with the Empress Eugénie (1826–1920) on board. A new opera, *Aïda*, was commissioned from Giuseppe Fortunino Francesco Verdi (1813–1901), first given in Cairo on 24 December 1871, with a text by Antonio Ghislanzoni based on a scenario by Mariette and a French text by Camille du Locle. Now this opera was *not* written for the opening of the Suez Canal, but was ordered by the Khedive of Egypt to open the new Cairo Opera House in the same year (1869). However, scenery and costumes were held up in Paris during the Franco-Prussian War of 1870–71, and the première had to be postponed from January to December 1871. *Aïda* was set in Ancient Egypt, the scenes being the Palace of the Pharaoh at Memphis, the Temple at Memphis, a Hall in the Apartments of Amneris (daughter of Pharaoh), the Gate of Thebes, the Banks of the Nile, a Hall in the Palace of Pharaoh, and a Dungeon with a Temple above. All these scenes were, and are, splendid

25 EDWARDS (1877).

vehicles for the most spectacular Egyptianising sets,[26] but these days (as with *Die Zauberflöte*) designers seem frightened of exploiting such possibilities (or, more likely, are so ignorant of historical styles), that we get (far too often) dreary non-architectural sets. The effects of the opera on Taste were not dissimilar to the impact of the showy films of the twentieth century that featured Cleopatra and Egyptianising décor.

When Mariette died, he was entombed in a stone sarcophagus, a replica of an Old Kingdom exemplar. Mariette was succeeded as Director of the Antiquities Service at the Museum at Bulaq, Cairo, by another Frenchman, Sir Gaston Maspero (1846–1916), who discovered the amazing cache of royal mummies at Deïr-el-Bahari in the 1880s: these mummies had been moved from their tombs by Ancient Egyptian priests after serious looting began during the twenty-first Dynasty. This great discovery, including the papyri and the texts on the coffins (the funerary goods and precious ornaments had long since been stolen), provided Maspero and Egyptologists with an enormous amount of material. Egyptology was now a great and growing science. Thereafter, inexact Egyptianising caricatures (though occasionally found) became rare, and serious attempts to create scholarly Revival buildings and artefacts were made.

The Egyptian Revival in the Hands of Serious Egyptologists

Thomas Lee (1794–1834) designed the Wellington Monument, Blackdown Hill, Somerset, in 1817–18, a triangular obelisk, drawings for which were exhibited at the Royal Academy in 1818. Later, in 1853–54, Egyptianising features were added to the monument by Charles Edmund Giles of Taunton (*fl.* 1849–68): it therefore became a lofty monument on a polygonal battered base decorated with the winged globe, cavetto cornices, and torus mouldings. Once again, Egyptianising tendencies in the West of England should be noted.[27]

Then came the scholarly gates at Abney Park Cemetery, mentioned above, with which Bonomi was involved. Bonomi then joined forces with Owen Jones to produce a spectacular work of the Egyptian Revival for the Crystal Palace[28] at Sydenham, South London: this was the Egyptian Court

26 For *Aïda* and other Egyptianising theatre, *see* HUMBERT, PANTAZZI, AND ZIEGLER (*Eds*) (1994), 390–447.
27 GRINSELL (1972), 9.
28 ROUTLEDGE & SONS (1854). ROUTLEDGE's *Guide to the Crystal Palace, The Ten Chief Courts of the Sydenham Palace*, and the *Official Guide* of 1854, which includes a description of the Egyptian Court by its designers, are useful. *See also* JONES and BONOMI (1854): *Description of the Egyptian Court erected at the Crystal Palace*. The Author is indebted to Mr Ralph Hyde for this reference.

(**Plate 188**), consisting of a series of rows featuring models of bas-reliefs, columns, deities, Græco-Egyptian columns, hieroglyphs, Karnak lions, other Egyptian lions, pharaohs, Romano-Egyptian columns, the Rosetta Stone, statues, and a mock-up of the *colossi* at Abu-Simbel (**Plate 189**). The massive columns, based on those at the temple at Karnak, were particularly admired, 'on account of the beautiful manner in which the decorations' were executed. Such a public display of Egyptian architecture and sculpture (much of it actually designed by Jones and Bonomi in a scholarly manner) brought the Egyptian style before a wide public. Hieroglyphic inscriptions actually meant something, and were not used decoratively: the Sydenham Egyptian Court contained hieroglyphs to signify 'Victoria' and 'Albert',[29] and also stated that in the seventeenth year of the reign of Her Majesty, the Ruler of the Waves . . ., the architects, painters, and sculptors built the palace as a book for the instruction of men and women of all countries, regions, and districts. The composition was by Samuel Sharpe (1799–1881)[30] and Bonomi himself.

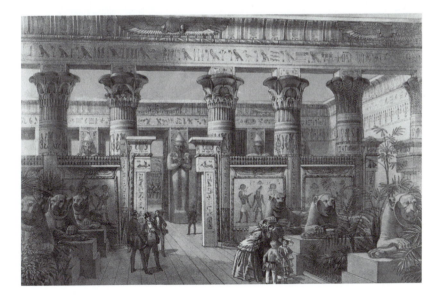

Plate 188 *Egyptian Court by Owen Jones and Joseph Bonomi Jr at the Crystal Palace, Sydenham, London, of 1854. Lithograph by Day & Son (GLCL).*

29 ROUTLEDGE & SONS (1854) and JONES and BONOMI (1854).

30 Samuel Sharpe was a distinguished Egyptologist and translator of the Bible. He published *The Early History of Egypt* in 1836 and other important volumes on hieroglyphs, *Egypt under the Romans*, and *Egypt under the Ptolemies*. His *Egyptian Inscriptions* (1837, 1841, and 1855) contained a very large body of hieroglyphical writing. He was responsible for the 'Historical Notice of the Monuments of Egypt' in JONES and BONOMI (1854). *See Dictionary of National Biography* (1917), **xvii** (London: Oxford University Press), 1363–5.

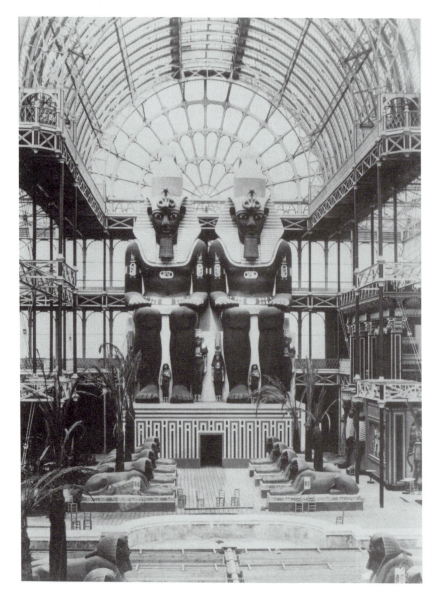

Plate 189 *The Colossi of Abu Simbel designed by Jones and Bonomi for The Egyptian Court at the Crystal Palace. From a photograph by Philip Delamotte of 1854* (MC, Mansell/TimePix).

The second half of the nineteenth century could boast several important design theorists, including Semper, who was profoundly influenced by the 1851 Exhibition in London, and who designed some of the sections of that Exhibition himself. He later taught in Sir Henry Cole's (1808–82) School of Design at Marlborough House under the Department of Practical Art, and in 1861–3 he published *Der Stil in den Technischen und Tektonischen Künsten, oder praktische Ästhetik* (Style in the Technical and Structural Arts, or Practical Æsthetics) in which he incorporated researches into primitive, Oriental, and European cultures, as did Auguste-Alexandre-Philippe-Charles Blanc (1813–82), in his *Grammaire des Arts du Dessin* (1867). Semper developed a theory of evolution in art, and stated that the history of architecture really began with a history of practical art. The characters of architectural styles, he said, were expressed in certain forms of early industrial art, applied in necessary objects.[31] Semper proved his argument by comparing an Ancient Egyptian *situla*,[32] or jug for drawing water from the river, with a Greek jar for collecting water from a spring, and pointed out that the form of each vessel expressed its function, not only as a container for water, but the method of carrying it. In *Der Stil* Semper contrasted Greek Doric with Egyptian temples, and found that Egyptian examples expressed the 'heaviness' of the Egyptian character and spirit, a conclusion that we might question. However, Semper was closely involved professionally with Jones, Cole, and others, and was interested in the idea of creating exemplars for educational purposes in order to raise the general level of taste, so he is relevant to this study.

The Egyptian Court at Sydenham, therefore, was a product of the high-minded theories of educationalists in that it attempted to provide accurate, scholarly models of buildings that could be seen by many, and Jones and Semper were among the theorists who influenced the concept of pavilions that would be related to aspects of applied art. There were several important nineteenth-century exhibitions where Egyptian objects, or Egyptianising artefacts, were given a suitably Nilotic architectural setting. Semper's own studies of the primitive and the exotic led him to admire the sophistication of Ancient Egyptian architecture, and he saw in its art and architecture some profoundly expressive possibilities.

Earlier, King Friedrich Wilhelm IV of Prussia had been instrumental in creating one of the finest of scholarly Egyptianising interiors ever conceived: this was in the new museum on the *Spreeinsel* (an island dividing the River Spree into two branches) in Berlin, a structure intended to house the collections not included in Schinkel's museum (built 1824–30) which therefore became known as the *Altes Museum* (Old Museum). The architect

31 SEMPER (1880).
32 It was also called *hydreion* (from ύδρία, a water-pot). *See* **Plates 6** and **7**.

for the *Neues Museum* (New Museum) was Schinkel's former assistant, Friedrich August Stüler (1800–65), and construction began in 1843, the year after Lepsius's expedition to Egypt had commenced. Stüler's Neo-Classical design harmonised beautifully with Schinkel's great building, and the interiors were specially designed to house the Egyptian collections, by then vastly enlarged when Lepsius returned to Prussia in 1846.

The galleries opened in 1850, and the Egyptian collections were displayed in a series of rooms grouped around the top-lit Egyptian Court, the décor of which was proposed by Lepsius. Now the importance of this Court cannot be over-stated, for it was the finest attempt to create an historically correct work of Egyptianising architecture, fully five years *before* the Bonomi/Jones Egyptian Court at the Crystal Palace at Sydenham. Sixteen columns with bell-capitals surrounded the Berlin Court, and an inscription in hieroglyphs, devised by Lepsius, praised the modern pharaoh, Friedrich Wilhelm IV, for founding the museum. The walls were decorated with seventeen mural paintings by Johann Wilhelm Schirmer (1807–63), assisted by Carl Graeb, Eduard Biermann, Eduard Pape, and Max Schmidt: these murals showed a wide variety of Ancient Egyptian buildings in Nilotic settings.

This splendid polychrome Egyptian Court was recorded in a painting (1850) by Eduard Gärtner (1801–77), and printed as a lithograph in Stüler's *Das Neue Museum zu Berlin*, first published in 1853 (**Colour Plate XXXV**). Unfortunately, this very important, scholarly, sumptuous, and early piece of Egyptianising Historicism was a casualty of the 1939–45 war. The Museum was indeed a *Gesamtkunstwerk* (total work of art), and its significance as a model for the display of artefacts from different cultures cannot be over-emphasised.[33]

Egyptian features, as part of garden-design (as has been demonstrated above), were not uncommon, and there were the occasional full-blooded Egyptianisms such as those of Canina in Rome and Menelaws at Tsarskoe Selo. Perhaps the most captivating of all gardens where Egyptian motifs were used is that at Biddulph Grange in Staffordshire, an unexpected and exotic creation of James Bateman (1811–97) and his wife, Maria Sibylla Warburton, who moved to Biddulph in 1838. The gardens were laid out mostly in the 1840s, with considerable assistance from the painter and designer Edward William Cooke (1811–80 – who had visited Egypt), and were described in *The Gardener's Chronicle* of 18 October 1856:[34] they were conceived as a series of scenes alluding to different styles, countries, and cultures, including China and Egypt. The strangest part of the garden is the Egyptian Court: there, two stone sphinxes of faintly bucolic mien flank a

33 *See* HUMBERT, PANTAZZI, and ZIEGLER *(Eds)* (1994), 342–3.
34 *See* PETER HAYDEN (1978): 'Edward Cooke at Biddulph Grange', in *Garden History*, **vi**/1 (Spring), 25–32.

path that leads to a battered pylon-like entrance (also of stone), but the rest of the ensemble, consisting of two pyramids on square pedestals, massive, blocky Egyptianising forms, and a great central truncated steep pyramid, is all of clipped yew. It is a wonderfully effective idea, brilliantly rendered, and darkly mysterious. Here, one can imagine the *Zwei schwarzgeharnischte Männer* from Act II of *Die Zauberflöte* guarding the gloomy portico which leads to a dark tunnel at the end of which is a statue of the physically unattractive deity Bes. It is not surprising the *Gardener's Chronicle* noted that the 'appearance of the whole court is unique, and being thoroughly excluded from the rest of the grounds, and entered upon suddenly in both directions, it contributes to that change of scene which must always be delightful'. Quite so: it is a place where anything might happen; it is a marvellous, mysterious, moving, evocative design (**Plate 190**).

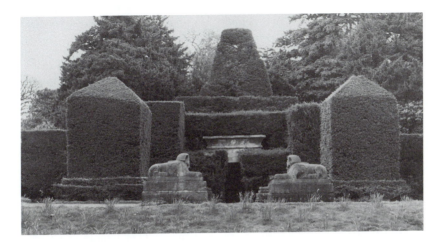

Plate 190 *The Egyptian Garden at Biddulph Grange, Staffordshire, of 1856, designed by James Bateman and Edward Cooke. Photograph of 1980 (JSC).*

A number of fine and archæologically respectable buildings followed, none more correct, colourful, and scholarly than the Egyptian Temple in Antwerp Zoo, built 1855–56 by Charles Servais (1828–92) (**Colour Plate XXXVI**). It was based on the style of the temples of Philæ and Dendera, and was inspired by the Egyptian Court at Sydenham. Servais consulted Bonomi, who helped him with the hieroglyphs and with the correctly Egyptianising details for the building (which houses elephants): the frieze states in hieroglyphs that in the year of our Lord 1856, under His Majesty the King, Sun and Life of Belgium, Son of the Sun, Léopold the First, the building was erected to give joy and instruction to the citizens of Antwerp (**Plate 191**). Others involved in the design of the details were Samuel

eM	TeR	eNT	piNouTeR	eNTi	NoHem	MDCCCLVI	KHaR	Hon-eF
In	het jaar	van de	God		Verlosser	1856	onder	Z. M.

SouKHeb	Ra ONKH–Belgica	Si Ra	Leopold APe	AiRiTOU
de Koning,	Zon en leven van België,	Zoon van de Zon,	Leopold de Eerste.	werd gemaakt

Pa TeN	SchAIt	eR Ou Het Antverpia	Se-AKer	RuT.
dit huis	een boek	om te verblijden Antwerpen	en te onderwijzen	zijn bewoners.

Plate 191 *Hieroglyphs and their Flemish translation at the Egyptian Temple, Antwerp Zoo, from* Zoo. *Uitgave van de Kon. Mij. voor Dierkunde van Antwerpen (Dr Eugène Warmenbol and Mevr Petra Maclot).*

Sharpe[35] and Dr Louis Delgeur (1819–88). The building underwent a particularly happy restoration in 1988, during which scholarly reconstructions of the schemes of decoration and colour were carried out,[36] but by 2002 had once more deteriorated.

Also scholarly, solid, and archæologically convincing is the remarkable (and little-known) Freemasons' Hall, Mainridge, Boston, Lincolnshire, of 1860–63, clearly based on the portico of the Nubian temple at Dendur taken from Denon (**Plate 192**): it originally consisted of an entrance-hall, kitchen, and banquet-room, with the Lodge-room above, and the massive and spectacular façade is of gault brick with ashlar dressings, in the form of a pylon, with distyle *in-antis* portico with palm-capitals, and cavetto cornice adorned with a winged solar globe supported by *uræi*. As with the Egyptian Court in Berlin and the Antwerp examples, it has an inscription in hieroglyphs. At Boston, this is placed on the lintels, although part of the inscription is on the abaci, but, unlike the Antwerp building, the hieroglyphs are precisely carved into the stonework, rather than painted: they state that 'In the Twenty-Third Year of the Reign of Her Majesty the

35 *See* footnote 30 above.
36 W. VAN DEN BERGH (1957): 'De Egyptische Tempel', in *Zoo*, **iii** (January), 80–3. Heer Jan Geerærts, Director of the *Koninklijke Maatschappij voor Dierkunde van Antwerpen* very kindly provided information. Dr Eugène Warmenbol and Mevr Petra Maclot also very kindly showed the building to the present writer. *See Zoo Anvers* (April 1988), **iv**, 1–53, and GENS (1861).

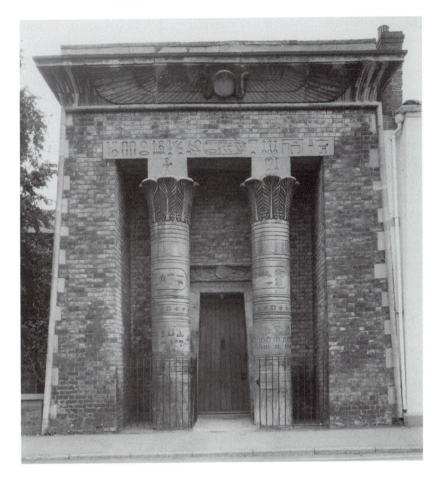

Plate 192 *The Freemasons' Hall, Mainridge, Boston, Lincolnshire, of 1860–63. A powerful and archæologically correct evocation of an* in antis *arrangement of portico in the Egyptian style constructed of yellow brick with limestone dressings. The inscription on the lintel above the palm-capitals reads 'In the Twenty-Third year of the Reign of Her Majesty the Royal Daughter Victoria, Lady Most Gracious, this Building was Erected'* (Addys [Boston] Ltd, No. 12168A, collection JSC).

Royal Daughter Victoria, Lady Most Gracious, this Building was Erected', and also give the date of dedication as 28 May 1863. Victoria became Queen on 20 June 1837, so the inscription must refer to the *commencement* of the building, rather than its *completion*, which was in the twenty-sixth year of her reign, thus the Hall was begun in 1860.

The interior was decorated with Egyptian motifs, including the winged globe with *uræi*, the scarab, the lotus, the eternal serpent, all embellished with strong colour, and included a 'Masonic canopy' or

painted representation of the sky emblazoned with golden stars. This building is so fine, and the hieroglyphs and details are so archæologically correct, someone in the know must have been involved in its design: Joseph Bonomi Jr is the most likely candidate, but so far, documentary evidence is lacking. An Egyptianising timber doorcase survives at 3 High Street, Warwick, and consists of columns supporting a somewhat heavy semicircular pediment, and the entire ensemble is richly embellished with lotus- and papyrus-enrichment, although colouring is absent: it appears also to have been associated with a Freemasonic Lodge.

Curiously, the *Exposition Universelle* of 1867 in Paris contained two Egyptianising pavilions: one, the *Pavillon de l'Isthme de Suez*, by Chapon,[37] was a clumsily composed and ill-assorted jumble of unscholarly bits and pieces; but the other, the splendid and colourful *Temple Égyptien*, was designed by Drevet with Mariette as consultant, and was inspired by the western temple at Philæ – it had a pylon at the end of an avenue of sphinxes, and left little to be desired in the way of authenticity.[38]

Publication of Roberts's *Egypt and Nubia* and Gardner Wilkinson's *Manners and Customs of the Ancient Egyptians*, together with the popularisation of Ancient Egyptian art and architecture (as at the Exhibition buildings), led to a growing familiarity with the Egyptian style. Importation of Egyptian cotton to Lancashire caused the naming of the Cairo Mill in Burnley, and there were other such examples. The tough, no-nonsense architecture of Ancient Egypt, as has been mentioned above, was ideally suited to industrial and practical structures (such as pylons for suspension-bridges, battered walls for dams and retaining-walls, and so on), and can be found in James Pilbrow's spectacular Maidstone Water-Works building (with battered stock-brick buttresses and a heavy cavetto cornice of stucco [1860]) at East Farleigh, Kent, beside the River Medway.[39] Under the enlightened mayoralty of George Thompson, the municipal authorities of Sydney, Australia, built a sewerage system (1857) that was ventilated through the tip of a commemorative obelisk set on a battered pylon-like base: the latter has a cavetto cornice embellished with winged globes on all four sides, and the cornice itself carries eight sphinx-like bodies terminating in four heads, one at each corner of the obelisk-base (**Plate 193**).

Another curious application of the Egyptian style to engineering works is the Egyptian arch over the Newry-Camlough road, near Bessbrook, in County Armagh, Northern Ireland: it carries the main railway-line of the former Dublin & Belfast Junction Railway, was built in

37 Illustrated in HUMBERT (1989a), 72.
38 *Ibid.*, 73.
39 Illustrated in CURL (1982), plate 179.

Plate 193 *Egyptianising base of a hollow obelisk used as a ventilator to the sewers of Sydney, Australia, 1857* (the late Mr K. T. Groves, taken at the request of the Author).

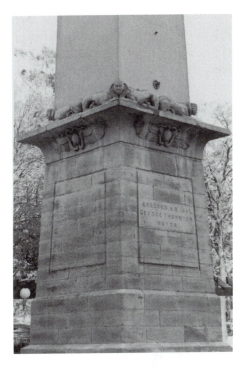

1851, and was designed by the railway engineer Sir John Benjamin Macneill (*c*.1793–1880) in collaboration with the builder William Dargan (1799–1867).[40] The same team was responsible for the design and construction of the Craigmore Railway Viaduct (opened 1852) near by, the piers of which are elegantly battered, and so suggestive of an Egyptianising style as well as giving an appearance of great strength. Apparently the only other railway structure of any size built in the Egyptianising style in Ireland was the Broadstone terminus in Dublin, designed by J. S. Mulvany. The Egyptian arch has suffered from recurring bomb-damage in recent years.

One other Egyptianising design in Northern Ireland deserves mention here: that is Dunore House, Aldergrove, County Antrim, an extraordinary building of 1870. The centrally-placed front door and its flanking lights are separated by four pilasters in the form of inverted obelisks capped by four Egyptianising heads, two of which are bearded pharaohs, the other two being either Egyptian queens or Nubians. All four wear the *nemes* head-dress with rearing *uræi*, and each rests on a block embellished with an incised cartouche containing hieroglyphs. Inside, the toothed serpent motif of the balustrade can be regarded as an Egyptianising feature.[41]

40 *See* C. E. B. BRETT (1999): *Buildings of County Armagh* (Belfast: Ulster Architectural Society), 254–5.
41 C. E. B. BRETT (1996): *Buildings of County Antrim* (Belfast: Ulster Architectural Heritage Society and The Ulster Historical Foundation), 139, 208.

Some of the most interesting Egyptianisms in design of the second half of the nineteenth century occur in the work of Christopher Dresser (1834–1904), one of the first and few Victorian designers of any standing who actually accepted the necessity of using machines. Dresser eschewed any nostalgia for hand-crafts, and designed with the new manufacturing processes in mind. He was profoundly influenced by Owen Jones, and his own *Principles of Decorative Design* (1873) reflects this indebtedness. Dresser admired the 'severity, rigidity of line', and 'sort of sternness' in Egyptian ornament, and noted that with severity there was always dignity.[42] Nobility, massiveness, and solidity were admirable aspects of Ancient Egyptian design, and Dresser drew especial attention to the structural principles used in Ancient Egyptian furniture, comparing products of his own day unfavourably with it. Several of his designs are based on Egyptian prototypes, including the mahogany sofa with leather seat and back, strengthened with ties to the cross-rails between the legs (**Plate 194**). Yet Dresser took the view that Egyptian ornament, being symbolic, was not really suited to contemporary wants, although he could admire the noble qualities of Egyptian design as 'our just inheritance'.[43] Dresser's influence in design was considerable, and his admiration for real Egyptian furniture is often expressed in his writings.

During the 1870s and 1880s many examples of English furniture were made with scholarly Egyptianising ornament, some of it based on Jones's *Grammar*, and some copied from New Kingdom furniture exhumed from tombs. Three fine examples may be mentioned here: first of all, the wooden stool (1870), painted with designs based on Owen Jones's *Grammar* (**Plate 195**); secondly, the spectacular and beautifully-proportioned English wardrobe in the Egyptian taste (1878–80), of oak and pine, decorated with Egyptian motifs that owe much to both Dresser and Jones (**Plate 196**); and the very pleasing 'Thebes stool', of mahogany with a leather seat, patented and marketed by Liberty & Company (**Plate 197**),[44] which will be mentioned below.

There was an important exhibition of Egyptian antiquities in New York in 1852, and this, with the permanent Egyptian Court at Sydenham, and the discoveries based on archæological excavations under Mariette and others, encouraged a vogue for Egyptianisms in design. Brass lions' and leopards' feet, sphinx-heads and -paws, lotuses, palms, scarabs, winged globes, cavetto cornices, pylon-forms, and other motifs were commonly employed, notably in furniture, and especially in the United States of America (where Egyptianisms enjoyed an almost continuous vogue) and in

42 DRESSER (1873), 4. *See also* DRESSER (1876), 8.
43 Now in the Victoria & Albert Museum. *Circ.* 511, 1965.
44 *See* CONNER (*Ed.*) (1983), 97–114.

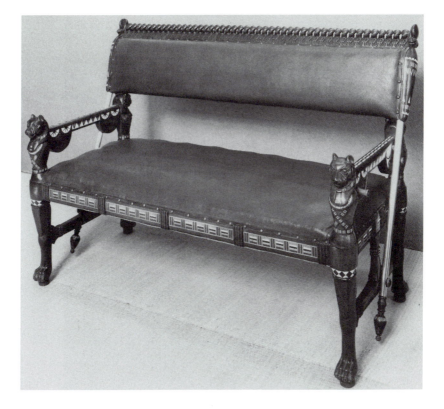

Plate 194 *Sofa of 1880 with Egyptianising detail (leopards' heads, simple patterns in primary colours, etc.) by Christopher Dresser* (V & A).

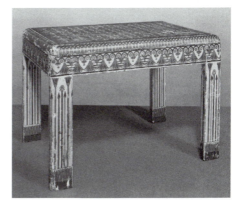

Plate 195 *Stool of 1870, made of wood, and painted with Egyptianising designs derived from Owen Jones's* The Grammar of Ornament *(1856). The top of the stool is painted with designs derived (somewhat freely) from plate X, no. 16, and the legs from plate IV, no. 17* (V & A G. F 2443).

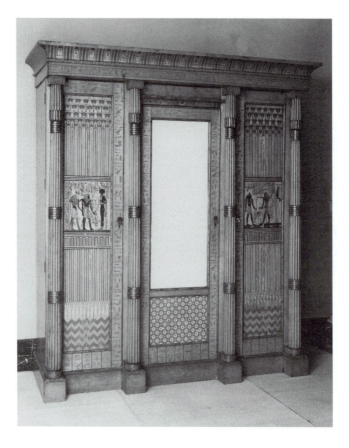

Plate 196 *English wardrobe of 1878–80, of oak and pine, with Egyptianising motifs* (V & A G 44646.14).

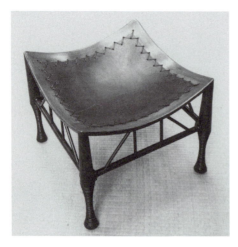

Plate 197 *'Thebes' stool patented and marketed by Liberty & Company in 1884* (V & A).

France (where the Empire style was revived, and remained an inspiration). Space precludes the inclusion of the enormous range of Egyptianising artefacts here, but readers are referred to other sources.[45]

The obelisk of red granite in London known as 'Cleopatra's Needle' lay in the sands near Alexandria for centuries before it was presented to the British Nation by Mohammed Ali (c.1769–1849), Viceroy of Egypt, in 1820, as a memorial to Nelson and Abercromby. In fact there were two obelisks called by the same name,[46] and the other was presented to the United States of America in 1869 by the Khedive Ismail (1830–95 – Mohammed Ali's grandson) at the time of the opening of the Suez Canal. The American obelisk was removed to New York by Lieutenant-Commander Henry H. Gorringe, and re-erected in Central Park in January 1881. Both obelisks were originally erected by Tuthmosis III in c. 1468 BC at Heliopolis, but were moved to Alexandria under the ægis of Augustus in 10 BC to stand in front of the temple to the recently deified Julius Cæsar: the obelisks stood on the backs of inscribed bronze crabs, attributes of the Roman sun-god Sol.[47] Lepsius described them, but they have suffered greatly since then through the inclement Northern climate.

The British obelisk was transported in a purpose-made cylinder, the *Cleopatra*, towed by the paddle-steamer *Olga*: John Dixon, engineer, devised the cylindrical craft (built 1875), and the obelisk was erected on the Victoria Embankment beside the Thames on 12 September 1878. The length of time between the making of the gift and the efforts to accept it (55 years) is an indictment of nineteenth-century official parsimony as well as of technology, for it will be remembered that Romans of imperial times transported even larger obelisks by sea to their capital some 1,800 years before. The transportation of the 'Needle' to London was made possible largely through the generosity of Dr William James Erasmus Wilson, FRS (1809–84 – who was knighted in 1881),[48] and the re-erection of the monument on its new Egyptianising stone base set with bronze ornament was also carried out under Dixon's direction, although the design (1880) of the fine bronze sphinxes (cast by Young & Company) was by George John Vulliamy (1817–86) (**Plate 198**).

Thus London acquired a genuine Ancient Egyptian obelisk, a fine Egyptian Revival base for it with flanking sphinxes, and a series of benches along the Embankment with sphinx- and camel-features on the cast-iron

45 CONNER (*Ed.*) (1983), *passim*, and HUMBERT, PANTAZZI, and ZIEGLER (*Eds*) (1994), *passim*.
46 Which is very odd, because Cleopatra committed suicide some twenty years *before* Augustus had the obelisks moved to Alexandria, so they had no connection at all with the Egyptian queen.
47 CLAYTON (1982), 58.
48 Wilson was interested in Egyptian antiquities in more than an amateur capacity, and knew the lands by the Nile.

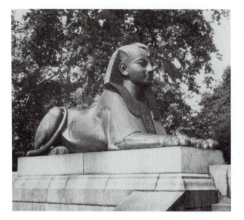

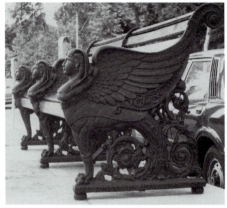

Plate 198 *One of a pair of bronze sphinxes (modelled on a stone sphinx at Alnwick Castle, Northumberland), flanking the obelisk erected in 1880 on the Embankment in London, designed by George John Vulliamy, Architect to the Metropolitan Board of Works, and cast by Young & Company. Photograph of 1979 (JSC).*

Plate 199 *Egyptianising cast-iron seat-supports on the Embankment, London (JSC).*

elements made by Z. D. Berry & Sons at the Albion Works, Westminster, and based on designs made by the office of Sir Joseph William Bazalgette (1819–91), Engineer to the Board of Works, in 1874. The benches that grace the Embankment today are reproductions of the original 1874 Bazalgette-Berry designs made by the SLB Foundry, of Sittingbourne, Kent (1977) (**Plate 199**). Excavations at Tel-el-Amarna in 1887 and the arrival of genuine Egyptian obelisks in London and New York gave further impetus to Egyptianising tendencies in design.

The Individual Contribution of Alexander 'Greek' Thomson

The extraordinary architecture of Alexander Thomson, known as 'Greek'[49] Thomson (1817–75), most of which is in the Glasgow area, should not be seen as pure Greek Revival, for other un-Greek and exotic elements were often found in his designs. In 1855 he designed the Scottish Exhibition Rooms in Glasgow: among the exhibits were cases and drawings of

49 Although he could just as easily have been nicknamed 'Egyptian' or (as Mr Alexander Stoddart has remarked) 'Semitic' Thomson because of the allusions in his architecture.

Egyptian antiquities;[50] and he acknowledged the influence of Sir John Gardner Wilkinson, David Roberts, and John Martin on his own work.

In 1874 Thomson gave a lecture on 'The Development of Architecture; the Spirit of the Egyptian Style' in which he stressed the possibilities of meanings in Egyptian architecture to express ideas. 'There are the pyramid, the obelisk, and the rudimentary temple forms, each having its sides sloped in greater or less degree and by this peculiarity suggesting common relationship. I have already spoken of the pyramid as expressing the simple idea of stability or duration. Suppose that idea to be distinctly impressed upon the mind; then look at the obelisk. The same idea is reproduced less strongly, but there is another element added, that of proportion, expressing the idea of justice or truth. And these two ideas readily combine'.[51] Thomson was interested in the Egyptian use of spatial sequences, of repetition, and of painted decoration, and these interests show in his designs. He made it clear in the Haldane Lectures[52] that he believed Greek architecture and design derived from Egyptian prototypes: 'the Egyptians sought to realise the idea of endless duration, and so all their works expressed that longing after immortality. The Greeks aimed at perfection, and all that they did bears evidence of the earnestness and ability with which they sought to realise their idea'. However, Thomson insisted that although the Greeks got their basic ideas from Egypt, they did not copy Egyptian work, but built on principles of design that had been established in Egypt.[53] Thomson praised the architectural phantasies of Martin as well as the paintings of Turner and Roberts for showing the 'mysterious power of the horizontal . . . in carrying the mind away into space', and noted the 'repose' of Egyptian architecture and its expression of 'quietly waiting till all the bustle is over' in his 'Inquiry into the Appropriateness of the Gothic Style for the proposed Buildings for the University of Glasgow'.[54]

What is obvious is that Thomson used Egyptianising motifs and themes with great assurance, but he was much more than a Revivalist, for he was a synthesiser of styles and an inventor of genius, although it must be emphasised that there can be no question he was influenced by the Prussian architect Karl Friedrich Schinkel, whose use of bands of windows with square, squat, mullion-columns linked in horizontal bands (as in the Berlin *Schauspielhaus* [1818–26]) was a favourite motif of Thomson (as in Moray Place, Strathbungo [1859]). We know that Thomson possessed a copy of Schinkel's *Sammlung Architektonischer Entwürfe,* and the motifs that occur in

50 CONNER (*Ed.*) (1983), 94.
51 STAMP (*Ed.*) (1999), 135. *See also* McFADZEAN (1979), 214, and 216–18.
52 Reprinted in STAMP (*Ed.*) (1999), 107–82.
53 STAMP (*Ed.*) (1999), 145.
54 In the Mitchell Library, Glasgow, printed in STAMP (*Ed.*) (1999), 63–88.

Plate 200 *Alexander 'Greek' Thomson's Moray Place, Strathbungo, Glasgow (1857–9), in which the regular row of square mullions is reminiscent of Schinkel's use of the same motif at the Berlin Schauspielhaus of 1818–21. Schinkel invented this type of mullioned arrangement by giving continuous rows of square Egyptian columns (see* **Colour Plate III** *and* **Plate 5**) *the details of the Greek choragic monument of Thrasyllus (see Select Glossary,* **Fig. 18**) *in Athens (both the Greek and Egyptian exemplars had been published only a few years before Schinkel designed the Schauspielhaus). Photograph by Bryan & Shear Ltd, Glasgow* (Mitchell Library, Glasgow, M 3395 2).

Thomson's and Schinkel's work (the repetitive square mullion-columns in long bands, the *Rundbogenstil* of Lombardy, asymmetrical Grecian-inspired compositions, and the low-pitched Italianate roofs [unsuitable for both Brandenburg and Glasgow!]) are far too close to be unrelated, although Dr McFadzean was unconvinced when he published his pioneering study in 1979. The *Schauspielhaus*-Moray-Place motif of horizontal bands of window separated by short mullion-columns square on plan (**Plate 200**) is itself a synthesis of Græco-Egyptian motifs: the element comes from the choragic monument of Thrasyllus,[55] which was first accurately published in Stuart and Revett's *The Antiquities of Athens*, II (1789),[56] but the idea of

55 *See* drawing in the Select Glossary (**Fig. 18**).
56 STUART and REVETT (1762–1830): **ii**, Ch. IV, plate 3. 1787 is the date given on the title-page, but the book did not actually appear until 1789.

multiplying the form in long rows came from Ancient Egyptian architecture, such as the Elephantine temples (**Plate 5**) or the Mortuary Temple of Queen Hatshepsut at Deïr-el-Bahari (**Colour Plate III**).

Thomson's St Vincent Street church, Glasgow (1859), is a good example of his ability to mix many elements in a whole. As the site has a sharp fall, Thomson created a dramatic and massive podium, and set his church on this mighty base, with hexastyle Greek Ionic porticoes at each end, but with clerestorey-strips of windows down each side divided by pairs of coupled columns again square on plan, and clearly derived from the Thrasyllus monument. Near the ends of the flanking aisles are two of Thomson's favourite Egyptianising devices: tall battered pylons rising above the cornices. On the plain tower, near the top, are T-shaped openings which are Græco-Egyptianising herms facing each other and supporting the lintel over. Above, four battered pylon-forms help to support the drum with its peristyle of stocky Egyptianesque columns (**Plate 201**). Now there are all sorts of curious things going on in the design of this church, not least quotations from the publications of the American architect Minard Lafever (1798–1854).[57] But, as the present writer has attempted to argue elsewhere,[58] there appear to be sundry allusions and memory-triggering devices in some of Thomson's buildings, not least various pointers to the lost Temple of Solomon. For example, the two Grecianised herms facing each other in the T-shaped opening in the tower may allude to the Cherubim in the Holy of Holies within the Temple (T), and within the church the very original capitals may have been intended to suggest the 'chapters' of the Temple (as described in the Old Testament), with their strange Orientalism. Thomson was widely-read, and left several deeply-thought essays, so there is no doubt he was steeped in Biblical and architectural literature. In the St Vincent Street church was he attempting to create a new expression of church architecture, linking it with allusions to the lost Temple in Jerusalem described in the Bible? It is an intriguing possibility, and will require further research, although the present writer has proposed some arguments in favour of the idea.

Even odder was Thomson's design for Queen's Park church (1867 – destroyed in the 1939–45 war): it had a high cupola not unlike the upper stage of the St Vincent Street tower, but the front elevation was much more Egyptian than Greek in its inspiration, for the entrance was a huge pylon-form with two columns supporting the lintel and the Egyptianising cornice set against the blank wall of the temple-like block behind. Four square Egyptianising columns

57 STAMP and MCKINSTRY (*Eds*) (1994), 199–205.
58 JAMES STEVENS CURL: 'Thomson's use of sun and star motifs' in *The Alexander Thomson Society Newsletter* (*ATSN* hereafter), **xi** (October 1994), 'St Vincent Street church as a mnemonic of the Temple of Solomon', in *ATSN*, **xii** (January 1995), 'Meanwhile, back at the Temple', in *ATSN*, **xiv** (December 1995), 'More Temple Talk', in *ATSN*, **xvi** (May 1996), 'St Vincent Street and the Temple of Solomon', in *ATSN*, **xviii** (February 1977), and 'Thoughts on Thomson', in *ATSN*, **xxviii** (February 2001).

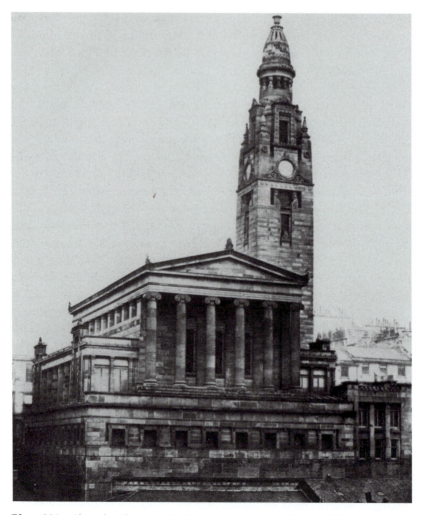

Plate 201 *Alexander Thomson's St Vincent Street church, Glasgow (1859), showing the Egyptian pylon-forms in the tower and breaking through the side-walls of the aisle above which is the clerestorey of square columns. Note the two Cherubim facing each other in the T-shaped opening in the tower beneath the clock. Photograph of c.1890* (RCAHMS GW.2017).

carried the entablature under the low Grecian pediment, and along the sides were strips of clerestorey windows with squat square columns or piers reminiscent of Schinkel's *Schauspielhaus* treatment, while pylon-forms flanked the main block. At Queen's Park the Egyptian influence was particularly strong, and must have owed something to the *Description* or to Denon[59] as well as to the publications of Minard Lafever (**Plate 202**).

59 GOMME and WALKER (1968), 128–9 also note this. The Author is indebted to Professor Walker for discussing Thomson with him.

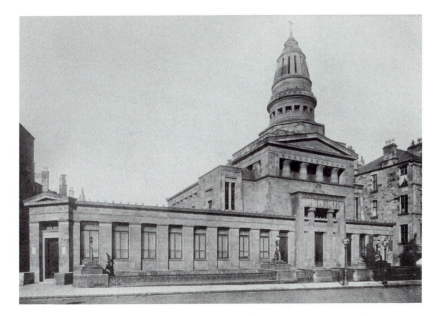

Plate 202 *Queen's Park church, Glasgow, of 1867, designed by Alexander 'Greek' Thomson. Both the clerestorey of the main temple-block and the long, low, single-storey element at the front have variants of the mullion-columns derived from the* Schauspielhaus *in Berlin by Karl Friedrich Schinkel of 1818–21. There is a large entrance-pylon with Egyptianising columns set in antis, and two smaller pylons framing variants on the Thrasyllus monument flank the main temple. Four squat Egyptianising columns are set within a frame under the low Greek pediment. The crowning cupola combines Greek, Egyptianising, and almost Indianising elements. Photograph by Bryan & Shear Ltd, Glasgow* (Mitchell Library, Glasgow, M 3395 7).

Thomson's 'Grecian' building (1865) at 336–356 Sauchiehall Street, Glasgow, has short Egyptianising columns set in front of the glazing on the top floor, an idea developed further in the 'Egyptian Halls' at 84–100 Union Street (1871–73). The latter is probably his most remarkable design for a warehouse, for the whole façade is exceedingly vigorous and inventive, with Egyptianising columns standing in front of a glass wall on the top storey beneath a gigantic entablature. Each storey, in fact, is given a distinct architectural treatment, and there are quotations from archaic Greece as well as Egypt (**Plate 203**). At 200 Nithsdale Road, Glasgow (1871), Thomson designed a symmetrical villa with Egyptianising columns set in a recess in a plain stone wall, a Thrasyllus quotation for the windows, and with Egyptianising palm-leaf chimneys. Thomson's work here, as elsewhere, often displays a synthesis of Greek and Egyptian elements, although he always reinterpreted those elements with considerable élan and

Plate 203 *The Egyptian Halls, Nos 84–100 Union Street, Glasgow, of 1871–3, by Alexander Thomson, a remarkable assemblage of inventively treated Egyptian and Greek motifs. Photograph of c.1890* (RCAHMS. GW/2020).

sureness of touch.[60] Subtle Egyptianisms are also found in the interiors of Great Western Terrace (1867).[61]

With the works of 'Greek' Thomson the use of Egyptianising forms reached new heights of invention. Echoes of his work recur later, but without many overt Egyptianisms. The Schinkel-Thomson string of horizontal windows subdivided by means of square mullion-columns recurs in modified forms in the works of (for example) Frank Lloyd Wright (1867–1956) – Robie House (1908), Larkin Building, Buffalo (1904), and Unity Temple, Oak Park (1905–06); of Joseph Maria Olbrich (1867–1908) – *Hochzeitsturm*, Darmstadt; and of Otto Wagner (1841–1918) – his own villa in Vienna. The Schinkel-Thomson square-mullioned windows also occur at the Villa Hügel, Essen (1873, to designs by Schwarz and Rasch), where big-breasted muscular and alert bronze sphinxes (1897–1904) by Max Dennert flank the entrance to the Krupp house (**Plate 204**).[62]

60 STAMP and MCKINSTRY (*Eds*) (1994).
61 The Author is indebted to Dr and Mrs Maurice Lindsay for allowing him to inspect these.
62 Discussed in DEMISCH (1977).

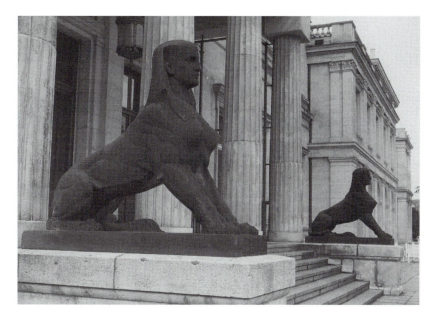

Plate 204 *Bronze sphinxes by Max Dennert at the Villa Hügel, near Essen, designed 1897 and completed in 1904* (Mr Alan Spencer).

The Victorian Vision of Egypt

Roberts was the first professional artist to visit Egypt (1838) independent of any patron or archæological expedition for the sole purpose of painting.[63] This he did in order to collect material for publication, and the results, in *Egypt and Nubia* and *The Holy Land.., Egypt, and Nubia*, were triumphs. Roberts illustrated both Ancient Egyptian monuments and the Islamic architecture of Egypt in superbly drawn and coloured images. As noted earlier, associations with the Bible, Ancient Egyptian antiquities, and exotic Orientalism ensured the success of his efforts. Now realistic views of buildings in their natural settings were produced to satisfy public demand.[64] Roberts was followed by William James Müller (1812–45).

Once Egyptian scenery and Egyptian art, artefacts, and architecture were adequately recorded, however, many artists could paint elaborate scenes of life in Ancient Egypt without having to travel in Egypt at all. Many such compositions included details that were well researched and accurately shown, but the whole was as much an invention of the artist's imagination as the *capricci* of Martin and Roberts (**Colour Plate XXVIII**) had been earlier.

63 CONNER (*Ed.*) (1983), 115.
64 *Ibid.*

Sir Edward John Poynter's (1836–1919) celebrated *Israel in Egypt* (1867) shows a mixture of architectural elements from Edfu, Gizeh, Heliopolis, Qurna, Philæ, and Thebes, all in pristine condition, and peopled by many figures, whilst the statues of lions being towed into position are based on those brought back from Nubia by Algernon, Lord Prudhoe (1792–1865), and which had been in the British Museum since 1835.[65] *Israel in Egypt* created a sensation when it was shown at the Royal Academy in 1867, and, by mixing accurate representations of buildings of pharaonic Egypt with an Old-Testament subject, satisfied Victorian taste (**Colour Plate XXXVII**). Indeed, throughout the Victorian period, one of the main reasons for a lively interest in Ancient Egypt was its link with Biblical stories, and the supposed sites of Biblical events were visited, sketched, and later photographed.[66]

Sir David Wilkie (1785–1841) visited Egypt to collect scenes for Biblical subjects he intended to paint (his *Sketches in Turkey, Syria, and Egypt 1840 and 1841* was published posthumously in 1843), and William Holman Hunt (1827–1910) visited Egypt in 1854 to find material for Old Testament subjects. Thomas Seddon (1821–56) was in Egypt in 1853–54 to seek Biblical associations, as was Frederick Goodall (1822–1904). Edward W. Lane's (1801–76) *Manners and Customs of the Modern Egyptians* (1836) was a comprehensive study of the Egyptian way of life, and was a useful reference-work for artists and laymen alike. Sir Lawrence Alma-Tadema[67] (1836–1912) was one of the most practised exponents of archæological and historical authenticity in his paintings, as reconstructions of life in Antiquity became a fashionable subject for artists. Alma-Tadema used material from Wilkinson's *Ancient Egyptians* in his first Egyptianising painting, *The Ill Father* (1850), and later incorporated drawings of items in the British Museum. His celebrated *Pastimes in Ancient Egypt* (1863, but repainted before being exhibited at the Paris *Salon* of 1864) contains accurate representations of Egyptian detail, architecture, décor, and furniture, and his sketch-books were crammed with drawings of Egyptian objects. Other paintings by Alma-Tadema with Egyptian themes include *An Egyptian Widow* and *Death of the First-Born*, and the artist even had accurate copies of Egyptian furniture made for his studio. Edwin Long (1821–91) exhibited *The Gods and their Makers* at the Royal Academy in 1878: it shows the interior of an Ancient Egyptian studio in which statues of deities were being made, but it was already his third Egyptianising picture, painted four years after his visits to Egypt and Syria. It is typical of Long's meticulous work, and something of the

65 *See* MACREADY and THOMPSON (*Eds*) (1985), 112–20, for a discussion of this painting.
66 CONNER (*Ed.*) (1983), 117.
67 For Alma-Tadema *see* BORGER (1978), RAVEN (1980), and HUMBERT (1989*a*).

enormous amount of research put into minute details in the picture may be gleaned by studying the canvas. In *Anno Domini* or *The Flight into Egypt* (1883) Long contrasted the 'Great Mothers', Isis and Mary, depicting them against a background of the Ptolemaïc temple of Horus at Edfu.

Holman Hunt described how, in furnishing his house, he was determined to eschew the vulgar furniture of his day, and was among the first artists to realise the creative possibilities of imitating the construction of Egyptian furniture, even before Dresser. He based his fine designs for Egyptianising furniture of the 1850s on the celebrated stool from Thebes in the British Museum, and had the pieces of furniture made by John Gregory Crace (1809–89). Soon other members of the Pre-Raphaelite Brotherhood had Egyptianising furniture made.[68] Now this Thebes stool accorded with Dresser's principles of sound structural design, pleasing lines, and quality of materials, and copies of it made of mahogany with a leather seat were marketed by Liberty & Company from 1884 (**Plate 197**).[69] Liberty's was not the only firm to exploit a fashion for the Nile style: designs by Edward William Godwin (1833–86) were produced commercially by William Watt and by Collinson & Lock, and marketed by the Art Furnishers Alliance in Bond Street in the 1870s and 1880s. Godwin was particularly interested in the lattice-bracing of Ancient Egyptian stools, and his sketch-books demonstrate his interest in Egyptian furniture and decoration.[70]

Henry W. Batley (*fl.* 1870–1908) designed furniture for Collinson & Lock, and, in his *A Series of Studies for Domestic Furniture and Decoration* (1883), showed designs in the Jacobean, Japanese, and Egyptian styles. *The Study for a Dining-Room* of 1878 contains Egyptianising décor, and was described by Batley as an attempt to adapt the 'various styles of architecture to modern interior decoration . . . The walls are supposed to be painted in flat colourings, representing fish, flesh, and fowl. The dado is composed of an ornamental India matting, with surbase in wood . . . The chimney piece is in white and coloured marbles, massively constructed . . . furniture is severe and heavy in form'.[71]

Eclecticism and Design

Apart from the big collections of Egyptian Antiquities in major centres such as London, Berlin, Turin, and Paris, there were important local collectors such as Joseph Mayer (1803–86) who was based in Liverpool, and who

68 HUNT, W. HOLMAN (1905–6), **ii**, 134–6.
69 Victoria & Albert Museum, *Circ.* 439, 1965.
70 Victoria & Albert Museum E223–1963 box A 123 b. *See* CONNER (*Ed.*) (1983), 102–3.
71 CONNER (*Ed.*) (1983), 96.

designed jewellery in an Egyptianising style. Indeed, jewellery accounted for much Egyptian Revival work in the course of the century, and there are countless examples. The Symbolists from 1885 included Nilotic elements in their pictures, for eclecticism, the occult, and the expression of poetic ideas were fundamental to them. Periodicals such as *Pléiade*, *Décadent*, *Vogue*, and *Symboliste* promoted interest in Egyptianising design, while the shops of Liberty and Tiffany purveyed objects inspired by Ancient Egyptian artefacts to an eager public. Sarah Bernhardt's (1845–1923) performances in Sardou and Moreau's *Cléopâtre* (1890) also did much to popularise the Nile style. Early *Art-Nouveau* designs often contained Egyptianising motifs (as in the profile of an Egyptian princess after Alphonse Mucha [1860–1939] in an American brooch of *c.*1896),[72] and some work by Paul Follot (1877–1941) had distinctly Egyptian antecedents in his use of the papyrus motif (*c.*1900).[73]

Throughout the last four decades of the nineteenth century, and especially from 1880, there were thousands of examples of Egyptianising design: gold cuff-links featuring hieroglyphs and Egyptianesque figures, scarab-bracelets, brooches with Egyptian allusions, rings with sphinxes, Pharaonic heads, scarabs, and much else, and statuettes in the forms of *naöphorus*, Antinoüs, or other Egyptianising figures, survive in plenty.[74] Some overt Egyptianisms occur in the works of Arnold Böcklin (1867–1901) and his circle: the celebrated *Toteninsel* of 1880, has eerie Egyptianesque entrances to rock-cut tombs in the Isle of the Dead,[75] and Karl Wilhelm Diefenbach's (1851–1913) painting based on Böcklin's *Toteninsel* (the *Isola dei Morti* of 1905) has a full Egyptian gorge-cornice embellished with a winged globe over the entrance to what looks like a vast underground chamber, flanked by two extremely sinister figures with folded arms.[76] In both these paintings, Egyptian elements associated with permanence and with death contribute to the disturbing images. The *Toteninsel* was considered to be one of the most distinguished Symbolist paintings produced outside France, and its morbid subject appealed to the Surrealists.

Obvious Egyptianisms can be found in the badges of regiments that had seen service in Egypt, in postage-stamps featuring Ancient Egyptian architecture issued in Egypt and printed by the firm of De La Rue, and even in *Old Moore's Almanac* (first published 1791) where hieroglyphs are

72 LORING (1979), 114–21. *See also* the *Catalogue* of the Exhibition at the Metropolitan Museum of Art, New York (16 January–11 March 1979).

73 *Ibid.*

74 See CONNER (*Ed.*) (1983), *passim.*

75 PALMA and NUZZI (*Eds*) (1980), 103. *Catalogue* of the Exhibition at the Palazzina Mangani, Fiesole (24 July–30 September).

76 Illustrated in PALMA and NUZZI (*Eds*) (1980).

often in evidence. Indeed the last publication still carried the occasional advertisement for Ancient Egyptian charms in the 1980s. In Egypt itself hotels and other buildings erected to cater for European tourists were often in the Egyptian Revival style. A fashion for Egyptian cigarettes encouraged the production of Egyptianising cigarette-boxes and ash-trays (and even Egyptianesque smoking-rooms and furniture for such rooms), while other ephemera, such as posters, exploited and popularised the art and architecture of the Ancient Egyptians. Papyrus-heads and lotus-flowers were introduced into designs for chintzes, wallpapers, and fabric-design generally, especially in France, England, and America. Aspects of Taste under the first Napoléon enjoyed a new lease of life during the Second Empire, and Egyptianising themes recurred, while in England, designers such as Walter Crane (1845–1915) derived decorative motifs from the Egyptian lotus and from other exemplars. Frédéric Boucheron designed some sumptuous Egyptianising desk-furnishings for the Khedive Ismail Pasha in 1875, while Émile Gallé (1846–1904) produced vases and other objects in which Egyptian themes were exploited to considerable effect in the 1880s and 1890s.[77]

At the *Exposition Universelle* in Paris in 1889 the *Pavillon Égyptien*, with its two bud-capitaled columns set *in antis*, and prettily coloured, was just one of many late-nineteenth-century exhibition buildings in which the Egyptian style was exploited. The *Palais de l'Égypte* at the *Exposition Universelle*, also in Paris of 1900, was designed by Marcel Dourgnon, who juxtaposed an Arab Bazaar, a theatre in the *style égyptien polychromé*, and a temple in the *égyptien antique* style. An Egyptianising design for a Beacon of Progress was produced by Constant Desiré Despradelle (1862–1912) intended to typify the 'apotheosis of American civilisation, to be erected on the site of the World's Fair at Chicago': it was to be a gigantic obelisk nearly three times higher than the obelisk in Washington, D.C., and almost twice as tall as the Eiffel Tower in Paris. As Despradelle himself described this monster in *The Technology Review* (October 1900), there was to be an esplanade leading to the access to the principal terraces and platforms, where sculptures representing eminent men and significant events would stand. In the 'place of honour, in the axis of the monument', the names of the original thirteen colonies were to be inscribed. Upon the 'Stela', guarded by the eagle, was to be the goddess of the twentieth century, 'the modern Minerva, flanked by ranks of lions roaring the glory of America'.

At Wissant in the Pas-de-Calais, the painters Virginie Demont-Breton and Adrien Demont constructed a *typhonium* as their residence,

77 *See* HUMBERT (1989*a*) and HUMBERT, PANTAZZI, and ZIEGLER (*Eds*) (1994) for a stupendous array of material.

between 1889 and 1911, complete with pylon, coved cornice, and bas-relief showing the family of painters *à l'égyptienne*[78] and at Alberobello, Antonio Curri (1848–1916) built a fine Egyptianising entrance to the *Cimitero* there between 1882 and 1905.

Nineteenth-century eclecticism was not a simple matter, nor was it merely an exercise in the copying of past styles, as has sometimes been suggested by the ignorant, and eclecticism involving Egyptianising themes was one of the richest of tendencies in a century already rich in invention. Despite the influence of the Goths, and of all those who affected to despise Egyptianising eclectic design, the Nile style survived, and indeed flourished in the nineteenth century. It was to live on, renewed, in the twentieth, and was to enjoy further Revivals.[79]

78 HUMBERT (1989a), 76.
79 *See* CONNER (*Ed.*) (1983), *passim.*

CHAPTER X

The Egyptian Revival in the Twentieth Century

Introduction; Egyptianising Architecture from 1900 to 1922; Tutankhamun and Art-Déco; Later Developments; Epilogue

In the afternoon of time
A strenuous family dusted from its hands
The sand of granite, and beholding far
Along the sounding coast its pyramids
And tall memorials catch the dying sun,
Smiled well content, and to this childish task
Around the fire addressed its evening hours.

ROBERT LOUIS BALFOUR STEVENSON (1850–94):
Underwoods (1887), XXXVIII, lines 5–11.

At last have made wonderful discovery in Valley;
a magnificent tomb with seals intact;
re-covered same for your arrival; congratulations.

HOWARD CARTER (1873–1939):
Telegram to George Edward Stanhope Molyneux Herbert,
5th Earl of Carnarvon (1866–1923), on the discovery of
the Tomb of King Tutankhamun, November 1922.

Introduction

We have seen how Egyptianisms in design persisted through the nineteenth century, and that they were not merely a passing fad in the aftermath of the Napoleonic Campaign in Egypt. Almost as soon as the twentieth century began Berlin Zoo acquired its delightful ostrich-house, created in 1901 to designs by Heinrich Kayser (1842–1917) and Karl von Grossheim (1841–1911),[1] the interior of which was decorated with a reproduction of the Zodiac of Dendera and a diorama representing the *colossi* of Memnon.[2]

Far away, in Edinburgh, the Supreme Grand Royal Arch Chapter of Freemasons of Scotland obtained its splendid new Chapter Room at 78 Queen Street in 1900–01 to designs by Peter Henderson (1848–1912) (**Colour Plate XXXVIII**). Egyptianising motifs were included in furnishings and carpets, and the room was supposed to be 'in the style of an ancient Egyptian Temple'.[3] Henderson designed the entire decorative system, including the handsome chairs with Egyptianising head terminals.

Egyptianising furniture by Liberty and other firms became popular, and even became associated in the Italian mind with *Art Nouveau* to the extent that the style was called the *Stile Liberty* in Italy. Even elsewhere *Art-Nouveau* buildings and artefacts often acquired Egyptianising infusions: an example of 1906 can be found at 10 Rue du Général-Rapp in Strasbourg by Adolf Zilly (built, of course, when Strasbourg was within the territory of the German Empire), in which exuberant *Jugendstil* architecture is enlivened with Nilotic scenes in polychrome decorative panels.[4] Egyptian elements occur in Italian design of the early years of the twentieth century, and are strongly represented in the work of one of the most gifted designers of the time, Carlo Bugatti (1856–1940). The room Bugatti designed for Lord Battersea's house at 7 Marble Arch (*c*.1903) is a strange and exotic amalgam of Egyptianising and other elements: it was designed and made in Milan, and erected in London by a team of Italian craftsmen. Although the Egyptian motifs had become transformed in the design, their origins were unmistakeable: even the circular feature containing the two mirrors had stepped 'corbels' that recall post-Piranesian openings, while the fan-like feature between the two mirrors recalled the lotus-flower. Furniture had echoes of Regency Hopeian designs mixed with the robust imagination of Dresser, yet transformed into something quite new by Bugatti (**Plate 205**).[5]

1 Founded in 1872, this architectural firm was the epitome of a successful architectural practice in the Second Reich, and was renowned for its application of polychromy.
2 The exterior is illustrated in HUMBERT (1989*a*), 78.
3 *Building News* (26 July 1901), 105. *See also* CONNER (*Ed.*) (1983), 96.
4 *See* HUMBERT (1989*a*), 79.
5 The Author is indebted to Mr Christopher Wood, Miss Sylvia Katz, and the Design Council for information. Mr Wood kindly permitted the use of his photograph here.

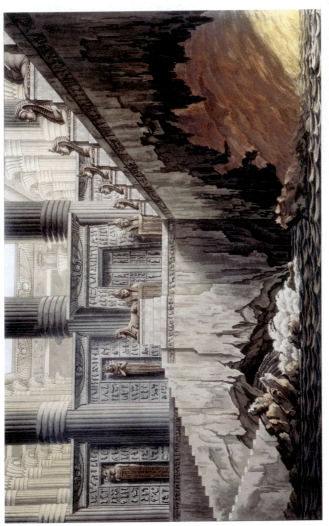

Plate xxiv Schinkel's design for Act II, Scene 31 (called 28 in Thiele), of Die Zauberflöte in the 1816 Berlin production at the Königliche Schauspiele-Opernhaus, showing the awesome entrances to the Trials by Fire and Water, above which is the mighty temple of the Sun, treated with great Egyptianising verve. The architecture is derived from Denon's Voyage (especially the portico from Dendera) and from the title-page of Norden's Travels in Egypt and Nubia. Other elements come from Schinkel's own Diorama project Das Labyrinth von Creta of 1807, and from Mauro Tesi's Raccolta di Disegni Originali, published in Bologna in 1787. Thiele's version of Schinkel's original project (see Schinkel Museum, SMB, KuSdZ, No. XXII/119 and SMB XVb/50–52) (THIELE/BL.1899.c.5).

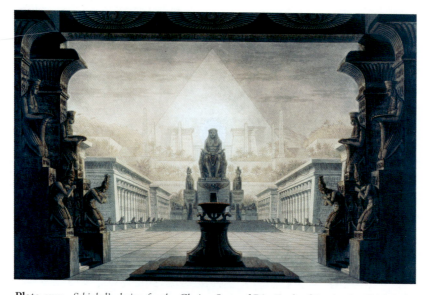

Plate xxv *Schinkel's design for the Closing Scene of* Die Zauberflöte *in the 1816 Berlin production at the* Königliche Schauspiele-Opernhaus, *showing the temple of the Sun. In the background is Osiris the Resurrected, the Invincible, the All -Wise, flanked by Apis-Bulls. On either side are Piranesian figures in attitudes of adoration, and in the distance is a huge pyramid rising from the light of the sun behind the head of Osiris, with pylon-towers and obelisks on either side. The colonnades* in antis *on each side are based on Denon's* Voyage *and other elements come from Piranesi and from Schinkel's own Diorama project* Das Labyrinth von Creta *of 1807. The Osiris figure mixes the Hadrianic figure of Antinoüs with elements from Piranesi's* DM, *and is the centrepiece of a spectacular final scene in which*

> Die Strahlen der Sonne vertreiben die Nacht,
> Zernichten der Heuchler erschlichene Macht
> *(the rays of the sun scatter the night,*
> *breaking asunder the might of the false dissembler).*

Here, Strength, Beauty, and Wisdom are lauded in the final chorus: words with powerful Freemasonic connotations. So Sarastro and his priests, presiding over the Egyptian Mysteries, represent the triumph of Benevolence and Freemasonry over the forces of superstition, lies, and darkness (see Schinkel Museum, SMB, Th/3) (THIELE/BL.1899.c.5).

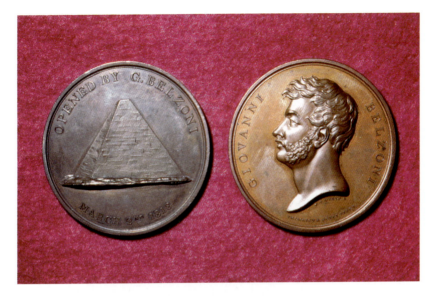

Plate xxvi *Bronze medal commemorating Giovanni Belzoni's opening of the pyramid of Kephren at Gizeh, 1818, made by T. I. Wells after a design by William Brockedon (1787–1854)* (PAC).

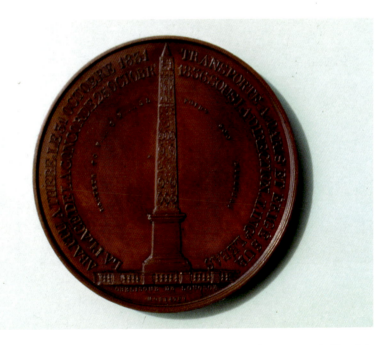

Plate xxvii *Bronze medal commemorating the erection of the obelisk from Luxor in the Place de la Concorde, Paris, on 25 October 1836. The inscription gave details of the obelisk's size and weight and of its re-erection* (PAC).

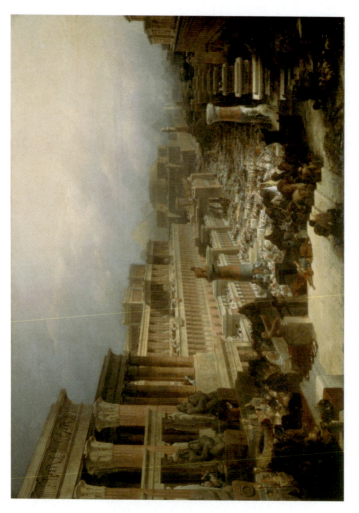

Plate xxviii The Departure of the Israelites (1829) by David Roberts (1796–1864). Oil on canvas, 137.2 × 182.9 cm. This painting inflated the scale of the architecture, the details of which were drawn partly from DENON (1802), but the verve of the composition, with its many distant pyramids, owes much to Roberts's expertise as a designer of theatrical sets (Birmingham Museums & Art Gallery).

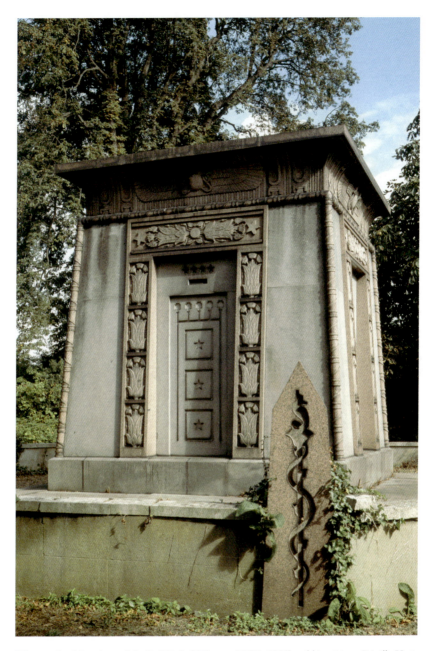

Plate xxix *Mausoleum of the 2nd Earl of Kilmorey (1787–1880) and his mistress, Priscilla Hoste (died 1854). It was originally erected to designs by Henry Edward Kendall the Younger (1805–85) in Brompton Cemetery, London, in 1854, was moved to Woburn Park, Chertsey, in 1862, and then translated to Gordon House, Isleworth, Middlesex, in 1870 (MaCh A240902).*

Plate xxx *Details of coloured decorations from Grave 24 at Saqqara, recorded in LEPSIUS (1849–59), **i**, Abth. I, Blatt 41* (UC).

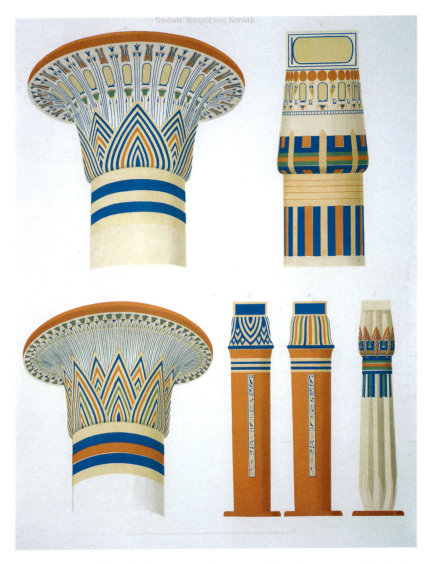

Plate xxxi *Two bell-capitals, a bud-capital, and three columns from the great temple at Karnak, from LEPSIUS (1849–59),* **ii**, *Abth. I, Blatt 81* (UC).

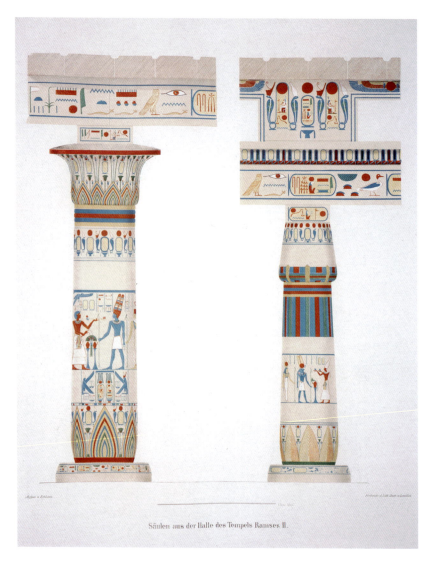

Säulen aus der Halle des Tempels Ramses II.

Plate xxxii *Bell and bud-capitals with the full Order of columns, base, capital, and entablature from the hall of the temple of Rameses II at Thebes. From LEPSIUS (1849–59),* **ii**, *Abth. 1, Blatt 90* (UC).

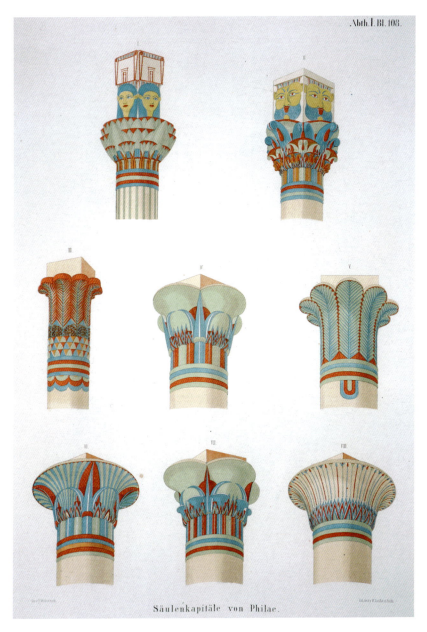

Säulenkapitäle von Philae.

Plate xxxiii *Various coloured capitals from Philæ. An example of the meticulously detailed and finely printed plates from LEPSIUS (1849–59),* **ii**, *Abth. I, Blatt 108* (UC).

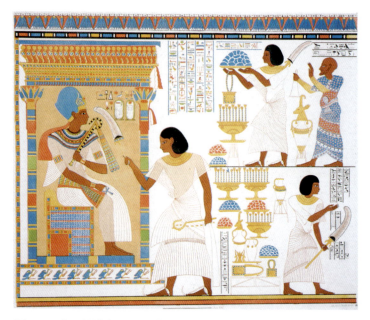

Plate xxxiv *Wall-decoration of XVIII Dynasty, New Kingdom, Thebes. From LEPSIUS (1849–59), **vi**, Abth. III, Blatt 115* (UC).

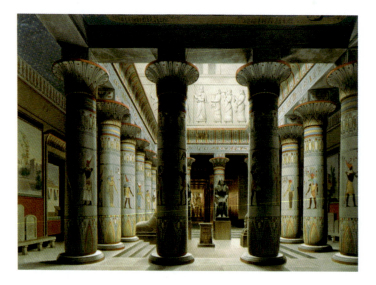

Plate xxxv *The Egyptian Court (1850) in the New Museum, Spreeinsel, Berlin, designed by Stüler, and decorated in the Egyptian style with Lepsius as consultant. From a lithograph entitled* Ägyptischer Vorhof im Neuen Museum *(Plate VII) in Stüler's monograph,* Das Neue Museum zu Berlin *(1853), based on a painting by Gärtner (1850)* (Stiftung Preussische Schlösser und Gärten Berlin-Brandenburg, Kupferstichbände B73).

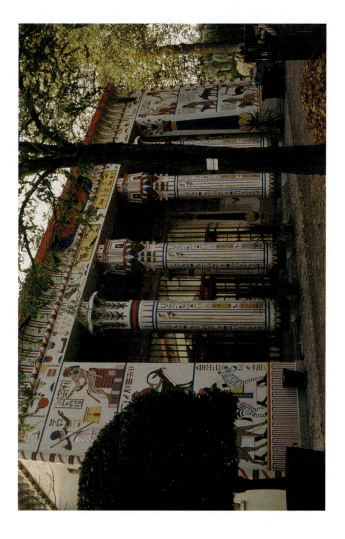

Plate xxxvi *The Egyptian Temple in Antwerp Zoo, designed by Charles Servais, with Joseph Bonomi Jr as consultant, and details by Dr Louis Delgeur and others. The hieroglyphs have meaning, and the main inscription tells us that the building was erected in 1856 in the reign of King Leopold* **(Plate 191)** *(Professor Peter Swallow).*

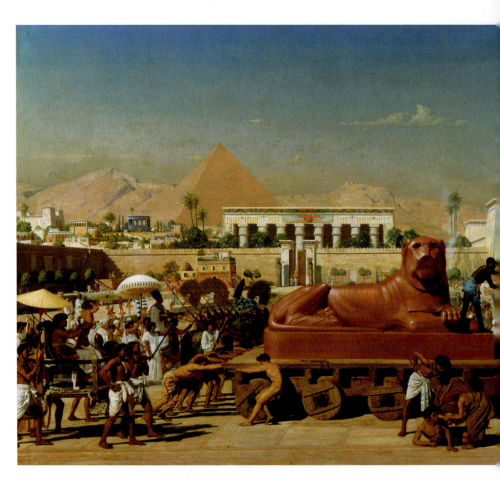

Plate xxxvii Israel in Egypt *(1867) by Sir Edward John Poynter (1836–1919). Oil on canvas, 137.2 × 317.5 cm. The artist's scholarly composition includes the Great Pyramid of Gizeh on the left; two of the temples at Philæ and the Trajanic Kiosk to the left of the pyramid; the temple of Seti I at Qurna behind the lion in the foreground; the pylon-towers of the temple at Edfu on the right, with an obelisk from Heliopolis and the large black seated figures of Amenhotep III from Thebes in front of them; and a much enlarged lion based on the fine pair brought to The British Museum in 1835. Despite its virtuosity, the anachronisms are somewhat startling: the 'Kiosk' for example, dates from the early Christian period, and did not exist when the Israelites were held captive in Egypt (GLCL).*

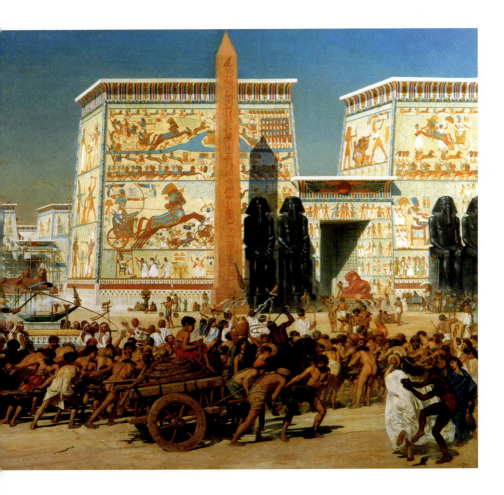

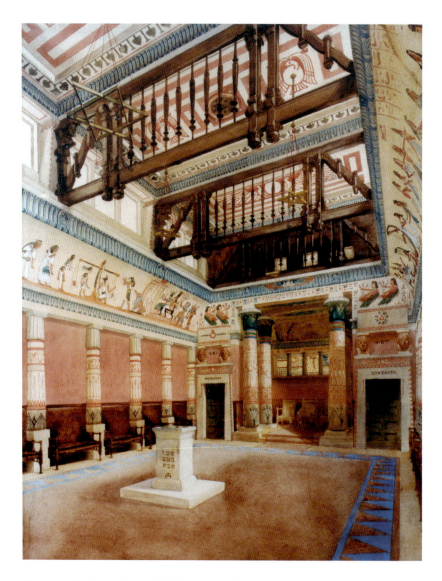

Plate xxxviii *Chapter-Room of 78 Queen Street, Edinburgh, for the Supreme Grand Lodge Royal Arch Chapter of Scotland, designed by Peter Lyle Henderson (1848–1912), and built 1901. This drawing (pencil and watercolour) was prepared by Robert F. Sherar in 1901. The use of Egyptian motifs extended to carpets and furniture. The Building News of 26 July 1901 (105) noted that the 'chapter-room is in the style of an Ancient Egyptian Temple . . . It has been suggested that (the figure decoration) should represent the story of Isis and Osiris . . . or be simply reproductions from the Book of the Dead . . . The ceiling is carried on timber trusses, the details of which are Assyrian in style. The upholstery of the seats is a deep crimson, and forms a sort of dado all round . . . The capitals of the large columns and the ceiling over the dais are in brilliant colours after the style of a peacock's tail'* (RCAHMS, EDD/846/CN).

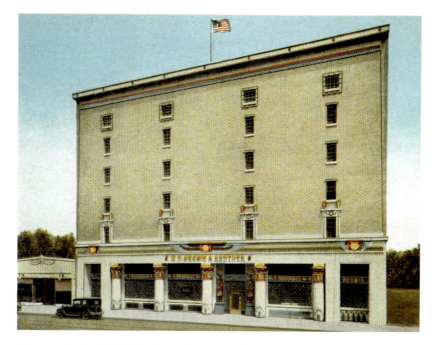

Plate xxxix (a) *W. C. Reebie & Brother, Inc., warehouse and general offices, 2325–33 N. Clark Street, Chicago, IL* (Chicago Historical Society, I CHi–35525/G81:108.1).

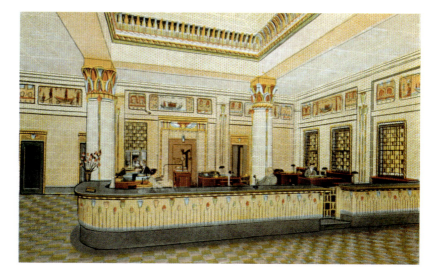

Plate xxxix (b) *Interior of the general office, 2325–33 N. Clark Street, Chicago, IL* (Chicago Historical Society, I CHi–35526/G81:108.1).

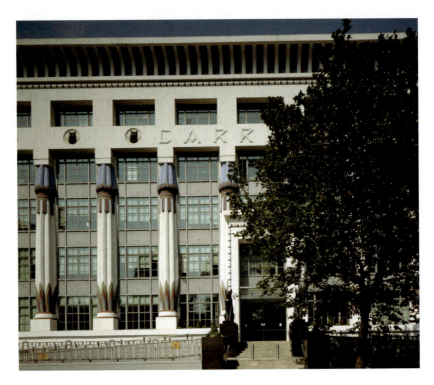

Plate xl *Entrance to the former Arcadia Works Building of Carreras Ltd, between Hampstead Road and Mornington Crescent, London, in 2002, showing the Carreras motifs of black cats and the Egyptianising detail* (MaCh J 280702).

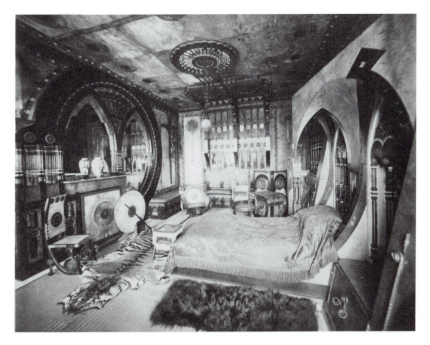

Plate 205 *Room designed for Lord Battersea at No. 7 Marble Arch, London, by Carlo Bugatti (1856–1940) in c.1903. Note the variation on the Piranesian stepped corbel motif over the mirrors on the left, and the fan-like feature between the mirrors that recalls the lotus-flower. The entire ensemble is exotic and orientalising* (Collection of Mr Christopher Wood. Design Council Neg. No. C2848).

Bugatti returned to a more instantly recognisable Egyptianising theme in his design for a War Memorial of *c.*1919: the form is Neo-Classical, recalling Desprez, Boullée, or Canova, and consists of a pyramid supporting an urn set against a rugged wall. In the centre of one face of the pyramid is a circular opening (a motif used to great effect in Lord Battersea's room of 1903) at the back of which are ghastly figures suggesting the carnage of the battlefield and the agonies of bodies in a slaughterhouse. This is a design of the utmost power, and is deeply moving (**Plate 206**).[6] The Egyptianising designs of Bugatti did not occur in isolation: in 1904 there was a Rationalist Congress held in Rome at which Giordano Bruno was elevated to the position of a hero of his country, in clear defiance of clerical conservatism and in direct opposition to the kind of contortions enshrined in the works of obfuscators like Cuomó and other crabbed hagiographers from the age of *Pio Nono*.

6 The Author is indebted to the late Mr Hugh G. Conway and to Miss Sylvia Katz. *See also The Amazing Bugattis*. A *Catalogue* of the Exhibition at the Royal College of Art (8 October to 18 November 1979).

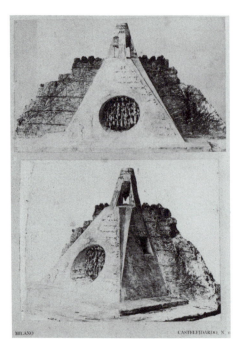

Plate 206 *Carlo Bugatti's design for a war-memorial of 1919* (Collection of the late Mr H. G. Conway. Design Council Neg. No. C2820/1).

Egyptianising Architecture from 1900 to 1922

Freemasonry encouraged an Egyptian Revival in its lodges. This is especially true of the lodges built under the ægis of the Grand Orient of Belgium between 1870 and 1914. The 'Temple of Perfect Union' (*La Parfaite Union*) in Mons, for example, designed by Hector Puchot (1842–1920), was intended to remind all who saw it that the Mons Lodge would work for the moral and intellectual emancipation of the community. An Egyptianising style would allude to a great culture that pre-dated Christianity (which itself owed much to Ancient Egypt), and would be a badge of anti-clericalism. The Mons Lodge, in the rue Chisaire, was inaugurated in 1890, and has numerous Egyptianising motifs: indeed the whole front is a variation on the pylon-tower theme.[7]

The Freemasonic Temple in the Boulevard d'Avroy in Liège houses the Lodge 'La Parfaite Intelligence et l'Étoile Réunies', and has a handsome Egyptianising doorcase of *c.*1910.[8] This may have been by Arthur Snyers, who was to go on to design the scholarly Egyptianising 'Palais du Royaume d'Égypte' at the *Exposition Internationale* at Liège in 1930. At Namur, in the

7 WARMENBOL (2001), 62. The Author is greatly indebted to Dr Warmenbol for much help over many years.
8 *Ibid.*, 63.

rue Félix Wodon, is the Freemasonic Temple (inaugurated 1908), designed by Jules Malevez: it has a monumental and vigorous Egyptianising portal.[9]

Dr Warmenbol and others have pointed out that Belgian Freemasons often made their affiliations overt, even in death, and quote a number of Egyptianising tombs to prove the point.[10] A good example is the tomb of Ferdinand Dierkens (*c.*1898) in the Westerbegraafplaats in Gent. One of the most handsome Freemasonic Temples in Belgium in which the Egyptian style played an important rôle was at 79 Lakenstraat, Brussels, designed by Paul Bonduelle (1877–1955). The 'Grote Tempel' was the largest room in the complex, and featured bud-capitals, winged *uræi*, Hathor-headed pilasters, and other motifs. Furthermore, Jachin and Boaz (the two columns associated with the Temple of Solomon) had bell-capitals and *abaci* decorated with pharaonic heads, complete with *nemes* head-dresses and rearing *uræi*.[11]

Unfortunately, the fine building that housed 'Les Amis du Commerce et la Persévérance Réunis' in the Meistraat, Antwerp, which had stunning Egyptian interiors, was demolished in 1982. It was designed by Pierre-François Laout (1825–1903) and Jean-Laurent Hasse (1849–1925),[12] with Egyptianising stucco-work by Henri Verbuecken (1848–1926).[13] As Dr Eugène Warmenbol and others have shown, Freemasonic rites with Egyptian connotations multiplied during the nineteenth century, given added impetus after the Napoleonic discoveries and the superb publications that followed. Several Belgian lodges adopted Egyptianising décor and tended to reject aspects of Freemasonry inherited from the British Isles, namely specific references to Christianity, preferring, instead, to make their connections with something far older. Antiquity and Ancient Egypt in particular had more attractions than the Bible, when Continental Freemasons 'transformèrent leurs locaux de la façon la plus heureuse en reconstituant le cadre historique antique des temples véritables'.[14]

In parts of the Continent, notably in Belgium, and, to a lesser extent in France, Freemasonry was virulently denounced by the Roman Catholic Church, for Freemasons in those countries tended to be strongly anticlerical, and even aggressively opposed to Roman Catholicism. The adoption of an Egyptianising style of architecture and interior décor would therefore differentiate Freemasonry from the Romanesque, Gothic, or Baroque of Roman Catholicism and had associations with something held to be far older, wiser, and (to many) more reasonable.

9 WARMENBOL (2001), 65.
10 *Ibid.,* 79. The Author is also indebted to Heer Marcel Celis for showing him various such Egyptianising tombs, etc., in Brussels and elsewhere.
11 *M & L. Monumenten und Landschappen.* 3 Jahrgang, No. 3 (May-June 1984), 33–35.
12 GUBEL *ET AL.* (1995), 33.
13 GRIETEN (*Ed.*) (2002), 285–306.
14 *See* MALLINGER (1978), 23. *See also* WARMENBOL (2001), 60.

And it was not just Belgium that adopted the Egyptian Revival for its buildings: Paris acquired the Temple du Droit Humaine in *c*.1912, a Freemasonic Lodge for women at 5 rue Jules Breton, Paris XIII[e]. Over the entrance-door is inscribed *Ordo ab Chao* (Order out of Chaos), a Freemasonic motto, and the gallery on the first floor is set behind severe palmiform (somewhat elongated) columns, with a balustrade composed of alternate *ankhs* and *djed*-columns. The crowning gorge-cornice is embellished with stylized vertical leaves and two winged triangles (**Plate 207**).[15] This is an unusually overt and very handsome admission of Freemasonic affiliation for either France or the United Kingdom. Belgium tended to be less inhibited, even aggressive in its Egyptianising iconography. In Scandinavia, too, Freemasonic architecture is generally reticent (apart from some symbolic devices placed discreetly on façades). An exception was the Lodge in Norrköping, Sweden (1868–9), which had an Egyptianising doorcase (with winged globe), a sphinx in a panel, and another winged globe on the attic storey.[16]

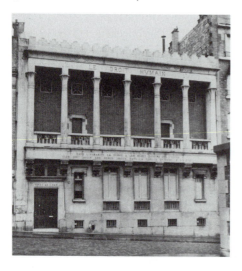

Plate 207 *'Temple du Droit Humaine', 5 rue Jules Breton, Paris XIII[e], of c.1912* (UGLE).

In architectural terms, however, it has to be recognised that in the British Isles the Nilotic style had been somewhat out of fashion since the denunciations of Pugin in the 1840s, although, as has been seen, there were occasional Freemasonic forays into the Egyptian Revival as at Boston, Lincolnshire, and Edinburgh. Nevertheless, Sir Frank Baines (1877–1933), Director of H. M. Office of Works, was bold enough to propose a National

15 HUMBERT (1998), 168–9. *See also* CURL (1996a).
16 *See* P. B. EKLUND (*c*.1880): *IX Frimurare Provinsens. Byggnader* (Stockholm: Central-Tryckeriet-P. B. Eklunds Forlag).

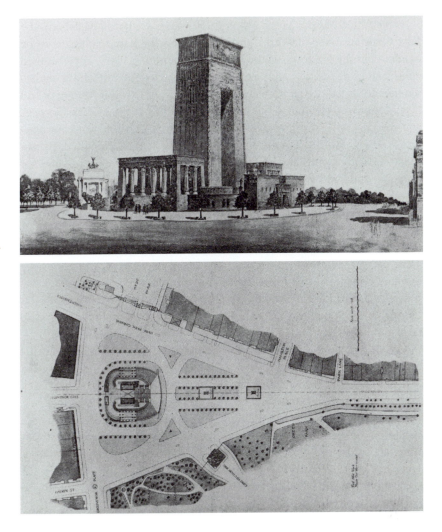

Plate 208 *Design for a National War Memorial at Hyde Park Corner, London, by Sir Frank Baines, Director of H.M. Office of Works, of 1920, in the form of a gigantic pylon with two flanking temples. From* The Builder *(JSC).*

War Memorial in an uncompromising and massive Egyptian style for a site at London's Hyde Park Corner (**Plate 208**). This proposal was not prepared officially on behalf of the Government, but was entirely conceived and carried out by Sir Frank Baines as his own idea of a War Memorial, and he thereby found very soon that he had stirred up a veritable hornets' nest of Pugin-indoctrinated opinion.[17]

17 *The Builder*, **cxix**/4042 (23 July 1920), 93.

Sir Alfred Moritz Mond (1868–1930 – later 1st Baron Melchett), the
First Commissioner of Works, gave permission for Baines's designs to be
exhibited in the tea-room of the House of Commons, where they 'aroused
considerable discussion' and 'excited extraordinary interest', both under-
statements, as we presently shall see.[18] It was noted that the Memorial had
been designed to occupy a 'commanding position at Hyde Park Corner',
and that it was 'in the form of a gigantic pylon with two flanking tem-
ples'.[19] *The Times* then observed that the architect had selected the Egyptian
style 'evidently feeling that the Egyptian period' was the most suitable 'for
immense scale and grandeur', and that his ambition clearly was to ensure
that 'the monument should be the most distinctive object in London'.[20] *The
Builder* commented that the conception seemed to 'embody one great idea
– that of sacrifice', and that the designs made a 'profound impression on
the collective feeling of the House of Commons'. However, that journal
went on to raise some cautionary points, and began to worry about the
Sublime phraseology, considering it both 'grandiose and absurd'. 'Will the
public', *The Builder* continued, 'understand that such descriptions . . . as
"immense", "cloudy forms", "gigantic symbol of immortality", "immense
scale and grandeur", and all the rest of it, are the merest moonshine?'.[21]

The trouble was that Baines was thinking in the terms of eighteenth-
and early-nineteenth-century architects, and the blank incomprehension
and hostility with which his scheme was greeted demonstrates how well
Pugin and others had done their work. The Sublime, it has to be said, was
definitely out of fashion. Members of Parliament questioned how such a
design on such a site 'could have been suggested by anyone who knew any-
thing about the origin of the war, or its consequences'.[22] Some criticisms
were not concerned with style, but only with getting jobs, and protests
were raised that H.M. Office of Works should design the National War
Memorial at all.[23]

Others denounced the Egyptian style as 'dreadful . . . Of all the
styles suited to London the Egyptian is the most unfit and alien; and the
bigger it might be, the more vulgar it would be. It is heavy, passive, sulky;
it is the style of a caste-ridden people; it requires the sunlight and the
desert; it would show the dirt; it proclaims complete indifference to the
hard estate of the poor'.[24] Selwyn Image (1849–1930) saw the design as
'pure pagan swagger', suitable for 'Berlin under the dominance of the ex-

18 *The Builder*, **cxix**/4041 (16 July 1920), 58.
19 *Ibid.*
20 *Ibid.*
21 *Ibid.*
22 *Ibid.*, **cxix**/4042 (23 July 1920), 93.
23 *Ibid.*, in a letter by John William Simpson (1858–1933), President of the Royal Institute of British Architects (1919–21).
24 *Ibid.* The Author is indebted to Mr Ralph Hyde for these references.

Kaiser'.[25] At the Annual General Meeting of the Society for the Protection of Ancient Buildings Hugh Thackeray Turner (1853–1937) declared Baines's design to be 'monstrous', and Sir Thomas Graham Jackson (1835–1924) opposed the design on the grounds that its symbolism belonged to a time when people could not read, and so was 'as little suited to modern ideas as the Pylon itself'.[26] He went on to say that the proposal was an 'offence against reason and good taste', and Thomas Batterbury (died 1922) called the design a 'monstrous erection', enquiring if the 'architect ever saw' Pugin's *Contrasts* (*sic*) in which there was a 'monstrosity in a pseudo-Egyptian style'.[27] It is revealing that a lampoon by Pugin (**Plate 183**) of 1843 (inaccurately stated by Batterbury to be from *Contrasts* when it was actually from *An Apology*)[28] was sufficient to damn a style or a building in 1920, for pro-Gothic attitudes, though weakening, were still well-ingrained among the older generations at the time. Baines proposed that his great pylon would be set on the axes of Piccadilly and Grosvenor Crescent, and would have been visible from the east all the way down Piccadilly: there can be no question that the design would have been very impressive, and as a work of twentieth-century Egyptian Revival it is of considerable interest (**Plate 208**).

Can anyone seriously defend the mess that is Hyde Park Corner today? It has Decimus Burton's (1800–81) Greek Revival screen, Constitution Arch, and other fine buildings, including Adams, Holden, & Pearson's splendid Royal Artillery Memorial (1921–5), with sculptures by Charles Sergeant Jagger (1885–1934),[29] but the space is little more than an ugly traffic-island, a disgrace to the metropolis. Baines's scheme would at least have given it some degree of order, and the critics, had they lived to see the place in 2002, might well have changed their tune.

Egyptianisms were also well to the fore in the Peace and War Memorial scheme designed by Cass Gilbert (1859–1934) for New York City in 1919, who stated that a 'War memorial should be so designed and executed' that it gave an impression suggestive of Courage, Bravery, Liberty, and Victory.[30] Gilbert's proposal consisted of a massive stepped base approached from ramps, crowned by a huge stepped pyramid.

However, even before the Great War of 1914–18 the influence of such buildings as the Mortuary Temple of Queen Hatshepsut at Deïr-el-Bahari was clear in the works of several architects. Peter Behrens (1869–1940), for example, quoted those long ranges of square unornamented capital-less

25 *The Builder*. Such anti-German remarks were commonplace at the time.
26 *Ibid.*
27 *Ibid.* He is inaccurately reported as 'Battenbury'.
28 PUGIN (1843). It is typical of critics such as Batterbury that they were never able (or could not be bothered) to check their 'facts', which were almost invariably nothing of the sort.
29 *See* ANN COMPTON (*Ed.*) (1986): *Charles Sergeant Jagger War and Peace Sculpture* (London: The Imperial War Museum).
30 *The American Architect* (January 1921), **cxix**.

columns from the colonnades at the Mortuary Temple, Deïr-el-Bahari (**Colour Plate III**), in his design for a crematorium at Delstern bei Hagen (1906–7),[31] while his *Hof des Vereins Deutscher Kalkwerke*,[32] at the *Ton,-Zement,- und Kalkindustrieausstellung*,[33] Berlin (1910), owed a debt to the temple of Hatshepsut and Thutmosis III at Medinet Habu of *c*.1479–1436 BC.[34] Pyramidal compositions, with starkly stripped and stepped elements, recur, notably in Gottlieb Eliel Saarinen's (1873–1950) project for the Parliament Building in Helsinki, Finland (1908 – not only essentially a pyramidal composition, but one with reminiscences of Egyptianising detail in its main entrance),[35] while Charles-Édouard Jeanneret (called Le Corbusier [1887–1966]), in his project for an *Atelier* of Arts at La Chaux-de-Fonds (1910),[36] used blocky cubic forms and a crowning pyramid, clearly derived from the Mortuary Temple of Mentuhotep at Deïr-el-Bahari.[37] Now Behrens, Le Corbusier, and Saarinen are not exactly obscure names, so it is very odd that their Egyptian-inspired works have been ignored by most commentators. This does seem to be another instance of facts being deliberately suppressed because those commentators have agendas of their own that are more important to them than their so-called bogus 'objectivity'.

Although these images are obvious and direct, less obvious is the debt Walter Gropius (1883–1969) owed to Ancient Egyptian architecture. Images of his celebrated building (designed in collaboration with Adolf Meyer [1881–1929 – who had previously worked with Behrens in 1907–8, and was a Theosophist, something usually not taken into account in discussions of Gropius and his works]) at the *Deutscher Werkbundausstellung*,[38] Köln (1914), usually show the symmetrical front flanked by curved glazed staircases. However, on either side of the entrance are windows subdivided by those Schinkel-Thomson square mullion-columns derived from Ancient Egyptian architecture, whilst above the stark repetitive façade rise two pylon-like forms. What is usually not shown is the plan of the building, which has startling resemblances to the Ptolemaïc temple of Horus at Edfu,[39] and a reconstruction of that temple was shown at an exhibition in Berlin in 1896, which Gropius may have seen. Gropius also worked in the office of Behrens from 1907 to 1910 just at the time Behrens was quoting from Ancient Egyptian buildings, yet, apart from Pehnt's perceptive comments, nobody seems to have noticed.

31 Illustrated in PEHNT (1987), 153.
32 Court of the Association of German Lime-Works.
33 Clay-, Cement-, and Lime-Industry Exhibition.
34 Pointed out by PEHNT (1987), 153–4.
35 Illustrated in PEHNT (1987), 152.
36 *Ibid.*, 155.
37 *Ibid.*
38 German Work Association Exhibition.
39 Illustrated in PEHNT (1987), 154–5.

Paul Michael Nikolaus Bonatz (1877–1956)[40] is remembered for the *Hauptbahnhof* (Main Railway-Station) in Stuttgart (1911–27) – a building usually described as influenced by Saarinen's Central Railway-Station in Helsinki (1910–14) – and for his work designing bridges and other buildings for the *Autobahn* (motorway) system under Fritz Todt (1891–1942). However, Bonatz knew Egypt well, and many of his drawings of Ancient Egyptian buildings survive from his trip there in 1913. If one looks at the powerful and sturdy treatment of the *Hauptbahnhofsgebäude* (Main Railway-Station building) in Stuttgart by Bonatz and Friedrich Eugen Scholer (1874–1949), not only is the Hatshepsut mortuary-temple recalled, but the wall-surface treatment of the temple complex of King Zoser at Saqqara by Imhotep (*c.* 2600 BC)[41] is quoted. Now these allusions to and quotations from Ancient Egyptian architecture are too common to be ignored (as they usually are): it should be remembered that the period immediately before the catastrophe of 1914–18 was one of intellectual ferment in which there was considerable interest in Egypt Ancient and Modern (quite apart from the interest shown in many other times and places). In Germany alone, there was much inspiration drawn from Ancient Egyptian and Biblical themes: just one example is the curious case of the *Legend of Joseph* (*Josephslegende*), a ballet based on a scenario by the German diplomat, æsthete, and *littérateur*, Count Harry von Kessler (1868–1934), which Hugo von Hofmannsthal (1874–1929 – who also contributed to the scenario) persuaded Serge Diaghilev (1872–1929), the impresario, to accept for the *Ballets Russes*: the music (completed in 1914) was by Richard Strauss (1864–1949). The *première* was given in Paris on 14 May 1914, with sets and costumes by José-Marie Sert and Léon Bakst (1866–1924 – an accomplished designer in the Egyptianising style): it would be difficult to imagine anything much more exotic than that.

Tutankhamun and *Art-Déco*

Further impetus to the use of Egyptianisms in design was given by the discovery of the tomb of Pharaoh Tutankhamun in 1922, the archæological triumph of the twentieth century, which had a tremendous effect on the decorative arts in Europe and America. The subsequent publicity was enormous, and the marvellous furnishings, treasures, and other objects stimulated a new phase in the Nile style, for they were of superlative quality and design, and almost overnight became models, and not only for rare

40 PAUL BONATZ (1950): *Leben und Bauten* (Stuttgart: Engelhornverlag Adolf Spemann).
41 These matters are discussed at length in PEHNT (1987), *passim.*

artefacts.[42] Modern publicity ensured a widespread following for Nilotic fashions. Women wore 'Cleopatra' ear-rings, while designers such as Pierre Émile Legrain (1889–1929) were strongly influenced by Egyptian proto-types, and used a rich variety of materials, such as ebony, vellum, shagreen, chromium-plated metal, zebra-skin, and lacquer. Following the revival of interest in things Egyptian in 1922, Egyptianising motifs appeared in objects from ash-trays to cinemas, from jewellery to furniture, from suburban draw-ing-rooms to company board-rooms, and were essential ingredients of the style known as *Art-Déco*. The furniture designed by Eileen Gray (1878–1976) often incorporated Egyptianising elements, notably in the handsome table she designed for Jacques Doucet in 1924, and was adapted (1978) as a 'lotus console' by Vermilion of Los Angeles. One of the features of *Art-Déco* and of Egyptianising styles was that their popularity coincided with a democratisation of art and artefacts, for *Art-Déco* was not confined to highbrow tastes, and indeed the cinema, the change of mood in society after 1914–18, and the excitement of the Tutankhamun discoveries, all con-tributed to this. Egyptianising objects were produced in various cheap as well as very expensive materials, and can be found made of anything from pressed metal, 'Bakelite' plastic, or pottery to chrome-and-enamelled work or gold-and-silver objects set with precious stones and embellished with expensive lacquers.

In architecture, Henri Sauvage (1873–1932) designed a series of massive stepped blocks of flats not unlike the pyramid of Zoser at Saqqara in the 1920s, and Otto Kohtz (1880–1956) produced a mighty pyramidal tower of flats (*Entwurf eines Hochhauses*) in 1924, but neither project was realised. One of the first buildings to quote from the artefacts in the tomb of Tutankhamun was Grauman's Egyptian Theater in Hollywood by Mendel S. Meyer and Holler, begun 1922, although the proscenium also quoted a variant of the Piranesian corbelled arch. Inspired by Grauman's Theater was the Zaring Egyptian Theater in Indianapolis (1925), by Frank B. Hunter, which also incorporated that familiar eighteenth-century 'Egyptian' motif, a stepped corbelled proscenium-arch.[43]

Yet before these spectacular American examples, and indeed before the discovery of Tutankhamun's tomb, Paris acquired its Egyptianising Cinéma Louxor[44] in 1920–21 on the Boulevard Magenta (**Plate 209**). The Egyptian style had long had an association with advertisement ever since Bullock's Museum in Piccadilly, and the advent of silent films, some of which attempted to show historical (and Ancient Egyptian) scenes, encour-aged yet another revival of the style for commercial and entertainment

42 For a good flavour of these *see* HUMBERT, PANTAZZI, and ZIEGLER (*Eds*) (1994), 506–51.
43 Illustrated in HUMBERT (1989*a*), 118–19.
44 HUMBERT (1989*a*), 82.

Plate 209 *The Louxor Cinema, No. 170 Boulevard Magenta, Paris, by Ripey & Tibéri, of 1920–21. The façade is decorated with multicoloured mosaics. Photograph of 1983* (JSC).

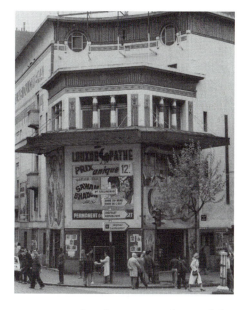

buildings. It is therefore important to recognise that a new phase of the Egyptian Revival had begun *before* 1922.

At 2325–2333 North Clark Street, Chicago, Illinois, for example, was built one of the most astonishing (and well-preserved today) buildings in the Egyptian Revival style: this is the Reebie Storage Warehouse, built in 1921–2 to designs by George S. Kingsley (1870–1956).[45] Founded by William Reebie (1859–1921) in 1880, the firm of W. C. Reebie & Brother determined to advertise itself by building an office and warehouse in a distinctive architectural style, and John Reebie (who had visited Egypt before 1921) decided on the Egyptian style, having seen another Egyptian Revival storage warehouse (that of the Dawson-Mayflower Moving Company) at Stockton, California, designed in 1918 by Glenn Allen. Clearly, foreign travel and advertising possibilities combined in a potent brew.

Kingsley, who believed that good architecture is good advertising, quoted from the temples at Dendera and Edfu, but the quality of the detail at Reebie's goes far beyond mere advertisement. The ornament on the building was carried out by the sculptor Fritz Albert (1860–1940), who had trained in Berlin before arriving in the USA in 1893 to work on the World's Columbian Exposition. Employed by the American Terra Cotta and Ceramic Company as the chief 'modeler' or sculptor, he worked on architectural commissions as well as on the design of artefacts. In 1907 he was appointed supervisor of the modelling department of the Northwestern

45 Well-illustrated in HUMBERT (1989*a*), 84–5 and 120–1.

Terra Cotta Company, the largest manufacturer of terra-cotta in the country, and in that capacity was responsible for the design of the Reebie Building decorations from 1921. Albert was knowledgeable about Egyptian architecture, and seems to have carried out other Egyptianising works at 4017 North Sheridan Road (1920) and 3052 West Carroll Avenue (1926), both in Chicago. His most famous creation is the faïence cladding of the Wrigley Building, Chicago (1919–24), but this is not Egyptian in style, and was designed by Graham, Anderson, Probst, and White.

Albert was familiar with the mysteries of hieroglyphs, and his may have been the mind behind the hieroglyphs on the Reebie building which read 'I have put protection upon your furniture and all sealed things', 'I have guarded all your property every day warding off devouring flames, likewise robbery', and 'Reebie Brothers'. It has been suggested that William Budge's *Hieroglyphic Dictionary* (1920) might have been the source, and that James Henry Breasted (1865–1935), Professor of Egyptology at the University of Chicago, may also have been involved,[46] but these matters deserve consideration in an extended monograph.

The Reebie warehouse and offices have a colourful front featuring five polychrome columns with papyrus and lotus capitals, two pharaonic figures guarding the entrance, a winged globe with *uræi* in the coved cornice, and Egyptianising architraves around the upper windows (**Colour Plate XXXIX** [a]). Inside the office is a wonderful array of polychrome Egyptianising details (**Colour Plate XXXIX** [b]),[47] as splendid as any Egyptianising cinema of the following decade.

Now the question must be asked as to why the Egyptian Revival style was used at Reebie's. As noted above, both the owner and the architect believed that advertising was an important consideration, and indeed a pharaonic sphinx's head with *nemes* head-dress was adopted as the logo of the Company. It was intended that the building should stand out and be noticed, so it falls in one sense into the category of commercial architecture, but the attention to detail sets it apart from, and superior to, concoctions of about a century earlier such as Robinson's Egyptian Museum in London, Foulston's library in Devonport, or the house in Penzance. Kingsley himself regarded the Egyptianising columns as 'salesmen', but the Reebie clan believed the Ancient Egyptians were 'the first moving and storage men',[48] a point emphasised in the decorative reliefs, one of which shows an Egyptian barge. The building was completed in 1922, the year in which King Tutankhamun's tomb was discovered, so the Reebies must have been

46 The above is based on COMMISSION ON CHICAGO LANDMARKS (1999): *Reebie Storage Warehouse 2325–33 N. Clark St Landmark Designation Report* (Chicago, IL: City of Chicago Department of Planning and Development), to which the Author is indebted.
47 The Author owes these items to the Chicago Historical Society.
48 COMMISSION ON CHICAGO LANDMARKS (1999), 14 (*see* note 46 above).

delighted when that momentous event occurred, for the publicity was enormous, and Reebie's benefited from it. The choice of style, therefore, had real commercial sense in it. There was one other factor: most warehouses where furniture was stored were grim and utilitarian, but Reebie's looked colourful, smart, and secure, a fit repository for treasured possessions, which added to its attractions.

Reebie's, therefore, was a pre-Tutankhamun phenomenon which gained from the discovery the year it was completed, but many other Egyptianising creations were at the very least prompted by Carter's great excavation. Three packet-boats run by the Messageries Maritimes steamship company, for example, the *Théophile Gautier*, the *Mariette Pacha*, and the *Champollion*, were fitted out in 1924–26 with sumptuous interiors in the Egyptianising style to designs by Jean Lefeuvre.[49] These ships were created for Mediterranean cruises: the décor was intended to provide Europeans with a flavour of their destination, and to make Egyptians feel at home while on board. The *Mariette Pacha* was scuttled in 1944, and the *Champollion* ran aground and was wrecked in 1952: they were great losses. The *Théophile Gautier* was broken up.

Preparations of potions and medicines are depicted in the polychrome mosaics of the *Pharmacie Sarret* at Clermont-Ferrand by L. Jarrier of *c*.1924,[50] and the building is embellished with papyrus bud-capitals, cavetto cornices, and other motifs familiar from the vocabulary of Egyptiana available to designers. Many such Egyptianising architectural episodes may be found in various locations far too numerous to be recorded here: it is sufficient to note that the style was very common during the 1920s and 1930s.

So it should be emphasised that the Nile style in the twentieth century could still have its devotees, but the discovery of the beautiful treasures of Tutankhamun in 1922 encouraged a new enthusiasm comparable with Roman and early-nineteenth-century Egyptomania. The Egyptian Revival had a further catalyst in 1925 through the *Exposition Internationale des Arts Décoratifs et Industrials Modernes* in Paris which stimulated the style known as *Art-Déco*.[51] The last[52] was influenced by certain elements found in Egyptianising design, notably the Piranesian stepped corbelled openings or pseudo-arches, canted arches, brightly-coloured geometrical ornament, and pyramidal compositions. There was also a powerful infusion of Mexican and Ancient Egyptian motifs: the Mexican influence was strong in the characteristic 'Aztec Temple' or stepped shape so popular at the time, yet this stepped form is found in the Saqqara pyramid and in Piranesi's

49 Illustrated in HUMBERT (1989a), 122–3.
50 Noted by the Author in Clermont-Ferrand in 1979, and illustrated in HUMBERT (1989a), 79.
51 HILLIER (1968) and DUNCAN (1988), and BENTON, BENTON, and WOOD (*Eds*) (2003).
52 HILLIER and ESCRITT (1997).

Diverse Maniere.[53] After all, stage-designs for *Die Zauberflöte*, Bullock's Egyptian Halls in Piccadilly, Thomas Hope's *Lararium* in Duchess Street, and the Egyptian House in Penzance all exploited the characteristic post-Piranesian Egyptianising stepped-arch opening. So, although Aztec temples were set on stepped pyramidal bases (and the battered-wall form was also employed), stepped pyramids were known in Ancient Egypt and in the Hellenistic world, and the stepped shape was a staple motif in European and American Egyptianising design. Stepped forms can be found on countless designs of the 1920s and 1930s, notably in the work of Ferdinand Preiss (1882–1943), whose onyx clocks were sometimes themselves stepped, and often had stepped faces. Demêtre Chiparus (1888–1950), who exhibited at the *Salon des Artistes Français* between 1914 and 1928, frequently favoured the stepped Egyptianising or 'Aztec' base, and modelled a number of nude semi-Egyptianising figures, although it has to be admitted his work verges perilously near the *Kitsch* on occasion.

Adelaide House, London Bridge (1921–5), by Sir John James Burnet (1857–1938), Thomas Smith Tait (1882–1954), and D. Raeside, was one of the first large post-Great-War buildings in London to be consciously modelled on a monumental Egyptianising style. As Vernon Blake pointed out in *The Architectural Review* when Adelaide House was nearing completion, English architects were attacking the problem of future building formulæ contemporaneously with their brethren on the Continent and the two Americas. Blake noted that modern designers had to face the problem of finding a new style at one with the æsthetic of the near future. He found the river-front 'distinctly Egyptian' (it is, in fact, really a pylon-form engaged with the wall behind [**Plate 210**]), and noted a just balance in the use of simplicity in alliance with concave elements of Egyptian architecture. The main entrance from London Bridge (**Plate 210**) was mausoleum-like, almost crushed by the apparent weight above, and the Order used was a kind of primitive Doric. Once again, the Egyptian starkness and the bold, simple lines of the building were regarded in the 1920s as modern and forward-looking, just as the architects of the eighteenth century, who used blocky, Egyptianising forms, were regarded at the time as very advanced. At Adelaide House there are lines of square mullion-columns that recall Schinkel's and Thomson's work, whilst the short stumpy piers under the curving cornice are reminiscent of some of Thomson's motifs in Glasgow (which is hardly surprising since the distinguished Scottish firm responsible for Adelaide House had strong Glaswegian connections), and have echoes of the Chicago School.

53 PIRANESI (1769).

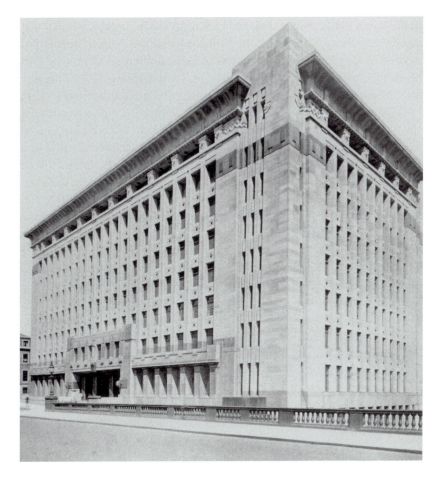

Plate 210 *Adelaide House, London Bridge, of 1924–5* (JSC).

Thomas S. Tait was also consultant for the *Daily Telegraph* building at Nos 135–41 Fleet Street, London, of 1928–31, designed by Charles Ernest Elcock (1878–1944)[54] of the architectural firm of Elcock & Sutcliffe. This is another remarkable instance in which Græco-Egyptian elements fuse in a new synthesis. The much-praised *Daily Express* building (1929–33), almost next door at Nos 120–9, by Herbert Owen Ellis (1857–1940) and William Lee Clarke (1878–1956) in collaboration with Sir Evan Owen Williams (1890–1969 – who was mostly responsible for the job from 1930), is supposed to be a key modern building,[55] but its entrance-hall (1932) was a sensational, shining Expressionist *Art-Déco* work, with a cascade-like motif

54 The Belfast-born and trained Elcock had been assistant to Burnet 1901–5.
55 It is reckoned to be the first instance of a building in London clad with a curtain-wall.

in the centre of the ceiling, designed by Robert Atkinson (1883–1952), that recalls the palm-columns of the South Drawing-Room at the Royal Pavilion at Brighton, the palm-capitals of Edfu, and the 'restoration' (1799) of an Egyptian temple by Louis-François Cassas (1756–1827). This fine interior is always ignored by the admirers of curtain-wall claddings.

The most spectacular of all London's Egyptian Revival architecture of the 1920s was the Carreras Building on Hampstead Road, backing on to Mornington Crescent, completed in 1928. *The Builder* described it as a novel essay in architectural design, constructed entirely in reinforced concrete, and decorated in brilliant colours in the Egyptian style. Those colours found a suitable background in the rendering of white cement and sand applied to the concrete surfaces, whilst the colours themselves were made of cement mixed with ground glass.[56] Architects were Marcus Evelyn & O. H. Collins,[57] while Arthur George Porri (*c*.1877–1962) prepared the plans and a Classical elevation. Collins submitted an Egyptian elevation which was accepted and adapted to suit Porri's plans. The choice of the Egyptian style was deliberately commercial, associated with the excitement generated by the discovery of Tutankhamun's tomb, with the fashion for Egyptian artefacts encouraged by Hollywood spectaculars, and with the Black Cat trade-mark of the firm of Carreras: indeed, the original intention, according to drawings by A. G. Porri & Partners, was to call the building Bast House, after the cat-goddess of Bubastis, but the somewhat unfortunate possibilities suggested in English by the name ensured that the structure became known as the Arcadia Works Building (**Plate 211**). The Board-Room was originally painted with Egyptianising motifs in rich, glowing colours. Unfortunately, Pugin's legacy was deadly, and Pevsner and other critics rounded on the building in due course: in 1961 (to appease vociferous critics) the columns were squared up and cased in, and the brilliant Egyptianising decorations were obliterated, but in 1998–9 a partial restoration took place (**Colour Plate XL**).

Porri was also involved in the design of another Egyptianising building – Museum (later Britannia) House, 231–232 Shaftesbury Avenue, London, designed by Hobden & Porri of Finsbury Square: plans are dated March, 1927 – in which year the architects applied for 'means-of-escape' approval.[58] The building has a handsome Egyptianising façade, complete with cavetto cornices and winged globes, and was to be let in floors for offices and

56 *The Builder*, **cxxxv**/4476 (16 November 1928), 799, and information provided by Mr T. Dimmick of the Archives Collection of Carreras Rothmans. Mr L. A. Porri, of A. G. Porri & Partners, was also most helpful regarding this building, and has the Author's thanks.
57 M. E. Collins (1861–1944) worked briefly in Frankfurt-am-Main (1880–1), and travelled in Egypt, and elsewhere, before joining his father, Hyman Henry Collins (1833–1905), in practice in London.
58 On behalf of Museum Estates Ltd, of 6 Coptic Street.

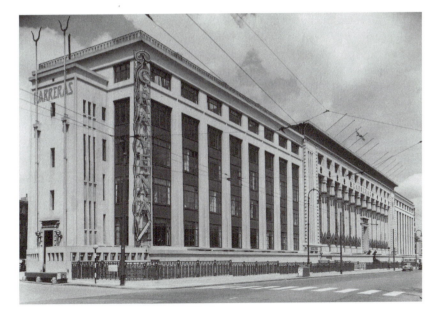

Plate 211 *Arcadia Works Building of Carreras Ltd, between Hampstead Road and Mornington Crescent, London, by M. E. & O. H. Collins, with A. G. Porri, of A. G. Porri & Partners, as consultant, of 1927–28, a spectacular example of the Egyptian Revival of the 1920s, photographed shortly after it was completed* (Archives Collection of Carreras Rothmans Ltd – Photograph by Stewart Bale Ltd).

showrooms. By June 1929 Hobden and Porri had completed the designs of the internal partitions and finishes.[59]

A fashion for Egyptiana ensured that countless Egyptianising objects were designed and marketed: some English furniture was faced with embossed coloured leather featuring Egyptianising figures, hieroglyphs, winged globes, and the like; Bichara produced obelisk-shaped perfume-bottles ornamented with hieroglyphs and made of acid-etched crystal, while the cardboard case in which the bottle was sold was also an obelisk ornamented with Egyptianising motifs;[60] Huntley & Palmer, the biscuit manufacturers, produced decorated-metal Egyptianising tins in the shape of vases in 1924; jewel-boxes embellished with Egyptianising themes were popular *c.*1925; and Singer, the sewing-machine makers, had used Egyptianising transfers on some of their models since *c.*1912.[61] Exotic coloured Egyptianising façades were erected, encouraged by Cook's Tours

59 Information kindly provided by Mr L. A. Porri and Mr Peter Bezodis.
60 *Catalogue* of the *Egyptomania* Exhibition at the Metropolitan Museum of Art, New York, 1979. *See also* LORING (1979), 114–21.
61 Model 15 K 71, for example.

in Egypt, Tutankhamun, and the fashion for *Art-Déco*, and often associated with 'Oriental' themes. Coffee, for example, was certainly exotic and eastern, and so can be found in Bewley's Oriental Café at 78–79 Grafton Street, Dublin, where the colourful façade, complete with crowning cavetto cornice and winged solar globe and *uræi*, is indubitably Egyptianesque. Such a widespread familiarity with Egyptianising themes, and their association with exotica and luxury, would encourage Egyptianising tendencies in restaurants and hotels: one of the finest examples was in the Strand Palace Hotel foyer of 1930, designed by Oliver Percy Bernard (1881–1939), in which the stepped motif, diagonal canted forms, and *Art-Déco* mix in a heady brew (**Plate 212**).

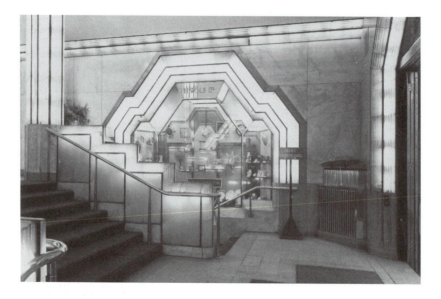

Plate 212 *The foyer of the Strand Palace Hotel of 1929–30 by Oliver Percy Bernard (1881–1939). The Piranesian stepped motif recurs in the illuminated balustrade of the stair, while the canted arch also recurs in the glazed shop-front behind* (V & A No. GX1637).

As has been mentioned above, Egyptianising design was encouraged by theatrical performances and staging. *Die Zauberflöte* and *Aïda* are two clear and obvious examples, but *Thaïs* by Jules-Émile-Frédéric Massenet (1842–1912), given at the Paris Opéra in 1894, and Sarah Bernhardt's (1844–1923) *Cléopâtre* (1890) undoubtedly also had their effects, as did *Isis: New Egyptian Mystery* at the Théâtre Robert Houdin in Paris in 1893. Theda Bara (1890–1955) and Helen Gardner (*c.*1885–1968) wore Egyptian costumes in films in the second decade of the twentieth century, but Cecil B. De Mille's (1881–1959) spectacular *The Ten Commandments* of 1923

actually pre-empts the *Art-Déco* style by mixing Egyptianising elements in a very rich visual feast. Other films, directly inspired by the Tutankhamun discoveries, appeared in the 1920s, including *Die Sklavenkönigin* (The Slave Queen) (1925), followed by the horror-film of 1932 (*The Mummy*), and then the superb *Cleopatra* of 1934 by Cecil B. De Mille, starring Claudette Colbert (1903–96).[62]

Egyptianising cinemas have already been mentioned, including the Louxor in Paris, but others followed in the wake of the Tutankhamun discoveries. One of the first in England was the Kensington Cinema, Kensington High Street, by Davis, Granger, and Leathart for Joseph T. Mears Theaters (opened 1926): the exterior had two set-back pylons, and reflected, to some extent, the style of Adelaide House. *The Architectural Review* considered the façade to be a 'great block . . ., solid and arresting as the front of an Egyptian temple', and praised its 'strength and massiveness' and the 'spreading granite podium'.[63] Charles Nicholas (*fl.*1892–1926) and John Edward Dixon-Spain (1878–1955) designed the New Gallery Kinema, Regent Street, another Egyptianising essay with painted figure-friezes by Gertrude Halsey,[64] while the Carlton, Green Street, Upton Park, Essex (1929), by George Coles (1884–1963), had an Egyptianising entrance-façade in the form of a wide pylon-like front, with a cobra-frieze surmounted by a winged globe, and two columns with palm-capitals set *in antis* (**Plate 213**).[65] The Carlton was built for Clavering & Rose Theatres, who seem to have favoured the Egyptianising style, for George Coles was again the architect for the same firm's Carlton, Essex Road, Islington, of

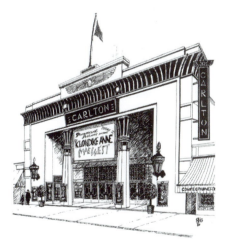

Plate 213 *The Carlton Cinema, Green Street, Upton Park, Essex (1929) by George Coles* (Drawing by Richard Hamilton Gray, Cinema Theatre Association).

62 *See* HUMBERT (1989*a*), 288–307.
63 *See* ATWELL (1981), 57–8.
64 *The Builder*, **cxxix**/4300 (3 July 1925), 2–5.
65 Information from Mr Richard Gray, Archivist of the Cinema Theatre Association, and Mr David Atwell.

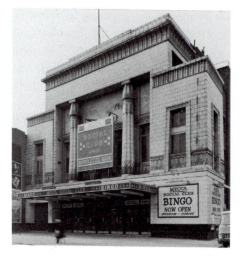

Plate 214 *The Carlton Cinema, Essex Road, Islington, London, by George Coles, 1929–30. The façade is clad in cream faïence with vermilion, green, blue, and yellow embellishments. It has come down in the world. Photograph of 1973 (GLPL No. 73/2542).*

1929–30 (**Plate 214**), with its handsome polychrome faïence façade.[66] There were other fine faïence façades across the Atlantic, too, including the Egyptian Theater at De Kalb, Illinois (1929), by E. F. Behrens.

John Stanley Coombe Beard (1890–1970) also designed several theatres influenced by the Egyptian style, one of his best being the Luxor, Cross Deep, Twickenham,[67] where the Egyptianising themes were carried within the auditorium, and the façade was a mixture of Egyptianising and *Art-Déco* motifs. At Sale, Cheshire, the Pyramid cinema was completed in 1930 to designs by Drury and Gomershall of Manchester,[68] and had one of the more distinguished Egyptianising façades, while the interior was Egyptianising *Art-Déco*, with a superb organ in the Egyptian Revival style. Manchester itself could boast the Riviera cinema, with an Egyptianising front and lotus-bud capitals. Mr Atwell considers the Carlton, Essex Road, London, to be 'a far more assured exercise in the idiom than any of its three other Egyptian rivals in England'.[69]

Perhaps one of the finest of the large British cinemas with an Egyptianising flavour was the Astoria at Streatham, built by Griggs & Son to designs by Edward Albert Stone (born 1880) for the Astoria Theatre Company, and opened on 30 June 1930. Interior decoration was by Marc-Henri & Laverdet. The foyer had a semi-vaulted ceiling and an elaborate plaster open frieze supported by square piers with lotus-capitals: walls were red, and the frieze was picked out in green, gold, and black. *The Bioscope*

66 As note 65 above. In a letter to the Author of 14 June 1979 Mr Gray opined that the Carlton was probably the most successful of the Egyptianising cinema façades. *See* ATWELL (1981), 96.
67 For Rialto (Twickenham) Ltd, built by Minter & Co, and opened on 18 November 1929.
68 ATWELL (1981), 96.
69 *Ibid.*

reported that in no theatre in London could there be found 'such unique decoration as that designed for the ladies' rest-room at the Streatham Astoria' with its 'coloured relief mural decoration of an Egyptian female figure, bathing in a lotus-filled pool', forming the background of a 'specially designed lounge-settee'. The auditorium had a 'daring Egyptian decorative scheme in which the brilliant colourings of that country' were introduced, including 'pure vermilion' with mouldings and embellishments of black and gold. Flanking walls of the balcony were divided into panels acting as the bases for two of the 'most remarkable mural decorations ever introduced into a theatre', and depicting a 'distinct tableau' from Ancient Egyptian history in vivid colours.[70] Indeed, the effects of the use of Egyptianising motifs seem to have been extraordinarily rich: *The Bioscope* described the decorative scheme as 'brilliant, and bizarre', an interesting use of the terms in the light of Piranesi's comments in the eighteenth century. The 'modernistic' streamlined manner of cinema-design in the 1930s was often not guiltless of Egyptianising tendencies: at the Odeon, Woolwich, for example, the lamp-posts by the yard entrance had simplified and slender palm-shafts derived from Græco-Egyptian prototypes (**Plate 215**). This 'modernistic' streamlined style mixed with *Art-Déco* and Egyptianising elements was particularly favoured for the lavish temples of popular entertainment, and for inexpensive but good-quality hotels such as the Strand Palace (**Plate 212**).

At the corner of Argyll Street and Great Marlborough Street, London (near Oxford Circus Underground Station), stands Palladium (formerly Ideal) House (1929), designed by the American architect Raymond Mathewson Hood (1881–1934 – who is more famous for the *Chicago Tribune* tower, Chicago, IL [1922–5], designed with John Mead Howells [1868–1959]), in collaboration with Stanley Gordon Jeeves (*c.*1888–1964). It is faced with black polished Swedish granite, with cast-bronze frames (gilded and enamelled with yellow, gold, orange, green, and red) around some of the window- and door-openings, and the crowning-cornice, frieze, and attic-cornice are of American green granite, with enamelled gilded cast-bronze enrichments coloured yellow, red, and green. Gilding, furthermore, was of twenty-two-carat English gold-leaf, so the overall effect of the building was (and is) exceedingly rich, in the manner of the lushly floral and Egyptianising motifs of the *Exposition Internationale des Arts Décoratifs et Industriels Modernes* of 1925 (**Plate 216**). Ideal House attracted a great deal of attention, and was reviewed by Arthur Trystan Edwards (1885–1973) as 'The Moor of Argyll Street' in *The Architectural Review*:[71] he was critical of the building of unrelated structures in established streets, and

70 *The Bioscope* (18 June 1930), and information kindly provided by Mr Richard Gray (*see* Note 65).
71 A. TRYSTAN EDWARDS (1929): 'The Clash of Colour or the Moor of Argyll Street', in *The Architectural Review* (June), 289–99. *See* BENTON, BENTON, and WOOD (*Eds*) (2003).

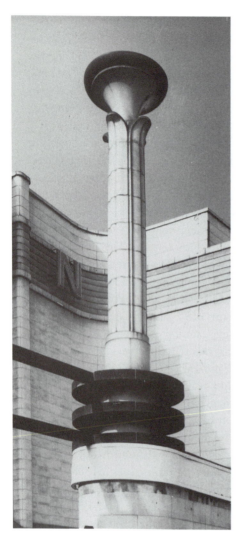

Plate 215 *Detail of a lamp-standard from the Odeon Cinema at Woolwich, London, with Egyptianising ornament in faïence. Photograph of 1973 (GLPL No. 73/11290).*

Plate 216 *Ideal (later Palladium) House at the corner of Argyle Street and Great Marlborough Street, by Raymond Hood and Gordon Jeeves, 1929. Photograph of 1980 (JSC).*

mentioned the commercial flavour of the design in his review. Entrances and ground-floor openings of this interesting building have been maltreated in recent years and disfigured by inappropriate signs. However, in the gilded enamelled bronze enrichments we can find echoes of Pueblo pottery design from New Mexico; Aztec art; *Art-Déco* motifs; volute ornaments from Ancient Egyptian wall-paintings and from tombs and vase-painting in

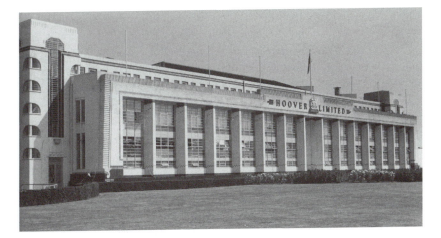

Plate 217 *Former Hoover Factory by Wallis, Gilbert, & Partners, on Western Avenue, London, of 1931–32. The long front with battered sides is a version of an Egyptian temple-front, whilst loculi-like openings are recalled in the windows of the towers (which also sport a tall window with head composed of the chamfered or canted pseudo-arch). The Piranesian stepped motif also recurs in the centrepiece. Photograph of 1980 (JSC).*

Cyprus; and Egyptian lotiform decorations. Also obvious are the stepped corbelled openings above doors which, as we have seen, are derived from Piranesi's *Diverse Maniere*, and recur throughout more than two centuries where Egyptianising design was attempted. The building was one of the most sophisticated of *Art-Déco*-Egyptianising works of architecture in the British Isles: it is a pity it has not been much appreciated.

Factories, too, often had Egyptianising motifs mixed with *Art-Déco* themes: a good example is the Hoover Factory by Wallis, Gilbert, & Partners[72] of 1931–32 on Western Avenue, London (**Plate 217**).[73] In this extraordinarily fine building influences from Ancient Egypt, from the 1925 Paris Exposition, from eighteenth-century visions of underground vaulting with funereal *loculi*, from Piranesi's *Diverse Maniere*, and from Cubist experiments can be detected in a marvellous synthesis of elements fashionable in the 1920s and 1930s. The whole main front has battered sides recalling the temples at Dendera and elsewhere, and the gate-posts were battered too, like pylons.

Wallis, Gilbert, & Partners were also responsible for the Firestone Factory, Western Avenue, London, of 1928–29, which had a fine Egyptianising-*Art-Déco* centrepiece embellished with decorative ceramic

72 Thomas Wallis (1873–1953) founded the firm in 1914. The identity of 'Gilbert' has never been established, but later Douglas T. Wallis (1901–68) and J. W. McGregor became partners in the firm.
73 HITCHMOUGH (1992), describes and illustrates this building in detail.

tiles – this excellent building was hurriedly demolished in 1980 to pre-empt its long-overdue Listing. Thomas Wallis was a distinguished Neo-Classical architect who became interested in the possibilities of using Egyptianising elements in his designs to create monumental buildings: he exploited the decorative properties of faïence to make colourful façades, and his work unquestionably was in the first rank of distinguished inter-war architecture. It is tragic that recognition of his designs as part of a continuous Egyptianising Neo-Classical tradition has been so delayed, and most unfortunate that Pevsner damned his work in unequivocal terms. A growing interest in the architecture and art of the 1920s and 1930s will no doubt help to put this recurring influence of Egyptianising motifs into perspective, and not before time, for critics have far too often taken their cue from Pugin (and later from Pevsner) and have castigated Egyptianisms, looking upon them as some kind of immoral aberration. For example, the Carreras factory (**Plate 211**) was described as 'abominable',[74] while work by the distinguished firm of Wallis, Gilbert, & Partners was denounced as 'offensive',[75] quite obviously because these buildings did not help to promote the Pevsnerian Modern Movement myth. 'Factories', we are told in Pevsner's volume on *Middlesex*, 'are on the whole atrociously bad, Modernism at its showiest and silliest'.[76] The damage done by remarks such as these, like those dished out by Pugin, can stick. Official approval, reflected in the 'Listings' of buildings of architectural or historical interest, has been slow in coming to those damned by critics such as Pevsner, which reflects badly on any supposed independence of æsthetic judgement among those responsible. The Carreras building was stripped of its glorious colourful Egyptianising elements between 1961 and 1998, and the Firestone Factory has been destroyed. It is odd that Pevsner, who almost worshipped Gropius, does not seem to have connected the latter's building for the *Werkbundausstellung* at Köln in 1914 with the temple of Horus at Edfu, for the similarities are rather obvious.[77]

Thomas Wallis, Wendy Hitchmough tells us, 'invented his own Egyptian style, borrowing a little from Owen Jones, a little from archæological records and published documentation, evolving and refining motifs in a water-colour sketch-book of patterns and mouldings'.[78] Quite so, but, as the present writer has shown, other elements, from a wide variety of sources, provided precedents for this marvellously eclectic design. Not least of those sources were Neo-Classical *esquisses* of the late-eighteenth

74 NIKOLAUS PEVSNER (1952): *London Except the Cities of London and Westminster* (Harmondsworth: Penguin Books Ltd), 371.
75 NIKOLAUS PEVSNER (1951): *Middlesex* (Harmondsworth: Penguin Books Ltd), 130.
76 *Ibid.*, 21. Pevsner's schema was accepted wholesale, almost without demur.
77 PEHNT (1987), 154.
78 HITCHMOUGH (1992), no pagination, but opposite plate 14.

century, Piranesian originals, such as some of those in the *Diverse Maniere* (e.g. the canted forms), Ancient Egyptian battered fronts, and the strong colouring of Ancient Egyptian work as revealed by people such as Roberts and Lepsius.

Later Developments

Many admired the 'primitive' vernacular architecture of Egypt as well, notably houses in Karnak, with their battered walls, flat roofs, and simplified openings. The distinguished German art-historian, Wilhelm Worringer (1881–1965), in his *Ägyptische Kunst, Probleme ihrer Wertung* (1927),[79] drew attention to the resemblance of modern buildings such as grain- and cement-silos to Ancient Egyptian hypostyle halls, with their massive and closely-spaced columns, while some of the tendencies seen in architecture influenced by Cubism also had Egyptianising aspects.

In his *Abstraktion und Einfühlung: Ein Beitrag zur Stilpsychologie*,[80] he took as his starting-point the idea that a work of art can enhance human capacities for empathy, and that a perception of beauty derives from being able to identify with an object. He argued that the highly stylised and conservative character of Ancient Egyptian art did not mean its practitioners were incompetent or incapable of recording reality with any accuracy, but because it satisfied deep psychological needs. He proposed that, in periods of anxiety and uncertainty, mankind seeks to abstract objects, transforming them into permanent, absolute, transcendental forms. Thus the fear and alienation experienced in a period of rapid social change and industrialisation, the perception that individualism was being threatened by hostile collectivism, and the experience of the disaster of 1914–18, might be seen as rekindling the ancient need for abstract forms to counteract that alienation.[81]

Now Worringer was influenced by the writings of Theodor Lipps (1851–1914), who emphasised the notion that æsthetic pleasure is derived from empathy, and that if an empathy required by an object can be felt by an individual without opposition or reservation, then the object will be perceived as beautiful by that person. He was also affected by the ideas of Alois Riegl (1858–1905), who objected to the opinion that good design was the result of functional requirements, the properties of materials, and techniques. For example, Riegl saw the evolution of the acanthus-leaf in

79 Egyptian Art, Problems of Evaluation, published in Munich.
80 First published as a thesis in Neuwied, 1907, it came out in book form in 1908, and has rarely been out of print since. The title means Abstraction and Empathy: a Contribution to the Psychology of Style.
81 TURNER (*Ed.*) (1996), **xxxiii**, 384.

Antique decoration not as a progress towards naturalism but as a striving towards the perfection of formal design. Riegl took the art of Ancient Egypt as his paradigm, and this was noted and further developed by Worringer.[82]

Is it not precisely this feeling of empathy and familiarity that caused apologists for the Modern Movement (who desired a *tabula rasa* and the destruction of history) so much trouble? An exaggerated hatred of Historicism should arouse suspicions. Why, for example, did Pevsner, who unquestionably made a great contribution to the early history of the Egyptian Revival, detest those Egyptian-inspired buildings of the 1920s and 1930s about which he was so scathing, and of that fact there can be no doubt? Without wishing to be dogmatic, it could perhaps be that the uncomfortable presence of a lively and popular architectural style did not aid Pevsner's attempts to propose a seamless and logical progression from selected architecture of the nineteenth century to the International Style of the twentieth, a style which, though almost universally adopted, has not been greatly successful in attracting devotees outside the world of architecture, has often been appallingly shoddy and unpleasant for both users and beholders, and has not even been 'functional' in any sense whatsoever. Most of all, it failed in that it did not inspire affection: it did not rise to the empathy test any more than did *musique concrète* or the more extreme forms of atonalism.

From the perspective of the early twenty-first century it does seem that there was a more-or-less uninterrupted fascination with Ancient Egyptian art and architecture from Hellenistic times, especially during the Roman Empire, the Italian and French Renaissance, the eighteenth century (especially in the Europe of the Enlightenment), virtually all the way through the nineteenth century (especially during the first three decades, and in various bursts of enthusiasm thereafter), and at times during the twentieth century, notably immediately after the discovery of Tutankhamun's tomb in 1922, when Egyptianisms merged with Aztec design and other trends to produce what became known as the Modernistic style (as in the Hoover Building, Western Avenue, London), especially after the celebrated *Exposition International des Arts-Décoratifs et Industriels Modernes* in Paris in 1924–5. There have been subsequent Egyptianising spasms since the 1939–45 war, notably in the 1980s and 1990s, and it remains to be seen if the huge exhibition of 2002–3 at the Royal Academy[83] in London dealing with the Aztecs will have any effect on subsequent revivals.

Pevsner's detestation of an inter-war Egyptianising style begins to look like wilful myopia, for there were commentators who spotted that

82 *See* WILHELM WORRINGER (1927): *Ägyptische Kunst. Probleme ihrer Wertung*, published in Munich.
83 16 November 2002–11 April 2003.

Egyptianisms were certainly alive and well, even when the International Modern Movement was supposed to be sweeping all before it. Werner Manfred Maria Ellis Hegemann (1881–1936), for example, saw Egyptianisms emerging in the *Bauhaus* in Weimar in the period 1919–23.[84] Frank Lloyd Wright's hypostyle office-hall for the Johnson Wax Company in Racine, Wisconsin (1936–39), certainly suggests a thinner kind of Egyptianesque column and capital, but the Egyptian roots are there. Overt Egyptianisms, such as battered walls and the Schinkel-Hatshepsut-Thrasyllus mullion-columns, were found in early work by Wilhelm Kreis (1873–1955), but the latter's series of projects for massive memorials to the success of German arms also drew on Ancient Egypt, on Neo-Classical France (notably the work of Boullée and Ledoux), on Piranesi, on Gilly, and on stereometrically pure forms.[85] Elements from Schinkel with an Egyptian ancestry were quoted by Albert Speer (1905–81) in many of his projects of the 1940s, and Marcel Breuer (1902–81), in his project for the church of St Francis de Sales, Muskegon, Michigan (1961–67), used stark, battered, Egyptianising forms.[86]

Spain also remained faithful to Egyptiana during the twentieth century. Dr Saguar Quer[87] has chronicled numerous nineteenth-century designs for the theatre; for tombs and monuments; for the exotic *Pastelería*, 'La Flor de Almíbar' in Zaragoza (1888–1900), designed by Ricardo Magdalena (it included a splendid Egyptianising room); and much else, including a motor-car of 1908 decorated with Egyptianising motifs designed by José Vilaseca y Casanovas for D. José Carreras,[88] which veers dangerously close to what might be described as High Camp.

However, Spain is relatively rich in Egyptian Revival material, both realised and unrealised. There is some vigorous Egyptianising detail on the Palacio de Comunicaciones in Madrid (1904–17),[89] and much else to delight the eye in the Spanish capital. Luis Moya Blanco designed a spooky Cestius-proportioned pyramid (on a gigantic monumental scale), the faces of which were perforated with semi-circular headed *loculi*, for his unrealised *Sueño arquitectónico para una exaltación nacional* (1937). However, at the celebrated *Valle de los Caídos*, the realised entrance to the monastery (1940) consisted of a blocky mass with coved cornice flanked by two unperforated pylon-towers between which is a somewhat incongruous semi-circular headed entrance. Designed by Pedro Muguruza Otaño, it is a powerful work of the Egyptian Revival designed and built in the early Franco period.

84 WERNER HEGEMANN (1924): 'Weimarer Bauhaus und ägyptische Baukunst', in *Wasmuths Monatshefte für Baukunst*, Jg. 8/3–4, 86.
85 PEHNT (1987), 159.
86 *Ibid.*
87 SAGUAR QUER (1997).
88 *Ibid.*, 406.
89 *Ibid.*, 405.

A taste for monumental hugeness in which Egyptianisms were given free rein can be found in projects for a Temple of Sorrow (1912) by Teodoro Anasagasti y Algán and in the Monument to Civilisation (or the Victory of the Idea over Nature) of 1919 by Casto Fernández-Shaw e Iturralde (1896–1978).[90] More recently, the Egyptian Revival recurs in a zoological context with the Aquarium of Madrid Zoo, a massive square battered building surmounted by a pyramid, the whole inaugurated in 1995 and designed by Carlos Baldrich Boxó and José Luis Domínguez Blas.

Of course popular entertainment helped to keep Egyptianising artefacts and forms before the public. Vivien Leigh (1913–67) played Cleopatra in 1945, and there were sundry films, including the spectacular *Ten Commandments* (Cecil B. De Mille again, this time in 1956), the *Curse of the Pharaohs* (Terence Fisher, 1959), several horror-films featuring tombs, mummies, and so on, and the Elizabeth Taylor *Cleopatra* (Joseph L. Mankiewicz, 1963).[91] There were other films featuring 'artists' as diverse as Donald Duck, Bugs Bunny, and Astérix coming into contact with sphinxes, mummies, and Cleopatra, whilst films such as *Cleopatra Queen of Sex* (1972) doubtless helped the image of the Egyptianising style as exotic, erotic, and luxurious to remain firmly established in the mind of the public. Some films made for television in the 1980s returned to Tutankhamun's Curse and other well-trodden paths.[92]

Now the Cleopatra films with Colbert and Taylor ensured further survival and revival of aspects of the Nile style, while the huge success of the exhibition of treasures from the tomb of Tutankhamun that came to London and New York in the 1970s caused its own revival of interest in things Egyptian. Not only were there catalogues and books illustrating and describing the 'unearthed royal treasure', but manufacturers once more rose to the occasion and produced Egyptianising objects in much the same way as they did in the 1920s. The Boehm Studio made a collection of the treasures in porcelain, and Wedgwood (which had been in the forefront of making attractive Egyptianising pieces from the eighteenth century) brought out a replica of the mask of the pharaoh in gilt porcelain. Trinkets, items of clothing, ties, diaries, ear-rings, brooches, rings, and books decorated with the motifs from Tutankhamun's tomb were produced in large quantities. Even a 'pop'-song called *Tutankhamun* was released in the 1970s, and the present writer recalls seeing a juke-box in a bar in Germany called the 'Tutankhamun' model. Camel-, pyramid-, and Tutankhamun-mask-stickers appeared on the backs of cars. Egyptomania was certainly not

90 SAGUAR QUER (1997), 402–3.
91 HUMBERT (1989a), 286–307.
92 *See*, for example, LUC DELVAUX: 'Les "Aventures de Papyrus" de Lucien De Gieter: approche égyptologique d'une bande dessinée', in HUMBERT (*Ed.*) (1996), 609–24.

dead even then. Richard Knapple produced an Egyptian Room, with furniture of hand-carved and painted wood for Bloomingdale's in 1977: columns had painted bell-capitals with lotus-flower decoration, and the cavetto cornice was embellished with lotus and papyrus. Ptolemy Designs of New York advertised (1978) a magnificent Egyptian throne-chair of hand-carved wood, gilded and painted, based on Tutankhamun's throne, and in the same year Boehm Studio, New Jersey, brought out a pair of falcon emblems of painted porcelain, while Wedgwood issued a limited edition of their Canopic vase from a mould of 1800, of terracotta on black Jasper-ware, and marketed a smaller edition of a sphinx *couchant* also in terracotta on black Jasper-ware. Philip Graf Wallpapers of New York marketed a wallpaper called 'Nile Odyssey' to designs by Bob Mazzini on which lotus-flowers and other Nilotic motifs flourish.

There were other Egyptianisms too: Charles de Beistegui erected a Ledouxesque pyramid of brick with stone dressings on his estate at Groussay in 1960–70, and the Glyndebourne Festival Opera produced *Die Zauberflöte* in 1978 with designs by David Hockney (**Plate 218**). In 1977–84 James Stirling, Michael Wilford, and Associates built the *Staatsgalerie* in Stuttgart

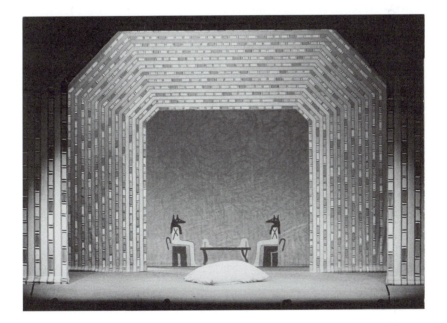

Plate 218 *Design by David Hockney (born 1937) for the 1978 production of* Die Zauberflöte *for the Glyndebourne Festival Opera, Glyndebourne, Lewes, Sussex. The form of the chamfered or canted arch, a favourite Art-Déco motif, derives from the Piranesian interpretation of the Egyptian style (GG, No. 0968.15).*

which employs a spectacular Egyptian coved cornice,[93] whilst in the circular court in the centre is a primitivist interpretation of a Greek Doric distyle arrangement supporting a tough ornamented lintel, reminiscent of Ehrensvärd's Karlskrona Dockyard. At Wadsworth, Illinois, Jim Onan built himself a dwelling in the form of a gilded pyramid set on an artificial lake, begun in 1977, complete with an alley of seventy-five sphinxes, and a lavishly Egyptianising interior.[94] Onan seems to have been inspired by the décor of such spectacular films as *The Ten Commandments*, but the attractions of the purity of form, strong colours, and the easily recognisable character of Ancient Egyptian architecture played their parts in his choice of style. Certainly his house was conceived on the grandest scale. Ieoh Ming Pei (born 1917) created his metal-and-glass *Pyramide* in front of the Louvre in Paris (1984–89), and Gérard Chamaillou designed (1985) a floating 'Hâpitrône' consisting of a pyramid of open metalwork with a solid white pyramid inside the structure.[95] Also in Paris Gai Aulenti (b. 1927) incorporated elements reminiscent of Egyptianising forms in the *Musée d'Orsay*, while Charles Alexander Jencks (b. 1939) has experimented with Egyptianisms in London.

It is interesting that the Egyptian Revival has survived in the United States of America to a degree unknown elsewhere. Mention has been made of the wondrous Reebie offices and warehouse in Chicago, but there were other manifestations of the style in the twentieth century. Among these may be mentioned the house at Wesley Hills in the State of New York of 1915 by Walter Robb Wilder, with a wide glazed front set behind a colonnade with bud-capitals and held between two pylon-towers. Mercifully, this astonishing but little-known house was rescued and restored in 1984.[96]

California has its fair share of Egyptianising architecture including the scholarly, stark, and severe Rosicrucian Temple at San José; a much-mutilated electric sub-station and tramway station at San Diego (by E. M. Hoffmann, of 1923–4),[97] now a garage;[98] the Egyptian Court Apartments also in San Diego (1926) at Park Boulevard; Pharaoh's Court Apartments (which incorporate details similar to those of Grauman's Egyptian Theater in Hollywood), again in San Diego; and an Egyptianising house (1926) which incorporates the stepped corbelled opening that derives from Piranesian images.[99]

93 PEHNT (1987), 159, also picks this up.
94 *See* HUMBERT (1989a), *passim.*
95 *Ibid.*, 89.
96 RICHARD A. FAZZINI: 'L'Égyptomanie dans l'architecture américaine', in HUMBERT (*Ed.*) (1996), 229–78.
97 *The Evening Tribune* of San Diego, CA (1 July 1924).
98 FAZZINI (1996), 268. *See* note 96 above.
99 *Ibid.*, 271.

Thomas White Lamb (1871–1942), best-known as a designer of theatrical sets, conceived a superb Egyptianising architectural ensemble for the Pythian Temple, New York (1927), and the Detroit, MI, Zoo acquired bucolic Egyptianising details for its hippopotamus and giraffe houses (*c*.1932), possibly for the associations with the Nile. More recently, the Memphis, TN, Zoo and Aquarium (1990–1), gained an entrance in the Egyptian style. Curiously, unlike its European predecessors at Antwerp and Berlin Zoos, the Detroit examples revert to pseudo-hieroglyphs, proving, as Fazzini has noted, that exact archaeological attention to detail is not necessarily a fundamental preoccupation of Egyptomania.[100]

Memphis now possesses the Great American Pyramid, 88 metres high, inaugurated in 1991, and Las Vegas obtained another huge pyramid, the Luxor Hotel-Casino, which opened in 1993: at the entrance is a huge sphinx and obelisk, and inside the décor is Egyptianising (in the Casino there is even a reproduction of a painting by David Roberts on the wall).

Now of course there is quite a lot of Professor Carrott's 'Commercial Picturesque' about these ventures, but, unlike their nineteenth-century predecessors, the Memphis and Las Vegas pyramids are vast, so they probably lurch towards what might be described as a 'Commercial Sublime' category. It is interesting that the Mellon Bank Center, Philadelphia, PA (1990),[101] has a curved cornice atop battered pylon-forms, and the entire skyscraper is surmounted by a pyramid. It was designed by KPF (the New York architectural partnership of A. Eugene Kohn [b. 1930], William Pederson [b. 1938], and Sheldon Fox [b. 1930]).

Epilogue

At the very end of the twentieth century was completed at Canary Wharf, Isle of Dogs, London, the extraordinary *Four Seasons* hotel. It is Egyptianising with battered white walls and a huge gorge-cornice, and was completed in 2000 under the direction of the British architects RHWL (Renton Howard Wood & Levin). However, the original design emanated from the French architect, Philippe Starck (b. 1949).[102]

Now that Post-Modernism, especially Post-Modern Classicism, is no longer fashionable, and many designers (especially in America) are adopting a more discriminating approach to eclecticism, historical references might

100 FAZZINI (!996), 248. *See* note 96 above.

101 In Philadelphia also stands John Haviland's Egyptianising Pennsylvania Fire Insurance Company's façade of 1838, sympathetically enlarged in 1901. *See* CARROTT (1961). Professor Carrott suggested that the Egyptian style suggested 'a feeling of solid, enduring, dependability' suitable for the offices of an insurance company.

102 Information kindly provided by RHWL of London and the RIBA.

seem to offer a wide range from which to select motifs that can be freely interpreted. Cornices of the Egyptian type, massive colonnades of the Hatshepsut kind at Deïr-el-Bahari, and battered walls and doorcases are motifs in designs of the 1980s and 1990s that recur. Revivals of Egyptian forms have enjoyed a remarkably long life: in 1981, for example, the Nile Valley style in dress was promoted by leading fashion designers; while at the Summer Exhibition of the Royal Academy of Arts in London there was even exhibited a pencil drawing for a new obelisk for Harlow, Essex by the Modernist firm of Sir Frederick Gibberd & Partners.[103] Cotton-squares for sale in a shop in Fiesole in 1980 had Egyptianising motifs in the border-friezes coloured brown, white, red, blue, and green. The graphic-designer, Theodore Menten, produced a number of stencil-patterns based on Ancient Egyptian painted decorations for use in interior décor, and many artists and craftsmen incorporated Egyptianisms in fashion, jewellery, fabrics, needle-work, wallpapers, and *objets d'art* during the 1980s and early 1990s. The inspiration lies in Antiquity, in the great richness of late-eighteenth-century and Napoleonic design, in the examples of Ancient Egyptian artefacts found in the tomb of Tutankhamun, in a growing appreciation of the *Art-Déco* styles of the 1920s,[104] and in a realisation of the wide palette of Egyptian-inspired objects produced from the 1930s.

It is also quite clear that the potency of Ancient Egyptian design as an inspiration for the following centuries remains undiminished as the twenty-first century moves through its first decade.[105]

103 No. 1363 in the *Catalogue*. The firm was founded by (Sir) Frederick Ernest Gibberd (1908–84), who spent his last years embellishing the garden of his house at Harlow. Gibberd was appointed in 1946 as chief architect and planner of the new town there, and remained in charge until 1972.

104 In 2003, a major exhibition of this style was held at the Victoria & Albert Museum in London. *See* BENTON, BENTON and WOOD (*Eds*) (2003).

105 *See* PEHNT(1987) for a wider discussion of twentieth-century Egyptianising influences in architecture, notably on Bonatz, Gropius, and Breuer. His paper is a welcome antidote for those who have imbibed too many toxic apologies for the 'purity' of the International Modern Movement. The Author records here his gratitude to Herr Dr Pehnt for corresponding with him and sharing ideas.

CHAPTER XI

A Postscript

Introduction; The Longevity of Nilotic Themes; Afterword

E'en as the o'erflowing Nile presageth famine.

<div style="text-align: right;">

WILLIAM SHAKESPEARE (1564–1616):
Antony and Cleopatra, Act 1, Scene 2, line 50.

</div>

Non tibi sunt tristes curæ nec luctus, Osiri,
sed chorus et cantus et levis aptus amor,
sed varii flores et frons redimita corymbis,
fusa sed ad teneros lutea palla pedes,
et Tyriæ vestes et dulcis tibia cantu
et levis occultis conscia cista sacris.

(Not sorrow nor care, but song and dance, Osiris,
and light-hearted love are apt,
and flowers of every hue and forehead decked with ivy-berries,
saffron robes falling to tender feet,
Tyrian vestments, dulcet songs upon the pipe,
and wicker shrine for thy holy Mysteries).

<div style="text-align: right;">

ALBIUS TIBULLUS (*c.*54–*c.*18 BC):
Elegies, Book I, Elegy 7, lines 43–48.

</div>

Introduction

A subject that has occupied the mind for more than four decades is difficult to leave without regret. Exploring it has been illuminating in very many ways, and, looking back, although the spark was struck in Salzburg in 1960 when Schinkel's superb designs made a huge impact, Egypt had impinged long before then. Perhaps an interest was first aroused in some quiet gallery in a provincial museum, when contemplating a shrunken mummified body that lay wrapped in linen in a painted, shaped coffin within a glass case, the blackened face and tiny shrivelled hands visible outside the elaborate bandages. Perhaps it all began in the presence of vast Egyptian sculptures in the British Museum, or perchance it was something seemingly inconsequential, such as a brilliantly-drawn comic-strip in the 1940s in which children had penetrated some dark Ancient Egyptian tomb where mummies and pharaonic statues came to life,[1] or perhaps some improbably exotic book, such as *The Green Eyes of Bâst* (1920) by Sax Rohmer (1883–1959), *The Egyptian Mummy* (1939) by Captain William Earl Johns (1893–1968),[2] or *The Cat of Bubastes* (1889) by George Alfred Henty (1832–1902), fired the imagination in childhood and stimulated a lifelong interest in the great civilisation of the lands bordering the Nile. What ever started it all, it has been clear throughout adult life that Egyptian-inspired artefacts and works of architecture are far more commonly found than most people seem to imagine: from humble door-knockers in County Donegal to sphinxes in Islington, and from a former flax-mill in Leeds to a former factory making vacuum-cleaners in London, the Nile Style recurs.

And it was not just fashion or whim that was responsible for the various phases of enthusiasm for things Egyptian. As the late Spiro Kostof (d. 1991) has noted, the 'style was especially successful in the United States where it was applied, for a whole train of associations, to prisons, medical colleges, libraries, cemetery gates, and even churches and synagogues'.[3] Quite so, and it was precisely the *versatility* of the Egyptian Revival (with its historically non-Nilotic accretions, such as those invented by Piranesi, which became accepted as *Echt*-Egyptian by later generations of designers, as has been demonstrated above) that enabled it to be applied to a huge variety of situations, from Belgian Freemasonic Temples[4] to the charming little Egyptian Revival former synagogue[5] in King Street, Canterbury, Kent,

1 Luc Delvaux has discussed some later comic-strips in HUMBERT (*Ed.*) (1996), 609–24.
2 Better-known for his 'Biggles' adventure-stories.
3 SPIRO KOSTOF (1995): *A History of Architecture* (New York, NY: Oxford University Press), 572. *See also* CARROTT (1978), 130–7.
4 *See*, for example, WARMENBOL and WASSEIGE (1990) and WARMENBOL (1995*b*).
5 In 2002 it was the King's School music-and rehearsal-room.

erected 1847–8 to designs perhaps by Hezekiah Marshall;[6] from the wondrous book-case made in 1828 by Johann Hoegl to hold the *Description de l'Égypte* (which had been commissioned by the Abbé Albert IV Nagnzaun for the library of St Peter's Benedictine Abbey in Salzburg and was probably designed by him)[7] to the Sèvres *Service Égyptien* described and illustrated above; and from cemetery-entrances to cinemas.

Full-blooded Egyptianising stage-sets were designed and made for numerous operatic productions, including Schinkel's memorable work for the 1816 *Die Zauberflöte* in Berlin, the superb sets for the première of *Aïda* (1871) in Cairo by Philippe-Marie Chaperon (1823–1906) and Édouard Despléchin (1802–71) under the general direction of Mariette,[8] and the interesting work, also by Despléchin, for the 1863 Paris production of *Moïse* (composed 1827 to a libretto by Étienne de Jouy and Luigi Balocchi by Gioacchino Antonio Rossini [1792–1868]).[9]

The style was used to great effect by Piranesi in the *Caffè* by the Spanish Steps in Rome, described and illustrated earlier, and in the *Caffè Pedrocchi* in Padua, where it was given a more sober and scholarly airing to designs by Giuseppe Jappelli, with sculptures by Giuseppe Petrelli (1805–58) and paintings by Belluno Pietro Paoletti (1801–47).[10] It enlivens the lands of the South (the extraordinary room in the Villa Borghese in Rome, and the examples from Spain alluded to above) and can be found in the cold North (Menelaws's Egyptian Gate in Russia, the Egyptian temple in the park of the Łazienki Palace, Warsaw, *c.*1820, by Jakub Kubicki [1758–1833], and the Vestibule Égyptien (1803) in the palace at Pavlovsk, by Ivan Prokofiev [1758–1828] and Andrei Nikiforovich Voronikhin [1759–1814], to name but a few fine works).[11]

Sphinxes are found all over Europe and America, as well as lionesses and lions copied from the Antique exemplars in Rome. As for obelisks, they are very familiar objects, and pyramids, too, are not rare in the West. Prince Hermann Ludwig Heinrich von Pückler-Muskau (1785–1871), for example, created a fine landscape garden at his family seat at Branitz, near Cottbus, which included pyramids and lakes: under one of the pyramids the Prince was duly interred, but there are other pyramids to be found in plenty outside Egypt, from the pyramid of Cestius in Rome to the vast hotel in

6 The lintel over the door is of the stepped type. Predictably, this pretty building was given short shrift in *The Buildings of England. North East and East Kent* (1976).

7 HUMBERT, PANTAZZI, and ZIEGLER (*Eds*) (1994), 326–7. The Hathor-headed capitals were made by the sculptor Hitzl, and painted decorations were by Conto.

8 HUMBERT, PANTAZZI, and ZIEGLER (*Eds*) (1994), 423–7. Chaperon also designed some of the sumptuous sets for the 1880 production of *Aïda* at the Paris *Opéra*.

9 HUMBERT, PANTAZZI, and ZIEGLER (*Eds*) (1994), 391–447.

10 *See* BERTRAND JAEGER: 'Le café Pedrocchi de Padoue et la "modification du regard" porté sur l'Égypte ancienne en Italie au XIXᵉ siècle', in HUMBERT (*Ed.*) (1996), 189–225.

11 *See* HELEN WHITEHOUSE: 'L'Égypte sous la Neige', in HUMBERT (*Ed.*) (1996), 163–86.

Las Vegas. There was even a proposal, in 1903, to erect in Hyde Park, London, a Great National Monument in the form of a large pyramid, complete with sculpture-galleries, catacombs, and viewing-galleries, for the commemoration and entombment of the Great and Good.[12]

Egypt is with us still, in many guises and in many locations, and this has been so for more than two millennia: its fascination, and what Luc Delvaux and Eugène Warmenbol have called 'un air subtil, un dangereux parfum',[13] have remained potent catalysts for the Western imagination. It is unquestionably true that Egyptianising motifs and themes permeated nineteenth-century design, for example, to a far greater extent than is usually acknowledged, and that the twentieth century, too, had its fair share of these as well. The sources are well-known, although some have perhaps not had the attention they deserve.[14]

The Longevity of Nilotic Themes

Beneath the conventional histories that purport to deal with Classical (especially Roman) Antiquity, the Renaissance, Baroque, and the world of the European Enlightenment of the eighteenth century, lurk strange themes[15] that are only recently being explored in any systematic way, though there is an immense amount still to be done. The archæological, artistic, and literary evidence for the importance of Egyptianising art, theology, and culture in the Græco-Roman world is irrefutable, whilst the Nilotic deities occupied a central, rather than peripheral, place during the four-hundred-and-fifty-odd years of the Roman Empire before Christianity was more-or-less firmly established. As has been discussed above, there are many aspects of the Isiac religion that appear to have survived, especially in relation to the Marian *cultus*, and it is submitted that Ancient Egyptian culture, in its widest sense, has been of considerable significance in the development of Western European civilisation.

Throughout two millennia, especially during the first centuries of our era, and again during the eighteenth, nineteenth, and twentieth centuries, Ancient Egyptian art, artefacts, and architecture have inspired designers. Nilotic elements were particularly important in furniture-design, and were liberally quoted in *Directoire*, Napoleonic-*Empire*, Regency, later-nineteenth-

12 *See* WALSH (1903).
13 DELVAUX and WARMENBOL (1991).
14 An underestimated book (small and inexpensive) may have had more Egyptianising influence than has hitherto been suspected, especially on interior design. This was LORENZO ROCCHEGGIANI and PIETRO RUGA's *Invenzioni diverse di mobili ed utensili . . . per usi comuni della vita*, published in Milan in 1811. *See* PETER THORNTON (1984): *Authentic Décor: the Domestic Interior 1620–1920* (London: Weidenfeld & Nicolson), 142.
15 *See,* for example, CURL (2002*b*).

century, *Art-Déco*, and subsequent styles. Receptive observers cannot fail to notice the recurring Egyptianisms in Western art and architecture, notably in Neo-Classical, late-Victorian, and inter-war styles. Egypt, in short, has been a continuously attractive source of design ideas, and a quarry from which creative artists have taken motifs from Classical Antiquity to the present. Richly-ornamented Egyptian artefacts, the brilliant colouring of Egyptian decorations, the superb craftsmanship of Egyptian furniture, sculpture, and architecture, and the stark, brooding solemnity of Egyptian buildings have long fascinated Europeans, who responded especially to the purity of forms such as the obelisk, the pyramid, and the pylon. Battered walls, mastabas, the organisation of axially-planned temples (such as that of Horus at Edfu), the stark simplicity of the wall-treatments of the Mortuary complex at Saqqara, the powerful geometry, and the primitive quality of Egyptian vernacular buildings have demonstrably influenced twentieth-century architects (even those of the so-called Modern Movement who claimed to be influenced by nobody, and announced they were starting from scratch).[16]

The idea of Egypt (dark, mysterious, inaccessible Egypt) as the source of all wisdom (a notion made all the more attractive by the lure of unreadable, incomprehensible hieroglyphs) gained credence from the fifteenth century, and the Hermetic, or Egyptian, tradition began to play an important rôle in cultural affairs. Of course Egypt enjoyed a similar reputation during the first centuries of the Roman Empire, when Isiac Mysteries and Nilotic deities attracted the devotion of the Emperors themselves, and the great *Isæum Campense* was at the height of its glory. The gigantic complex of the *Isæum Campense* seems to have occupied a site about three times the size of the Pantheon and its subsidiary structures (interestingly, the apsidal southern end of the *Isæum* appears to have had a radius approximately the same as that of the still-standing rotunda of the Pantheon: from the chapel-like *Serapæum* in the south to the northernmost end of the *dromos* the *Isæum Campense* was *c.*220 metres long and *c.*70 metres wide, while the apsidal end had a radius in the region of 30 metres).[17]

Future enlightenment was hoped for, and sought, through the Hermetic texts, the Cabbala, and alchemy during the Renaissance period in those pre-Newtonian centuries: somehow, through a study of hieroglyphs, Hermeticism, and much else, the ancient wisdom the Egyptians were thought to have possessed would be uncovered. The delvers into Hermetic-Egyptian labyrinths seem to have believed there were unseen, irrational forces that had to be recognised as part of the cosmos: by ignoring them it was felt that those of a more rational, 'scientific' bent

16 *See* PEHNT (1987).
17 *See* Select Glossary.

could miss essentials. Hermetical-alchemical-Cabbalistic investigators developed a sense of exclusiveness and secrecy, for the sharing of esoteric knowledge with the profane, unworthy, corrupt, immoral, or stupid was seen as far too dangerous. Those who had been introduced to Isiac mysteries in Antiquity kept things to themselves, for the mystical experiences they had could not be shared with the profane: a similar sense of secrecy was apparent among those pursuing Hermeticism, alchemy, and Cabbalistic studies, and later among those who moved in Rosicrucian or Freemasonic circles. At the centre of it all was a sense of being guardians of esoteric and ancient wisdom (how else does one explain those extraordinary complex sundials found in Scotland, a land not noted for its bright weather?).[18] During the sixteenth century, indeed, something like a radical reformation that envisaged a basic change in society, education, religion, and sensibility, embracing every aspect of human activity, seems to have been on the boil. The worlds of Kircher, Fludd, Maier, Dee, Pico della Mirandola, Giordano Bruno, and what Dr Yates has called 'The Rosicrucian Enlightenment' certainly included a contemplation of Ancient Egypt (or an idea of it).[19]

In post-Newtonian times, when spiritual torpor and scepticism gained ground, Egyptianising notions, Hermetic researches, alchemy, and all the rest of it seemed absurd to the Enlightenment, just as many of the pagans of Antiquity found the worship of crocodiles, bulls, and animal-headed deities beneath contempt. Even Octavian, exhorting his troops at Actium, ridiculed Egyptian devotion to reptiles and animals, and later, as Augustus, observed that he worshipped deities, not bulls. Vespasian, who had once kept vigil with Titus in the *Iseum* before his official Triumph, could joke on his death-bed that he fancied he was turning into a god. When Shakespeare could put 'I have Immortal longings in me'[20] into the mouth of his Cleopatra, it was no use: Augustus and the Græco-Roman world of Antiquity knew she was dead, killed by the *uræi* that once represented her power. The rattle of the *sistrum* and the zoömorphic deities of the Nile could not prevail over the might of Rome, yet they invaded Italy nevertheless, and the great goddess Isis was installed in glory in the capital of the world.

To the eighteenth-century English Augustan, to the eighteenth-century French aristocrat (steeped in Enlightenment ideas of the *philosophes*), and to the worldly clerics and princes of the *Aufklärung*, Hermes, Psammeticus, and the curious Egyptianising tendencies that had gone on in Rome (even in Vatican circles) were absurd, had gone the way of futile incantations, and

18 For this topic *see* CURL (2002*b*), 48–51.
19 *See* YATES (1947, 1964, 1966, 1972).
20 *Antony and Cleopatra* (1606–7), Act V, Scene 2, line 282.

were indicative of lack of rigour in mental matters. Rain-bearing Madonnas in Southern Italy were as foreign and as improbable as the tearful Isis herself, while the tenebrous realms of occultism and pseudo-Egyptian 'studies' that evolved in sixteenth- and seventeenth-century Europe were repellent to rational minds. Later, notably in the nineteenth and early-twentieth centuries, the aureole of the gentle Madonna herself became a hard ring of obfuscation and bigotry. That transformation, of course, was in part a reaction after the anti-clerical excesses of the French Revolution and the Terror. The Enlightenment had more of the darker, unimagined side of things within it than the *philosophes* and the Augustans could ever admit, yet, like the clear meridian splendour of a glorious day in the South, that Enlightenment, too (in spite of its rationalist pretensions and its confident belief in progress and the chimærical perfectability of Man), harboured, in the words of Paul-Charles-Joseph Bourget (1852–1935), *Le Démon du Midi*[21] (although Bourget suggested by this phrase more the vicious cruelties of the Middle Ages). Psalm 90, in the *Vulgate*, speaks terrifyingly of the Demon of Mid-Day in *Non timebis a timore nocturno . . . ab incursu et demonio meridiano . . .* At the end of the eighteenth century the Demon of Mid-Day, in the pure light of the Enlightenment, unleashed untold horrors, since Reason reasoned itself out of existence. A longed-for balance, wherein all aspects of the world, even the contradictions, were to be included, collapsed: gone was an ancient equipoise. The Enlightenment held within it its own Demon, and one day it escaped.

Yet Egypt remained in the collective imagination. Laurence Sterne (1713–68), in *The Life and Opinions of Tristram Shandy*, makes much of the naming of his hero in volume iv (1761–2) when he was christened 'Tristram' instead of 'Trismegistus', allegedly because neither the parson nor the godfather could get their tongues around the name preferred by 'Walter Shandy', the infant's father, who was enraged by the occurrence.[22] This is not the only indication of eighteenth-century concerns with the arcane and Egyptianising tastes that seem to have been current at that time: Batty Langley (1696–1751), the landscape-gardener, architect, and prolific producer of architectural books, whose influence on Georgian architecture should never be under-estimated, called four of his sons Archimedes, Euclid, Hiram, and Vitruvius, 'indicative both of Langley's architectural pretensions and of his interest in Freemasonry'.[23] Thus a fascination for things connected with Ancient Egypt (or what was thought to be Ancient Egyptian) lurked just beneath the surface, even in Georgian England.

21 Title of a novel (1914), generally recognised as Bourget's masterpiece.
22 Miss Alison Kelly kindly drew the Author's attention to this in a personal communication of 6 September 1993.
23 COLVIN (1995), 598.

Many of the artefacts manufactured at the Lambeth works founded by Mrs Eleanor Coade (1733–1821) were in an Egyptianising style. Coade Stone was a type of fine, hard, water-resistant, artificial stone, manufactured from 1769, and consisting of China clay, sand, and crushed material that had already been fired. It was used for architectural ornaments and components such as capitals, urns, key-stones, and statuary: it was even used for whole funerary monuments. The product was also called *Lithodipyra*, meaning twice-fired stone, and its stability during firing enabled the finished size of an artefact to be accurately estimated during modelling.[24]

Mention has already been made of the Antinoüs figures now at Buscot Park, Berkshire (now Oxfordshire),[25] which appear to correspond to the figure shown in Thomas Hope's famous room at Duchess Street in London.[26] The Buscot figures are stamped 'Coade and Sealy[27] 1800'. Thomas Hope illustrated[28] the front and side elevations of a stone seat adorned with winged female seated sphinxes with lotus-flower finials at the tops of the back uprights (**Plate 107**). This appears to be the Coade Stone throne, a pair of which may be found at Parham Park, Sussex,[29] although the lotus-ornaments are missing, but the small holes were clearly intended for the fixings of some sort of ornament, so it is highly likely that the Parham Park thrones once stood in Duchess Street.[30]

The Campidoglio lions in Rome (**Plates 36–37**) (they look like lionesses because the manes are hidden beneath variants of the *nemes* head-dress) and Antique sphinxes in Rome were drawn by Tatham and published in his *Etchings* in 1799–1800: they provided the models for Mrs Coade's lions and sphinxes that were turned out in considerable numbers. The so-called Cat Gates at Culzean Castle, Ayrshire, for example, were decorated with Coade Stone lions (one marked COADE LAMBETH 1802) based on Tatham's publication.[31]

Alison Kelly's admirable publication of 1990 contains a huge amount of information about Coade Stone artefacts, and she pays due regard to the importance of Tatham as a source for some of the designs. Apart from Culzean Castle, she cites Egyptian lions[32] at Kinmel Park, Clwyd, one bought by Thomas Hope (perhaps that shown in plate xvi of his *Household Furniture*), and a few others: they seem to have been in reasonable demand.

24 KELLY (1990), describes the product in detail.
25 *Ibid.*, 95.
26 Plate viii of his *Household Furniture and Interior Decoration* (1807), reprinted 1970.
27 John Sealy (1749–1813) became Mrs Coade's business partner in 1799.
28 Plate xix of HOPE (1807).
29 Illustrated in KELLY (1990), 94.
30 Personal communication from Miss Kelly of 6 September 1993.
31 *Ibid.*, and *see* KELLY (1990), 74, 429.
32 She calls them lionesses, but, as previously noted, the application of a type of *nemes* head-dress in Antiquity served to disguise any mane and therefore the sex of the animal.

Perhaps the most surprising Egyptian reference of eighteenth-century London society is that connected with The Medical Society of London, a discussion-group composed of ten surgeons, ten physicians, and ten apothecaries, one of the original founders of which was Dr John Coakley Lettsom (1744–1815). The Society met at a house in Bolt Court, Fleet Street, provided by the beneficence of Lettsom: in this building was a large emblematical Coade Stone medallion, duplicated at Dr Lettsom's house in Camberwell. The Camberwell medallion seems to have been destroyed (with the house), but The Medical Society still owns its version, which can be found in its offices at Chandos Street, Cavendish Square, London. The design (**Plate 219**) consists of a pyramid of the Cestius type forming the background to the principal figure (the Great Goddess Isis of Saïs, or Isis-Hygeia), standing on a severe block on either side of which is a sphinx (signifying mystery). On the block is an *ouroboros* (an attribute of eternity) surrounding the Greek inscription which translates as:

> I am all that has been and shall be created,
> and no mortal has ever removed my robe.

The bridge visible to the right of the pyramid allegorically links Egypt (note the palm) with the Classical civilisations of Greece and Rome, and the toppled broken Ionic column (itself an attribute of Wisdom) emphasises that claims of medicine originating in Greece were superseded by knowledge that Egypt was the true begetter of that science.

Now Isis of Saïs was the great revealer of the mysteries of Nature, and was a universal benefactress, but, more especially, she presided over medicine, which some hold she invented, as she was the first to discover the salutary use of drugs and minerals, and the essence of all beneficial plants.[33] This link with Egypt is interesting in the context, for received wisdom held that the history of medicine went back to Ancient Greece and Asclepius, but the latter had become identified with Horus/Harpocrates and with Osiris/Serapis (and therefore associated with Isis), even in Antiquity. Dr Lettsom, a Quaker who held all sorts of advanced ideas for his time, believed that medicine began, not with the Greeks, but with the Egyptians, and that the Greeks learned their medical skills from the Egyptians, thus the medallion (which is very large, and represents 'a considerable feat of potting'[34]) had references to Egypt that were quite deliberate, and had significance in the context of eighteenth-century ideas.

33 Personal communication about this medallion from Miss Alison Kelly of 6 September 1993. *See also* KELLY (1990), 169. *See also* JAMES EDWARDS (1801): *A Companion from London to Brighthelmstone in Sussex*, a pamphlet in which the Camberwell medallion is described.

34 Miss Kelly's phrase.

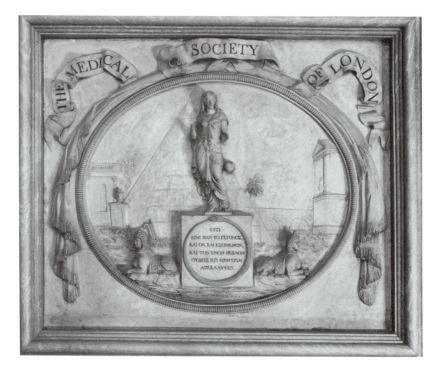

Plate 219 *Coade Stone panel with medallion now in the meeting-room of The Medical Society of London, 11 Chandos Street, Cavendish Square, London. It was originally in the Society's premises at Bolt Court, Fleet Street, and is marked 'COADE LITHODIPYRA 1787'. The (unfortunately damaged) figure of Isis-Hygeia stands on a severe block embellished with an inscription in Greek framed by an ouroboros and flanked by sphinxes. Behind the goddess is a pyramid of the Cestius type. The palm-tree underlines the Nilotic connection. Behind the sphinx on the left is a toppled broken Ionic column, suggesting that received wisdom (holding that the history of medicine began with the Greeks) had been superseded by a recognition that medicine began, not with the Greeks, but with the Egyptians. The bridge links Egypt with the Classical culture of Greece and Rome (MaCh A3/051202).*

Not unconnected with this symbolism was the Fountain of Regeneration erected on the ruins of the Bastille in Paris to designs by Jacques-Louis David (1748–1825): it was intended to astonish contemporaries, and although it no longer exists, the illustrations of it can astonish us today. It consisted of a podium on which was a stepped pedestal supporting a seated figure of Isis as a Goddess of Nature, flanked by seated lionesses, and wearing the *nemes* head-dress with a crescent-moon supporting a globe. Out of her breasts the Goddess poured the pure and health-giving 'liquor of regeneration' which flowed into a basin decorated

with outstretched wings and cornucopiæ. The attribute of the crescent-moon associates the figure with Diana and Hathor.

Although similar designs had appeared earlier (e.g. at Monceau in 1773[35] and not infrequently in designs by Hubert Robert), the Fountain of Regeneration was not intended as a reproduction of a fashionable theme: it was imbued with symbolism that conveyed the virtues of Ancient Egypt, and could have many associations, political, religious, and social. But it was, more than anything, a deliberate attempt to provide a work based on Isis and her attributes, and therefore a mnemonic of a whole religious ideology. So two exemplars, the many-breasted Diana and Isis, provided the inspiration for a simulacrum of Nature, the Mother and Nurse of All, and mysteries impenetrable to Mankind.

When the fountain was inaugurated (10 August 1793), Marie-Jean Hérault de Séchelles (1759–94) spoke:

> 'O Nature! Receive this expression of the eternal devotion
> of the French people to thy laws! And may these fruitful waters
> springing from thy breasts, this pure draught
> that quenched the thirst of the first humans,
> consecrate in this Cup of Fraternity and Equality
> the oaths that France swears to thee on this day.'[36]

Many commented favourably upon the Fountain, finding it 'true to the statues of the Egyptians' (it was nothing of the sort, for the only things that suggested Egypt were the head-dress, the crescent-moon, the *shendyt* attire, the lionesses, and the winged cornucopiæ). Jean-Georges (or Johann Georg) Wille (1715–1808) hoped that the monument would be permanent, and the figure cast in bronze, but the temporary plaster statue (treated to resemble bronze) was destroyed at the beginning of the Directory (*Directoire*) in 1795, and the Cup of Fraternity did Hérault de Séchelles little good: he was guillotined in 1794. The design survives in engravings, notably that by Isidore-Stanislaus Helman (1743–*c*.1806) after a drawing by Charles Monnet (1732–after 1808).[37]

We are beginning to understand the full impact of Ancient Egypt on the West, thanks to the immense amount of scholarly effort made over recent years.[38] Certainly the importance of Egyptomania in Neo-Classicism, in the nineteenth century, and in the early twentieth century is now recognised, but the survival of Egyptianising motifs in much so-called Modern architecture is curiously undervalued or understated, possibly because recognition would sully its supposed 'purity', and that would not do at all.

35 CARMONTELLE (1779), 9–10.
36 Translated from the *Discours Prononcé par Marie-Jean Hérault de Séchelles* (Paris: s.n., Year II [1793]), 3–4.
37 For the Fountain *see* HUMBERT, PANTAZZI, and ZIEGLER (*Eds*) (1994), 158–9.
38 *See*, for example, HUMBERT (1989a), HUMBERT, PANTAZZI, and ZIEGLER (*Eds*) (1994), and HUMBERT (*Ed.*) (1996), among many other works listed in the Select Bibliography.

Earlier, for example, as previously described, Saarinen's design (1908) for a parliament-building in Helsinki, Finland, was essentially a pyramidal composition, and also included paraphrases of Egyptianising detail.[39] And, as noted above, Peter Behrens, in several designs,[40] drew upon those long colonnades of square columns that occurred at the Mortuary Temple at Deïr-el-Bahari, and which had been admirably exploited (though Grecianised with the Thrasyllus monument) by Schinkel and Thomson. Square columns recurred in Behrens's *Werkbund* Pavilion, Bern, of 1917; in Ludwig Mies van der Rohe's (1886–1969) design for the Kröller-Müller house and gallery, Den Haag, Netherlands (1912); in Frank Lloyd Wright's work (e.g. Robie House, Chicago [1908], and Unity Temple, Oak Park, Chicago [1906]); in Otto Wagner's (1841–1918) designs for some of the *Stadtbahn* (City Railway) stations in Vienna (1894–1901); in Robert van't Hoff's (1887–1979) Huis ter Heide, Utrecht, Netherlands (1915–16); and in the long colonnade of the *Hochzeitsturm* and exhibition buildings at Mathildenhöhe, Darmstadt (1905–7), by Josef Maria Olbrich (1867–1908). There are many other examples which it would be tedious to list here, but which will be obvious to those who trouble to use their eyes and make the appropriate associations.

The Egyptian gorge-cornice made its reappearance on the *Neue Staatsgalerie*, Stuttgart (1977–84), designed by James Frazer Stirling (1926–92) and Michael Wilford (born 1938), and again at No. 1 Poultry, City of London (from 1985, completed 1997), and, as previously noted, a stumpy version of Greek Doric used by Carl August Ehrensvärd for the entrance to the dockyard at Karlskrona (1785), similar to Ehrensvärd's 'Egyptian Architecture in a Nordic Landscape' (**Plate 79**), was quoted by James Stirling Michael Wilford & Associates as the centrepiece of the circular court of the Stuttgart gallery.[41]

Such harkings-back to Ancient Egypt and primitive Greek Doric from eighteenth-century Sweden in the 1970s and 1980s would have been difficult for Modernists to accept in the 1950s and 1960s, although Berthold Lubetkin (1901–90), of Tecton, at the Highpoint II development (1936–8), at Highgate, London, had designed an entrance-canopy apparently partly supported by copies of two of the caryatids from the Erechtheion in Athens, which some saw as a 'witty' reference to Classicism, but others perceived as a vulgar manifestation of *Kitsch*, as a betrayal of the Modern Movement, or as a case of 'surrealism in architecture',[42] depending on which position seemed desirable to adopt at the time.

39 Illustrated in PEHNT (1987), 152.
40 The crematorium and exhibition-building are illustrated in PEHNT (1987), 153–4.
41 *See* JAMES STEVENS CURL (1991): 'Neue Staatsgalerie, Stuttgart, 1977–84', in COLIN NAYLOR (*Ed.*) (1991): *Contemporary Masterworks* (Chicago, IL, and London: St James Press), 475.
42 BRIDGET CHERRY and NIKOLAUS PEVSNER (1998): *London 4 North* (London: The Penguin Group), 411.

Of course International Modernism turned out to be just another style after all, and all the posturings of its adherents were gradually but reluctantly exposed. That style was supposed to be 'functional' and to be 'logical' and 'scientifically based', but its shortcomings were soon apparent, and it became clear that it was really only a style *suggesting* all those things.[43] The International Modernists and their apologists attempted to abolish 'The Styles', meaning the historical styles of architecture such as Gothic, Classicism, Baroque, and so on, and claimed they were discarding 'style'. Believing in what they fondly imagined to be 'Objectivity', they conceived of 'objective form' determined entirely by function, but this was always a myth, yet they believed their own mythology. They held that International Modernism was *not* a style, but the last development of Architecture, what everyone had been striving towards since Time began, like some Holy Grail. And if International Modernism produced ugly buildings, that was perfectly all right, because the admiration of æsthetically beautiful things was regarded as characteristic of the bourgeois æsthetic, and the aim of Modern Movement architecture was to lead to social 'progress' and the destruction of the bourgeoisie.[44] And, confronted with the design of Highpoint II, dismayed critics floundered for language to express what had actually happened: 'functional objectivity' had been abandoned and International Modernism had been exposed for what it was – just another style.[45]

Harry Stuart Goodhart-Rendel (1887–1959) held that style was the least important of all the unimportant elements of architecture. He also opined that to object unconditionally to a style is unworthy of rational criticism, for style, he said, was only a language, and can 'of itself' neither 'mar nor make' the beauty of 'what it conveys'. As a believer in rational eclecticism he held that Modernism, if regarded as a style and not a religion, *might* have possibilities, but he deplored the International Modernists' insistence on moral values, their rejection of æsthetic values, and their puritanical, prim-lipped, negative attitudes.[46] In particular, he felt that to use architecture as an instrument of moral good was both futile and ridiculous. To Goodhart-Rendel, Le Corbusier was born old-fashioned, and had the 'worst Victorian ethical view of architecture',[47] a comment from which it would be difficult to dissent.

43 For a discussion of style *see* CROOK (1987).

44 For a taste of this and other nonsense, *see The Architectural Review*, **cix**/651 (March 1951), 136, and *The Architectural Review*, **lxxi** (May 1932), 207.

45 *See* a review of Highpoint II by ANTHONY COX (1938), in *Focus*, **ii**, 79. *See also The Architectural Review*, **lxxxiv** (October 1938), 165–76.

46 GOODHART-RENDEL (1953), 17, 254–6.

47 *Architectural Association Journal*, **lii** (1937), 63, and *see Journal of the Royal Institute of British Architects*, **xxxv** (1928), 585–6.

Goodhart-Rendel was himself an architect of great originality. His own Hay's Wharf Building,[48] Tooley Street, London (1929–31), possesses traces of Egyptianisms in its *Art-Déco*-Modernist elevations. In this fine building he demonstrated his independence of mind as well as his sureness of touch, but his arguments in 1936–8 about the necessity of keeping the flag of artistic autonomy flying cut little ice, as English Modernism, infused with a strong dose of European *émigré* totalitarianism, metamorphosed into an intolerant political crusade.[49]

When, after the present Prince of Wales's 'carbuncle' speech proved to be the catalyst in scuppering the proposals by Ahrends, Burton, & Koralek (1982–6) for London's National Gallery in Trafalgar Square, a competition was held to design what became known as the Sainsbury Wing: this was won by the architectural firm headed by the proponent of 'Complexity and Contradiction'[50] in architecture, Robert Charles Venturi (born 1925). The Sainsbury Wing (completed 1991) carried on one of its elevations a partial continuation of the Classical Order of William Wilkins's original elevation facing Trafalgar Square, but, curiously, most commentators missed (or probably did not recognise) the Egyptianising quotations on other capitals elsewhere in the building. Such odd blindness (or ignorance) is difficult to excuse. Nevertheless, there in the heart of London, is a newish building by an American architectural firm, in which Egyptianising elements may be found.

In 1988 Richard Gilbert Scott, son of Sir Giles Gilbert Scott (1880–1960) and great-grandson of Sir George Gilbert Scott (1811–78), unveiled his design for the new Art Gallery beside Guildhall in the City of London. One could almost hear the sharp intakes of breath and gnashing of teeth when the former Royal Fine Art Commission and other cultural commissars saw it, for it was not recognisably 'Modern', and it did not fit easily into any acceptable category. It did have some slightly Gothic flavours in the angular tracery, and that seems to have been what horrified the official guardians of the nation's architectural conscience (although the dismal record of British architecture should not encourage any confidence in the judgement or open-mindedness of the arbiters of taste: indeed, the objections to Mr Scott's stylistic nods to Gothic could be seen as pusillanimous prejudice, worthy of contempt and of Goodhart-Rendel's strictures).

But in fact there is not much, apart from the angular tracery, that can be regarded as Gothic at all in Mr Scott's design: the dominant motif is the canted arch, used in the main front, in the 'Gothic' tracery, in the window-

48 Now (2002) St Olave's House.
49 CROOK (1987), 253–4.
50 *See* ROBERT VENTURI (1966): *Complexity and Contradiction in Architecture* (New York: Museum of Modern Art).

heads, and even in the dormers. Thus the building owes much to a theme that was primarily associated with Egyptianising architecture from the time of Piranesi. That theme was also used by Sir Owen Williams (one of the heroes of British Modernists) for the M1 Motorway bridges (1951–9), but that, presumably, is different, such are the double standards that prevail.

Scott's brilliant eclectic design was realised, and the building was opened in 2000. It was ignored by most architectural critics (whose silence proves their dismal incapacity to form fearless and independent æsthetic judgements), but is a great tribute to the Corporation of London for which it was built. The Art Gallery is a serene and dignified addition to the ancient City of London and to the architectural ensemble around Guildhall (Mr Scott also designed the seven-storey Guildhall extension to the north and west, built 1969–75, and containing the Guildhall Library).[51] It works well, *especially as architecture*, and shows that elements of the Egyptian Revival can still be relevant to architecture today.[52]

Mr Scott's work is as good a note as any on which to draw this section to a close.

Afterword

Delvers into ill-lit and fusty regions where pre-'scientific' Egyptological speculations lurk, may stumble upon doors that open and reveal enchantingly lovely Arcadian landscapes that bask in an unspoiled clarity.

Yet studies of Classical Antiquity that ignore the singular importance of Ancient Egypt are to be found in plenty. Architectural text-books that deal with the buildings of Ancient Rome and the Roman Empire in which not one word about *Isæa*, Egyptianising architecture and artefacts, or Nilotic influences can be found are ubiquitous: given our knowledge of the widespread importance of Egyptianising themes and motifs, this is nothing short of astonishing. Antiquarian controversy is often obscurantist, it is true, but a failure to acknowledge the importance of Ancient Egypt in European iconography, culture, religion, art, and architecture is indicative of blindness, intellectual dishonesty, or worse. The vigour and the importance of the Ancient Egyptian legacy has often been veiled, as though from the terrible realms of Seth, for reasons (or lack of them) that one cannot respect. The treatment of Giordano Bruno points to a truth: orthodox opinion

51 *See* SIMON BRADLEY and NIKOLAUS PEVSNER (1997): *London I The City of London* (London: Penguin Group), 298–306.

52 For an appraisal of this building, *see* GAVIN STAMP (2002): 'London's Modern Goth', in *Country Life*, **cxcvi**/47 (21 November), 58–9. Professor Stamp perhaps over-emphasises the Gothic elements at the expense of the Egyptian.

cannot admit the Ancient Egyptian influences in Western culture, either in religion or in aspects of art and architecture, despite the immense amount we now know concerning the subject.[53] Is this for *religious* or, perchance, for *racial* reasons? It could be both, but it is far more likely to be for considerations of depressing ignorance.

Eternal verity and ageless serenity are suggested by the splendours, starknesses, and apparent simplicities of those basic Ancient Egyptian artefacts and architectural forms. To the scholar today, aided by the immense amount of well-researched publications and exhumed artefacts to be found in the great Egyptological collections, an awareness of the persistence of Ancient Egyptian themes in religion, iconography, art, and architecture creates fresh and fascinating perspectives: there is a satisfying sense of continuity, for the *tabula rasa* is a patent absurdity (although contemporary schooling in Britain is doing its best to make that a reality). To consider the survival of the much-loved goddess and of so many objects, motifs, and theological nuances that were a familiar part of human experience when she was omnipotent in ancient times is sufficient to put into their place the futilities and disagreeable dissonances of the present age. There is a sense of kinship with a robust, healthy, and kindly past in harmony with the earth, the moon, the waters, and the sun that is entirely beneficent. In a Southern evening, when the air is deliciously scented with fennel and rosemary, and tranquillity fills the soul, one can understand something of equilibrium, and of the golden dawn of European civilisation. In retrospect, the Græco-Roman world seems to be held in a meridian warmth in the centuries when the Great Goddess was universally revered.

Probably no culture (even those of Central America, which, in any case, were of relatively short duration) has produced such mighty works of architecture that are so instantly memorable, so grand, so powerful, so impressive, as did Ancient Egypt. The pyramid, the obelisk, the pylon, the sphinx, the serene seated deities, and the symmetrical and Sublime temples are among the purest geometrical shapes ever created by Mankind, and are best seen within a luminously clear landscape where the colours are strong, and the light is not diffused in mist or in haze. For, after all, unwholesome veiling and tepid wind blew from the domains of the frightful Seth, destroyer of Osiris and enemy of Isis, while the clear light of the life-giving sun and the benevolent, friendly moon, the wholesome sweet waters, and the calm heavens were presided over by the Great Goddess who spread her kindly and magical influence over the lands of the Nile, and subsequently over the whole civilised Western world. Her presence has been one of the most radiant and tranquil assets of the Christian Church, although she has

53 *See* YATES (1964).

undergone some subtle (and not-so-subtle) metamorphoses, not all of them, it has to be admitted, for the better. Isis, after all, was no prude, and her enchantments, on the whole, have been benevolent and affectionate towards Mankind.

An Ancient Egyptian Trinity presided over the creation of a remarkably long-lived architectural expression that incorporated mighty, stark, clear forms. The imagination of Neo-Classicists saw their pyramids, obelisks, spheres, and cubes in the pellucid landscapes of Horatian verdure, where shapes and geometries would read, devoid of fripperies or unnecessary ornament.

At the beginning of the twenty-first century Ancient Egypt remains an inspiration, and we own a great cultural debt to that civilisation. The architectural, iconographical, thematic, and decorative manifestations of Ancient Egyptian culture are only some aspects of an influence that has penetrated deeply into the historical development of Western Europe, yet, almost unaccountably, apart from some important exhibitions,[54] hitherto has not attracted the attention and understanding it so patently merits.

54 *See* SIEVERNICH and BUDDE (*Eds*) (1989), 18–83, 384–472; and HUMBERT, PANTAZZI, and ZIEGLER (*Eds*) (1994); and HUMBERT (*Ed.*) (1996).

quid referam ut volitet crebras intacta per urbes
alba Palæstino sancta columba Syro? . . .
qualis et, arentes cum findit Sirius agros,
fertilis æstiva Nilus abundet aqua?

(why tell of white doves flying, through crowded towns,
sacrosanct in Syro–Palestine? . . .
how fertile Nile floods the summer pastures,
when Sirius cracks the thirsty fields?)

ALBIUS TIBULLUS (*c.*54–*c.*18 BC):
Elegies, Book I, Elegy 7, lines 17–18 and 21–22.

SELECT GLOSSARY

Ægyptian ingenuity was more unsatisfied, contriving their bodies in sweet consistences, to attend the return of their souls. But all was vanity, feeding the winde, and folly. The Ægyptian Mummies, which *Cambyses* or time hath spared, avarice now consumeth. Mummie is become Merchandise, *Mizraim* cures wounds, and *Pharaoh* is sold for balsams.

SIR THOMAS BROWNE (1605–82):
Hydriotaphia (1658), Ch. V.

Pyramids, Arches, Obelisks, were but the irregularities of vain-glory, and wilde enormities of ancient magnanimity.

Ibid.

This list is intended to help readers unfamiliar with deities, motifs, and artefacts associated with Ancient Egyptian or Egyptianising art and architecture, but has no pretensions to be comprehensive. Drawings are by the Author, based on many sources, including sketches by him made in various museums and collections: those sources are identified in the captions.

Aaron's rod. 1. Ornament resembling a staff with budding leaves. **2.** Ornamental rod with a serpent twined around it, not to be confused with the *caduceus* or *Wand of Hermes* (*see* **caduceus**: [**Fig. 13**]).

abacus (*pl.* **abaci**). Flat-topped plate, block, or *tailloir* on top of a *capital*, crowning the *column* and supporting the *entablature*. The Egyptian *abacus* is thick, sometimes elaborated in the form of a *naos* or shrine (*see* **capital**: [**Fig. 16**]).

acacia. Genus of leguminous shrubs or trees of the *Mimosaceæ*, especially *Mimosa Nilotica*. Egyptian deities were said to have been born under the sacred acacia near Heliopolis, and *Horus*, in one version, emerged from the acacia. It was associated with both birth and death, and found an important place in Freemasonic legend.

acroter, acroterion, acroterium (*pl.* **acroteria**). **1.** Plinth or *fastigium*, one placed over the apex and one over each extremity of a *Classical pediment*, usually carrying a statue or ornament (*see* **portico**: [**Fig. 38(a)**]). **2.** Ornament or statue with no plinth in those positions. **3.** Ridge of a Classical temple. **4.** *Horn* or *ear* of an *altar*, *sarcophagus*, or *stele*.

ædicule, ædicula (*pl.* **aedicules, aediculæ**). **1.** Shrine or *sacellum* within a temple, either a large *niche* or a *pedestal* supporting two or more columns carrying an *entablature* and *pediment*, thus forming a frame or canopied housing for a cult-statue. **2.** Architectural frame around a doorway, niche, or window-aperture, consisting of two columns or pilasters over which is an entablature with pediment, like a miniature *distyle* building: such an opening is said to be *aediculated*, and in cases in Classical *Antiquity* where it was associated with Egyptian deities, especially *Isis*, the *pediment* was often *segmental*. In Egyptian or Egyptianising design such an ædicule may be in the form of a *pylon-tower* or similar *battered* shape, and contain a statue of a deity: it may or may not have an arrangement of columns or pilasters, and is

also called a *naos* (see **naöphorus**: [**Fig. 33**], **Colour Plate VIII**, and **Plates 42, 51, 69, 74**, and **117**).

ægis. Large semicircular apron-like necklace, symbolic of protection, and of the encircling arms of a benevolent, all-powerful deity. The vulture's outstretched wings also signify divine protection (**Fig. 1**).

Fig. 1. *Bronze ægis (c. seventh to fourth centuries BC) consisting of a head of Isis crowned with* uræi *on either side of which is the falcon-head of Horus (after the example in the Petrie Collection, University College London).*

Æolic. Primitive type of Greek proto-Ionic capital, probably derived from Asiatic, Phœnician, and Egyptian designs, with *volutes* apparently growing from the *shaft* rather than arranged like a *pulvinus* on top. A *palmette* was placed between the volutes (*see* **capital**: [**Figs. 16(a)** and **(b)**]).

Æsculapius. Roman god of healing and medicine, the Greek god **Asclepius**. His attributes were a serpent and a staff, the former sometimes coiled around the latter. He was identified with *Serapis (Sarapis)-Osiris*.

Agathodaimon. Alexandrian serpent-god of fortune, very popular during the Græco-Roman period.

air. Essential for life, it was personified by *Shu*, the air-god.

Aken. Keeper of the *Underworld* ferry, who had to be awakened by *Mahaf* each time the ship was required to travel.

Aker. Earth-god in charge of the point where the east and west horizons met in the *Underworld*. He was responsible for opening the gates so that *pharaoh* could enter the Underworld, and was represented as two human heads facing away from each other, or, alternatively, as two lions seated back-to-

back. Efficacious in countering the poison of serpents and the bites of insects, he secured the coils of the dangerous snake-god *Apophis* after the last's dismemberment. During the hours of darkness the sun-god's ship travelled along a safe passage above Aker's spine, depicted as a disc carried in a stylised horizon (**Fig. 2**).

Fig. 2. Aker *as two lions back-to-back with the sun on the horizon, c.1250 BC (after an image in The British Museum).*

Amaunet. Goddess whose shadow provided divine protection. With *Mut*, a consort of *Amun*. She played a major part in rituals connected with *pharaoh's* accession and other festivals commemorating his reign. With *Min*, she has been shown leading various deities in processions connected with *pharaonic* celebrations. She has been identified with *Neith*, and one was one of the snake-headed deities of the *Ogdoad*. As one of the eight Ogdoad deities she could also be transformed into a baboon greeting the sun as it rose.

Amemet. Fire-spitting snake who destroyed the damned in the *Underworld*.

Amenhotep, **Amenhotpe**, or **Amenhetep** (*c.* 1440–*c.*1350 BC). Scribe (known as the *Son of Hapu*) who rose to pre-eminence as an overseer of the Royal Works. He appears to have been the architect of many significant buildings at Thebes and in Nubia, and so important was he that he was not only given pharaoh Amenhotep III's (reigned *c.*1391–*c.*1353 BC) eldest daughter as wife, but a mortuary-temple in Western Thebes, otherwise exclusively reserved for royalty. His reputation for wisdom and excellence in numerous fields was such that he was deified in the Ptolemaïc period (304–30 BC), and declared to be the inseparable brother of *Imhotep*. He appears to have been regarded as an important and effective intermediary through which supplications could reach the ear of *Amun*.

Am-Heh. Fierce dog of the *Underworld* who lived in a lake of fire and devoured millions of unfortunates who fell foul of the deities. Only *Amun* could control his bloodthirsty savagery.

Ammut. Frightful goddess of the *Underworld* who killed and ate all those whose lives on earth were weighed in the balance and found wanting, so she appears in scenes where hearts are weighed in the presence of *Thoth*. A composite being, her head is shown as that of a crocodile-like creature, her front legs and torso are those of a lion or leopard, and her back legs and rear end are those of a hippopotamus. Her main job was to eat the hearts of all perceived as unworthy to live in the lands ruled by *Osiris*.

amulet. Small figure of deities (especially *Bes*, *Osiris*, and *Tawaret*), worn to protect the wearer. Amulets could also be animals (e.g. ram-heads or scarab-beetles), or symbols such as the *ankh* or *djed*.

Amun or **Ammon**. Also known as *Amun-Re* of Thebes, his temples include the Great Temple of Amun at Karnak aligned along an east-west axis, and embraced the vast and impressive *hypostyle hall* with its 134 columns. He was supreme deity of the Ancient Egyptian pantheon, usually shown enthroned, and wearing a *modius* crown with two high plumes on top to indicate he was a sky-god. The god's chief consort was *Mut*, and their son was *Khons*, although he also cohabited with *Amaunet*. He was associated with the ram with curved horns (a connection often shown as a ram's head rising from a lotus-flower with a rearing *uræus* on its forehead and a sun-disc supported on the horns), and the processional ways leading to his temples were lined with *criosphinxes* (ram-headed lions), each with a miniature *pharaoh* between its paws. The imagery was derived from the ram's procreative powers, and, although Amun is often depicted anthropo-morphically, enthroned like pharaoh, he is also commonly shown as an ithyphallic figure (*Amun-Min*).

Amun was protean and rich in names, thus could elude representation. So awesome was his all-permeating nature that he could not be satisfactorily categorised or depicted. The Greeks perceived him as *Zeus*, and this association persisted during the Roman Empire. Amun as a protector of *pharaoh* was an important part of Egyptian kingship, and several monarchs took his name: *Amenhotep*, for example, suggests that Amun was content, and Queen Hatshepsut took the name *Khenemet-Amun*, which suggests she was united with Amun. As pharaoh was 'son of *Re*', Amun was perceived as the father of every pharaoh, and Amun helped pharaoh to achieve dominion. Amun was also the creator of the *Ogdoad* as a serpent-deity capable of regular renewal just as a snake discards its skin: in this form he was known as *Amun Kem-Atef*, and was the *kneph*, an immortal capable of self-regeneration in perpetuity, probably associated iconographically with the egg. Indeed, Amun can appear as the Nile Goose, or Great Honker (*Gengen Wer*), who carries the eggs that provide life. As he abided in all things, Amun was also the soul (*ba*) of all (**Fig**. 3).

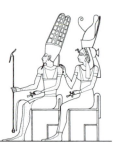

Fig. 3. Amun *is shown* (left), *enthroned, and wears a* modius *surmounted by two high plumes symbolising Upper and Lower Egypt. Mut wears the combined crowns of Upper and Lower Egypt above a vulture head-dress. Both deities hold an ankh, and Amun holds a* was *sceptre (after* SEYFFERT [1899]*).*

Anat. Ruthless Syrian warrior-goddess, mistress of the sky, who was held by the Egyptians to be, with *Astarte*, a daughter of the sun-god *Re*, and wife of *Seth*. She is usually shown with a high crown flanked with curving plumes, and armed with a shield and weapon. Sometimes her iconography is confused with that of *Hathor*, and she appears on occasion with *Min*, but she is more usually associated with *Reshef*.

Andjety. Anthropomorphic god, probably the prototype of *Osiris*, whose attributes are similar.

Anhur. *See* **Onuris**.

animals. Depictions of animals, animal-headed creatures, or composites made up of different animals have disturbed many observers. However, the Ancient Egyptians seem to have regarded animals as possessing the archetypal qualities of their deities (e.g. bull=power and regeneration; cow=mother; and ram=sexual power and fecundity), so animals were regarded as expressive of certain features of divinities. Some sacred animals could be *manifestations* of deities, representing the eternal soul (*ba*) of a god or goddess: *Amun-Re*, for example, was made manifest by the ram, *Ptah* by the Apis-Bull, and *Suchos* by the crocodile. Thus, the reverence shown to animals at certain cult-centres did not mean that the creatures themselves were worshipped: what was important was what the animals *represented*. The main cult centres were as follows:

bull: Heliopolis, Hermonthis, and Memphis;
cat: Bubastis;
cow: Aphroditopolis and Dendera;
crocodile: Crocodilopolis and Kôm Ombo;
falcon: Edfu and Philæ;
ibis: Abydos and Hermopolis;
and ram: Elephantine, Esna, Herakleopolis, and Mendes.

Certain animal-heads on otherwise anthropomorphic deities suggested the ferocity of lions (*Sakhmet*) or the association of jackals with dead bodies (*Anubis*). However, the subject is far too complex to be discussed at length here (*see* LURKER [1980], for further enlightenment).

ankh. Cross surmounted by a circlet used in *hieroglyphs*, later identified with the *nimbus* and Cross (*crux ansata*) of the Crucifixion, possibly a stylised form of some kind of magic knot (*see also* tyet). It signifies life and resurrection, and is very common in Egyptian and Egyptianising iconography as an attribute of the deities, meaning eternal life-giving powers (**Fig**. 4).

Fig. 4. Ankh *from the reverse of the medal (1826) designed by Jean-Jacques Barré (1793–1855) to commemorate the furtherance by Louis XVIII of the* Description de l'Égypte *(after the medal in the Author's Collection).*

anta (*pl.* **antæ**). Square or rectangular *pier*, formed by the thickening of the end of wall, e.g. in Greek temples, where the side walls terminate (*see* **portico**: [**Figs. 38**(a) and (**b**[**iii**])], and **choragic monument**: [**Fig. 18**]). When *porticoes* were formed by carrying the side-walls out beyond the front wall of the *naos* and placing columns in a line between the *antæ*, the columns, portico, and temple are described as *in antis* (*see* **portico**: [**Fig. 38**(**b**[**iii**])]). Greek *antæ* can have *capitals* and *bases* differing from those of the *Order* proper, unlike Roman *pilasters*, which are usually identical in detail to the columns save for having rectangular plans. Moreover, *antæ* have either very slight or no *entasis*, and therefore have parallel sides, unlike pilasters. In Egyptianising architecture, a *distyle in antis* arrangement is often found, frequently set in a *pylon*-like front, and the *antæ* may be omitted, leaving plain walls (*see* **Plates 5**, **30**, and **192**).

antefix, antefixum (*pl.* **antefixes, antefixa**). Decorative termination of the covering-tiles over the joints of roof-tiles placed on the eaves-tiles or on top of the *cyma* of the *cornice*, and sometimes on the *ridge-crest* of a Greek temple (*see* **portico**: [**Fig. 38**(a)]). It was usually embellished with the *anthemion* motif, but in *Classical* buildings devoted to Egyptian deities, *antefixa* have been found decorated with *uræi* and lotuses (*see* **Plate 20**). *Antefixa* do not occur in Ancient Egyptian architecture (**Fig. 5** and *see also* **portico**: [**Fig. 38**(a)]).

Fig. 5. *Greek antefix:* antefixa *were not used by the Ancient Egyptians, but the Romans used Egyptianising* antefixa *in some of their Isiac buildings (after examples from the Parthenon in Athens).*

antelope. Animal form of the goddess *Satis*, provider of water.

anthemion (*pl.* **anthemia**). Decorative group of leafy forms resembling a radiating cluster on the same plant, and sometime called *honeysuckle*: it occurs in *Classical* architecture above *acroteria*, on *antefixa*, on *cornices*, and elsewhere, often used alternately with the *palmette* or *lotus* as horizontal embellishments on *friezes*. It is similar to certain elements in Egyptian design (**Fig. 6**).

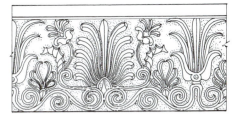

Fig. 6. *Greek* anthemion *alternating with* palmette *on a frieze, with scrolls and other ornament (after an example from the north doorway of the Erechtheion, Athens, and SPIERS [1893]).*

Anti. Hawk-deity often shown on a crescent-shaped ship, supervisor of the ship of *Sokar*. He decapitated the goddess *Hathor*, after which *Re* and the *Ennead* had his skin and flesh removed from his body, and *Thoth* restored the head of the cow-goddess. The flayed skin or part of a carcass on a pole is the *imyut* symbol. Anti's skin was preserved with the milk of the cow-goddess *Hesat*.

Antinoüs (*c.*110–130). Companion of Publius Aelius Hadrianus, Emperor Hadrian (reigned AD 117–38). He drowned in the Nile, claimed by some to have been an act of self-worship (and therefore connected with the legend of *Narcissus*), suicide, or ritual sacrifice. He was mourned extravagantly by Hadrian, who founded the city of Antinoöpolis in his memory. Elevated to the status of a god, cults, festivals, and statues of Antinoüs proliferated in his honour. Statues depict him as a handsome youth, sculpted in the manner of Greek work of the fifth century BC, identified sometimes with *Dionysus*. His most celebrated statue

(discovered in 1740 at the *Villa Adriana* at Tivoli) shows him in an Egyptianising guise, with *nemes* head-dress, *shendyt* kilt-like garment, left foot placed before right, and arms held straight and rigidly with clenched fists at his sides (the *pharaonic* stance), although even in his Egyptian form Antinoüs keeps his Polycleitean features. Figures of Antinoüs occur as cult-statues, as *telamones*, and recur in *Renaissance* and *Neo-Classical* designs (**Figs. 7[a]** and **7[b]**: and *see also* **Colour Plates VIII** and **X** and **Plates 27, 28, 29, 43, 44, 45, 51** [lower], **66, 68, 69, 71, 73, 74, 75, 82, 99, 110,** and **117**).

Fig. 7.
(**a**) *Antinoüs in marble relief, showing the youth in Græco-Roman guise (after* SEYFFERT [1899])

(a)

(**b**) *Egyptianising statue of Antinoüs with* nemes *head-dress and* shendyt *kilt, the figure in* pharaonic *stance, left foot before right, and arms held rigidly at the sides (after the celebrated statue from the* Villa Adriana, *Tivoli, discovered in 1740 and restored, now in the* Museo. Greg. Egizio, Rome, 99).

(b)

Antique. Used in the architectural sense to denote work of Græco-Roman *Antiquity*.

Antiquity. Ancient times, especially the period when the *Classical* civilisations of Greece and Rome were in the ascendant.

antis. *See* **anta** and **portico**.

Anubis. Egyptian deity with the head of a dog, dog-ape, or jackal, identified with *Hermes/Mercury*. As lord of the sacred lands he was the god of cemeteries and embalming, having invented the embalmer's craft, and watched over the dead. He was supposed to have been the son of *Re* and *Nephthys*, but in

another version he was the offspring of Nephthys by an adulterous (and incestuous) union with *Osiris*. Other candidates for his mother are the cow-goddess *Hesat*, the cat-goddess *Bastet*, and even the Great Goddess *Isis* herself.

He is commonly shown as a black crouching desert-dog, with sharply pricked ears and long hanging tail (**Fig. 8[a]**), but is also found as a dog- or jackal-headed black human male, ears pricked (*see* **Colour Plate VII**): in one hand he carries the *ankh*, and in the other the *was* sceptre of stability (**Fig. 8[b]**). The black colour alludes to the change of colour of dead bodies after their mummification. In his canine form his alert, crouching body is on top of the chest containing the viscera in their jars protected by the *Sons of Horus*, and these, in turn, were further protected by the tutelary goddesses, but Anubis guarded them all as, literally, top dog.

Anubis was of immense importance as the overseer of embalming, of purification of dead bodies, and of anointing of mummies. He ensured that incense was burned and that the bodies (now no longer offensive) were wrapped in linen made under the ægis of the goddess *Tayet*. Instructed by *Re*, Anubis perfected the technique of pressing strips of linen to the faces of bodies, and to bind the heads to prevent decomposition and the obliteration of facial features. Anubis's emblem closely connected with his work as an embalmer was the animal skin fixed to a pole, the *imyut*, derived from the legend of *Anti*.

This powerful deity was also closely involved, with *Thoth*, in the weighing of hearts in the Hall of Judgement and guided the dead who passed the test to the presence of Osiris the Invincible, the Resurrected, the All-Wise. By the Græco-Roman period Anubis had graduated as a cosmic deity, with powers over the heavens and the earth. He brought light to mankind, was a powerful prætorian guard of Osiris, transformed the lower part of his body into the form of a serpent, and ran a useful sideline as a producer of love-potions. All in all, he had impressive attainments.

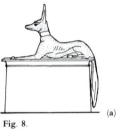

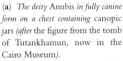

(a)

(b)

Fig. 8.
(a) *The deity* Anubis *in fully canine form on a chest containing* canopic jars *(after the figure from the tomb of Tutankhamun, now in the Cairo Museum).*
(b) *Anthropomorphic* Anubis *holding the* was *sceptre and ankh (after several sources).*

Anukis or **Anqet**, or **Anuket**, or **Anket**. Goddess of the cataracts of the lower Nile, called 'daughter of *Re*' and 'divine child' of *Khnum* and *Satis*, but has also been identified as a *consort* of Khnum and *mother* of Satis. She is usually shown with *modius* head-dress at the front of which is a rearing *uræus* and on top of which is an impressive superstructure of ostrich-feathers. She is sometimes identified with *Hathor*, and assisted *Khnum* in the supervision of the cataract region.

ape. *See* **baboon**.

Apedemak. Anthropomorphic lion-headed god of war, usually holding a sceptre topped by a seated lion. He may have been associated with *Tefnut*.

Apis. Immensely important bull-deity, son, soul, and herald of *Ptah*, closely associated with *pharaoh* as god-king. The Apis-Bull, 'son of *Isis*', was entirely black save for a white triangle on his forehead, and between his horns rose the *uræus* behind which (framed by the horns) was the sun-disc. Over his powerful shoulders and haunches were the wings of the vulture-goddess, and his tail was dressed in two strands, indicating Upper and Lower Egypt (**Fig. 9**). Some idea of the significance of the cult of Apis may be gained from the huge underground necropolis, the place of entombment of mummified Apis-Bulls at Saqqara, the cemetery of Memphis,

re-discovered by Auguste Mariette (1821–81) in 1851. On his death, Apis became *Osiris*, and thus *Osiris-Apis* became the Græco-Roman *Osorapis* or *Serapis/Sarapis* (*see* **Serapis**: **Fig. 47**) widely venerated during the Roman Empire, and closely associated with the hugely important Egyptian cult of *Isis*. The Isæum – tomb of the cow-mother of Apis-Bulls – was discovered as late as 1970. The sacred Egyptian bull, identified not only with Osiris and Serapis, but with *Jupiter* too, recurred in *Classical, Renaissance*, and *Neo-Classical* art (*see* **Plates 39, 62[b], 70, 71, 108**, and **129**).

Fig. 9. Apis-Bull (*c. 600 BC*) *with, on his forehead (note the white triangle) a rearing* uræus *and a sun-disc, and over his shoulders and rear-quarters the wings of the vulture-goddess* Nekhbet *(after an original in The British Museum).*

Apophis. Snake-god of the *Underworld*, enemy of the sun-god *Re*. He was eternally hostile, symbolising the forces of chaos. His gigantic coiled body suggested a vast void, and those swallowed by him entered a state of non-existence which was hugely feared by Ancient Egyptians. He was identified with *Seth*, and attacked the vessel (*solar barque*) carrying the sun every morning.

architrave. **1**. Lowest part of an *entablature* resting on the *abaci* of columns, so it is essentially a *lintel* (*see* **capital**: [**Fig. 16(g[iii])**]). **2**. Mouldings surrounding a window, door, panel, or niche (*see* **Vitruvian opening**: [**Fig. 53**]).

arcosolium (*pl.* **arcosolia**). Arched recess or sepulchral *loculus* in a *tomb* or *catacomb*.

Arensnuphis. Anthropomorphic god with plumed crown, who emerged during the Græco-Roman period. He had a small temple at Philæ dating from the end of the third century BC, and was venerated there as a companion of *Isis*. He occurs on the walls of the temple from Dendur (now in New

York), where, with *Peteese* and *Pihor*, he receives the veneration of Emperor Augustus.

Arsaphes. Fertility god, called *Herishef*, who appeared as a *ram*. He was identified with *Re*, *Osiris*, and *Hercules*.

Art-Déco. Fashionable style of European and American design and interior decoration (also known as the *Style Moderne*) that superseded *Art Nouveau* in the period immediately before and after the 1914–18 war. In the 1920s and 1930s it evolved further, taking its name from the *Exposition des Arts Décoratifs et Industriels Modernes* in Paris in 1924–5. It is characterised by rectilinear and stepped forms, the *chevron*, and bright primary colours: it was strongly influenced by Ancient Egyptian design, but more especially by the *Piranesian* and post-Piranesian *interpretation* of Egyptian forms, prompted by the discovery of *Tutankhamun's* tomb in 1922. It exploited the stepped corbel, the stepped gable, and the canted 'arch' (*see* **Plates 212** and **217**).

Artemis. Twin sister of *Apollo*, and daughter of *Zeus* and *Leto*, she is also called *Diana*. She is the goddess of light by night, identified with all possible goddesses of the moon and night. She was a huntress, so her attributes are the *bow*, *horns* of animals, and the *crescent-moon*. Cult-statues of *Artemis of Ephesus* feature horned animals in the wrappings of her body, a *nimbus* around the head, and necklaces comprised of eggs or the testicles of sacrificed animals (formerly thought to be breasts [*multimammiam*]): they were important motifs in *Antique* and *Neo-Classical* art, and are especially associated with the *Egyptian Revival* from the time of *Piranesi*. Artemis of Ephesus was identified with *Isis* (*see* **Plates 9, 47, 61, 66**).

Asclepius. The god of medicine (also called *Æsculapius*) in the Græco-Roman world, who could resurrect the dead, and is associated with fountains and springs. His attribute is a staff, with serpents coiled round it, as a symbol of rejuvenation, healing, prophecy, and wisdom. He is identified with *Horus*, and with *Osiris/Serapis* (*see* **Isis**).

Ash. Anthropomorphic god of the Sahara, controller and protector of oases, who could also be hawk-headed, and was sometimes identified with *Seth*.

ass. Ass-headed creatures guarded the gates of the *Underworld*. Associated with *Seth*, and scapegoat for Seth's crimes.

assessors. The 42 deities forming the jury to assess the lives of new arrivals in the *Underworld*. Those unworthy, having had their hearts weighed, were passed to *Ammut* to be devoured.

Astarte. Canaanite warrior-goddess identified with the Mesopotamian *Ishtar* and the Egyptian *Anat*, so daughter of *Re* (or *Ptah*) and wife of *Seth*. She sometimes wore bulls' horns to signify her aggression and dominating character, and was associated with horses and chariots. She was also known as *Ashtoreth*, and may have had a sexual relationship with the sea-god *Yamm*.

astreated. Embellished with stars or star-like ornament. Particularly associated with *Piranesi* and *Neo-Classicism*.

atef. Tall white head-dress, starting as a cone, but curved with upward diminution, with a bulbous top: it usually had plumes fixed on either side, and was associated especially with *Osiris* and the crown of Upper Egypt (*see* **crown**: [**Fig. 19(e)**]).

Aten. 1. Sun-god, identified with *Re*. His iconography consists of a disc with the *uræus* rearing forth from its lowest arc, and rays radiating from the disc. For a few decades Aten was elevated to supremacy in the fourteenth century BC during the reign of Pharaoh Akhenaten. 2. Sun-disc.

Atum. Sun-god of Heliopolis, creator of the universe. He is depicted as a bearded man wearing the crowns of Upper and Lower Egypt. His semen fathered *Shu* and *Tefnut*, so he was 'bull of the *Ennead*', by copulating with himself. He was powerful as a

vanquisher of hostile elements, and overcame both *Nehebu-Kau* and *Apophis*, the dangerous and destructive serpents. He was a protector of the dead on their travels through the *Underworld*. He was identified with the *scarab* because he procreated alone.

ba. Eternal soul, or manifestation of a deity, eg. the *Apis-bull* as a *ba* of *Osiris*.

Ba-Pef. Obscure deity associated with grief and pain.

Baal. Syrian sky-god, usually shown wearing a tall horned head-dress, carrying a huge thunderbolt in one hand and a weapon in the other. He was identified with *Seth* and with the *warrior-pharaoh*, so enjoyed a cult-following at Memphis. He conquered *Yamm*, the sea-god, but was later killed and entered into the *Underworld*. Like *Osiris*, he was restored to life by his sister-consort, in this case *Anat*.

Baalat. Canaanite goddess identified with *Hathor* who was a female version of *Baal* and who guarded the trade in cedar-wood from Lebanon.

Babi. Ferocious baboon-god who controlled the darkness, and whose *phallus* was the bolt on the doors of heaven. The ferry-boat of the *Underworld* had Babi's phallus as its mast, so his strength could hardly be doubted. His favourite dish was human entrails, so he could be particularly dangerous during the *weighing of hearts* ritual. He was identified with *Seth*.

baboon. Very early in Egyptian theology there was a baboon-god called *Hedj-war*, a prototype of *Thoth*, patron of scribes and inventor of hieroglyphs. A moon-deity, Thoth as baboon often carries the moon-disc on his head. Baboons greeted the rising sun with much noise, and so were depicted in Ancient Egyptian art as greeting the sun with raised paws.

Banebdjedet. Ram-god (actually a billy-goat), identified with *Khnum*, who was involved in the legal wranglings concerning the quarrel between *Horus* and *Seth*. *Atum*

called him in to help, and *Banebdjedet*, accompanied by *Tatenen*, argued that *Neith's* counsel should be sought. Neith advised the award to Horus, but Banebdjedet clearly favoured Seth for reasons of primogeniture. This ram-god had as his consort the fish-goddess *Hatmehyt*, and he was also claimed as sire of *Harpocrates* (the concept of the god-child symbolising the union of two temple deities). He was a symbol of fecundity, venerated by women desiring to bear children.

barque. **1**. A small sailing-ship. It is often shown carried aloft, especially as the *solar barque* (see **solar barque**: [**Fig. 49**]), with a *naos* containing an image of the deity in the centre of the craft (see **Re**: [**Fig. 41**]). **2**. A kind of stretcher or palanquin resembling a Nilotic boat carried in religious processions on the shoulders of priests, and containing the *naos* within which was the image of the deity, but invisible to onlookers.

Bastet. Cat-goddess, daughter of the sun-god *Re*, whose cult-centre was at Bubastis in the north-east Delta. Like the lioness-headed goddess she could be ferocious, but on occasion could be stroked. Large cemeteries for cats at Bubastis and elsewhere, in which the goddess's sacred creatures were entombed, attest to the importance of her cult. She was associated with *Artemis*, *Tefnut*, and *Sakhmet* (**Fig. 10**).

Fig. 10. *The cat-goddess Bastet holding a hooped* sistrum *in her right hand and her protective* ægis *in her left. She has four kittens at her feet (adapted from an image in The British Museum).*

Bat. Cow-goddess of Upper Egypt, commonly found in jewellery: she had a human head with cows' horns and ears, and was identified with *Hathor*.

batter. Inclined plane. A wall that is sloping, thicker at the bottom than at the top, with a face that inclines or rakes, is said to be battered, as on a *pylon*-tower (*see* **pylon**: [**Fig. 40**]).

bee. When *Re* wept his tears became bees, symbols of Lower Egypt. Honey was an important ingredient in the making of *ointments*, perfumes, and agreeable unguents, so was significant in Ancient Egyptian ritual. A *bee* is sometimes represented with a *sedge* plant (symbol of Upper Egypt) to signify royal domain over the two lands (**Fig. 11**).

Fig. 11. *Sedge (Upper Egypt) and bee (Lower Egypt) (after the carvings on the temple of Amun at Karnak).*

bell. Bell-shaped *capital* of an Ancient Egyptian *column*, like an inverted bell (*see* **capital**: [**Fig. 16(c)**]).

benben. Early form of *obelisk*, associated with *Amun*.

Benu or **Bennu**. Heron wearing a crown flanked by plumes, sacred to the sun-god of Heliopolis. Benu may have been one of the forms adopted by *Atum*, and was a symbol of rebirth, and so identified with the *phoenix*.

Bes. Visually unattractive but benign Egyptian dwarf-deity, more or less linked to the *Apis* cult. Misshapen and crouching, he was often shown with hands on knees, with a grotesque, bearded, leering face. He was frequently depicted with a lion's mane and ears, wearing a plumed crown, and his tongue was shown protruding. Bes was the patron of matrimony (with *Taweret*) and of childbirth, and during the Roman period his statuettes

show him as a legionary. He was associated with the *sa* sign of protection (*see* **sa**: [**Fig. 44**]). He protected against snakes and scorpions, and was rather jolly, given to music-making and merriment, so was extremely popular (**Fig. 12**).

Fig. 12. *Roman Egyptianising version of* Bes *(after the marble statue in* Museo Greg. Egizio, *Rome, 48).*

black. Associated with the *Underworld*, dead bodies, and embalming, it was applied to images of (in particular) *Anubis*.

blood. As with many civilisations, blood was associated with creative powers, so *Hu* and *Sia* grew from the blood of *Re*, and cedar-trees sprouted from the blood of *Geb*.

Boaz. Column on the right hand of the *Temple of Solomon* in Jerusalem as one approached the portal. It signifies *strength*, the *First Degree* of Apprentice, and the *Senior Warden* of a *Freemasonic Lodge*. It is associated with the *Doric Order* (*see* CURL [2002*b*]). Boaz, being stability and strength, is therefore identified with the *djed* column of Ancient Egypt, an attribute of *Osiris* and of *Ptah*.

Book of the Dead. Funerary text aimed to aid the dead in the passage through the *Underworld*. It was commonly illustrated with scenes showing the Opening of the Mouth and the Weighing of the Heart in the Hall of Judgement presided upon by *Osiris*.

bow. Attribute of War and the Hunt, and especially of *Artemis-Diana* and *Neith*.

Buchis. Sacred bull, an incarnation of *Re* and *Osiris*. Like the *Apis-Bull*, he was entombed in great splendour. The *Bucheum*, a huge underground catacomb at Hermonthis, was rediscovered in 1927.

bud. Capital in the form of a bud. *Lotus* and *papyrus* buds are common features of Ancient Egyptian decorative schemes (*see* **capital**: [**Fig. 16(d)**]).

bull. *See* **Apis**. As *Great Inseminator*, the bull was associated with the creation of life. Even inundation of the Nile Valley could be seen as the result of intervention of a bull.

caduceus (*pl.* **caducei**). Winged *baton* with *serpents* wrapped round it: it is an attribute of *Hermes/Mercury* (so called Wand of Hermes) and sometimes of *Asclepius/Horus/Harpocrates* (*compare* **Aaron's rod**). It is commonly found in *Neo-Classical* designs, with Egyptianising and *Græco-Roman* ornament (**Fig. 13**).

Fig. 13. *Neo-Classical* caduceus *(after an English early nineteenth-century carving).*

canephora (*pl.* **canephoræ**). Female figure with a basket on her head, used in Greek architecture instead of a *column*, or as a free-standing statue, not to be confused with *Caryatid(e)s, Atlantes*, or *Telamones*.

canopic jar. Bulbous container (properly called *visceral jar*) to hold the internal organs of the dead after disembowelling during mummification, with the lid in the form of a head. There were four such jars, each with a different head, representing the *Sons of Horus* responsible for protecting the preserved internal organs of the deceased. The humanoid head represented *Imsety*, and it was the lid of the jar containing the liver. The intestines had a hawk-headed jar (*Qebehsenuef*), the lungs a baboon-headed jar (*Hapy*), and the stomach a jackal-headed jar (*Duamutef*) (**Fig. 14[a]**). The form with humanoid head was favoured as an ornament

in *Antiquity* and during the *Neo-Classical* period, and was called *Osiris Canopus* (**Fig. 14[b]**).

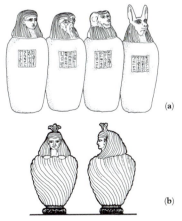

(a)

(b)

Fig. 14.
(a) Canopic jars, *properly called* visceral jars, *they have the heads of the* Sons of Horus *as stoppers. These are (*left to right*)* Imsety *(liver),* Qebehsenuef *(intestines),* Hapy *(lungs), and* Duamutef *(stomach) (after examples in the City Museum, Bristol, and The British Museum).*
(b) *Decorative* canopic *ornament. The head, with lotus-bud, is Antique, and the rest is heavily restored strigillated work (after the original from the* Villa Adriana, *Tivoli, probably the* Canopus, *and now in the* Museo. Greg. Egizio, *Rome, 125).*

Canopus. Alexandrian town in Egypt, the model for Hadrian's celebrated *Canopus* at Tivoli (*Tibur*) near Rome (**Plate 26**), completed AD 134–8. The latter was intended to evoke profane and sacred Egypt, and it was laid out around a canal (a *Euripus*) to suggest a Nilotic landscape, complete with sculptured animals and figures (**Fig. 15**). Along the banks of the canal were many Egyptian and Egyptianising statues (including *Antinoüs*, the Antinoüs-*telamones*, the *Apis-Bull, Isis, Min, Osiris, Ptah, pharaohs*, a *queen, naöphori, priests, offertory statues, baboons, crocodiles, falcons, sphinxes, canopic jars, vases*, sundry *reliefs*, and an *elephant*), whilst at one end of the canal was a *Serapæum* (for the worship of *Serapis/Osiris*) in the form of a semi-circular Sanctuary. Tivoli ceased to be an imperial residence in 222, was abandoned, became a fort in 534, and, after the Barbarian invasions, was forgotten, until the Antinoüs *telamones* were rediscovered in the middle of the fifteenth century.

Thereafter, a huge range of Egyptian and Egyptianising pieces was discovered, notably the celebrated Antinoüs in 1740 (*see* ROULLET [1972] and other sources mentioned in the Select Bibliography).

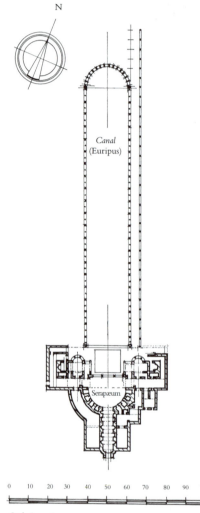

N

Canal (Euripus)

Serapæum

0 10 20 30 40 50 60 70 80 90 100

Scale in metres

Fig. 15. *Plan of the* Canopus *at the* Villa Adriana, *Tivoli (after various sources).*

cant. The cutting-off of the angle of a square. A *canted arch* derives from *Piranesian* designs, and was thought to be Egyptian. It is a variant on the *corbelled pseudo-arch* (*see* **Plates 109, 138, 143, 212,** and **218**).

capital. *Chapiter*, head, or topmost member of a *colonnette, column, pier, pilaster,* etc., defined by distinct architectural treatment, and often ornamented. Types of capital relevant to this study include:

Æolic: unsatisfactory term for a primitive type of proto-Ionic (**Figs. 16[a]** and **16[b]**);

bell: inverted bell-like form in Ancient Egyptian architecture (**Fig. 16[c]**);

bud: Ancient Egyptian type in the form of a *lotus-bud* (**Fig. 16[d]**);

Hathor-headed: Ancient Egyptian type carved on each face with an image of the goddess Hathor, and having a large box-like *abacus*, also carved with a variety of images. A good example of the Hathor-headed capital occurred at the temple of Hathor, Dendera (110 BC-AD 68) (**Fig. 16[e]**), and another example, where the Hathor-heads occur on the *abacus* rather than on the capital itself, occurred at the Ptolemaïc temple of Isis, Philæ (**Fig. 16[f]**);

lotus: Ancient Egyptian type in the form of a lotus-bud (**Fig. 16[d]**) or decorated with lotus-flowers;

palm: Ancient Egyptian type resembling the top of a palm-tree (i.e. *palmiform*), surrounded by closely spaced vertical palm-fronds and leaves (**Fig. 16[g(i)]**), the column-shaft frequently having vertical bands or large convex reed-forms to accentuate verticality and suggest bundles of palm-fronds tied together. A variant is the *Greek Corinthian* capital from the Tower of the Winds, Athens (*c*.50 BC), with one row of acanthus-leaves and an upper row of palm-leaves under a square abacus (**Fig. 16[g(ii)]**). Palm-forms also occur on the elegant Greek Corinthian capital of the Choragic Monument of Lysicrates (334 BC) in Athens (**Fig. 16[g(iii)]**);

papyrus: Ancient Egyptian type, the lower part of which is similar to that of a bell-capital, and the upper part is composed of a series of upward-pointing trumpets, the whole decorated with papyrus-buds and plants (**Fig. 16[h]**);

volute: Ancient Egyptian type formed of lotus-flowers and volutes, possibly a precedent for the *Classical Corinthian* capital (**Fig. 16[i]**).

Fig. 16. *Capitals:*

(**a**) *primitive type of proto-Ionic capital (the so-called Æolic type) from Larissa in Æolis, with volutes seeming to grow from the shaft. Some of the volute motifs seem to resemble stylised Egyptian representations of the lotus, but the exemplar is archaic Greek (after an example in the Istanbul Museum);*

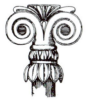

(**b**) *proto-Ionic capital from Neandria, with fan-like palmette motif between the volutes (which again spring from the shaft, unlike the developed Greek Ionic Order). These so-called Æolic (archaic Greek) capitals may be a prototype of the Greek Ionic Order, but their ancestors are clearly Asiatic, Phœnician, and Egyptian types. The palmette pattern was borrowed by Minoan Cretans from Egypt, and Greeks of the seventh and sixth centuries BC appear also to have derived it afresh from Egyptian sources. Many designs found in Cyprus and elsewhere feature paintings of capitals of the 'Æolic' type, with marked Egyptian influence (after an example in the Istanbul Museum);*

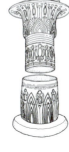

(**c**) bell: *Ancient Egyptian bell-capital from Thebes, showing lotus-flowers and papyrus-stalks and -buds combined, whilst the bell-shape of the whole capital resembles a stylised papyrus plant (after various sources);*

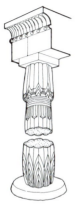

(**d**) bud: *Ancient Egyptian Order, showing a column carved with convex reed-forms to suggest plant growth (note the lotus-leaves at the base), with bud-capital, derived from the lotus-bud, and plain abacus carrying an entablature at the top of which is an Egyptian cavetto or gorge-cornice with a continuous row of vertical leaves or rearing uræi over a torus or roll (after various sources);*

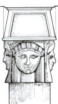

(**e**) Hathor-headed: *Egyptian capital based on an example from the Ptolemaïc temple of Hathor at Dendera. Note that the enlarged abacus represents a battered-sided building, the 'birth-house' of the deity (after ROSENGARTEN [1893]).*

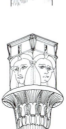

(**f**) Hathor-headed: *Egyptian bell-capital from the Ptolemaïc temple of Isis at Philæ decorated with stylised lotus and papyrus, over which is a shrine-like abacus decorated with Hathor-heads (after various sources);*

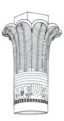

(**g[i]**) *Egyptian palm-capital from the Ptolemaïc temple of Horus, Edfu (after various sources);*

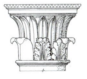

(**g[ii]**) *Greek 'Corinthian' palm-capital from the Tower of the Winds, Athens (c. 50 BC), with a row of acanthus-leaves and an upper row of palm-leaves. It was a type widely used in the eighteenth century (after CURL [1999, 2000]);*

(**h**) papyrus: *Egyptian papyrus-capital from Philæ (after LEPSIUS [1849–9]);*

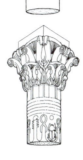

(**i**) volute: *Egyptian volute-capital from Philæ, similar in form to Greek and Roman Corinthian capitals, but unmistakably Egyptian (after LEPSIUS [1849–59]).*

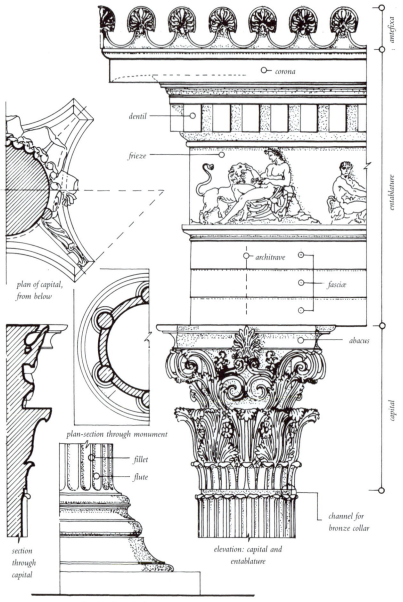

antefixa

corona

dentil

frieze

entablature

architrave

fasciæ

*plan of capital,
from below*

abacus

capital

plan-section through monument

fillet

flute

*channel for
bronze collar*

*section
through
capital*

*elevation: capital and
entablature*

elevation: base of column

Fig. 16(g[iii]). *Greek Corinthian Order from the choragic monument of Lysicrates at Athens (334 BC), with unusual flutings terminating in leaves, and suggesting the* uræus *frieze of upright cobra-heads facing outwards. The foliage above consists of 16 small lotus-leaves over which is a single row of acanthus-leaves between which are eight-petalled flowers like the Egyptian lotus. Palmettes were placed at the centre of each concave side of the abacus. The channel between the top of the flutes and the capital was filled with a bronze ring (after* CURL *[1999, 2000]).*

cartouche. Rectangular frame with curved ends enclosing the hieroglyphs signifying the *prenomen* (Throne name) and *nomen* (birth name) of *pharaoh* (**Fig. 17**). This rope-like frame may allude to power or eternity.

(a)

(b)

(c)

(d)

Fig. 17. *Four cartouches showing the hieroglyphic equivalent of four names:* (from top to bottom):
(a) *PTOLMYS;*
(b) *KLEOPATRA;*
(c) *TIBERIUS;*
(d) *TRAJAN.*

caryatid(e) (*pl.* **caryatid(e)s**). Carved, draped, straight, standing female figure (*cora*), supporting on its head an *astragal* (enriched with *bead-and-reel*), *ovolo* (enriched with *egg-and-dart*), and square *abacus*, used as a substitute in Greek architecture for a column, and supporting an *entablature*. A female figure used instead of a column with a basket on her head is called a *canephora*. A straight male figure used instead of a column is a *telamon*.

cat. Sacred animal, enemy of *Apophis*. The male was associated with *Re* and the female with the solar eye and scarab. Huge cemeteries for cats were established near Bubastis. *See* **Bastet**.

catacomb. **1**. Single, subterranean crypt, gallery or passage, lined with regular recesses (*loculi*) or arched niches (*arcosolia*) for the entombment of corpses. **2**. the plural, *catacombs*, is the term for a large subterranean public cemetery of great size, labyrinthine, and on many levels.

cavern deity. God or goddess of which there were at least a dozen, dwelling in caves in the *Underworld*, who ensured the extermination of the enemies of *Re*. They included *Ammut*.

cavetto (*pl.* **cavetti**). Hollow moulding with its profile a quadrant of a circle, mainly used on *cornices*. It is also called a *gorge*, *hollow*, *chamfer*, *throat*, or *trochilus*. A *cavetto cornice* is the characteristic *Egyptian gorge* or cornice of most Ancient Egyptian buildings, sometimes plain and sometimes decorated with vertical leaves. It usually has a *torus* moulding below it (**Colour Plates XI, XVIII, XX, XXIV, XXV, XXVIII, XXXII, XXXV, XXXVI, XXXVII, XXXVIII, XXXIX**, and **XL**, and **Plates 5, 25, 30, 54, 84, 97, 98, 110, 111, 117, 118, 119, 120, 121, 127, 128, 140, 146, 149, 150, 151, 154, 155, 156, 157, 159, 160, 162, 168, 169, 175, 176, 177, 179, 180, 182, 183, 185, 188, 190, 192, 193, 209, 210, 211, 213**, and **214**). (*See also* **Egyptian gorge**: [**Fig. 22**] and **pylon** [**Fig. 40**]).

centipede. The god *Sepa* of Heliopolis was invoked as a protector against enemies. A mortuary deity, he was associated with *Osiris* and *necropoleis*.

cherub. Winged male child, also called a *Cupid*, *Love*, or *Amorino*, not to be confused with the unwinged *putto*.

choragic monument. Commemorative structure in Ancient Greece erected by the winner of a competition featuring choral dances in Dionysiac festivals. The monuments, of which the most celebrated were those of Lysicrates (*see* **capital**: [**Fig. 16(g[iii])**]) and Thrasyllus (**Fig. 18**) in Athens, supported the bronze tripod given as a prize. The choragic monument of Thrasyllus had two *antæ*, between which was a single column, square on plan. The *tænia* above the plain architrave had a continuous row of *guttæ* beneath, and the *frieze* had no *triglyphs*, but was adorned with wreaths (*see* STUART and REVETT [1789], **ii**, Ch. IV, Pl. 3).

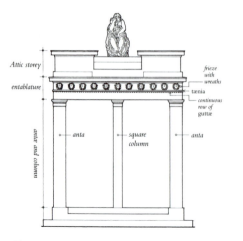

Fig. 18. *The choragic monument of Thrasyllus, Athens (319–279 BC) was an influential motif in Neo-Classicism, and, with its details applied to continuous rows of square columns (themselves inspired by buildings such as the mortuary-temple of Queen Hatshepsut at Deïr-el-Bahari and smaller temples such as that at Elephantine), was used by several architects (e.g. Karl Friedrich Schinkel [1781–1841] at the Berlin Schauspielhaus [Playhouse – 1818–21], and Alexander 'Greek' Thomson [1817–75] at Moray Place [see Plate 200], Strathbungo, Glasgow [1857–9]), and is a good example of the synthesis of Greek and Egyptian elements in architectural design. Schinkel quoted the whole Thrasyllus monument at the main entrance of Charlottenhof, Potsdam (1826–7), and the continuous row of guttæ at the Neue Wache (New Guard House), Unter den Linden, Berlin (1816–18). This version of the monument is the Bazouin mausoleum, Père-Lachaise cemetery, Paris* (drawing based on studies by the Author, and on Plate 11 of NORMAND [1832]).

colonnade. Series of columns in a straight line carrying an *entablature*. If four in a row, the range is called *tetrastyle*; if six, *hexastyle*; if eight, *octastyle*; if ten, *decastyle*, etc. When a colonnade stands before a building, supports a roof, and serves as a porch, it is called a *portico*, and if it surrounds a building or garden, it is a *peristyle*. An arrangement of two columns between *antæ* is called *distyle in antis* and a portico of four columns standing in front of the antæ is *prostyle tetrastyle*, so *prostyle* means with columns standing in front of a building forming a portico (*see* **portico**: [**Figs**. **38(a)**, **38(b)** and **38(c)**]).

colour. Very important to the Egyptians, colour had associations as follows:

blue:	the heavens, infinity, and eternity;
black:	death, the *Underworld*, and rebirth;
green:	goodness, life, resurrection, the place of the Blessed;
red:	life, Lower Egypt, danger, anger, victory, aggression, fire, blood, damnation. *Seth* was supposed to have red eyes and red hair;
red and white:	opposites (as in the crowns of Lower and Upper Egypt), but together expressive of wholeness. Red hippopotami were male and hostile, and white hippopotami were female and sacred;
russet-red:	men
white:	earthly power, purity, sanctity, Upper Egypt, joy
yellow:	women.

columbarium (*pl.* **columbaria**). *Dovecote*, or a building with niches on the inside of the walls, such as a structure to store urns or ash-chests.

column. Upright, detached, structural member in compression, usually circular on plan, but also polygonal or square, supporting a *lintel* or an *entablature*. Egyptian columns usually sat on bases, and bulged outwards above the base before tapering towards the top, where the capital (of the *bell*, *bud*, *papyrus*, *volute*, *Hathor-head*, or *palm* type) again bulged outwards over the shaft. Sometimes shafts were like a bundle of stems (*see* **capital**: [**Fig**. **16**]). In temples, columns were perceived as supports for heaven: columns with *palm-capitals* (*see* **capital**: [**Fig**. **16(g[i])**]) and *papyrus-capitals* (*see* **capital**: [**Fig**. **16(h)**]) both alluded to concepts of the sun-god in the heavens.

cone. Earthenware cones, inscribed on the circular end with the names and titles of tomb-owners, were placed above the entrances to many Theban tombs.

430

corbel. Cantilevered block built into a wall and projecting from it, supporting any superincumbent load such as an arch, beam, parapet, truss, etc. A *corbel-arch* is constructed by cantilevering horizontal blocks out from both sides of an opening until the 'arch' is closed at the top, and is a *pseudo-arch* (*see* **Plates 65**, **66**, **138**, **140**, **142**, **146**, **156**, **212**, and **217**).

corn. Associated with life-giving and -preserving forces, it was also symbolic of resurrection, especially in connection with *Osiris*.

cornucopia (*pl*. **cornucopiæ**). *Goat's horn* overflowing with flowers and fruit, also called a *Horn of Plenty*, associated with the *Nile* and with the *Tears of Isis* (*see* **Colour Plate VIII**, and **Plates 21** and **38**). (*See also* **Isis**: [**Fig. 28** (**c**)]).

Cosmati. Inlaid geometrical decorative patterns of marble, mosaic, and coloured stones, associated with the *Italian Romanesque* style. The term derives from a family of sculptors called *Cosma*, or *Cosmas*, who flourished at that time (*see* **Plate 33**). In the present work use of the term will mean objects made by the Cosmati (*see* HUTTON [1950]).

cove. Concave moulding, or coving. A *coved cornice* is a *cavetto* or *gorge*, that is, with a large concave section (*see* **Egyptian gorge**: [**Fig. 22**]).

cow. Sacred to *Hathor* and *Isis*, the cow was mother of *Anubis* and of the *Apis-Bull*. Linked both to heaven and the *Underworld*, it represented belief in continuity of life after death. As *Hesat* she suckled *pharaoh*. The importance of cows to Ancient Egyptians may be understood when contemplating the vast burial-places of the *Isæum* at Saqqara, discovered only in 1970.

creation. Ancient Egyptian legends concerning creation are several and varied. Some concern a mound arising from the waters and a primæval deity who begat himself. At Heliopolis *Atum* was the deity who created *Shu*, god of the air, and *Tefnut* (goddess of moisture), who, in turn, were the parents of the earth-god *Geb* and the sky-goddess *Nut* (who was elevated to her position in the sky by her father, Shu). However, in another legend the idea of creation was conceived by *Ptah*, and given existence by being spoken by him. At Hermopolis the mound was presented by *Thoth* with an egg, which opened to reveal the sun, and in a second version a *lotus*-bud floated on the surface of the waters, opened as a flower, and revealed *Horus* as the infant sun, thus beginning the whole creation cycle. All the legends involved a logical, orderly progression.

crescent. Symbol of the moon, and therefore an attribute of *Artemis/Diana/Isis*: it appears to have suggested the segmental pediment, unknown in *Classical* architecture before the first century of our era, and was particularly associated with Isiac temples and shrines (*see* **Colour Plates V** and **XIX**, and **Plates 17**, **18**, and **49**).

criosphinx. *Ram-headed lion* (*see* **Plate 127**).

crocodile. The crocodile was worshipped at Athribis as *Khenty-Khet*, but became the falcon-deity *Horus*. At Thebes he was *Suchos* (*see* **Suchos**: [**Fig. 50**]), who was specially venerated at Kôm Ombo (where there was a vast crocodile cemetery). The crocodile's open jaws were perceived as emblematic of the abyss, and, as the enemy of the gods, the creature was equated with *Seth*. The *Devourer of Hearts* in the *Hall of Judgement* had a crocodile's head, and crocodiles threatened the dead in their journeys in the *Underworld*. Crocodile motifs are found on *Regency* furniture and artefacts associated with the *Egyptian Revival* and Nelson's victory at the Battle of the Nile in 1798. It also recurred in *Antiquity* as an allusion to the *Nile* (*see also* **Plates 17**, **18**, **21**, **125**, **130**, and **131**).

crook. A sceptre carried by gods, *pharaohs*, and important officials as a sign of authority. It was particularly associated with *Osiris*. It emphasised pharaoh as the shepherd caring for his people.

crown. An important feature of Ancient-Egyptian iconography was the crown and head-dress, insignia of deities and *pharaohs*, symbols of authority. Common types of crown were:

(a) the white crown (*hedjet*) of Upper Egypt, associated with the protective powers of the goddess *Nekhbet* (**Fig. 19[a]**);

(b) the *modius*, rather like a truncated cone with the upper pointed part removed, and the conoid shape cut to fit over the forehead, ears, and neck (**Fig. 19[b]**);

(c) the red crown (*deshret*) of Lower Egypt, like a *modius*, but with an elevated rear part, associated with the protective powers of the goddess *Wadjet* (**Fig. 19[c]**);

(d) the combined crowns (*pschent*) of Upper and Lower Egypt (**Fig. 19[d]**);

(e) the *atef* crown, associated with *Osiris*, was the crown of Upper Egypt on top of which was a small solar disc, and plumes were fixed to either side of the crown (**Fig. 19[e]**);

(f) the head-dress of *Nephthys*, an enclosure shown on plan, with a superimposed basket (**Fig. 19[f]**);

(g) the blue or war crown (*khepresh*), adorned with circular gold enrichments (**Fig. 19[g]**);

(h) the crown of two plumes atop a *modius*, associated with *Amun* and *Horus* (**Fig. 19[h]**);

(i) the vulture head-dresss of *Isis, Mut,* and *Nekhbet*, often surmounted by the double-crown of Upper and Lower Egypt (**Fig. 19[i]**);

(j) ram's horns with rearing *uræi*, the whole surmounted by a tall *hedjet*-type crown over which is a sun-disc, and on either side of which are plumes, particularly associated with *Khnum* (**Fig. 19[j]**);

(k) hieroglyphic sign for 'throne', associated with *Isis* (**Fig. 19[k]**);

(l) *modius* crown topped with feathers, associated with *Anuket*, Mistress of the Nile (**Fig. 19[l]**);

(m) cow's horns, *uræus*, and disc of *Hathor* (**Fig. 19[m]**);

(n) cow's horns, disc, and vulture head-dress of *Isis* (**Fig. 19[n]**);

(o) ram's horns, rearing *uræi*, and twin plumes of *Suchos* (**Fig. 19[o]**);

(p) disc surmounted by serpent associated with *Herakhty, Horus,* and *Sakhmet* (**Fig. 19[p]**);

(q) feather or plume of *Maat* or *Shu* (**Fig. 19[q]**);

(r) moon-disc over crescent of *Khons* (**Fig. 19[r]**);

and

(s) crown of *Satis*, that of Upper Egypt with antelope-horns and *uræus* (**Fig. 19[s]**).

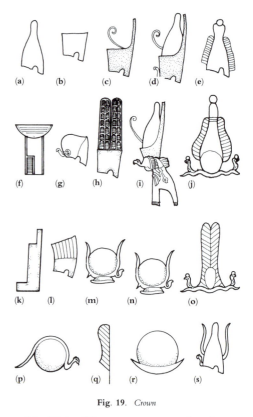

Fig. 19. *Crown*

cubit. Unit of linear measurement based on a sixteenth of the level by which the *Nile* rose in flood, and subsequently based on the distance from the elbow to the middle finger-tip. The Egyptian cubit was about 52.42cm, and a *Royal Cubit* was the length of a forearm plus the width of a hand. Cubits are depicted as *putti* on the famous statue of the Nile in the Vatican (*see* **Plate 21**).

Cupid. The god of Love, or a winged male child, or *cherub*, not to be confused with the unwinged *putto*.

cynocephalus. Humanoid figure with a dog's head (such as *Anubis*), or a dog-faced baboon, probably connected with initiation into the *Mysteries* (*see* **Thoth**) (**Fig. 20**).

Fig. 20. *Roman* cynocephalus, *or dog-faced baboon in the Egyptianising style (after* CAYLUS [1759], *iii*, 27–28, Pl. VI [2–3]*).*

Dedwen. Anthropomorphic god, protector of incense supplies.

deification. *Pharaoh* was *Horus* when alive and *Osiris* when dead. Deification of mortal men was rare among the Egyptians: exceptions were the architects *Amenhotep* and *Imhotep*, both of whom were also associated with healing and medicine, and the brothers *Peteese* and *Pihor* whose cult temple and burial-place was at Dendur, having been drowned in the Nile. *Antinoüs* was another example of a human being deified after drowning in the Nile.

demon. Demons were reckoned to be dangerous features of the *Underworld*, the personifications of evil, and creatures of *Sakhmet*. One of the most unpleasant was *Ammut*, crocodile-headed, with the front legs and torso of a lion and the back legs and rear end of a hippopotamus, known as the 'Devourer of Hearts' in the *Hall of Judgement*.

demotic. Script used by ordinary people, as opposed to hieroglyphic texts. It first appeared around 700 BC, and was much used by the Ancient Egyptians well into the Roman period. It is one of three scripts used on the Rosetta Stone, the other two being in Greek characters and hieroglyphs.

dentil. Small, rectangular or cubic projection used in series closely set in a *Classical*

entablature, under the *cornice*, associated with the bed-mouldings of the *Composite*, *Corinthian*, *Ionic*, and (sometimes) *Roman Doric Orders*. It is unknown in Ancient Egyptian architecture (**Plate 19**). (*See also* **capital**: [**Fig. 16(g[iii])**]).

Denwen. Pyromaniac serpent-god kept severely under control by more powerful deities.

desert. All barren land outside the cultivated Nile Valley, the entrance to the *Underworld*, the domain of *Ha*, defender of Egypt. The hostile desert was represented by *Seth*, enemy of *Osiris*.

deshret. The red *crown* of Lower Egypt (*see* **crown**: [**Fig. 19(c)**]).

Diana. *See* **Artemis**.

diminution. The decrease in diameter in the upper part of a *column*. The continuing contraction of the diameter or the cross-section with the height of anything.

Directoire. The style prevalent in France in the 1790s, before the *Empire* style, often including Egyptian motifs prompted by Napoléon's Egyptian campaigns.

djed. A column with four discs on top, capped by two plumes, sometimes represented as a rod with four bars across it, particularly associated with *Ptah* and *Osiris*, symbolic of resurrection. It also represents *strength* and *stability*, so is a forerunner of *Boaz*. Its

Fig. 21. Djed *column (after* the example in the temple of Seti I at Abydos*).*

iconography may relate to that of the *sistrum* (**Fig.** 21).

dromos. Straight, formal, entrance-avenue of great magnificence, lined on either side by *columns, obelisks, sphinxes, statues*, etc., as at the huge *Isæum Campense*, Rome (first to fourth century AD) (*see* **isæum**: [**Fig.** 27(**b**)]).

duality. Ancient Egyptians perceived much as a balance between two elements, creating unity: examples are the two lands of Upper and Lower Egypt; the crescent-moon (i.e. *solar barque* or *cow's horns* supporting the *sun-disc*); *Isis* and *Osiris*; and *Horus* and *Seth*.

Duametef or **Duamutef**. Jackal-headed *Son of Horus* found as the stopper of *canopic jars* containing the stomach removed during mummification (*see* **canopic jar**: [**Fig.** 14(**a**)]).

eclecticism. Design involving disparate elements from various styles put together in a coherent way, or drawing from many sources in design.

egg. Emblem of the creation of the world and of wholeness, associated with the *ankh*, with the *kneph*, and with immortality, supposedly created by *Ptah*. The necklace of *Artemis of Ephesus* may be composed of eggs or perhaps may be representative of testicles (*see* **Plate 9**).

Egyptian architecture. Ancient Egyptian architecture was monumental, of the *columnar* and *trabeated* type, and its most celebrated survivals are temples and tombs. It featured *battered walls, pylon-towers, pyramids, obelisks, cavetto* (or *gorge*) *cornices*, large columns with *lotus, palm, papyrus*, and other *capitals, hypostyle halls*, courts, vast processional ways flanked by sphinxes, *criosphinxes*, etc., stylised sculpture, and hieroglyphs. Egyptian architecture influenced other styles: the rock-cut tombs at Beni-Hasan, for example, have proto-*Doric* columns, and many Egyptian motifs were absorbed by the Hellenistic cultures and by the Roman Empire. *Neo-Classicism, Art-Déco*, and *Post-Modernism* drew on Ancient Egyptian motifs.

Egyptian gorge. Large *cavetto* cornice between a flat horizontal slab-like element at the top, and a *torus*, often enriched, below (**Fig.** 22 and *see* **gorge**).

Fig. 22. Gorge-cornice *with vulture-winged solar globe, or disc, with uræi (rearing cobras). This motif is usually found in the* cavetto *or* gorge *moulding that crowned* pylon-towers, walls, door-cases, *and other elements in Egyptian architecture, and was a symbol of protection (after a drawing by the Author).*

Egyptian hall. Large *Classical* room having an internal *peristyle* carrying a smaller upper *Order* or *pilastered clerestorey* above the *entablature*. It was evolved by Andrea Palladio (1508–80) based on descriptions by Vitruvius (Marcus Vitruvius Pollio [*fl.* 46–30 BC]), and had little to do with *Egyptian architecture*.

Egyptian mysteries. Rites involving the mysteries of *Isis* and the final mysteries of *Osiris*, mentioned in Græco-Roman texts and further embellished in descriptions by the Abbé Terrasson (1670–1750) in his *Séthos*, a work which had a profound influence on Continental Freemasonic and quasi-Freemasonic rituals, as well as informing much of the more solemn parts of Mozart's *Die Zauberflöte* (1791).

Egyptian Revival. Some elements of Ancient Egyptian design were found in Hellenistic and Roman architecture in *Antiquity*. After Egypt became part of the Roman Empire and Egyptian deities (especially the goddess *Isis* and her consort *Osiris* [whom the Greeks and Romans called *Serapis* or *Sarapis*]) were venerated by the Romans, the process accelerated: not only were many Egyptian artefacts, including *obelisks*, brought to Rome and re-erected there, but countless objects in the Egyptian style were made in Europe. Ancient obelisks were again set up in Renaissance Rome, where they may be seen in various locations today, and huge numbers of Egyptian and Egyptianising artefacts re-

emerged to grace the collections in the Vatican and elsewhere. During the latter half of the eighteenth century, Egyptian motifs began to intrigue designers in the West. G. B. Piranesi (1720–78) designed an 'Egyptian' interior (*see* **Plate 62**) for the *Caffè degl' Inglesi* (*c.*1768), which he published together with a number of fire-surrounds in an 'Egyptian' style (*see* **Plates 63–72**), in *Diverse maniere d'adornare i Cammini* (Different Ways of Decorating Chimneypieces [1769]). This work included illustrations of the Roman *telamones* and a recently discovered figure of *Antinoüs* from Tivoli (all second century AD), bogus *hieroglyphs*, *Apis-Bulls*, various Nilotic motifs, and also corbelled pseudo-arches of stepped form which passed into Western artistic consciousness as 'Egyptian'. In the latter part of the eighteenth century, many architects, influenced by French theorists such as M.-A. Laugier (1713–69) and J.-L. de Cordemoy (1631–1713), began to discard all that was deemed inessential, and, prompted by a growing admiration for the simple and primitive, explored the possibilities of basic geometries that would bring clarity, severity, and integrity to their compositions. Forms, such as battered rectilinear buildings, obelisks, and pyramids, were combined with cubes, spheres, and other stereometrically pure elements in the evolving language of *Neo-Classicism*. Eighteenth-century archaeological activity that encouraged a scholarly and accurate revival of the design of Antiquity continued processes begun in Rome, Pompeii, Herculaneum, Greece, Sicily, and Pæstum, by investigating Egypt. The Napoleonic investigations of Egyptian architecture, published from 1802 by Vivant Denon (1747–1825) and the *Commission des Sciences et Arts d'Égypte* from 1809 to 1828, did for the Egyptian Revival what Stuart and Revett's great *Antiquities of Athens* had done for the Greek Revival. *Empire* and *Regency* designs became permeated with Egyptianising tendencies after the Franco-British campaigns in Egypt (1798–1801) and the subsequent division of information and objects: so great was the enthusiasm for Egypt that *l'Égyptomanie* (Egyptomania) played an enormous rôle in early-nineteenth-century taste in both France and Britain, and enthusiasm for things Egyptian spread to other countries, even crossing the Atlantic. Egyptianising elements are very common, and, apart from entire buildings and interiors in the Egyptian Taste, include battered square chimney-pots with Egyptian cornices, lotus-buds and -leaves, obelisks, pyramids, and sphinxes. Even *Antinoüs* recurs as a garden ornament. Battered towers resembling flanking Egyptian temple-pylons were ideally suited for suspension-bridges, whilst battered retaining-walls and dams often had profiles derived from Ancient Egyptian precedents. Funerary architecture was often in the Egyptian style, especially in the period 1820–50. Egyptology ensured a continuous enthusiasm for Egyptianising design, and a further stimulus occurred when Tutankhamun's tomb was re-discovered in 1922. The 1924–5 *Exposition International des Arts-Décoratifs et Industriels Modernes* in Paris prompted a fusion of Egyptian, Egyptianising, and Aztec elements, to create the *Art-Déco* style, though the influence of Piranesi was still strong. More recently, both *Post-Modernism* and *Rational* architecture have incorporated aspects of Egyptian design, the potency of which remains strong.

Egyptian triangle. A 3–4–5 triangle, the base representing *Osiris*, the perpendicular *Isis*, and the hypotenuse *Horus*. The principle is fundamental to *surveying* and *architecture* because by setting out a triangle with sides proportional to 3, 4, and 5, a right-angle can be constructed.

elephant. Used in decoration to suggest Africa or Egypt. An elephant with an *obelisk* on its back derives from an illustration of 1499 in *Hypnerotomachia Poliphili* (*see* **Plates 40** and **50**), and is to be noted standing before the church of Santa Maria sopra Minerva in Rome, built on the site of part of the great *Isæum Campense.*

Eleusinian mysteries. The most sacred and august of the mysteries of the Græco-Roman

world, like *Isiac* mysteries much concerned with *wanderings, trials, death,* and *light.*

Empire. 1. The Roman Empire. 2. The Holy Roman Empire. 3. A Neo-Classical style evolved during the Napoleonic period, blending *Etruscan, Roman, Pompeian, Greek, Egyptian,* and the *Primitive* styles, usually given as *Empire,* corresponding to the British *Regency* and American *Directory* styles.

Ennead. Company of nine gods (*Pesedjet*) at Heliopolis consisting of the sun-god as creator and his immediate descendants, so included *Atum* (the bull), *Shu, Tefnut, Geb, Nut, Isis, Osiris, Seth,* and *Nephthys*. At other cult-centres the Ennead could vary, sometimes including deified pharaohs: Seti I included three statues of himself in the Ennead of Amun, with Osiris, Horus, Re, Ptah, and Isis.

entablature. In *Classical Orders* the entire horizontal mass of material carried on columns and pilasters above the *abaci* (*see* **capital**: [**Fig. 16(g[iii])**]). Normally it consists of three main horizontal divisions, the *architrave* (essentially the *lintel* spanning between columns), the *frieze* (occasionally omitted), and *cornice*. In Ancient Egyptian architecture it usually consists of an architrave, a *torus* moulding, and a *cavetto* or *gorge* only (*see* **Plates 5, 25,** and **54**).

Euripus. A pond or canal, often surrounded by colonnades and statuary, as at the *Canopus* of the *Villa Adriana* at Tivoli (*see* **Canopus** [**Fig. 15**]).

eye. Decorative eyes are common in Egyptian and Egyptianising ornament, but the eye has special significance relating to *Osiris,* for he beholds all land and sea with many eyes, and he possesses the *All-Seeing Eye* (that was never at rest) over the rewards of those who entered his realm. The sun and the moon were the 'eyes of *Horus*'. The *uræus* was the fire-spitting eye of the sun-god. In *Freemasonry* an eye suggests *Superintending Providence,*

knowing and seeing everything: it is an emblem of the degree of Master-Mason, for God is All Eyes, and represents T∴G∴A∴O∴T∴U∴ (The Great Architect of the Universe) (*see* **wedjet-eye**: [**Fig. 56**]).

falcon. Sacred animal of royalty and the deities, especially *Horus,* who protected the earth with his wings. There were other falcon-gods: *Montu,* god of war, *Re,* the sun-god, and *Sokar,* the mortuary-god. *Hathor* could become a female falcon, and the *ba,* or soul, was often shown as a falcon.

Fetket. Brother of the sun-god *Re.*

fire. A metaphor of the dawn, and the power of the royal *uræus* to destroy *pharaoh*'s foes. Fire could neutralise the powers of *Seth,* and it was an attribute of *Taweret*. However, fire, in the form of the fire-spitting serpent *Amemet,* could also destroy the dead, threatening their survival.

fish. The Ancient Egyptians regarded fish as unclean, and associated with the destructive *Seth*. The *Oxyrhynchus* fish was supposed to have eaten the *phallus* of the dismembered *Osiris,* murdered by Seth, so was not regarded with much favour, but other fish were sacred, associated especially with *Hathor, Neith,* and Osiris.

flabellum (*pl.* **flabella**). A fan, often seen as an attribute of a divine creature, especially of *Min*. It could also represent a shadow.

flagellum (*pl.* **flagella**). A flail or scourge, a symbol of authority and attribute of *Min* and *Osiris*. *Pharaoh* carried a flagellum to emphasise his power.

flower. Symbol of the beginning of the world and of the unfolding of life. As bouquets they represented the fragrance of the gods.

fly. Flies are a nuisance, and difficult to discourage, so they were equated with bravery.

fountain. *Isiac* and *Marian* emblem associated with *purity* and with *healing*. The *Fons Pietatis* of the *Blessed Virgin Mary* and *Isis*.

four. A significant *number*. There were four cardinal points, four *canopic jars*, four *Sons of Horus* protected by *Isis*, *Neith*, *Nephythys*, and *Serket*, and much else.

fourteen. An important *number*, signifying the fourteen pieces into which *Osiris* was cut by *Seth*. The moon (*Isis*), at the end of fourteen days after the full moon, enters *Taurus* and becomes united with the *Sun* from which she collects fire on her disc during the fourteen days that follow. It also suggests the cult of the Fourteen Saints, the fourteen days of burial in the Freemasonic Master's degree, and the time between the full moon and the new.

fragrance. Sweet smells and agreeable scents were associated with divinity and everlasting life. They also had a practical purpose in that they could counteract the odours of putrefaction and death, so *ointments* and *unguents* were greatly prized by the Ancient Egyptians.

Freemasonry. A system of morality, veiled in allegory, and illustrated by symbols (e.g. the tools of the operative Mason and the Architect): a secret or tacit Brotherhood (*see* CURL[2002*b*]).

frog. Creature associated with primæval life, sacred to *Heket*, goddess of birth.

garden. Gardens, well planted with trees and fragrant shrubs, were the abodes of deities, especially of *Amun*, *Horus*, and *Isis*. They were desirable places, plentifully supplied with water, and so became symbols of survival after death, the gardens of the blessed.

gate deity. Gate guardian of the *Underworld* who protected the various portals through which the deceased had to pass. Knowledge of their names would help to disarm them.

gazelle. Sacred creature of *Anukis*. It appears to have become associated with gracefulness and nimbleness, so images of it appeared on the head-dresses of concubines and favourite wives. It was particularly associated with *Reshef*.

Geb. The god of the earth, and father of *Osiris*, *Isis*, *Nephthys*, and *Seth*, by *Nut*, his sister-con-sort, the *sky-goddess*. He was the eldest son of *Shu*, who was the earth-god, and president of the divine tribunal of kingship. He support-ed *Horus* in his struggles with *Seth*, and so upheld the claims of a reigning *pharaoh*. He is often shown reclining on his side, with an arm bent at the elbow, and his erect *phal-lus* sometimes points upwards towards the sky-goddess *Nut*. His head-dress was the *crown* of Lower Egypt, and his sign is often given as a goose.

Gengen Wer. A goose, often *Amun* in disguise, associated with divine creative energy. Known as the *Great Honker*, *Gengen Wer* had within it the egg which symbolised future life. Also connected with *Geb*.

girdle. Symbol of *chastity* and *purity*, analogous to the *Freemasonic apron*, and associated with *strength* and *power*. Græco-Roman statues of *Isis* show her with a girdle tied with the Isiac or mystic knot at the front, just under the breasts: this girdle is called the *tyet* (*see* **tyet**: [**Fig. 52**]), and is connected with the sign of life, the *ankh* (*see also* **Plates 6, 7, 94**, and **ankh**: [**Fig. 4**]).

globe. The *Supreme Being*. The emblem of *power* and *enlightenment*. The *disc* or *globe* with *uræi* and *vulture's wings*, representing the earth and the heavens. The sun or the full moon (*see* **Colour Plates XI, XXIV,** and **XXV,** and **Plates 19, 54, 84, 96, 98, 111, 118, 123, 128, 150, 151, 154, 155, 156, 157, 159, 162, 168, 169, 180, 183, 185, 188, 190,** and **192**).

goat. The sacred goat, *Banebdjedet*, was often depicted as a *ram*, and was a symbol of fecundity.

gold. As a precious metal not subject to deterioration or change, it was a symbol of immortality, and a divine metal associated with the sun-god *Re*. The *pyramidions* on top of *obelisks* were sheathed in pure gold.

goose. As an egg-laying creature the goose was associated with the creation-myth of the first god emerging from an egg, and, as the 'Great Cackler' or 'Honker', connected with *Amun* (*see* **Gengen Wer**). Later, in the Græco-Roman period, it became regarded as an attribute of *Horus/Harpocrates*. As with much Ancient Egyptian religion, there were contradictions however, for the goose was also perceived as an embodiment of *Seth*, and so was slain in great numbers as a sacrificial creature.

gorge. *Cavetto* moulding, or *throating*, less recessed than a *scotia*. A *gorge-cornice* is a large cavetto or *Egyptian cornice* (*see* also **cavetto** and **Egyptian gorge**: [**Fig. 22**]).

grave-goods. As the after-life was thought to be similar to life on earth, food, tools, clothing, weapons, servants, and concubines were entombed with the dead in very early times. This was eventually superseded by the provision of substitute goods, models, and even pictures.

green. *See* **colour**.

guardian deities. The Egyptian *Underworld* consisted of a route along which were *pylon-towers* and gates protected by fierce guardians who could be placated by knowledge of their secret names (the parallel with *Initiation Rites* will be clear). Serpents, jackals, *Apophis*, and so on are guardians, but the gateways themselves were personified as goddesses. To pass, the dead had to recite the names of these personified deities and identify the guardian gods (shown seated and armed, anthropomorphic but with animal heads [e.g. *bull*, *hippopotamus*, *snake*, or *vulture*]).

Ha. Anthropomorphic god of the desert and oases, defender of Egypt against enemies from the West, especially Libya.

hair. Shaven heads of priests were connected with rules of hygiene and bodily purification. Cutting off of locks of hair was associated with mourning. A long plaited lock of hair hanging to the right side of the head was a traditional arrangement for young men or boys, and representations of the young *Horus* or of young princes feature this side-lock of hair, which may have been associated with ideas of eternal youth and immortality (*see* **Isis**: [**Fig. 28(b)**]).

Hall of Judgement. Place where the *weighing of the heart* of the deceased took place with *Anubis* and *Thoth* in attendance, and *Ammut the Devourer* eagerly waiting. The 42 *assessors* were also present, and successful candidates were led by *Horus* to *Osiris*, attended by *Isis* and *Nephthys*.

hand. A symbol of creative powers, and so signifies the female element.

Hapi or **Hapy**. 1. God of the yearly flooding of the Nile, usually shown with paunch, pendulous breasts, and Nilotic flora on his crown. 2. *Son of Horus*, under the protection of *Nephthys*, who guarded the lungs of a deceased person in its *canopic jar*, identified by a baboon's head (*see* **canopic jar**: [**Fig. 14(a)**]).

hare. Sacred animal, perceived as divine because of its quick reactions and speed, related in some way (as yet unclear) to *Osiris*.

Harmachis. Sun-god, interpreted as *Horus* in one of his guises.

Haroeris. The mature *Horus*, also known as *Harwer*.

Harpocrates, The younger *Horus*, in his Græco-Roman manifestation, often depicted as a *putto*, with finger to the lips, and hence associated with *silence* and *secrecy*. He sometimes holds a *cornucopia* (*see* **Isis**: [**Fig. 28(c)**]).

Harwer. *See* **Haroeris**.

Hathor. Universal cow-goddess, symbolic mother of *pharaohs*, daughter of the sun-god *Re*, and 'lady of the sky'. She appears in various guises: a slender woman on whose head-dress is a crown of cow-horns embracing a sun-disc; a cow; and a *capital* on a column or the *abacus*. Her cult-centre was at Dendera, and she was later identified with *Isis* and *Aphrodite*, as the Egyptian goddess of love. Her attribute was the *sistrum*. She was the Great Mother of all that is embraced by the universe, and her Semitic equivalent was *Astarte*. She was probably the forerunner of *Isis* (**Fig. 23**).

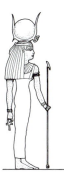

Fig. 23. Hathor *carrying the* ankh *and a* was *sceptre. On her head is a crown of cow-horns and a sun disc. The* uræus *is also present (after a figure of the XVIII dynasty [c. 1567–1320 BC]).*

Hathor-headed. *Column* with a *capital* or *abacus* featuring the Egyptian sky-goddess *Hathor*, the *celestial cow*. Hathor can wear cow's horns and a sun-disc, but on capitals she has a human face, cow's ears, and a wig with curling lappets on the sides. (*see* **Colour Plate XXXVI** and **Plates 96, 123, 145, 147**, and **153**) (*see also* **capital**: [**Figs. 16(e)** and **16(f)**]).

Hatmehyt or **Hatmehit**. Fish goddess of the Nile Delta, consort of *Banebdjedet*, the ram-headed deity.

Hauhet or **Hehet**. Goddess of the primordial abyss, a member of the *Ogdoad*.

Haurun. Earth-god associated with the Sphinx at Giza, protector against wild animals. He was identified with *Harmachis*.

head. The Ancient Egyptians were terrified of walking upside-down in the *Underworld*, for those placed on their heads were destroyed by fire-spitting demons. Damage or loss of the head could be a singular disaster, so the heads of mummies were protected with masks. Even substitute 'reserve-heads' were sometimes placed in tombs in the Old Kingdom, notably at Gizeh.

head-cloth. *See* **nemes**.

heart. Symbol of life, without which life is impossible. Oddly enough, the heart was not removed during the embalming process, despite the fact that the lungs, stomach, liver, and intestines were taken out (*see* **canopic jars, Sons of Horus**). In the *Hall of Judgement*, presided over by *Osiris* and the *assessors*, the heart of the deceased was weighed by *Anubis* against the feather of truth, the attribute of *Maat*, and the results were recorded by *Thoth*. In attendance at this nerve-wracking ceremony was the repulsive 'Devourer of Hearts', *Ammut*, ever-eager and hopeful.

hedjet. The tall white *crown* of Upper Egypt (*see* **crown**: [**Fig. 19(a)**]).

Heh. Deity personifying infinity, usually anthropormorphic, kneeling on a basket, holding a palm-frond in one hand and an *ankh* in the other. *Heh* was a member of the *Ogdoad*, and his female equivalent *Hehet* or *Hauhet*.

Hehet. *See* **Heh** and **Hauhet**.

Heket. Frog-goddess, who hastened the last stages of childbirth, and was consort of *Haroeris*, the mature *Horus*. She was regarded as the female counterpart of *Khnum*.

Henet. *See* **pelican**.

Herakhty. *Horus* with a lion's head, deity of the morning sun.

herdsman. *See* **shepherd**.

Heret-Kau. Goddess with powers in the after-life. She seems to have been involved in

rituals during the foundation of temples, with *Isis* and *Neith*.

herm. *Pedestal*, square on plan, terminating in a head of *Hermes* or some other figure. The pedestal may be tapered downwards, like an inverted *obelisk*. A *herm*, unlike a *term*, does not include the torso and waist, but is only the head, although feet may appear at the bottom of the pedestal, and the form was common in Egyptian Revival work, where the head usually has the *Nemes* head-dress. In *Antiquity* herms often had the male reproductive organs protruding from the front face of the pedestal (**Fig. 24**), but in the *Neo-Classical* period these were omitted.

Fig. 24. *Ithyphallic Greek herm (after* a mutilated relief in the Glyptothek, Munich*)*.

Hermes. **1**. The *Messenger*, identified with *Thoth*, and the Secretary of *Osiris*. **2**. *Hermes Trismegistus*, the Thrice Great, or Thrice Wise, who invented *hieroglyphs*, and who is identified with *Euclid*. Identified later with *St John*.

Heryshaf or **Herishef**. Ram-god with anthropomorphic body in *pharaonic stance* wearing the *shendyt* kilt (*see* **Antinoüs**: [**Fig. 7(b)**]): his head is that of a long-horned ram, and on his head is the *atef* crown of *Osiris*, flanked by two plumes. Immediately above his horns is the sun-disc of *Re*. He was identified with *Atum* and *Heracles*.

Hesat. Cow-goddess bearing divine milk to feed mankind, heal injuries, and preserve dead flesh. In one legend she preserved the flayed flesh of *Anti* and tied it to a pole, thereby creating the *imyut* symbol. In another legend she was the mother of *Anubis*, with whom the *imyut* is identified. She was also mother of *Mnevis*.

Hetepes-Sekhus. Cobra-goddess and eye of *Re*, who destroyed the souls of the enemies of *Osiris* in the *Underworld*. In her battles she was assisted by a pack of crocodiles.

hieratic. Cursive evolution of the *hieroglyphic* script, much simplified, commonly used in legal, literary, and religious documents.

hieroglyph. Design representing a meaning, a word, or a sound (*see* **cartouche**: [**Fig. 17**]). Bogus hieroglyphs were used as *Renaissance* and *Neo-Classical* ornament before Egyptian hieroglyphs were deciphered in 1822 (*see* PARKINSON [1999]).

hippopotamus (*pl.* **hippopotami**). The 'river-horse' could be associated with *Seth* (in which case it was hunted and destroyed), or it could be a symbol of female fertility as the goddess *Tawaret*, and so could be prized and cherished.

Historicism. The use of past styles in architecture, especially scholarly revivalist architecture, so employed as a term of abuse by *Modernists*.

horizon. A hill with twin peaks between which the sun arose, and where the sun set, a symbol of the dwelling-place of *pharaoh* and *Re*.

horn. **1**. Volute, especially of the *Ionic Order*. **2**. Projection at each corner of an *altar*, *altar-chest*, *sarcophagus*, or *stele*, also called *ear*. **3**. *Cornucopia*, or *Horn of Plenty*. **4**. Cow's horns of *Isis*. **5**. Symbol of fear and might, often occurring as the crowning head-dress of several deities (*see* **crown**).

Horus. There were two deities of this name: the first was Horus the Elder, the falcon-headed symbol of divine kingship, lord of the sky (**Fig. 25**); and Horus the Younger, conceived after a necrophilous union between the dead *Osiris* and *Isis* (transformed for the purpose into a kite). Horus the Younger was brought up by his mother in secret, and is frequently shown in statuary being suckled by the Great Goddess, an imagery strongly evocative of the Madonna

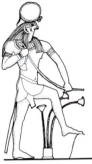

Fig. 25. Horus *as a falcon-headed anthropomorphic deity with papyrus plants emblematic of Lower Egypt (*composite image *after* an original in the Cairo Museum *and from the tomb of Seti I in the Valley of the Kings, Thebes).

and Child (*see* **Isis**: [**Fig. 28(b)**]). He was identified later with *Apollo, Harpocrates,* and *Priapus,* is often shown as a *putto,* with a finger in his mouth (in Egyptian texts he is referred to a the 'child with his finger in his mouth'), and is therefore associated with *silence* and with *secrecy* (*see* **Harpocrates** and **Isis**: [**Fig. 28(c)**]). The legends are further complicated because the Elder Horus is sometimes regarded as the brother of Osiris, but another tradition regards Seth and Horus as brothers. The Younger Horus was weak in infancy and youth, but grew in strength, until he vanquished Osiris's murderer, Seth, but lost an eye in the process, later restored by *Hathor,* or in other legends, by *Thoth.* There seems to be evidence that the elder Horus was the victor over Seth: this indicates a merging of these two myths. By a ruse, Isis obtained *Re's* secret name, knowledge of which conferred limitless power, and passed this intelligence to her son, Horus, who thereby became one of the almighty Egyptian Trinity (or *triad*) of Isis, Osiris, and Horus. Every *pharaoh* was the incarnation of the younger Horus, and 'son of Isis', the goddess-mother, the Great Queen. As *Horapollo,* Isis established him as *Pantocrator* of the world, and, like his namesake, Horus the sky-god, was often shown falcon-headed (**Fig. 25**). The restored 'eye of Horus' is often shown in Egyptian iconography, and conferred protection, and as a cosmic deity his right eye is the sun and his left the moon. The legend of the passing on of the secret name or word has its parallels in Freemasonic lore and the story of the Master-Builder (who has connections with *Imhotep* and *Ptah*). One of his most important cult-

centres was at Edfu, but he was also worshipped as *Haroeris* at Kôm Ombo, and as *Re-Herakhty* at Heliopolis. His legends are extraordinarily complicated and cannot be dealt with here in any great depth. *See also* **canopic jar** and **Sons of Horus**.

hours. Twelve goddesses of the *Underworld,* daughters of *Re,* shown as women, each with a five-pointed star over her head. They represented the rule of time over those forms of chaos which could destroy the universe. They controlled the life-spans of all living creatures.

house. Maternal symbol. *Hathor* as the 'house of *Horus*', and *Isis* was the 'house of *Osiris*'.

Hu. Deity personifying authority, who, with *Sia,* was created from blood dropped from *Re's phallus* during the latter's act of self-mutilation (probably self-circumcision).

hydreion (or **hydræum** [*pl.* **hydræi**] or **hydria** [*pl.* **hydriæ**]). Ornamental water-vessel, jug, or ewer, also known as *situla,* an attribute of *Isis,* usually shown held in her left hand, whereas the *sistrum* is held in her right (*see* **Isis**: [**Fig. 28(c)**]).

hypostyle. Covered *colonnade.* A *hypostyle hall* is a large room with a flat roof carried on many massive columns close-set in rows, the middle rows often having taller columns to accommodate a *clerestorey.* It is found in Ancient Egyptian temples such as the Great Temple of *Amun* at *Karnak* (*c.*1570–*c.*1200 BC) (**Fig. 26**).

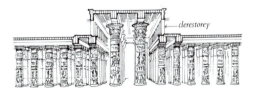

Fig. 26. Hypostyle hall *of the Great Temple at Karnak, showing the bell-capitals* supporting the taller element with the clerestorey, and the bud-capitals *carrying the rest of the roof* (see **capital**) (*after various sources, including* FLETCHER [1954], ROSENGARTEN [1893], *and* STATHAM [1950]).

ibis. The *ibis religiosa*, a wading bird with curved bill, was the incarnation of *Thoth*. Huge ibis necropoleis have been found at Hermopolis and Saqqara. The crested ibis was considered to be suggestive of the transfigured dead.

ichneumon. The mongoose was associated with *Horus* and *Re*, for the latter was supposed to have changed himself into a mongoose in order to fight *Apophis*, the terrible snake of the *Underworld*. The ichneumon was also identified with *Wadjet*.

Ihy. Juvenile god, the son of *Horus* and *Hathor*, who represented the joy aroused by the *sistrum*, or sacred rattle, used mostly in the worship of Hathor, and later in the devotions due to *Isis*.

image. To the Ancient Egyptians an image took on reality, and was another means of ensuring immortality. Statues of deities took on a reality of their own, so that they were not mere mnemonics or aids to worship, but *became* the deities, resident in their cult-centres.

Imhotep (*fl. c.*2600 BC). Ancient Egyptian architect to King *Zoser* (*Djoser* [reigned *c.*2630–*c.*2611 BC]), who built the celebrated step-pyramid and mortuary complex at *Saqqara*. Imhotep was identified with *Asclepius*, and was called 'son of *Ptah*', eventually (*c.*750) becoming the deified (*see* **deification**) Architect of the Universe himself, and one of the *Trinity*, with *Horus* and *Isis*. He shared his cult-centres with *Amenhotep*. He is credited with the invention of building with cut and dressed masonry, was an accomplished author, and a healer, versed in medicine.

Imsety. *Son of Horus*, under the protection of *Isis*, who guarded the liver of a deceased person in its *canopic jar*, identified by a humanoid head (*see* **canopic jar**: [**Fig. 14(a)**]).

imyut or **imiut**. Animal-skin on a staff, a sign of protection, associated with *Anubis* and the legend of *Anti*.

in antis. Between *antæ* (*see* **anta** and **portico**: **Figs. 38[a]** and **38[b(iii)]**).

incense. Censing was associated with *purification*, but its rising smoke could be interpreted as a signal to 'the other side', i.e. the world of the gods. The burning of incense also had a practical purpose in that it disguised the smells of putrefaction during the process of mummification.

inversion. One conception of the *Underworld* was that it was upside-down compared with earthly life, and everything was back-to-front. The Egyptians were frightened of being placed on their heads in the Underworld, but earnestly hoped that they would move from death to re-birth, just as the sun travelled 'backwards' in its *solar barque* each night to arise in the morning.

Ipy. Hippopotamus-goddess, protector and suckler of *pharaoh*. As the *Great Ipet* she was considered to have borne *Osiris*, and may have been the forerunner of *Taweret*.

isæum (*pl.* **isæa**). A temple where *Isis* was worshipped. One of the greatest was the *Isæum Campense* in Rome (*see* **isæum**: [**Figs. 27(a)** and **27(b)**]).

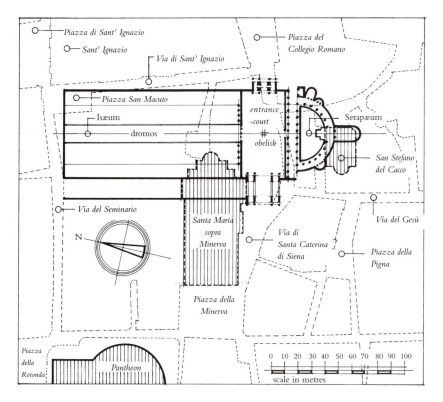

Fig. **27**(**a**). *Isæum Campense, Rome. Conjectural plan showing the Isæum Campense in relation to the street pattern of modern Rome, the Pantheon, and churches: the modern street-plan is shown pecked, and the Isæum is shown overlaid in bold. It should be noted how part of the church of Santa Maria sopra Minerva relates to geometries established by the Isæum (after various sources, including ROULLET [1972] and the fragments of the famous Roman marble map).*

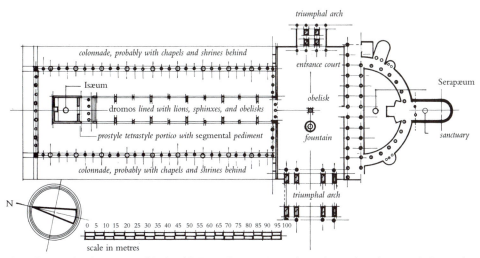

Fig. **27**(**b**). *Hypothetical reconstruction of the plan of the Isæum Campense, Rome, showing the axis relating the Isæum, the dromos, the obelisk in the entrance-court, and the Serapæum (after various sources, including ROULLET [1972] and the fragmentary Roman marble map).*

Ishtar. Mesopotamian astral goddess, associated with warfare, fertility, and sexuality. She is identified as *Astarte-Ashtoreth*, her emblem was the eight-pointed star, and her accompanying animal was the lioness.

Isis. The deity (her name seems to have meant 'seat' or 'throne') most extensively venerated by the Ancient Egyptians (**Fig**. **28[a]**), and subsequently throughout the Græco-Roman world. She may have been a manifestation of the pharaonic throne, and, as his symbolic mother, 'bore' *pharaoh*. Her brother and husband was *Osiris*, her sister was *Nephthys*, and her son was *Horus/Harpocrates/Horapollo*, vanquisher of *Seth/Typhon*, and *Pantocrator* of the world (although some legends hold that *Horus the Elder*, the falcon-headed sky-god, was Seth's conqueror). Isis could resurrect the dead, could blind and could cure blindness with her *sistrum*, and gave birth to Horus the Younger by means of a miraculous union with the dead Osiris, whose body she gathered up and preserved, and who, with her sister Nephthys (as kites), she mourned. The two goddesses are often depicted with outstretched wings, protecting the dead, or as two snakes in the *solar barque*. Isis became the most universal of all goddesses, and ruled in heaven, on earth, on the sea, and in the world below. She was identified with *Artemis/Diana*, with *Demeter*, with *Aphrodite/Venus*, with *Hera* (consort of *Zeus*), with *Pallas Athena*, and with many others. Her attributes were the *crescent-moon*, the *cow's horns*, the *rose*, the *fountain*, the *lotus*, and much else, and she was clearly the forerunner of the Marian *cultus* of the Christian Church, especially obvious in the iconography of *Isis Lactans*, in which she is shown suckling the young Horus (**Fig**. **28[b]**), who grew up in the seclusion of the Delta marshes of Lower Egypt, protected by his mother's great magic, for she was the 'eye of *Re*', and identified with *Sirius*, just as *Osiris* was identified with *Orion*. She could change shape, and, as the Isis-cow, gave birth to the *Apis-Bull* of Memphis, which is associated with *Ptah* and Osiris. She was often shown with a throne on her head, or with cow's horns and sun-disc: her special amulet was the

tyet, or girdle with a loop or knot at the front derived from the *ankh* (**Fig**. **28[c]**) (*see also* **tyet**: [**Fig**. **52**]). One of her finest temples was at Philæ, and one of the biggest centres of her cult in the Roman world was the *Isæum Campense* in Rome itself (*see* **isæum** [**Figs**. **27**(a) and **27**(b)], and *see also* **Plates 6**, **7**, and **8**) (*See* WITT [1971]: *passim*).

Fig. **28**(a). *Egyptian type of* Isis, *wearing the* tyet *or girdle with knot, a symbol connected with the* ankh. *She holds a* naos sistrum, *and* menat, *and her horned vulture head-dress contains the lunar disc (after a representation in the temple of Seti I, Abydos).*

Fig. **28**(b). *Isis lactans. The goddess Isis suckling* Horus *whose curling lock of hair may be seen (*Harpocrates*) (composite image, after exemplars in the Egyptian Museum, Berlin, the* Museo Greg. Egizio, *Rome, 57, and elsewhere).*

Fig. **28**(c). *Roman Isis holding the hoop sistrum in her right hand and* hydreion *in the left, with the crescent-moon disc, and plumes on her head. She wears the knotted* tyet *on her breast. By her side is* Horus/Harpocrates, *finger in mouth, holding a cornucopia (after a pre-war illustration of the Roman statue in the Glyptothek, Munich).*

Iusaas. Heliopolitan goddess, whose name celebrated her greatness. She wore a *scarab-beetle* on her head. Like *Nebethetepet* she was a female balance to the male creative principle symbolised in *Atum*, and helped to bring the world into being.

Jachin The left-hand *column* in front of the *Temple of Solomon* when approaching the portal. It was associated with *Establishment* and *Legality*, with the *Junior Warden* of a Masonic Lodge, and with the *Fellow Craft* in Freemasonry (*see* CURL: 2002*b*).

jackal. Desert-dwelling wild dog, often a scavenger in necropoleis. By association, the jackal-headed deities *Anubis* and *Wepwawet* were closely associated with the *Underworld* and with funerary ritual.

ka. Spiritual and intellectual power, the creative life-force, born with a person and created by *Khnum*, which lived on after death and had to be maintained.

Kamutef. Literally 'bull of his mother', it refers to *Amun* and *Min*, both of whom begat themselves without a father. Amun, as a primæval deity, when assuming the form of a snake, was called **Kematef** (or **kneph** in Greek).

Kauket or **Keket**. Snake-headed goddess who dwelt in darkness, and appeared as a *baboon* when greeting the sun. A member of the *Ogdoad*.

Kek. Male deity of the *Ogdoad*, shown as frog-headed or as a *baboon* greeting the sun. He dwelt in darkness. His female equivalent was **Keket** or **Kauket**.

khepresh. *See* **crown** (**Fig. 19[g]**).

Khepri. The sun-god at dawn on the eastern horizon personified in the *scarab-beetle* pushing the sun-disc up from the *Underworld* at the start of its journey across the heavens. The sacred dung-beetle (*Ateuchus*, or *Scarabæus sacer*) was a familiar sight to Ancient Egyptians as it rolled balls of dirt across the ground, and out of those rolled balls scarab-beetles emerged, so it was assumed that some sort of spontaneous creation had occurred, by-passing the more familiar means by which species reproduced themselves. Thus *Khepri* was perceived as self-created through his own will, and so was a manifestation of *Atum* and later of *Re*. During the hours of darkness the sun-disc, in some legends, was supposed to be carried through the night-sky in the body of *Nut* into which Khepri had eased it only to retrieve it at dawn, propelling it like a dirt-ball (*see* **solar barque**: [**Fig. 49**]). Occasionally Khepri will have a ram's head, and sometimes he is anthropomorphic with his head as a whole *Scarabæus sacer*.

Kherti or **Kherty**. Ram-god, both protector and potential enemy, guardian of royal tombs, and earth-god. At one time he was associated with *Osiris*, but seems to have been identified eventually with *Khnum*, an altogether more benevolent deity.

Khnum. Ram-headed god who controlled the annual flooding of the Nile from the caverns of *Hapy*, the deity personifying that flood. The goddesses *Anukis* (his consort) and *Satis* (his daughter) assisted him in supervision of the cataracts, and he himself was 'lord of the crocodiles', a title emphasised by the fact that the goddess *Neith*, mother of the crocodile-god *Sobek*, inhabited Khnum's temple at Esna. In other legends Satis was his consort and Anukis their daughter. As a ram, controller of the life-giving waters, and lord of the cataract as 'soul of the sun-god', he, as *Khnum-Re*, became a creator-god, and his iconography therefore sometimes showed him at a potter's wheel, moulding a human being into existence. In his person *Re*, *Shu*, *Osiris*, and *Geb* were united.

Khons. Moon-god, sometimes regarded as the son of *Amun* and *Mut*, and sometimes as the offspring of *Sobek* and *Hathor*, he was also identified with *Shu* and *Horus*, as the son of *Osiris*'s leg. On occasion he was depicted with a falcon's head, but more often with a human head. On his head was a crescent-moon supporting the circle of the new moon, and as a moon-god his sacred animal was the *baboon*. Often shown wearing a tight sack-like garment, his bearded head paradoxically wore the curving 'lock of youth' which fell over his right shoulder.

king. *See* **pharaoh**.

kneph. **1**. A winged *egg* or *globe* with *serpent* or serpents. **2**. *Amun* in the form of a serpent, called **Kematef**.

knot. Associated with binding and releasing, knots were magical and closely connected with *amulets* (*see* **tyet**).

ladder of heaven. **1**. The sun's rays in control of *Re*. **2**. Rope-ladder, or ladder made of two *djed*-columns, an emblem of resurrection.

leopard. Animal associated with *Mafdet*, as were panthers.

lettuce. Attribute of fertility, especially of *Min*.

light. An emblem of goodness, purity, and divinity, dispelling darkness and evil. Like much else in Ancient Egyptian mythology, light and darkness were opposites, in conflict, and the darkness injured the lunar eye, restored by *Thoth*.

lily. Emblem of purity, similar to the *lotus* in Egyptian art.

lion. Important animal, associated with the sun, *Re*, light, and fire. *Horus* acquired a lion's head as *Herakhty*. Lions could suggest death and destruction at night, but rebirth in the morning (a point emphasised by the leonine paws on biers). The most important leonine deity was female, the fearsome *Sakhmet*, and the goddess *Mekhit* was also ferocious. The god *Aker* was represented by two male lions seated back-to-back, or as a tract of land with a human or leonine head at either end: he guarded the entrance to the *Underworld*, and the terrible lion was suitable as a guardian of temple-gates, royal thrones, and other special places. *Sphinxes* and *criosphinxes* have lions' bodies.

lotus. Plant (the Egyptian water-lily [*Nymphæa speciosum*], which shuts its flowers at night and sinks beneath the water, only to rise up and open at daybreak) much used in architectural ornament (**Fig. 29** and *see* **canopic jar**: [**Fig. 14(b)**]). It was regarded as close to fire and water, to divine light and to primæval darkness, and was an expression of rebirth. Formalised flowers, buds, and leaves of *lotiform* type were used in Ancient Egyptian

architecture as well as in *Greek* and *Neo-Classical* ornament. *Lotus-bud* and *lotus-flower* capitals both occur in Egyptian or Egyptianising buildings, whilst the bud is also found on the foreheads of Isiac statues. The lotus is related to the *palmette* and to the *lily*, has strong connections with *Isis*, the *Virgin Mary*, and the *fleur-de-lis*, and was a plant particularly associated with Upper Egypt and with *Seth* (*see* **Plates 6-8** and **94**).

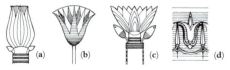

Fig. 29.
(**a**) *typical Egyptian* lotus-bud *painted decoration;*
(**b**) *Egyptian* lotus-flower *painted decoration resembling a fan form and the* palmette*;*
(**c**) *Egyptian* lotus-flower *painted decoration;*
(**d**) *fragment of necking ornament from a column of the temple of Apollo, Naukratis (Greek), featuring* lotus-flowers *and -buds. The lotus became a favourite decorative motif of the Greeks, and was often combined with the* palmette*, appearing alternately with it on friezes* (*see* **anthemion**: [**Fig. 6**]) (*after various sources*).

love. Personified as *Cupid*.

lunette. Semi-circular opening framed by an arch or a vault. A variant is the segmental opening, a form identified with *Isis*.

lustration. Rite of *purification* by pouring water on a person's head, an obvious forerunner of *Baptism*.

Maat. Goddess of Justice, Law, Moral Integrity, Truth, and Cosmic Harmony, whose emblem was an ostrich-plume worn on her head. Through her authority *pharaoh* ruled, and her model life was an example to all. It seems that Egyptian law-officers wore emblems or effigies of Maat when involved in cases. It was her image that was used as the counterbalance when the hearts of the dead were weighed before the *assessors* in the *Hall of Judgement*.

mace. Royal attribute, a weapon with a ball-like heavy object at one end, used to smite enemies, and often depicted in Egyptian art.

Mafdet. Fierce panther-goddess, killer of scorpions and snakes, who presided over judicial authority and executions. Her image occurred on the instrument used to execute criminals.

Mahaf. Ferryman of the *Underworld* and herald of *Re*.

malachite. Associated with joy, and, being green, was emblematic of an eternally green garden of the blessed. In particular, it was the stone of *Hathor*.

mammisæum. Building where a deity became incarnate, also called (dubiously) a *Mammisi*-temple.

mandet. *See* **solar barque**.

Mandulis. Lower Nubian sun-god, depicted with a crown of ram's-horns over which were tall plumes, sun-discs, and *uræi*. Identified with *Horus*, he was closely associated with *Isis*.

mastaba. Ancient Egyptian rectangular tomb with a flat roof and battered sides, the typical place of entombment for nobles in the Old Kingdom.

mausoleum (*pl.* **mausolea**). Monumental sepulchral building, or any grand roofed tomb. It may contain *sarcophagi*, *coffins*, or *cinerary urns*. It is named after the great tomb of *Mausolos*, King of Caria, at *Halicarnassus*, the modern Bodrum (*see* CURL [2002*c*]).

Mayan arch. *Corbelled* or *pseudo-arch* of triangular form, favoured in *Art-Déco* work of the 1920s and 1930s, and related to Egyptianising forms derived from the designs of *Piranesi*.

Mehen. Serpent-goddess, shown coiled, protecting the ship of *Re* in the *Underworld* (*see* **Re**: [**Fig. 41**]).

Mehet-Weret. Cow-goddess of the sky, sometimes referred to as the mother of *Re*, and identified with *Neith*.

Mekhit. Lioness-headed goddess, the consort of *Onuris*.

menat. Necklace of beads with a counterpoise which could be held (**Fig. 30**). It was shaken like a rattle by the priestesses of *Hathor*, and was associated with healing. *Cleopatra* holds a *sistrum* in her right hand and a *menat* in her left in **Plate 2**.

Fig. 30. Menat *(after* several examples*)*.

Mensa Isiaca. Also called the *Bembine Tablet of Isis*, it is a plate of bronze inlaid with silver in the Egyptianising style perhaps made for a Roman sanctuary in the reign of the *Emperor Claudius* (reigned AD 41–54 – whose name, written in hieroglyphs, is the only part of the text that means anything), and is now in the *Museo Egizio*, Torino, 7155. The design includes figures and *bogus hieroglyphs*. The tablet was discovered at the beginning of the sixteenth century, and bought by *Cardinal Pietro Bembo* (1470–1547) for his collection. It was published in 1559 by *Enea Vico de Parma* (1523–67), and was subsequently used as a reference for all Egyptological studies until it was identified as Roman work in the nineteenth century. Motifs from the *Mensa Isiaca* recurred on Egyptianising designs from the sixteenth until the nineteenth century, and were prominent in the work of *Piranesi* (*see* **Plate 42**).

Meretseger or **Mertseger**. Powerful cobra-goddess, lover of silence and guardian of the Valley of the Kings in Western Thebes, depicted as a cobra about to strike, or as a cobra or scorpion with a human female head. She was a powerful incentive for workmen engaged in building or cutting tombs, as she struck down or blinded those who committed crimes or bore false witness.

mesektet. Nilotic boat with high prow and stern (*see* **Re**: [**Fig. 41**] and **solar barque**: [**Fig. 49**]), regarded as the *night-barge*.

Meskhenet or **Meshkhent**. Presiding goddess of childbirth, shown as a tile or a brick with a female head, or as a woman with a brick on her head (Ancient Egyptian women squatted on bricks in order to give birth).

Methyer. Goddess of the primæval waters who, as a cow, brought the sun-god into the world and raised him up on high between her horns. Identified with *Hathor* and *Isis*.

Mihas. Lion-god, the son of *Bastet*.

milk. There are many Ancient Egyptian representations of *pharaoh* as *Horus* being suckled by *Isis*, *Anukis*, and the celestial cow. Milk was representative of purity because of its whiteness.

Min. Protector-god, shown as a bearded male figure wearing a crown from which hung a long ribbon, and above which rose two very tall plumes. One arm was raised from the elbow to the finger-tips, shown framed within the acute fold of the royal *flagellum* (whip), a representation of sexual penetration. As a fertility-god, Min's phallus projected at right angles from his body (**Fig. 31**). Sometimes he was shown with a lion's head, and his attributes were a bed of *lettuces*, a *naos* surmounted by a *flabellum* around which were lettuces, and a small dwelling before which were bulls' horns fixed to a pole. At some time Min was identified with *Horus*, and *Isis* was therefore perceived as his mother, but at other times Isis was Min's consort, with Horus as their son. He became a deity of vegetation.

Fig. 31. *Ithyphallic* Min, *wearing high plumes on his crown, and with his arm raised within the acute fold of the* flagellum, *signifying sexual penetration (after a relief on a funerary* stela *[c.1250 BC] in The British Museum).*

mirror. Attribute of *Hathor* and *Isis* consisting of an elliptical or oval polished plate with a bone or timber handle.

Mnevis. Sacred bull-god wearing the sun-disc and *uræus* between his horns, particularly associated with Heliopolis. The son of the cow-god *Hesat*, he represented the sun-god on earth as an incarnation of *Re*, and so had similarities to *Apis*.

Moderne. The *Art-Déco* style.

Modernist. **1**. Architectural style of the 1920s and 1930s incorporating decorative devices owing much to *Art Déco*, *Aztec*, and *Ancient Egyptian* styles, prompted by the *Exposition des Arts Décoratifs et Industriels Modernes* in Paris in 1924–5. Among its commoner motifs were geometrical abstract patterns based on *Classical* ornament, including *fluting*, *wave-scrolls*, and repetitive *medallions*, with *chevrons*, *canted* and *corbelled* 'arches', *mouldings* stepped over surfaces, and geometric patterns introducing an *Egyptianising-Piranesian* flavour to it. Colours were vivid, influenced by artefacts discovered in Tutankhamun's tomb in 1922, so blacks, vermilions, greens, yellows, blues, and lavish gilding and chrome were *de rigueur*, often in enamels and in glazed openings. *Modernistic* buildings (as they were often called) also incorporated streamlining and curved walls. A good example of a Modernistic building is the former Hoover Building (*see* **Plate 217**), Western Avenue, London (1931–5), by Wallis, Gilbert, & Partners, a work much hated by *Modernists*. **2**. Person subscribing to the doctrines and principles of the International Modern movement for whom *Modernistic* architecture was anathema.

modius (*pl.* **modii**). **1**. Roman *corn-measure*, often found on the head of *Serapis/Osiris* (*see* **Plate 31** and **Serapis**: [**Fig. 47**]). It was a symbol of the Lower World. **2**. Tall cylindrical head-dress associated with certain Egyptian deities, often surmounted by two plumes (*see* **crown**: [**Figs. 19(b)** and **19(h)**]).

Montu or **Month**. War-god with a falcon-head over which rose two plumes, a disc, and a *uræus*, the son of *Re*. He was also depicted as a winged griffin. Sometimes identified with *Reshep*, but more often as the maker of victorious *pharaohs*. His sacred animal was a white bull with a black face, called *Buchis*. The necropolis, the *Bucheum*, for such sacred animals was rediscovered in 1927 at Hermonthis.

moon. The light shed at night: an attribute of *Isis/Artemis*. Depicted as a disc resting on a crescent, it occurs as a head-dress of *Khons*. Adored by *baboons*, the moon was regarded as the sun at night, and the theories and myths associated with the sun were adapted to fit the lunar context. The moon was also regarded as the left eye of the sky-god, and the waning of the moon was associated with the ascendancy of *Seth* over *Horus*, whose eye was ripped out, thus explaining the vanishing moon.

Mut. Goddess of *Thebes*, she wore the head-dress of a *vulture* surmounted by the crowns of Upper and Lower Egypt (or sometimes only the crown of Upper Egypt), and carried a *lily-sceptre* and an *ankh* (**Fig. 32**. *See also* **Amun**: [**Fig. 3**]). Sometimes she was a *lioness-headed goddess*, and, like *Isis* and *Hathor*, was symbolic mother of *pharaoh*. Her lioness character ensured she became *Mut-Bastet*, was consort of *Amun*, and adopted as the mother of *Khons*. Her Northern Egyptian equivalent was *Sakhmet* (*see* **Sakhmet**: [**Fig. 45**]).

Fig. 32. Mut *wearing a vulture head-dress surmounted by the combined crowns of Upper (white, bulbous) and Lower (like a red modius extended upwards at the back) Egypt. She carries a sceptre and an* ankh *(after an illustration of a papyrus of the XX Dynasty in The British Museum)*.

myrrh. Myrrh-trees were sacred to *Hathor*, mistress of the fragrances. Precious myrrh was employed as an *ointment* in *purification*, especially when the mouths of the dead were anointed to make them pure for food offered in sacrifice.

name. Knowledge of the names of *demons* was sufficient to destroy their powers, but survival after death was only possible if the names of the dead were preserved. Thus the obliteration of names from his monuments was an appalling fate for any dead Egyptian. A name encapsulated a person's being, and was far more than a mere label of identification. Deities such as *Osiris* and *Isis* had many names, thus ensuring their omnipotence and survival.

naöphorus (*pl.* **naöphori**). Statue holding a small shrine (often in the form of a battered case containing a statuette). The supporting figure was often shown kneeling and carrying the *naos* on the lap, and was common in European temples dedicated to *Isis* and *Serapis* (**Fig. 33**).

Fig. 33. *Ancient Egyptian* naöphorus: *it was known in Rome in the sixteenth century, so had been imported to Italy in* Antiquity *(after the black basalt example at the* Museo Nazionale, Naples, 1068*)*.

naos. **1**. Sanctuary of a temple, equivalent to the *cell* or *cella* of a Roman temple. **2**. A small shrine or tabernacle, often portable, and held by a *naöphorus* (*see* **naöphorus**: [**Fig. 33**]).

Naunet. Goddess of the primordial abyss, a member of the *Ogdoad*, so depicted as a *baboon* or snake-headed.

Nebethetepet. Heliopolitan goddess, sometimes identified with *Hathor*, but, like *Iusaas*, closely associated with the creator-god *Atum*, whom she assisted in the birth of the universe.

Nefertum or **Nefertem**. God of the lotus-flower, usually shown with a lotus-plant on his head, but sometimes with a lion-head, in

which form he was the son of *Sakhmet* and *Ptah*, but *Bastet* was also perceived as his possible mother, as was *Wadjet*.

Nehebu-Kau or **Nehebkau**. Two-headed snake-god and protector on earth and in the *Underworld*, the son of *Serket* or of *Geb* and *Renenutet*.

Neith. Creator-goddess who emerged from primæval waters to make the world. She was the patroness of weaving, and invented birth. She has been regarded as the consort of *Seth*, and as a sky-goddess with the title of Great Cow. She was the mother of the crocodile-god *Suchos*, and protector of the *Son of Horus*, *Duamutef*, the jackal-headed guardian of the deceased's stomach. Her attributes were the bow, arrows, and a shield, so she was associated with war and with the hunt.

Nekhbet. Protector of monarchs, mother-goddess and protective nurse of *pharaoh*, *Nekhbet* was the vulture-goddess of Upper Egypt, depicted with spread wings and clasping the attributes of eternity in her claws. If one wing were to be stretched in front of her, her rôle as protector would be emphasised. She was a goddess of childbirth. Her head and beak appear with *Wadjet* the rearing *uræus* above pharaoh's forehead as a symbol of the union of Lower and Upper Egypt (*see* **Wadjet**: [**Fig**. **54**]).

Nekhen. Jackal-headed deity of Upper Egypt, protective ancestor of *pharaoh*.

nemes. Type of Ancient-Egyptian *head-dress* commonly found on statues of *pharaohs*, with a tight band across the forehead and striped hangings at the sides of the head (*see* **Plate 27** and *see* **Antinoüs**: [**Fig**. **7**(**b**) and **Wadjet**: [**Fig**. **54**]). It may be an allusion to the Upper Egyptian goddess *Nekhbet's* vulture-wings.

Neo-Classicism. Movement that sought to rediscover the art and architecture of *Classical Antiquity*. It included *Roman* and *Greek* exemplars, then themes from *Herculaneum* and *Pompeii* (towns overwhelmed by the eruption of Vesuvius in AD 79), and finally motifs from *Ancient Egypt*. It also experimented with *stereometrically pure* and *primitive* forms, giving rise to a new architecture from which enrichment was often eliminated. Ancient Egyptian *pyramids*, *obelisks*, and *blocky massive buildings* were ideally suited to the æsthetic search for pure geometrical shapes. It emerged during the eighteenth century, and recurred in the nineteenth and twentieth centuries (*see* CURL [2001]).

Neper. God of barley and wheat subject to *Hapy*, who ensured that silt would be deposited so that crops could be grown. He was depicted with grains scattered on his body, and shared certain characteristics with *Osiris*.

Nephthys. Sister of *Isis* and *Osiris*, daughter of *Geb* and *Nut*, goddess of the *Ennead* of Heliopolis, and a mourner for the dead, who was *Virgo Intacta*. Nevertheless, she was associated with *Seth*, and, in one legend, gave birth to *Anubis* after a liaison with *Osiris*. She was an important funerary goddess, and protected the baboon-headed *Hapy*, one of the *Sons of Horus*, into whose care the lungs were placed in the *canopic jar*. She protected *pharaoh* through the dark *Underworld*, and mourned him as her own brother Osiris. Like Isis, she could transform herself into a kite, and although closely connected to Seth as her brother and sexual partner, suffered none of the hatred meted out to that deity.

night. A very different thing compared with primæval darkness, night was divinely made, and, as it gave way to day with the rising of the sun, so it was emblematic of the resurrection of the dead.

nimbus. Circular *halo* around the head of an image.

Nome. Ancient Egypt was subdivided for administration purposes into 42 *Nomes*, or districts, each with its own deities carrying symbols of the appropriate Nomes above their heads.

nomen. Pharaoh's name following the phrase 'son of *Re*'.

numbers. These had special significance for Ancient Egyptians. A few examples are given here:

1:	being indivisible, it represented the beginning;
2:	day and night, duality, man and woman;
3:	father, son, and child; the triad; *Osiris*, *Isis*, and *Horus*; *Amun*, *Mut*, and *Khons*; morning, noon, and evening;
4:	associated with the understanding of space, and with the cardinal points (in the solar cult of Heliopolis four-sided altars emphasised this); twice four created the *Ogdoad* of Hermopolis, or 4 pairs of primæval deities;
7:	perfection, for *Re* had seven *bas*, and *Hathor* was a seven-fold goddess. The 42 *assessors*, or judges of the dead, were a multiple of 7;
9:	wholeness; *pharaoh*'s subject peoples, and the number of the *Ennead* of Heliopolis, an all-powerful assembly of deities;
1000:	symbolised by the *lotus*, it suggested a very large amount of anything;
100,000:	its attribute, the tadpole, suggested enormous numbers;
1,000,000:	the deity *Heh*, personifying infinity and eternity.

Nun. Deity personifying the primæval waters from which the creator-god *Atum* emerged. *Nun* was sometimes depicted supporting the *solar barque* (*see* **solar barque**: **Fig. 49**), and was often identified with the Nile. He was a member of the *Ogdoad*.

Nut. The *sky-goddess*, personification of cosmic elements and forces, depicted in human form but sometimes as a bee or as the *sky-cow*. She was the daughter of *Shu* and *Tefnut*. After union with her brother, *Geb*, the earth-god, she bore *Isis*, *Osiris*, *Nephthys*, and *Seth*. She was often shown supporting herself on her toes and finger-tips, her body forming an arch over all the world, for she represented the vault of heaven or the celestial canopy. She was the mother of *Re*: she swallowed him each evening and gave birth to him each morning, so she was associated with resurrection.

obelisk. Tall tapering *shaft*, square on plan, usually monolithic, with battered sides and a pyramidal top (*pyramidion*), often incised with *hieroglyphs*, called *benben*, a manifestation of *Amun*, in Heliopolis, and often regarded as the dwelling-place of that deity. An Ancient Egyptian form, obelisks were usually found in pairs (probably to include dual solar and lunar symbolism), flanking axes, such as a temple *dromos*, but, on their introduction to Europe from the time of Augustus (reigned 27 BC-AD 14), when the first Egyptian obelisks were re-erected from 10 BC, they were usually treated as single free-standing objects, and acquired *pedestals* on which to perch. Later commemorative obelisks (e.g. Morrison's Ross Monument, Rostrevor, Co Down [1826]) were not monoliths, but constructed of *ashlar* (*see* **Colour Plates IV**, **VIII**, and **XXV**, and **Plates 10–16, 40, 50, 58, 62[b], 65, 69, 71, 73, 87, 115, 118, 136, 140, 148, 151, 152, 154, 158, 161, 170, 173, 180, 183, 184**, and **185**).

Ogdoad. Eight deities, four frog-headed gods and four snake-headed goddesses symbolic of chaos before the rise of the sun-god. They also appeared as *baboons* when greeting the dawn. The eight were *Nun* and *Naunet* (primæval waters); *Heh* and *Hauhet* or *Hehet* (infinity of space); *Kek* and *Kauket* or *Kaket* (primæval darkness [as opposed to the less terrifying and finite *night*]); and *Amun* and *Amaunet* (invisibility).

oil. Apart from its practical uses, oil was employed in ritual anointing, and seven oils were used in the mortuary ritual together with water and incense, for oils helped to prevent decay of the body essential to the Ancient Egyptian concept of the afterlife.

ointment. Oils were employed for anointing to protect an individual from the powers of darkness. They were also used in rituals of *purification*, and, boiled with *myrrh* and wax, provided the *unguents* needed for protection from decay. Unguents were also important because of their fragrance, transforming a putrefying corpse into a sweet-smelling mummy.

ollarium. Niche in a Roman *vault* or *columbarium* to hold *cinerary urns*, usually in pairs.

Onuris or **Anhur**. Bearded, spear-bearing sky- and hunter-god depicted with a crown of four high plumes and a *uræus*. His consort was the lioness-goddess *Mekhit*, and he supported *Horus* and *Re*. He was identified with *Shu*, and his consort with *Sakhmet* and *Tefnut*.

orientation. Because the sun, in its daily progression across the sky, was so important to Ancient Egyptian religion, so was orientation. Birth and death were associated with east and west, and the dead dwelt in necropoleis to the west of fertile lands, so were called 'westerners'. Temples and tombs were generally orientated east–west. Some temples (e.g. that of *Hathor* at Dendera) were aligned on *Sothis*, the dog-star, sacred to Isis (who appears on reverse types of drachmas [or drachms] riding the dog). Similarly, left and right had considerable importance for Ancient Egyptians. Life entered a body from the right side, and death came through the left. *Pharaoh* was equated with the sun and the right eye, and the Queen was equated with the moon and the left eye. Left was identified with the east and right with the west.

Orion. Constellation identified with *Osiris* and *pharaoh*.

ornament. Ancient Egyptian ornament was certainly colourful and decorative, but much of it also had profound symbolic meaning, lifting that which it adorned to a higher plane.

Common ornament was the continuous *frieze* of rearing *uræi*, the *lotus* and *papyrus* (both in bud and flower form), coils, spirals, scrolls, stylised flowers as rosettes, winged solar discs, stylised figures, hieroglyphs, and symbols of deities.

Osiride. Pier with an engaged figure of *Osiris* in front of it: unlike a *caryatid(e)*, the *pier*, rather than the *figure*, supported the structure (**Fig**. 34). The figure of Osiris was also found seated.

Fig. 34. Osiride, *featuring Osiris wearing the atef crown and holding the crook and the flagellum (or flail), symbols of kingship (after examples in Thebes).*

Osiris. Consort and brother of *Isis*, the first-born of *Geb* and *Nut*, who enjoyed the most general veneration, was a protective funerary god, and whose realm was the *Underworld*. However, he brought agriculture and wine-growing to the world, and was called *Wennefer*, the perfect one. He usually appeared as wrapped in the linen of the embalmers, but his arms were shown free of the bandages, holding the crook and flail of kingship (*see* **Osiride**: [**Fig**. 34]). His *atef* crown was decorated with plumes on either side. He was killed by *Seth*, but there is one version of the legend that claims he died by drowning in the Nile near Memphis, and so was associated with the annual inundation which brought the dead lands back to life. Isis gathered up his flesh, and *Thoth* and *Horus* raised him on his side before the embalming ritual took place (in other versions, Seth dismembered the body and Isis searched and found the pieces, using her formidable powers to re-assemble her brother). Even more remarkable (if possible) was the impregnation of Isis (as a kite) by the dead

Osiris, which caused the goddess to bear the younger *Horus*. In yet another legend, Seth threw Osiris's *phallus* into the Nile, where it was eaten. Isis then manufactured another phallus, but the super-supernatural means by which Horus was conceived suggest that the Marian *cultus* owes at least something to Ancient Egypt.

Osiris is particularly associated with the *djed* column, symbolising stability and continuity, which was known as *Osiris's backbone*. The Egyptian monarchy and Osiris were closely linked, and when *pharaoh* died he became Osiris, king of the Underworld, just as on earth he was Horus, who carried on Osiris's work after the last's death. Osiris was the lost sun, monarch of the infernal regions, supreme judge of the dead, and the embodiment of wisdom. Connected with the constellation of *Orion* (where he 'dwelt'), he was also linked with the sun, emphasised through his 'residence' at Heliopolis. In the Upper World Osiris continued to live and work through the power of Horus, and he was ever-renewed by his incarnation in the form of the black bull *Apis*, and was therefore called *Osiris-Apis*, or *Osorapis*. He was identified with *Dionysus, Zeus, Amun*, and *Pan*, as *Serapis* (or *Sarapis*), shown with a corn-measure (*modius*) on his head (*see* **Serapis**: [**Fig. 47**]). Temples of Serapis often had a *Lady Chapel* attached, dedicated to Isis.

Osiris Canopus. Figure in the shape of a *canopic jar* with a male head on top, not used as a *visceral jar*, it appears as a reverse type on coins struck in Roman Alexandria, and as an ornament in both *Antiquity* and the *Neo-Classical* period (*see* **canopic jar**: [**Fig. 14(b)**]).

ouroboros or **uroboros** (*οὐροβόρος*). Symbol of a snake in the form of a circle, eating its tail: it represents continuity, eternity, or infinity.

Pakhet. Lioness-goddess identified with *Artemis*, the Greek goddess of the hunt.

palm. The inspiration for much decorative work (**Fig. 35**). Palm-trees were represented

in Egyptian architecture as *columns* with *vertically-banded shafts* and *tightly-packed leaves* forming the *capital* (*see* **capital**: [**Fig. 16(g[i])**]). A *palmette* was a stylised palm-leaf, often used with the *anthemion* (*see* **anthemion**: [**Fig. 6**]), and is also found alternating in bands with the *lotus* (*see* **Colour Plates XI** and **XXXVI** and **Plates 54, 132, 188**, and **192**). Palms were associated with Upper Egypt, fertility, and with the goddesses *Hathor* and *Nut*: they were especially sacred to *Re*, for the branches resembled that deity's high crown. Palm-trees with double or triple trunks were symbolically linked with *Min* and *Thoth*. A *palm-leaf* signified a year, and if worn as a head-dress, signified longevity or even eternity.

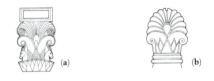

Fig. 35.
(a) *Egyptian wall-painting showing a capital-like arrangement with voluates and lotus-flower;*
(b) palmette *design with vestigial floral and volute decorations from Cyprus: the* anthemion *of Greek decorations usually featured the lotus or palmette, and the design bridges Egyptian and Greek ornament (after various sources).*

Panebtawy. Offspring of 'Haroeris', or *Horus* as he grew in strength, lord of Upper and Lower Egypt, and therefore symbolising the legitimacy of *pharaoh* as ruler of the two lands. His mother was *Tasenetnofret*.

panther. *See* **leopard**.

papyrus (*pl.* **papyri**). The paper-reed (*Cyperus papyrus* or *papyrus antiquorum*), used decoratively (**Fig. 36**), symbolising that which had risen from the primæval waters. Columns with papyrus *capitals* supporting the roofs of temples alluded to primæval creation (*see* **capital**: [**Fig. 16(h)**]). *Papyriform* means in the shape of a cluster of papyrus leaves and flowers. Papyri were associated with green, joy, triumph, and that which flourishes. The plant was an emblem of Lower Egypt, and

was associated with *Wadjet*, *Bastet*, and *Horus* (*see* **Plates 23, 54**, and **188**). It was used to make material on which to write.

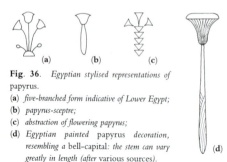

Fig. 36. *Egyptian stylised representations of* papyrus.
(**a**) *five-branched form indicative of Lower Egypt;*
(**b**) *papyrus-sceptre;*
(**c**) *abstraction of flowering papyrus;*
(**d**) *Egyptian painted papyrus decoration, resembling a bell-capital: the stem can vary greatly in length (after various sources).*

Pe. Falcon-headed god of Lower Egypt, protective ancestor of *pharaoh*.

pediment. In *Classical* architecture, a low-pitched triangular *gable* following the roof-slopes, crowning a *portico* or a façade, and often containing sculpture in its *tympanum*. The profile of the top part of the *entablature* was repeated on the *raking* sides. Pediments also occur over doors, windows, and niches. Whilst *triangular* pediments are the most common (**Figs. 37[a]** and **37[b]**), *segmental pediments* (**Fig. 37[c]**) were introduced during the Roman Empire, associated with the cults of *Isis* and *Artemis of Ephesus* because of the shape of the *crescent-moon* and the *bow-shape* of the huntress's weapon. However, the curved roof and segmental pediment also belong to an old tradition in Ancient Egyptian wood-and-reed buildings which entered the Classical language of architecture via Ptolemaïc Egypt (*See* MEYBOOM [1995], 248, [Note 83]). (*see* **Plates 17, 18**, and **19**).

Fig. 37(a). *triangular* pediment (shown pecked), *with* open-topped *or* broken-apex triangular *pediment* (shown with solid lines only);

Fig. 37(b). open-bed *or* broken-base triangular *pediment* (shown pecked), *with* true broken *or* open triangular *pediment* (shown with solid lines only);

Fig. 37(c). segmental *pediment* (shown pecked), *with* open-topped segmental *pediment* (shown with solid lines only) *(after* CURL [1999, 2000]*).*

pelican. Deity capable of removing large numbers of hostile beings from the waters in its capacious beak. The pelican (*Henet*) could foretell how the dead would fare in their journeyings in the *Underworld*, and had connections with the concept of the dead being able to leave the tomb and worship the sun.

Persic. A *Persic column* has a bell-shaped capital and a base of the same size, and was much ornamented with *lotus*. It was an ingredient of *Egyptianising* ornament of the early nineteenth century, although owing much to Achæmenian prototypes from Persepolis.

Pesedjet. *See* **Ennead**.

Peteese (or **Pedesi)**. Minor deity, who, with his brother *Pehor* or *Pihor*, was drowned in the Nile, and therefore had associations with *Osiris*. The Roman-Egyptian temple erected at Dendur in their honour is now in the Metropolitan Museum of Art, New York. Their fate had parallels in the deification of *Antinoüs*.

phallus (*pl.* **phalli**). Ancient Egyptian imagery often incorporates ithyphallic male figures (i.e. with erect phalli): examples include *Geb*, *Min* (*see* **Min**: [**Fig. 31**]), and *Osiris*, suggesting fertility and the victory of the life-force over death.

pharaoh. Deified monarch or king of Upper and Lower Egypt, identified on earth as the personification of *Horus*, and the link between the afterlife and life on earth. As 'son of *Re*' he was also guarded by the vulture-goddess of Upper Egypt (*Nekhbet*) and the cobra-goddess of the Delta (*Wadjet*), both of whom appear on his head-dress (*see*

454

Wadjet: [**Fig. 54**]). Pharaoh became a god through elaborate ritual presided over by *Horus* and *Thoth*: on his death he ceased to be Horus and became *Osiris* as king of the *Underworld*.

pharaonic stance. Male figure standing with left foot before right, with arms held rigidly at the sides, often with *nemes* head-dress and *shendyt* kilt (*see* **Antinoüs**: [**Fig. 7(b)**]).

phoenix. Sacred bird of Heliopolis. It was called by the Egyptians *benu* or *bennu*, and *phoenix* by the Greeks. It was perceived as the *ba* of *Re* and as a manifestation of *Osiris*. It was supposed to live on the *benben* or *obelisk*, and, according to Greek legend, it burned itself to death and rose again from the fire, so was associated with sunrise and with resurrection of the dead.

Picturesque. Eighteenth-century English *æsthetic category* which defined a building, a building in a landscape, or a landscape that resembled a composition by *Poussin*, *Claude*, or *Salvator Rosa* as *Picturesque*, from *pittoresco*, meaning '*in the manner of the painters*', and was hugely influential throughout Europe. Asymmetrical compositions, natural features, and buildings that seemed to belong to the setting were important ingredients of the Picturesque, which also encouraged *eclecticism* and the association of certain architectural styles for building types.

pig. An unclean animal, associated with *Seth*, who attacked *Horus* in the guise of a black boar. Pigs were sacrificed as part of the lunar festivals to *Isis* and *Osiris*. *Nut* became a celestial sow, devoured the stars, and gave birth to them again, so the sow was a popular *amulet* associated with fertility.

Pihor. *See* **Peteese**.

pluteus. Low wall set between Classical columns, about a third of the height of the columns, in a *colonnade*, common in the later Egyptian architecture of the Ptolemaïc and Roman periods (*see* **Plate 96**).

portico. Covered ambulatory consisting of a series of columns spaced at regular intervals supporting a roof, normally attached as a colonnaded porch to a building. The volume so created can be open or partly enclosed at the sides, stand before a building such as a temple, and often have a *pediment* over the front, in which case it is described as a *temple-front*. A *Classical* portico can be defined with precision. The main types are:

prostyle: with the columns set in a line standing before and detached from the front wall of the building behind (**Figs. 38[a]** and **38[b(i)** and **(ii)]**).

in antis: with the columns set in a line between the projecting walls enclosing the sides of the portico, i.e. between the *antæ* (*see* **anta**) of the walls (**Fig. 38[b(iii)]**);

engaged: with the ensemble of columns, entablature, and pediment embedded in the front wall (**Fig. 38[c(ii)]**);

In both *in antis* and *prostyle* porticos, the design is further defined by the number of columns visible on the front elevation. The commonest varieties are:

distyle (2, usually *in antis* [**Fig. 38(b[iii])**]); *tristyle* (3); *tetrastyle* (4); *pentastyle* (5); *hexastyle* (6 [**Fig. 38(c[i])**]); *heptastyle* (7 [**Fig. 38(c[ii])**]); *octastyle* (8 [**Fig. 38(c[iii])**]); *enneastyle* (9); *decastyle* (10); and *dodecastyle* (12). A portico with 4 columns standing in front of the main building behind is *prostyle tetrastyle*, and if it has 2 set between the *antæ* of flanking walls, it is *distyle in antis*.

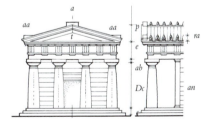

Fig. 38(a). *Greek unfluted prostyle tetrastyle portico (after* CURL [1999, 2000]).

a	acroter	*Dc*	*Doric unfluted column*
aa	acroteria angularia	*e*	*entablature*
ab	abacus	*p*	*pediment*
an	anta	*ra*	*row of* antefixa
c	*crepidoma*	*t*	*tympanum*

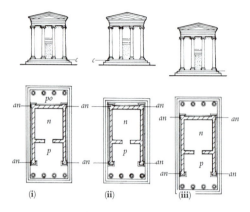

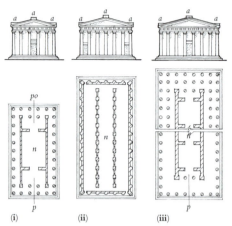

Fig. 38(b). *Column arrangements for a small Greek Ionic temple:*
(i: left) amphi-prostyle tetrastyle, *or* amphi tetra-prostyle, *i.e.*
with four columns standing in front of and at each end of the cell;
(ii: middle) prostyle tetrastyle *or* tetra-prostyle, *i.e. with four*
columns standing in front of the cell;

(iii: right) distyle in antis, *i.e. with two columns standing in front*
of the cell set between antæ *terminating the projecting cell walls, an*
arrangement only found on very small temples, tombs, or shrines.

In Egyptian Revival work similar arrangements are found, with
Egyptian substituted for Greek detailing (after CURL [1999,
2000]*).*

c	3–step crepidoma,	an	anta
	the top step of which is	n	naos or cell
	the stylobate	p	pronaos
po	posticum or epinaos		

Fig. 38(c). *Various types of Greek-Doric temple-plans:*
(i: left) peripteral hexastyle, *i.e. with colonnades surrounding the*
cell or naos, and six columns at each end forming the porticoes and
carrying the triangular pediments;

(ii: middle) pseudo-peripteral septostyle *(or heptastyle), i.e.*
with all columns engaged with the temple walls, and with seven
engaged columns at each end, resulting in entrances off-centre;

(iii: top right) half-plan, dipteral octastyle, *i.e. with two rows of*
columns surrounding the cell, and eight at each end forming the
porticoes and carrying the pediments;

(iii: bottom right) half-plan, pseudo-dipteral octastyle, *i.e. with*
a wider space between the walls of the cell and the peristyle, and with
eight columns at each end forming the porticoes and carrying the
pediments. This wide space suggests that further colonnades ought to
stand behind the outer ones (after CURL [1999, 2000]*).*

a	acroter	n	naos
po	posticum or epinaos	p	pronaos

Post-Modernism. Late twentieth-century style that seemed to reject the *Modern Movement*, and had some *Historicist* references, such as *pediments, columns, keystones*, and the like, but often used in a whimsical and unscholarly manner. It had echoes of *Egyptianising* elements in it, and some critics welcomed its complexities and contradictions.

prenomen. *Pharaoh's* name following the phrase 'King of Upper and Lower Egypt'.

primæval mound. The Ancient Egyptians believed that the world emerged from the primæval waters as a mound, and the first deity took his rest on it. Nilotic islands subject to the rise and fall of the waters were seen as mnemonics of the mound, and of death and resurrection, so were chosen as sites

for 'tombs' of Osiris. In temples, such as those at Karnak, the raised floor-levels probably allude to the primæval mound.

procession. Ancient Egyptian religious processions were intended to make the existence of deities visible, although the image was concealed in a *naos* on a *barque* or stretcher carried on the shoulders of priests. Each year *Hathor* was carried from Dendera to *Horus* at Edfu, an allusion to the union of the deities of the sky and sun.

pschent. Combined crowns of Upper and Lower Egypt (*see* **crown**: [**Fig. 19(d)**]).

Ptah. Egyptian god of fire, and creator-god, associated mostly with *Memphis*. Wearing a tightly-fitting skull-cap (or perhaps shaven-

headed), he carried the *was*, or sceptre of dominion (consisting of a rod at the top of which were the four bars of the *djed* column [stability] and the *ankh* [life]), and his body was closely wrapped (**Fig. 39**). Ptah was the creator of skills in architectural design, and the real architect, *Imhotep*, was regarded as his son, the Great Architect of the Universe. Ptah was also lord of truth, and could blind those swearing false oaths. The sacred bull *Apis* was the intermediary between the deity and mankind, and Ptah's consort was *Sakhmet*. As the deity of craftsmen, Ptah himself was closely associated with the stupendous works of architecture of Ancient Egypt.

Fig. 39. *The deity* Ptah *holding the* was *sceptre of dominion that combines the* ankh *(life) and* djed *(stability) symbols (after an original in The Cairo Museum).*

pteron. An external peripteral *colonnade* (*see* **Plate 5**). (*See also* **portico**: [**Fig. 38(c)**]).

purification. Rituals required purification, usually by means of water. The dead were also purified by means of bathing as well as *ointments* and *unguents*. Baptism is the Christian equivalent of Ancient Egyptian *lustration*, and the water-basins in front of temples were forerunners of holy-water *stoups* and *fonts*.

putto (*pl.* **putti**). Unwinged male child or chubby male baby, found in *Classical* and *Baroque* sculpture. *Putti* are given to obesity, and have a knowing air, as though they have been up to no good. The Græco-Roman *Harpocrates* is usually depicted as a *putto* (*see* **Plate 21** and *see also* **Isis**: [**Fig. 28(c)**]). *Compare* **cherub**.

pylon. *Portal* of an Ancient Egyptian temple composed of two massive *battered* towers, usually decorated with bas-relief sculptures and hieroglyphs, flanking a lower framed gateway

which, like the towers, was crowned by a *cavetto* or *gorge-cornice*. The towers may be mnemonic of *Isis* and *Nephthys*, who raised the sun, and they were guardians of the deity in his sanctuary behind. The towers had their corners finished with *torus* mouldings that were continued horizontally at the tops of the battered walls under the gorge-cornices (**Fig. 40**). Some authorities use the terms *pylon*, *propylon*, *pylône* for the gateway and *propyla* for the towers. A *pylon-form* resembles one of the towers, and indeed the term *pylon* is now usually given to the towers, following the precedent set by the editors of the *Description de l'Égypte* (1820s). Pylon-forms (often found in nineteenth-century chimney-pots) lent themselves to the towers of suspension-bridges, such as I. K. Brunel's (1806–59) structure over the gorge at Clifton, Bristol (1829–36, completed 1861 after modification), and the battered profile was widely employed for retaining-walls, plinths, and dams (*see* **Plates 17, 98, 115, 127, 128,** and **208**).

Fig. 40. (left) *typical battered Egyptian* pylon-*tower with gorge-cornice and torus moulding framing the façade;* (right) *adaptation of the form as a doorcase (after an original drawing by the Author).*

pyramid. Solid standing on a square base with four steeply *battered* triangular sides meeting at an *apex*, used as *mausolea* in Ancient Egypt, and recurring in *Neo-Classical* designs. It may have evolved from stepped forms derived from the *mastaba*, and its origins may lie in the concept of the *primæval mound*. The top of a pyramid was linked with the form at the top of an *obelisk*, and was connected with the idea of the rays from the sun, for *pharaoh*, after

all, entered the afterlife as *Son of Re*. Other types of pyramid include the stepped form found in both Ancient Egyptian and Meso-American Pre-Columbian architecture. Pyramids appealed to *Neo-Classical* designers for their stereometrical purity of form, and pyramidal compositions were common for funerary monuments. Before the rediscovery of Egypt from the eighteenth century, pyramids were often confused with *obelisks*, and fat obelisks with pyramids, but the two forms are quite distinct (*see* **Plates 24, 30, 41, 53, 55, 56, 62, 64, 75, 80, 81, 83, 86, 91, 110, 112, 114, 122, 123, 124, 163, 167, 170,** and **184**).

Qadesh. Goddess of ecstasy and sensual pleasure, often found as part of a triad with the ithyphallic *Min* (*see* **Min**: [**Fig. 31**]) and the bearded god *Reshep* (*see* **Reshep**: [**Fig. 42**]). She may have been a composite goddess based on *Anat* and *Astarte*. She was depicted standing naked on the back of a lion, presenting lotus-flowers to Min and papyrus-plants or snakes to Reshep (allegories of eroticism and fecundity). She was sometimes identified with *Hathor*.

Qebehsenuef or **Qebsennuef**. *Son of Horus*, represented by a hawk-headed stopper on a *canopic jar* containing the intestines removed during the process of mummification (*see* **canopic jar**: [**Fig. 14(a)**]). He was protected by *Serket*.

ram. As a powerful animal associated with fecundity, it was identified with *Khnum* at Elephantine and Esna, with *Heryshaf* at Herakleopolis (south of Crocodilopolis), and as *Kherti* in the district of Letopolis (on the west side of the Nile opposite Heliopolis). It was also associated with *Amun*, but in that case its horns curved downwards (in others they projected more or less horizontally). *Re* was often depicted as a ram-headed deity (*see* **Re**: [**Fig. 41**]).

Re. Immensely powerful sun-god, whose influence permeated the earth, the sky, and the *Underworld*, and whose cult-centre was

Heliopolis. He was found as a falcon wearing the sun-disc (framed by the cobra-goddess's body) on his head. When in the Underworld he assumed the form of a ram-headed man, but the cobra-goddess *Mehen*, signifying his power to kill instantly, was nearly always in attendance on him (**Fig. 41**). *Pharaoh* was held to be the *son of Re*, and therefore divine. Re was the creator, emerging from the primæval *lotus*, and was responsible for ordering the rising of the Nile, thereby bringing water to the dry lands. He appears to have instituted circumcision, by mutilating his own *phallus*, from the blood of which evolved the notions of authority and intellect. He became identified with other deities, or even coalesced with them, including *Amun* and *Khnum*: he also seems to have merged, in a curious way, with *Osiris*.

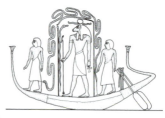

Fig. 41. Re *as ram-headed god in the* Underworld, *travelling on the* mesektet *night-boat protected by the serpent-goddess* Mehen *shown coiled around Re's kiosk standing on the boat's deck (after a representation of Re's journey in the XIX Dynasty tomb of Seti I, Thebes).*

red. *See* **colour**.

Regency. English style of interior decoration and architecture during the incapacity of *King George III* (1810–20): it was predominantly *Neo-Classical*, with a considerable *Empire* input, and it included *Egyptianising* and *Oriental* motifs. It continued during the reign of *King George IV* (1820–30).

Renenutet. Cobra-goddess, a female figure with a rearing cobra instead of a face, protectress of *pharaoh* by merging with the king's *uræus*. She was especially a goddess of fertility and of harvests. She was connected with the production of linen to wrap mummies, and controlled the destinies of

mankind. With *Meskhenet* she was present at childbirth, and encouraged the will in babies to live. She was also identified with *Maat*, goddess of truth and order: in the Græco-Roman period she became *Hermouthis* or *Thermouthis*, and later a manifestation of *Isis*.

Reshef, **Reshep**, or **Reshpu**. War- and thunder-god of Syrian extraction, bearded like a Syrian rather than an Egyptian, sometimes wearing the white crown of Upper Egypt, and sometimes with a banded head-dress with a gazelle's head or horns in front and a long ribbon trailing from the top or rear. He usually carried a spear and a shield, and has been identified with *Montu* and *Seth*. He was often associated with *Min* and *Qadesh* (**Fig. 42**).

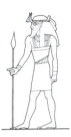

Fig. 42. *Version of the war-god* Reshep, *bearded, wearing a gazelle's head on his forehead, and carrying a spear (after a relief on a funerary* stela *[c.1250 BC] in The British Museum).*

right and left. *See* **orientation**.

ring. A symbol of eternity, without a beginning and without end (*see* **ouroboros**). The hieroglyph for eternity resembled a loop with two ends tied in a knot, a form found in protective *amulets* (**Fig. 43**). It has similarities to the frame of a *cartouche* (*see* **cartouche**: [**Fig. 17**]). Other looped or knotted forms found as amulets include the *ankh* (*see* **ankh**: [**Fig. 4**]), the *tyet* (*see* **tyet**: [**Fig. 52**]), and the *sa* (*see* **sa**: [**Fig. 44**]).

Fig. 43. *Knotted ring, symbolic of eternity (after examples from numerous sources).*

Rod of Æsculapius. A *staff* entwined with *serpents*, resembling the *caduceus*, but without the wings.

rope. A symbol of bondage, often depicted in association with bound captives and animals. It was also a symbol of fate, and could be transformed into a serpent.

rose. Associated with *Isis* and *Horus/Harpocrates*, the rose is the flower of *silence* and *secrecy*, hence *sub rosa*. It is the emblem of the *Virgin Mary* and of *Isis*.

route. The route the sun took each day for Ancient Egyptians had parallels with their own lives, because the night journey of the sun was fraught with dangers, yet each morning the sun was reborn and passed through the heavens. A route through a large temple complex between rows of *sphinxes* and *criosphinxes*, through portals flanked by *pylon-towers* and *obelisks*, through courts, a *hypostyle hall*, between more pylon-towers and sequences of spaces, towards a holy of holies, alluded to rites of initiation and to the purification of the soul after death.

sa. Sign of protection associated with *Bes* (*see* **Bes**: [**Fig. 12**]) and *Taweret*: it was therefore especially connected with childbirth (**Fig. 44**).

Fig. 44. *Symbolic of protection, the* sa *represents a primitive shelter made of* papyrus *plants (after examples from numerous sources).*

sacred lake. Each year the waters of the Nile brought life to the lands flanking its course, suggesting the *primæval mound* emerging from the primæval waters. Large temples therefore had artificial 'sacred lakes' in which renewal took place with each dawning day, and the sun-god cleansed himself. Essentially large places for *purification*, priests ritually bathed there, the dead were cleansed, and the sacred *barque* of the deity of the temple ceremonially sailed there.

Sakhmet or **Sekhmet**. Ferocious fire-breathing lioness-headed war-goddess of Memphis (**Fig. 45**), daughter of *Re* and

consort of *Ptah*, sometimes identified with *Mut*. She was a symbol of the heroism of *pharaoh* in battle. She has been called 'Lady of the Acacia', and was identified with *Bastet*. Her son was *Nefertum*, the important lotus-god. Even *Seth's* minions and the snake *Apophis* were no match for her, for she was the fire-spitting *uræus* and *eye of Re*.

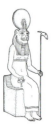

Fig. 45. Sakhmet *the lioness-goddess, shown seated. Representations of the goddess* Wenut *were similar to those of Sakhmet (composite image after example in the Villa Albani-Torlonia, Rome, 562, The Cairo Museum, and the beautiful* Wenut *in the* Musée du Louvre, *N4535).*

sandal. **1**. Symbol of authority and property, as well as an item of footwear. **2**. Symbol of purity.

sarcophagus (*pl.* **sarcophagi**). *Stone* or *terracotta coffin*, sometimes, if *Classical*, with a pitched lid and *acroteria* at the corners. This type of pitched lid with simplified *acroteria* was adapted for the cappings of piers in the *Neo-Classical* period, and in this usage is called a *cinerarium lid*. Some Egyptian sarcophagi have segmental-topped lids (*see* **Plate 30**).

Satis, **Satjit**, or **Satet**. Guardian-goddess of Egypt's southern frontier and Lower Nubia, known as 'Mistress of Elephantine', shown wearing the white crown of Upper Egypt, further embellished with antelope-horns, a *uræus*, and/or plumes. As giver of water, she was associated with the annual Nile flood, and provided supplies of water for purification of dead bodies. She was daughter of *Khnum* and *Anukis*, or, in another version, consort of Khnum and mother of Anukis. She had a relationship with *Montu*.

scarab. Symbol of the *sun*, of *regeneration*, and of *good fortune*: it is a large winged *dung-beetle* (*see* **Colour Plate XIII [b]**). The Ancient Egyptians believed that the beetle spontaneously arose by an act of self-creation from a ball of dung, and so, personified as

Khepri, who pushed the sun up above the horizon and rolled it across the sky (*see* **solar barque**: [**Fig. 49**]), was identified with the creator-god *Atum*. Scarabs were made of stone, faïence, etc., with undersides incised with *hieroglyphs*. They were used for seals and as amulets.

scorpion. As with other dangerous creatures, scorpions were venerated by the Ancient Egyptians, and were often found as protective *amulets*. *Isis* was assisted by seven scorpions against her foes, and scorpions were personified by the goddess *Serket*, protector of the living and the dead, and, with *Isis*, *Neith*, and *Nephthys*, watched over the body of *Osiris*. She was also protector of *Qebehsenuef*, one of the *Sons of Horus* (*see* **canopic jar**: [**Fig. 14(a)**]).

Sebek. Crocodile, associated with **Suchos**.

Sebiumeker. Anthropomorphic god of fecundity, sometimes associated with *Apedemak*.

sedge. Plant of the *Cyperaceæ*, a family distinguished from grasses by its triangular stems and leaf-shoots, often used in iconography to denote Upper Egypt (*see* **bee**: [**Fig. 11**]).

Sefkhet-Abwy. Goddess of libraries and scripts. She was shown with a seven-pointed star set below a bow-like arc, and seems to have been a variant of *Seshat*.

sekhem. **1**. Power, an attribute of deities and monarchs. It was symbolised by a staff of office, often associated with *Anubis* and *Osiris* (**Fig. 46**). **2**. Elements, e.g. stars, perceived as standing between deities and men.

Fig. 46. *Top of* sekhem *sceptre associated with authority (after several sources).*

Sekhmet. See **Sakhmet**.

Selket. See **Serket**.

Selkis. Greek form of *Selket*. See **Serket**.

Senmut or **Senenmut** (*fl. c.*1473–*c.*1458 BC). Ancient Egyptian architect and courtier whose career was associated with the reign of Queen Hatshepsut (*c.*1479–*c.*1458 BC). His master-work of architecture is the mortuary temple at Deïr-el-Bahari (*c.*1473–*c.*1458 BC), with its great ranges of square columns, massive ramps joining the three main levels, and powerful, monumental symmetry (*see* **Colour Plate III**). The complex includes columns that are seen by some as proto-*Doric*, *Osiride* features, and numerous *sphinxes*. It is one of the finest and most original of all the buildings of the New Kingdom (1550–1069 BC), and influenced European and American *Neo-Classicism*.

Sepa. Centipede-god of Heliopolis, sometimes with a donkey's head, and sometimes shown in the form of a mummy with two horns. He was identified with *Horus* as a god of the dead and of mortuaries, and he was regarded as a protector against enemies of the deities.

Serapeion. *Temple* where the god *Serapis* or *Sarapis* was worshipped. It usually had a *Lady Chapel* or *Isæum* attached to it, where *Isis* was venerated (*see* **isæum**: [**Figs**. 27(a) and 27(b)]). At Saqqara the *Serapeion* was the site of the burials of the sacred *Apis-Bulls*.

Serapis or **Sarapis**. Anthropomorphic composite god with Egyptian and Hellenistic attributes (he was introduced to Ptolemaïc Egypt in the third century BC), combining *Osiris* and *Apis* (*Osorapis*) in the character of *god of the Lower World*. The idea of the god in *Antiquity* was extended to include *Osiris*, *Pluto*, *Asclepius-Æsculapius*, and *Zeus-Jupiter*. Serapis was particularly associated with healing and agricultural fecundity, and is usually represented with a *modius*, or *corn-measure*, on his head (**Fig**. 47). (*See also* **Plate 31**), an attribute connected with his

importance as a deity of the corn-supply from Egypt to Rome. He is sometimes accompanied by an animal with the head of a dog, lion, or wolf, and with a serpent coiled round the body. He was immensely important, and his cult (the main centre was the *Serapeion* in Alexandria) was widespread throughout the Græco-Roman world (*see* HORNBOSTEL [1973]) (*See* **modius**).

Fig. 47. *Græco-Roman version of* Osiris *as* Serapis/Sarapis, *shown with the* modius, *or corn-measure (symbol of the* Underworld*), on his head (after the bust in the* Sala Rotonda, *Vatican Museum, Lippold III, 1, 549).*

serekh. Rectangular frame around the name of *pharaoh*, pre-dating the more familiar *cartouche* (*see* **cartouche**: [**Fig**. 17]).

Serket, **Selket**, or **Selkis**. Scorpion-goddess, usually a human female with a scorpion with raised tail poised to strike perched on her head, important as a protector of *Qebehsenuef*, the *Son of Horus* who guarded the intestines removed during the process of mummification. She tied up *Apophis*, and guarded sharp bends on the path in the *Underworld*.

serpent. Associated with *healing*, and with *wisdom*, it is found on the *caduceus*, and with the *winged globe*. As a life-giving creature, it was associated with the four female members of the *Ogdoad*, and even *Amun*, as a primæval deity, adopted the form of the snake *Kematef*. The most significant serpent-deity was *Wadjet*, who, as the *uræus*, appeared on *pharaoh's* head-dress (*see* **Wadjet**: [**Fig**. 54]). Snakes could be enemies of the gods, such as *Apophis*, foe of *Re*, but *Mehen*, the coiled snake, attended *Re* in his journey in the *Underworld* (*see* **Re**: [**Fig**. 41]). The snake, because it could discard its skin, was associated with life after death. The snake with its tail in its mouth symbolised eternity,

the vastness of the sea, and *primæval waters*, and is called *ouroboros* or *uroboros*. Snakes could also be *Isis* and *Nephthys*.

Seshat. Chief goddess of scripts, senior to *Sefkhet-Abwy*, wearing a panther-hide over her linen tunic, and with a seven-pointed star over her head. She was shown holding a notched palm-branch (suggesting years or the measurement of time), and she had responsibility for recording all sorts of data. In some respects she was also involved in setting out the foundations of buildings, so was important in architecture.

Seshmu. *See* **Shezmu**.

Sesy. Flame-breathing snake of the *Underworld*.

Seth. Enormously strong son of *Geb* and *Nut*, and therefore brother of *Osiris*, *Isis*, and *Nephthys*. As god of chaotic forces, he was associated with violence and with the terrible Semitic goddess *Astarte* or *Ashtoreth*, sometimes called 'daughter of Ptah'. He was also lord of all metals. He was the murderer of Osiris and enemy of Horus (whose eyes he cut out [but these were restored by *Hathor*, using gazelle's milk, or, in another version, by Thoth] and whom he assaulted sexually). Seth was held to be responsible for storms, presided over chaotic realms (e.g. deserts and the sea) and forces, and was hostile to cultivated regions. He is often represented with a human body and a head that seems to be a cross between that of a donkey and a pig (**Fig. 48**). His consorts were *Anat* and *Astarte*, and he was identified with *Typhon*. His realms were dark and horrible places, and held great terrors for Ancient Egyptians. Hippopotami, normally regarded as benign, could sometimes run amok, destroying boats and crops, in which case the offenders were perceived as incarnations of Seth and were killed. He could also become a crocodile, a panther, a donkey, an ass with a serpent's head, and even a goose, so he was nothing if not protean, and extremely dangerous. Interestingly, in one legend Horus tore off Seth's testicles and a foreleg during their battles for supremacy: the Egyptians called the Great Bear constellation 'the foreleg of Seth'. He was also associated with non-Egyptian or foreign lands, and so was regarded as a national enemy.

Fig. 48. Seth, *holding a lotus-plant associated with Upper Egypt (after* an image in The Cairo Museum*)*.

Seven Wonders of the Ancient World. The *Pyramids* at Gizeh, the *Hanging Gardens and Walls* of Babylon, the *Temple of Artemis* at Ephesus, the statue of *Zeus* at Olympia, the *Mausoleum* at Halicarnassus, the *Colossus* of Rhodes, and the *Pharos* at Alexandria.

shabti, shawabti. *See* **ushabti**.

shadow. Part of a human being, with body and soul. It was depicted as black, leaving a tomb with a bird representing the *ba*. It was also represented by the *flabellum*, symbolising protection.

Shay. Personification of destiny, depicted in human form. As god of fate, he pre-determined the lives of men, and represented the years allotted to a life. He was often associated with *Meskhenet* and *Renenutet*, and in the Græco-Roman period he merged with the Alexandrian serpent-god of fortune, *Agathodaimon*.

shemset. Girdle with an apron-like element of pendent beads, a symbol of power, sometimes shown as an apron with narrow strips of leather suspended from a belt around the waist. It was associated with the god *Sopedu*.

shendyt. Ancient Egyptian kilt-like garment such as that worn by *Antinoüs* in the celebrated statue from Tivoli re-discovered in 1740 (*see* **Antinoüs**: [**Fig. 7(b)**]).

shepherd. Mankind was regarded as a herd of cattle, cared for by a benevolent *Amun*. *Re* was referred to as a shepherd, and *pharaoh* was also seen as a divine shepherd, hence the *crook* insignia.

Shesmetet. Lioness-goddess, apparently another manifestation of *Sakhmet*.

Shezmu or **Sheshmu**. God, sometimes anthropomorphic, and sometimes leonine. As a butcher he prepared and cooked minor deities and certain humans as food for *pharaoh*, to build up his strength. He also prepared grape-juice for making wine, and presented it to the monarch, so he was a god of wine-presses, although his implements often pressed human hearts instead of grapes, thus causing the sky to glow red at sunset. On the brighter side, Shezmu also produced first-class oils and perfumes in his many presses, so he was the god of perfume.

shield. Symbol of protection, often shown with two crossed arrows above, particularly associated with *Neith*. It was also an attribute of *Reshef*.

ship. Symbol of a journey from one life to another, to the Ancient Egyptians an important aspect between life and death. *See* **barque** and **solar barque**.

shrew. Sacred animal of *Horus*, possibly representing the god's darker side, for shrews have poor sight and live underground. Shrews were associated with blindness and death, and were also involved in the rebirth of the sun.

Shu. With his sister-wife *Tefnut*, one of the two deities created by *Atum* the sun-god. His was the task of bringing *Re* and *pharaoh* back to life each day, and as an air-god he invented head-rests that enabled sleepers to breathe easily. He was sometimes depicted with arms raised carrying *Nut*, but could be dangerous in the *Underworld* where he and his cronies tortured and killed some of those passing through. However he was also a benign protector against the hostile *Apophis*.

Sia. God of the intellect, who was born of blood from the self-inflicted wound in *Re*'s *phallus*, and was shown by Re's side carrying *papyri* on which achievements of the mind were recorded. He was associated with the creative side of *Ptah*.

sistrum (*pl.* **sistra**). This musical instrument used in religious worship is of two distinct types. These are the *naos* type (in which the handle terminates in a cow-eared *Hathor* head above which is a naos [often containing a *uræus* (see **Isis**: [**Fig. 28(a)**])] surmounted by two or three curling wires), and the hoop type (in which three or four metal bars with attached jangling discs were fixed through a looped piece of metal attached to a handle). (*See* **Bastet**: [**Fig. 10**]). It may relate to the *djed* column to represent *strength* and *stability* (see **Plates 2, 6, 7, 8, 52**, and **94**).

situla (*pl.* **situlæ**). As **hydreion**.

Sobek. *See* **Suchos**.

Sokar. Hawk-headed god, often with an elaborate crown of horns, two *uræi*, a sun-disc, and a conical *atef* crown. He may have represented *Osiris*, having been killed by *Seth*, but he was important as a god of earth's fertility. He became fused with *Ptah* as *Ptah-Sokar*, was consort of *Sakhmet*, and became *Ptah-Sokar-Osiris*. As a resurrected god, he was lord of the important necropolis near Memphis, and he was shown as a powerful deity holding his wings open, borne on a serpent-headed boat. As a craftsman, the Ptah side of his persona became significant, for he designed and made silver bowls used by the dead as basins for their feet, and he was also involved in the manufacture of powerful aromatic mixtures used in rituals.

solar barque. There were two *boats* or *barques* which carried the heavenly bodies: the day-barque *mandet*, and the night-barque, *mesektet* (**Fig. 49**).

solar eye. The sun was regarded as a falcon above the earth, so was the right eye of *Horus*. It was also the 'eye of *Re*', and the disc between *Hathor's* horns. The *solar eye* could have an existence independent of either Re or Horus, and could be transformed into the *uræus* on *pharaoh's* forehead.

Sons of Horus. Four deities who guarded embalmed internal organs and whose heads were represented on *canopic jars* (*see* **canopic jar**: [**Fig. 14(a)**]): they were *Imsety* (liver), represented by a human head; *Hapy* (lungs), represented by a baboon-head; *Duamutef* (stomach), represented by a jackal-head; and *Qebehsenuef* (intestines), represented by a hawk-head. Each Son was protected by a goddess: Imsety by *Isis*, Hapy by *Nephthys*, Duamutef by *Neith*, and Qebehsenuef by *Serket*. They were also among the seven protectors of the *sarcophagus* of *Osiris*.

Sopedu or **Sopdu**. Crouching falcon-god, the offspring of *pharaoh* (as *Orion* or *Osiris*) and *Sothis*, called *Horus-Sopedu*, the star-god, protector of Egypt and symbol of pharaoh's power. He could also be represented anthropomorphically wearing the *shemset* girdle and on his head two falcon-feathers.

Sothis. The dog-star, or *Sirius*, known to the Egyptians as *Sopdet*, which, when it appeared in the sky, announced the annual flooding of the Nile. As goddess, she was associated with the constellation *Orion* and with the bringing of fertility to the lands each year. By the familiar process of association *Isis* became *Sothis*, *Osiris* became *Orion*, and their offspring, *Horus*, became *Sopedu*. Sothis appears as a woman wearing the crown of Upper Egypt flanked by horns and surmounted by a star, but also is manifest as a large dog.

soul. To the Ancient Egyptians, a human being was made up of a *body*, a *name*, a *shadow*, a *ka*, a *ba*, and an *ankh*. The *ba* was depicted as a bird with a humanoid head; the *ka* by a double of the person or by two arms raised; and the *ankh* by the crested *ibis*.

sphinx. Creature with the body of a *lion* and a *humanoid head*, often with the *nemes* head-dress, and sometimes depicted as female, with breasts. Egyptian sphinxes were never winged, and were usually male, although the sex is often indeterminate. They were benevolent guardians, representing *pharaoh's* power (*see* **Colour Plates VIII** and **XXII**, and **Plates 8, 10, 17, 18, 21, 33, 53, 55, 62[a], 63, 70, 71, 73, 78, 91, 109, 124, 130, 131, 132, 136, 144, 158, 159, 164, 165, 175, 184, 189, 190, and 198**).

spina. *Barrier* in the centre of a Roman *circus*, dividing it into two long runs, at the ends of which the chariots turned. It was often decorated with *obelisks*, *statuary*, and *trophies*.

spiral. Emblematic of growth and decay, it represented life. Spirals formed the head-dress of *Meskhenet*.

stair. Symbol of ascension and resurrection from the dead. It can also represent the *primæval mound*.

stag. Emblem of *Artemis/Diana*.

star. Often found in *Neo-Classical* and *Egyptianising* schemes of decoration influenced by *Piranesi*. Stars are particularly associated with *Isis* and with the *Virgin Mary*, but in Ancient Egyptian belief there were stellar deities known as the 'Imperishable Ones' clearly visible in the night sky. *Pharaoh* himself was the Morning Star who accompanied the star-deities, partly in the

rôle of guide, so extending his divinity beyond that of the solar cults, for the constellations were composed of followers of *Osiris*. Those constellations passed in boats across the heavens, and were perceived as groupings of stellar deities (**Colour Plate XIX** and **Plate 126**).

stele, **stela** (*pl.* **stelai**). Slab of stone carved with reliefs, inscriptions, etc., sometimes funerary, but sometimes secular.

step. A *stepped arch* has a stepped head, and can be formed of *corbel*-courses: it is a feature of *Egyptianising* and *Art-Déco* forms (*see* **Plates 65, 66, 102, 138, 140, 142, 146, 156, and 212**).

stone. Symbol of durability, so used for tombs, temples, and monuments to ensure survival.

Sublime. An eighteenth-century *æsthetic category* associated with ideas of *awe, intensity, power, ruggedness, terror, great size*, and the ability to stimulate *imagination* and the *emotions*. It is associated with *limitlessness, storms, waterfalls, mighty mountains*, and *Nature* in the raw. In architecture, an exaggerated scale, powerful unadorned fabric, and gloomy cavernous structures would be classed as *Sublime*, so Egyptian architecture would fit the category.

Suchos. Crocodile-headed god, also called *Sobek*, whose main cult-centres were Crocodilopolis and Kôm Ombo. His sweat created the waters of the Nile and made

Fig. 50. *Crocodile-god Suchos wearing his plumed head-dress with horns and uræi, and carrying a was sceptre and an* ankh *(after a relief at the Ptolemaïc temple of Kôm Ombo).*

plants green. He became identified with *Re*, *Horus*, and life-giving water. He was symbolic of pharaonic power, and was a son of *Neith*. He was shown as a crocodile with a plumed head-dress, or sometimes as a male human body with a crocodile's head (**Fig. 50**). His consort was *Hathor*, and their son was *Khons*.

sun. Personified as *Re*, there were other solar deities, including *Herakhty* and *Khepri* (both representing the morning sun), and *Atum* and *Khnum* (representing the evening sun).

sun-disc. Circular disc or part of a globe with wings and rearing *uræi*, often occurring on a *cavetto* cornice (*see* **Egyptian gorge**: [**Fig. 22**]).

supporter of heaven. The god *Shu* supported the goddess *Nut* with his arms. *Heh* was also shown kneeling supporting the sky with his upraised arms. Other supporters included *Onuris*.

swallow. The dead were believed to become swallows in order that they might fly unrestrained. *Isis* could flutter as a swallow.

sword. Symbol of strength, for he who held it was master of life and death.

sycamore. Celestial tree, a manifestation of *Nut*, who shielded the dead *Osiris* and tended his *soul* among her branches. Both *Hathor* and *Suchos* were associated with sycamores. A tall sycamore was believed to stand in the east of the sky on which the deities sat.

Ta-Bitjet. Scorpion-goddess and consort of *Horus* who was efficacious in alleviating the effects of toxic bites through her blood spilled when she lost her virginity.

Tasenetnofret. Goddess-consort of *Horus* when he came to maturity, and mother of *Panebtawy*, who seems to have been *Hathor* in another guise.

Tatenen or **Tatjenen**. Deity representing the appearance of fertile silt after Nilotic

flooding: he was shown as a bearded man with a crown of ram's horns and solar disc surmounted by a pair of plumes. Like *Ptah*, he was a creator-god, was identified with that deity, and seen as a begetter of all deities. He was identified with *Geb*, and guarded *pharaoh's* path through the *Underworld*.

Taweret or **Taurt**. Despite her repulsive appearance (designed to scare the living daylights out of any forces likely to harm women during childbirth), this goddess was benevolent, and was associated with the protective sign *sa* (*see* **sa**: [**Fig. 44**]). With the head of a hippopotamus, swollen belly, pendulous human breasts, leonine legs and arms, and crocodile's tail, she was no beauty, but seems to have been much loved by Egyptians of all classes, to judge from the great number of her amulets and images which still survive. She also sported a tall head-dress of horns and plumes, and seems to have evolved from *Ipy*. She became a stellar goddess, and her attribute was *fire*. She often carried the *ankh* and the *sa*.

Tayet. Goddess-provider of woven cloth, especially the bandages used to wrap mummified bodies, and the *Ptah*-decorated hangings that discreetly screened the rituals of embalming.

Tefnut. Female deity created by *Atum*, consort of her brother *Shu*, and mother of *Geb* and *Nut* (parents of *Osiris*, *Isis*, *Seth*, and *Nephthys*). Closely identified with moisture, she was able to create the purest water from her vagina in order to provide the means by which *pharaoh's* feet could be washed. Like many female deities, she could become a lioness, or acquire a lioness's head, and she could also become a serpent rising above a sceptre. Like *Ptah*, she was creative, and built a fine pharaonic palace in Lower Egypt. With her ability to make moisture she seems to have been the deity who created the life-giving morning dew. She was also the solar eye and the *uræus*.

tekenu. **1**. Crouching man wrapped in skins. **2**. Pear-shaped bundle. **3**. Naked male figure with arms and legs drawn in. It may have represented human sacrifice, or may have represented the dead.

telamon (*pl.* **telamones**). *Male figure* used instead of a *column* to carry an *entablature*. *Telamones* are straight, and not bowed in an attitude of struggle, like *Atlantes*: they sometimes had *nemes* head-dresses, and were Egyptianising, as with the *Villa Adriana* examples, now in the Vatican (*see* **Colour Plate VIII**, and **Plates 28**, **43**, **44**, **45**, **62[b]**, **66**, **68**, **69**, **71**, **75**, and **82**).

temple. Archaic temples were probably reed huts with curved roofs (probably the origin of the segmental *pediment*) standing at one side of an enclosed court at the entrance to which stood two flagpoles. More developed temples had a court, *hypostyle hall*, and sanctuary containing the shrine, and the axis that ran through the complex was flanked by *pylon-towers*, *obelisks*, and avenues of *sphinxes* and *criosphinxes*. Columns representing *palms*, *papyrus*, and *lotus* suggested growth from the earth, and they supported the ceiling decorated to suggest the sky with stars and birds.

tent ceiling. *Camp-ceiling*, or one with a sagging inward curve, also known as a *coom-* or *comb*-ceiling. It is also a ceiling with *canted* sides sloped to follow the lines of the rafters, as in a *garret*, or a *canted arch*.

term, **terminal**. *Pedestal* like an inverted *obelisk*, proportioned like the lower part of a human figure, merging into a *bust* (often with torso), sometimes with feet appearing under the base of the pedestal: in such cases the heads are often found with *nemes* head-dresses in Egyptianising styles. It therefore differs from a *herm*. A *terminal pedestal* is similar in appearance, but the bust stands on the pedestal, which is separate (*see* **Plates 45**, **69**, **73**, and **75**).

tet. *See* **tyet**.

Thoth. Important moon-god in charge of all scientific and literary knowledge, who supervised those who recorded it. He appeared as a *baboon* or *ibis* squatting on stacks of writing-tablets (**Fig. 51**). He was also depicted anthropomorphically with an ibis-head, wearing a crown in the form of the crescent-moon partially framing the full-moon disc. The curved beak of the ibis also alluded to a new moon, and the colouring of the bird's plumage (black and white) was also appropriate to suggest the waning and waxing of the moon. The baboon imagery is more obscure, but may have something to do with the organisation of baboon society and the rumpus packs make at dawn, perceived, perhaps, as a hymn to the sun. The Egyptians actually portrayed baboons in attitudes greeting or facing *Re* or the rising sun, and Thoth himself was seen as the 'son of Re', or as having sprung from *Seth's* head, although he became a powerful ally of *Horus*. Devoted to truth and impartiality, Thoth was also a great peacemaker, although he could be ferocious when necessary.

As the deity of scribes, Thoth invented the hieroglyphic system. Scribes were sometimes shown with Thoth-baboons perched on their shoulders, and sometimes seated cross-legged taking dictation from the Thoth-baboon near by. Thoth protected the papyri on which such a huge amount was recorded, and he was the guardian of sacred knowledge that could only be passed on to the initiated, and was not even known to *pharaoh* himself. The parallels with esoteric societies such as *Freemasonry* will be clear, and indeed Thoth has certain affinities with *Hermes/Mercury* (especially *Hermes Trismegistus*, the 'Thrice-Great') and even with *St John* as the Messenger. Thoth recorded all the souls entering the *Underworld*, and supervised the scales on which the hearts of the dead were weighed against Truth. It was Thoth who reported to *Osiris* the results of his investigations into the life of a recently dead person.

Fig. 51. *The deity Thoth in cynocephalous form, i.e. the dog-headed baboon, with crescent-moon horns and moon-disc. He sits on a stack of writing-tablets to emphasise his rôle as recorder and scribe (after an example from the Later Period in the Musée du Louvre, Paris).*

tomb. Tombs of important persons had three essential elements: the chamber in which the mummy lay; the mortuary chapel where the dead person was provided with necessities; and chambers containing a statue of the deceased. The tomb had to be as secure as possible, and was elaborately decorated.

tongue. Symbol of will, and the means by which utterance of an idea or conception may be imparted and given reality. *Ptah* created the world through his word.

Topographical Decoration. Decoration showing real places, such as scenes of Ancient Egyptian architecture copied from DENON's *Voyage*, of 1802, or other locations.

transformation. The dead were thought to be capable of transforming themselves as expressions of immortality. *Osiris* could be found in growing corn, in the life-giving water of the Nile, in tall trees, and, like *Isis*, was protean, with many names.

tree. Sundry deities were believed to have originated in trees: *Re* sprang from the *sycamore*, *Horus* from the *acacia*, and *Wepwawet* from the *tamarisk*. *Nut* gave birth to *Osiris* beneath an unidentified tree. Thus *tree-cults* flourished in the Nile Valley, especially those of the acacia and sycamore. Tree-goddesses included *Hathor* and *Nut*, and certain trees, notably the *date-palm* and the *sycamore*, were regarded as trees of life. Trees also symbolised resurrection. The *willow* was sacred to *Osiris* as that tree sheltered his coffin when his soul (as a *phoenix*) alighted on the branches above, and the willow was associated with fertile, well-watered land.

triad. In Ancient Egypt there were several groupings of three deities associated with cult-centres, usually composed of a father, a mother, and a son, or a male, a female, and another male. The most important triad was that of *Osiris*, *Isis*, and *Horus*. Other triads included *Amun*, *Mut*, and *Khons* at Thebes; *Ptah*, *Sakhmet*, and *Nefertem* at Memphis; *Horus*, *Hathor*, and *Horus the Younger* at Edfu; and *Khnum*, *Anukis*, and *Satis* at Elephantine (in the last case the third member of the triad was female).

tyet or **tet**. Girdle worn by *Isis*, knotted just beneath the breasts (*see* **Isis**: [**Fig. 28(c)**]). It may be associated with the goddess's menstrual blood, perceived as life-giving, and resembles the *ankh* (**Fig. 52**). It was often found with the *djed* pillar, alluding to *Isis* and *Osiris*.

Fig. 52. *Sign resembling the* ankh *with the arms folded down, called* tyet *or* tet, *and particularly associated with* Isis: *it was a knot in the goddess's girdle (see* **Fig. 28[c]**), *and symbolic of her blood (after various sources).*

uch. *Papyrus*-stem surmounted by two plumes, associated with the worship of *Hathor*, and a symbol of the supports of heaven.

Udjat. *See* **Wadjet**.

Underworld. The Ancient Egyptian *Underworld* was a perilous place for the recently dead, whose progress through it was fraught with hideous dangers. There are certain parallels with initiation-rites in mystery religions and esoteric cults. The whole business of the Underworld and its organisation is far too complex to be discussed here. However, the major deities of the Underworld were *Aker*, *Apophis*, the *assessors*, the *cavern deities*, the *gate deities*, the *hours*, and, of course, the great god *Osiris*, but others were involved too, notably *Thoth*, who presided over the recording of information. The dead who had led far from blameless lives could expect the worst, especially from the *cavern deities*, who exterminated the enemies of *Re* and fed on their bodies and souls.

Although the living did much to appease these deities with offerings and sacrifices, the caverns were well-provided with furnaces to dispose of the detritus of extermination. Among the deities were jackal-headed gods, snake-guardians, *Sesy*, *Nehebu-Kau*, a shoal of catfish-headed deities led by *Osiris*, *Nut* and *Osiris* (in ithyphallic mode), *Tatenen* as the personification of Egypt, the deities of the sea, sundry goddesses carrying bloody axes, and the ferocious devourer of the dead, *Ammut*, from whom there was no escape.

In addition, there were the fierce armed *gate deities*, guarding the approaches to the various pylon-flanked gates along the route of the dead. Knowledge of the secret names of the deities would help to neutralise them, so considerable study was necessary to prepare for death. Each portal had a guardian deity, was itself visualised as an architectural composition although given the name of a female deity, and had a ferocious snake before it. The number of gates varied: records include routes with 7, 12, and 21 gates, each associated with fearsome deities and scenes.

union. Upper and Lower Egypt were united under *pharaoh*, represented by the *two crowns*, by the vulture-head of *Nekhbet* (Upper Egypt) and the rearing *Wadjet* or *uræus* (Lower Egypt), and by the *lotus* (Upper Egypt) and *papyrus* (Lower Egypt). *Horus* and *Seth* were depicted winding the two plants around the hieroglyph for *unity* (lungs and wind-pipe).

uræus (*pl.* **uræi**). Representation of the sacred asp, cobra, or serpent, e.g. on the *nemes* head-dresses of Ancient-Egyptian pharaohs and deities, or on either side of winged discs or globes on the *gorge-cornices* in Egyptian architecture (*see* **Plate 192** and **Egyptian gorge**: [**Fig. 22**]). The *uræus* was the symbol of *sovereignty* backed by *force*, represented by *Wadjet*, the *cobra-goddess*, preserver of royal authority, rearing up to strike any enemy of *pharaoh* (*see* **Plate 22** and *see also* **Wadjet**: [**Fig. 54**]).

ushabti. Figure of a mummiform servant placed in a tomb to carry out menial tasks for

the deceased in the after-life. It was a substitute for the real servants who were once killed to accompany the dead.

visceral jar. *See* **canopic jar**.

Vitruvian opening. An *opening*, such as a doorway or a window, with *battered* sides, like an Egyptian *pylon*, wider at the bottom than at the top (**Fig. 53**). It is so-called because it was described by *Marcus Vitruvius Pollio*, who flourished in the days of *Julius Caesar* and *Augustus*, and who was the author of *De Architectura*, the only surviving architectural text from *Antiquity*.

Fig. 53. *Vitruvian opening with lugged architrave, based on the exemplar from the interior of the 'Temple of Vesta' at Tivoli (c. 80BC), also called the* Tivoli window. *It was described by Vitruvius and published by Palladio (after various sources).*

vulture. *Nekhbet*, the goddess of Upper Egypt, depicted as a vulture or wearing a vulture head-dress. A vulture's head appears with the *uræus* symbol of Lower Egypt on *pharaoh's* head-dress to symbolise the *union* of the Two Lands (*see* **Wadjet**: [**Fig. 54**]). The vulture was sacred to *Mut*, and appears as her head-dress. Outstretched vulture-wings are found with sun-discs and rearing *uræi* in *gorge-cornices* (*see* **Egyptian gorge**: [**Fig. 22**]).

Wadj Wer. Deity of procreation, fertility, and prosperity. He was depicted with enlarged breasts and a distended belly, but was nonetheless male, and carried the *ankh* suspended from his arm.

Wadjet or **Udjat**. The fire-spitting cobra-goddess of the Nile Delta (Lower Egypt), protector of *pharaoh's* authority in Lower Egypt (**Fig. 54**). She usually appears as a rearing *uræus*, but can also be a lioness as the 'eye of *Re*'. *See* **uræus**. She occurs with the *vulture*-goddess *Nekhbet* as a symbol of the

union of the Two Lands. She was associated with the *papyrus* plant, with the upbringing of *Horus*, and with *Isis*.

Fig. 54. *Pharaonic nemes head-dress with* (right) *rearing* Wadjet *uræus* (symbol of kingship and tutelary goddess of Lower Egypt) *and* (left) *the head of* Nekhbet, *vulture-goddess of Upper Egypt. Thus the unity of Upper and Lower Egypt was symbolised above the pharaoh's forehead* (after *the head-dress on the gold mask of Tutankhamun, now in The Cairo Museum*).

was. The sceptre of dominion (e.g. as borne by *Ptah*), which consists of a rod on top of which are the four rods of the *Djed* column (stability) above which is the *ankh* (life). It has other forms, including an animal-headed staff (**Fig. 55**).

Fig. 55. Was *sceptres alternating with* ankh *symbols set above a series of stylised wicker-work baskets (after a decorative frieze in the temple of Hathor at Dendera of the Ptolemaïc period [probably after 116 BC]).*

water. Out of the *primæval waters* the world emerged as a *primæval mound*, or *lotus*, or an *egg*. They were personified by *Nun*.

wedjet-eye. Symbol of power, and a protection from evil, it was the lunar or left eye of *Horus*, stolen by *Seth*, but miraculously restored (**Fig. 56**).

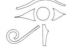

Fig. 56. *Stylised wedjet-eye, or left* (lunar) *eye of* Horus *(after several painted examples in The British Museum).*

weighing of the heart. A commonly depicted scene in tombs and books of the dead, showing the dead person in the *Hall of Judgement* before a balance in which his or her *heart* is weighed against the feather of truth in the form of the goddess *Maat*. *Anubis* adjusts the *plummet* (the criterion for rectitude or truth) and *Thoth*, *ibis*-headed, inscribes the result. Eagerly waiting is *Ammut*, the crocodile-headed 'Devourer of Hearts', who consumes the hearts of those found wanting. This ceremony took place before the 42 *assessors*. At the end of a satisfactory weighing, the deceased was led to *Osiris*, attended by *Isis* and *Nephthys*, and presented as a candidate for admission to a new existence.

Weneg. God of cosmic order, son of *Re*, who, like *Maat*, supported the heavens. He was also a judge.

Wenut. Usually depicted as a hare or a snake, she occasionally appears as a lioness-headed goddess, similar to *Sakhmet*. She was associated with Hermopolis, and a beautiful example (*c*.700 BC) can be found in the *Musée du Louvre*, Paris (N 4535).

Wepwawet. Jackal-god and warlike protector of *pharaoh*, identified with *Horus*. As an 'opener' of the ways, his adze split open pharaoh's mouth as part of the funerary ritual, and he also facilitated birth by opening the passage from the uterus. He also seems to have been some sort of facilitator or guide in the *Underworld*.

white. *See* **colour**.

willow. *See* **tree**.

wind. The 'breath of life' was associated with several deities. The cool north wind originated in the throat of *Amun*, and *Hathor* of the *sycamore* breathed the breath of life through her lips. *Shu*, lord of the air, brought the north wind to the living and the dead, but *Seth* was associated with the pestilential south wind.

wine. *Osiris* was lord of the vine, and was venerated as the deity of vineyards. Indeed, in one legend Osiris was conceived by his mother who ate the fruit of the cosmic vine. *Isis* also conceived *Horus* by this parthenogenetic means. Wine was regarded as a life-giving beverage, and the deity of the wine-presses, *Shezmu*, gave wine to the dead to revive them, but could also crush the heads of wrong-doers.

winged disc. Solar or heavenly symbol, consisting of two outstretched wings on either side of a *sun-disc*. The wings have been interpreted as those of a falcon (and so connected with *Horus*), or as those of a vulture (thus connected with *Nekhbet*). The two *uræi* on either side of the sun-disc emphasised the *pharaonic* sumbolism, and the ensemble of winged disc and *uræi* was commonly employed as a protective device on *stelai* and on gorge-cornices (*see* **Egyptian gorge**: [**Fig. 22**]).

word. Ancient Egyptians believed that words had power, and their creative thoughts were given reality by means of the *tongue*. *Ptah*, for example, created by the word, and *Re* created deities by uttering their names. Knowledge of a name was power.

Wosret. Theban goddess, probably a predecessor of *Mut* and consort of *Amun*.

wreath. **1**. Symbol of innocence. **2**. Token of victory over an enemy, usually made of olive leaves.

Yah. Anthropomorphic moon-god associated with the crescent of the new moon, the falcon, and the ibis, so had affinities with *Khons* and *Thoth*.

Yamm. Sea deity connected with *Renenutet* and *Astarte* (who seems to have caused him to moderate his demands for tribute).

SELECT BIBLIOGRAPHY

The stream of the river Nile can water the earth,
and the word of the monk Nilus can delight the mind.

<div style="text-align: right">

ST GREGORY OF NAZIANZUS 'THE THEOLOGIAN' (329–389):
'On Nilus the Great Hermit', *Greek Anthology*, Book 1, *Epigram* 100.

</div>

This Select Bibliography has no pretensions to completeness, for the subject is vast, and has spawned a huge number of publications. The admirable series, *Religions in the Græco-Roman World*, formerly *Études Préliminaires aux Religions Orientales dans l'Empire Romain*, published by E. J. Brill of Leiden, now provides a formidable scholarly resource for students of Classical Antiquity (on which the present writer has drawn), but the immense amount of research that has gone into Egyptian-inspired works of art in the West is only hinted at here. Every item to which this study is indebted is listed, however, and it is hoped that the following will aid those who wish to pursue further those themes that are mentioned in the book.

A. List of Journals, Periodicals, and major series of publications relevant to the subjects mentioned in the book

Abhandlungen der Bayerischen Akademie der
 Wissenschaften, Philosophisch-Historische Klasse
Acta antiqua Academiæ Scientiarum Hungaricæ
Acta archæologica Academiæ Scientiarum Hungaricæ
Acta Classica Universitatis Scientiarum Debreceniensis
Alte und Moderne Kunst
Altertum, Das
American Jewish Historical Quarterly
American Journal of Archæology
American Journal of Philology
American Journal of Semitic Languages and Literature
American Monthly Magazine
American Quarterly Review
American Research Center in Egypt Newsletter
L'Ami de la Maison
Ampurias
The Ancient World
Annalen van de Koninklijke Oudheidkundige Kring van
 het Land van Waas
Annales de l'Académie Royale d'Archéologie de Belgique
Annales du Musée
Annales du Service des Antiquités d'Égypte
Annali dell'Istituto di corrispondenza archeologica
Annali dell'Istituto di Filologia Moderna dell'Università di
 Roma
L'Année épigraphique
Annuaire de l'Institut de Philologie et d'Histoire Orientales
 de l'Université de Bruxelles
Antaius
Antichità di Roma
Antiques
L'Antiquité classique
Antiquity
Antwerpen: Tijdschrift der Stad Antwerpen
Apollo
Aramco World Magazine
Archæologia
Archéologia
Archeologia classica
Architectural History
The Architectural Magazine
Architectural Review, The (British and American)
Architektonische Studien des Kaiserlich Deutschen
 Archæologischen Instituts
Archives de l'art français
Archives Internationales d'Historie des Sciences
Archivo Storico per la Sicilia Orientale
Ars Quatuor Coronatorum
Art and Antiques
Art and Archæology, The Arts through the Ages
Art and Artists
Art and Fact
L'Art Brut
Art Bulletin
Art e Dossier
Art News Annual
L'Arte
L'Artiste

Atti della Pontificia Accademia romana di archeologia,
 Rendiconti
Aufstieg und Niedergang der römischen Welt. Geschichte
 und Kultur Roms in Spiegel der neueren Forschung
L'Avant-Scène Opéra
Ballou's Pictorial Drawing-Room Companion
Bayerische Vorgeschichtsblätter
Beaux-Arts Magazine
Beiträge zur klassischen Philologie
Bibliotheca Orientalis
The Bioscope
Bonner Jahrbücher
De Brabantse Folklore
British Academy at Rome
Bruckmanns Pantheon. Internationale Jahreszeitschrift für
 Kunst
The Builder
Bulletin des Archives Verviétoises
Bulletin de Correspondence Hellénique
Bulletin de la Diana
Bulletin of the Egyptological Seminar
Bulletin de la Faculté des Lettres Strasbourg
Bulletin du Grand Orient de Belgique
Bulletin of the History of Medicine
Bulletin de l'Institut Archéologique Liègeois
Bulletin de l'Institut Français d'Archéologie Orientale
Bulletin of the Metropolitan Museum of Art
Bulletin de la Montagne Sainte-Geneviève
Bulletin Monumental
Bulletin du Musée de Beyrouth
Bulletin des Musées de France
Bulletin des Musées Royaux d'Art and d'Histoire
Bulletin van het Rijksmuseum, Amsterdam
Bulletin de la Société Française d'Égyptologie
Bulletin de la Société de l'Histoire de l'Art français
Bulletin des Travaux du Suprême Conseil de Belgique
Bulletin Universel
Bulletino archeologico communale di Roma
Bulletino della commissione archeologica comunale di Roma
Bulletino dell'Instituto di corrispondenza archeologica
Burlington Magazine
Cahiers d'Histoire égyptienne
Cahiers de Mariemont
Cahiers de Recherches de l'Institut de Papyrologie et
 d'Égyptologie de Lille
Les Cahiers de l'Urbanisme
Cambridge Ancient History
Canadian Art Revue
La Caricature, Politique, Morale, Littéraire, et Scénique
Les Carnets de l'exotisme
Chicago History
Chiron
Chronique d'Égypte: Bulletin Périodique de la Fondation
 Égyptologique Reine Élisabeth
Classical Journal
Classical Quarterly
Collection de l'École Française à Rome
Colloqui del Sodalizio

Coloquio Artes
Comptes rendues de l'Académie des Inscriptions et Belles
 Lettres
Connaissance des Arts
The Connoisseur
Connoisseur's Complete Period Guides
Construction Moderne
Country Life
Dissertationes Pannonicæ
Dizionario epigrafico de antichità
Égyptes
Elle
Emblematica
Encylopédie Méthodique
Epigraphica
Les Études Classiques
Études Préliminaires aux Religions Orientales dans l'Empire
 Romain
L'Evénement du Jeudi
Femmes d'Aujourd'hui
Le Figaro
Le Figaro magazine
Fondation Eugène Piot. Monuments et Mémoires
Le Français dans le Monde
FMR (Franco Maria Ricci)
Frankfurter Allgemeine Magazin
Gazette des Beaux-Arts
La Gazette de l'Hôtel Drouot
Germania
Germania Romana
Göttinger Miszellen
Göttinger Orientforschungen
GOYA Revista de Arte
Gymnasium
HAFNIA Copenhagen Papers in the History of Art
Hamburger Beiträge zur Archäologie
Harvard Theological Review
Heidelberger althistorische Beiträge und epigraphische Studien
Hermes
Hesperia. Journal of the American School of Classical
 Studies at Athens
L'Histoire
Historia
Historia Einzelschriften
Historische Zeitschrift
L'Illustration, journal universel
Interdisciplinary Science Reviews
L'Intermédiaire de chercheurs et curieux
Israel Exploration Journal
Jaarbericht Ex Oriente Lux
Jahrbuch für Antike und Christentum
Jahrbuch des deutschen archäologischen Instituts
Jahrbuch des kaiserlich deutschen archäologischen Instituts
Jahrbuch der Kunsthistorischen Sammlungen des
 Allerhöchsten Kaiserhauses
Jahrbuch des Museums für Kunst und Gewerbe in Hamburg
Jahrbuch für Numismatik und Geldgeschichte
Jahrbuch des Römisch-Germanischen Zentralmuseums
 Mainz
Jahreshefte des Österreichischen Archäologischen Instituts
Le Journal des Artistes
Journal des connaissances usuelles
Journal des Débats
Journal of Egyptian Archæology
Journal für Freymaurer

Journal of Garden History
Journal of Hellenic Studies
Journal of Near Eastern Studies
Journal of Roman Studies
Journal of the Society of Architectural Historians
Journal of the Society for the Study of Egyptian Antiquities
Journal of Theological Studies
Journal of the Warburg and Courtauld Institutes
Keramik-Freunde der Schweiz. Mitteilungsblatt
Klio
Kölner Jahrbuch für Vor- und Frühgeschichte
Konsthistorisk Tidskrift
Ktèma
Kunst und Antiquitäten
Kunstchronik
Der Kunsthandel
Landesgeschichte bei der Bayerischen Akademie der
 Wissenschaften
Latomus
Lettre d'information
Lettere Italiane
Lexikon der Ägyptologie
Libération
The London Magazine
Madame Figaro
Le Magasin pittoresque
Magazine of Art
Maisons d'Hier et d'Aujourd'hui
Maske und Kothurn
Médecine de France
Mélanges d'Archéologie et d'Histoire de l'École Française de
 Rome
Memoires de l'Académie Royale des Sciences de l'Institut de
 France
Le Mercure de France
The Metropolitan Museum of Art Journal
Minerva. The International Review of Ancient Art and
 Archæology
Mitteilungen des Deutschen Archäologischen Instituts.
 Römische Abteilung and Abteilung Kairo
Mitteilungen des Kaiserlich Deutschen Archäologischen
 Instituts. Römische Abteilung.
Mitteilungen des Kunsthistorischen Instituts in Florenz
Le Monde
Le monde inconnu
Le Moniteur Universel
M & L (Monumenten en Landschappen)
Monumenti, Musei, e Gallerie Pontificie
Monuments Historiques
Le Moyen Âge
Münchener Ägyptologische Studien
Münchener Jahrbuch der bildenden Kunst
Münchener Jahrbuch des Kunstgeschichte
Münstersche Forschungen
Muséart
Le Musée Vivant
Nachrichten der Akademie der Wissenschaften in Göttingen
Napoléon: Revue des Études Napoléoniennes
Nederlands Kunsthistorisch Jaarboek
Niederdeutsche Beiträge zur Kunstgeschichte Wissenschaft
North American Review
Notizie degli scavi di antichità communicate alle Reale
 Accademia dei Lincei
Le Nouvel Observateur
Nouvelle Clio. Revue de la découverte historique

Les Nouvelles de l'Estampe
Novum Testamentum. An International Quarterly for New
 Testament and Related Studies
Observer Magazine
L'Œil
Oppositions
Oriens Christianus
Orientalia
Orientalia Lovaniensa Periodica
Osiris
Oudheidkundige Mededelingen van het Rijksmuseum van
 oudheden te Leiden
Paris aux Cent Villages
Paris Illustré
Paris-Plaisirs
La Patrie
Patrimonie Monumental de la Belgique
Philologus
Phoenix
Photographies
Le Point
Popular Archæology
Le Précurseur
Proceedings of the Society of Biblical Archæology
Procès-verbaux de la Commission du Vieux Paris
Progressive Architecture
Publicaties van het Genootschap voor Napoleontische Studiën
Publications of the American Jewish Historical Society
La Publiciste
Quaderni di Palazzo Tè
Realenzyklopädie der klassischen Altertumswissenschaft
Reallexikon zur deutschen Kunstgeschichte
Recueil de Travaux relatifs à la Philologie et à l'Archéologie
 égyptiennes et assyriennes
Religion und Gesellschaft in der römischen Kaizerzeit,
 Kölner Historische Abhandlung
Religions in the Græco-Roman World
Religionsgeschichtliche Versuche und Vorarbeiten
Rendiconti della Pontificia Accademia di Archeologia
Revista Italiana di Numismatica e Scienze Affini
Revue de l'Archéologie moderne et d'Archéologie générale
Revue archéologique
Revue de l'Art
Revue des Arts-Musées du France
Revue belge d'histoire contemporaine
Revue de la Bibliothèque Nationale
Revue d'Égyptologie
Revue Encyclopédique
Revue des études anciennes
Revue des études latines
Revue des études Napoléoniennes
Revue de l'Histoire des Religions
Revue du Louvre et des Musées de France
Revue de Musicologie

Revue de Philologie
Revue de la Société des Amis du Musée de l'Armée
Savaria
Schweizerische Beiträge zur Altertumswissenschaft
Schweizerische Münzblätter
Scriptores Historicæ Augustæ
Siculorum Gymnasium
Silex
Sitzungsberichte der Heidelberger Akademie der
 Wissenschaften
Sitzungsberichte der königlichen-preussischen Akademie der
 Wissenschaften
Sitzungsberichte der Sächsischen Akademie der
 Wissenschaften zu Leipzig
Societas Scientiarum Fennica. Commentationes Humanarum
 Litterarum
Société d'Iconographie parisienne
Sociological Studies in Roman History
Sources orientales
Souvenir Napoléon
Storia dell'Arte
Studi Musicali
Studia Hellenistica
Studia Patristica
Studies in Architecture
Studies in the Renaissance
Studium Generale
Styles de France
The Sunday Times Magazine
Symbolon
Télérama
Le Théâtre
Time
Touring
Transactions of the American Philosophical Society
Transactions and Proceedings of the American Philological
 Association
Trigonum Coronatum Jaarboek
La Vie Wallone
Le Vieux Papier
Vivre à Boulogne
Wedgwood International Seminars
Welt Kulturen und moderne Kunst
Westdeutsche Zeitschrift für Geschichte und Kunst
Wörterbuch der Ägyptologie
Würzburger Jahrbücher
Xenia
Yale Classical Studies
Zeitschrift für ägyptische Sprache und Altertumskunde
Zeitschrift für Bildende Kunst
Zeitschrift der deutschen morgenländischen Gesellschaft
Zeitschrift für Kunstgeschichte
Zeitschrift für Papyrologie und Epigraphik
Zoom op Zoo

B. Some Relevant Exhibition Catalogues

The Age of Neo-Classicism (London: 1972)
L'Art en France sous le Second Empire (Paris: 1979)
The Arts under Napoléon (New York: 1978)
Bartholdi l'Égyptien (Cairo: 1991)
Bonaparte en Égypte (Paris: 1938)
Alexandre-Théodore Brongniart, 1739–1813. Architecture et décor (Paris: 1986)
Les Grands Boulevards (Paris: 1985)
Le Brun: Versailles (Paris: 1985–6)
Les collections égyptiennes dans les musées de Saône-et-Loire (Autun: 1988)
L'Égypte et l'Expédition Française de 1798 à 1801 (Mont-de-Marsan: 1978–9)
L'Égypte des Pharaons (Marcq-en-Baroeul: 1977–8)
L'Égypte d'un architecte: Ambroise Baudry, 1838–1906 (La Roche-sur-Yon: 1998)
The Egyptian Movement in American Decorative Arts, 1869–1939 (Yonkers, NY: 1990)
Egyptomania (New York: 1979)
Egyptomania. Egypt in Western Art 1730–1930 (Paris, Ottawa, Vienna: 1994–5)
Europa und der Orient 800–1900 (Berlin: 1989)
Les Grands Services de Sèvres (Paris: 1951)

Hittorff: un architecte du XIXᵉ siècle (Paris: 1986)
Iside (Milan: 1997)
Jardins de France, 1760–1820. Pays d'illusion. Terre d'expériences (Paris: 1977)
Joséphine et l'Égypte (Malmaison: 1998)
Joséphine. Parures, décors, et jardins (Malmaison: 1969)
Leo von Klenze. Architect zwischen Kunst und Hof 1784–1864 (Munich: 2000)
Bernard Molitor (Luxembourg: 1995)
Napoléon aux Invalides, 1840, le Retour des Cendres (Paris: 1990)
Peintures, aquarelles, dessins et sculptures du XIXᵉ siècle (Paris: 1986)
Piranesi (London: 1978)
Piranèse et les Français (Paris, Rome, and Dijon: 1976)
Pont Neuf (Paris: 1978)
Rêves d'Égypte (Paris: 1998)
Un collectionneur pendant la Révolution: Jean-Louis Soulavie (1752–1813) (Paris: 1989)
Visionary Architects (Houston, Saint Louis, New York, Chicago, San Francisco: 1967–8).
Charles De Wailly, peintre architecte dans l'Europe des Lumières (Paris: 1979).

C. Books, papers, and articles

AALDOS, G. J. D. (1961): 'Germanicus und Alexander der Grosse', in *Historia*, **x**, 382–4.

ABBATE, FRANCESCO (*Ed.*) (1968): *Il Neoclassicismo* (Milan: Fabbri).

ABDOUN, SALEH (1971): *Genesi dell'Aïda* (Parma: Quaderni dell'Istituto di Studi Verdiani).

ACADÉMIE DE FRANCE À ROME (1976): *Catalogue* of the Exhibition *Piranèse et les Français: 1740–1790* (Paris, Rome, and Dijon: Académie de France à Rome [Villa Medici]).

ACADÉMIE DES BEAUX-ARTS (1787–96): *Collection des prix que la ci-devant Académie d'architecture proposoit et couronnoit tous les ans* (Paris: Basan, Joubert, and van Cléemputte). Issued in 20 *cahiers* of 6 plates each, except no. 18 which has 7 plates. Edited first by A.-P. PRIEUR, and then by P.-L. VAN CLÉEMPUTTE.

—(1806): *Projets d'architecture et autres productions de cet art, qui ont mérités les Grands Prix accordés par l'Académie.* The engraved title-page reads *Grands Prix d'architecture. Projets couronnés par l'Académie d'architecture et par l'Institut de France. Gravés et publiés par Allais, Détournelle, et Vaudoyer* (Paris: Allais, Détournelle, and Vaudoyer).

—(1818–34): *Grands Prix d'Architecture. Projets couronnés par l'Académie Royale des Beaux-Arts de France* (Paris: A.-L.-T. Vaudoyer & L.-P. Baltard**).**

ACERRELLOS, R.S. (*pseudonym*): *see* REGHELLINI – of SCIO.

ACHEN, SVEN TITO (1975): *Symboler omkring os* (Copenhagen: Gad).

ACKERMANN, RUDOLF (*Ed.*) (1809–28): *Repository of Arts, Literature, Commerce, Manufactures, Fashions, and Politics* (London: R. Ackermann).

—(1819): *Pictorial Cards, in Thirteen Plates each containing four subjects* . . . etc. The set is entitled *Beatrice, or, The Fracas.* (London: R. Ackermann).

ACQUIER, HIPPOLYTE, and COMBES D'AURIAC, FRÉDÉRIC (1852): *Les Cimetières de Paris, ouvrage historique, biographique, et pittoresque* (Paris: Albert).

ACTES DU 113ᵉ CONGRÈS NATIONAL DES SOCIÉTÉS SAVANTS (1991): (Paris: Éditions du Comité des travaux historiques et scientifiques).

ACTES DU 114ᵉ CONGRÈS NATIONAL DES SOCIÉTÉS SAVANTS (1990–2): (Paris: Éditions du Comité des travaux historiques et scientifiques).

ADAMS, FRANK DAWSON (1954): *The Birth and Development of the Geological Sciences* (New York: Dover Publications).

ADAMS, P. (*Ed.*) (1978): *see* HOPKINS, K.

ADAMS, WALTER MARSHAM (1898): *The Book of the Master, or the Egyptian Doctrine of the Light born of the Virgin Mother* (New York, NY: Putnam).

ADLINGTON, WILLIAM (1924): *see* APULEIUS MADAURENSIS, LUCIUS.

ADRIANI, ACHILLE (1959) *Divagazioni intorno ad una coppa pæsistica del Museo di Alessandria* (Rome: 'L'Erma' di Bretschneider).

—(1961): *Repertorio d'arte dell' Egitto greco-romane* (Palermo: Fondazione 'Ignazio Mormino' del Banco di Sicilia).

—(1972): *Lezioni sull'arte alessandrina* (Naples: Libreria scientifica editrice).

ÆLIANUS, CLAUDIUS (1864–66): *De Natura Animalium* . . . (Leipzig: B.G. Teubner).

AGE OF NEO-CLASSICISM: *see* ARTS COUNCIL OF GREAT BRITAIN.

AHMED, LEILA (1978): *Edward W. Lane: a study of his life and works and of British ideas of the Middle East in the nineteenth century* (London: Longman).

AIDA IN CAIRO (1982): (Cairo: Banca Nazionale del Lavoro).

AIKIN, ARTHUR (1802): *see* DENON, BARON DOMINIQUE VIVANT.

ALBRIZZI, COUNTESS ISABELLA TEOTOCHI (1824): *The Works of Antonio Canova, in sculpture and modelling*, etc. (London: S. Prowett).

ALCOUFFE, DANIEL (1994): 'Le Salon le plus célèbre du XIXᵉ siècle; le mobilier du salon de Madame Récamier offert au département des Objets d'art du Louvre', in *Revue du Louvre*, **i** (February), 8–9.

ALDRED, CYRIL (1962): 'The Pharaoh Akhenaten: a problem in Egyptology and Pathology', in *Bulletin of the History of Medicine* (July–August) **xxxvi**/4, 293–316.

—(1965): *Egypt to the End of the Old Kingdom* (New York, NY: McGraw Hill).

—(1971): *Jewels of the Pharaohs* (London: Thames & Hudson).

—(1972): 'The Temple of Dendur', in *The Metropolitan Museum of Art Journal*, **xxxvi**/1.

—(1980): *Egyptian Art: In the Days of the Pharaohs 3100–320 BC* (London: Thames & Hudson).

—(1987): *The Egyptians* (London: Thames & Hudson).

—(1988): *Akhenaten, King of Egypt* (London: Thames & Hudson)

ALEMBERT, JEAN LE ROND D': *see* DIDEROT, DENIS.

ALEXANDER, ROBERT L. (1958): 'The Public Monument and Godefroy's Battle Monument', in *Journal of the Society of Architectural Historians*, **xviii**, 19–24.

—(1974): *The Architecture of Maximilian Godefroy* (Baltimore, MD: Johns Hopkins University Press).

ALEXANDRE-BIDON, DANIÈLE (1985): 'L'Archéologie à l'épreuve des media: méthodes, techniques et problématiques dans la fiction et la science-fiction', in *Revue d'Archéologie moderne et d'Archéologie générale*, **v**, 191–247.

—(1984): 'Les "archéologues de papier": fiction et réalités dans les histoires en images et les bandes dessinés', in *Le Vieux Papier*, 1–10.

ALFÖLDI, ANDRÁS (1934): 'Die Ausgestaltung des monarchisten Hofzeremoniells am römischen Kaiserhof', in *Mitteilungen des Deutschen Archäologischen Instituts, Römische Abteilung*, **xlix**, 1–118.

—(1937): 'A Festival of Isis in Rome under the Christian Emperors of the IVᵗʰ Century', in *Dissertationes Pannonicæ*, Ser. II, fasc.7 (Budapest: Institute of Numismatics and Archæology of the Pázmány University).

—(1954): 'Isiskult und Umsturzbewegung im letzten Jahrhundert der römischen Republik', in *Schweizerische Münzblätter*, **v**, 25–31.

—(1965–6): 'Die alexandrinischen Götter und die Vota Publica am Jahresbeginn', in *Jahrbuch für Antike und Christentum*, **viii–ix**, 53–87.

ALFÖLDY, G. (1989): 'Die Krise des Imperium Romanum und die Religion Roms', in *Religion und Gesellschaft in der römischen Kaiserzeit, Kölner Historische Abhandlung*, **xxxv**, 53–102.

—(1990): 'Der Obelisk auf dem Petersplatz in Rom', in *Sitzungsberichte der Heidelberger Akademie der Wissenschaften*), phil.-hist. Klasse 1990. 2

ALGAROTTI, CONTE FRANCESCO (1791–95): *Opere* (Venice: C. Palese).

ALISON, ARCHIBALD (1811): *Essays on the Nature and Principles of Taste* (Edinburgh: Bell & Bradfute).

ALLAIS, L.-J.: *see* ACADÉMIE DES BEAUX-ARTS.

ALLEMAGNE, HENRY RENÉ D' (1900): *Musée rétrospectif de la classe 100 de l'Expostion Universelle de 1900* (Saint-Cloud: Belin frères).

ALLEMANT, E. (1878): *Collection d'antiquités égyptiennes. Description historique et religieuse des monuments découverts sur les lieux par l'auteur* (London: Straker Bros.).

ALLEN, HAROLD (1962): 'Egyptian Influences in Wedgwood Designs', in *Seventh Wedgwood International Seminar* (Chicago, IL: Art Institute of Chicago), 65–85.

—(1978): 'My Egypt', in *Journal of the Society for Photographic Education*, **xvi**/1 (March).

ALLEN, THOMAS GEORGE (1960): *The Egyptian Book of the Dead: Documents in the Oriental Institute Museum at the University of Chicago* (Chicago, IL: Oriental Institute of the University of Chicago).

—(1974): *The Book of the Dead or Going forth by Day: Ideas of the Ancient Egyptians concerning the Hereafter as expressed in their own terms* (Chicago, IL: Oriental Institute of the University of Chicago).

ALLIOT, MAURICE (1949): *Le culte d'Horus à Edfou au temps des Ptolemées* (Cairo: L'Institut français d'archéologie orientale).

ALMÉRAS, HENRI D' (1904): *Cagliostro (Joseph Balsamo). La franc-maçonnerie et l'occultisme au XVIII^e siècle* (Paris: Société Française d'Imprimerie et de Librairie).

—(1910): *La Vie Parisienne sous la Révolution et le Directoire* (Paris: A. Michel).

ALTENMÜLLER, BRIGITTE H. (1975*a*): 'Anubis', in *Lexikon der Ägyptologie*, **i**, (Wiesbaden: O. Harrassowitz) *c.* 327–33.

—(1975*b*): 'Bes', in *Lexikon der Ägyptologie*, **i**, (Wiesbaden: O. Harrassowitz) *c.* 720–24.

—(1975*c*): 'Buto', in *Lexikon der Ägyptologie*, **i**, (Wiesbaden: O. Harrassowitz) *c.* 887–9.

—(1975*d*): 'Djed-Pfeiler', in *Lexikon der Ägyptologie*, **i**, (Wiesbaden: O. Harrassowitz) *c.* 1100–1105.

—(1975*e*): 'Falke', in *Lexikon der Ägyptologie*, **ii**, (Wiesbaden: O. Harrassowitz) *c.* 93–7.

ALTHEIM, FRANZ (1938): *A History of Roman Religion*, tr. H. MATTINGLY (London: Methuen).

ALTICK, RICHARD DANIEL (1978): *The Shows of London* (Cambridge, MA: Belknap Press).

AMBELAIN, ROBERT (1978): *Cérémonies et Rituels de la Maçonnerie Symbolique* (Paris: Éditions Robert Laffont).

AMELUNG, WALTHER (1903–56): *Die Skulpturen des Vaticanischen Museums* (Berlin: G. Reimer).

AMERICAN JEWISH HISTORICAL SOCIETY (from 1893): *American Jewish Historical Quarterly*, also called *Publications of the A.J.H.S.* (New York, NY: A.J.H.S.).

AMERICAN JOURNAL OF ARCHÆOLOGY, THE (from 1897): The *Journal* of the Archæological Institute of America (Baltimore, MD, etc.).

AMERICAN JOURNAL OF SEMITIC LANGUAGES AND LITERATURE (1884–1941) (Chicago, IL: University of Chicago Press)

AMERICAN MONTHLY MAGAZINE, THE (1833–38) (New York, NY: Bancroft, Hill, & Carvill).

AMERICAN QUARTERLY REVIEW, THE (1827–37): (Philadelphia, PA: Carey, Lea, & Carey).

AMIABLE, LOUIS (1897): *La Respectable Loge: Les Neufs Sœurs* (Paris: Félix Alcan).

—, and GUIEYSSE, PAUL (1988): *L'Égypte ancienne et la franc-maçonnerie* (Paris: Trédonie).

AMIET, PIERRE (1981): *Art in the Ancient World* (New York, NY: Rizzoli).

AMPÈRE, JEAN-JACQUES-ANTOINE (1868): *Voyage en Égypte et en Nubie* (Paris: Michel Lévy).

ANDERSON, JAMES (*Ed.*) (1723): *The Constitutions of the Free-Masons* (London: John Senex and John Hooke).

ANDIA, BÉATRICE DE, and TEXIER, SIMON (*Eds*) (1994): *Les Canaux de Paris* (with the collaboration of FRANÇOIS BEAUDOUIN *ET AL.*) (Paris: Délégation à l'action artistique de la ville de Paris).

ANDRÉ, ANNE (1987): 'Paris: pharaons-sur-Seine', in *L'Evénement du Jeudi*, **cxxii** (5–11 March), 92–3.

ANDRÉ, CHRISTIAN KARL (*Ed.*) (1790–96): *Der Freymeurer, oder Compendiöse Bibliothek alles Wissen würdigen über geheime Gesellschaften* (Göttingen, Gotha, Halle, and Eisenach: Johann Christian Dieterich & Johann Jacob Gebauer).

ANDREWS, CAROL (1990): *Ancient Egyptian Jewelry* (New York, NY: H. N. Abrams).

—(1994): *Amulets of Ancient Egypt* (Austin, TX: University of Texas Press).

ANDROUET DU CERCEAU, JACQUES (1611): *Livre d'Architecture* (Paris: J. Berjon).

ANGELICOUSSIS, E. (1992): *The Woburn Abbey Collection of Classical Antiquities* (Mainz-am-Rhein: P. von Zabern).

ANNALI DELL' INSTITUTO DI CORRESPONDENZA ARCHEOLOGIA (from 1829): (Rome).

ANONYMOUS (1812): *O ∴ ou Histoire de la fondation du Grand Orient de France* (Paris: s.n.).

—(1878): 'Cercle Artistique: Les Antiquités Égyptiennes de M. Allemant', in *Le Précurseur*, Year 43/329.

—(1891*a*): 'Consécration du Nouveau Temple de la R[espectable] [Loge] La Parfaite Union, Rue Chasaire, à l'Or[ient] de Mons', in *Bulletin du Gr[and] Or[ient] de Belgique*, **xviii**, 84–116.

—(1891*b*): 'R[espectable] [Loge] Les Amis de la Parfaite Intelligence, à l'Or[ient] de Huy', in *Bulletin du Gr[and] Or[ient] de Belgique*, **xviii**, 126–49.

—(1909): 'R[espectable] [Loge] La Bonne Amitié à l'Or[ient] de Namur'. Compte rendu de la Fête d'Inauguration de Nouveau Temple', in *Bulletin du Gr[and] Or[ient] de Belgique*, **xxxvii**, 157–76.

—(1911): 'Tenue du 10 mars 1911', in *Bulletin des Travaux du Suprême Conseil de Belgique*, **liv**, 8–14.

—(1920): 'In memoriam Hector Puchot', in *Bulletin des Travaux du Suprême Conseil de Belgique*, **lviii**, 165.

—(1994): 'Influencia egipcia en la pintura europea de los siglos XVII y XVIII', in *Saber ver, lo contemporaneo del Arte*, **xviii** (September–October), 6–48.

ANQUETIL, GILLES (1989): 'Egyptomania', in *Le Nouvel Observateur*, **mcclxiv** (26 January), 26–35.

ANSIEAU, JOËLLE (1983): 'Deux Sculptures de Georges Lacombe: Isis et le Christ', in *La Revue du Louvre et des Musées de France*, **iv**, 287–95.

ANTICHITÀ DI ROMA (1647–71): contains works by DUPÉRAC, ROSSI, *ET. AL.* (Rome: s.n.).

L'ANTIQUITÉ CLASSIQUE (from 1932): (Brussels, etc.).

ANTOINE, JACQUES-DENIS (1826): *Plans des divers étages et coupe de l'Hôtel des Monnaies à Paris, etc.* (Paris: Beance ainé).

APULEIUS MADAURENSIS, LUCIUS (1924): *Metamorphoseon libri XI*. Various editions, but see the edition *tr.* WILLIAM ADLINGTON, edited by F. J. HARVEY DARTON (London: Navarre Society).

ARAGO, M. (1838): 'Éloge Historique de M. Joseph Fourier, par M. Arago, Secrétaire Perpétuel, lu a la Séance publique du 18 Novembre, 1833', in *Memoires de l'Académie Royale des Sciences de l'Institut de France*, xiv, xcii, xciii

ARCHÆOLOGY (from 1948): (Cambridge, MA: Archæological Institute of America).

L'ARCHÉOLOGIE ET SON IMAGE (1988): Colloquium, VIIIe rencontres internationales d'archéologie et d'histoire d'Antibes (29–31 October 1987 [Juan-les-Pins]). Contains contributions from ADAM, ALEXANDRE-BIDON, CHANTE, ELOY, and HUMBERT.

ARCHER, B. A. (*tr.*) (1990): *see* CHUVIN, PIERRE.

ARCHITECTURAL MAGAZINE, THE (1834–38): (London: Longman, Rees, Orme, Brown, Green, & Longman).

ARCHITECTURAL PUBLICATION SOCIETY (1853–92): *see* PAPWORTH, WYATT ANGELICUS VAN SANDAU.

ARCHITECTURAL REVIEW, THE (from 1896): (London). Also the American *THE ARCHITECTURAL REVIEW* (Boston, MA: Bates, Kimball, & Guild, etc., [from 1891]).

ARCHITEKTONISCHE STUDIEN DES KAISERLICH DEUTSCHEN ARCHÆOLOGISCHEN INSTITUTS, **iii** (1889).

ARGAN, G. C. (1988): 'Il pensiero dell'antico nell'arte occidentale', in *Storia dell' Arte*, **lxii**, 13–23.

ARIZZOLI-CLEMENTEL, PIERRE (1972): 'Le Mausolée de Turenne aux Invalides', in *Revue de la Société des Amis du Musée de l'Armée*, **lxxvi**, 5–12.

—(1976): 'Les Sourtouts Impériaux en Porcelaine de Sèvres, 1804–1814', in *Keramik-Freunde der Schweiz, Mitteilungsblatt*, **lxxxviii** (May), 17 f.

—(1978): 'Charles Percier et la Salle Égyptienne de la Villa Borghèse', in *Actes du Colloque 'Piranèse et les Français'* (12–14 May 1976) (Rome), 1–32.

ARMS, JOHN H. D' (1970): *Romans on the Bay of Naples. A Social and Cultural Study of the Villas and their Owners from 150 B.C. to A.D. 400* (Cambridge, MA: Harvard University Press).

ARNOLD, DIETER (1985): 'Moses und Aïda. Das alte Ägypten in der Oper', in *Ägypten-Dauer und Wandel*, 173–180.

ARNOLD, DIETER (2003): *The Encyclopædia of Ancient Egyptian Architecture*, NIGEL & HELEN STRUDWICK (*Eds*) (London: Tauris).

ARS QUATUOR CORONATORUM (various dates): Transactions of the Quatuor Coronati Lodge, No. 2076. (London: Quatuor Coronati Lodge, No. 2076).

ART BULLETIN, THE (from 1913): (New York, NY, etc: College Art Association of America).

ARTS COUNCIL OF GREAT BRITAIN (1972): *The Age of Neo-Classicism*. The *Catalogue* of the fourteenth Exhibition of the Council of Europe (9 September - 19 November 1972) (London: The Arts Council of Great Britain).

—(1978): *Piranesi. Catalogue* of the Exhibition by JOHN WILTON-ELY (London: The Arts Council of Great Britain).

THE ARTS UNDER NAPOLEON (1978): *Catalogue* of the Exhibition (New York: Metropolitan Museum of Art).

ASHBY, THOMAS (*Ed.*) (1965): *see* PLATNER, SAMUEL BALL.

ASSMANN, JAN (1984): *Ägypten: Theologie und Frömmigkeit einer frühen Hochkultur* (Stuttgart: Kohlkammer).

ATHANASI, GIOVANNI D' (1836): *A Brief Account of the Researches and Discoveries in Upper Egypt, made under the direction of Henry Salt, Esq.* (London: J. Hearne).

ATWELL, DAVID (1981): *Cathedrals of the Movies. A History of British Cinemas and their Audiences* (London: The Architectural Press Ltd).

AUBERT, JACQUES-F. (1974): *Statuettes égyptiennes: chaouabtis, ouchebtis* (Paris: Librairie d'Amérique et d'Orient).

AUBRY, A. (1811): *Description du Château d'eau situé sur l'esplanade du boulevard Bondi, dont l'inauguration a été faite le 15 août 1811* (Paris: A. Aubry).

AULANIER, CHRISTIANE (from 1947): *Histoire du Palais et du Musée du Louvre* (Paris: Éditions des Musées nationaux).

—(1961): *Le Musée Charles X et le département des antiquités égyptiennes* (*Histoire du Palais et du Musée du Louvre*) (Paris: Éditions des Musées nationaux).

—(1968): 'Cabinet des dessins, trois nouvelles donations', in *La Revue du Louvre et des musées de France*, **i**, 48–9.

AULARD, F.-V.-A. (1892): *Le Culte de la Raison et le Culte de l'Être Suprême 1793–94* (Paris: F. Alcan).

AUMONT, LOUIS-MARIE-AUGUSTIN, DUC D' (1782): *Catalogue des vases, colonnes, tables de marbres rares, figures de bronze . . . bijoux et autres effects importants qui composent le cabinet de feu M. Le Duc d'Aumont* (Paris: P. F. Julliot fils, J. A. Paillet).

AUNE, L.J. (1929): *Frimureriet: Dets Historie i Skandinavien* (Copenhagen: H.C. Bakkes Boghandel).

AURENHAMMER, HANS (1973): *J.B. Fischer von Erlach* (London: Allen Lane).

AUTEXIER, PHILIPPE (1997): *La Lyre Maçonne: Haydn, Mozart, Spohr, Liszt* (Paris: Detrad/A.V.S.).

AVERLINO, ANTONIO DI PIERO (1965): *see* FILARETE, ANTONIO AVERLINO.

AXTELL, HAROLD LUCIUS (1907): *The Deification of Abstract Ideas in Roman Literature and Inscriptions* (Chicago, IL: The University of Chicago Press).

AZIZA, CLAUDE (1996): 'Les romans de momies: fantasme(s) d'archéologie ou d'histoire?', in HUMBERT (*Ed.*) (1996), 553–83.

BABELON, ERNEST (1885–6): *Description historique et chronologique des monnaies de la République romaine* (Paris: Rollin & Feuardent).

BACLER D'ALBE, LOUIS-ALBERT-CHRISTIAN (1822): *Promenades pittoresques et lithographiques dans Paris et ses environs* (Paris: G. Engelmann).

BADAWY, ALEXANDER M. (1966): *A History of Egyptian Architecture* (Berkeley, CA: University of California Press).

—(1975): 'The Approach to the Egyptian Temple in the Late and Græco-Roman Periods', in *Zeitschrift für ägyptische Sprache und Alterumskunde*, **cii**, 79ff.

BADENHAUSEN, ROLF (1938): *Die Bildbestände der Theatersammlung Louis Schneider* (Berlin: Selbstverlag der Gesellschaft für Theatergeschichte).

BAECHLER, J. (1959): *Recherches sur la diffuson des cultes isaïques en Italie du IIe s. av. J.-C. au IIe s. ap. J. C.* Dissertation (University of Strasbourg)

BAEGE, WERNER (1913): *De Macedonum Sacris* (Halle: M. Niemeyer).

BAERLOCHER, M. (1983): *Grundlagen zur systematischen Erfassung koptischer Textilien* (Basel: Graphische Betriebe Coop Basel).

BAINES, JOHN (*tr.*) (1974): *see* SCHÄFER, HEINRICH.

BAINES, J., and MALEK, J. (1980): *Atlas of Ancient Egypt* (London: Phaidon Press Ltd).

BALAS, EDITH (1981): 'The art of Egypt as Modigliani's stylistic source', in *Gazette des Beaux-Arts*, **mcccxlv** (February) 87–94.

BALAVOINE, C., ET AL. (1986): *Le modèle à la Renaissance* (Paris: J. Vrin).

BALDUS, H. R. (1991): 'Zur Aufnahme des Sol Elagabalus-Kultes in Rom, 219 n. Chr.', in *Chiron*, **xxi**, 175–8.

BALLANTYNE, JAMES (1866): *The Life of David Roberts R.A., compiled from his journals and other sources* (Edinburgh: A. & C. Black).

BALLOU'S PICTORIAL DRAWING-ROOM COMPANION (1851–59): (Boston, MA: F. Gleason).

BALTARD, L.-P. (1818–34): *see* ACADÉMIE DES BEAUX-ARTS.

BALTRUŠAÏTIS, JURGIS (1955): *Le Moyen-âge fantastique; antiquités et exotismes dans l'art gothique* (Paris: A. Colin).

—(1957): *Aberrations. Quatre essais sur la légende des forms* (Paris: O. Perrin).

—(1967): *La Quête d'Isis. Introduction à l'Égyptomanie. Essai sur la légende d'un mythe* (Paris: O. Perrin).

BANDIERA, JOHN D. (1983): 'The City of the Dead: French eighteenth-century designs for funerary complexes', in *Gazette des Beaux Arts*, **mccclxviii** (January), 25–32.

BAQUÉS ESTAPÉ, L. (1975–80): 'Improntas de diez escarabeos egypcios de supuesta procedencia ibicenca', in *Ampurias*, **xli-xlii**, 377–90.

BARBEGUIÈRE, J. (1784): *La maçonnerie mesmérienne* (Amsterdam: s.n.).

BARBER, W.H. *ET AL.* (1967): *The Age of the Enlightenment. Studies Presented to Theodore Besterman* (London: University of St Andrews).

BARING, SIR THOMAS, BART. (1838): *A Bibliographical Account and Collation of La Description de l'Égypte, presented to the Library of the London Institution, by Sir Thomas Baring, Baronet, President*: etc. (London: privately printed).

BARING-GOULD, SABINE (1914): *The Lives of the Saints* (Edinburgh: J. Grant).

BARKER, WILLIAM BURCKHARDT (1853): *Lares and Penates: or, Cilicia and its Governors* (London: Ingram, Cooke, & Co.).

BARKER, W. R. (1906): *The Bristol Museum and Art Gallery. The development of the institution during a hundred and thirty-four years, 1772–1906* (Bristol: J. W. Arrowsmith).

BARNES, J. D. (1967): 'The Family and Career of Septimius Severus', in *Historia*, **xvi**, 87–107.

BARONE, GIUSEPPINA (*Ed.*) (1983–4): *Studi in onori di Achille Achiani* (Rome: 'L'Erma' di Bretschneider).

BARRETT, ANTHONY A. (1989): *Caligula: the corruption of power* (London: B. T. Batsford Ltd).

BARRIER, JANINE (1997): 'Bélanger et Angleterre', in CONSTANS, MARTINE, *ET AL.* (1997a), 135–66.

BARROUX, ROBERT and MARIUS (1956): 'Les origines légendaires de Paris', in *Paris et île-de-France* (Paris: Robert Barroux).

—, ROBERT (1959): 'Statue et légende d'Isis à Saint-Germain-des-Prés', in *Le Moyen Age*, No. 3 (**lxv**, fourth series, t. xiv).

BARRY, REV. ALFRED (1867): *Memoir of the Life and Works of the late Sir Charles Barry* (London: J. Murray).

BARRY, JAMES (1809): *The Works of James Barry* (London: T. Cadell & W. Davies).

BARTA, G. (1968): 'Legende und Wirklichkeit – das Regenwunder des Marcus Aurelius', in *Acta Classica Universitatis Scientiarum Debreceniensis*, **iv**, 85–91.

BARTA, WINFRIED (1980): 'Funktion und Lokalisierung der Zirkumpolarsterne in den Pyramidtexten', in *Zeitschrift für Ägyptische Sprache und Altertumskunde*, **cvii**, 1–14.

—(1984): 'Re', in *Lexikon der Ägyptologie*, **v** (Wiesbaden: O. Harrassowitz), c. 156–80.

BARTHOLDY, PAUL (1886): *Bericht über das Kaiserfest i. O. Strassburg i. E. am 12. September 1886* (Neuwied/Rhein: Louis Heuser).

BARTIER, J. (1987): *see* LIGOU, D. (*Ed.*).

BARTLETT, WILLIAM HENRY (1850): *The Nile Boat: or, Glimpses of the Land of Egypt* (London: A. Hall, Virtue & Co.).

BARTOLI, JEAN-PIERRE (1996): 'À la recherche d'une représentation sonore de l'Égypte antique: l'égyptomanie musicale en France de Rossini à Debussy', in HUMBERT (*Ed.*) (1996), 481–506.

BARTOLI, PIETRO SANTI (1757–60), but *see* the edition of (1783–7): *Recueil de peintures antiques trouvées à Rome* (Paris: Molini et de Lamy). Contains J. J. BARTHÉLEMY'S 'Explication de la mosaïque de Palestrina', printed in the 1757–60 edition for the first time.

BASAN (1787–96): *see* ACADÉMIE DES BEAUX-ARTS.

BASCLE DE LAGRÈZE, GUSTAVE (1887): *Les Catacombes de Rome* (Paris: Firmin-Didot).

BASSI, ELENA (1936): *Giannantonio Selva, architetto veneziano* (Padua: A. Milani).

BAUMGARTEN, SÁNDOR (1958): *Le Crépuscule Néo-Classique. Thomas Hope* (Paris: Didier).

BAYER-NIEMEIER, EVA, BORG, BARBARA, BURKARD, GÜNTER, *ET AL.* (1993): *Liebighaus-Museum Alter Plastik, Frankfurt-am-Main, Ägyptische Bildwerke Band III: Skulptur, Malerei, Papyri, und Särge* (Melsungen: Gutenberg).

BEAN, JACOB (1960): *Les Dessins italiens de la collection Bonnet à Bayonne* (Paris: Éditions des Musées nationaux).

BEARD, MARY, and CRAWFORD, MICHAEL (1985): *Rome in the Late Republic* (Ithaca, NY: Cornell University Press).

BEAUCOUR, FERNAND ÉMILE (1983): *La Campagne d'Égypte (1798–1801) d'après les dessins inédits de Noël Dejuine* (Levallois: Société de sauve-garde du château impérial de Pont-de Briques).

—, LAISSUS, YVES, and ORGOGOZO, CHANTAL (1989): *La Découverte de l'Égypte* (Paris: Flammarion).

BEAUDOUIN, FRANÇOIS (1994): see ANDIA, BÉATRICE DE.

BEAUJEU, J. (1955): *La religion romain à l'apogée de l'Empire* (Paris: Société d'édition des Belles Lettres).

BEAULIEU, M. (1946): 'Les Esquisses de la Décoration du Louvre au Département des Sculptures', in *Bulletin Monumental*, **civ**, 249–63.

BEAUTHEAC, NADINE, and BOUCHART, FRANÇOIS-XAVIER (1985): *L'Europe Exotique* (Paris: éd. du Chêne).

BEAUVALLET, PIERRE-NICOLAS (1804–7): *Fragmens d'architecture, sculpture, et peinture, dans le style antique* (Paris: Joubert).

BECHER, ILSE (1965): 'Oktavians Kampf gegen Antonius und seine Stellung zu den ägyptischen Göttern', in *Das Altertum*, **xi**, 40–7.

—(1966): *Das Bild der Kleopatra in der griechischen und lateinischen Literatur* (Berlin: Akademie Verlag).

—(1970a): 'Der Isiskult in Rom – ein Kult der Halbwelt?', in *Zeitschrift für ägyptische Sprache und Altertumskunde*, **xcvi**, 81–90.

—(1970b) 'Antike Heilgötter und die römische Staatsreligion', in *Philologus*, **cxiv**, 211–55.

BECKER, FELIX (1950–53): see THIEME, ULRICH.

BEENKEN, HERMANN THEODOR (1952): *Schöpferische Bauideen der Deutschen Romantik* (Mainz-am-Rhein: Matthias-Grünewald Verlag).

BEER, GAVIN RYLANDS DE (1953): *Sir Hans Sloane and the British Museum* (London: Oxford University Press).

BEGEMANN, GEORG E. WILHELM (1906): *Die Tempelherrn und die Freimaurer* (Berlin: E.S. Mittler u. Sohn).

—(1909–10): *Vorgeschichte und Anfänge der Freimaurerei in England* (Berlin: E. S. Mittler u. Sohn).

—(1911): *Vorgeschichte und Anfänge der Freimaurerei in Irland* (Berlin: E. S. Mittler u. Sohn).

—(1914): *Vorgeschichte und Anfänge der Freimaurerei in Schottland. Die alten schottischen Werklogen* (Berlin: E. S. Mittler u. Sohn).

BEINLICH, HORST (1984a): 'Räucherarm', in *Lexikon der Ägyptologie*, **v**, (Wiesbaden. O. Harrassowitz), c.83.

—'Seelen', in *Lexikon der Ägyptologie*, **v** (Wiesbaden. O. Harrassowitz), c.804–6.

—'Sterne', in *Lexikon der Ägyptologie*, **vi** (Wiesbaden. O. Harrassowitz), c.11–14.

BELGRADO, JACOPO (1786): *Dell' Architettura Egiziana, dissertazione d'un Corrispondente dell' Accademia delle Scienze di Parigi*, (Parma: Dalla Stamperia Reale).

BELIDOR, BERNARD FOREST DE (1737): *Architecture hydraulique* (Paris: C. A. Jombert).

BELL, SIR HAROLD IDRIS (1954): *Cults and Creeds in Græco-Roman Egypt* (Liverpool: Liverpool University Press).

BELLAIGUE, GEOFFREY DE (1968): 'Martin-Eloy Lignereux and England', in *Gazette des Beaux-Arts*, **lxxi** (May–June), 283–94.

BELLERMAN, JOHANN JOACHIM (1821): *Geschichtliche Nachrichten aus dem Alterthume über Essäer und Therapeuten* (Berlin: F. Maurer).

BELZONI, GIOVANNI BATTISTA (1820): *Narrative of the Operations and Recent Discoveries within the Pyramids, Temples, Tombs, and Excavations, in Egypt and Nubia; and of a Journey to the Coast of the Red Sea, in Search of the Ancient Berenice; and Another to the Oasis of Jupiter Ammon* (London: J. Murray).

—(1821): *Forty-four Plates illustrative of the Researches and Operations of Belzoni in Egypt and Nubia* (London: J. Murray).

—(1822): *Six New Plates* (London: J. Murray).

BEN TOR, DAPHNA (1989): *The Scarab. A Reflection of Ancient Egypt* (Jerusalem: Israel Museum).

BÉNÉDITE, GEORGES AARON, *ET AL.* (*Ed.*) (1907): *Catalogue général des antiquités du Musée du Caire* (Cairo: L'Institut français d'archéologie orientale).

—(1924): *L'art Egyptien dans les lignes générales* (Paris: Éditions A. Morancé).

BENGTSON, HERMANN (1979): *Die Flavier* (Munich: Beck).

BENINCASA, COUNT (1787): see ROSENBERG-ORSINI, JUSTINE (WYNNE), GRÄFIN VON.

BENOIT, FRANÇOIS (1897): *L'Art François sous la Révolution et l'Empire* (Paris: L. H. May).

BENTON, CHARLOTTE, BENTON, TIM, and WOOD, GHISLAINE (*Eds*) (2003): *Art Deco 1910–1939* (London: V & A Publications). *Catalogue* to accompany the Exhibition held at the Victoria and Albert Museum, 2003.

BENYOVSZKY, KÁROLY (1926): *Das alte Theater* (Bratislava [Pressburg]: K. Angermayer).

—(1929): *Theatergeschichtliche Kleinigkeiten* (Bratislava [Pressburg]: S. Steiner).

—(1934): *Johann Nepomuk Hummel, der Mensch und Künstler* (Bratislava [Pressburg]: Eos-Verlag).

BENZAKEN, JEAN-CHARLES (1991): 'Iconographie du monnaies et médailles de la Fête du 10 août 1793', in *Actes du 113ᵉ et du 114ᵉ congrès national des sociétés savants* (Paris: Éditions du Comité des travaux historiques et scientifiques), 291–312.

—(1993): 'David et la numismatique', in *Actes du Colloque David contre David*, edited by RÉGIS MICHEL (Paris: La Documentation française), 965–985.

BÉRAGE, —(1776): *Supposed author of Les Plus Secrets Mystères des Hauts Grades de la Maçonnerie Dévoilés*, edited by KARL FRIEDRICH KÖPPEN (Berlin: Haude & Spener).

BÉRANGER, J. (1953): 'Recherches sur l'aspect idéologique du principat', in *Schweizerische Beiträge zur Altertumswissenschaft*, **vi** (Basel: Reinhardt).

BÉRANGER, PAUL (1819): *see* SAINT-ALBIN, J. S. C. DE

BERGDOLL, BARRY (1994): *Karl Friedrich Schinkel: An Architecture for Prussia*, with photographs by ERICH LESSING (New York, NY: Rizzoli International Publications Inc.).

BERGER, PETER L. (1967): *The Sacred Canopy. Elements of a Sociological Theory of Religion* (Garden City, NY: Doubleday).

BERGH, W. VAN DEN (1957): *see* ZOO.

BERGMAN, JAN (1968): *Ich bin Isis. Studien zum memphitischen Hintergrund der griechischen Isisaretalogien. Historia Religionum 3* (Uppsala: Universitetet; Stockholm: Almqvist & Wiksell).

—(1970): *Isis-seele und Osiris-Ei. Zwei ägyptologische Studien zu Diodorus Siculus I 27, 4–5* (Uppsala: Universitetet; Stockholm: Almqvist & Wiksell).

—(1980): 'Isis', in *Lexikon der Ägyptologie*, **iii** (Wiesbaden: O. Harrassowitz), c. 186–203.

BERKENHOUT, JOHN (1767): *The Ruins of Pæstum or Posidonia, a city of Magna Græcia in the Kingdom of Naples. Containing a description and views of the remaining antiquities, with the history . . . and some observations on the ancient Dorick order* (London: The Author).

BERLANDINI, J. (1979): 'Petits monuments royaux de la XXIᵉ à la XXVᵉ dynastie', in *Hommages à la mémoire de Serge Sauneron 1927–1976,* **i**, *Bibliothèque d'Étude*, 81 (Cairo: Institut français d'archéologie orientale du Caire) 89–114.

BERLEV, O. D. (1971): 'Les prétendus "citadins" au Moyen-Empire', in *Revue d'Égyptologie*, **xxiii**, 23–48.

BERNAL, MARTIN (1987): *Black Athena: The Afroasiatic Roots of Classical Civilization*, **i**: *The Fabrication of Ancient Greece 1785–1985* (New Brunswick, NJ: Rutgers University Press).

—(1991): *Black Athena: The Afroasiatic Roots of Classical Civilization*, **ii**: *The Archæological and Documentary Evidence* (New Brunswick, NJ: Rutgers University Press).

BERNARD, J.-P.: 'Métro Pyramides', in *Silex*, **xiii** (Le rêve égyptien), 131–6.

BERNIER, CLAUDE-LOUIS (1798): *see* PERCIER, CHARLES.

BERNOYER, FRANÇOIS (*Ed.*) (1976): *Avec Bonaparte en Égypte et en Syrie, 1798–1800* (Abbeville: Les presses françaises).

BERTIER DE SAUVIGNY, GUILLAUME DE (1977): *La Restauration, 1815–1830* (Paris: Hachette).

BETANCOURT, PHILIP P. (1977): *The Æolic Style in Architecture. A Survey of Its Development in Palestine, the Halikarnassos Peninsula, and Greece, 1000–500 B.C.* (Princeton, NJ: Princeton University Press).

BETZ, JACQUES (1954): *Bartholdi* (Paris: Éditions de Minuit), 123–4, 268.

BEUREN, OTTO (*pseudonym*) (1884): *see* RAICH, JOHANN MICHAEL.

BEUTHER, CARL FRIEDRICH (1963): *see* JUNG, OTTO.

BEYEN, HENDRICK GERARD (1938): *Die pompejanische Wanddekoration vom zweiten bis zum vierten Stil*, **i** (Den Haag: M. Nijhoff).

—(1960): *Die pompejanische Wanddekoration vom zweiten bis zum vierten Stil*, **ii** (Den Haag: M. Nijhoff).

BIANCHI, ROBERT STEVEN (1980): 'Not the Isis Knot', in *Bulletin of the Egyptological Seminar*, **ii**, 2–31.

—(1981): 'Two Ex-Votos from the Sebennytic Group', in *Journal of the Society for the Study of Egyptian Antiquities*, **xi**, 31–36.

—(1988): *Cleopatra's Egypt: age of the Ptolemies* (Brooklyn, NY: Brooklyn Museum).

BIEDERMEIER, FRANZ (1986): 'Les Vaudoyer, un siècle d'architecture', in *Beaux-Arts Magazine*, **xxxiv** (April), 31.

BIET, LÉON-MARIE-DIEUDONNÉ (1925–50): *see* GOULIER, CHARLES-PIERRE.

BIGELOW, JACOB (1860): *A History of the Cemetery of Mount Auburn* (Boston and Cambridge, MA: J. Munroe & Co.).

BIHAN, ALAIN LE (1966): *Francs-Maçons Parisiens du Grand Orient de France* (Paris: Bibliothèque Nationale).

—(1967): *Loges et Chapitres de la Grande Loge et du Grand Orient de France (2ᵉ moitié du XVIIIᵉ siècle)* (Paris: Bibliothèque nationale).

BINNEY, MARCUS (1981): 'My Favourite Garden: Biddulph Grange, Staffordshire', in *Observer Magazine* (19 April), 36.

BIONDO, FLAVIO (1558): *see* BLONDUS, FLAVIUS.

BIRCH, SAMUEL (1878): *see* WILKINSON, SIR JOHN GARDNER.

BIRLEY, ANTHONY RICHARD (1997): *Hadrian: The Restless Emperor* (London and New York, NY: Routledge).

—(1999): *Septimius Severus* (London: Routledge).

—(2000): *Marcus Aurelius* (London: Routledge).

BISCHOFF, ERICH (1913–14): *Die Elemente der Kabbalah* (Berlin: H. Barsdorf).

BITTNER, NORBERT (1818): *Theaterdekorationen nach den Original Skizzen des K.K. Hoftheater Mahlers Anton de Pian. Radiert und verlegt von Norbert Bittner* (Vienna: N. Bittner).

BIVER, COMTESSE MARIE-LOUISE (1963): *Le Paris de Napoléon* (Paris: Plon).

BJÖRKMAN, G. (1977): 'Harsiese', in *Lexikon der Ägyptologie*, **ii** (Wiesbaden: O. Harrassowitz), c.1018–20.

BLACK, ANTONY (1984): *Guilds and Civil Society in European Political Thought from the Twelfth Century to the Present* (Ithaca, NY: Cornell University Press).

BLACKMAN, A. M. (*tr.*) (1927): *see* ERMAN, ADOLF.

BLAIR, GEORGE (1857): *Biographic and Descriptive Sketches of Glasgow Necropolis* (Glasgow: Ogle).

BLANCOT, CHRISTIANE, and GRETHER, FRANÇOIS (1987): 'Des vestiges au devenir d'un site, le basin de La Villette', *Monuments Historiques*, **cliv** (December), 32–7.

BLAVATSKY, HELENA PETROVNA (1877): *Isis Unveiled: a master-key to the mysteries of ancient and modern science and theology* (New York, NY: J.W. Bouton).

BLEEKER, CLAAS JOUCO (1963): 'Isis as Savior Goddess', in *Festschrift E. O. James* (Manchester: Manchester University Press).

—(1967): *Egyptian Festivals. Enactments of Religious Renewal* (Leiden: E. J. Brill).

481

—(1973): *Hathor and Thoth: Two Key Figures of the Ancient Egyptian Religion* (Leiden: E. J. Brill).

BLOCH, H. (1945): 'A New Document of the Last Pagan Festival in the West, 393–394 A.D.', in *Harvard Theological Review*, **xxxviii**, 199–244.

BLOK, J. H. (1995): *The Early Amazons. Modern and Ancient Perspectives on a Persistent Myth* (Leiden: E. J. Brill).

BLOMME, A. (1909): 'L'Égyptologie en Belgique', in *Annales de l'Académie Royale d'Archéologie de Belgique*, **lxi**, 6 series, 1 (Antwerp: J. van Hille-de Backer), 569–658.

BLONDEL, JACQUES-FRANÇOIS (1754): *Discours sur la nécessité de l'étude de l'architecture* (Paris: Jombert).

—(1771–7): *Cours d'Architecture* (with PIERRE PATTE) (Paris: Desaint).

—(1774): *L'Homme du monde éclairé par les arts* (Amsterdam: Monory).

BLONDEL, SPIRE (1887): *L'Art pendant la Révolution* (Paris: H. Laurens).

BLONDUS, FLAVIUS (BIONDO, FLAVIO) (1558): *Roma ristaurata, et Italia illustrata* (Venice: Domenico Giglio).

BLUNT, ANTHONY (1937–38): 'The "Hypnerotomachia Poliphili" in XVIIth – Century France', in *Journal of the Warburg Institute* (London: The Warburg Institute), **i**, 117–37.

—(1941): *François Mansart and the Origins of French Classical Architecture* (London: The Warburg Institute).

—(1954): *The Drawings of G.B. Castiglione and Stefano della Bella in the Collection of H.M. the Queen at Windsor Castle* (London: Phaidon Press Ltd).

BOARDMAN, JOHN (1971): *see* KURTZ, DONNA C.

—, GRIFFIN, JASPER, and MURRAY, OSWYN (1986): *The Oxford History of the Classical World* (Oxford: Oxford University Press).

BOAS, GEORGE E. (1935): *see* LOVEJOY, ARTHUR ONCKEN.

—(1950): *The Hieroglyphics of Horapollo* (New York, NY: Pantheon Books).

BOASE, THOMAS SHERRER ROSS (1959): *English Art, 1800–1870* (Oxford: Clarendon Press).

BOATWRIGHT, MARY TALIAFERRO (1987): *Hadrian and the City of Rome* (Princeton, NJ: Princeton University Press).

BOBER, P. B., and RUBINSTEIN, R. (1986): *Renaissance Artists & Antique Sculpture. A Handbook of Sources* (Oxford: Oxford University Press).

BÖCKLIN, ARNOLD (1980): *Arnold Böcklin: la Cultura Artistica in Toscana* (Rome: De Luca Editore).

BODNAR, EDWARD WILLIAM (1960): *Cyriacus of Ancona and Athens* (Brussels-Berchem: Latomus).

BOEMER, F. (1989): 'Isis und Sarapis in der Welt der Sklaven. Eine Nachlese', in *Gymnasium*, **xcvi**, 97–109.

BOËTHIUS, AXEL, and WARD-PERKINS, J.B. (1970): *Etruscan and Roman Architecture* (Harmondsworth: Penguin Books Ltd).

BOEUF APIS, SYMBOLE DES LABORATOIRES NOVO, LE (1983): (Bagsværd: éd. Novo Industri A/S).

BOHDAN, CAROL L. (1980): 'Egyptian-inspired Furniture, 1800–1922', in *Art and Antiques*, **iii**/6 (November–December), 64–71.

BÖHEIM, JOSEPH MICHAEL (*Ed.*) (1798–99): *Auswahl von Maurer Gesängen mit Melodien der vorzüglichsten Componisten in Zweij Abtheilungen getheilt* (Berlin: s.n., but later by 'F. Maurer', 1817–19).

BOISSARD, JEAN-JACQUES (1597–1602): *Romanæ Urbis Topographiæ et Antiquitatum* (Frankfurt-am-Main: T. de Bry).

BOISSIER, GASTON: (1909): *La fin du paganisme* (Paris: Hachette). A later edition of 1987 was published in Hildesheim).

BOITARD, PIERRE (1834): *Manuel complet de l'architecte des jardins . . .* (Paris: Encyclopédie Roret).

BOLTON, ARTHUR THOMAS (1929): *Lectures on Architecture by Sir John Soane . . ., as delivered . . . from 1809 to 1836* (London: Jordan-Gaskell).

BONACASA, NICOLA, and VITA, ANTONINO DI (1983–4): 'Alessandria e il mondo ellenistico-romano' in BARONE, GIUSEPPINA (*Ed.*).

BONANNI, PHILIPPO, S.J. (i.e. BUONANNI, FILIPPO) (1773–82): *Rerum Naturalium Historia . . . in Museo Kircheriano* (Rome: Zempelliano)

BONAPARTE EN ÉGYPTE (1938): Exhibition Catalogue (Paris: Musée de l'Orangerie. See also 'Au Musée de l'Orangerie: Bonaparte en Égypte', in *L'Illustration*, No. 4982 (27 August 1938), 541–543. The *Catalogue* was prepared by MAXIME KAHN and MAURICE SERRULAZ.

BONGIOANNI, ALESSANDRO (*Ed.*) (2001): *Illustrated Guide to the Egyptian Museum in Cairo* (Cairo: American University of Cairo Press).

—, and GRASSI, RICCARDO (1994): *Torino, L'Egitto e l'Oriente: fra Storia e Leggenda* (Turin: Angelo Manzoni).

BONNEAU, DANIELLE (1964): *La Crue du Nil, divinité égyptienne à travers milles ans d'histoire (332 av. – 641 ap. J. C.)* (Paris: C. Klincksieck).

—(1970): 'Le préfet d'Égypte et le Nil', in *Études offerts à Jean Macqueron* (Aix-en-Provence: Faculté de droit et des sciences économiques d'Aix-en-Provence).

BONNEFOY, YVES (*Ed.*) (1981): *Dictionnaire des Mythologies et des Religions des Sociétés traditionelles et du Monde antique* (Paris: Flammarion).

BONNER, CAMPBELL (1950): *Studies in Magical Amulets* (Ann Arbor, MI: University of Michigan Press).

BONNET, HANS (1952): *Reallexikon der ägyptischen Religionsgeschichte* (Berlin and New York, NY: De Gruyter). *see also* the later 1971 edition.

BONNET, JACQUES (1980): *see* GAUME, MAXIME.

BONNEVILLE, NICOLAS DE (1791): *De l'esprit des religions* (Paris: Impr. Du Cercle social).

BONOMI, JOSEPH (1854): *see* JONES, OWEN.

BONSER, K.J. (1960): 'Marshall's Mill, Holbeck, Leeds', in *The Architectural Review*, **cxxvii**/758, 280–2.

BOOR, J. (1952): *Masonería* (Madrid: s.n.).

BORD, GUSTAVE (1908): *La Franc-Maçonnerie en France des Origines à 1815* (Paris: Nouv. Librairie Nationale).

BOREL, PETRUS (1836): *L'Obélisque de Louqsor* (Paris: chez les marchands de nouveautés).

BOREUX, CHARLES (1932): *Musée National du Louvre, Département des antiquités égyptiennes. Catalogue-guide* (Paris: Musées nationaux).

BORG, BARBARA (1993): *see* BAYER-NIEMEIER, EVA.

BORGER, R. (1978): *Drei Klassizisten: Alma Tadema, Ebers, Vosmaer* (Leiden: Ex Oriente Lux).

BORGHOUTS, J. F. (1966): 'Op zoek naar het graf van Imhotep', in *Phoenix*, **xii**, 360–7.

BORN, IGNAZ EDLER VON (1783–88): *Physikalische Arbeiten der einträchtigen Freunde in Wien* (Vienna: Loge zur wahren Eintracht).

—(1784): 'Über die Mysterien der Ägypter', in *Journal für Freymaurer* (Vienna: '5784'), 15–132.

BORZSÁK, S. (1969): 'Das Germanikusbild des Tacitus', in *Latomus*, **xxviii**, 588–600.

BOS, AGNÈS (*Ed.*) (1998): *see* HEALEY, CATHERINE.

BOSSI, S. (1824–27): *see* COOPER, EDWARD JOSHUA.

BOSTICCO, SERGIO (1952): *Musei Capitolini. I monumenti egizi ed egittizzanti* (Rome: Cataloghi dei musei comunali di Roma).

BOTHMER, BERNARD VON, MÜLLER, HANS WOLFGANG, and MEULENAERE, HERMAN DE (1960): *Egyptian Sculpture of the Late Period, 700 B.C. to A.D. 100*, edited by ELIZABETH RIEFSTAHL (Brooklyn: Brooklyn Institute of Arts and Sciences).

—, MEULENAERE, HERMAN DE (1986): 'The Brooklyn Statuette of Hor, Son of Pawen', in *Egyptological Studies in Honor of Richard A. Parker* (Hanover, NH: Brown University by University Press of New England), 1–15.

BOTTI, GIUSEPPE (1897): *Fouilles à la Colonne Théodosienne* (Alexandria: L. Carrière).

—, and ROMANELLI, PIETRO (1951): *Le Sculture del Museo Gregoriano Egizio* (*Monumenti vaticani di archeologia e d'arte*, **ix** (Città del Vaticano: Tip. Poliglotta vaticana).

BOUBE-PICCOT, CHRISTIANE (1975): *Les bronzes antiques du Maroc*, **ii**. *Le mobilier*. Published as part of *Études et travaux d'archéologie marocaine*, **v** (Rabat: Ministère d'État chargé des affaires culturelles et de l'enseignement original. Direction des monuments historiques et des antiquités).

BOUCHART, FRANÇOIS-XAVIER (1985): *see* BEAUTHEAC, NADINE.

BOUCHER, FRANÇOIS (1925–6): *Le Pont-Neuf* (Paris: Le Goupy).

BOUCHER, STÉPHANIE (1971): *Vienne. Bronze antiques. Inventaire des collections publiques françaises* (Paris: Éditions des Musées nationaux).

—(1976): *Recherches sur les bronze figures de Gaule pré-Romaine et Romaine*, **ccxxviii** (Paris: Bibliothèque des Écoles Françaises d'Athénes et de Rome).

BOUILLART, JACQUES (1724): *Historie de l'abbaye royale de Saint-Germain-des-Prez* (Paris: G. Depuis).

BOULLÉE, ÉTIENNE-LOUIS (1968): *Architecture, Essai sur L'Art* (Paris: Hermann).

BOULOUMIÉ, BERNARD (1971): *Les oenochoés en bronze du type 'Schnabelkanne' en Italie* (Paris: École français de Rome).

BOURGEOIS, EMIL (1930): *Le Style Empire* (Paris: Laurens).

BOURKE, JOHN WILLIAM PATRICK (1961): *Baroque Churches of Central Europe* (London: Faber & Faber Ltd), 124–5.

BOURNON, FERNAND (1909): *La Voie Publique et son Décor* (Paris: Librairie Renouard).

BOURRIAU, J. (1984): 'Salbefässe', in *Lexikon der Ägyptologie*, **v** (Wiesbaden: O. Harrassowitz), c. 362–6.

BOUSSEL, PATRICE (1969): *Guide de l'Île-de-France mystérieuse* (Paris: Tchou).

BOUSSET, WILHELM (1906): *Die Offenbarung Johannis* (Göttingen: Vandenhoeck).

BOVOT, J. L. (1993*a*): 'L'Égypte ancienne au cinema: le peplum en pagne', in *Portens pour l'an-delà. L'Égypte, le Nil et le "Champs des Offrandes"* (Paris), 246–54.

—(1993*b*): 'Le décor des films "égyptiens" ou l'art d'évoquer les pharaons', in *Égyptes Histoires et cultures*, **iii**, 130–40.

BOWDER, D. (1978): *The Age of Constantine and Julian* (London: Elek).

BOWIE, KAREN (*Ed.*): *see* HEALEY, CATHERINE.

BOWMAN, ALAN K. (1990): *Egypt after the Pharaohs: 330 B.C.–642 A.D.* (Oxford: Oxford University Press).

BOX, HUBERT STANLEY (*Ed.*) (1963): *see* MAS-CALL, ERIC LIONEL.

BOYER, FRANÇOIS (1969): 'Napoléon et la restitution par les musées du Louvre et de Versailles des œuvres d'art confisquées sould la Révolution', in *Archives de l'art français*, **xxxiv**, 66–7.

BOYLAN, PATRICK (1922): *Thoth: the Hermes of Egypt* (London: H. Milford for Oxford University Press).

BRACCIOLINI, POGGIUS (1996): *Opera Omnia* (Turin: Bottega d'Erasmo).

BRADY, THOMAS ALLEN (1935): *The Reception of the Egyptian Cults by the Greeks* (Columbia. MO: University of Missouri Press).

BRAGANTINI, IRENE, and VOS, M. DE (1982): *Le decorazioni della villa romana della Farnesina in Museo Nazionale Romano*, **ii**/1 (Rome: De Luca Editore).

BRAHAM, ALLAN (1980): *The Architecture of the French Enlightenment* (London: Thames & Hudson).

BRAMSEN, HENRIK BOE (1959): *Gottlieb Bindesbøll – Liv og Arbejder* (Copenhagen: Selskabet til udgivelse af skrifter om danske mindesmærker; i commission hos Høst).

BRANDON, SAMUEL GEORGE FREDERICK (1967): *Jesus and the Zealots* (Manchester: Manchester University Press).

BRAUN, HUGH (1950): *see* STATHAM, HENRY HEATHCOTE.

BRAYLEY, EDWARD WEDLAKE, and BRITTON, JOHN (1841–48): *A Topographical History of Surrey* (London: Tilt & Bogue).

BREASTED, JAMES HENRY (1959): *Development of Religion and Thought in Ancient Egypt* (New York, NY: Harper).

—(*Ed.*) (1962): *Ancient Records of Egypt* (New York, NY: Russell & Russell).

BRECCIA, EVARISTO (1970): *Le Musée gréco-romain d'Alexandrie 1925–1931* (Rome: 'L'Erma' di Bretschneider).

BREGMAN, JAY (1982): *Synesius of Cyrene, Philosopher-Bishop* (Berkeley, CA, Los Angeles, CA, and London: University of California Press).

BREMER, JOHANN GOTTFRIED (1793): *Die symbolische Weisheit der Aegypter aus dem verborgensten Denkmälern des Alterthums; ein Theil der ægyptischen Maurerey, der zu Rom nicht verbrannt worden*, edited by KARL PHILIPP MORITZ (Berlin: K. Matzdorff).

BRESC-BAUTIER, GENEVIÈVE, and PINGEOT, ANNE (1986): *Sculptures des jardins du Louvre, du Carrousel et des Tuileries* (Paris: Ministère de la culture, Éditions de la Réunion des musées nationaux).

BRESLAUER, M., AND KOEHLER, K. (*Eds*) (1924): *Werden und Wirken. Ein Festgruss Karl W. Hiersemann zugesandt* (Leipzig: K. F. Koehler).

BREUIL, ABBÉ DU (1612): *Le Théatre des antiquitez de Paris* (Paris: P. Chevalier).

BRIED, J., and HUMBERT, J.-B. (1980): *Tell Keisan (1971–1976) une cité phénicienne en Galilée* (Fribourg-Göttingen: Éditions universitaires).

BRIESE, CHRISTOPH (1985): 'Früheisenzeitliche bemalte phönizische Kannen von Fundplätzen der Levatenküste', in *Hamburger Beiträge zur Archäologie*, **xii**, 7–118.

BRIFFAULT, ROBERT (1927): *The Mothers; a study of the origins of sentiments and institutions* (London: George Allen & Unwin).

BRINCKMANN, ALBERT ERICH (1915–19): *Die Baukunst des 17. und 18. Jahrhunderts in den romanischen Ländern* (Berlin – Neubabelsberg: Akademische Verlagsgesellschaft Athenaion m.b.h.).

BRINDLEY, WILLIAM, and WEATHERLEY, W. SAMUEL (1887): *Ancient Sepulchral Monuments Containing Illustrations of over Six Hundred Examples from Various Countries and from the Earliest Periods down to the end of the Eighteenth Century* (London: Vincent Brooks Day, & Son).

BRINKS, JÜRGEN (1973): 'Die Ägyptisierenden Nachzeichnungen und Entwürfe des Klassizistischen Architekten Georg Ludwig Friedrich Laves', in *Niederdeutsche Beiträge zur Kunstgeschichte Wissenschaft*, **xii**, 81–116.

BRION, MARCEL (1960): *Pompeii and Herculaneum* (London: Elek).

BRISSAUD, PHILIPPE (1979): 'La céramique égyptienne du règne d'Aménophis III à la fin de l'époque ramesside', in *Hommages à la mémoire de S. Sauneron*, I/81 (Cairo: Bibliothèque d'Étude), 11–32.

—(1993): *Bulletin de las Société Française des Fouilles de Tanis*, **vii**, 79–94.

BRITTON, JOHN (1841–48): *see* BRAYLEY, EDWARD WEDLAKE.

—, and PUGIN, AUGUSTUS CHARLES (1825): *Illustrations of the Public Buildings of London* (London: J. Taylor).

BROCKEDON, W. (1846–9) and 1855–6): *see* ROBERTS, DAVID.

BRONGNIART, ALEXANDRE-THÉODORE (1814): *Plans . . . du Cimetière Mont-Louis . . . etc.* (Paris: A.-T. Brongniart).

BROOKS, CHRISTOPHER (1999): *The Gothic Revival* (London: Phaidon Press Ltd).

BROSE, J. (1978): *see* QUATREBARBES, E. DE.

BROUGHTON, THOMAS ROBERT SHANNON (1952): *The Magistrates of the Roman Republic*, with MARCIA L. PATTERSON with a supplementary volume (New York, NY: American Philological Association).

BROVARSKI. E. (1978): *Corpus Antiquitatum Ægyptiacarum. Museum of Fine Arts Boston*, Fasc. 1, *Canopic Jars* (Mainz-am-Rhein: P. von Zabern).

—(1982): 'Kohl and Kohl Containers', in FREED, RITA E. (*Ed*), 216–227.

BROWN, PETER ROBERT LAMONT (1978): *The Making of Late Antiquity* (Cambridge, MA: Harvard University Press).

BROWN, RICHARD (1842): *Domestic Architecture: containing a history of the science, and the principles of designing Public Edifices, Private Dwelling Houses, Country Mansions, and Surburban Villas, with practical dissertations on every branch of building, from the choice of site, to the completion of the appendages. Also, some observations on Rural Residences, their characteristic situation and scenery; with instructions on the art of laying out and ornamenting grounds; exemplified in Sixty-Three Plates, containing Diagrams, and Exemplars of the various Styles of Domestic Architecture, with a description, and wood-cuts of the appropriate furniture, garden, and landscape scenery of each* (London: G. Virtue).

BROWN, WILLIAM (1856): *The Carpenter's Assistant; containing a succinct account of Egyptian, Grecian, and Roman Architecture* (New York, NY: Livermore & Rudd).

BROWNLEE, DAVID (Ed.) (1986) *Friedrich Weinbrenner: Architect of Karlsruhe* (Philadelphia, PA: University of Pennsylvania Press).

BROZE, M., and TALON, PH. (*Eds*) (1992): *L'Atelier de l'orfèvre. Mélanges offerts à Philippe Derchain* (Leuven: Peeters), 183–200.

BRUCE, JAMES (1790): *Travels, between the years 1765 and 1773, through part of Africa, Syria, Egypt, and Arabia, into Abyssinia, to discover the Source of the Nile* (London: Robinson, and Edinburgh: Ruthven).

BRÜES, EVA (1965): *Kunstchronik*, **xviii**, 315f.

BRUNET, M. (1953): *see* VERLET, PIERRE.

BRUNNER, H. (1975): 'Chons', in *Lexikon der Ägyptologie*, **i** (Wiesbaden: O. Harrassowitz), 960–3.

—(1977): 'Götter Kinder' in *Lexikon der Ägyptologie*, **ii** (Wiesbaden: O. Harrassowitz), 648–51.

BRUNNER-TRAUT, EMMA (1965): 'Spitzmaus und Ichneumon als Tiere des Sonnengottes', in *Nachrichten der Akademie der Wissenschaften in Göttingen*, I. *Philologisch-Historische Klasse*, **vii**, 123–63.

—(1968*a*): 'Ägyptische Mythen im Physiologus (zu Kapitel 26, 25, und 11)', in *Festschrift für Siegfried Schott zu seinem 70. Geburtstag*, edited by W. HELCK (Wiesbaden: O. Harrassowitz), 13–44.

—(1968*b*): *Altägyptische Tiergeschichte und Fabel. Gestalt und Strahlkraft* (Darmstadt: Wissenschaftliche Buchgesellschaft).

—(1971): 'Ein Königskopf der Spätzeit mit dem "Blauen Helm" in Tübingen', in *Zeitschrift für Ägyptische Sprache und Altertumskunde*, **xcvii**, 18–30.

—(1974): *see* SCHÄFER, HEINRICH.

—(1977): 'Die Sehgott und Hörgott in Literatur und Theologie', in *Festschrift Eberhardt Otto* (Wiesbaden: O. Harrassowitz), 125–145.

—, and HELLMUT, and ZICK-NISSEN, JOANNA (1984): *Osiris, Kreuz, und Halbmond: die drei Religionen Ägyptens* (Mainz-am-Rhein: P. von Zabern).

BRUNT, P. A., and MOORE, J. M. (*Eds*) (1967): *Res gestæ divi Augusti: The Achievements of the Divine Augustus* (London: Oxford University Press).

BRUSCHI, A. *ET AL.* (1978): *Scritti rinascimentali di architettura* (Milan: Il Polifilo).

BRUWIER, MARIE-CÉCILE (1911): 'La collection égyptienne de Raoul Warocque', in *Cahiers de Mariemont*, **xviii-xix**, 46–75.

—(1998): *L'Égypte au regard de J.-J. Rifaud (1786–1852): lithographies conservées dans les collections de la Société royale d'Archéologie, d'histoire, et de folklore de Nivelles et du Brabant wallon* (Nivelles: Société royale d'Archéologie de Nivelles et du Brabant wallon).

BRYAN, BRUCE (1924): 'Movie realism and archæological fact', in *Art and Archæology, The Arts throughout the Ages*, **xviii**/4 (October), 137–40.

BUCK, JIRAH DEWEY (1911): *Mystic Masonry; or, the symbols of Freemasonry and the Greater Mysteries of Antiquity* (Chicago, IL: Ezra A. Cook).

BUDDE, HENDRIK (*Ed.*) (1989): *see* SIEVERNICH, GEREON.

BUDDE, LUDWIG, and NICHOLLS, RICHARD (1967): *A Catalogue of the Greek and Roman Sculpture in the Fitzwilliam Museum, Cambridge* (Cambridge: Cambridge University Press).

BUDGE, SIR ERNEST ALFRED THOMPSON WALLIS (1901): *Egyptian Magic* (London: K. Paul, Trench, Trübner & Co. Ltd).

—(1902*a*): *Egypt under the Saïtes, Persians, and Ptolemies* (London: Kegan Paul, Trench, Trübner & Co.).

—(1902*b*): *A History of Egypt from the end of the Neolithic period to the death of Cleopatra VII, B. C. 30* (London: K. Paul, Trench, Trübner & Co. Ltd).

—(1904): *The Gods of the Egyptians; or, Studies in Egyptian Mythology* (London: Methuen & Co., and Chicago, IL: Open Court Publishing Co.).

—(1909): *The Liturgy of Funerary Offerings* (London: K. Paul, Trench, Trübner & Co. Ltd).

—(1910): *The Nile. Notes for Travellers in Egypt and in the Egyptian Sûdan* (London and Cairo: T. Cook & Son [Egypt] Ltd)

—(1911): *Osiris and the Egyptian Resurrection* (London: P. Warner).

— (1925): *The Mummy. A Handbook of Egyptian Funerary Archæology* (Cambridge: Cambridge University Press)

—(1926): *Cleopatra's Needle and other Egyptian Obelisks* (London: The Religious Tract Society).

—(1928): *The Book of the Dead* (London: K. Paul, Trench, Trubner & Co. Ltd).

—(1933): *Legends of Our Lady Mary the perpetual Virgin and her mother Hannâ, translated from the Ethiopic manuscripts* (London: H. Milford for Oxford University Press).

—(1933): *One Hundred and Ten Miracles of Our Lady Mary . . .* (London: H. Milford for Oxford University Press).

—(1934): *From Fetish to God in Ancient Egypt* (London: H. Milford for Oxford University Press).

BUDISCHOVSKY, M.-C. (1977): *La diffusion des cultes isaïques autour de la mer Adriatique* (Leiden: E. J. Brill).

BUHL, M. L. (1947): 'The Goddesses of the Egyptian Tree Cult', in *Journal of Near Eastern Studies*, **vi**, 80–97.

BUILDER, THE (from 1842): *An illustrated weekly magazine for the architect, engineer, archæologist, constructor, sanitary reformer, and art-lover* (London: The Builder).

BULLETINO DELLA COMMISSIONE ARCHEOLOGICA COMUNALE DI ROMA (from 1872): (Rome: later editions published by 'L'Erma' di Bretschneider).

BULLOCK, WILLIAM (1814): *A Companion to the London Museum and Pantherion . . . now open for Public Inspection in the Egyptian Temple, Piccadilly, London* (London: William Bullock).

BULTE, JEANNE (1981): *Catalogue des Collections égyptiennes du Musée National de Céramique à Sèvres* (Paris: éd. du CNRS).

BUONANNI, FILIPPO (1773–82): *see* BONANNI, PHILIPPO, S. J.

BURCHARD, JOHN ELY, and BUSH-BROWN, ALBERT (1961): *The architecture of America; a social and cultural history* (Boston, MA: Little, Brown).

BURCKHARDT, JAKOB CHRISTOPH (1937): *The Civilization of the Renaissance in Italy*, tr. S.G.C. MIDDLEMORE (Vienna: Phaidon; London: George Allen & Unwin).

—(1949): *The Age of Constantine the Great*, tr. MOSES HADAS (New York, NY: Pantheon Books).

BURCKHARDT, JOHN LEWIS (1819): *Travels in Nubia* (London: J. Murray).

BUREL, J. (1911): *Isis et les Isaïques sous l'Empire romain* (Paris: s.n.).

BURKARD, GÜNTER (1993): *see* BAYER-NIEMEIER, EVA.

BURKE, EDMUND (1757): *A Philosophical Enquiry into the Origin of Our Ideas of the Sublime and Beautiful* (London: R. & J. Dodsley).

BURKERT, WALTER (1987): *Ancient Mystery Cults* (Cambridge, MA, and London: Harvard University Press).

BURNETT, ANDREW (1987): *Coinage of the Roman World* (London: Seaby).

BURY, JOHN BAGNELL (1958): *A History of the Later Roman Empire* (New York, NY: Dover Publications).

BUSBY, C.A. (1808): *A Series of Designs for Villas and Country Houses. Adapted with Economy to the Comforts and to the Elegancies of Modern Life* (London: J. Taylor).

BUSH-BROWN, ALBERT (1961): *see* BURCHARD, JOHN ELY.

BUTCHER, EDITH LOUISA (1897): *The Story of the Church in Egypt; being an outline of the History of the Egyptians under their successive Masters from the Roman Conquest until now* (London: Smith Elder, & Co.).

CAILLIAUD, FRÉDÉRIC (1821): *Voyage à l'oasis de Thèbes, 1815–1818* (Paris: Imprimerie Royale).

CALATRAVA, J. (1992): 'Isidoro Bosarte y la nueva egiptomania del final del siglo XVIII', in *Cauadernos de Arte de la Universidad de Granada*, **xxii**, 373–83.

CALCAGNINI, CÉLIO (1544): *Opera Aliquot* (contains a piece on things Egyptian) (Basel: H. Frobenium & N. Episcopium).

CALVERLEY, AMICE M., and GARDINER, ALAN HENDERSON (1933–58): *The temple of King Sethos I at Abydos* (London: The Egypt Exploration Society, and Chicago, IL: Chicago University Press).

CALVESI, MAURIZIO (1983): *Il sogno di Polifilo prenestino* (Rome: Officina).

—(1987): 'Hypnerotomachia Poliphili', in *Storia del l'Arte*, **lx**, 85–136.

—(1988*a*): 'Il Mito dell'Egitto nel Rinascimento-Pinturicchio, Piero di Cosimo, Giorgione, Francesco Colonna', in *Art e Dossier*, **xxiv** (May).

—(1988*b*): 'Il mosaico di Palestrina', in *Art e Dossier*, **xxiv**, (May), 20–31.

CAMERON, ALAN (1964): 'The Roman Friends of Symmachus', in *Journal of Roman Studies*, **xxiv**, 14–28.

CAMERON, AVERIL (1983): 'Eusebius of Cæsarea and the Rethinking of History', in GABBA, EMILIO (*Ed.*): *Tria Corda: Scritti in onore di Arnaldo Momigliano* (Como: Edizioni New Press), 71–88.

CAMP, MAXIME DU (1889): *Le Nil (Égypte et Nubie)* (Paris: Hachette).

CANCELLIERI, FRANCESCO GIROLAMO (1811): *Il Mercato, il Lago dell'Acqua Vergine, et il Palazzo Panfiliano nel circo Agonale detto volgarmente Piazza Navona* (Rome: F. Bourlié).

CANINA, LUIGI (1828): *Le nuove fabbriche della Villa Borghese, denominata Pinciana* (Rome: Dalla Societá Tipografica).

—(1848–56): *Gli edifizj di Roma antica cogniti per alcune reliquie . . .* (Rome: Canina).

CAPART, JEAN (1900): 'Mélanges', in *Recueil de Travaux relatifs à la Philologie et à l'Archéologie égyptiennes et assyriennes*, **xxii**, 105–12.

—(1902): *Recueil de Monuments Égyptiennes* (Brussels: Vromant & Co.).

—(1947): *L'art égyptien. Choix de documents, IV. Les arts mineurs* (Brussels: Vromant & Co.).

CAPLAT, MORAN (*Ed.*) (1978): *Glyndebourne Festival Opera 1978* (Glyndebourne: Festival Opera).

CAPPE, AUGUST WILHELM HEINRICH (1801): *Authentische Geschichte der Freymaurerey im Orient von Hildesheim* (Hildesheim: s.n.).

CARETTONI, GIANFILIPPO (1983): *Das Haus des Augustus auf dem Palatin* (Mainz-am-Rhein: P. von Zabern).

CARLISLE, R. (1979–80): *see* RICHARDSON III, J.

CARMIGNIANI, JUAN CARLOS (1988): *see* TRANIÉ, JEAN.

CARMONTELLE, LOUIS CARROGIS, *called* (1779): *Jardin de Monceau, près de Paris, appartenant à . . . M. le duc de Chartres* (Paris: Delafosse).

CARO, STEFANO DE (*Ed.*) (1992): *Alla ricerca di Iside: analisi, studi, e restauri dell'Iseo pompeiano nel Museo di Napoli* (Rome: ARTI).

CAROLIS, E. DE (1988): *see* CONTICELLO DE SPAGNOLIS, M.

CARPEGGIANI, P. (1985): 'Labyrithos. Metafora e mito nella corte dei Gonzaga', in *Quaderni di Palazzo Tè*, **ii**, 55–67.

CARRÉ, JEAN-MARIE (1932): *Voyageurs et écrivains français en Égypte* (Cairo: Institut français d'archéologie orientale).

—(1935): *Voyage en Égypte* (Paris: Éditions Montaigne).

CARROGIS, LOUIS (1779): *see* CARMONTELLE.

CARROTT, RICHARD G. (1961): 'The architect of the Pennsylvania Fire Insurance Building', in *Journal of the Society of Architectural Historians*, **xx**/3 (October), 138–9.

—(1966): 'The neo-Egyptian style in American architecture', in *Antiques*, (October), 482–8.

—(1978): *The Egyptian Revival. Its Sources, Monuments, and Meaning. 1808–1858* (Berkeley, CA, Los Angeles, CA, and London: University of California Press).

CASSARD, ANDRÉS (1932): *Manual de la Masonería; ó sea El tejador de los ritos antiguo escocés, francés y de adopción* (Barcelona: Editorial B. Bauzá).

CASSAS, LOUIS-FRANÇOIS (1799–1800): *see* PORTE DU THEIL, F.-J.-G. DE.

CASTELLI, PATRIZIA (1979): *I geroglifici e il mito dell'Egitto nel Rinascimento* (Florence: EDAM).

CASTIGLIONE, L. (1957): 'Griechish-ägyptische Studien: Beiträge zur Deutung des Mosaiks von Praeneste', in *Acta antiqua Academiae Scientiarum Hungaricae*, **v**, 209 ff.

CAUBET, ANNIE, KARAGEORGHIS, VASSOS, and YON, MARGUERITA (1981): *Les antiquités de Chypre: Age du bronze* (Paris: Éditions de la Réunion des musées nationaux).

CAYLUS, ANNE-CLAUDE-PHILIPPE DE THUBIÈRES, COMTE DE (1752–67): *Recueil d'Antiquités Égyptiennes, Étrusques, Grecques, et Romaines* (Paris: Desaint & Saillant).

CELIS, MARCEL (1984): 'De egyptiserende maçonnieke tempels van de Brusselse Loges "Les Amis Philanthropes" en "Les Vrais Amis de l'Union et du Progrès Réunis"', in *M & L. Monumenten en Landschappen*, **iii**/3 (May–June), 25–41.

CERCEAU, JACQUES ANDROUET DU (1611): *see* ANDROUET DU CERCEAU.

ČERNÝ, JAROSLAV (1952): *Ancient Egyptian Religion* (London: Hutchinson's University Library).

CHABAS, FRANÇOIS-JOSEPH (1868): *Traduction complète des inscriptions hiéroglyphiques de l'obélisque de Louqsor, place de la Concorde, à Paris* (Paris: Maisonneuve et cie).

—(1877): *see* COOPER, WILLIAM RICKETTS.

CHAMPIGNEULLE, BERNARD (1961): *Promenade dans les jardins de Paris, ses bois, et ses squares* (Paris: Club des libraries de France).

CHAMPION, VIRGINIE, LEMOINE, BERTRAND, and TERREAUX, CLAUDE (1995): *Les Cinémas de Paris 1945–1995* (Paris: Délégation à l'action artistique de la ville de Paris).

CHAMPOLLION, JEAN-FRANÇOIS (1822): *Lettre à M. Dacier* (Paris: Didot).

—(1824*a*): 'Antiquités égyptiennes. Collection Drovetti', in *Revue encyclopédique*, **xxii**, 767.

—(1824*b*): 'Papyrus égyptiens. Extrait des lettres de M. Champollion', in *Bull. univ.* **i**, 297–303.

—(1824–6): *Lettres à M. le duc de Blacas d'Aulps* (Florence: G. Piatti).

—(1833): *Lettres écrites d'Égypte et de Nubie en 1828 et 1829* (Paris: Didot).

—(1835–45): *Monuments de l'Égypte et de la Nubie* (Paris: Didot).

—(1841): *Mémoire sur les signes employées par les anciens Égyptiens* (Paris: Imp. Royale).

—(1909): *Lettres de Champollion le jeune recueillés et annotés*, edited by HERMINE HARTLEBEN (Paris: E. Leroux).

CHAMPOLLION-FIGEAC, JACQUES-JOSEPH (1833): *L'Obélisque de Louqsor Transporté à Paris. Notice historique, descriptive et archéologique sur le monument, avec la figure de l'Obélisque et l'interprétation de ses inscriptions hiéroglyphes, d'après les dessins et les notes manuscrites de Champollion le Jeune* (Paris: Didot).

CHAPOUTHIER, FERNAND (1935): *Les Dioscures au Service d'une Déesse, Étude d'Iconographie Religieuse* (Paris: E. de Boccard).

CHARBONNEAUX, J. (1957): 'Sarapis et Isis et la double corne d'abondance', in *Hommages à Waldemar Deonna. Latomus, Revue d'études latines*, **xxviii**, 131 ff.

CHARPENTIER, JOSANE (1980): *La France des lieux et des demeures alchimiques* (Paris: Retz).

CHASTEL, ANDRÉ (1956): *L'Art Italien* (Paris: Libraire Larousse).

—(1966*a*): *The Studios and Styles of the Renaissance* (London: Thames & Hudson).

—(1966b): 'The Grand Eccentrics: The Moralizing Architecture of Jean-Jacques Lequeu', in *Art News Annual*, **xxxii**, 70–83.

—(1968): 'Les Villes et les Fables', in *Médecine de France*, **cxc** (March), 55–6.

—(1975): *Marcel Ficine et l'Art* (Geneva: Droz).

CHASTEL, ÉTIENNE-LOUIS (1857): *Histoire de la Destruction du Paganisme dans l'Empire d'Orient* (Paris: Académie des Inscriptions et Belles-Lettres).

CHAUSSARD, PIERRE-JEAN-BAPTISTE (1800): *Monuments de L'heroisme français; nécessité de ramener à un plan unique . . .* etc. (Paris: Panckoucke).

CHELLIS, ELIZABETH (1949): 'From the Nile to the Trent', in *Antiques* (October), 260.

CHOUKAS, MICHAEL (1935): *Black Angels of Athos* (Brattleboro, VT: Stephen Daye Press).

CHRIST, KARL (1956): *Drusus und Germanikus. Der Eintritt der Römer in Germanien* (Paderborn: Schöningh).

—(1977): 'Zur augusteischen Germanienpolitik', in *Chiron*, **vii**, 149–205.

—(1979): *Krise und Untergang der römischen Republik* (Darmstadt: Wissenschaftliche Buchgesellschaft).

—(2001): *Die römische Kaiserzeit: von Augustus bis Diokletian* (Munich: Beck).

CHRIST, YVAN (1967): *Le Marais* (Paris: A. Balland).

—(1970): *Paris des utopies* (Paris: A. Balland).

CHRISTIANSEN, ERIK, and DAHL HERMANSEN, BO (*Eds*) (2001): *Arven fra Ægypten II: Genopdagelse. Mystik og videnskas* (Aarhus: Tidsskiftet Sfinx).

CHRONIQUE D'ÉGYPTE: BULLETIN PÉRIODIQUE DE LA FONDATION ÉGYPTOLOGIQUE REINE ÉLISABETH (from 1925): (Brussels: Musées Royaux du Cinquantenaire).

CHUVIN, PIERRE (1988): *see* YOYOTTE, J.

—(1990): *A Chronicle of the Last Pagans*, tr. B. A. ARCHER (Cambridge, MA, and London: Harvard University Press).

CIACERI, EMANUELE (1905): 'La festa di S. Agata e l'antico culto di Iside', in *Archivo Storico par la Sicilia Orientale*, **ii**, 265 ff.

—(1911): *Culti e Miti nella Storia dell'Antica Sicilia* (Catania: F. Battiato).

CIAPPONI, L. A. (1980): *see* COLONNA, FRANCESCO.

CLARAC, CHARLES OTHON FRÉDÉRIC JEAN BAPTISTE, COMTE DE (1841–53): *Musée de sculpture antique et moderne* (Paris: Imprimerie royale).

CLARIDGE, A. (1978): *see* WARD-PERKINS, JOHN BRYAN.

CLARK, ROBERT THOMAS RUNDLE (1960): *Myth and Symbol in Ancient Egypt* (London: Thames & Hudson).

CLAUSEN, ERNST ALEXANDER (1914): *Die Freimaurer; Einführung in das Wesen ihres Bundes* (Berlin: Alfred Unger).

CLAY, JEAN (1980): *Romanticism* (New York, NY: The Vendome Press and Oxford: The Phaidon Press Ltd).

CLAYTON, PETER A. (1982): *The Rediscovery of Ancient Egypt. Artists and Travellers in the Nineteenth Century* (London: Thames & Hudson Ltd).

—(1994): *Chronicle of the Pharaohs* (London: Thames & Hudson Ltd).

CLÉBERT, JEAN-PAUL (1958): *see* ROCHEGUDE, FÉLIX, MARQUIS DE.

CLÉEMPUTTE, P.-L. VAN: *see* ACADÉMIE DES BEAUX-ARTS.

CLEMEN, CARL CHRISTIAN (1912): *Primitive Christianity and its non-Jewish Sources* (Edinburgh: T. & T. Clark).

—(1913): *Der Einfluss der Mysterienreligionen auf das älteste Christentum* (Giessen: A. Töppelmann).

—(1914): 'Der Isiskult und das Neue Testament', in *Heinrici Festschrift: Neutestamentliche Studien* (Leipzig: J.C. Hinrichs).

—(1931): *Religions of the World, their Nature and their History* (London: G.G. Harrap & Co. Ltd).

CLERC, G., KARAGEORGHIS, V., LAGARCE, F., and LECLANT, J. (1976): *Fouilles de Kition, II, Objets égyptiens et égyptisants: scarabées, amulettes, et figurines en pâte de verre et de faience, vase plastique en faience. Sites I and II, 1959–1975* (Nicosia: Department of Antiquities).

CLÈRE, MARCEL LE (1978): *Cimetières et Sépultures de Paris; Guide Historique et Practique* (Paris: Hachette).

COARELLI, FILIPPO (1974): *Guida archeologica di Roma* (Milan: A. Mondadori).

—(1982): *Guide archeologiche Laterza* (Rome and Bari: G. Laterza).

—(1984): 'Iside Capitolina, Clodio e i mercanti di schiavi', in BARONE, GIUSEPPINA (*Ed.*), 461–75.

COCHIN, CHARLES-NICOLAS (1880): *Mémoires inédits de Charles-Nicolas Cochin sur le Comte de Caylus*, (Paris: Baur).

COFFIN, DAVID (1960): *The Villa d'Este at Tivoli* (Princeton, NJ: Princeton University Press).

—(1964): 'Ligorio on the nobility of the arts', in *Journal of the Warburg and Courtauld Institutes*, **xxvii**, 191–210.

COHEN-HADAD, BERNARD (2001): *Respectable Loge Demain* (Paris: EDIMAF).

COLE, WILFRED P. (*Ed.*) (1970): *see* MONTGOMERY, CHARLES F.

COLLETT-SANDARS, W. (*tr.*) (1893): *see* ROSEN-GARTEN, A.

COLLINS, J. (2000): 'Obelisk designs by Giovanni Stern', in *The Burlington Magazine*, **cxlii** (February), 90–100.

COLOMB, SIMONE (1954): 'Quelques vues de Paris par Janinet vers 1780–1790', in *Mélanges Lavedan: Urbanisme et architecture* (Paris: H. Laurens, and Évreux: impr. de Hérissey), 90.

COLOMBIER, PIERRE DU (1931): *Poussin* (Paris: G. Crès).

—(1955): *L'Architecture française en Allemagne au XVIII Siècle* (Paris: Presses Universitaires de France).

COLONNA, FRANCESCO (1499): *Hypnerotomachia Poliphili* (Venice: Aldus Manutius). *See also Hypnerotomachie, ou discours du songe de Poliphile* (1963: a facsimile of the 1546 French edition (Paris: Club des libraires de France). *See also* GODWIN, JOSCELYN (1999), and the critical edition of 1980, with commentary by G. POZZI and L. A. CIAPPONI (Padua: Antenore).

COLVIN, HOWARD M. (1995): *A Biographical Dictionary of British Architects 1600–1840* (New Haven, CT, and London: Yale University Press). *See also* the 1978 edition published by John Murray).

COMBES, EDMOND (1846): *Voyage en Égypte, en Nubie*, etc. (Paris: Desessart).

COMBES D'AURIAC, FRÉDÉRIC (1852): *see* ACQUIER, HIPPOLYTE.

COMMISSION DES SCIENCES ET ARTS D'ÉGYPTE (1809–28): *Description de l'Égypte, ou, Recueil des observations et des recherches qui ont été faites en Égypte pendant l'expédition de l'armée* française. The volumes dated 1809–13 had the imprint 'Imprimerie impériale', and the title continued *publié par les ordres de sa Majesté l'empereur Napoléon le Grand*; those dated 1817–30 had the imprint 'Imprimerie Royale', and the title continued *publié par ordre du gouvernement*. The editor was EDMÉ-FRANÇOIS JOMARD. The text is in this order: *Antiquités-Descriptions* 1809–18 (2 vols.); *Antiquitiés-Mémoires* 1809–18 (2 vols.); Plates 1809–22 (5 vols.); *État moderne* 1809–22 (2 vols. in 3); plates 1809–17 (2 vols.); *Histoire naturelle* 1809–29 (2 vols.); plates 1809–17 (2 vols. in 3); *préface et explication des planches* (*c.* 1828) (1 vol.); *Carte topographique de l'Égypte* 1818 (1 vol.); oversize plates from *Antiquities* and *État Moderne* (2 vols.). Thus there were 9 volumes of text and 12 volumes of plates, or 21 volumes in 23, depending on the arrangement of the binding. Some bibliographies have recorded 25 volumes, and matters are further complicated by the three sizes of folio. The usual agreed number of volumes is 21, but the different sizes of folios required special book-cases to be constructed, as at the Benedictine Abbey at Salzburg (*see* HUMBERT, PANTAZZI, AND ZIEGLER [*Eds*] [1994], 264–6, 326–7). *See also* the edition published in Paris by C.-L.-F. Panckoucke, 1820–30, with atlases.

CONFALIONERI, GIULIO (1948): *Prigonia di un artista; il romanzo di Luigi Cherubini* (Milan: Genio).

CONNAISSANCE DES ARTS (from 1952): (Paris: Société d'études et publications artistiques).

CONNER, PATRICK (1979): *Oriental Architecture in the West* (London: Thames & Hudson Ltd).

—(*Ed.*) (1983): *The Inspiration of Egypt. Its Influences on British Artists, Travellers, and Designers, 1700–1900. Catalogue* of the Exhibition of that title held at Brighton Museum (7 May–17 July 1983) and at Manchester City Art Gallery (4 August–17 September). (Brighton: Brighton Borough Council).

—(1985): 'Wedding Archæology to Art: Poynter's Israel in Egypt', in *Influences in Victorian Art and Architecture* (*see* MACREADY, SARAH).

CONNOISSEUR, THE (from 1901): (London: National Magazine Co.).

CONNOISSEUR'S COMPLETE PERIOD GUIDES TO THE HOUSES, DECORATION, FURNISHING AND CHATTELS OF THE CLASSIC PERIODS, THE (1968): edited by RALPH EDWARDS and L.G.G. RAMSEY (London: The Connoisseur).

CONRADS, ULRICH, and SPERLICH, HANS G. (1960): *Phantastische Architektur* (Stuttgart: G. Hatje).

CONSTANS, MARTINE, *ET AL.* (1997*a*): *Bagatelle dans ses jardins* (Paris: Action artistique de la ville de Paris).

—(1997*b*): 'Le château du comte d'Artois', in *Bagatelle dans ses jardins* (Paris: Action artistique de la ville de Paris).

CONTICELLO DE SPAGNOLIS, M., and CAROLIS, E. DE (1988): *Le lucerne di bronzo di Ercolano e Pompei* (Rome: 'L'Erma' di Bretschneider).

COOK, B.F. (1976): *Greek and Roman Art in the British Museum* (London: British Museum Publications).

COOPER, EDWARD JOSHUA, and BOSSI, S. (1824–27): *Views in Egypt and Nubia* (London: J. Murray).

COOPER, WILLIAM RICKETTS (1873): *The Serpent Myths of Ancient Egypt* (London: R. Hardwicke).

—(1877): *The Horus Myth in its relation to Christianity* (London: Hardwicke & Bogue).

—(1877): *A Short History of the Egyptian Obelisks, with translations of many of the hieroglyphic inscriptions, chiefly by M. FRANÇOIS CHABAS* (London: S. Bagster & Sons).

CORBO, A.M. (1972): 'L'attivita romana e il testamento di Giovanni Antinori, architetto de Pio VI', in *L'Arte*, **xvii**, 133–46.

CORLETT, DUDLEY S. (1923): 'Art on the Screen; or the film of Tutankhamen', in *Art and Archæology, The Arts through the Ages*, **xvi**/6 (December).

CORLISS, RICHARD (1988): 'Twin Shrines to the Silver Screen', in *Time*, **xxxix** (26 September), 46–7.

CORROZET, GILLES (1550): *Les Antiquitez, histories et singularitez . . . de Paris* (Paris: Vve J. Bonfonss. d).

—(1874): *La Fleur des Antiquitez . . . de Paris* (Paris: L. Willem) – a facsimile of the 1532 edition published in Paris by Jacob.

CORRINGTON, G. PATTERSON (1989): 'The Milk of Salvation: Redemption by the Mother in Late Antiquity and Early Christianity', in *Harvard Theological Review*, **lxxxii**, 393–420.

CORSU, FRANCE LE (1977): *Isis mythe et mystères* (Paris: Les Belles Lettres).

COULET, HENRI (1984): 'Quelques aspects du mythe de l'Égypte pharaonique en France au XVIIIe siècle', in *Le Miroir égyptien* (Marseilles: Actes des Rencontres Méditerranéennes de Provence), 21–8.

COUNTRY LIFE (from 1897): (London: Country Life Ltd).

COURT DE GÉBELIN, ANTOINE (1776): *Monde Primitif, analysé et comparé avec le monde moderne* (Paris: Court de Gébelin).

COUSSILLAN, AUGUSTE ANDRÉ (1966): *see* HILLAIRET, JACQUES.

CRABB, P. G. (*tr.*) (1988): *see* HANNESTAD, NIELS.

CRAMER, FREDERICK HENRY (1954): *Astrology in Roman Law and Politics* (Philadelphia, PA: American Philosophical Society).

CRAMER, M. (1953): 'Das Koptische und die Entzifferung der Hieroglyphen', in *Oriens Christianus*, 116–31.

CRAWFORD, MICHAEL HEWSON (1974): *Roman Republican Coinage* (London and New York, NY: Cambridge University Press).

—(1978): *The Roman Republic* (Hassocks: Harvester Press, and Atlantic Highlands, NJ: Humanities Press).

—(1985*a*): *Coinage and Money under the Roman Republic* (Berkeley, CA: University of California Press).

—(1985*b*): *see* BEARD, MARY.

CRAWFORD, WILLIAM (1834): *Report on the Penitentiaries of the United States* (London: HMSO).

—, and RUSSELL, WHITWORTH (1837): *Extracts from the Second Report of the Inspectors of Prisons for the Home District* (London: HMSO).

CROOK, JOSEPH MORDAUNT (1970): *see* EASTLAKE, CHARLES L.

—(1972): *The Greek Revival. Neo-Classical Attitudes in British Architecture 1760–1870* (London: John Murray).

—(1987): *The Dilemma of Style* (London: John Murray).

CROSNIER-LECONTE, MARIE-LAURE (1998): see VOLAIT, MERCEDES.

CROUS, J. W. (1940): 'Ein antiker Freis bei Sebastiano del Pombio', in *Mitteilungen des Deutschen Archäologischen Instituts. Römische Abteilung*, **lv**, 65–77.

CUISSET, GENEVIÈVE (1990): 'Jean-Pierre et François Fouquet, artistes modeleurs', in *Gazette des Beaux-Arts*, **1456–1457** (May–June), 227 and 229.

CULLUS, PHILIPPE (*Ed.*) (2000): see DESPY-MEYER, ANDRÉE.

CUMONT, FRANZ VALÉRY MARTIN (1911): *The Oriental Religions in Roman Paganism* (Chicago, IL: The Open Court Publishing Co.).

CUNNALLY, J. (1984): *The Role of Greek and Roman Coins in the Art of the Italian Renaissance* (Philadelphia, PA: Ph Diss., University of Pennsylvania).

CURL, JAMES STEVENS (1982): *The Egyptian Revival. An Introduction Study of a Recurring Theme in the History of Taste* (London: George Allen & Unwin Ltd).

—(1984*a*): 'Egypt in Paris', in *Country Life*, **clxxvi**/4534 (12 July), 132–3.

—(1984*b*): 'The Design of Early British Cemeteries', in *Journal of Garden History*, **iv**/3 (July/September), 223–54.

—(1986): 'Du Nil à la Seine', in *Connaissance des Arts*, No. 411 (May), 80–5.

—(1991*a*): 'Aspects of the Egyptian Revival in Architectural Design in the Nineteenth Century: Themes and Motifs', in GOVI, CURTO, and PERNIGOTTI (*Eds*), 89–96.

—(1991*b*): 'Altes Museum, Berlin', in *The Architects' Journal*, **cxciii**/25 (19 June), 30–49.

—(1991*c*): 'Charlottenhof, Potsdam', in *The Architects' Journal*, **cxciv**/4 & 5 (24 & 31 July), 22–39.

—(1993): *A Celebration of Death* (London: B. T. Batsford Ltd).

—(1994*a*): *Egyptomania. The Egyptian Revival as a Recurring Theme in the History of Taste* (Manchester: Manchester University Press).

—(1994*b*): 'Young's *Night Thoughts* and the origins of the garden cemetery movement', in *Journal of Garden History*, **xiv**/2 (April–June), 92–118.

—(1996*a*): 'Les thèmes décoratifs égyptisants et la franc-maçonnerie', in JEAN-MARCEL HUMBERT (*Ed.*). (1996), 347–65.

—(1996*b*): Review of POPELKA (1994) under the title of 'Ephemeral Architecture', in *Print Quality* (March), **xiii**/1, 69–71.

—(1997): 'Gardens of Allusion', in *Interdisciplinary Science Reviews*, **22**, 325–42.

—(1999, 2000): *Oxford Dictionary of Architecture* (Oxford: Oxford University Press).

—(2000*a*): 'Egypt in Rome – an Introductory Essay. I: Isis, obelisks, and the Isæum Campense', in *Interdisciplinary Science Reviews*, **25**/1 (Spring), 53–64.

—(2000*b*): 'Egypt in Rome – an Introductory Essay. II: The Villa Adriana and the beginnings of Egyptology', in *Interdisciplinary Science Reviews* **25**/2 (Summer), 123–35.

—(2000*c*): *The Victorian Celebration of Death* (Thrupp, Stroud: Sutton Publishing Ltd).

—(2001*a*): *Classical Architecture. An Introduction to its Vocabulary and Essentials, with a Select Glossary of Terms* (London: B. T. Batsford Ltd).

—(*Ed.*) (2001*b*): *Kensal Green Cemetery. The Origins & Development of the General Cemetery of All Souls, Kensal Green, London, 1824–2001* (Chichester: Phillimore & Co. Ltd).

—(2002*a*): *Georgian Architecture* (Newton Abbot: David & Charles Ltd).

—(2002*b*): *The Art and Architecture of Freemasonry. An Introductory Study* (London: B. T. Batsford, and Woodstock, NY: Overlook Press).

—(2002c): *Death and Architecture. An Introduction to Funerary and Commemorative Buildings in the Western European Tradition, with Some Consideration of their Settings* (Thrupp, Stroud: Sutton Publishing Ltd).

—(2002*d*): *Piety Proclaimed. An Introduction to Places of Worship in Victorian England* (London: Historical Publications Ltd).

CURTO, SILVIO (1985): *Le sculture egizie ed egittizzanti nelli Ville Torlonia in Roma* (Leiden: E. J. Brill).

—(1990): see DONADONI, S.

—(*Ed.*) (1991): see GOVI, CRISTIANA MORIGI.

CURZON, J. BRIAN (1981): 'The Gods and their Makers, - The Story of a Painting', in *Popular Archæology*, **iii**/1, (July), 33–6.

DACIER, EMILE (1911): *Le Jardin de Monceau avant la Révolution*, Société d'Iconographie parisienne, Year 3, 1910, 56, no. 1.

DAGEN, PHILIPPE (1984): '"L'Exemple Égyptien": Matisse, Derain et Picasso entre fauvisme et cubisme (1905–1908)', in *Bulletin de la Société de l'Histoire de l'Art français*, 289–302.

DAGOT, HENRI (1988): 'Des pyramides au Louvre?', in *Le Figaro Magazine*, **xiii**/535 (5 March), 100–3.

DAHL HERMANSEN, BO (*Ed.*) (2001): see CHRISTIANSEN, ERIK.

DAHLHEIM, N. (1982): 'Die Funktion der Stadt im römischen Weltreich', in *Stadt und Herrschaft: römische Kaiserzeit und hohes Mittelalter*, edited by FRIEDRICH VITTINGHOFF (Munich: R. Oldenbourg), 15–74.

DAICOVICIU, CONSTANTIN (1938): *La Transilvania nell' antichità* (Bucharest: s.n.).

—, and H. (1963): *Sarmizegethusa* (Bucharest: Editura Meridiane).

DALTON, ORMONDE MADDOCK (1911): *Byzantine Art and Archæology* (Oxford: The Clarendon Press).

DALY, CÉSAR (1872): *L'architecture privée au XIX^e siècle*, 2^e series, **iii** (Paris: Ducher & Cie).

DANNENFELDT, KARL HENRY (1948): *Late Renaissance Interest in the Ancient Orient* (Chicago, IL: University of Chicago Thesis). Available on film reproduction.

—(1959): 'Egypt and Egyptian Antiquities in the Renaissance', in *Studies in the Renaissance*, **vi** (Houston, TX: Rice Institute), 7–27.

DARBY, MICHAEL (1972): '"The Egyptian Spell": The Legacy of Egypt', in *The Sunday Times Magazine* (19 and 26 March), 19–27 and 22–29 respectively.

DARESSY, GEORGES (1906): *Catalogue général des antiquités égyptiennes du Musée du Caire. Statues de divinités.* (Cairo: Press of the French Institute of Oriental Archaeology).

D'ARMS, J. H. (1970): *see* ARMS, J. H. D'.

DARNTON, ROBERT (1970): *Mesmerism and the End of the Enlightenment in France* (New York, NY: Shocken Books).

DARTON, F. J. HARVEY (1924): *see* APULEIUS MADAURENSIS, LUCIUS.

DAVARI, S. (1904): *Descrizione dello storico Palazzo del Tè* (Mantua: Segna).

DAVID, ANN ROSALIE (1973): *Religious Ritual at Abydos* (Warminster: Aris & Phillips).

—(1980): *A Guide to Religious Ritual at Abydos* (Warminster: Aris & Phillips).

DAVID, ELISABETH (1994): *Mariette Pacha, 1821–1881* (Paris: Pygmalion/G. Watelet).

DAVID, LOUIS (n.d., but probably 1793): *Rapport fait au nom du Comité d'Instruction publique, pour l'explication de la médaille frappée en commemoration de la réunion civique de 10 août 1793* (Paris: Imprimerie nationale).

DAVIES, GERALD STANLEY (1910): *Renascence; the sculptured tombs of the fifteenth century in Rome* (London: J. Murray).

DAVILLIER, CHARLES (1870): *Le Cabinet du Duc d'Aumont et les amateurs de son temps* (Paris: Aubry).

DAWSON, CHRISTOPHER MOUNSEY (1944): *Romano - Campanian Mythological Landscape Painting* (London: H. Milford at Oxford University Press).

DAWSON, WARREN ROYALE, and UPHILL, ERIC P. (1972): *Who was Who in Egyptology* (London: Egypt Exploration Society).

DEAL, J. N. (1826): *Dissertation sur les Parisii ou parisiens, et sur le culte d'Isis chez les Gaulois* (Paris: F. Didot).

DEBENEDETTI, ELISA (1979): *Valadier* (Rome: Bulzoni).

DEBRUGE, J. (1926): 'Histoire de la R[espectable] [Loge] La "Parfaite Intelligence et l'Étoile Réunies" à l'Orient de Liège, rédigée à l'occasion de son 150ᵉ anniversaire', in *Bulletin du Grand Orient de Belgique*, 182–99.

DEBUS, ALLEN G. (*Ed.*) (1988): *see* MERKEL, INGRID.

DEBUSSCHÈRE, PIERRE (1998): 'Jules Pollet, Peintre du Temple', in *Trigonum Coronatum. Jaarboek*, **vi**, 108–39.

DECHARNEUX, BAUDOUIN, and NEFONTAINE, LUC (2001): *La Franc-maçonnerie: En pleine lumière, à contre jour* (Brussels: Labor).

DEININGER, J. (1965): *Die Provinziallandtage der römischen Kaiserzeit. Von Augustus bis zum Ende des 3. Jahrhunderts n. Chr.*, *Vestigia*, **vi** (Munich and Berlin: Beck).

DEISSMANN, GUSTAV ADOLF (1925): *Paulus: eine Kultur-und Religionsgeschichtliche Skizze* (Tübingen: J.C.B. Mohr).

DELAFOSSE, JEAN-CHARLES (1768): *Nouvelle Iconologie Historique; ou, Attributs Hieroglyphiques . . .* (Paris: The Author).

—(1850): *Style Louis XVI. L'Oeuvre de Delafosse* (Paris: Armand Guérinet).

DELILLE, ABBÉ JACQUES (actually MONTANIER, JACQUES, *called*) (1782): *Les Jardins, ou l'art d'embellir les Paysages* (Paris: Didot).

DELORT DE GLÉON (1889): *L'architecture arabe des Khalifes d'Égypte à l'Exposition Universelle de Paris en 1889: La rue du Caire* (Paris: E. Plon, Nourrit).

DELVAUX, LUC (1996): 'Les "Aventures de Papyrus" de Lucien De Gieter: approche égyptoloogique d'une band dessinée', in HUMBERT (*Ed.*) (1996), 609–24.

—, DE PUTTER, TH., DOYEN, F., KARLSHAUSEN, CHR., PREYS, R., and WARMENBOL, E. (1993): contributions in DIERKENS and DUVOSQUEL (*Eds*) (Brussels: Crédit communal).

—, and WARMENBOL, EUGÈNE (1991): *Les divins chats d'Égypte: un air subtil, un dangereux parfum* (Leuven: Peeters).

DEMETZ, FRÉDÉRIC-AUGUSTE (1838): *Lettre sur le Système Pénitentiaire* (Paris: L'Imprimerie Royale).

DEMEY, A. (1983): 'Het Land van Waas, Tien eeuwen Bouwkunst', in *Annalen van de Koninklijke Oudheidkundige Kring van het Land van Waas. Buitengewone Uitgave*, **xviii**, 186–91.

DEMISCH, HEINZ (1977): *Die Sphinx, Geschichte ihrer Darstellung von der Anfängen bis zur Gegenwart* (Stuttgart: Urachhaus).

DE MONTULÉ, É. (1823): *see* MONTULÉ, ÉDOUARD DE.

DEMPSEY, CHARLES GATES (1963): 'Representations of Egypt in the Paintings of Nicholas Poussin', in *Art Bulletin*, **xlv**/2, 109–19.

DENNIS, JAMES TEACKLE (*tr.*) (1910): *The Burden of Isis; being the Laments of Isis and Nephthys* (London: J. Murray).

DENON, BARON DOMINIQUE VIVANT (1802): *Voyage dans la Basse et la Haute Égypte, pendant les campagnes du général Bonaparte* (Paris: P. Didot l'aîné). *see also* the English edition (1802 by E.A. KENDAL), with an account of the invasion of Egypt by the French. (London: B. Crosby & Co.). *See also* the version (1803) *tr.* by ARTHUR AIKIN (London: T. Longman & O. Rees).

DENT, EDWARD J. (1960): *Mozart's Operas: A Critical Study* (London: Oxford University Press).

DERCHAIN, P. (1959): 'Religion égyptienne et sculpture romane?', in *Chronique d'Égypte*, **xxxiv**/69–70, 184–7.

—(1962): 'Mythes et dieux lunaires en Égypte', in *Sources orientales*, **v**, 19–68

—, and HUBAUX, J. (1953): 'Vespasien au Sérapéum', in *Latomus*, **xii**, 38–52.

DERNIE, D. (1996): *The Villa d'Este at Tivoli* (London: Academy Editions).

DEROY, L. (1946–48): 'Le monument funéraire du chanoine Hubert Mielemans à l'église Sainte-Croix à Liège', in *Bulletin de l'Institut Archéologique Liégeois*, **lxvi**, 5–46.

DESCRIPTION DE L'ÉGYPTE (1809–28): *see* COMMISSION DES SCIENCES ET ARTS D'ÉGYPTE.

DESGODETS, ANTOINE BABUTY (1822): *Gli edifizj antichi di Roma* (Rome: V. Poggioli). *See also* the *Supplemento* (Rome: Tipi della Rev. Cam. Apostolica, 1843). *See* VALADIER.

DESPY-MEYER, ANDRÉE, CULLUS, PHILIPPE, and JACOBS, JOHAN (*Eds*) (2000): *Bruxelles. Les francs-maçons dans la cité* (Gent: Tijdsbeeld, and Brussels: Parcours maçonnique).

DESROCHES-NOBLECOURT, CHRISTIANE (1965): *Tutankhamen* (Harmondsworth: Penguin).

DESSENNE, A. (1957): *'Le Sphinx'*, *Étude Icono-graphique* (Paris: E. De Boccard).

DÉTOURNELLE, A. (1806): see ACADÉMIE DES BEAUX-ARTS.

DE VERNINAC SAINT-MAUR, R.-J.-B. (1835): see VERNINAC DE SAINT-MAUR, R.-J.-B. DE.

DEWACHTER, MICHEL (1987): see GILLESPIE, CHARLES COULSTON.

—(1996): 'Le choc en retour: L'Égyptomanie des égyptologues', in HUMBERT (*Ed.*) (1996), 425–34.

—(*Ed.*) (1990): *L'Égypte, Bonaparte, et Champollion* (Figeac: Association pour le Bicentenaire Champollion).

—, and FOUCHARD, ALAIN (*Eds*) (1994): *L'égyptologie et les Champollion* (Grenoble: Presses universitaires de Grenoble).

DEWANDEL, A. (1941/2): *Geschiedenes van den Isiscultus in het westersche romeinsche Rijk* (Leiden: E. J. Brill).

DEWULF, M. (1978): 'De Egyptische Zaal van het Kasteel Moeland te St.-Niklaas, opgericht als tempel der Rosenkruisers', in *Annalen van de Koninklijke Oudheidkundige Kring van het Land van Waas*, **lxxxi**, 34–43.

DIBNER, B. (1952): *Moving the Obelisks: A Chapter in engineering history* (Norwalk, CT: Bundy Library).

DIDEROT, DENIS (1821–34): *Œuvres de Denis Diderot* (Paris: J.-L.-J. Brière).

—, and ALEMBERT, JEAN LE ROND D' (1751–80): *Encyclopédie ou dictionnaire raisonné des sciences, des arts, et des metiers, par une société de gens de lettres* (Paris: C. L. F. Panckoucke).

—(1782–1832): *Encyclopédie methodique* . . . (Paris: C. L. F. Panckoucke).

DIECKMANN, LISELOTTE (1970): *Hieroglyphics. The history of a literary symbol* (Saint-Louis, MO: Washington University Press).

DIERKENS, ALAIN (1995*a*): 'Le monument funéraire de la famille Goblet d'Alviella à Court-Saint-Étienne', in DIERKENS (*Ed.*) 193–211.

—(*Ed.*) (1995*b*): *Eugène Goblet d'Alviella, historien et franc-maçon. Problèmes d'histoire des religions*, **vi** (Brussels: Éditions de l'Université de Bruxelles).

—, and DUVOSQUEL, JEAN-MARIE (*Eds*) (1993): *Henri-Joseph Redouté et l'expédition de Bonaparte en Égypte* (Brussels: Crédit communal).

DIETRICH, D. (1966): *Der hellenistische Isiskult als kosmopolitische Religion und die sogenannte Isismission* (Leipzig: University of Leipzig Dissertation).

—(1968): 'Die Ausbreitung der alexandrinischen Mysteriengötter Isis, Osiris, Serapis und Horus in griechisch-römischer Zeit', in *Das Altertum*, **xiv**, 201–11.

DIFFIE, W. (1999): see PARKINSON, RICHARD.

DILL, SAMUEL (1937): *Roman Society from Nero to Marcus Aurelius* (London: Macmillan & Co. Ltd).

DINDORF, LUDWIG AUGUST (1870–71): *Historici Græci Minores* (Leipzig: B.G. Teubner).

DINSMOOR, WILLIAM BELL (1950): *The Architecture of Ancient Greece* (London: B. T. Batsford Ltd).

DIZIONARIO BIOGRAFICO DEGLI ITALIANI (DBI) (from 1960): (Rome: Istituto della Enciclopedia Italiana).

DOANE, THOMAS WILLIAM (1883): *Bible Myths and their Parallels in Other Religions: Being a comparison of the Old and New Testament myths and miracles with those of heathen nations of Antiquity, considering also their Origin and Meaning* (New York, NY: W. Bouton).

DOBÓ, Á. (1968): *Die Verwaltung der römischen Provinz Pannonien* (Amsterdam: Adolf M. Makkert).

DODSON, AIDAN (1995): *Monarchs of the Nile* (London: Rubicon Press).

—(2000): *After the Pyramids. The Valley of the Kings and Beyond* (London: Rubicon Press).

DOLLMAYR, H. (1901): 'Giulio Romano und das classische Alterthum', in *Jahrbuch der Kunsthistorischen Sammlungen des Allerhöchsten Kaiserhauses*, **xxii**, 178–220.

DOLZANI, CLAUDIA (1971): 'Elementi Egittologici nell'azione dell'opera "Aïda"', in ABDOUN, SALEH: *Genesi dell'Aïda* (Parma: Istituto di Studi Verdiani).

DOMASZEWSKI, ALFRED VON (1895): *Die Religion des römischen Heeres* (Trier: F. Lintz).

—(1902): 'Die Beneficiarierposten und die römischen Strassennetze', in *Westdeutsche Zeitschrift für Geschichte und Kunst*, **xxi**, 158–211.

—(1908): *Die Rangordnung des römischen Heeres* (Bonn: A. Marcus & E. Weber).

DONADONI, S., CURTO, S., and DONADONI ROVERI, A.M. (1990): *L'Egitto dal mito all'egittologia* (Milan: Fabbri).

DONNET, ALEXIS (1840–57): *Architectonographie des théâtres de Paris* (Paris: Lacroix & Baudry).

DORESSE, JEAN (1960): *Des hiéroglyphes à la Croix: ce que le passé pharaonique a légué au Christianisme* (Istanbul: Nederlands Historisch-Archæologisch Instituut in het Nabije Oosten).

—(1960): *The Secret Books of the Egyptian Gnostics* (London: Hollis & Carter).

DORIVAL, BERNARD (1951): 'Sources of the Art of Gauguin from Java, Egypt, and Ancient Greece', in *Burlington Magazine*, **xciii**/577 (April), 118–22.

DOUGLAS, NORMAN (1915): *Old Calabria* (London: M. Secker).

DOWNES, KERRY (1977): *Vanbrugh*, **xvi** of *Studies in Architecture* (London: Zwemmer).

DOWNEY, ROBERT EMORY GLANVILLE (1963): *Ancient Antioch* (Princeton, NJ: Princeton University Press).

DOWNING, ANDREW JACKSON (1841): *A Treatise on the Theory and Practice of Landscape Gardening* . . . (New York, NY: Wiley & Putnam).

—(1842): *Cottage Residences* (New York, NY: Wiley & Putnam).

DOYEN, F. (1993): see DELVAUX, L.

DRACK, WALTER, and FELLMANN, RUDOLF (1988): *Die Römer in der Schweiz* (Stuttgart: K. Theiss).

DRESSEL, H. (1909): 'Das Iseum Campense auf einer Münze des Vespasianus', in *Sitzungsberichte der königlichen-preussischen Akademie der Wissenschaften*, **xxv**, 640–8.

DRESSER, CHRISTOPHER (1862): *The Art of Decorative Design* . . . (London: Day & Son).

—(1873): *Principles of Decorative Design* (London: Cassell, Petter, & Galpin).

—(1876): *Studies in Design for House Decorators, Designers, and Manufacturers* (London: Cassell, Petter, & Galpin).

—(1886): *Modern Ornamentation* . . . (London: B.T. Batsford Ltd).

DREXLER, WILHELM (1884–1937): 'Isis', in ROSCHER, W. (Ed.): ii/1, 360–550.

—(1889): Der Isis-und Sarapis-Cultus in Kleinasien (Vienna: Numismatische Zeitschrift).

—(1890): Der Cultus der ägyptischen Gottheiten in der Donauländern. Mythologische Beiträge, i (Leipzig: B.G. Teubner).

DREYFOUS, MAURICE (1906): Les Arts et les artistes pendant la période révolutionnaire (1785–1795) (Paris: Paul Paclot).

DRIAULT, ÉDOUARD (1927): L'Hôtel Beauharnais à Paris (Paris: A. Morancé).

—(1939): Napoléon architecte (Paris: Presses Universitaires de France).

—(1940): 'L'Égypte et Napoléon', in Revue des Études Napoléoniennes, clxxxiv (March–April), 122 and 128.

DRIOTON, ÉTIENNE (1942): Le Théâtre Égyptien (Cairo: éd. de la Revue du Caire).

DROWER, MARGARET S. (1958): see MONTET, PIERRE.

—(1985): Flinders Petrie: A Life in Archæology (London: V. Gollancz).

DRUMONT, ÉDOUARD ADOLPHE (1879): Les Fêtes nationals à Paris (Paris: L. Baschet).

DRYSDALL, D. (1987): 'The Hieroglyphs of Bologna', in Emblematica, ii, 225–47.

DUBOIS, LÉON-JEAN-JOSEPH (1818): Catalogue d'antiquités égyptiennes . . . formant la collection de feu m. le Cᵗᵉ de Choiseul-Gouffier (Paris: Dubois).

—(1826): Description des objets d'art qui composent le cabinet de feu M. le baron V. Denon . . . (Paris, Tilliard).

—(1837): Description des antiquités égyptiennes . . . composant la collection de feu m. J.F. Mimaut . . . (Paris: C.L.F. Panckoucke).

DUBOIS, P.-F.-L. (1809–10): see KRAFFT, JOHANN KARL.

DUBOY, PHILLIPE (1986): Lequeu. An Architectural Enigma (London: Thames & Hudson).

DUBUFFET, JEAN (1965): 'Moindre l'égyptologue', in L'Art Brut, fasc. 4 (Paris), 101–18.

DUCHAINE, P. (1911): La franc-maconnerie belge au XVIIIᵉ siècle (Brussels: P. van Fleteren).

DUCUING, M. Fr. (Ed.) (1867): L'Exposition universelle de 1867 illustré (Paris: Administration 106 Rue Richelieu).

DUHN, FRIEDRICH VON (1881–2): see MATZ, FRIEDRICH.

DULAURE, JACQUES-ANTOINE (1825): Histoire civile, physique, et morale de Paris (Paris: Baudouin frères).

DÜLMEN, RICHARD VAN (1975): Der Geheimbund der Illuminaten (Stuttgart-Bad Cannstadt: F. Frommann).

DUMONT, GABRIEL-PIERRE-MARTIN (1763): Parallèle de plans des plus belles salles de spectacles d'Italie et de France (Paris: s.n.).

—(1764–68): Recueil de plusieurs parties d'architecture de différents maîtres tant d'Italie que de France (Paris: The Author).

DUMONT, MARIE-JEANNE (1988): Paris Arabesques: Architectures et Décors Arabes et Orientalistes à Paris (Paris: Éditions Eric Koehler).

DUNAND, FRANÇOISE (1973): Le Culte d'Isis dans le Bassin Oriental de la Méditerranée: I: Le Culte d'Isis et les Ptolemées; II: Le Culte d'Isis en Grèce; III: Le Culte d'Isis en Asie Mineure clergé et rituel des santuaires Isaïques (Leiden: E. J. Brill).

—(1979): Religion Populaire en Égypte Romaine (Leiden: E. J. Brill).

—(1980): 'Cultes égyptiens hors d'Égypte. Essai d'analyse des conditions de leur diffusion', in Religions, pouvoir Rapports Sociaux, Centre de Recherches d'Histoire Ancienne, xxxii, 69–148.

—(1990): Catalogue des terres cultes gréco-romaines d'Égypte (Paris: Réunion des musées nationaux) .

—(2000): Isis: mère des Dieux (Paris: Errance).

DUNCAN, ALASTAIR (1988): Art Deco (London: Thames & Hudson Ltd).

DUPONCHEL, AUGUSTE (Ed.) (1841–44): Nouvelle Bibliothèque des Voyages Anciens et Modernes . . . (Paris: P. Duménil).

DUPUIS, CHARLES-FRANÇOIS (1790): 'Initiation, initié', in Encyclopédie Méthodique: Antiquités, Mythologie (Paris: C. L. F. Panckoucke).

—(1822): Origine de tous les cultes, ou Religion universelle (Paris: E. Babeuf).

DUPUY, MARIE-ANNE (1999): see ROSENBERG, PIERRE.

DURAND, JEAN-NICOLAS-LOUIS (1797): see LEGRAND, JACQUES-GUILLAUME.

—(1799–1801): Recueil et parallèle des édifices de tout genre anciens et modernes, remarquables par leur beauté, par leur grandeur, ou par leur singularité, et dessinées sur une même echelle (Paris: Gillé).

—(1802–05): Précis des Leçons d'Architecture données à l'École Polytechnique (Paris: Durand). See also the Nouveau Précis of 1813.

DÜRIEGL, GÜNTER, and WINKLER, SUSANNE (Eds) (1992): Freimaurer, Solange die Welt besteht (Vienna: Eigenverlag der Museen der Stadt Wien).

DURKHEIM, ÉMILE (1945): The Elementary Forms of Religious Life, tr. KAREN E. FIELDS (New York, NY: Free Press).

DURLIAT, MARCEL (1974): 'Alexandre du Mège et les mythes archéologiques à Toulouse dans le premier tiers du XIXᵉ siècle', in Revue de l'Art, ccxliii, 30–41.

DUTHOY, R. (1974): 'La fonction sociale de l'Augustalité', in Epigraphica, xxxvi, 135–54.

DUVAL, AMAURY (1801): Des Sépultures (Paris: C. L. F. Panckoucke).

—(1813): Les fontaines de Paris . . . (Paris: Firmin Didot).

DUVAL, PAUL-MARIE (1961): Paris antique des origins au IIIᵉ siècle (Paris: Hermann).

DUVOSQUEL, JEAN-MARIE (Ed.) (1993): see DIERKENS, ALAIN.

EAMES, CLARE (1958–9): 'The Emperor's Cabinet', in Bulletin of the Metropolitan Museum of Art, xvii, 108–112.

EASTLAKE, CHARLES L. (1970): A History of the Gothic Revival with an Introduction by J. MORDAUNT CROOK (Leicester: Leicester University Press, and New York, NY: Humanities Press).

'DE ECHO VAN EGYPTE' (1984): Kunstschrift Openbaar Kunstbezit, 28è Jg, No. 5, (September–October).

EBERS, KARL FRIEDRICH (Ed.) (1817): Sarsena, oder der volkommene Baumeister, enthaltend die Geschichte und Entstehung des Freimaurerordens und die verschiedenen Meinungen darüber . . . etc. (Bamberg: Kunz).

ECKELS, C.W (1950): 'The Egyptian Revival in America', in *Archæology*, **iii**, 164–9.

ECKERT, EDUARD-ÉMIL (1855): *Le Franc-Maçonnerie dans sa veritable signification* . . . etc. (Liège: J. –G. Lardinois).

EDGAR, C. C. (1904): *Greek bronzes. Catalogue general des antiquités égyptiennes du Musée du Caire* (Cairo: Impr. de l'Institut français d'archéologie orientale).

—(1905): *Græco-Egyptian glass* (Cairo: Institut français d'archéologie orientale).

EDMOND, CHARLES (1867): *L'Égypte à l'Exposition universelle de 1867* (Paris: Dentu).

EDWARDS, AMELIA ANN BLANFORD (1877): *A Thousand Miles up the Nile* (London: Longmans Green & Co.). *See also* the second edition (1889).

EDWARDS, IORWERTH EIDDON STEPHEN (1972): *The Pyramids of Egypt* (New York, NY: Viking Press).

EDWARDS, RALPH (1954 and 1968): *see* MAC-QUOID, PERCY. *See also CONNOISSEUR'S COMPLETE PERIOD GUIDES.*

EGGEBRECHT, EVA (1982): *Ägypten: Faszination und Abenteuer* (Mainz-am-Rhein: P. von Zabern).

EGGER, HERMANN (1902): 'Entwürfe Baldassare Peruzzis für den Einzug Karls V in Rom. Eine Studie zur Frage über die Echtheit des sienasischen Skizzenbuches', in *Jahrbuch der Kunsthistorischen Sammlungen des Allerhöchsten Kaiserhauses*, **xxiii**, Part 1, 1–44.

—(1910): *Architektonische Handzeichnungen alter Meister* (Vienna & Leipzig: F. Wolfrum & Co.).

—(1913–16): *see* HÜLSEN, CHRISTIAN CARL FRIEDRICH.

L'EGITTO FUORI DELL'EGITTO. DALLA RISCOPERTA ALL'EGITTOLOGIA (1991): *see* GOVI, CRISTIANA MORIGI.

EGYPT AND THE HELLENISTIC WORLD (1983): *Proceedings* of the International Colloquium, Leuven, May 1983. *Studia Hellenistica*, **xxvii**.

L'ÉGYPTE AU REGARD DE J.-J. RIFAUD (1998): *See* BRUWIER, MARIE-CÉCILE.

L'ÉGYPTE DES PHARAONS (1977): *Catalogue* of the Exhibition held at Marcq-en-Baroeul (October 1977 to January 1978).

L'ÉGYPTE ET L'EXPÉDITION FRANÇAISE DE 1798 À 1801 (1978): *Catalogue* of the Exhibition held at Mont-de-Marsan (October 1978 to January 1979).

ÉGYPTE-FRANCE (1929): *Catalogue* of the French Exposition (Cairo).

—(1949): *Catalogue* of Exposition at the Musée des Arts Décoratifs, Pavillon de Marsan (October–November) (Paris: Éd. des Presses Artistiques).

L'ÉGYPTE DANS L'ICONOGRAPHIE ET LA BANDE DESSINÉE (1987): Colloquium held in Cairo at the Centre d'Études et de Documentation économique, juridique et sociale, Institut Français d'Archéologie Orientale (15–17 May 1987). Contributions by BERTHET, BRUNON, CORTEGGIANI, ENAN, JOUTARD, and VOLAIT.

'THE EGYPTIAN REVIVAL' (1984): Review in *Gazette les Beaux-Arts*, **civ**/1389 (October), 22–3.

'THE EGYPTIAN SPELL' (1972): *The Sunday Times Magazine* (19 March and 26 March), 19–27 and 22–9 respectively.

EGYPTOMANIA (1979): (New York, NY: Metropolitan Museum of Art).

EINGARTNER, JOHANNES (1991): *Isis und ihre Dienerinnen in der Kunst der römischen Kaiserzeit* (Leiden: E. J. Brill).

ELBERT, CLAUDIA (1988): *Die Theater Friedrich Weinbrenners. Bauten und Entwürfe* (Karlsruhe: Verlag C. F. Müller GmbH).

ELIA, OLGA (1941): *Le pitture del tempio d'Iside, MdP III, Pompeii III-IV* (Rome: La libreria del Stato).

ELIADE, MIRCEA (1959): *The History of Religions* (Chicago, IL: University of Chicago Press).

—(1978–85): *A History of Religious Ideas*, tr. WILLARD R. TRASK (Chicago, IL: University of Chicago Press).

ELMES, JAMES (1821): *Lectures on Architecture* . . . (London: C. & J. Ollier).

—(1827): *Metropolitan Improvements, or, London in the Nineteenth Century* (London: Jones & Co.).

EMERY, WALTER BRYAN (1961): *Archaic Egypt* (Harmondsworth: Penguin Books Ltd).

—(1965): *Egypt in Nubia* (London: Hutchinson).

ENCICLOPEDIA DELL'ARTE ANTICA, CLASSICA, E ORIENTALE (1958–73): I-VIII e *Supplemento* (Rome: Istituto Poligrafico dello Stato).

ENCYCLOPÆDIA OF RELIGION AND ETHICS (1908–27): *see* HASTINGS, JAMES, *ET AL.*

ENGEL, LEONARD (1906): *Geschichte des Illuminaten-Ordens* (Berlin: H. Bermüller Verlag).

ENGELMANN, HELMUT (1975): *The Delian Aretalogy of Sarapis* (Leiden: E. J. Brill).

ENKING, RAGNA (1939): 'Der Apis-Altar Johann Melchior Dinglingers. Ein Beitrag zur Anseinandersetzung des Abendlandes mit dem alten Ägypten', in *Leipziger Ägyptologische Studien*, **xi** (Glückstadt: J.J. Augustin).

ENSOLI, VITTOZZI SERENA (1990): *Musei Capitolini. La Collezione Egizia* (Cinsello Balsamo: Silvana editoriale).

EPINOIS, HENRI, COMTE D' (1896): *Les Catacombes de Rome* (Paris: A. Savaète).

ERBESATO, G. M. (1987): *Il Palazzo Te di Giulio Romano* (Florence: Moretti/Scala).

ERLANDE-BRANDENBURG, ALAIN (1976): *L'Église abbatiale de Saint-Denis* (Paris: Éditions de la Tourelle).

ERMAN, ADOLF (1893): 'Obelisken römischer Zeit. I. Obelisken in Beneventum', in *Mitteilungen des deutschen archäologischen Instituts, Römische Abteilung*, **viii**, 210–18.

—(1894): *Life in Ancient Egypt*, tr. H. M. TIRARD (London: Macmillan & Co.).

—(1896): 'Obelisken römischer Zeit. II. Der Obelisk des Antinous', in *Mitteilungen des deutschen archäologischen Instituts, Römische Abteilung*, **xi**, 113–21.

—(1917): *Römische Obelisken* (Berlin: G. Reimer).

—(1927): *The Literature of the Ancient Egyptians* . . . tr. A. M. BLACKMAN (London: Methuen & Co. Ltd).

—(1937): *La Religion des Égyptiens*, tr. HENRI WILD (Paris: Payot).

—, and GRAPOW, HERMANN (1961): *Ägyptisches Handwörterbuch* (Hildesheim: G. Olms).

ESCRITT, STEPHEN (1997): *see* HILLIER, BEVIS.

'L'ÉTERNELLE FASCINATION DES OBÉLISQUES' (1958): *Connaissance des Arts*, **lxxiii** (March), 36–41.

ETLIN, RICHARD A. (1977): 'Landscapes of Eternity: Funerary Architecture and the Cemetery, 1793–1881', in *Oppositions*, **viii**, 14–31.

—(1982): 'The Geometry of Death', in *Progressive Architecture* (May), 134–7.

—(1984): *The Architecture of Death. The Transformation of the Cemetery in Eighteenth-Century Paris* (Cambridge, MA, and London: M. I. T. Press).

EUROPA UND DER ORIENT 800–1900 (1989): *see* SIEVERNICH, GEREON.

EXOTISCHE WELTEN, EUROPÄISCHE PHANTASIEN (1987): *Catalogue* of Exhibition (2 September–29 November) (Stuttgart).

EYDOUX, HENRI-PAUL (1974): 'L'Égypte à Paris', in *Monuments curieux et sites étranges* (Paris: Perrin).

FAGAN, BRIAN M. (1977): 'Auguste Mariette and Verdi's *Aida*', in *Antiquity*, **li**, 55.

—(1981): *L'Aventure archéologique en Égypte* (Paris: Pygmalion).

FAGUET, ÉMILE (1896): 'Au Chat Noir', in *Revue Encylopédique*, **cxxvi**, 79–80.

FAIDER-FEYTMANS, GERMAINE-M. (1979): *Les bronzes romains de Belgique* (Mainz-am-Rhein: Verlag P. von Zabern).

FAIRMAN, HERBERT WALTER (1974): *The Triumph of Horus* (London: B. T. Batsford Ltd).

FARINA, GIULIO (1929): *La pittura egiziana* (Milan: Fratelli Treves).

FASTNEDGE, RALPH (1962): *Sheraton Furniture* (New York, NY: T. Yoseloff).

—(1965): *see* JOURDAIN, MARGARET.

FAULKNER, RAYMOND OLIVER (1969): *The Ancient Egyptian Pyramid Texts* (Oxford: The Clarendon Press).

—(1973–8): *The Ancient Egyptian Coffin Texts* (Warminster: Aris & Phillips).

FAY, BERNARD (1935): *Revolution and Freemasonry* (Boston, MA: Little Brown & Co.).

—(1961): *La Franc-Maçonnerie et la révolution intellectuelle du XVIII^e Siècle* (Paris: Librairie Français).

FAZZINI, RICHARD A. (1988): 'Rêve et réalité. La persistance d'une certaine image de l'Égypte', in *Le Courier de l'UNESCO* (September), 33–5.

—(1996): 'L'égyptomanie dans l'architecture américaine', in HUMBERT (*Ed.*) (1996), 229–78.

FEARS, J. R. (1977): *Princeps a Diis Electis: The Divine Election of the Emperor as a Political Concept at Rome* (Rome: American Academy).

FEAVER, WILLIAM (1975): *The Art of John Martin* (Oxford: The Clarendon Press).

FEGDAL, CHARLES (1923): *Les Vieilles enseignes de Paris* (Paris: E. Figuière & cie).

FELICE, MAURO DE (1982): *Miti ed allegorie egizie in Campidoglio* (Bologna: Pàtron).

FELLMANN, RUDOLF (1988): *see* DRACK, WALTER.

FENNELL, C. A. M. (*tr.*) (1882): *see* MICHAELIS, ADOLF THEODOR FRIEDRICH.

FERGUSON, JOHN (1970): *The Religions of the Roman Empire* (Ithaca, NY: Cornell University Press).

FESCH, PAUL (1976): *Bibliographie de la franc-maçonnerie et des Sociétés secrètes* (Brussels: G.A. Deny).

FIELDS, KAREN E. (*tr.*) (1945): *see* DURKHEIM, ÉMILE.

FIENSCH, GÜNTHER, and IMDAHL, MAX (*Eds*) (1966): *Festschrift Werner Hager* (Recklinghausen: Bongers). Contains contributions from NOEHLES *ET AL.*

FILARETE, ANTONIO AVERLINO (1965): *Treatise on Architecture; being the treatise by Antonio di Piero Averlino, known as Filarete* (New Haven, CT: Yale University Press).

FINDEL, GOTTFRIED JOSEPH GABRIEL (1893): *Geschichte der Freimaurerei von der Zeit ihres Entstehens bis auf die Gegenwart* (Leipzig: Findel).

FIRMICUS MATERNUS, JULIUS (1938): *De Errore Profanarum Religionum, ad Constantium & Constantem Augustos Liber* (Brussels: éd. de la Revue de l'Université de Bruxelles).

FISCHER, HENRY GEORGE (1968): *Dendera in the Third Millenium B.C.* (Locust Valley, NY: J. J. Augustin).

FISCHER, M. (1999): *see* PARKINSON, RICHARD.

FISCHER VON ERLACH, JOHANN BERNHARD (1725): *Entwurff einer Historischen Architektur, in Abbildung unterschiedener verühmter Gebäude, des Alterthums und fremder Völker* (Leipzig: The Author).

FISCHOFF, EPHRAIM (*tr.*) (1963): *see* WEBER, MAX.

FISHER, C. D. (*Ed.*) (1985): *see* TACITUS, P. CORNELIUS.

FISHWICK, D. (1991): *The Imperial Cult in the Latin West: Studies in the Ruler Cult of the Western Provinces of the Roman Empire* (Leiden: E. J. Brill).

FITZGERALD, EDWARD (1871): *A Hand Book for the Albany Rural Cemetery* (Albany, NY: van Benthuysen Printing House).

FLAUBERT, GUSTAVE (1972): *Flaubert in Egypt*, tr. F. STEEGMULLER (London: Bodley Head).

FLAXMAN, JOHN (1865): *Lectures in Sculpture* (London: Bell & Daldy).

FLEDELIUS, K. (2001): 'Ægypteri hos frimurerne', in CHRISTIANSEN, E. (*Ed.*), 91–106.

FLEMING, JOHN (1962): *Robert Adam and his Circle in Edinburgh and Rome* (Cambridge, MA: Harvard University Press).

FLETCHER, SIR BANISTER (1954): *A History of Architecture on the Comparative Method for Students, Craftsmen & Amateurs* (London: B.T. Batsford Ltd).

FLUDD, ROBERT (1617): *Tractatus apologeticus integritatem Societatis de Rosea Cruce defendens . . .* (Leiden: G. Basson).

—(1617–24): *Utriusque cosmi maioris scilicet et minoris metaphysica, physica atque technica historia . . .* (Oppenheim: J.-T. de Bry).

FOCILLON, HENRI (1918): *Giovanni-Battista Piranesi; essai de catalogue raisonné de son oeuvre* (Paris: Renouard).

—(1928): *Giovanni-Battista Piranesi* (Paris: H. Laurens).

FOLLIOT, FRANCK (1988): 'Projets de fontaines parisiennes sous le premier Empire par l'architecte Achille Leclère', in *Bulletin de la Société de l'Histoire de l'Art français*, 160, 163.

FOISSY-AUFRÈRE, MARIE-PIERRE (1985): *Égypte et Provence* (Avignon: Fondation du Muséum Calvet).

FONTAINE, PIERRE-FRANÇOIS-LÉONARD (1801): *see* PERCIER, CHARLES.

FORBIN, LOUIS-NICOLAS-PHILIPPE-AUGUSTE, COMTE DE (1819): *Voyage dans le Levant en 1817 et 1818* (Paris: Imp. Royale).

—(1819): *Travels in Egypt . . . 1817–1818* (London: R. Phillips & Co.).

FORD, B. (1946–8): 'The Memoirs of Thomas Jones', in *Journal of the Walpole Society*, **xxxii**.

FORTESCUE, ADRIAN (1948): *The Ceremonies of the Roman Rite described* (London: Burns, Oates, and Washbourne Ltd).

FORTINI-BROWN, P. (1988): *Venetian Narrative Painting in the Age of Carpaccio* (New Haven, CT, and London: Yale University Press).

FOSCA, FRANÇOIS (1934): *Histoires des cafés de Paris* (Paris: Firmin-Didot et cie).

FOSTER, J. R. (*tr.*): see GARZETTI, ALBINO.

FOUCART, BRUNO (1985*a*): 'Une pyramide flottante', in *Connaissance des Arts*, **ccccvi** (December).

—(1985*b*): see LOSTE, SÉBASTIEN.

FOUCART, PAUL FRANÇOIS (1975): *Les mystères d'Eleusis* (New York, NY: Arno Press).

FOUCHARD, ALAIN (*Ed.*) (1994): see DE-WACHTER, MICHEL.

FOULSTON, JOHN (1838): *The Public Buildings erected in the West of England, as designed by John Foulston* (London: J. Williams).

FOUQUIER, MARCEL (1912): *Paris au XVIIIᵉ siècle; ses divertissements, ses moeurs, Directoire et Consulat* (Paris: Émile-Paul).

FOWDEN, G. (1993): *The Egyptian Hermes. A historical approach to the Late Pagan mind* (Princeton, NJ: Princeton University Press).

FOWLER, WILLIAM WARDE (1911): *The Religious Experience of the Roman People from the Earliest Times to the Age of Augustus* (London: Macmillan & Co. Ltd).

—(1914): *Roman Ideas of deity in the last century before the Christian era* (London: Macmillan & Co. Ltd).

FOX, ROBIN LANE (1995): *Pagans and Christians* (San Francisco, CA: HarperSanFrancisco).

FRAGEROLLE, GEORGES (1896): *Le Sphinx* (Paris: Enoch, and E. Flammarion).

FRANCASTEL, PIERRE (1939): *Le Style Empire du Directoire à la Restauration* (Paris: Larousse).

FRANC-MAÇONNERIE (1983): *Un siècle de franc-maçonnerie dans nos régions, 1740–1840. Catalogue* of an exhibition in the Galerie CGER (17 May–31 July 1983) (Brussels: R. Coolen).

FRANCO, BARBARA (1976): *Masonic Symbols in American Decorative Arts* (Lexington, MA: Museum of Our National Heritage).

—(1980): *Bespangled Painted & Embroidered Decorated Masonic Aprons in America 1790–1850* (Lexington, MA: Musuem of Our National Heritage).

FRANKFORT, HENRI (1961): *Ancient Egyptian Religion* (New York, NY: Harper).

—(1971): *Kingship and the Gods* (Chicago, IL: University of Chicago Press).

FRANKLIN, ALFRED (1907): *L'Institut de France* (Paris: Librairie Renouard).

FRASER, DOUGLAS, HIBBARD, HOWARD, and LEWINE, MILTON J. (*Eds*) (1967): *Essays in the History of Art presented to Rudolf Wittkower on his sixty-fifth birthday* (London and New York, NY: Phaidon).

FREBAULT, MARCELLE (1957): Letter in *The Architectural Review*, **cxxi**/722 (March), 152.

FREED, RITA E. (*Ed.*) (1982): *Egypt's Golden Age. The Art of Living in the New Kingdom 1558–1085* (Boston, MA: Museum of Fine Arts).

FREEDLEY, GEORGE (1940): *Theatrical Designs from the Baroque through Neoclassicism . . .* (New York, NY: H. Bittner & Co.).

—(1955): *A History of the Theatre . . .* (New York, NY: Crown Publishers).

FRESHFIELD, E.H. (1922): 'Notes on a Vellum Album containing some Original Sketches of Public Buildings and Monuments, drawn by a German Artist who visited Constantinople in 1574', in *Archæologia*, **lxxii** (Oxford: Society of Antiquaries of London), 88ff.

FRESNAULT-DERUELLE, PIERRE (1983): *L'image manipulée* (Paris: Edilig).

—(1983): 'La Bande dessinée: objet de civilisation', in *Le Français dans le Monde*, **clxxiii** (November/December), 104–111.

FREY, KATIA (1995): 'L'enterprise napoléonienne', in MASSOUNIE, PRÉVOST-MARCILHACY, and RABREAU (1995), 104–23.

FREY, MARTIN (1989): *Untersuchungen zur Religion und zur Religionspolitik des Kaisers Elagabel, Historia Einzelschriften*, **lxii** (Stuttgart: F. Steiner).

FRICK, KARL R. H. (1973): *Die Erleuchteten: Gnostisch-Theosophische und Alchemistisch-Rosenkreuzerische Geheimgesellschaften bis zum Ende des 18. Jahrhunderts, ein Beitrag zur Geistesgeschichte der Neuzeit* (Graz: Akademische Druck – u. Verlagsanstalt).

FRIESEN, S. J. (1993): *Twice Neokoros. Ephesus, Asia, and the Cult of the Flavian Imperial Family* (Leiden: E. J. Brill).

FÜRTWANGLER, ADOLF (1910): *Beschreibung der Glyptothek König Ludwigs I zu München* (Munich: A. Burchholz).

G., G. (1826): *Promenade sérieuse au Cimetière du Père La Chaise* (Paris: Imprimerie de Lachevardière fils).

GABBA, EMILIO (*Ed.*) (1983): see CAMERON, AVERIL.

GABRIELI, G. (*Ed.*) (1925): see ROSELLINI, IPPOLITO.

GABRIELLI, DOMENICO (2002): *Dictionnaire Historique du Père-Lachaise XVIIe-XIX siècles* (Paris: Éditions de l'Amateur).

GAGÉ, J. (1931): 'Divus Augustus', in *Revue Archéologique*, Ser. 5, **xxxiv**, 11–41.

—(1981): 'La mystique impériale et l'épreuve des "jeux". Commode-Hércule et l' "anthropologie" héracléenne', in *Aufstieg und Niedergang der römischen Welt. Geschichte und Kultur Roms im Spiegel der neueren Forschung*, **ii**/17.2 (Berlin and New York, NY: W. de Gruyter), 662–83.

GALLET, MICHEL (1964): *Demeures Parisiennes; l'époque de Louis XVI* (Paris: Le Temps).

—(1980): *Claude-Nicolas Ledoux, 1736–1806* (Paris: Picard).

GALTIER, G. (1989): *Maçonnerie égyptienne. Rose-croix et Néo-chevalerie: les fils de Cagliostro* (Paris: Éditions de Rocher).

GAMER-WALLERT, INGRID (1970): *Fische und Fischkulte in alten Ägypten* (Wiesbaden: Otto Harrassowitz).

—(1978): *Ägyptische und ägyptisierende Funde van der Iberischen Halbinsel* (Wiesbaden: Reichert).

GANDY, JOSEPH MICHAEL (1805*a*): *Designs for Cottages, Cottage Farms, and Other Rural Buildings; including Gates and Lodges* (London: J. Harding).

—(1805*b*): *The Rural Architect; consisting of Various Designs for Country Buildings, . . .* (London: J. Harding).

GANDY, JOHN PETER (1852): *see* GELL, SIR WILLIAM.

GANNAL, FÉLIX (1884): *Les Cimetières depuis la fondation de la monarchie française* . . . etc. (Paris: Muzard et fils).

GARCIN, JÉROME (1987): 'En plein dans le Nil', in *L'Événement du Jeudi*, **cxxii** (5–11 March), 86.

GARDINER, SIR ALAN HENDERSON (1933–58): *see* CALVERLEY, AMICE M.

—(1957): *Egyptian Grammar* (London: Oxford University Press).

—(1961): *Egypt of the Pharaohs: an Introduction* (Oxford: Clarendon Press).

GAREFFI, A. (1977): 'Egizierie umanistiche. La mantica geroglifica tra Quattro e Cinquecento', in *Annali dell'Istituto di Filologia Moderna dell' Università di Roma*, 13–20.

—(1980): *see* SAVARESE, G.

GARIN, E. (1988): *Ermetismo del Rinascimento* (Rome: Editori Riuniti).

GARRAUD, ABBÉ J. RENÉ (1887): *Un artiste dijonnais, Joseph Garraud, 1807–1880* (Dijon: Darantierre).

GARZETTI, ALBINO (1974): *From Tiberius to the Antonines. A History of the Roman Empire AD 14–192*, tr. J. R. FOSTER (London: Methuen).

GATIER, P.-L. (1991): 'De l'Antiquité à la Renaissance: quelques inscriptions latines du Forez et le sphinx de la Bâtie d'Urfé', in *Bulletin de la Diana*, **lii**, 657–65.

GATTI, G. (1943–4): 'Topografia dell'Iseo Campense', in *Rendiconti della Pontificia Accademia di Archeologia*, **xxvi**, 117–63.

GAU, FRANÇOIS-CHRÉTIEN (1822–27): *Antiquités de la Nubie, ou, Monuments inédits des bords du Nil, situés entre la première et la seconde cataracte* (Stuttgart: J.G. Cotta).

GAUME, MAXIME, and BONNET, JACQUES (1980): *Le Sphinx de la Bastie d'Urfé* . . . (Sainte-Étienne: Reboul).

GAUTHIER-LACHAPPELLE, A. (1801): *Des Sépultures* (Paris: Dupont).

GAUTIER, THÉOPHILE (1852): *Emaux et Camées* (Paris: E. Didier).

GAY, PETER (1967): *The Enlightenment: An Interpretation. The Rise of Modern Paganism* (London: Weidenfeld & Nicolson).

GAZETTE DES BEAUX-ARTS (from 1859): (Paris: J. Claye, etc.).

GÉBELIN, FRANÇOIS (1931): *La Sainte-Chapelle et la Conciergerie* (Paris: H. Laurens).

GEFFCKEN, JOHANNES (1914): *Kaiser Julianus* (Leipzig: Dieterich).

—(1920): *Das Christentum in Kampf und Ausgleich mit der Griechisch – Römischen Welt* (Leipzig and Berlin: B.G. Teubner).

GEIGER, ANDRÉ (1931): In *L'Illustration*, No. 603 (23 May).

GELL, SIR WILLIAM, and GANDY, JOHN PETER (1852): *Pompeiana: The Topography Edifices, and Ornaments of Pompeii* (London: H.G. Bohn).

GÉNARD, PIERRE MARIE NICOLAS JEAN (1876): *Catalogue du Musée d'antiquités d'Anvers* (Antwerp: J. E. Buschmann).

—(1881): *Catalogue de la Collection d'Antiquités Égyptiennes. Musée d'Antiquités d'Anvers* (Antwerp: Buschmann).

—(1894): *Musée d'Antiquités d'Anvers. Catalogue de la collection d'antiquités égyptiennes* (Antwerp: Musée d'antiquités d'Anvers).

GENOUX, D. (1966): 'Travaux éxecutés par Rolland pour Lhuillier, Rousseau, etc.', in *Bulletin de la Société de l'Histoire de l'Art français*, 189–99.

GENS, ÉMILE (1861): *Promenade au Jardin Zoologique d'Anvers* (Antwerp: Buschmann).

GEORGE, BEATE, and PETERSON, BENGT (1979): *Die Karnak-Zeichnungen von Baltzar Cronstrand 1836–1837* (Stockholm: Medelhavsmuseet).

—(1980): *Baltzar Cronstrand I Egypten 1836–1837: En svensk officer bland faraoniska tempel och gravar* (Stockholm: Nationalmuseum – Medelhavsmuseet).

GERARDS, ÉMILE (1909): *Paris souterrain* (Paris: Garnier).

GERDTS, WILLIAM H. (1966): 'Egyptian motifs in nineteenth-century American painting and sculpture', in *Antiques* (October), 495–501.

GERKAN, A. VON (1931): 'Der Lauf der römischen Stadtmauer vom Kapitol zum Aventin', in *Mitteilungen des Deutschen Archäologischen Instituts. Römische Abteilung*, **xlvi**, 153–88.

GERMANN, GEORG (1972): *Gothic Revival in Europe and Britain: Sources, Influences, and Ideas*, tr. GERALD ONN (London: Lund Humphries Publishers Ltd).

GHALI, IBRAHIM AMIN (1986): *Vivant Denon ou la conquête du bonheur* (Cairo: Institut français d'archéologie orientale du Caire).

GIEDION, SIGFRIED (1922): *Spätbarocker und Romantischer Klassizismus* (Munich: Bruckmann).

—(1967): *Space, Time, and Architecture* (Cambridge, MA: Harvard University Press).

GIEHLOW, KARL (1915): 'Die Hieroglyphenkunde des Humanismus in der Allegorie der Renaissance', in *Jahrbuch der Kunsthistorischen Sammlungen des Allerhöchsten Kaiserhauses*, Bd. **xxxii**, Hft. 1. (Vienna: F. Tempsky), 1–232.

GILBERT, CHRISTOPHER (1971): '"Thebes" Stool by Liberty & Co.', in *Burlington Magazine*, **cxiii**/ 825 (December), 741.

GILBERT, OTTO (1883): *Geschichte und Topographie der Stadt Rom in Altertum* (Leipzig: B. G. Teubner).

GILBERT, PIERRE (1942): 'Le Fronton Arrondi en Égypte et dans l'art Gréco-Romain', in *Chronique d'Égypte: Bulletin Périodique de la Fondation Égyptologique Reine Élisabeth*, **xvii** (Brussels: Musées Royaux de Cinquantenaire, Year 17), 83–90.

—(1943): *Le Classicisme de l'Architecture égyptienne* (Brussels: Fondation Égyptologique Reine Élisabeth).

GILCHRIST, AGNES ADDISON (1950): *William Strickland, Architect and Engineer, 1788–1854* (Philadelphia, PA: University of Pennsylvania Press).

GILLESPIE, CHARLES COULSTON, and DEWACHTER, MICHEL (Eds) (1987): *The Monuments of Egypt: the Napoleonic edition: the complete archæological plates from La Description de l'Égypte* (Princeton, NJ: Princeton Architectural Press and the Architectural League of New York).

GIRAUD, PIERRE MARTIN (1801): *Les Tombeaux, ou, essai sur les sépultures* (Paris: Desenne).

GIRAUD, Y. (Ed.) (1982): *L'emblème à la Renaissance* (Paris: Société d'Edition d'Enseignement Supérieur).

GIROUARD, MARK (1977): *Sweetness and Light: The 'Queen Anne' Movement 1860–1900* (Oxford: Clarendon Press).

GIVEON, RAPHAEL (1985): *Egyptian Scarabs from Western Asia from the Collections of the British Museum* (Freiburg: Univeritätsverlag, and Göttingen: Vandenhoeck & Ruprecht).

GLANVILLE, STEPHEN RANDOLPH KINGDOM (1932): *Studies presented to F. Llewellyn Griffith* (London: Egypt Exploration Society, and H. Milford, for Oxford University Press).

GLEASON, F. (1851–9): *see BALLOU'S PICTORIAL DRAWING-ROOM COMPANION.*

GLOAG, JOHN (1965): *English Furniture* (London: A. & C. Black).

—(1966a): *A Short Dictionary of Furniture* (London: George Allen & Unwin Ltd).

—(1966b): *A Social History of Furniture Design, from B.C. 1300 to A.D. 1960* (London: Cassell).

GLODARIU, I. (1976): *Dacian Trade with the Hellenistic and Roman World*, tr. N. HAMPARTUMIAN, British Academy at Rome, Supplement Series **viii**.

GLOTON, J.-J. (1961): 'Les Obéliques romains de la Renaissance au Néo-Classicisme', in *Mélanges d'Archéologie et d'Histoire du l'École Française de Rome*, **lxxiii**, 437–69.

GODS AND THEIR MAKERS, THE (1981): Exhibition dealing with the Victorians and Ancient Egypt (Burnley: Towneley Hall Art Gallery and Museums).

GODWIN, JOSCELYN (1979a): *Athanasius Kircher. A Renaissance Man and the Quest for Lost Knowledge* (London: Thames & Hudson Ltd).

—(1979b): *Robert Fludd: Hermetic Philosopher and Surveyor of Two Worlds* (London: Thames & Hudson Ltd).

—(1981): *Mystery Religions in the Ancient World* (London: Thames & Hudson Ltd).

—(1999): *Hypnerotomachia Polifili – The Strife of Love in a Dream*, by FRANCESCO COLONNA: the entire text translated for the first time into English, with an Introduction by JOSCELYN GODWIN, with the original woodcut illustrations (London: Thames & Hudson Ltd).

GOLD, BARBARA K. (*Ed.*) (1982): *Literary and Artistic Patronage in Ancient Rome* (Austin, TX: University of Texas Press).

GOLZIO, VINCENZO (1936): *Raffaello nei Documenti . . .* (Spoleto: Panetto & Petrelli).

GOMBRICH, ERNST (1951): 'Hypnerotomachiana', in *Journal of the Warburg and Courtauld Institutes*, **xiv**, 119–22.

—(1989): 'Le Fantôme de la Liberté - Le rêve de la Raison: le symbolisme de la Révolution française', in *FMR (Franco Maria Ricci)*, **xxi** (August), 1–24.

GOMME, ANDOR, and WALKER, DAVID (1968): *Architecture of Glasgow* (London: Lund Humphries).

GONDOIN, JACQUES (1780): *Description des écoles de Chirurgie* (Paris: Cellot & Jombert).

GONZÁLEZ-PALACIOS, ALVAR (1966): *Antonio Canova* (Milan: Fabbri).

—(1966): *Del Direttorio all'Impero* (Milan: Fabbri).

—(1969): *The Age of Louis XVI* (London: Hamlyn).

—(1969): *Il Mobile nei Secoli* (Milan: Fabbri).

—(1970): *The French Empire Style* (Feltham: Hamlyn).

—(1993): 'Jacques-Louis David: le décor de l'Antiquité', in *Actes du Colloque: David contra David*, t. II, 951–2, figs. 208–9, 1003.

GONZENBACH, VICTORINE VON (1957): *Untersuchungen zu den Knabenweihen im Isis-Kult der römischen Kaiserzeit* (Bonn: R. Habelt).

GOODENOUGH, ERWIN RAMSDELL (1928): 'The Political Philosophy of Hellenistic Kingship', in *Yale Classical Studies*, **i**, 55–102.

—(1931): *The Church in the Roman Empire* (New York, NY: H. Holt & Co.).

—(1953–68): *Jewish Symbols in the Græco-Roman Period* (New York, NY: Pantheon Books).

GOODHART-RENDEL, HARRY STUART (1953): *English Architecture since the Regency: an Interpretation* (London: Constable & Co. Ltd).

GORDON, ELEANOR, and NERENBERG, JEAN (1979–80): 'Chicago's Colorful Terra Cotta Façades', in *Chicago History* (Winter), 224–233.

GORRINGE, HENRY HONEYCHURCH (1882): *Egyptian Obelisks* (New York, NY: H. H. Gorringe).

GOTHEIN, MARIE LOUISE (1928): *A History of Garden Art* (New York, NY: E.P. Dutton & Co.).

GOTTLIEB, GUNTHER (*Ed.*) (1989): *Raumordnung im römischen Reich* (Munich: E. Vogel).

GOULET, NICOLAS (1808): *Observations sur les embellisements de Paris et sur les monumens qui s'y construisent* (Paris: Leblanc).

GOULIER, CHARLES-PIERRE, BIET, LÉON-MARIE-DIEUDONNÉ, GRILLON, EDMÉ-JEAN-LOUIS, and TARDIEU, FEU (1825–1850): *Choix d'édifices publics, projetés et construits en France depuis le commencement du XIXe siècle* (Paris: L. Colas)

GOVI, CRISTIANA MORIGI, CURTO, SILVIO, and PERNIGOTTI, SERGIO (*Eds*) (1991): *L'Egitto fuori dell' Egitto. Dalla riscoperta all' Egittologia. Atti del Convegno Internazionale*, Bologna (26–29 March 1990), with contributions from CURL, HUMBERT, JAEGER, JAMES, SCHNEIDER, *ET AL.* (Bologna: Cooperativa Libraria Universitaria Editrice Bologna).

GRAEFE, ERHART (1982): 'Addendum à l'article de W.K. Simpson sur "Mariette and Verdi's *Aïda*"', in *Bulletin of the Egyptological Seminar*, **iv**, 79.

GRAILLOT, HENRI (1912): *Le Culte de Cybèle, Mère des Dieux, à Rome et dans l'Empire Romain* (Paris: Fontemoing).

GRAMACCINI, GISELA (1992): 'L'inventaire après décès de Jean-Guillaume Moitte (1746–1810)', in *Gazette des Beaux-Arts* (January), 36–7.

—(1993): *Jean-Guillaume Moitte (1746–1810). Leben und Werk* (Berlin: Akademie Verlag).

GRANDJEAN, SERGE (1950): 'Le Cabaret égyptien de Napoléon au Musée du Louvre', in *Bulletin des Musées de France*, **iii** (April), 62–5.

—(1953): *see VERLET, PIERRE.*

—(1955): 'L'Influence Égyptienne à Sèvres', in *Publicaties van het Genootschap voor Napoleontische Studiën*, Aflevering 8 (September) (Den Haag: A. Sijthoff).

—(1959): 'The Wellington-Napoleonic Relics', in *The Connoisseur*, **cxliii**, 223–230.

—(1964): *Inventaire après décès de l'Impératrice Joséphine à Malmaison* (Paris: Ministère d'État – Affaires culturelles).

—(1966): *Empire Furniture, 1800 to 1825* (London: Faber).

—(1985): 'Musée de Malmaison, le "Cabaret Égyptien" de l'Impératrice Joséphine', in *La Revue du Louvre et des Musées de France*, **ii**, 123–8.

GRANDJEAN, YVES (1975): *Une Nouvelle Arétalogie d'Isis à Maronée* (Leiden: E. J. Brill).

GRANET, SOLANGE (1963): *La Place de la Concorde* (Paris: Gallimard).

GRANVILLE, A. B. (1825): 'An Essay on Egyptian Mummies', in *Phil. Trans. Roy. Soc.* **cxv**, 269–316. See also *Felix Farley's Bristol Journal* (11 December 1824), 3.

GRAPOW, HERMANN (1961): see ERMAN, ADOLF.

GRASSI, RICCARDO (1994): see BONGIOANNI, ALESSANDRO.

GREAVES, JOHN (1646): *Pyramidographia, or, A Description of the Pyramids in Ægypt* (London: G. Badger).

GREEN, T. M. (1992): *The City of the Moon God* (Leiden: E. J. Brill).

GREENER, LESLIE (1966): *The Discovery of Egypt* (London: Cassell).

GREENHILL, THOMAS (1705): Νεκροκηδεία: *or The Art of Embalming . . .* (London: The Author).

GREENOUGH, HORATIO (1947): *Form and Function* (Berkeley, CA: University of California Press).

GRESSLER-LÖHR, BEATRIX (1972): see MÜLLER, HANS WOLFGANG.

GRETHER, FRANÇOIS (1987): see BLANCOT, CHRISTIANE.

GRENIER, JEAN-CLAUDE (1990): 'La Décoration statuaire du "Serapeum" du "Canope" de la Villa Adriana. Essai de reconstitution', in *Monumenti, Musei, e Galleria Pontificie* (Città del Vaticano: Monumenti, musei, e gallerie ponteficie).

GRIETEN, STEFAAN (Ed.) (2002): *Vreemd Gebouwd: Westerse en Niet-Westerse Elementen in Onze Architectuur* (with contributions from MACLOT, WARMENBOL, *ET AL.*) (Turnhout: Brepols Publishers).

GRIFFIN, MIRIAM TAMARA (1984): *Nero, the End of a Dynasty* (London: B. T. Batsford Ltd).

GRIFFITHS, J. GWYN (1960): *The Conflict of Horus and Seth, from Egyptian and Classical Sources: A Study in Ancient Mythology* (Liverpool: Liverpool University Press).

—(1964): 'Isis in Oxford', in *Chronique d'Égypte*, **xxxix**, 67–78.

—(Ed.) (1970): *Plutarch's de Iside et Osiride* (Cardiff: University of Wales Press)

—(1975): *Apuleius of Madauros. The Isis-Book. (Metamorphoses, Book XI)* (Leiden: E J. Brill).

—(1980): *The Origins of Osiris and his Cult* (Leiden: E. J. Brill).

GRILLON, EDMÉ-JEAN-LOUIS (1825–50): see GOULIER, CHARLES-PIERRE.

GRIMM, GÜNTER (1963): *Bibliography on the Mensa Isiaca*, in *Jahrbuch d. Römisch-Germanischen Zentralmuseums Mainz*, **x**, 214.

—(1969): *Die Zeugnisse ägyptischer Religion und Kunstelemente in römischen Deutschland* (Leiden: E.J. Brill).

GRINSELL, LESLIE V. (1972): *Guide Catalogue to the Collections from Ancient Egypt* (Bristol: City Museum).

GROBERT, JACQUES-FRANÇOIS-LOUIS (1801): *Description des Pyramides de Ghizé, de la ville du Caire et de ses environs* (Paris: Logerot-Petiet).

GROSSEGGER, ELISABETH (1981): *Freimaurerei und Theater 1770–1800* (Vienna: Böhlau).

GRUEBER, HERBERT APPOLD (1970): *Coins of the Roman Republic in the British Museum* (London: British Museum).

GRUEN, ERICH S.(1990): *Studies in Greek Culture and Roman Policy* (Leiden: E. J. Brill).

GUBEL, ERIC, *ET AL.* (1995): *Egypte Onomwonden: Egyptische oudheden van het museum Vleeshuis* (Antwerp: Stad Antwerpen & Pandora). An excellent publication dealing with the collections held in the city of Antwerp, with contributions from DELVAUX, WARMENBOL, *ET AL.*

GUÊPIÈRE, PIERRE-LOUIS-PHILIPPE DE (1759): *Recueil d'esquisse d'architecture . . .* (Stuttgart: Cotta).

GUEQUIER, J. (1903): 'R[espectable] L[oge] La Liberté `a l'Or[ient] de Gand. La construction d'un Temp[le] maçonn[ique]', in *Bulletin du Gr[and] Or[ient] de Belgique*, **xxi**, 91–104.

GUÉRIN DALLE MESE, J. (1991): *Égypte. La Mémoire et le Rêve: itinéraire d'un voyage, 1320–1601* (Florence: L. Olschki).

GUEY, J. (1948): 'Encore "la pluie miraculeuse"', in *Revue de Philologie*, **xxii**, 16–62.

GUIDA AI MUSEI VATICANI (1979): (Città del Vaticano). See PAPAFAVA, F. (*Ed.*) (1979).

GUILLAUME, JEAN (1979): 'Fontainebleau 1530: le pavillon des Armes et sa Porte Égyptienne', in *Bulletin Monumental*, 137–III, 225–40.

GUILLAUMOT, CHARLES AXEL (1768): *Remarques sur un livre intitulé, observations sur l'architecture de M. L'abbé Laugier* (Paris: De Hansy).

—(1801): *Essai sur les Moyens de déterminer ce que constitue la beauté essentielle dans l'architecture* (Paris: Perronneau).

—(1801): *Observations sur le tort que font à l'architecture les déclamations hasardées et exagerées . . .* (Paris: Perronneau).

GUILLERME, JACQUES, and HAROUEL, JEAN-LOUIS (1981): 'Lubersac et les infortunes de la dédicace', in *Gazette des Beaux-Arts*, No. 1346 (March), 104–10.

GUIMET, E. (1896): *L'Isis romaine. Comptes rendues de l'Académie des Inscriptions et Belles-Lettres*, 155–60.

—(1912): 'Les Isaïques de la Gaule', in *Revue archéologique*, **ii**, 199f.

GUIEYSSE, PAUL (1988): see AMIABLE, LOUIS.

GUITERMAN, HELEN (1978): *David Roberts R.A. 1796–1864* (London: The Author).

—, and LLEWELLYN, BRIONY (*Eds*) (1987): *David Roberts* (Oxford: Phaidon Press Ltd).

GUNNIS, RUPERT (1968): *Dictionary of British Sculptors 1660–1851* (London: Murray's Book Sales).

GÜNTHER, URSULA (1973): 'Zur Entstehung von Verdis Aida', in *Studi Musicali*, Anno II, No. 1, 15–71.

GURLITT, CORNELIUS (1888): *Geschichte des Barockstiles, des Rococo und des Klassizismus in Belgien, Holland, Frankreich, England* (Stuttgart: Ebner & Seubert).

GUSMAN, PIERRE (1904): *La villa impériale de Tibur* (Paris: A. Fontemoing).

GUTHRIE, WILLIAM KEITH CHAMBERS (1952): *Orpheus and Greek Religion* (London: Methuen).

GWILT, JOSEPH (1903): *An Encyclopædia of Architecture, Historical, Theoretical & Practical*, revised with additions by WYATT PAPWORTH (London: Longmans).

GWYN GRIFFITHS, J. (1960): see GRIFFITHS, J. GWYN

HABACHI, LABIB (1978): *The Obelisks of Egypt* (London: Dent).

—(1984): *The Obelisks of Egypt: skyscrapers of the past* (Cairo: American University in Cairo Press).

HADAS, MOSES (tr.) (1949): see BURCKHARDT, JAKOB CHRISTOPH.

HAHN, J., and LEUNISSEN, M. M. (1990): 'Statistical Method and Inheritance of the Consulate under the early Roman Empire', in *Phoenix*, **xliv**, 60–81.

HALFMANN, HELMUT (1986): *Itinera principum. Geschichte und Typologie der Kaiserreisen im römischen Reich. Heidelberger althistorische Beiträge und epigraphische Studien*, **ii** (Stuttgart: F. Steiner Verlag Wiesbaden).

HALL, MANLY PALMER (1928–75): *The Secret Teaching of All Ages: An Encyclopedic Outline of Masonic, Hermetic, Qabbalistic, and Rosicrucian Philosophy* (Los Angeles, CA: Philosophical Research Society).

HALLS, JOHN JAMES (1834): *The Life and Correspondence of Henry Salt* (London: R. Bentley).

HAMER, MARY (1994): 'The Concord Obelisk and the French Political Imaginary', in DEWACHTER and FOUCHARD (*Eds*) (1994), 347–54.

HAMILTON, WILLIAM RICHARD (1809): *Ægyptiaca: or, some account of the ancient and modern state of Egypt* (London: T. Payne, *et al.*).

HAMLIN, TALBOT FAULKNER (1944): *Greek Revival Architecture in America* (London: Oxford University Press).

—(1955): *Benjamin Henry Latrobe* (New York, NY: Oxford University Press).

HAMMER, KARL (1983): *Hôtel Beauharnais* (Munich: Artemis Verlag).

HAMON-JUGNET, MARIE, and OUDIN-DOGLIONI, CATHERINE (1991): *Le Quai d'Orsay, l'Hôtel du Ministre des Affaires étrangères* (Paris: Éditions du Félin).

HAMONT, PIERRE-NICOLAS (1843): *L'Égypte sous Méhémet-Ali* (Paris: Léautey et Lecointe).

HAMMOND, MASON (1959): *The Antonine Monarchy* (Rome: American Academy in Rome).

—(1968): *The Augustan Principate in Theory and Practice during the Julio-Claudian Period* (New York, NY: Russell & Russell).

HAMPARTUMIAN, N. (tr.) (1976): see GLODARIU, I.

HANNESTAD, NIELS (1988): *Roman Art and Imperial Policy*, tr. P. G. CRABB (Aarhus: Aarhus University Press).

HANOTAUX, GABRIEL (*Ed.*) (1931–40): *Histoire de la Nation Égyptienne* (Paris: Société de l'Histoire Nationale).

HÄNSEL-HOHENHAUSEN, MARKUS (1989): *Die deutschsprachligen Freimaurer-Zeitschriften des 18. und 19. Jahrhunderts: Bibliographie* (Frankfurt-am-Main: R. G. Fischer).

HÁRICH, JÁNOS (1937): *A Kismartoni várkert története* (Budapest: s.n.).

HAROUEL, JENA-LOUIS (1981): see GUILLERME, JACQUES.

HARPRATH, R. (1986): *Der Codex Coburgensis. Das erste systematische Archäologiebuch* (Coburg: Kunstsammlung der Veste Coburg).

HARRIS, E. and J. R. (1965): *The Oriental Cults in Great Britain* (Leiden: E. J. Brill).

HARRIS, JOHN (1957): Letter in *The Architectural Review*, **cxxii**/726 (July), 2.

—(1961): *Regency Furniture Designs from Contemporary Source Books 1803–1826* (London: A. Tiranti).

—(1970): *Sir William Chambers, Knight of the Polar Star* (London: Zwemmer).

HARRIS, J.R. (*Ed.*) (1971): *The Legacy of Egypt* (Oxford: Oxford University Press).

HART, GEORGE (1986): *A Dictionary of Egyptian Gods and Goddesses* (London: Routledge & Kegan Paul).

HARTLEBEN, HERMINE (1906): *Champollion* (Berlin: Weidmann).

—(*Ed.*): (1909): see CHAMPOLLION, JEAN-FRANÇOIS.

HARTT, FREDERICK (1958): *Giulio Romano* (New Haven, CT: Yale University Press). Reprinted in New York in 1981 by Hacker Art Books.

HARVEY, SIR PAUL (1969): *The Oxford Companion to English Literature* (Oxford: University Press).

HASQUIN, HERVÉ (*Ed.*) (1981): *Hommages à la Wallonie, Mélanges d'histoire, de littérature, et de philologie wallones offerts à Maurice A. Arnould et Pierre Ruelle* (Brussels: Éditions de l'Université de Bruxelles).

HASTINGS, JAMES, ET AL. (*Ed.*) (1908–27): *Encylopædia of Religion and Ethics* (Edinburgh: T. & T. Clark).

HATCH, EDWIN (1957): *The Influence of Greek Ideas on Christianity* (New York, NY: Harper).

HATFIELD, ROBERT GRIFFITH (1844): *The American House Carpenter* (New York, NY: Wiley & Putnam).

HATHERLY, ANA (1985): 'Pyramides, obeliscos, mausoleus e Lisonias do Barroco Portugues', in *Coloquio Artes* (September).

HATZFELD, G. (1919): *Les trafiquants italiens dans l'Orient hellénique* (Paris: E. de Boccard).

HAUG, GENEVIÈVE (LEVALLET) (1912): *Rome et la Renaissance de l'antiquité à la fin du XVIIIᵉ siècle* (Paris: Fontemoing).

—(1934): *Claude-Nicolas Ledoux, 1736–1806* (Paris and Strasbourg: Librairie Istra).

HAUSSER, ELISABETH (1968): *Paris au jour le jour, 1900–1919* (Paris: Les Éditions de Minuit).

HAUSSIG, H. W. (*Ed.*) (1965): *Wörterbuch der Mythologie* (Stuttgart: E. Klett).

HAUSSMANN, GEORGES-EUGÈNE (1890–3): *Mémoires* (Paris: Victor-Harvard).

HAUTECOEUR, LOUIS-EUGÈNE-GEORGES (1912): *Rome et la Renaissance de l'antiquité à la fin du XVIIIᵉ siècle – Essai sur les origins du style Empire* (Paris: Fontemoing & cie).

—(1925): 'L'Expédition d'Égypte et l'art français', in *Napoléon, Revue des Études Napoléoniennes* (Paris: January–February), 81–87.

—(1943–57): *Histoire de l'architecture classique en France* (Paris: A. Picard).

—(1958): *L'Art sous la Révolution et l'Empire en France, 1789–1815* (Paris: Flammarion).

HAVEN, MARC (1964): see LALANDE, EMMANUEL.

HAY, DENYS (*Ed.*): (1967): *The Art of the Renaissance* (New York, NY: McGraw Hill).

HAYÈRE, J.-T. (1865): *Éloge funèbre du Président A. Lincoln*, etc. (Paris: E. Martinet).

HAYES, WILLIAM CHRISTOPHER (1959): *The Scepter of Egypt* (Cambridge, MA: Harvard University Press).

HEAD, CHARLES FRANKLIN (1833): *Eastern and Egyptian Scenery, Ruins . . .* (London: Smith, Elder, & Co).

HEALEY, CATHERINE, BOWIE, KAREN, and BOS, AGNÈS (*Eds*) (1998): *Le Père-Lachaise* (Paris: Éditions Action Artistique de la Ville de Paris).

HECKSCHER, WILHELM SEBASTIAN (1947): 'Bernini's Elephant and Obelisk', in *The Art Bulletin*, **xxix/**3 (September), 154–182.

HEDERER, OSWALD (1964): *Leo von Klenze: Persönlichkeit und Werk* (Munich: G.D.W. Callwey).

HEIM, F. (1988): 'Les auspices publics de Constantin à Théodose', in *Ktèma*, **xiii**, 41–53.

HEINEN, H. (1911): 'Zur Begründung der römischen Kaiserkulte', in *Klio*, **xi**, 129–77.

HELBIG, WOLFGANG (1963–72): *Führer durch die öffentlichen Sammlungen klassischer Altertümer in Rom*, edited by HERMINE SPEIER (Tübingen: E. Wasmuth).

HELCK, HANS WOLFGANG (1965): 'Die Mythologie der alten Ägypter', in H. W. HAUSSIG (*Ed.*), **i**, 313–406.

—, and OTTO, EBERHARD (*Eds*) (1956): *Kleines Wörterbuch der Ägyptologie* (Wiesbaden: O. Harrassowitz).

—(1968): *see* BRUNNER-TRAUT, EMMA (1968*a*).

—(1975–85): *Lexikon der Ägyptologie* (Wiesbaden: O. Harrassowitz).

HEMBERG, BENGT (1950): *Die Kabiren* (Uppsala: Almqvist & Wiksells boktr.).

HEMPEL, EBERHARD (1949): *Geschichte der Deutschen Baukunst* (Munich: F. Bruckmann).

HENNE AM RHYN, OTTO (1869): *Das Buch der Mysterien. Leben und Treiben der geheimen Gesellschaften aller Zeiten und Völker* (St-Gallen: Altwegg-Weber zur Treuburg).

—(1894): *Die Freimaurer; deren Ursprung, Geschichte, Verfassung, Religion, und Politik* (Leipzig: M. Spohr).

HENNIKER, SIR FREDERICK (1823): *Notes during a visit to Egypt, Nubia, the Oasis, Mount Sinai, and Jerusalem* (London: J. Murray).

HENRICHS, A. (1968): 'Vespasian's Visit to Alexandria', in *Zeitschrift für Papyrologie und Epigraphik*, **iii**, 51–80.

HERDER, JOHANN GOTTFRIED VON (1877–1913): *Sämmtliche Werke* (Berlin: Weidmann).

HERMANN, A. (1962): 'Aegyptologische Marginalien zur Spätantiken Ikonographie', in *Jahrbuch für Antike und Christentum*, **v**, 60 ff.

HERODOTUS (1992): *The Histories*, tr. GEORGE RAWLINSON (London: Everyman).

HEROLD, J. CHRISTOPHER (1962): *Bonaparte in Egypt* (New York, NY: Harper & Row).

HÉRON DE VILLEFOSSE, RENÉ (1942): *Prés et bois parisiens* (Paris: B. Grasset).

HERSEY, GEORGE L. (1976): *Pythagorean Palaces: Magic and Architecture in the Italian Renaissance* (Ithaca, NY: Cornell University Press).

HEUTEN, G. (1931): 'La diffusion des cultes égyptiens en Occident', in *Revue de l'histoire des religions*, **civ**, 409–16.

HEYOB, S. K. (1975): *The Cult of Isis among women in the Græco-Roman World* (Leiden: E. J. Brill).

HIBBARD, HOWARD (1966): *Bernini* (Baltimore. MD: Penguin).

—(*Ed.*) (1967): *see* FRASER, DOUGLAS.

HIGGINBOTTOM, DAVID (1976): *The Royal Pavilion at Brighton* (Brighton: Royal Pavilion, Art Gallery, and Museums).

HILLAIRET, JACQUES (AUGUSTE ANDRÉ COUSSILLAN) (1966): *Dictionnaire historique des rues de Paris* (Paris: Éditions de Minuit).

HILLIER, BEVIS (1968): *Art Deco of the 20s and 30s* (London: Studio Vista).

—, and ESCRITT, STEPHEN (1997): *Art Deco Style* (London: Phaidon Press Ltd).

HIMMELHEBER, GEORG (1974): *Biedermeier Furniture*, tr. SIMON JERVIS (London: Faber).

HINARD, FRANÇOIS (1985): *Les proscriptions de la Rome républicaine* (Rome: École française de Rome).

HINES, COLIN, with RIDDLE, PAUL, and CHEETHAM, KEITH (2003): *Art Deco London* (Twickenham: Park House Press).

HIRSCHFELD, GUSTAVE (1938): *Arcs de Triomphe et Colonnes Triomphales de Paris* (Grenoble: B. Arthaud).

HISTOIRE ET BANDES DESSINÉES. IMAGES DE L'ÉGYPTE ANCIENNE (1987): (Besançon: Imprimerie de la Faculté des Sciences et Imprimerie du Recordat). Contains articles by BOURGEOIS, CORTEGGIANI, ELOY, and THIEBAUT, etc.

HITCHCOCK, HENRY-RUSSELL (1958): *Architecture: Nineteenth and Twentieth Centuries* (Baltimore, MD: Penguin). *See* the revised edition, published at Harmondsworth by Penguin Books Ltd in 1977.

—(1972): *Early Victorian Architecture in Britain* (New York, NY: Da Capo Press).

HITCHMOUGH, WENDY (1992): *Hoover Factory*, in *Architecture in Detail* series (London: Phaidon Press Ltd).

HITTORFF, JACQUES-IGNACE (1836): *Précis sur les pyramidions en bronze doré employés par les anciens Égyptiens comme couronnement de quelques-uns de leurs obélisques* (Paris: Paul Renouard).

HOBBS-HALMAY, H. M. (1992): 'The Development of Egyptian Revival in San Diego County', in *The Journal of San Diego History*, **xxxviii/**2 (Spring).

HOBSON, CHRISTINE (1987): *Exploring the World of the Pharaohs: A Complete Guide to Ancient Egypt* (London: Thames & Hudson).

HOEBANX, J. J. (1980): 'L'implantation et l'expansion de la Franc-Maçonnerie à Bruxelles et en Wallonie des origins à 1980', in HASQUIN, H. (*Ed.*), 293–320.

—(2000): 'Des loges dans la cité', in DESPY-MEYER, A. (*Ed.*), 10–27.

HOELBL, G. (1979): *Beziehungen der ægyptischen Kultur zu Altitalien* (Leiden: E . J. Brill).

HOFFMANN, ALFRED (1963): *Der Landschaftsgarten* (Hamburg: Broschek).

HOFLAND, BARBARA (WREAKS) HOOLE (1819): *A Descriptive Account of the Mansion & Gardens of White-Knights, a Seat of His Grace the Duke of Marlborough* (London: W. Wilson).

HÖFLER, A. (1935): *Der Sarapishymnus des Ailios Aristeides, Tübinger Beiträge zur Altertumswissenschaft* (Stuttgart: W. Kohlhammer).

HOLLAND, PHILEMON (tr.) (1923): *see* SUETONIUS.

HOLLERICH, M. J. (1989): 'Myth and History in Eusebius's *De Vita Constantini: Vit. Const.* 1.12 in its contemporary setting', in *Harvard Theological Review*, **lxxxii**, 421–45.

HOLMBERG, MAJ SANDMAN (1946): *The God Ptah* (Lund: C.W.K. Gleerup).

HONOUR, HUGH (1954): 'Curiosities of the Egyptian Hall', in *Country Life*, **cxv** (7 January), 38–9.

—(1955): 'The Egyptian Taste', in *The Connoisseur*, **cxxxv**/ 546, 242–6.

—(1961): *Chinoiserie. The Vision of Cathay* (London: J. Murray).

—(1969): *Cabinet Makers and Furniture Designers* (London: Weidenfeld & Nicolson).

—(1977): *Neo-Classicism* (Harmondsworth: Penguin Books Ltd).

HOPE, THOMAS (1807): *Household Furniture and Interior Decoration* (London: Longman Hurst, Rees, and Orme).

—(1840): *An Historical Essay on Architecture* (London: J. Murray).

HOPFNER, THEODOR (1922–25): *Fontes Historiæ Religionis Ægyptiacæ* (Bonn: A. Marx and E. Weber).

HOPKINS, KEITH (1978): 'Economic Growth and Towns in Classical Antiquity', in *Towns in Societies*, edited by PHILIP ADAMS and EDWARD ANTHONY WRIGLEY (Cambridge: Cambridge University Press).

—(1980): 'Taxes and Trade in the Roman Empire', in *Journal of Roman Studies*, **lxx**, 101–25.

—(1983): *Death and Renewal. Sociological Studies in Roman History*, **ii** (Cambridge: Cambridge University Press).

—(2000): *A World full of Gods: Pagans, Jews, and Christians in the Roman Empire* (London: Phoenix).

HORÁNYI, MÁTYÁS (1962): *The Magnificence of Eszterháza* (London and Budapest: Akadémiai Kiadó).

HORN-ONCKEN, ÄLSTE (1935): *Friedrich Gilly 1772–1800* (Berlin: Deutscher Verein für Kunstwissenschaft).

HORNBLOWER, S., AND SPAWFORTH, A. (*Eds*) (1996): *The Oxford Classical Dictionary* (Oxford: Oxford University Press).

HORNBOSTEL, WILHELM (1973): *Sarapis: Studien zur Überlieferungsgeschichte, den Erscheinungsformen und Wandlogen der Gestalt eines Gottes* (Leiden: E. J. Brill).

HORNEMANN, BODIL (1951–69): *Types of Ancient Egyptian Statuary* (Copenhagen: Munksgaard).

HORNUM, MICHAEL B. (1993): *Nemesis, the Roman State, and the Games* (Leiden: E. J. Brill).

HORNUNG, ERIK (1967): *Einführung in die Aegyptologie* (Darmstadt: Wissenschaftliche Buchgesellschaft).

—(1983a): *Conceptions of God in Ancient Egypt – The One and the Many* (London: Routledge & Kegan Paul).

—(1983b): *Tal der Könige* (Berlin: Artemis).

—(1990): *Zum Bild Ägyptens im Mittelalter und in der Renaissance* (Freiburg/Schweiz–Göttingen: Universitätsverlag -Vandenhoeck & Ruprecht).

HORST, PETER WILLEM VAN DER (1984): *Chæremon. Egyptian Priest and Stoic Philosopher* (Leiden: E. J. Brill).

HÔTE, NESTOR L' (1836, 1840): *see* L'HÔTE, NESTOR.

HOULIHAN, PATRICK F. (2001): *Wit and Humour in Ancient Egypt* (London: Rubicon Press).

HOWARD, NOËL (1978): *Hollywood sur Nil* (Paris: Fayard).

HOWARD-VYSE, RICHARD WILLIAM HOWARD, and PERRING, JOHN SHAE (1840–42): *Operations carried on at the Pyramids of Gizeh in 1837* (London: J. Fraser).

HOWATSON, M.C. (*Ed.*) (1990): *The Oxford Companion to Classical Literature* (Oxford: Oxford University Press).

HOWLAND, RICHARD HUBBARD (1953): *The Architecture of Baltimore* (Baltimore, MD: Johns Hopkins Press).

HUBALA, ERICH (1956): 'Diverse maniere. Bemerkungen zu G.B. Piranesi's ägyptischen Kaminen', in *Festgabe für Hans Sedlmayr* (Munich: Universität).

—(1958): 'Egypten', in *Reallexikon zur deutschen Kunstgeschichte*, Bd. **4**, S. 750–75.

—(1972): 'Das alte Ägypten und die bildende Kunst im 19. Jahrhundert', in *Welt Kulturen und Moderne Kunst* (Munich).

HUBERT, EMANUELLE (1972): 'Les "mystères" de l'Égypte avant Champollion', in *Archéologia*, **lii** (November), 52.

HUDSON, CHARLES (1868): *History of the Town of Lexington . . .* (Boston, MA: Wiggins & Lunt).

HUGHES-HALLETT, LUCY (1990): *Cleopatra: Histories, Dreams, and Distortions* (London: Bloomsbury).

HUISMAN, GEORGES MAURICE (*Ed.*) (1957): *Histoire générale de l'art* (Paris: Librairie A. Quillet).

HÜLSEN, CHRISTIAN CARL FRIEDRICH (1907): *La Roma Antica di Ciriaco d'Ancona* (Rome: Lœscher)

—(1910a): *Il Libro di Giuliano da Sangallo* (Leipzig: O. Harrassowitz).

—(1910b): *Le Illustrazioni della* 'Hypnerotomachia Poliphili' *e le antichità di Roma* (Florence: L. S. Olschki).

—(1917): *Römische Antikengärten des XVI Jahrhunderts* (Heidelberg: C. Winter).

—(1933): *Das Skizzenbuch des Giovannantonio Dosio* (Berlin: H. Keller).

—, and EGGER, HERMANN (1913–16): *Die römischen Skizzenbücher von Maerten van Heemskerck . . .* etc. (Berlin: J. Bard).

HUMBERT, CHANTAL (1983): 'L'Égyptomanie au zénith Napoléonien', in *La Gazette de L'Hôtel Drouot*, **xxxi** (23 September), 24–5.

HUMBERT, J.-B. (1980): *see* BRIED, J.

HUMBERT, JEAN-MARCEL (1971a): Recherches sur les monuments égyptiens et égyptisants de Paris. Memoire of an historical study. Paris IV. Egyptology.

—(1971b): 'Les Monuments égyptiens et égyptisants de Paris', in *Bulletin de la Société française d'Égyptologie*, **lxii** (October), 9–29.

—(1974): 'Les Obélisques de Paris: projets et réalisations', in *Revue de l'Art*, **xxiii**, 9–29.

—(1975): L'Égyptomanie à Paris et dans la région parisienne (architecture, décoration, et mobilier) de 1775 à 1825. Doctoral Thesis (Third Cycle) presented at the Sorbonne.

—(1976a): 'À propos de l'égyptomanie dans l'oeuvre de Verdi. Attribution à Auguste Mariette d'un scénario anonyme de l'opéra *Aida*', in *Revue de Musicologie*, **lxiii**/2, 229–256.

—(1976b): '*Aida* entre l'égyptologie et l'égyptomanie', in *L'Avant-Scène Opéra*, **iv** (July–August), 9–14.

—(1976c): 'Quand l'Égypte fleurit à Paris', in *Touring*, No. 885 (November), 24–9.

—(1979a): 'L'Obélisque de Louxor', in *Paris aux Cent Villages*, **xlvii** (August), 16–20.

—(1979b): 'L'Égyptomanie dans l'art occidental', in *Silex*, **xiii** (September), 105–14.

—(1981): 'L'Obélisque de Louxor', in *L'Intermédiaire de chercheurs et curieux*, **ccclviii** (January), 86–7.

—(1982): 'Mariette et Aïda, ou l'égyptologie gagné par l'égyptomanie', in *Vivre à Boulogne*, **xiv** (January), 23–5.

—(1984a): 'Actualité de l'égyptomanie', in *Revue de l'Histoire des Religions*, **cci**/1, 106–8.

—(1984b): 'Hommage à Mariette Pacha', in *Programme des spectacles donnés aux Arènes de Nîmes lors du premier festival* (Nîmes: July, 16–23). Reprinted in *Antiquity*, **lix** (July 1985), 101–4, as 'Mariette Pacha and Verdi's *Aida*'.

—(1985a): 'Présence de l'égyptomanie dans l'architecture urbaine, thèmes et symboles', in *Résumé des communications du 110ᵉ Congrès National des Sociétés Savantes*, Montpellier, 1–5 April 1985 (Paris: Ministère de l'Education Nationale, Comité des Travaux Historiques et Scientifiques), 74. The same theme is given in *Actes du 110ᵉ Congrès National des Sociétés* published in *Études Languedociennes* (Paris: Ministère de l'Education Nationale, Comité des Travaux Historiques et Scientifiques, 1985), 423–42.

—(1985b): 'Paris liegt am Nil' (with WILFRIED WIEGAND), in *Frankfurter Allgemeine Magazin*, **cclxxiv** (31 May), 52–60.

—(1987a): L'Égyptomanie, sources, thèmes et symboles. Étude de la réutilisation des thèmes décoratifs empruntés à l'Égypte ancienne dans l'art occidental du XVIᵉ siècle à nos jours. Doctoral Thesis, Letters and Humanities, Sorbonne, Paris IV.

—(1987b): 'Panorama de quatre siècles d'égyptomanie', in *Bulletin de la Société française d'Égyptologie*, **cx** (October), 48–77.

—(1987c): 'La réinterprétation de l'Égypte ancienne dans l'architecture du XIXᵉ siècle: un courant original en marge de l'orientalisme', in *Actes du Colloque Pascal-Xavier Coste* (Marseilles: 27–29 November).

—(1987d): 'L'Égyptomanie dans les collections du musée de l'Armée', in *Revue de la Société des Amis du Musée de l'Armée*, **i**, 39–51.

—(1988a): 'Égyptologie et Égyptomanie: imprégnation dans l'art occidental de quatre siècles d'une cohabitation harmonieuse', in *Catalogue* of the Exhibition (27 May–3 October) *Les Collections égyptiennes dans les musées de Saône-et-Loire* (Autun: Musée Rolin, 1988). see also the *Catalogue* of the Exhibition (28 May–3 October 1988) *L'Égypte redécouverte* (Autun: Bibliothèque Municipale, 1988).

—(1988b): 'Les Pharaons d'Hollywood: archéologie et égyptomanie au cinéma', in *L'Archéologie et son image*, the *Actes* of a colloquium held at Antibes, 1987, and published at Juan-les-Pins.

—(1989a): *L'Égyptomanie dans l'Art Occidental* (Paris [Courbevoie]: ACR Édition Internationale).

—(1989b): 'Le Symbolisme de l'égyptomanie révolutionnaire et son influence sur l'avenir du phénomène', in *Actes du 114ᵉ Congrès National des Sociétés Savantes* (3 - 9 April). *See also Résumé des Communications* (Paris: 1989).

—(1990a): 'Napoléon et l'Égypte, ou l'osmose de deux mythes', in DEWACHTER, M. (*Ed.*) (1990), 31–7.

—(1990b): *L'égyptomanie: sources, themes et symboles: etude de la réutilisation des themes décoratifs empruntés à l'Égypte ancienne dans l'art occidental du XVIᵉ siècle à nos jours: thèse de doctorat d'État* (Lille 3: ANRT)

—(1991): 'Egyptomanie et decoration intérieure aux XIXᵉ siècle', in GOVI, CURTO, and PERNIGOTTI (*Eds*) (1991), 221–231.

—(1993a): 'Rêves d'Égypte: l'égyptomanie, mythes, et symboles', in *Égyptes*, **iii**, 21–9.

—(1993b): 'Aïda de l'archéologie à l'égyptomanie', in 'Verdi, Aïda', *L'Avant-scène Opéra*, **iv**/2, 8–15.

—(1994a): 'Egyptomania', in *Muséart*, **xxxvii** (February), 66–9.

—(1994b): 'Les décors égyptisants des jardins: étapes d'un parcours initiatique?', and 'Le jardin du retour', in *Les Carnets de l'exotisme*, **xiii** (1st semester), 51–4.

—(1994c): 'Denon et la découverte d'Égypte', in HUMBERT, PANTAZZI, and ZIEGLER (*Eds*) (1994), 200–5. *See also* Humbert's other contributions on pp. 216–9 and 450–7.

—(1994d): 'Dendera [*sic*] et son reinterpretation aux XVIIIᵉ et XIXᵉ siècles', in *Hommages à Jean Leclant*, **iv**, 137–146. (Cairo: Institut français d'archéologie orientale, Bibliothèque d'étude, **cvi**/4).

—(1994e): 'La redécouverte de Dendera (*sic*) et son interprétation dans l'art du XIXᵉ siècle', in *Hommages à Jean Leclant*, **iv**. (Cairo: Institut français d'archéologie orientale, Bibliothèque d'étude, **cvi**/4).

—(1995): 'Le Goût égyptien dans l'œuvre de Molitor et des ébénistes contemporains', in *Catalogue* of the exhibiton *Bernard Molitor* (Luxembourg), 110–45.

—(1996): 'Postérité du sphinx antique: la sphinxomanie et ses sources', in HUMBERT (*Ed.*) (1996), 99–138.

—(*Ed.*) (1996): *L'Égyptomanie à l'épreuve de l'archéologie. Actes du colloque international organisé au musée du Louvre par le Service culturel les 8 et 9 avril 1994* (Brussels: Éditions du Gram, and Paris, Musée du Louvre). *See also* HUMBERT's own contributions on pp. 21–35 and 97–138.

—(1997a): 'Sources multiples and incertaines: comment la redécouverte de l'Égypte s'est traduite dans l'art', in *Actes du Colloque* [18–21 May 1995]: *La Redécouverte de la Grèce et de l'Égypte au XVIIIᵉ et au début du XIXᵉ siècle* (Nantes: Presses de l'Universitaire de Nantes), 177–89.

—(1997b): 'Le Metamorfosi di Iside tra il XVI a il XIX secolo', in *Catalogue* of the exhibition *Iside* (Milan: Electa), 626–33.

—(1997c): 'La folie des pyramides, des Lumières au grand Louvre', in *L'Histoire* (December), 32–3.

—(1997d): 'Égyptomanie', in *Dictionnaire européen des Lumières* (Paris: Presses universitaires de France).

—(1998): *L'Égypte à Paris* (Paris: Éditions Action Artistique de la Ville de Paris).

—, PANTAZZI, MICHAEL, and ZIEGLER, CHRISTIANE (*Eds*) (1994): *Egyptomania: Egypt in Western Art 1730–1930. Catalogue* (also published in French as *Égyptomanie: L'Égypte dans l'Art Occidental, 1730–1930*) of an Exhibition held at the Musée du Louvre, Paris (20 January–18 April 1994), National Gallery of Canada, Ottawa (17 June–18 September 1994), and Kunsthistorisches Museum, Vienna (16 October 1994–29 January 1995) (Paris and Ottawa: Éditions de la Réunion des Musées Nationaux, National Gallery of Canada, and Spadem, Adagp, 1994).

HUMPHREY, JOHN H. (1986): *Roman Circuses. Arenas for Ancient Racing* (Berkeley: University of California Press).

HUMPHRIES, D. (*tr.*) (1721–25): *see* MONTFAUCON, BERNARD DE.

HUNT, CHARLES CLYDE (1939): *Masonic Symbolism* (Cedar Rapids, IA: Laurence Press Co.).

HUNT, JOHN DIXON, AND SCHUYLER, DAVID (*Eds*) (1984): *Journal of Garden History*, **iv**/3 (July–September). Special issue devoted to cemeteries, with contributions from CURL, ETLIN, *ET AL.*

HUNT, LEIGH (1861): *A Saunter through the West End* (London: Hurst & Blackett).

HUNT, WILLIAM HOLMAN (1905–06): *Pre-Raphælitism and the pre-Raphaelite Brotherhood* (London: Macmillan).

HUSSEY, CHRISTOPHER (1955–56): *English Country Houses* (London: Country Life).

HUTTON, E. (1950): *The Cosmati: the Roman marble workers of the XIIth and XIIIth centuries* (London: Routledge & Kegan Paul).

IMDAHL, MAX (*Ed.*): (1966): *see* FIENSCH, GÜNTHER.

IMMAGINI PER AIDA (1983): *Catalogue* of the Exhibition held in Parma, Istituto di Studi Verdiani.

INWOOD, HENRY WILLIAM (1834): *Of the Resources of Design in the Architecture of Greece, Egypt, and other Countries . . .* (London: John Williams, Library of the Fine Arts).

IRBY, CHARLES LEONARD, and MANGLES, JAMES (1823): *Travels in Egypt and Nubia, Syria, and Asia Minor* (London: T. White & Co.).

ISAAC, BENJAMIN (1990): *The Limits of Empire. The Roman Army in the East* (Oxford: The Clarendon Press).

ISRAELIT-GROLL, SARAH (*Ed.*) (1990): *Studies in Egyptology Presented to Miriam Lichtheim* (Jerusalem: The Magnes Press, Hebrew University of Jerusalem).

ISSARTEL, THIERRY (1990): 'Les Projets pour le tombeau de Napoléon', in the *Catalogue* of the exhibition *Napoléon aux Invalides, 1840, le Retour des Cendres* (Paris: Musée de l'armée: Fondation Napoléon), 121–51.

ISTEL, EDGAR (1928): *Die Freimaurerei in Mozarts Zauberflöte* (Berlin: A. Unger).

IVERSEN, ERIK (1958): 'Hieroglyphic Studies of the Renaissance', in *Burlington Magazine*, **c**/658 (January), 15–21.

—(1961): *The Myth of Egypt and its Hieroglyphs in European Tradition* (Copenhagen: Gad). *See also* the 1993 edition (Princeton, NJ: Princeton University Press).

—(1968): *Obelisks in Exile* (Copenhagen: Gad).

IXNARD, P. MICHEL D' (1791): *Recueil d'Architecture . . .* (Strasbourg: Treuttel).

JACOBS, EDGAR-P. (1955): *Le mystère de la Grande Pyramide* (Brussels: Éditions du Lombard).

JACOBS, JOHAN (*Ed.*) (2000): *see* DESPY-MEYER, ANDRÉE.

JACZYNOWSKA, M. (1981): 'Le culte de l'Hercule romain au temps du Haute Empire', in *Aufstieg und Niedergang der römischen Welt. Geschichte und Kultur Roms im Spiegel der neueren Forschung*, ii/17.2 (Berlin and New York, NY: de Gruyter), 631–61.

JAEGER, BERTRAND (1991): 'L'Egitto antico alla Corte dei Gonzaga', in GOVI, *ET AL.* (*Eds*) (1991), 233–53.

—(1992): 'La création du Musée égyptien de Turin et le goût égyptisant au Piémont', in *Sesto Congresso Internazionale di Egittologia, Atti* (Turin: International Assocation of Egyptologists).

—(1994): 'La loggia delle muse nel Palazzo Te e la Reviviscenza dell'Egitto Antico nel Rinascimento', in *Mantova e l'antico Egitto da Giulio Romano a Giuseppe Acerbi. Atti del Convegno di Studi*, Mantua, 23–24 May 1992 (Florence: Leo S. Olschki Editore).

—(1996): 'Le café Pedrocchi de Padoue et la "modification du regard" porté sur l'Égypte ancienne en Italie au XIXe siècle', in HUMBERT (*Ed.*) (1996), 189–225.

JAEGHER, F. DE (1970): 'La Loge "Les Philadelphes" à Verviers', in *Bulletin des Archives Verviétoises*, **vi**, 15–37.

JAFFÉ, IRMA B. (1972): *see* WITTKOWER, RUDOLF.

JAHN, OTTO (1856): *W. A. Mozart* (Leipzig: Breitkopf und Härtel).

JAHRBUCH DES KAISERLICH DEUTSCHEN ARCHÄOLOGISCHEN INSTITUTS (from 1886): (Berlin: W. de Gruyter).

JAHRBUCH D. RÖMISCH-GERMANISCHEN ZENTRALMUSEUMS MAINZ (1963): **x**, 214.

JAL, P. (1961): 'La propagande religieuse à Rome au cours des guerres civiles de la fin de la République', in *L'Antique classique*, **xxx**, 395–414.

JAMES, EDWIN OLIVER (1966): *The Tree of Life: An archæological study* (Leiden: E.J. Brill).

JAMES, MONTAGUE RHODES (1921): *A Descriptive Catalogue of the Latin manuscripts in the John Rylands Library at Manchester* (Manchester: Manchester University Press).

JAMES, THOMAS GARNET HENRY (1961): *Ancient Egypt: a Cultural Topography* (Chicago, IL: University of Chicago Press). *See* KEES, HERMANN.

—(*Ed.*) (1979): *An Introduction to Ancient Egypt* (London: British Musuem Publications Ltd).

—(1982): *Excavating in Egypt: The Egyptian Exploration Society 1882–1982* (Chicago, IL: University of Chicago Press).

JAMESON, ANNA BROWNELL (1907): *Legends of the Madonna as represented in the Fine Arts* (London: Hutchinson & Co.).

JANNEAU, GUILLAUME (1964): *L'Époque Louis XVI* (Paris: Presses universitaires de France).

JANSSEN, JOZEF MARIE ANTOON (1943): 'Athanase Kircher "Égyptologue"', in *Chronique d'Égypte*, **xviii** (Brussels: Musées Royaux du Cinquantenaire).

JANSSEN, ROSALIND M. and JAC. J. (1990): *Growing Up in Ancient Egypt* (London: Rubicon Press).

—(1996): *Getting Old in Ancient Egypt* (London: Rubicon Press).

JARDÉ, AUGUSTE (1925): *Études critiques sur la vie et le règne de Sévère Alexandre* (Paris: De Boccard).

JARRY, PAUL (from 1922): *Les Vieux Hôtels de Paris* (Paris: F. Contet et al.).

JEAN, GEORGES (1992): *Writing: The Story of Alphabets and Scripts*, tr. JENNY OATES (London: Thames & Hudson Ltd).

JERVIS, JOHN BLOOMFIELD (1851): *Description of the Croton Aqueduct* (New York, NY: G.F. Nesbitt & Co.).

JERVIS, SIMON (*tr.*) (1974): *see* HIMMELHEBER, GEORG.

JOANNE, ADOLPHE LAURENT (1863): *Paris illus- tré* (Paris: L. Hachette).

JOHNSON, J. STEWART (1966): 'Egyptian Revival in the Decorative Arts', in *Antiques*, **xc** (October), 489–94.

JOLLOIS, JEAN-BAPTISTE-PROSPER (1904): *Journal d'un ingénieur attaché à l'expédition d'Égypte, 1798–1802*, edited by G. MASPERO (Paris: E. Leroux).

JOMARD, EDMÉ-FRANÇOIS (contributor to and editor of the *Description de l'Égypte*) (1812): *Recueil d'observations et de mémoires sur l'Égypte* (Paris: Imprimerie Impériale).

—(1819): *Notice sur les nouvelles découvertes faites en Égypte* . . . (Paris: Baudouin).

—(1822): *Description d'un étalon métrique orné d'hiéro- glyphes découvert dans les ruines de Memphis par les soins de M. le chev. Drovetti* (Paris: J. M. Eberhart).

—(1825): 'Antiquités égyptiennes', in *Bull. univ.* **iii**, 225–7.

—(1828): 'L'école égyptienne de Paris', in *J. Asiatique*, **ii**, 96–116.

—(1829): *Description Générale de Memphis et des Pyramides* (Paris: Imp. Royale).

JONES, BERNARD E. (1977): *Freemasons' Guide and Compendium* (London: Harrap).

JONES, BRIAN W. (1992): *The Emperor Domitian* (London and New York, NY: Routledge).

JONES, GWILYM PEREDUR (1942): *see* KNOOP, DOUGLAS.

JONES, OWEN (1843): *Views on the Nile* (London: Graves & Warmsley).

—(1856): *The Grammar of Ornament* (London: Day & Son).

—, and BONOMI, JOSEPH (1854): *Description of the Egyptian Court erected at the Crystal Palace* (London: Crystal Palace Library).

JONES-DAVIES, M. T. (*Ed.*) (1981): *Emblèmes et devis- es au temps de la Renaissance* (Paris: Y. Touzot).

JORDAN, HENRI (1907): *Topographie der Stadt Rom im Altertum* (Berlin: Weidmannsche Buchhandlung).

JOUDIOU, GABRIELLE (1994a): 'Du Nil à la Seine, Pierre-Simon Girard', in ANDIA and TEXIER (*Eds*), 90–4.

—(1994b): 'La fontaine aux lions', in ANDIA and TEXIER (*Eds*), 139–40.

JOUGUET, PIERRE (1944): *Trois études sur l'hellénisme* (Cairo: Impr. de l'Institut Français d'Archéologie Orientale).

—(1947): *La domination romaine en Égypte aux deux pre- miers siècles après Jesus-Christ* (Alexandria: Publications de la Société Royale d'Archéologie).

JOURDAIN, FRANTZ (1892): *L'Exposition Universelle de 1889. Constructions élevées au Champ de Mars par M. Ch. Garnier, etc.* (Paris: Librarie Centrale des Beaux- Arts).

JOURDAIN, MARGARET, and FASTNEDGE, RALPH (1965): *Regency Furniture 1795–1830* (London: Country Life Ltd).

JOURNAL OF EGYPTIAN ARCHÆOLOGY, THE (from 1914): (London: Egypt Exploration Fund).

JOURNAL OF HELLENIC STUDIES, THE (from 1880): (London: Council of the Society for the Promotion of Hellenic Studies).

JOURNAL OF NEAR EASTERN STUDIES (from 1942): (Chicago IL: The University of Chicago Press).

JOURNAL OF ROMAN STUDIES, THE (from 1911): (London: Society for the Promotion of Roman Studies).

JOURNAL OF THEOLOGICAL STUDIES (from 1899): (London: Oxford University Press, and later London: Dawson).

JOURNAL OF THE WARBURG AND COUR- TAULD INSTITUTES (from July 1937): (London: Warburg Institute, University of London).

JOY, EDWARD THOMAS (1977): *English Furniture 1800–1851* (London: Sotheby, Parke, Bernet Publications).

JULLIAN, PHILIPPE (1961): 'Napoléon sous l'empire des pharaons', in *Connaissance des Arts*, **cxviii** (December), 124–33.

JULLIOT FILS, F., and PAILLET, A. J. (1782): *See* AUMONT, LOUIS-MARIE-AUGUSTIN, DUC D'.

JUNG, OTTO (1963): *Der Theatermaler Friedrich Christian Beuther (1777–1856) und seine Welt* (Emsdetten/Westf.: Lechte).

JUNK, VICTOR (1899): *Goethes Forsetzung der Mozartschen Zauberflöte* (Berlin: A. Duncker).

JUNKER, HERMANN (1965): *Das Geburtshaus des Tempels der Isis in Philä* . . . (Vienna: Kommissionsverlag H. Böhlaus Nachf.).

KAHN, MAXIME (1938): *see* BONAPARTE EN ÉGYPTE.

KAHRSTEDT, U. (1958): *Kulturgeschichte der römischen Kaiserzeit* (Bern: Francke).

KAIN, ROGER (1978): 'Napoleon I and urban plan- ning in Paris', in *The Connoisseur*, **cxcvii**/791 (January), 44–51.

KAISER, W. (*Ed.*) (1967): *Ägyptisches Museum Berlin* (Berlin: Staatliche Museen Preussischer Kulturbesitz).

KARAGEORGHIS, VASSOS (1976): *see* CLERC, G.

—(1981): *see* CAUBET, ANNIE.

KARIG, J. S., and KISCHKEWITZ, H. (1992): 'Ein ungebautes Ägyptisches Museum für Berlin', in *Jahrbuch der Berliner Museen*, **xxxiv**.

KARLHAUSEN, CHR. (1993): *see* DELVAUX, L.

KASTL, H. (1964): *Der lateranensische Obelisk in Rom: Schicksal eines antiken Baudenkmals* (Munich: Heinz Moos).

KATER-SIBBES, G. J. F., and VERMASEREN, M. J. (1975a): *Apis, I. The Monuments of the Hellenistic- Roman Period from Egypt* (Leiden: E. J. Brill).

—(1975b): *Apis, II. Monuments from outside Egypt* (Leiden: E. J. Brill).

KAUFMANN, EMIL (1933): *Von Ledoux bis Le Corbusier: Ursprung und Entwicklung der Autonomen Architektur* (Vienna and Leipzig: Verlag Passer).

—(1952): *Three Revolutionary Architects: Boullée, Ledoux, and Lequeu. Transactions of the American Philosophical Society*, New Series, **xlii**, Part 3 (Philadelphia: American Philisophical Society).

—(1968): *Architecture in the Age of Reason: Baroque and Post-Baroque in England Italy, and France* (New York, NY: Dover Publications).

KEEP, ANN E. (*tr.*) (1963 and 1967): *see* WOLDER- ING, IRMGARD

—(1973): *see* MORENZ, SIEGFRIED.

KEES, HERMANN (1926): *Ägyptische Kunst* (Breslau: F. Hirt).

—(1942): *Bemerkungen zum Tieropfer der Ägypter und seiner Symbolik*, in *Nachrichten der Akademie der Wissenschaften in Göttingen*, Phil.-hist. No. **ii**.

—(1943): *Farbensymbolik in ägyptischen religiösen Texten*, in *Nachrichten der Akademie der Wissenschaften in Göttingen*, Phil.-hist. No. **xi**.

—(1953): *Das Priestertum im ägyptischen Staat, vom neuen Reich bis zur Spätzeit* (Leiden: E.J. Brill).

—(1956): *Totenglaube und Jenseitsvorgestellungen der alten Ägypter* (Berlin: Akademie Verlag).

—(1961): *Ancient Egypt: a Cultural Topography*, edited by T. G. H. JAMES (Chicago, IL: University of Chicago Press).

—(1966): 'Herz und Zunge als Schöpferogane in der ägyptischen Götterlehre', in *Studium Generale*, **xix**, 124–6.

—(1983): *Der Götterglaube im alten Ägypten* (Berlin: Akademie Verlag).

KELLY, ALISON (1990): *Mrs Coade's Stone* (Upton-upon-Severn: The Self Publishing Association Ltd).

KEMPEN, WILHELM VAN (1928): *Die Baukunst des Klassizismus in Anhalt nach 1800* (Marburg: Verlag des Kunstgeschichtlichen Seminars der Universität Marburg).

KENDAL, E. A. (1802): *see* DENON, BARON DOMINIQUE VIVANT.

KENNER, H. (1956): 'Die Götterwelt der Austria Romana', in *Jahreshefte des Österreichischen Archäologischen Instituts*, **xliii**, 57–100.

KENT, C., *ET AL.* (1973): *Die römische Münze* (Munich: Hirmer).

KERSAINT, ARMAND-GUY-SIMON DE COET-NEMPREN, COMTE DE (1792): *Discours sur les monuments publics, prononcé au Conseil du Département de Paris* (Paris: P. Didot).

KESTLER, JOHANN STEPHAN (1680): *Physiologia Kircheriana experimentalis* . . . (Amsterdam: Jansson-Waesberg).

KHAN, SOPHIE (1996): 'De la métaphore égyptienne à l'archéologie imaginaire: les fabulations de l'art contemporain', in HUMBERT (*Ed.*) (1996), 627–50.

KIENITZ, FRIEDRICH KARL (1953): *Die politische Geschichte Aegyptens vom 7. bis zum 4. Jahrhundert vor der Zeitwende* (Berlin: Akademie Verlag).

KIMBALL, FISKE (1944): 'Romantic Classicism in Architecture', in *Gazette des Beaux-Arts*, **xxv**, 95–112.

KING, ANNE (1893): *Dr Liddon's Tour in Egypt and Palestine in 1886* (London: Longmans Green).

KING, ALEC HYATT (1984): *A Mozart Legacy. Aspects of the British Library collections* (London: The British Library).

KIRBY, R.S. (*Ed.*) (1820): *Kirby's wonderful and Eccentric Museum; or, Magazine of Remarkable Characters* (London: R.S. Kirby).

KIRCHER, ATHANASIUS (1636): *Prodromus Coptus sive Ægyptiacus* (Rome: S. Cong: de Propag: Fide).

—(1643): *Lingua Ægyptiaca Restituta* (Rome: H. Scheus).

—(1647): *Rituale Ecclesiæ Ægyptiacæ sive Cophtitarum . . . ex lingua Copta et Arabica in Latinam transtulit* (Rome?: s.n.).

—(1650): *Obeliscus Pamphilius hoc est, interpretatio nova* (Rome: L. Grignani).

—(1652–54): *Œdipus Ægyptiacus hoc est universalis hiero-glyphicæ veterum doctrinæ temporum injuria abolitæ instauratio . . .in three volumes* (Rome: V. Mascardi).

—(1666): *Obelisci Ægyptiaci, nuper inter Isæi romani rudera effossi, interpretatio hieroglyphica Athanasii Kircheri* (Rome: Varessii).

—(1676): *Sphinx Mystagoga sive Diatribe Hieroglyphica* . . . (Amsterdam: Jansson-Waesberg).

—(1679): *Turris Babel; sive, Archontologia qua primo prisco-rum post diluvium hominum vita*, . . . (Amsterdam: Jansson-Waesberg).

KISCHKE, HORST (1996): *Die Freimaurer: Fiktion, Realität, und Perspektiven* (Wien: Ueberreuter).

KISCHKEWITZ, H. (1992): *see* KARIG, J. S.

KITAJAWA, JOSEPH M. (*Ed.*) (1985): *The History of Religions: Retrospect and Prospect* (New York, NY: Macmillan, and London: Collier Macmillan).

KJELLBERG, PIERRE (1973): *Le Guide des Statues de Paris* (Paris: La bibliothèque des arts).

—(1978*a*): 'Les Prémices de l'Empire', in *La Gazette de l'Hôtel Drouot*, **xxxviii** (10 November), 32–3.

—(1978*b*): 'Une colline en quête d'architecture', in *Connaissance des Arts*, **cccxv** (May), 79.

KLEIN, RICHARD (1971): *Symmachus. Eine tragische Gestalt des ausgehenden Heidentums* (Darmstadt: Wissenschaftliche Buchges.).

KLEIN DIEPOLD, RUDOLF (1901): *Arnold Böcklin* (Berlin: Gose & Tetzlaff).

KLENZE, LEO, RITTER VON (1847): *Sammlung architektonischer Entwürfe für die Ausführung bestimmt oder wirklich Ausgeführt* (Munich: Cotta).

KLOSS, GEORG FRANZ BURCKHARD (1844): *Bibliographie der Freimaurerei und der mit ihr in Verbindung Gesetzen Geheimen Gesellschaften* (Frankfurt-am-Main: J.D. Sauerländer).

—(1845): *Die Freimaurerei in ihrer Wahren Bedeutung aus den alten und ächten Urkunden der Steinmetzen, Masonen, und Freimaurer* (Leipzig: O. Klemm).

—(1848): *Geschichte der Freimaurerei in England, Irland, und Schottland aus ächten Urkunden dargestellt (1685 bis 1784) nebst einer Abhandlung über die Ancient Masons* (Leipzig: O. Klemm).

—(1852–53): *Geschichte der Freimaurerei in Frankreich aus ächten Urkunden dargestellt (1725–1830)* (Darmstadt: G. Jonghaus).

KNEISNER, FRIEDRICH (1912): *Geschichte der Deutschen Freimaurerei in ihren Grundzügen dargestellt* . . . (Berlin: A. Unger).

KNOOP, DOUGLAS, and JONES, G.P. (1942): *Freemasonry and the Growth of Natural Religion* (Frome and London: Butler & Tanner Ltd).

—(1947): *The Genesis of Freemasonry: an account of the rise and development of Freemasonry in its Operative Accepted, and Early Speculative Phases* (Manchester: Manchester University Press).

KOBBERT, M. (1914): 'Kult', in *Realenzyklopädie der klassischen Alterumswissenschaft*, Second Series, **i**/2 (Stuttgart: J. B. Metzlersche Verlagsbuchhandlung), 565–75.

KÖBERLEIN, ERNST (1962): 'Caligula und die ägyptischen Kulte', in *Beiträge zur klassischen Philologie*, **iii** (Meisenheim-am-Glan: A. Hain), 23.

KOCH, RICHARD (1911): *Br ∴ Mozart, Freimaurer und Illuminaten, nebst einigen freimaurerischen kulturhis-torischen Skizzen* (Bad Reichenhall: Koch).

KOEHLER, K. (*Ed.*) (1924): *see* BRESLAUER, M.

KOESTERMANN, E. (1953): 'Der pannonische-dalmatische Krieg, 6–9 n. Chr.', in *Hermes*, **lxxxi**, 345–78.

—(1958): 'Die Mission des Germanicus im Orient', in *Historia*, **vii**, 331–75.

KOPPELKAMM, STEFAN (1987): *Der imaginäre Orient; Exotische Bauten des achtzehnten und neunzehnten Jahrhunderts in Europe* (Berlin: Wilhelm Ernst & Sohn Verlag).

KÖPPEN, KARL FRIEDRICH (1821): *Crata Repoa: ou Initiations aux anciens mystères des prêtres d'Égypte*, translated from the German *Crata Repoa: oder Einweihungen in der alten geheimen Gesellschaft der ägyptischen Priester* published in Berlin in 1778 (Paris: Bailleul). *see also* BÉRAGE, – (1776).

KORNEMANN, E. (1901): 'Zur Geschichten der antiken Herrscherkulte', in *Klio*, **i**, 51–146.

KÖRTE, WERNER (1932): 'Giovanni Battista Piranesi als praktischer Architekt', in *Zeitschrift für Kunstgeschichte*, **ii** (Berlin: W. de Gruyter & Co.).

KRAEMER, ROSS SHEPARD (1992): *Her Share of the Blessings: Women's Religions among Pagans, Jews, and Christians in the Greco-Roman World* (Oxford and New York, NY: Oxford University Press).

KRAFFT, JOHANN KARL (otherwise JEAN-CHARLES) (1801–03): *Plans, coupes, élévations des plus belles maisons et des hôtels construits à Paris et dans les environs* (Paris: Krafft & Ransonnette).

—(1809): *Recueil des plus jolies maisons de Paris et de ses environs* (Paris: Impr. de J. L. Scherff).

—(1809–10): *Productions de plusieurs architectes français et étrangers, relatives aux jardins pittoresques et aux fabriques de divers genres . . .* (with P.-F.-L. DUBOIS) (Paris: de Levrault).

—(1812a): *Recueil d'architecture civile, contenant les plans, coupes, et élévations des châteaux, maisons de campagne, . . .* (Paris: Bance ainé).

—(1812b): *Plans, coupes, élévations des plus belles maisons et des hôtels construits à Paris et dans les environs* (with PIERRE-NICOLAS RANSONETTE) (Paris: Imprimerie de Clousier).

—(1831): *Constructions, plans, et décorations des jardins de France, d'Angleterre, et d'Allemagne* (Paris: Bance ainé).

—(1849): *Choix des plus jolies maisons de Paris et de ses environs, édifices et monuments publics* (Paris: Maison Bance ainé).

—(1849): *Maisons de campagne, habitations rurales, châteaux, fermes, jardins anglais, temples, chaumières, kiosques, ponts, etc.* (Paris: Bance ainé).

KRAFT, K. (1950–1): 'Zu den Schlagmarken des Tiberius und Germanicus. Ein Beitrag zur Datierung des Legionslager Vindonissa und Oberhausen', in *Jahrbuch für Numismatik und Geldgeschichte*, **ii**, 21–35.

KRYGER, KARIN (1983): 'Der Philosoph, ein raffaelisches Motiv in Wiedewelts Werk', in *HAFNIA Copenhagen Papers in the History of Art*, **ix**, 7–24.

—(1985): *Allegori og Borgerdyd: Studier i det nyklassicistiske gravmæle i Danmark 1760–1820* (Copenhagen: Christian Ejlers' Forlag).

—(1986): *Frihedsstøtten* (Odense: Landbohistorisk Selskab).

KUENZL, HANNELORE (1973): *Der Einfluss des alten Orients auf die europäische Kunst besonders im 19. und 20. Jh.* (Köln: Inaugural Dissertation).

KULTZEN, R. (1959/60): 'Die Malereien Polidoros da Caravaggio im Giardino del Bufalo in Rom', in *Mitteilungen des Kunsthistorischen Institutes in Florenz*, **ix**, 99–120.

KUNOTH, GEORGE (1956): *Die historische Architektur Fischers von Erlach* (Düsseldorf: L. Schwann).

KUNST UND ANTIQUITÄTEN (1989): No. 3, devoted to Egyptomania, with articles by OTTILLINGER, SCHMIDT, SCHOSKE, STROMBERG, SYNDRAM, THOMAS, and WITT-DÖRRING on various aspects of the Egyptian Revival.

KUNTZ, EDWIN (1947): 'Böcklins "Toteninsel"', in *Der Kunsthandel*, **lxvi** (Heidelberg), 7.

KURTZ, DONNA C., and BOARDMAN, JOHN (1971): *Greek Burial Customs* (London: Thames & Hudson).

LABRECQUE, YVETTE (1973): *see* TRAN TAM TINH, VINCENT.

LABROUSE, M. (1937): 'Le pomerium de la Rome impériale', in *Mélanges d'Archéologie et d'Histoire de l'École Français de Rome*, **liv**, 165–99.

LACLOCHE, FRANCIS (1981): *Architectures de cinémas* (Paris: Éditions du Moniteur).

LACOUTURE, JEAN (1988): *Champollion: une vie de lumières* (Paris: B. Grasset)

LADURIE, EMMANUEL LE ROY (*Ed.*) (1990): *Mémoires d'Égypte: hommage de l'Europe à Champollion* (Strasbourg: Nuée bleue).

LAET, SIGRIED J. DE (1944): *Aspects de la vie sociale et économique sous Auguste et Tibère* (Brussels: Off. de publicité).

LAFAYE, GEORGES LOUIS (1883): *Histoire du culte des divinités d'Alexandrie: Sérapis, Isis, Harpocrate et Anubis hors de l'Égypte depuis les origins jusqu'à la naissance de l'école néo-platonique* (Paris: Thorin).

—(1885): 'L'introduction du culte de Sérapis à Rome', in *Revue de l'Histoire des Religions*, **xi**, 327–9.

—(1904): *Les Divinités alexandrines chez les Parisii* (Paris: Société des Antiquaires de France).

LAFEVER, MINARD (1835): *The Beauties of Modern Architecture* (New York, NY: D. Appleton & Co.).

—(1856): *The Architectural Instructor, containing a history of architecture from the earliest times . . .* (New York, NY: G.P. Putnam & Co.).

LAGARCE, F. (1976): *see* CLERC, G.

LALANDE, EMMANUEL (1964): *Le Maître Inconnu. Cagliostro, étude historique et critique sur la haute magie, par Marc Haven* (Lyon: P. Derain).

LAMBRECHTS, PIERRE (1956): *Augustus en de egyptische godsdienst. Mededelingen van de koninklijke vlaamse Academie voor Wetenschappen, Letteren en schone Kunsten van België, Klasse der Letteren*, **xviii**/2 (Brussels: AWLSK).

—(1958–62): 'La politique religieuse, des empereurs romains. Leur attitude envers les cultes égyptiens et phrygiens', in *Nouvelle Clio. Revue de la découverte historique*, **x**/2, 243–4.

LANCASTER, CLAY (1947): 'Oriental Forms in American Architecture 1880–1870', in *Art Bulletin*, **xxix**/3 (September), 183–93.

—(1950): 'The Egyptian Style and Mrs Trollope's Bazaar', in *Magazine of Art*, **xliii**, 94ff.

LANCE, ADOLPHE (1872): *Dictionnaire des architectes français* (Paris: A. Morel & Cie).

LANCIANI, RODOLFO AMEDEO (1897): *The ruins and excavations of ancient Rome* (London: Macmillan & Co. Ltd).

—(1906): *La Villa Adriana: guida e descrizione* (Rome: R. accademia dei Lincei).

—(1989–2000): *Storia degli scavi di Roma e notizie interno le collezioni romane di antichità* (Rome: Quasar).

LANDI, GAETANO (1810): *Architectural Decorations: A Periodical Work of Original Designs invented from the Egyptian, the Greek, the Roman, the Etruscan, the Attic, the Gothic, etc. for Exterior and Interior Decoration of Galleries, Halls, Apartments, etc. either in Painting or Relief* (London: The Author).

LANDON, CHARLES-PAUL (1806–9): *see* LEGRAND, JACQUES-GUILLAUME.

—(Ed.): (1812): *Annales du Musée et de l'École moderne des Beaux-Arts* (Paris: C.-P. Landon *et al.*).

LANE FOX, ROBIN (1995): *see* FOX, ROBIN LANE.

LANG, SUSAN (1956): *see* PEVSNER, NIKOLAUS.

LANKHEIT, KLAUS (1968): *Der Tempel der Vernunft: Unveröffentlichte Zeichnungen von Boullée* (Basel and Stuttgart: Birkhäuser).

LANT, ANTONIA (1996): 'L'antiquité égyptienne revue par le cinéma, ou, Pourquoi filmer les pharaons?', in HUMBERT (*Ed.*) (1996), 587–605.

LANZAC DE LABORIE, LÉON DE (1905): *Paris sous Napoléon* (Paris: Plon-Nourrit et cie).

LASSALLE, ÉMILE (1844): *Promenades pittoresques aux cimetières du Père-Lachaise, de Montmartre, du Montparnasse et autres, ou Choix des principaux monuments élevés dans ces Champs de Repos; dessinés et Lithographiés par Lassalle et Rousseau. Texte par Jⁿ Marty* (Paris: A. Fourmage).

—(1846): *Les Principaux Monuments Funéraires Du Père-Lachaise, de Montmartre, du Mont-Parnasse et autres Cimetières de Paris Dessinés et Mesurés Par Rousseau, architecte, et Lithographiés Par Lassalle, Accompagnés d'une Description succincte du monument et d'une Notice historique sur le personnage qu'il renferme, Par Marty* (Paris: Amédée Bédelet).

LATTE, KURT (1960): *Römanische Religionsgeschichte* in *Handbuch der Altertumswissenschaft* series (Munich: C. H. Beck).

LAUER, JEAN PHILIPPE (1955): *Les Statues Ptolémaïques du Sarapieion de Memphis* (Paris: Presses Universitaires de France).

—(1962 onwards): *Histoire Monumentale des Pyramides d'Égypte* (Cairo: Institut Français d'Archéologie Orientale).

—(1988): *Le Mystère des Pyramides* (Paris: Presses de la Cité).

LAUGIER, MARC-ANTOINE (1753): *Essai sur l'Architecture* (Paris: Duchesne).

LAURENS, HENRY (1987): *Les Origins intellectuelles de l'expédition d'Égypte. L'Orientalisme islamisant en France (1698–1798)* (Istanbul and Paris: Éditions Isis).

—(1997): *L'Expédition d'Égypte: 1798–1801* (Paris: Éditions du Seuil).

LAUTH, F. J., and LEPSIUS, C. R. (1866 and 1867): Reports in *Zeitschrift für Ägyptische Sprache und Altertumskunde*, 92–6 and 17–20.

LAVAGNINO, EMILIO (1956): *L'arte moderna dai Neoclassici ai Contemporanei* (Turin: Unione Tipografico-Editrice Torinese).

LAVALLÉE, JOSEPH, MARQUIS DE BOIS-ROBERT (1798): *Notice Historique sur Charles Dewailly, Architecte* (Paris: The Author).

LAWSON, JOHN CUTHBERT (1910): *Modern Greek folklore and ancient Greek religion* (Cambridge: Cambridge University Press).

LAZARD, LUCIEN (1914): *Deux Jardins Disparus. Le jardin Ruggieri, le jardin du Delta* (Paris: Bulletin de la Société Le Vieux Montmartre).

LAZARE, FÉLIX and LOUIS (1844): *Dictionnaire administratif et historique des rues de Paris et de ses monuments* (Paris: F. Lazare).

LAZZARONI, MICHELE, and MUNOZ, ANTONIO (1908): *Filarete, scultore e architetto del secolo XV* (Rome: W. Modes).

LEACH, E. WINSOR (1982): 'Patrons, Painters, and Patterns: The Anonymity of Romano-Campanian Painting and the Transition from the Second to the Third Style', in GOLD, B. K. (*Ed.*), 135–73.

LEBAS, JEAN-BAPTISTE-APOLLINAIRE (1839): *L'Obélisque de Luxor* (Paris: Carilian-Gœury & V. Dalmont).

LEBÈGUE, RAYMOND (1943): *Les correspondants de Peiresc dans les anciens Pays-Bas* (Brussels: Office de Publicité).

LECAS-MARTINON, CHANTAL (1986): 'La Place de la Concorde: Hittorff et l'esthétique moderniste', in the *Catalogue* of the exhibition *Hittorff, un architecte du XIXᵉ* (Paris: Musée Carnavalet), 325–9.

LECHEVALLIER-CHEVIGNARD, GEORGES, and SAVREUX, MAURICE (1923): *Le Biscuit de Sèvres* (Paris: A. Morancé).

LECLANT, JEAN (1956): 'Notes sur la propagation des cultes et monuments égyptiens en Occident à l'époque impériale', in *Bulletin de l'Institut Français d'Archéologie Orientale*, **lv**, 173–9.

—(1959): 'Reflets de l'Égypte dans la littérature latine après quelques publications recents', in *Bulletin de la Faculté des Lettres Strasbourg*, **xxxvii**, 303–8.

—(1963): Notices in *Orientalia*, **xxxii**

—(1968): 'Histoire de la diffusion des cultes égyptiens', in *Problèmes et méthodes d'histoire religions*, 92–6.

—(1969): 'En quête de l'égyptomanie', in *Revue de l'Art*, **v**, 82–8.

—(1972–91): *Inventaire bibliographique des Isiaca* (Leiden: E J. Brill).

—(1976): *see* CLERC, G.

—(1985): De l'égyptophilie à l'égyptologie: érudits, voyageurs, collectionneurs et mécènes', in *Comptes rendus de l'Académie des Inscriptions et Belles-Lettres. Séance Publique Annuele lecture (22 November)* (Paris: CRAI Institut), 4ᵉ fasc., 630–47.

—(1986): 'Isis déesse universelle', in *Bulletin de Correspondence Hellénique*, Supplement **xiv**, 341–54.

—, ET AL. (1992–3): *Il VI Congresso Internazionale di Egittologia. Torino, 1–8 Settembre, 1991* (Turin: International Association of Egyptologists).

LECLERE, MARIE-FRANÇOISE (1989): 'Egyptomania', in *Le Point*, No. 854 (30 January), 12–16.

LECREULX, FRANÇOIS-MICHEL (1778): *Discours sur le goût applique aux arts et particulièrement à l'architecture . . .* (Nancy: de Hoener).

LEDIARD, THOMAS (Tr.) (1732): *The Life of Séthos, Taken from Private Memoirs of the Ancient Egyptians. Translated from a Greek Manuscript into French. And now faithfully done into English from the Paris Edition. By Mr Lediard* (London: J. Walthoe). *See* TERRASSON, JEAN.

LEDOUX, CLAUDE-NICOLAS (1804): *L'architecture considerée sous le rapport de l'art, des moeurs et de la législation* (Paris: The Author, printed by Perronneau).

—(1847): *L'Architecture de Claude-Nicolas Ledoux* (Paris: Lenoir).

LEDOUX-LEBARD, DENISE (1965): *Les ebénistes parisiens du XIX^e siècle (1795–1870)* (Paris: De Nobele).

—(1966): 'Le bureau de Louis-Phillipe', in *Connaissance des Arts*, **clxvii** (January), 40–1.

LEDOUX-LEBARD, GUY and CHRISTIAN (1959): 'Les Meubles du Premier Empire conservés dans l'ancien château de la reine Hortense à Arenenberg', in *Bulletin de la Société de l'Histoire de l'Art français*, 65.

LEFEBRE, GEORGES (1945): 'L'Égypte et le vocabulaire de Balzac et de Théophile Gautier', in *Académie des Inscriptions et Belles Lettres*, 15–16.

LEFEVER, F.-A. (1988): 'Egyptiserende constructies uit Napoleons tijd', in *De Brabantse Folklore*, **cclviii** (June), 98–120.

LEFEVRE, R. (1973): *Villa Madama* (Rome: Editalia).

LEFUEL, HECTOR (1925): *Boutiques parisiennes du Premier Empire* (Paris: Albert Morancé).

LEFUEL, OLIVIER (1970): 'L'influence de la Campagne d'Égypte sur l'art français', in *Souvenir Napoléon*, **cclv** (July), 26–9.

LEGH, THOMAS (1816): *Narrative of a Journey in Egypt and the Country beyond the Cataracts* (London: J. Murray).

LEGRAND, JACQUES-GUILLAUME (1797): *Recueil et parallèle des édifices de tout genre anciens et modernes remarquables par leur beauté . . . par J.-N.-L. Durand . . . avec un texte extrait de l'histoire générale de l'architecture, par J.-G. Legrand* (Paris: Gillé fils).

—(1806–9): *Description de Paris et de ses édifices* (Paris: C.-P. Landon).

LEHNER, H. (1924): 'Orientalische Mysterienkulte im römischen Rheinland', in *Bonner Jahrbücher*, **cxxix**, 36–91.

LEIPOLDT, JOHANNES (1926): *Die Religionen in der Umwelt des Urchristentums* (Leipzig: A. Deichert).

—(1953): *Heilige Schriften; Betrachtungen zur Religionsgeschichte der Antiken Mittelmeerwelt* (with SIEGFRIED MORENZ) (Leipzig: O. Harrassowitz).

LELIÈVRE, PIERRE (1942): *Vivant Denon, directeur des Beaux-Arts de Napoléon* (Angers: Éditions de l'Ouest).

LE MOËL, MICHEL (1997): *see* MOËL, MICHEL LE.

LEMOINE, BERTRAND (1995): *see* CHAMPION, VIRGINIE.

LEMONNIER, HENRI (1911 onwards): *Procès-verbaux de l'Académie royale d'architecture, 1671–1793* (Paris: J. Schemit).

LENOIR, ALEXANDRE (1806): *Description historique et chronologique des monumens de sculpture réunis au Musée des monumens français* (Paris: Chez l'auteur, Laurent Guyot, Levrault, Hacquart, Tezari).

—(1834): *De l'obélisque de Louqsor* (Paris:P. Baudoin).

—(1989): 'Les Colosses Funèbres – les pyramides éphémères de la Révolution française', in *FMR (Franco Maria Ricci)*, **xxi** (August), 25–50.

LENOIR, MARIE-ALEXANDRE (1814): *La Franche-Maçonnerie rendue à sa véritable Origine, ou l'Antiquité de la Franche-Maçonnerie prouvée par l'explication des mystères anciens et modernes* (Paris: Fournier, etc.).

LENORMAND, CHARLES (1867): 'L'Égypte à l'Exposition Universelle de 1867', in *Gazette des Beaux-Arts* (tiré à part), 25.

LEONCINI, L. (1987): 'Frammenti con trofei navali e strumenti sacrificali dei Musei Capitolini', in *Xenia*, **xiii**, 13–24.

LEOSPO, ENRICHETTA (1978): *La Mensa Isiaca di Torino* (Leiden: E. J. Brill).

LEPAGE, J.-B. (1836): *Réponse à la notice de M. Hittorff sur les pyramidions en bronze doré* (Paris: H. Fournier).

LEPSIUS, CARL RICHARD (1849–59): *Denkmäler aus Ægypten und Æthiopien*. 12 vols (Berlin: Nikolaische Buchhandlung).

—(1853): *Discoveries in Egypt, Ethiopia, and the Peninsula of Sinai in the years 1842–1845* (London: R. Bentley).

—(1866–67): *see* LAUTH, F. J.

LE ROY, LADURIE, E. (*Ed.*) (1990): *see* LADURIE, E. LE ROY.

LEROY, JULIEN DAVID (1758): *Les ruines des plus beaux monuments de la Grèce . . .* (Paris: H.L. Guerin & L.F. Delatour).

LESKO, LEONARD H. (1972): *The Ancient Egyptian Book of Two Ways* (Berkeley, CA: University of California Press).

—(*Ed.*): *Egyptological Studies in honor of Richard A. Parker* (Hanover, NH: Brown University and University Press of New England).

LESSING, ERICH (1994): *see* BERGDOLL, BARRY.

LESSING, GOTTHOLD EPHRAIM (1925): *Werke* (Berlin: Deutsches Verlagshaus Bong & Co.).

LEUNISSEN, M. M. (1990): *see* HAHN, J.

LEVER, JILL (1980): *see* WATKIN, DAVID.

LEVI, DORO (1947): *Antioch Mosaic Pavements* (Princeton, NJ: Princeton University Press).

LEVICK, BARBARA (1976): *Tiberius the Politician* (London: Thames & Hudson Ltd).

—(1978): 'A Cry from the Heart from Tiberius Caesar', in *Historia*, **xxvii**, 95–101.

LEWINE, MILTON J. (1967): *see* FRASER, DOUGLAS.

LEWIS, NAPHTALI (1999): *Life in Egypt under Roman Rule* (Atlanta, GA: Scholars Press).

LEXICON ICONOGRAPHICUM MYTHOLOGIAE CLASSICAE (LIMC) (from 1981): (Zürich/Munich: Artemis).

L'HÔTE, NESTOR (1836): *Notice Historique sur les Obélisques égyptiens, et en particulier sur l'Obélisque de Louqsor* (Paris: Leleux).

—(1840): *Lettres écrites d'Égypte en 1838 et 1839* (Paris: F. Didot).

LIARD, LOUIS (1909): *L'Université de Paris* (Paris: Librairie Renouard-H. Laurens).

LIBÉRATION (1986): 'Premiers Spots: Fellini pasta . . . et péplum parfumé', in *Libération* (20 February), 8. Deals with Egyptianising publicity on Television.

LICHTHEIM, MIRIAM (1973–80): *Ancient Egyptian Literature* (Berkeley, CA, Los Angeles, CA, and London: University of California Press).

LIEBESCHUETZ, J. H. W. G. (1979): *Continuity and Change in Roman Religion* (Oxford: Clarendon Press).

—(1990): *Barbarians and Bishops. Army, Church, and State in the Age of Arcadius and Chrysostom* (Oxford and New York, NY: Clarendon Press).

LIEGLE, J. (1941): 'Die Münzprägung Oktavians nach dem Siege von Aktium und die augusteische Kunst', in *Jahrbuch des deutschen archäologischen Instituts*, **lvi**, 91–119.

LIEU, S. N. C. (1994): *Manichæism in Mesopotamia and the Roman East* (Leiden: E. J. Brill).

LIGHT, HENRY (1818): *Travels in Egypt, Nubia, Holy Land, Mt. Libanon* [sic] *and Cyprus in the year 1814* (London: Rodwell & Martin).

LIGOU, DANIEL (*Ed.*) (1987): *Dictionnaire de la franc-maçonnerie* (Paris: Presses Universitaires).

—, *ET AL.* (2000): *Histoire des Francs-Maçons en France* (Toulouse: Drivat).

LIGUORI, ST ALFONSO MARIA DE' (1834–43): *Oeuvres Complètes* (Paris: Parent-Desbarres).

—(1837): *Les Gloires de Marie* (Paris: Gaume frères).

LINDERT, WILGERT TE (1998): *Aufklärung und Heilserwartung: philosophische und religiöse Ideen Wiener Freimaurer (1780–95)* (Frankfurt-am-Main: P. Lang).

LINDERSKI, J. and A. (1974): 'The Quæstorship of Marcus Aurelius', in *Phoenix*, **xxviii**, 213–23.

LINDNER, ERICH J. (1926): *Die königliche Kunst im Bild. Beiträge zur Ikonographie der Freimaurerei* (Graz: Akademische Druck u. Verlagsanstalt).

LINGS, MARTIN (1964): *Ancient Beliefs and Modern Superstitions* (London: Perennial Books).

LISTER, RAYMOND (1962): *Edward Calvert* (London: G. Bell).

LLEWELLYN, BRIONY (1986): see GUITERMAN, HELEN.

LLOYD, CHRISTOPHER (1973): *The Nile Campaign: Nelson and Napoleon in Egypt* (Newton Abbot: David & Charles).

LONDON MAGAZINE, THE (from 1820): (London: Baldwin, Cradock, and Joy) but *see especially* 1824.

LONG, ROBERT CARY (1849): *The ancient architecture of America . . .* (New York, NY: Bartlett & Welford).

LORING, JOHN (1979): 'Egyptomania: The Nile Style', in *The Connoisseur*, **cc**/804 (February), 114–121.

LOSTE, SÉBASTIEN, SCHNAPPER, ANTOINE, and FOUCART, BRUNO (1985): *Paris mystifié – La Grand Illusion du Grand Louvre* (Paris: Julliard).

LOUDON, JOHN CLAUDIUS (1833): *An Encyclopædia of Cottage, Farm, and Villa Architecture and Furniture . . .* (London: Longman, Rees, Orme, Brown, Green & Longman). *See also* the newer edition of 1846, edited by MRS JANE LOUDON.

—(1834–38): *The Architectural Magazine, and Journal of Improvement in Architecture; Building, and Furnishing, . . .* (London: Longman, Rees, Orme, Brown, Green & Longman).

LOVEJOY, ARTHUR ONCKEN, BOAS, GEORGE E., *ET AL.* (*Eds*) (1935): *A Documentary History of Primitivism and Related Ideas* (Baltimore, MD: Johns Hopkins University Press).

LUBERSAC, CHARLES-FRANÇOIS, L'ABBÉ DE (1775): *Discours sur les Monuments Publics* (Paris: D'Imprimerie royale).

LUCAS, PAUL (1704): *Voyage du Sieur Paul Lucas au Levant . . .* (Paris: G. Vandive).

—(1720): *Voyage fait en 1714 . . . dans la Turquie, l'Asie, Sourie, Palestine, Haute & Basse Égypte . . .* (Amsterdam: Steenhouwer & Uytwerp).

LUCIUS, ERNST (1904): *Die Anfänge des Heiligenkults in der Christlichen Kirche* (Tübingen: Mohr).

LUGAR, ROBERT (1805): *Architectural Sketches for Cottages, Rural Dwellings, and Villas, in the Grecian, Gothic, and Fancy Styles . . .* (London: J. Taylor).

—(1836): *Plans and Views of Ornamental Domestic Buildings, executed in the Castellated and Other Styles* (London: M. Taylor).

LURKER, MANFRED (1969): 'Hund und Wolf in ihrer Beziehung zum Tode', in *Antaius*, **x**, 199–216.

—(1971): 'Der Baum im Alten Orient. Ein Beitrag zur Symbolgeschichte', in *In Memoriam Eckhard Unger. Beiträge zu Geschichte, Kultur, und Religion des Alten Orients* (Baden-Baden: V. Koerner), 147–75.

—(1974): 'Zur Symbolbedeutung van Horn und Geweih unter besonderer Berücksichtigung der alto-rientalisch-mediterranen Kulturen', in *Symbolon*, **ii**, 83–104.

—(1980): *The Gods and Symbols of Ancient Egypt: An Illustrated Dictionary* (London: Thames & Hudson Ltd).

LUSSON, ADRIEN-LOUIS (1835): *Projet de trente fontaines pour l'embellissement de la ville de Paris* (Paris: Carilian-Goeury).

LUTERBACHER, FRANZ (1967): *Der Prodigienglaube und Prodigienstil der Römern* (Darmstadt: Wissenschaftliche Buchgesellschaft).

MAASS, JOHN (1956): Letter in *The Architectural Review*, **cxx**/717 (October), 212.

MACAULAY, JAMES (1975): *The Gothic Revival 1745–1845* (Glasgow and London: Blackie & Son Ltd).

MCCANN, A. M. (1968): *The Portraits of Septimius Severus, AD193–211* (Rome: American Academy in Rome).

MCCARTHY, MICHAEL (1987): *The Origins of the Gothic Revival* (New Haven, CT, and London: Yale University Press).

MCFADZEAN, RONALD (1979): *The Life and Work of Alexander Thomson* (London: Routledge and Kegan Paul).

MCKAY, H. A. (1994): *Sabbath and Synagogue. The Question of Sabbath Worship in Ancient Judaism* (Leiden: E. J. Brill).

MCKINSTRY, SAM (*Ed.*) (1994): *see* STAMP, GAVIN.

MACLOT, PETRA, and WARMENBOL, EUGÈNE (1984): 'Twee temples onder de slopershamer: aantekeningen bij de afbraak van het logegebouw van "Les Amis du Commerce et La Persévérance Réunis" te Antwerpen' (in collaboration with M. DE SCHAMPHELEIRE), in *M&L. Monumenten en Landschappen*, **iii**/3, 17–24.

—(1985): 'Bevangen door Egypte: de Egyptische Tempel in de Antwerpse Zoo in Kunsthistorisch en Historisch Perspectief', in *Zoom up Zoo* (Antwerp: Royal Zoological Society, June), 359–391.

—(1988*a*): 'Antwerpen aan de Nijl: Aantekeningen bij de bouw van een Egyptisch tempel te Antwerpen (1855–1862)', in *Antwerpen, Tijdschrift der Stad Antwerpen*, **i**, 34–43.

—(1988*b*): 'Tempel en stal in één: de Egyptische tempel in de Antwerpse zoo in kunsthistorisch en historisch perspectief', in *M&L. Monumenten en Landschappen*, **vii**/2, 24–35.

MACMULLEN, RAMSAY (1966): *Enemies of the Roman Order* (Cambridge, MA: Harvard University Press).

—(1981): *Paganism in the Roman Empire* (New Haven, CT, and London: Yale University Press).

—(1991): 'Hellenizing the Romans', in *Historia*, **xl**, 419–38.

MCQUITTY, WILLIAM (1965): *Abu Simbel* (London: Macdonald).

—(1976): *Island of Isis: Philae Temple of the Nile* (London: Macdonald & Jane's).

MACQUOID, PERCY, and EDWARDS, RALPH (1954): *The Dictionary of English Furniture* (London: Country Life Ltd).

MACREADY, SARAH, and THOMPSON, F.H. *(Eds)* (1985): *Influences in Victorian Art and Architecture.* Occasional Paper (New Series) No. **vii** of The Society of Antiquaries of London (London: Society of Antiquaries of London).

MCWILLIAM, COLIN (1971): *see* WALKER, DAVID.

MADAME FIGARO (1987): 'Clin d'oeil égyptien', 'Ce décor égyptien? Une maison anglaise', 'Shopping: l'éternel retour de l'Égypte', in *Madame Figaro,* No. 13242 (28 March), 94–107.

MADDEN, RICHARD ROBERT (1829): *Travels in Turkey, Egypt, Nubia, and Palestine in 1824–1827* (London: H. Colburn).

—(1841): *Egypt and Mohammed Ali* (London: Hamilton, Adams, & Co.).

MAEHLER, HERWIG, and STROCKA, VOLKER MICHAEL *(Eds)* (1978): *Das Ptolemäische Ägypten. Achten das internationelen Symposions 27–29 September 1976 in Berlin* (Mainz-am-Rhein: P. von Zabern).

MAHAN, DENNIS HART (1851): *An Elementary Course of Civil Engineering,* . . . (New York, NY: J. Wiley).

MAHDY, CHRISTINE EL (1989): *Mummies, Myth, and Magic in Ancient Egypt* (New York, NY: Thames & Hudson).

MAHMOUD KHALIL, MOHAMED (1937): *La Participation égyptienne à l'Exposition Internationale de Paris 1937* (Paris: s.n.).

MAIER, MICHAEL (1614): *Arcana Arcanissima, hoc est Hieroglyphica ægyptio-græca* . . . (London: T. Creede).

—(1617): *Symbola Aureæ Mensæ Duodecim Nationum* . . . (Frankfurt: L. Iennis).

MAILLET, BENOÎT DE (1735): *Description de l'Égypte, contenant plusieurs remarques curieuses* . . . (Paris: Genneau & Rollin)

MAJOR, HOWARD (1926): *The Domestic Architecture of the Early American Republic* (Philadelphia, PA: J.B. Lippincott).

MAJOR, THOMAS (1768): *The Ruins of Pæstum, otherwise Posidonia, in Magna Græcia* (London: T. Major).

MALAISE, M. (1972a): *Inventaire préliminaire des documents égyptiens découverts en Italie* (Leiden: E. J. Brill).

—(1972b): *Les conditions de pénétration et de diffusion des cultes égyptiens en Italie* (Leiden: E. J. Brill).

—(1984): 'La diffusion des cultes égyptiens dans les provinces européenes de l'Empire Romain', in *Aufstieg und Niedergang der römischen Welt. Geschichte und Kultur Roms im Spiegel der neueren Forschung,* **ii**, 17.3 (Berlin and New York, NY: de Gruyter), 1615–91.

MALEK, J. (1980): *see* BAINES, J.

MALLINGER, JEAN (1978): *Les Origines égyptiennes des usages et des symboles maçonniques* (Lille: F. Planquart).

MANDOWSKY, ERNA, and MITCHELL, CHARLES *(Eds)* (1963): *Pirro Ligorio's Roman Antiquities in MS XIII. B 7 in the National Library of Naples* (London: Warburg Institute University of London).

MANGANARO, G. (1961): 'Ricerche di Epigrafia siceliota, I. Perla Storia del Culto delle divinità orientali in Sicilia', in *Siculorum Gymnasium,* **xiv**, 182–3.

—(1964): 'Nuovo dediche con impronte die piedi alle divinità Egizia', in *Archeologia Classica,* **xvi**, 291–2.

MANGLES, JAMES (1823): *see* IRBY, CHARLES LEONARD.

MANILLI, J. (1650): *Villa Borghese fuori di Porta Pinciana* (Rome: L. Grignani).

MANLEY, DEBORAH, and RÉE, PETA (2001): *Henry Salt: Artist, Traveller, Diplomat, Egyptologist* (London: Libri Publications).

MANNING, SAMUEL (1875): *The Land of the Pharaohs* (London: The Religious Tract Society).

MANTOVA E L'ANTICO EGITTO DA GIULIO ROMANO A GIUSEPPE ACERBI (1994): *Atti del Convegno di Studi, Mantova,* 23–24 May 1992 (Florence: Leo S. Olschki Editore). Contains excellent papers by JAEGER *ET AL.*

MARCONI, PAOLO (1964): *Giuseppe Valadier* (Rome: Officina Edizioni).

MARÉ, ERIC SAMUEL DE (1954): *The Bridges of Britain* (London: B.T. Batsford Ltd).

MARGOLIN, J.-C. (1986): *Histoire du rébus* (Paris: Maisonneuve et Larose).

MARIETTE, FRANÇOIS-AUGUSTE-FERDINAND (1857): *Le Sérapeum de Memphis* (Paris: Gide).

—(1867): *Exposition Universelle de 1867: Description du Parc Égyptien* (Paris: Dentu).

—(1870–75): *Dendérah: description générale du grand temple* (Paris: A. Franck).

—(1875): *Karnak: étude topographique et archéologique* (Leipzig: J. Hinrichs).

—(1889): *Monuments divers* (Paris: F. Vieweg).

—(1893): *Voyage dans la Haute-Égypte* (Paris: H. Welter).

MARKLAND, JAMES HEYWOOD (1843): *Remarks on English Churches, and on the Expediency of Rendering Sepulchral Memorials Subservient to Pious and Christian Uses* (Oxford: J.H. Parker).

MARKX-VELDMAN, I. (1973): 'Het Grafmonument te Heemskerk en het gebruik van hiëroglyfen in de kring rondom Maarten van Heemskerck', in *Nederlands Kunsthistorisch Jaarboek,* **xxiv**, 27–44.

MARRACCIUS, HIPPOLYTUS (1648): *Bibliotheca Mariana alphabetico ordine digesta* . . . (Rome: F. Caballi).

—(1710): *Polyanthea Mariana, in qua libris octodecim* (Köln: F. Metternich). An earlier edition, *Polyanthea Mariana, in libros XVIII, distributa, in qua Deipara Virginis Mariæ* . . . ,was published in Köln by P. Ketteler in 1683, and a further edition in 20 parts was published in Rome by P. Corbolletti in 1694.

MARSH, FRANK BURR (1931): *The Reign of Tiberius* (London: H. Milford for Oxford University Press).

MARTELLI, GIUSEPPE (1980): *see* WOLFERS, NANCY, and MAZZONI, PIETRO.

MARTIN, GEOFFREY THORNDIKE (1978): *see* MASSON, OLIVIER.

—(1991): *The Hidden Tombs of Memphis: New Discoveries from the Time of Tutankhamun and Ramesses the Great* (New York, NY: Thames & Hudson).

MARTIN, HENRY (1926): *L'Art égyptien* (Paris: R. Ducher).

MARTIN, LUTHER H. (1987): *Hellenistic Religions* (Oxford and New York, NY: Oxford University Press).

MARTY (1844, 1846): *see* LASSALLE, ÉMILE.

510

MARUCCHI, ORAZIO (1898): *Gli Obelischi Egiziani di Roma . . .* (Rome: Ermanno Loescher & Co).

—(1890): 'I Leoni del re Nektanebo', in *Bulletino archeologico communale di Roma* (November).

—(1899): *Il Museo Egizio Vaticano descritto . . .* (Rome: V. Salviucci).

MASCALL, ERIC LIONEL, and BOX, HUBERT STANLEY (*Eds*) (1963): *The Blessed Virgin Mary* (London: Darton Longman, & Todd).

MASCARDI, VITALE (1635): *Festa fatta in Roma alli 25 di Febraio MDXXXIV* (Rome: s.n.).

MASKE UND KOTHURN (from 1955): Quarterly journal on theatrical matters (Vienna: Institut für Theaterwissenschaft an der Universität Wien). It contains useful Bibliographies. *See especially* the article by W. SCALICKI: 'Das Bühnenbild der Zauberflöte', **ii** (1956).

MASPERO, GASTON CAMILLE CHARLES (*Ed.*) (1904): *see* JOLLOIS, JEAN-BAPTISTE-PROSPER.

—(1909): *Histoire ancienne des peuples de l'Orient* (Paris: Hachette & Cie).

MASSON, OLIVIER, with MARTIN, GEOFFREY THORNDIKE, and NICHOLLS, RICHARD VAUGHAN (1978): *Carian Inscriptions from North Saqqâra and Buhen* (London: Egypt Exploration Society).

MASSOUNIE, DOMINIQUE, PRÉVOST-MAR-CILHACY, PAULINE, and RABREAU, DANIEL (1995): *Paris et ses fontaines de la Renaissance à nos jours* (Paris: Éditions Action Artistique de la Ville de Paris).

MATTHEWS, J. (1973): 'Symmachus and the Oriental Cults', in *Journal of Roman Studies*, **lxiii**, 179–95.

MATTIANGELI, P. (1981): 'Annio da Viterbo ispiratore di cicli pittorici', in *Annio da Viterbo. Documenti a ricerche* (Rome: Consiglio Nazionale della Ricerche).

MATTINGLY, H., *ET AL.* (from 1930): *Coins of the Roman Empire in the British Museum* (London: British Museum Publications).

MATZ, FRIEDRICH, and DUHN, FRIEDRICH VON (1881–2): *Antike Bildwerke in Rom mit Ausschluss der grösseren Sammlungen . . .* (Leipzig: K. W. Hiersemann).

MAU, A. (1882): *Geschichte der dekorativen Wandmalerei in Pompeji* (Berlin: G. Reimer).

MAURER, CARL (1812): *Handzeichnungen zum Theater Gebrauch von Carl Maurer, Fürstlich Esterhazyscher Hof Theater Decorateur* – unpublished manuscript dated 1812, Eisenstadt.

MAURICE, THOMAS (1800–01): *Indian Antiquities* (London: Maurice).

MAXWELL-HYSLOP, A. R. (*tr.*) (1958): *see* MONTET, PIERRE.

MAYASSIS, S. (1955): *Le Livre des Morts de l'Égypte ancienne est un livre d'initiation . . .* (Athens: Bibliothèque d'Archéologie Orientale d'Athènes).

MAYER, LUDWIG (1804): *Views in Egypt* (London: R. Bowyer).

MAYES, STANLEY (1959): *The Great Belzoni* (London: Putnam).

MAZZONI, PAOLO (1980): *see* WOLFERS, NANCY.

M.E.A.P. (1805): *Les Curiosités de Paris et de ses environs* (Paris: Roux).

MEEKS, CARROLL LOUIS VANDERSLICE (1956): *The Railroad Station; an Architectural History* (New Haven, CT: Yale University Press).

—(1966): *Italian Architecture 1750–1914* (New Haven, CT: Yale University Press).

MÉHÉDIN, LÉON (n.d.) *Album de mission en Égypte* (very rare item in the Bibliothèque Municipale, Rouen).

MEISE, ECKHARD (1969): *Untersuchungen zur geschichte der julisch-claudischen Dynastie. Vestigia,* **x** (Munich: Beck).

MELE, N. VALENZA (1981): *Museo Nazionale Archeologico di Napoli* (Rome: Istituto Poligrafico e Zecca dello Stato).

MELLINGHOFF, TILMAN (1987): *see* WATKIN, DAVID.

MELLOR, R. (1983): 'Archæology and the Oriental Religions in the West', in *The Ancient World*, **vii**, 3–4, 129–38.

MELTZER, E.S. (1978): 'Mariette and *Aida* once again', in *Antiquity*, **lii**, 50–51.

MENDELSSOHN, KURT (1986): *The Riddle of the Pyramids* (New York, NY: Praeger).

MENU, BERNADETTE (1987): *L'Obélisque de la Concorde* (Versailles: Éditions du Lunx). *see also Bulletin de la Société Française d'Égyptologie*, **cviii** (March), 26–54.

—(1994): 'Les frères Champollion et l'obélisque', in DEWACHTER and FOUCHARD (*Eds*) (1994), 77–90.

MENZEL, H. (1986): *Die römischen Bronzen aus Deutschland* (Mainz-am-Rhein: P. von Zabern).

MERCIER, ALAIN (1989): *see* VEYRIN-FORRER, JEANNE.

MERÉNYI, LAJOS (1895): *Herczeg Esterházy Pál nádor* (Budapest: Magyar Történelmi Társulat).

MERKEL, INGRID, and DEBUS, ALLEN G. (*Eds*) (1988): *Hermeticism and the Renaissance: Intellectual History and the Occult in Early Modern Europe* (Washington, DC: The Folger Shakespeare Library, and London: Associated University Presses).

MERKELBACH, REINHOLD (1962): *Roman und Mysterium in der Antike* (Munich: Beck).

—(1963): *Isisfeste in Griechisch – Römischer Zeit* (Meisenheim-am-Glan: A. Hain).

MERRILLEES, ROBERT S. (1990): *Living with Egypt's Past in Australia* (Melbourne, Victoria: Museum of Victoria).

—(1996): '"Israël en Égypte" aux antipodes: les premières synagogues en Australie', in HUMBERT (*Ed.*) (1996), 281–304.

MESLAY, OLIVIER (1994): 'À propos du cabinet du bord de l'eau d'Anne d'Autriche au Louvre et de quelques découvertes au palais du Luxembourg', in *Bulletin de la Société de l'Histoire de l'Art français*, 60.

MESPLÉ, PAUL (1957): 'Musée des Augustins de Toulouse', in *Revue des Arts-Musées de France*, Year **vii**/1 (January–February), 39, Fig. 3.

MESSERER, RICHARD (1966): 'Briefwechsel zwischen Ludwig I von Bayern und Georg von Dillis', in *Schriftenreihe zur Bayerischen Landesgeschichte-herausgegeben von der Kommission für Bayer. Landesgeschichte bei der Bayerischen Akademie der Wissenschaften*, **lxv** (Munich), 436–7 and 442–5.

METKEN, G. (1965): 'Jean-Jacques Lequeu ou l'architecture rêvée', in *Gazette des Beaux-Arts* (April), 214.

METZGER, B. M. (1984): 'A Classified Bibliography of the Græco-Roman Mystery Religion 1924–1973, with a Supplement 1974–1977', in *Aufstieg und Niedergang der römischen Welt. Geschichte und Kultur Roms im Spiegel der neueren Forschung*, **ii**, 17.3 (Berlin and New York, NY: de Gruyter).

MEULENAERE, HERMAN DE (1960): *see* BOTHMER, BERNARD VON.

—(1992): *L'Égypte Ancienne dans la Peinture du XIXème Siècle* (Knokke-Heist: Éditions Berko). *See also* the English edition (Knokke-Zoute: Berko).

MEULI, KARL (1975): *Gesammelte Schriften* (Basel and Stuttgart: Schwabe).

MEYBOOM, P. G. P. (1995): *The Nile Mosaic of Palestrina. Early Evidence of Egyptian Religion in Italy* (Leiden: E. J. Brill).

MÉZIÈRES, NICOLAS LE CAMUS DE (1780): *Le Génie de l'architecture, ou l'analogie de cet art avec nos sensations* (Paris: B. Morin).

MEZZANOTTE, GIANNI (1966): *Architettura Neoclassica in Lombardia* (Naples: Edizioni Scientifiche Italiane).

MICHAELIS, ADOLF THEODOR FRIEDRICH (1882): *Ancient marbles in Great Britain*, tr. C. A. M. FENNELL (Cambridge: Cambridge University Press).

MICHALOWSKY, K. (1978): *Great sculpture of Ancient Egypt* (New York, NY: Reynal).

MICHEL, RÉGIS (*Ed.*) (1993): *David contre David: Actes du colloque organisé au Musée du Louvre (6–10 December 1989)* (Paris: La Documentation français).

MIDDLEMORE, S. G. C. (*tr.*) (1937): *see* BURCKHARDT, JAKOB CHRISTOPH.

MIEL, EDMÉ JEAN-FRANÇOIS (1835): *Sur l'obélisque de Louqsor* (Paris: Imprimerie de Smith).

MIELSCH, H. (1987): *Die römische Villa. Architektur und Lebensform* (Munich: C. H. Beck).

MILHAUD, SYLVIE (1987): 'Pub: égyptez-moi, Benoît', in *L'Evénement du Jeudi*, **cxxii** (5–11 March), 92.

MILLER, F. (1977): *The Emperor in the Roman World 31 BC–AD 337* (London: Duckworth).

MILLIN, AUBIN-LOUIS (1790–99): *Antiquités Nationales . . .* (Paris: Drouhin).

—(1816): *Ægyptiaques; ou, Recueil de quelques Monuments ægyptiens inédits* (Paris: Wassermann).

—(1819–21): *Histoire Métallique de Napoléon; ou, Recueil des médailles et des monnaies qui ont été frappées depuis la première campagne de l'armée . . .* (London: J. Millingen).

MILTNER, FRANZ (1958): *Ephesos, Stadt der Artemis und des Johannes* (Vienna: F. Deuticke).

'MIROIR ÉGYPTIEN, LE' (1984): *Actes des Rencontres Méditerranéenes de Provence (17–19 January 1983)* (Marseilles). Contains contributions from COULET, ENAN, and JOUTARD.

MISSIRINI, MELCHIORRE (1825): *Della vita di Antonio Canova* (Milan: G. Silvestri).

—(1831): *Intera Collezione di Tutte le Opere Inventate . . . dal . . . Thorwaldsen* (Rome: P. Aureli).

MITCHELL, CHARLES (1963): *see* MANDOWSKY, ERNA.

MITTEILUNGEN DES KAISERLICH DEUTSCHEN ARCHÄOLOGISCHEN INSTITUTS. RÖMISCHE ABTEILUNG (from 1886): (Rome: Loescher).

MÓCSY, A. (1957): 'Zur Geschichte der peregrinen Gemeinden in Pannonien', in *Historia*, **vi**, 488–98.

—(1959): *Die Bevölkerung von Pannonien bis zu den Markomannenkriegen* (Budapest: Verlag der Ungarischen Akademie der Wissenschaften).

—(1970): *Gesellschaft und Romanisation in der römischen Provinz Moesia Superior* (Amsterdam: Adolf M. Hakkert).

MOEHRING, H.R. (1959): 'The Persecution of the Jews and the Adherents of the Isis Cult at Rome A.D. 19', in *Novum Testamentum. An International Quarterly for New Testament and Related Studies*, **iii**, 293–304.

MOËL, MICHEL LE (1997): *L'urbanisme parisien au siècle des Lumières* (Paris: Éditions Action Artistique de la Ville de Paris).

MOGES, H. (1987): 'Isis-Osiris', in LIGOU, D. (*Ed.*), 622–5.

MOISY, ALEXANDRE (1813): *see* DUVAL, AMAURY.

MOITTE, JEAN-GUILLAUME (1810): *see* REGNAULT DE LALANDE, F.-L.

MOLLARD-BESQUES, SIMONE (1992) *Catalogue raisonné des figurines et reliefs en terre-cuite grecs, étrusques, et romains*, iv-11 (Paris: Éditions des Musées nationaux).

MOMIGLIANO, ARNALDO (*Ed.*) (1963): *The Conflict between Paganism and Christianity in the Fourth Century* (Oxford: The Clarendon Press).

—(1987): *On Pagans, Jews, and Christians* (Middletown, CN: Wesleyan University Press, and Scranton, PA: Harper & Row).

MOMMSEN, THEODOR (1860): *Über das Römisches Münzwesen* (Berlin: s.n.).

—(1887–8): *Römisches Staatsrechts* (Leipzig: Hirzel).

MONTANIER, JACQUES (1782): *see* DELILLE, ABBÉ JACQUES.

MONTET, PIERRE (1928–29): *Byblos et l'Égypte . . .* (Paris: P. Geuthner).

—(1956): *Isis; ou, à la recherche de l'Égypte ensevelie* (Paris: Hachette).

—(1957): 'Hathor et le paypyrus', in *Kêmi*, **xiv**, 92–101.

—(1958): *Everyday Life in Egypt in the days of Ramesses the Great*, tr. A. R. MAXWELL-HYSLOP and MARGARET S. DROWER (London: E. Arnold).

—(1959): *Eternal Egypt*, tr. DOREEN WEIGHTMAN (New York, NY: Praeger).

MONTFAUCON, BERNARD DE (1719–24): *L'Antiquité expliquée et représentée en figures*, 10 vols (Paris: F. Delaulne). An English edition (*tr.* D. HUMPHRIES), was published in 1721–25.

MONTGOMERY, CHARLES F., and COLE, WILFRED P. (*Eds*) (1970): *The Cabinet-Maker and Upholsterer's Drawing-Book* (New York, NY: Praeger).

MONTORIO, SERAFINO (1715): *Zodiaco di Maria, ovvero Le dodice provincie del regno di Napoli, come tanti segni, illustrate da questo sole per mezo delle sue prodigiosissime immagini, che in esse quasi tante stella risplendono* (Naples: P. Severini).

MONTULÉ, ÉDOUARD DE (1823): *Travels in Egypt during 1818 and 1819* (London: R. Phillips).

MONUMENS ÉGYPTIENS, CONSISTANT EN OBÉLISQUES, PYRAMIDES, CHAMBRES SÉPULCHRALES, STATUES, ETC., LE TOUT GRAVÉ SUR DEUX CENS PLANCHES . . . AVEC LEURS EXPLICATIONS HISTORIQUES (1791): (Rome: Bouchard et Gravier, de l'Imprimerie de Jean Zempel).

MONUMENS DES VICTOIRES ET CONQUÊTES DES FRANÇAIS (1829): (Paris: C.-L.-F. Panckoucke). Another edition (no publisher given) was published in 1822.

M & L (MONUMENTEN EN LANDSCHAPPEN) (1984): This journal devoted its issue No. 3, (May–June), to the subject of *Égypte et franc-maçonnerie en Belgique*. It contains articles by MARCEL CELIS, PETRA MACLOT, and EUGÈNE WARMENBOL. The same journal devoted its issue No. 2 (March–April 1988), 13–71, to the restoration of the Egyptian temple at Antwerp Zoo, and contains articles by G.J. BRAL, L. DE CLERCQ, B. DELMOTTE, L. DELVAUX, M. DUPAS, P. MACLOT, A. MALLIET, W. SCHUDEL, J. VERBEKE, E. WARMENBOL, and E. DE WITTE.

MONTULÉ, ÉDOUARD DE (1821): *Travels in Egypt during 1818 and 1819* (London: R. Phillips).

MONVAL, JEAN (1918): *Soufflot: Sa Vie Son Oeuvre, Son Esthétique (1713–1780)* (Paris: A. Lemerre).

MOORE, C. H. (1907): 'The Distribution of Oriental Cults in the Gauls and the Germanies', in *Transactions and Proceedings of the American Philological Association*, **xxxviii**, 109–49.

MORA, F. (1990): *Prosopografia Isiaca* (Leiden: E. J. Brill).

MORENZ, SIEGFRIED (1949–50): 'Vespasian, Heiland der Kranken. Persönliche Frömmigkeit im antiken Herrscherkult', in *Würzburger Jahrbücher*, **iv**, 370–8.

—(1951): *Die Geschichte von Joseph dem Zimmermann* (Berlin: Akademie-Verlag).

—(1952): 'Die Zauberflöte; eine Studie zum Lebenszusammenhang Ägypten-Antike-Abendland', in *Münstersche Forschungen*, **v**, Heft 2. (Münster: Böhlau-Verlag).

—(1953): *see* LEIPOLDT, JOHANNES.

—(1954): *Der Gott auf der Blume. Eine ägyptische Kosmogonie und ihre Weltweite Bildwirkung* (Ascona: Artibus Asiæ, Supplement 12). Written with JOHANNES SCHUBERT.

—(1961): 'Ägyptische Nationalreligion und die sogenannte Isismission', in *Zeitschrift der deutschen morgenländischen Gesellschaft*, **xxxvi**, 432–6.

—(1968): *Die Begegnung Europas mit Ägypten* in *Sitzungsberichte der Sächsischen Akademie der Wissenschaften zu Leipzig*, **cxiii**, V (1968), 152f. *See also* the volume of the same title published in 1969 (Zurich: Artemis Verlag).

—(1973): *Egyptian Religion*, tr. ANN E. KEEP (London: Methuen).

MOREY, CHARLES RUFUS (1942): *Early Christian Art; an outline of the evolution of style and iconography in sculpture and painting from antiquity to the eighth century* (London: Oxford University Press).

MORITZ, KARL PHILIPP (1793): *see* BREMER, JOHANN GOTTFRIED.

MORKOT, ROBERT G. (2000): *The Black Pharaohs. Egypt's Nubian Rulers* (London: Rubicon Press).

MORLEY, JOHN (1993): *Regency Design 1790–1840* (London: A. Zwemmer Ltd).

MOSS, ROSALIND L. B. (1927–52): *see* PORTER, BERTHA.

MOSSAKOWSKI, STANISŁAW (1976–78 and 1978–80) : 'Il Mausoleo Dei Morstin a Varsavia ed

"egittologia" 600', in *Colloqui del Sodalizio*, Second Series, **vi**.

MOSSER, MONIQUE (1997): 'La perfection du jardin anglo-chinois', in CONSTANS, MARTINE, ET AL. (Paris: Action artistique de la ville de Paris), 135–166.

—, ET AL. (1986): *Alexandre-Théodore Brongniart, 1739–1813* (Paris: Musée Carnavalet).

MOUREY, GABRIEL (1921): *Essai sur l'art décoratif français moderne* (Paris: Ollendorff).

MOURLOT, F. (1895): *Essai sur l'histoire de l'augustalité dans l'empire romain* (Paris: É. Bouillon).

MOUSSET, ALBERT (1949, 1950): *Petite histoire des grands monuments, rues, et statues de Paris* (Paris: Amiot-Dumont, and Chambéry: Impr. Réunis).

MOZART UND DAS THEATER (1970): *Ausstellung zur Mozartwoche der Deutschen Oper am Rhein*, Düsseldorf (21 January–18 February) (Köln: Universität zu Köln, Institut für Theaterwissenschaft).

MUGNOS, FILADELFO (1658): *Historia della augustissima famiglia Colonna . . .* (Venice: Turrini).

MÜLLER, DIETER (1961): *Ägypten und die griechischen Isis-Aretalogien* (Berlin: Akademie-Verlag).

MÜLLER, HANS WOLFGANG (1960): *see* BOTHMER, BERNARD VON.

—(1963): 'Isis mit dem Horuskinde. Eine Beitrag zur Ikonographie der stillenden Gottesmutter im hellenistischen und römischen Ägypten', in *Münchener Jahrbuch der bildenden Kunst*, **xiv**, 7–33, 32 figs.

—(1975): 'L'Obélisque Albani (à Munich) avant son transfert à Paris', in *Bulletin de la Société française d'égyptologie*, **lxxii** (March), 7–22.

—(1976): 'Der Münchner Obelisk', in *Abhandlungen der Bayerischen Akademie der Wissenschaften, Philosophisch-Historische Klasse*.

—, and GRESSLER-LÖHR, BEATRIX (1972): *Staatliche Sammlung Ägyptischen Kunst* (Munich: Residenz Hofgartenstrasse)

MUNICH, N. (1984): 'Les Plafonds peints du Louvre', in *Archives de l'Art français*, New Series, **xxvi**, 107–63.

MUNOZ, ANTONIO (1908): *see* LAZZARONI, MICHELE.

MÜNSTER, MARIA (1968): *Untersuchungen zur Göttin Isis: vom Alten Reich bis zum Ende des Neuen Reiches* (Berlin: B. Hessling).

MÜNTZ, EUGÈNE (1896): *Raphael: his life works, and times* (London: Chapman & Hall, Ltd).

MURNANE, W. (1983): *The Penguin Guide to Ancient Egypt* (Harmondsworth: Penguin Books).

MURRAY, MARGARET ALICE (1949): *The Splendour that was Egypt* (London: Sidgwick & Jackson).

MURRAY, OSWYN (1986): *see* BOARDMAN, JOHN.

MURRAY, PETER (1962): 'Bramante Milanese: the Paintings and Engravings', in *Arte Lombardia*, **vii**.

—(1971): *Piranesi and the grandeur of ancient Rome* (London: Thames & Hudson Ltd).

MUSGRAVE, CLIFFORD (1959): *Royal Pavilion: an episode in the Romantic* (London: Leonard Hill).

—(1962): *Regency Furniture, 1800–1830* (New York, NY: T. Yoseloff).

MYLONAS, GEORGE EMMANUEL (1961): *Eleusis and the Eleusinian Mysteries* (Princeton, NJ: Princeton University Press).

NASH, ERNEST (1961–62): *Pictorial Dictionary of Ancient Rome* (New York, NY: Praeger).

NEALE, JOHN PRESTON (1818–23): *Views of the Seats of Noblemen and Gentlemen, in England, Wales, Scotland, and Ireland* (London: Sherwood, Neely, and Jones).

NEFONTAINE, LUC (2001): *see* DECHARNEUX, BAUDOUIN.

'NEO-CLASSIQUE REVIENT, LE' (1988): Article in *Femmes d'Aujourd'hui*, **iv** (25 January), 38–41.

NERDINGER, WINFRIED (*Ed.*) (2000): *Leo von Klenze: Architekt zwischen Kunst und Hof 1784–1864* (Munich: Prestel Verlag).

NERENBERG, JEAN (1979–80): *see* GORDON, ELEANOR.

NERVAL, GÉRARD LABRUNIE GÉRARD DE (1888): *Les Filles du Feu* . . . (Paris: Librairie des Bibliophiles).

NETTL, PAUL (1932): *Mozart und die königliche Kunst: die Freimaurerische Grundlage der "Zauberflöte"* (Berlin: F. Wunder).

NETTLESHIP, HENRY (1899): *see* SEYFFERT, OSKAR.

NETTLETON, E. (1836): *Nettleton's Guide to Plymouth, Stonehouse, Devonport, and the Neighbouring County* (Plymouth: E. Nettleton).

NEUFFORGE, JEAN FRANÇOIS DE (1757–68): *Recueil élémentaire d'architecture* . . . (Paris: The Author).

NEUMEYER, ALFRED (1938–39): 'Monuments to "Genius" in German Classicism', in *Journal of the Warburg Institute*, **ii** (London: Warburg Institute), 159–163.

NEVILL, ANTONIA (*tr.*) (2000): *see* TURCAN, ROBERT.

NEWTON, ROGER HALE (1942): *Town & Davis, architects, pioneers in American Revivalist Architecture, 1812–1870* . . . (New York, NY: Columbia University Press).

NIBBY, ANTONIO (1818): *Raccolta de' monumenti piu' celebri di Roma Antica* . . . (Rome: A. Poggioli).

—(1818–20): *Roma Antica* (Rome: Stamperia de Romanis).

NICHOLLS, RICHARD VAUGHAN (1967, 1978): *see* MASSON, OLIVIER; *see also* BUDDE, LUDWIG.

NICHOLS, JOHN, and STEEVENS, GEORGE (1808–10): *The Genuine Works of William Hogarth* (London: Longman, Hurst, Rees, and Orme).

NICHOLS, JOHN (1978): *Vespasian and the partes Flavianæ*, in *Historia Einzelschriften*, **xxviii** (Wiesbaden: Steiner).

NIEBUHR, CARSTEN (1774): *Reisebeschreibung nach Arabien und andern Ländern* (Copenhagen: N. Möller).

NILSSON, N. MARTIN PERSSON (1925 and 1949): *A History of Greek Religion* (Oxford: The Clarendon Press).

—(1940): *Greek Popular Religion* (New York, NY: Columbia University Press). *See also* the later Plon edition in French (1954).

NILSSON, STEN ÅKE (1964): 'Pyramid på Gustav Adolfs torg', in *Konsthistorisk Tidskrift*, **xxxiii**/1–2 (Stockholm).

NOBLE, PERCY (1908): *Anne Seymour Damer, a Woman of Art and Fashion 1748–1828* (London: Paul, Trench, Trübner, & Co. Ltd).

NOCK, ARTHUR DARBY (1934): 'Seviri et Augustales', in *Mélanges Bidez. Annuaire de l'Institut de Philologie et d'Histoire Orientales de l'Université de Bruxelles*, **ii**, 627–38.

—(1963): 'Religious Development from the Close of the Republic to the Reign of Nero', in *Cambridge Ancient History*, **x** (Cambridge: Cambridge University Press), 465–511.

—(1998): *Conversion: the Old and the New in Religion from Alexander the Great to Augustine of Hippo* (Baltimore, MD: Johns Hopkins University Press).

NOÉ, L. (1893–96): *Architecture and Sculpture in France* (Paris: Librairie de la Construction Moderne).

NOEHLES, K. (1966): *see* FIENSCH, GÜNTHER, and IMDAHL, MAX (*Eds*)

NORDEN, FREDERIK LUDVIG (1757): *Travels in Egypt and Nubia* (London: L. Davis and C. Reymers). *see* also the French edition, published in Copenhagen in 1755.

—(1780): *The Antiquities, Natural History, Ruins, and other Curiosities of Egypt, Nubia, and Thebes* (London: L. Davis).

NORMAN, BENJAMIN MOORE (1845): *Norman's New Orleans and Environs* (New Orleans, LA: B.M. Norman).

NORMAND, CHARLES (1852): *Nouveau Paralléle des Ordres d'Architecture des Grecs, des Romains et des Auteurs Modernes* (Paris: Normand Ainé & Carilian).

NORMAND, LOUIS-MARIE (1832): *Monumens Funéraires choisis dans les Cimetières de Paris et des principales villes de France* (Paris: Normand).

NORTH AMERICAN REVIEW, THE (from 1815): Edited by JARED SPARKS (1789–1866), EDWARD EVERETT (1794–1865), JAMES LOWELL RUSSELL (1819–91), HENRY CABOT LODGE (1850–1924), etc., it was first published in Boston, MA, and more recently at Cedar Falls, IA: University of Northern Iowa.

NOURRY, ÉMILE DOMINIQUE (pseudonym SAINTYVES, P.) (1908): *Les Vièrges mères et les naissances miraculeuses* (Paris: E. Nourry).

—(1936): *Saint Christophe, successeur d'Anubis, d'Hermès et d'Héracles* (Paris: E. Nourry).

NOVION, RAYMOND (1955): 'Présence de l'Égypte dans la vie Française', in *Le Musée Vivant*, **iv** (January), 85–8.

NOWINSKI, JUDITH (1970): *Baron Dominique Vivant Denon (1747–1825): Hedonist and Scholar in a Period of Transition* (Rutherford, NJ: Fairleigh Dickinson University Press).

NUZZI, CRISTINA (*Ed.*) (1980): *see* PALMA, ANNELIE DE.

OATES, JENNY (*tr.*) (1992): *see* JEAN, GEORGES.

L'OBÉLISQUE DE LOUXOR AU TERRE-PLEIN DU PONT-NEUF, LA STATUE D'HENRI IV À LA PLACE DE LA FONTAINE DESAIX (1833): (Paris: C.-L.-F. Panckoucke).

ODDONE, P. (1988): *La longue nuit des francs-maçons du Nord, 1940–1944* (Dunkerque: Éditions des Beffrois).

O'DONNELLY, ABBÉ (1851): *Extrait de la traduction authentique des hiéroglyphes de l'Obélisque de Louqsor à Paris* (Paris: Schlesinger Frères).

OECHSLIN, WERNER (1971): 'Pyramide et Sphère. Notes sur l'Architecture Révolutionnaire du XVIII^e Siècle et ses Sources Italiennes', in *Gazette des Beaux-Arts* (April), 201–38.

OHLENROTH, L. (1954): 'Augusta Vindelicum', in *Germania*, **xxxii**, 76–85.

OLDHAM, FRANK (1954): *see* WOOD, ALEXANDER.

OLIVA, PAVEL (1962): *Pannonia and the Onset of Crisis in the Roman Empire* (Prague: Nakl. Ceskoslovenské akademie ved).

OLLIVIER-BEAUREGARD, G. M. (1866): *Les divinités égyptiennes, leur origine, leur culte, et son expansion dans le monde. À propos de la collection archéologique de feu le docteur Ernest Godard* (Paris: Librairie Internationale, and Brussels: A. Lacroix, Verboeckhoven, et cie.).

ONN, GERALD (*Tr.*) (1972): *see* GERMANN, GEORG.

ONOFRIO, CESARE D' (1962): *Le Fontane di Roma* (Rome: Staderini).

—(1967): *Gli' obelischi di Roma* (Rome: Bulzoni).

OOTEGHEN, J. VAN (1959): 'Germanicus en Égypte', in *Les études classiques*, **xxvii**, 241–51.

ORANGE, HANS PETER L' (1947): *Apotheosis in Ancient Portraiture* (Oslo: H. Aschenhoug, and Cambridge, MA: Harvard University Press).

—(1953): *Studies in the Iconography of Cosmic Kingship in the Ancient World* (Cambridge, MA: Harvard University Press).

ORIENT L'AUTRE, D'UN (1985): 'Les Métamorphoses successives des perceptions et connaissances', in *Proceedings of the Colloquium* held in Cairo in 1985, and publications associated with the Exhibition *Le Caire-Paris* (18–22 April 1985) (Collection 'Recherches' of the Centre d'Etudes et de Documentation économique, juridique et sociale. Contains contributions from ÉTIENNE, VOLAIT).

ORLIAC, JEANNE D' (1930): *The Moon Mistress: Diane de Poitiers Grant' Sénéchalle de Normandy* (London: J.B. Lippincott Co.).

ORMOND, RICHARD (1965): 'Holman Hunt's Egyptian Chairs', in *Apollo*, **lxxxii/**41 (New Series) (July), 55–8.

ØRSTED. P. (1985): *Roman Imperial Economy and Romanization* (Copenhagen: Museum Tusculum Press).

ORY, PASCAL (1982): *Les Expositions universelles de Paris* (Paris: Éditions Ramsay).

OSBORNE, HAROLD (1970): *The Oxford Companion to Art* (Oxford: The Clarendon Press).

OTTO, EBERHARD (1966): *Egyptian Art and the Cults of Osiris and Amon* (London: Thames & Hudson Ltd).

—(1956): *see* HELCK, HANS WOLFGANG.

OTTO, WALTER GUSTAV ALBRECHT (1905–08): *Priester und Tempel im Hellenistischen Ägypten . . .* (Berlin and Leipzig: B.G. Teubner).

OUDIN-DOGLIONI, CATHERINE (1991): *see* HAMON-JUGNET, MARIE.

OWEN, ROBERT DALE (1849): *Hints on Public Architecture . . .* (New York, NY: Putnam).

PALMA, ANNELIE DE, and NUZZI, CRISTINA (1980): *Arnold Böcklin e la Cultura Artistica in Toscana* (Rome: De Luca Editore).

PANOFSKY, ERWIN (1943): *Albrecht Dürer* (Princeton, NJ: Princeton University Press).

PANTAZZI, MICHAEL (1994): 'Absolutisme et Lumières', in the *Catalogue* of the *Egyptomania* exhibition (*See* HUMBERT, PANTAZZI, and ZIEGLER (*Eds*) (1994), 116–23.

—(1994): 'Les Années Toutankhamoun', in the *Catalogue* of the *Egyptomania* exhibition. *See* HUMBERT, PANTAZZI, and ZIEGLER (*Eds*) (1994), 508–14.

—(*Ed.*) (1994): *see* HUMBERT, JEAN-MARCEL.

PAPAFAVA, F. (*Ed.*) (1979): *Guida ai Musei Vaticani* (Vatican City: Gestione Vendita Pubblicazioni Musei Vaticani).

PAPWORTH, WYATT ANGELICUS VAN SANDAU (*Ed.*) (1852, 1887, 1892): *The Dictionary of Architecture* (London: The Architectural Publication Society, published by Thomas Richards [**i-vi**] and Whiting & Co [**vii** and **viii**]).

—(1879): *J.B. Papworth: Architect to the King of Wurtemburg* (London: The Author)

—(*Ed.*) (1903): *see* GWILT, JOSEPH.

PAPYRUS ET POP ART. ARCHÉOLOGIE, ART ET BANDE DESSINÉE (1987) Associated with the Exhibition at Waux-Hall, Nivelles (17–31 October), and includes articles by CLAES, DECKERS, and ELOY.

PARENT, CLAUDE (1985): 'La Pyramide à l'envers', in *Le Monde* (14–15 April), II.

PARIBENI, ROBERTO (1930): *The Villa of the Emperor Hadrian at Tivoli* (Milan: Fratelli Treves).

—(1932): *Le Terme di Diocleziano e il Museo Nazionale Romano* (Rome: Libreria dello Stato).

PARISOTTI, A. (1888): *Ricerche sull' introduzione e sullo sviluppo del culto di Iside e Serapide, Studi e Documenti di Storia e Diritto*, **ix**, 43–55.

PARKINSON, RICHARD, with contributions by DIFFIE, W., FISCHER, M., AND SIMPSON, R.S. (1999): *Cracking Codes. The Rosetta Stone and Decipherment* (London: British Museum Press).

PARLASCA, KLAUS (1955): 'Die Isis- und Sarapisverehrung im römischen Köln', in *Kölner Jahrbuch für Vor- und Frühgeschichte*, **i**, 18–23.

—(1974): 'Motive antiker Stützfiguren an Kaminen des Frühklassizismus', in *Zeitschrift für Kunstgeschichte*, Band **xxxvi**, 276–8.

PARTHEY, GUSTAV (1833–40): *Wanderungen durch Sicilien und die Levante* (Berlin: Nikolai).

PARTRIDGE, ROBERT B. (1994): *Faces of Pharaohs: Royal Mummies and Coffins from Ancient Thebes* (London: Rubicon Press).

—(1996): *Transport in Ancient Egypt* (London: Rubicon Press).

PATCH, D. (1986): *see* WATTERS, D.

PATRIMOINE MONUMENTAL DE LA BELGIQUE, LE (1975a): *Patrimoine de Hainaut. Arrondissement de Mons* (Vol. **iv**) (Liège: P. Mardaga).

—(1975b): *Patrimoine de Namur. Arrondissement de Namur* (Vol. **v**) (Liège: P. Mardaga).

—(1990): *Wallonie. Province de Liège. Arrondissement de Huy* (Vol. **xv**) (Liège: P. Mardaga).

PATTE, PIERRE (1765): *Monumens érigés en France à la Gloire de Louis XV . . .* (Paris: The Author).

—(1769): *Mémoires sur les objets les plus importans de l'architecture* (Paris: Rozet).

—(1771–7): *see* BLONDEL, JACQUES-FRANÇOIS.

PATTERSON, MARCIA L. (1952): *see* BROUGHTON, THOMAS ROBERT SHANNON.

PATTERSON, RICHARD (1981) '"The Hortus Palatinus" at Heidelberg and the Reformation of the World', in *Journal of Garden History*, **i/**1 (January–March), 67–102, and **i/**2 (April–June), 179–202.

PAUL-ALBERT, NINO (1937): *Histoire du Cimetière du Père La Chaise* (Paris: Gallimard).

PAULI, GUSTAV (1942): *Die Kunst des Klassizismus und der Romantik* (Berlin: Propyläen-Verlag).

PAUW, CORNELIUS DE (1773): *Recherches philosophiques sur les Égyptiens et les Chinois . . .* (Berlin: G.J. Decker).

PAUW, JAN CORNELIS DE (1727): *Horapollinis Hieroglyphica græce & latine . . .* (Utrecht: Melchior, Leonardum Charlois).

PEEK, WERNER (1930): *Der Isishymnus von Andros, und verwandte Texte* (Berlin: Weidmannsche Buchhandlung).

PEHNT, WOLFGANG (1987): 'Altes Ägypten und neue Architektur', in *Bruckmanns Pantheon. Internationale Jahreszeitschrift für Kunst*, **xlv**, 151–160. An interesting paper in which Egyptian influences on architects, including BEHRENS, BONATZ, BREUER, LE CORBUSIER, GROPIUS, KREIS, STIRLING, *ET AL.*, are considered.

PEIGNOT, JÉRÔME (1968): 'Du Sexe des Sphinx', in *L'Œil*, **clxi** (May), 12–21 and 82.

—(1972): 'L'Obélisque phare du Soleil', in *L'Œil*, **ccv** (January), 18–25.

PENDLEBURY, JOHN DEWITT STRINGFELLOW (1930): *Ægyptiaca: a catalogue of Egyptian objects in the Ægean area* (Cambridge: The University Press).

PENHOUET, M. DE (1812): *Antiquités égyptiennes dans le département du Morbihan* (Vannes: Imprimerie de Veuve Maité-Bizette).

PENNA, AGOSTINO (1831–6): *Viaggio pittorico della Villa Adriana* (Rome: Tip. di P. Aurelj).

PENNY, NICHOLAS (1977): *Church Monuments in Romantic England* (New Haven, CT and London: Yale University Press).

PENNY MAGAZINE, THE (1832–46): (London: Charles Knight & Co.).

PÉPLUM, L'ANTIQUITÉ AU CINÉMA (1983): (Cinéma et Audiovisuel en Vâl-de-Marne).

PERCIER, CHARLES, and FONTAINE, PIERRE-FRANÇOIS-LÉONARD (1801): *Recueil de Décorations Intérieures* (Paris: The Authors).

—, and BERNIER, CLAUDE-LOUIS (1798): *Palais, Maisons et autres édifices modernes dessinés à Rome* (Paris: Ducamp).

PEREZ, ANNIE (1989): 'Dans la postérité des lumières', in *Connaissance des Arts*, **ccccviii** (June), 124–9.

PÉROUSE DE MONTCLOS, JEAN-MARIE (1969): *Étienne-Louis Boullée, 1728–1799, de l'architecture classique à l'architecture révolutionnaire* (Paris: Arts & Métiers Graphiques).

PERRING, JOHN SHAE (1840–2): *see* HOWARD-VYSE.

PERRY, CHARLES (1743): *A View of the Levant: particularly of Constantinople, Syria, Egypt, and Greece* (London:T. Woodward).

PESCE, G. (1957): *Sarcofagi romani di Sardegna* (Rome: 'L'Erma' di Bretschneider).

PETERS, WILHELMUS JOHANNES THEODORUS (1963): *Landscape in Romano-Campanian Mural Painting* (Assen: van Gorcum).

PETERSON, BENGT (1980): *see* GEORGE, BEATE.

PETIT-RADEL, LOUIS-CHARLES-FRANÇOIS (1804–6): *Les monumens antiques du Musée Napoléon* (Paris: F. & P. Piranesi).

PETRIE, SIR WILLIAM MATTHEW FLINDERS (1912): *Egypt and Israel* (London: SPCK).

—(1914): *Amulets* (London: Constable & Co. Ltd).

—(1932): *Seventy Years in Archæology* (London: Sampson Low, Marston).

PETRIKOVITS, HARALD VON (1980): *Die Rheinlande in römischer Zeit* (Düsseldorf: Schwann).

PEVSNER, NIKOLAUS (from 1951): *The Buildings of England* series (Harmondsworth: Penguin Books Ltd).

—(1957): 'Pedrocchino and Some Allied Problems', in *The Architectural Review*, **cxxii**/ 727 (August), 112–15.

—(1976): *A History of Building Types* (London: Thames & Hudson).

—, and LANG, SUSAN (1956): 'The Egyptian Revival', in *The Architectural Review*, **cxix**/712 (May), 242–254, later revised and republished in *Studies in Art, Architecture, and Design* (New York, NY: Walker & Co., 1968), **i**, 212–35 and 245–8.

—(1968): Essays including those on 'The Doric Revival' and 'The Egyptian Revival', in *Studies in Art, Architecture, and Design* (New York, NY: Walker & Co.).

PEYRE, MARIE-JOSEPH (1795): *Œuvres d'architecture* (Paris: A.-M. Peyre).

PEYRE NEVEU, ANTOINE-MARIE (1812): *Projects d'architecture* (Paris: F. Didot).

PFISTER, FRIEDRICH (1922): 'Religion', in *Realenkylopädie der klassischen Altertumswissenschaft*, **xi**, (Stuttgart: J. B. Metzlersche Verlagsbuchhandlung).

—(1978): *Der Alexanderroman: mit einer Auswahl aus den verwandten Texten* (Meisenheim-am-Glan: Hain).

PHILLIPS, J. PETER (2002): *The Columns of Egypt* (Manchester: Peartree Publishing).

PIANKOFF, ALEXANDRE (1953): *La Création du disque solaire*, in *Bibliothèque d'étude*, **xix** (Cairo: Impr. de l'Institut français d'archéologie orientale).

—(Tr.) and RAMBOVA, N. (Ed.) (1957): *Mythological Papyri* (New York, NY: Pantheon Books).

PICARD-SCHMITTER, M.-T. (1971): 'Bétyles Hellénistiques', in *Fondation Eugène Piot. Monuments et Mémoires*, **lvii**, 43–88.

PICART, BERNARD (1728–43): *Cérémonies et Coutumes Religieuses de tous les peuples du monde* (Amsterdam: J.F. Bernard).

PICCOTTINI, G. (1977): 'Die Stadt auf dem Magdalensberg – ein spätkeltisches und frührömisches Zentrum im südlichen Noricum', in *Aufstieg und Niedergang der römischen Welt. Geschichte und Kultur Roms im Spiegel der neueren Forschung*, **ii**/6 (Berlin and New York, NY: de Gruyter), 263–301.

PICTORIAL CARDS IN THIRTEEN PLATES EACH CONTAINING FOUR SUBJECTS . . . ETC. (1819): *see* ACKERMANN, RUDOLF (Ed.).

PIETERSMA, ALBERT (Ed.) (1994): *The Apocryphon of Jannes and Jambres the Magicians* (Leiden: E. J. Brill).

PIETRZYKOWSKI, M. (1986): 'Die Religionspolitik des Kaisers Elagabal', in *Aufstieg und Niedergang der römischen Welt. Geschichte und Kultur Roms im Spiegel der neueren Forschung*, **ii**/16.3 (Berlin and New York, NY: de Gruyter), 1806–22.

PIGANIOL, ANDRÉ (Ed.) (1965): *Les empereurs romains d'Espagne. Colloques internationaux du centre national de la recherche scientifique. Sciences humaines* (Paris: Éditions du Centre National de la Recherche Scientifique).

PIGNORIA, LORENZO (1608): *Characteres Ægyptii, hoc est sacrorum quibus Ægyptii*, etc. . . . (Frankfurt: Matthew Becker).

—(1669): *Mensa Isiaca, qua sacrorum apud Ægyptios ratio et simulacra subjectis tabulis æneis simul exhibentur et explicantur* (Amsterdam: A. Frisii).

PILLEMENT, GEORGES (1966): *Paris disparu* (Paris: B. Grasset).

—(1974): *Paris poubelle* (Paris: J. J. Pauvert).

PINGEOT, ANNE (1986): *see* BRESC-BAUTIER, GENEVIÈVE.

—(1989): 'Le décor extérieur du Louvre sur la Cour carrée et la rue de Rivoli (1851–1936)', in *Revue du Louvre*, **ii**, 112–24.

PIPER, DAVID (1983): 'The inspiration of Egypt beside the Brighton Sea', in *The Financial Times* (10 May), 21.

PIRANESI, GIOVANNI BATTISTA (1756): *Le Antichità Romane* (Rome: Stamperia di Angelo Rotili).

—(1761): *Della Magnificenza ed Architettura de' Romani* (Rome: The Author).

—(1769): *Diverse Maniere d'adornare i Cammini* . . . (Rome: Salomoni).

—(1972): *The Polemical Works, Rome 1757, 1761, 1765, 1769*, edited by JOHN WILTON-ELY (Farnborough, Hants.: Gregg).

PIRANESI E LA CULTURA ANTIQUARIA (1983): *Proceedings* of the Congress held in Rome in 1979 (Rome).

PIROLI, TOMMASO (1789–1807): *Le Antichità di Ercolano* . . . (Rome: Piroli).

PISAN, CHRISTINE DE (1499): *Les Cent Histoires de Troye* (Paris: Philippe Pigouchet).

PLANAT, JULES (1830): *Histoire de la régénération de l'Égypte* (Paris: J. Barbézat).

PLATNER, SAMUEL BALL (1965): *Topographical Dictionary of Ancient Rome*, edited by THOMAS ASHBY (Rome: 'L'Erma' di Bretschneider).

PLON, EUGÈNE (1873): *Thorvaldsen: His Life and Works* (Boston, MA: Roberts Bros.).

PLUTARCHUS, L. MESTRIUS (1906): *The Complete Writings* (New York, NY: The Colonial Co.). *See* especially the *Vitæ Parallelæ*, and the *Moralia*, containing *De Iside et Osiride*.

POCOCKE, RICHARD (1743–45): *A Description of the East and Some Other Countries* (London: J. & R. Knapton).

POGGIO BRACCIOLINI, GIAN FRANCESCO (1538): *Opera* (Basel: Heinrich Peter).

POISSON, GEORGES (1956): *Évocation du Grand Paris. La banlieue sud* (Paris: Les Éditions de Minuit).

—(1964): *Napoléon et Paris* (Paris: Berger-Levrault).

—(1970): 'L'Art de la Révolution à Paris, architecture et décors', in *Gazette des Beaux-Arts* (December), Note 119, 353.

POLLITT, J. J. (1965): 'The Egyptian Gods in Attica: some epigraphical evidence', in *Hesperia, Journal of the American School of Classical Studies at Athens*, **xxxiv**, 125–30.

POPELKA, LISELOTTE (1994): *Castrum Doloris, oder 'Trauriger Schauplatz': Untersuchungen zu Entstehung und Wesen ephemer Architektur* (Vienna: Verlag der österreichischen Akademie der Wissenschaften).

PORCACCHI, TOMMASO (1574): *Funerali antichi di diversi popoli, et nationi i forma, ordine et pompa di sepolture, di essequie, de consecrationi antiche et d'altro* . . . *Con le figure in rame di Girolamo Porro* (Venice: S. Galignani).

PORTE DU THEIL, FRANÇOIS-JEAN-GABRIEL DE (1799–1800): *Voyage pittoresque de la Syrie, de la Phœnicie, de la Paloestine et de la Basse Ægypte* (Paris: Imprimerie de la République).

PORTER, BERTHA, and MOSS, ROSALIND L.B. (1927–52): *Topographical Bibliography of Ancient Egyptian Hieroglyphic Texts, Reliefs, and Paintings* (Oxford: The Clarendon Press).

POSENER, GEORGES (1959a): *Dictionnaire de la Civilisation Égyptienne* (Paris: Hazan). Also published (1962) as *A Dictionary of Egyptian Civilization* (London: Methuen).

—(1959b): *see* SAUNERON, SERGE.

—(1960): *De la divinité du pharaon* (Paris: Imp. nationale).

POTTERTON, HOMAN (1975): *Irish Church Monuments 1570–1880* (Belfast: Ulster Architectural Heritage Society).

POWELL, CARYLL NICOLAS PETER (1959): *From Baroque to Rococo: An Introduction to Austrian and German Architecture from 1580 to 1790* (London: Faber & Faber Ltd).

POYET, BERNARD (1811): *Recueil des peintures et sculptures faites au corps législative* (Paris: Decle).

POZZI, G. (1980): *see* COLONNA, FRANCESCO.

PRAZ, MARIO (1964): *An Illustrated History of Interior Decoration* (London: Thames & Hudson Ltd).

—(1969): *On Neoclassicism* (London: Thames & Hudson Ltd).

PREGER, THEODOR CHRISTOPH (1901–07): *Scriptores Originum Constantinopolitanarum* (Leipzig: B.G. Teubner).

PREMERSTEIN, A. VON (1895): 'Augustales', in *Dizionario epigrafico di antichità romana*, **i**, 824–77.

PRESCOTT, HILDA FRANCES MARGARET (1957): *Once to Sinai: the further pilgrimage of Friar Felix Fabri* (London: Eyre & Spottiswoode).

PRÉVOST-MARCILHACY, PAULINE (1995): *see* MASSOUNIE, DOMINIQUE.

PREYS, R. (1993): *see* DELVAUX, L.

PRICE, S. R. F. (1980): 'Between Man and God', in *Journal of Roman Studies*, **lxx**, 28–43.

—(1983): *Rituals and Power: the Roman Imperial Cult in Asia Minor* (Cambridge: Cambridge University Press).

PRIEUR, A.-P. (1787–96): *see* ACADÉMIE DES BEAUX-ARTS.

PRISSE D'AVENNES, ACHILLE-CONSTANT-THÉODORE-ÉMILE (1878–79): *L'Histoire de l'Art Égyptien, d'après les Monuments*, 2 vols (Paris: A. Bertrand).

PRITCHARD, J. B. (Ed.) (1969): *Ancient Near Eastern Texts relating to the Old Testament* (Princeton, NJ: Princeton University Press).

'PUB ET LE PÉPLUM, LA' (1985): *L'Histoire*, **lxxxiii** (November), 80.

PUGIN, AUGUSTUS CHARLES (1825): *see* BRITTON, JOHN.

—(1829): *Paris and its Environs, displayed in a Series of Picturesque Views* (London: Robert Jennings).

PUGIN, AUGUSTUS WELBY NORTHMORE (1843): *An Apology for the Revival of Christian Architecture in England* (London: J. Weale).

PUTTER, TH. DE (1993): *see* DELVAUX, L.

PYNE, WILLIAM HENRY (1819): *The History of the Royal Residences of Windsor Castle . . .* (London: A. Dry).

PYRAMIDEN (1989): *Catalogue* of the Exhibition held in the Galerie Jules Kewenig (Köln: Frechen-Bachem).

QUAGEBEUR, JAN (1988): *Catalogue* of the Exhibition *Egypte Hertekend* (Leuven).

QUAGLIA, FERDINANDO (*c*.1850): *Les Cimetières de Paris. Recueil des plus remarquables monuments funèbres avec leurs inscriptions, dessinées par Quaglia, gravés par Collette* (Paris: A. Lévy).

—(*c*.1854): *Le Père Lachaise ou recueil de dessins aux traits et dans leurs justes proportions des principaux monuments de ce cimetière* (Paris: Lagny Frères).

QUATREBARBES, E. DE, and BROSE, J. (1978): 'La mystérieuse pyramide de Robermont', in *La Vie Wallonne*, **lii**, 221–5.

QUATREMÈRE DE QUINCY, ANTOINE-CHRYSOSTÔME (1803): *De l'architecture égyptienne, considérée dans son origine, ses principes et con goût, et comparée sous les mêmes rapports à l'architecture grecque* (Paris: Barrois).

—(1830): *Histoire de la vie et des ouvrages des plus célèbres architectes du XI^e siècle jusqu'à la fin du XVIII^e . . .* (Paris: J. Renouard).

QUICK, RICHARD (1931): *The Life and Works of Edwin Long, R.A.* (Bournemouth: Russell-Cotes Art Gallery and Museum).

QUINCEY, THOMAS DE (1889–90): *Collected Writings* (Edinburgh: A. & C. Black).

QUINCY (1803): *see* QUATREMÈRE DE QUINCY.

QUIRKE, STEPHEN, and ANDREWS, C. (1988): *The Rosetta Stone: Facsimile Drawing with an Introduction and Translations* (London: British Museum Publications).

RABREAU, DANIEL (1976): 'Le Théâtre Feydeau et la rue des Colonnes (1791–1829)', in *Actes du 100^e Congrès national des Sociétés Savantes* (Paris: Bibliothèque nationale), 255–73.

—(1984): 'Un opéra au Louvre', in *Beaux-Arts Magazine*, **xv** (July–August), 58–9.

—(1995): *see* MASSOUNIE, DOMINIQUE.

RAICH, JOHANN MICHAEL (1884): *Die innere Anwahrheit der Freimaurerei* (Mainz-am-Rhein: Franz Kirchheim).

RAMBOVA, N. (*Ed.*) (1957): *see* PIANKOFF, ALEXANDRE.

RAMSEY, L. G. G. (*Ed.*) (1968): *see* CONNOISSEUR'S COMPLETE PERIOD GUIDES . . . etc.

RAMSAY, SIR WILLIAM MITCHELL (1906): *Pauline and Other Studies in Early Christian History* (London: Hodder & Stoughton).

RANDALL, JAMES (1806): *A Collection of Architectural Designs for Mansions, Casinos, Villas, Lodges, and Cottages . . .* (London: J. Taylor).

RANSONETTE, PIERRE-NICOLAS (1812): *see* KRAFFT, JOHANN KARL.

RAVAL, MARCEL HUBERT (1946): *Claude-Nicolas Ledoux, 1736–1806* (Paris: Arts & Métiers Graphiques).

RAVE, PAUL ORTWIN (1953): *Karl Friedrich Schinkel* (Munich: Deutscher Kunstverlag).

RAVEN, MAARTEN J. (1980): 'Alma-Tadema als amateur-egyptoloog', in *Bulletin van het Rijksmuseum Amsterdam*, Jg **xxviii**/3, 103–17.

—(1981): *see* SCHNEIDER, HANS D.

—(1996): 'L'égyptomanie aux Pays-Bas: Alma-Tadema et Testas', in HUMBERT (*Ed.*) (1996), 463–78.

RAWLINSON, GEORGE (1992): *see* HERODOTUS.

RAWSON, ELIZABETH (1985): *Intellectual Life in the Late Republic* (Baltimore, MD: Johns Hopkins University Press).

READE, BRIAN (1953): *Regency Antiques* (London: B.T. Batsford Ltd).

REALE ACCADEMIA ERCOLANESE DI ARCHEOLOGIA (1757–92): *Le Antichità di Ercolano esposte* (Naples: Reale Accademia Ercolanese di Archeologia).

REBOLD, EMMANUEL (1851): *Histoire générale de la Franc-Maçonnerie* (Paris: A. Franck).

RÉE, PETRA (2001): *see* MANLEY, DEBORAH.

REES, JOAN (1995): *Writings on the Nile. Harriet Martineau, Florence Nightingale, and Amelia Edwards* (London: Rubicon Press).

—(1998): *Amelia Edwards. Traveller, Novelist, & Egyptologist* (London: Rubicon Press).

REEVES, CARL NICHOLAS (1990): *The Complete Tutankhamun: the king, the tomb, the royal treasure* (London and New York, NY: Thames & Hudson Ltd).

REGHELLINI, – OF SCIO (S.˙.M.˙.R.˙.DE, i.e. MONSIEUR REGHELLINI OF SCIO) (1829): *La Maçonnerie, considerée comme le Résultat des Religions égyptienne, juive, et chrétienne, par le F.˙.M. Reghellini De Schio* (Brussels: H. Tarlier). See also the Paris edition, published in 1833 by Dondey-Dupré). A German edition, *Die Freimaurerei in ihrem Zusammenhang mit den Religionen der alter Ægypter, der Juden, und der Christen. Nach dem französischens des F. M. R. de S.˙.*, etc., was published in Leipzig in 1835 by J.J. Weber. ACERELLOS, R. S., was the pseudonym of REGHELLINI OF SCIO.

—(1840): *Précis historique de l'Ordre du Temple, origine de la Fr.˙.Maç.˙. par le F.˙.M. Reghellini de Schio* (Paris: Or.˙. de Jérusalem, chez le Silence, l'an de la G.˙.L.˙. 5840).

REGNAULT DE LALANDE, F.-L. (1810): *Catalogue de vente de tableaux, dessins encadrés . . . après le décès de M. Moitte* (7–8 June), with a Notice on Jean-Guillaume Moitte, i-viii.

REICHEL, CAROLUS (1849): *De Isidis apud Romanos cultu* (Berlin: Schade).

REINACH, SALOMON (1897): *Répertoire de la statuaire grecque et romaine* (Paris: E. Leroux).

REINHARD, MARCEL (1971): *La Révolution, 1789–1799* (Paris: Hachette).

REITZENSTEIN, RICHARD (1956): *Die Hellenistischen Mysterienreligionen Nach ihren Grundgedanken und Wirkungen* (Stuttgart: B.G. Teubner).

RENARD, CAMILLE (n.d.): *Album archéologique dessiné par M. Camille-Renard . . . Égypte* (Liège: C. Claesen).

RENARD, JEAN-CLAUDE (1985): *L'Âge de la fonte: un art, une industrie 1800–1914* (Paris: Éditions de l'Amateur).

RENNELL, JAMES RENNELL RODD, BARON (1892): *The Customs and Lore of Modern Greece* (London: D. Stott).

RENOUVIER, JULES (1863): *Histoire de l'Art pendant la Révolution* (Paris: Vve J. Renouard).

RESPECTABLE LOGE (1884): *R[espectable] L[oge], Chap[itre] et Aréop[age] Les Amis de Commerce et La Persévérance Réunis à l'Orient d'Anvers. Tracé de la Fête du Conséc[ration] du Nouveau Temple. Tenue du 21 e J[our] du 8e M[ois] 5883* (Brussels: s.n.).

RÊVE ÉGYPTIEN, LE (1979): *see SILEX.*

REVETT, NICHOLAS (1762–1830): *see STUART, JAMES.*

REYBAUD, LOUIS, *ET AL.* (1830–36): *Histoire scientifique et militaire de l'expédition française en Égypte* (Paris: A.J. Dénain).

REYMOND, EVE A.E. (1969): *The Mythical Origin of the Egyptian Temple* (Manchester: Manchester University Press).

REYNOLDS, DONALD MARTIN (*Ed.*) (1989): *Selected Lectures of Rudolf Wittkower: The Impact of Non-European Civilizations on the Art of the West* (Cambridge: Cambridge University Press).

RHIND, ALEXANDER HENRY (1862): *Thebes: its Tombs and their Tenants* (London: Longman Green, Longman, & Roberts).

RHONÉ, ARTHUR (1879): *L'Égypte antique* (Paris: Imprimerie de A. Quantin).

RICCI, CORRADO (1930): *La Scenografia Italiana* (Milan: Fratelli Treves).

RICHARDSON, ALBERT EDWARD, *ET AL.* (1951): *Southill: A Regency House* (London: Faber & Faber).

RICHARDSON III, J., and CARLISLE, R. (1979–80): 'The Archælogical Significance of the Mausoleums in the Allegheny and Homewood Cemeteries in Pittsburgh: A Preliminary Statement', in *Markers. The Annual Journal of the Association for Grave Stone Studies*, **i**.

RICHARDSON, ROBERT (1822): *Travels along the Mediterranean* (London: T. Cadell).

RICHER, J. (1981): 'Isis romantique. Le mythe de la mère-épouse. Hélène, Sophie, Marie', in BONNEFOY, Y. (*Ed.*), 597–8.

RICHTER, G. M. A. (1965): *The Portraits of the Greeks* (London: Phaidon Press Ltd).

—(1971): *Engraved Gems of the Romans. A Supplement to the History of Roman Art* (London: Phaidon Press Ltd).

RIDLEY, RONALD T. (1998): *Napoleon's Proconsul in Egypt. The life and times of Bernardino Drovetti* (London: Rubicon Press).

RIEFSTAHL, ELIZABETH (*Ed.*) (1960): *see BOTHMER, BERNARD VON.*

—(1964): *Thebes in the time of Amunhotep III* (Norman, OK: University of Oklahoma Press).

RIETDORF, ALFRED (1940): *Gilly, Wiedergeburt der Architektur* (Berlin: H. von Hugo).

RIFAUD, JEAN-JACQUES (1830): *Tableau de l'Égypte, de la Nubie, et des lieux circonvoisins, depuis 1805 jusqu'au 1828* ... (Paris: Treuttel & Würtz). This work also appears as *Voyage en Égypte, etc. See also the German translation of 1830 by G. A. WIMMER* (Vienna: C. Gerold).

RIGONI, M. A. (1972): 'Un dialogo del Tasso: della parola al geroglifico', in *Lettere Italiane*, **xxiv**, 30–44.

RIMMER, WILLIAM GORDON (1960): *Marshalls of Leeds, Flax-Spinners, 1788–1886* (Cambridge: Cambridge University Press).

RINGGREN, H. (1969): 'Light and Darkness in Ancient Egyptian Religion', in *Liber amicorum. Studies in honor of C. J. Bleeker* (Leiden: E. J. Brill), 140–50.

RINSVELD, BERNARD VAN (1991): 'Les prétendues "cariatides" de la collection égyptienne du Léopold II', in *Bulletin des musées royaux d'Art et d'Histoire*, **lxii**.

—(1994): *Dieux et déesses de l'ancienne Égypte* (Brussels: Musées Royaux d'Art et d'Histoire).

—(1996): 'L'Égyptomanie au service de la politique: la visite de Bonaparte à Bruxelles en 1803', in HUMBERT (*Ed.*) (1996), 369–423.

RISTOW, GÜNTER (1980): *Römischer Götterhimmel und frühes Christentum* (Köln: Wienand Verlag).

RITSCHL, F. (1838): *Die alexandrinischen Bibliotheken unter den Ptolemäern* (Breslau: G. P. Aderholz).

RITTERLING, E. (1932): *Fasti des römischen Deutschland unter dem Prinzipat* (Vienna: L. W. Seidel).

RIZZO, G. (1936a): *Le pitture dell'Aula Isiaca di Caligola, MdP III, Roma II* (Rome: Istituto Poligrafico della Stato).

—(1936b): *Le pitture della 'Casa Livia', MdP III, Roma II* (Rome: Istituto Poligrafico della Stato).

ROBERTS, DAVID (1846–49): *Egypt and Nubia* with notes on the plates by W. BROCKEDON (London: F.G. Moon).

—(1855–56): *The Holy Land . . ., Egypt, and Nubia* with notes by W. BROCKEDON (London: Day & Son).

ROBINET, JEAN-FRANÇOIS-EUGÈNE (1896–8): *Le mouvement religieux à Paris pendant la Révolution* (Paris: L. Cerf).

ROBINSON, D. N. (1913): 'A Study of the Social Position of the Devotees of the Oriental Cult in the Western World', in *Transactions and Proceedings of the American Philological Association*, **xliv**, 151–61.

ROBIQUET, JACQUES (1912): *Gouthière* (Paris: H. Laurens).

ROCCHEGGIANI, LORENZO (1804): *Raccoltà di cento tavole rappresentanti i costumi religiosi . . . degle antichi Egiziani* (Rome: G. Raffaelo).

—, and RUGA, PIETRO (1811): *Invenzioni diversi di mobili ed utensili sacri e profani per usi comuni della vita* (Milan: di stampe e libri in S. Margherita). An earlier edition of 1806 was published in Rome (s.n.).

ROCHEFOUCAULD LIANCOURT, FRANÇOIS-ALEXANDRE-FRÉDÉRIC, DUC DE LA (1800): *Des Prisons de Philadelphie* (Paris: H. Agasse).

ROCHEGUDE, FÉLIX, MARQUIS DE, and CLÉBERT, JEAN-PAUL (1958): *Promenades dans les rues de Paris* (Paris: Club des Libraires de France).

ROCHER W. (*Ed.*) (1890–94): *Ausführliches Lexikon der griechischen und römischen Mythologie* (Leipzig: B. G. Teubner).

ROCKETT, WILLIAM (1982): 'The Egyptian Revival', in *Aramco World Magazine*, **xxxiii**/1 (January–February), 12–19.

ROEDER, GÜNTHER (1911): *Die Blumen der Isis von Philä* (Leipzig: Zeitschrift für ägyptische Sprache und Altertumskunde).

—(1915): *Urkunden zur Religion des alten Ägypten* (Jena: E. Diederichs).

—(1916): 'Isis', in *Realenzyklopädie der klassischen Altertumswissenschaft*, **xviii**/2 (Stuttgart: J. B. Metzlersche Verlagsbuchhandlung), 2084–2132.

—(1921): *Der Denkmäler des Pelizæus- Museums Zu Hildesheim* (Berlin: K. Curtius).

—(1959–61): *Die ägyptische Religion in Texten und Bildern* (Zürich: Artemis-Verlag).

ROGERS, R. S. (1932): 'Fulvia Paulina C. Sentii Saturnini', in *American Journal of Philology*, **liii**, 252–6.

ROLLIN, CHARLES (1740): *Histoire ancienne des Égyptiens, des Carthaginois, des Assyriens, des Babyloniens, des Medes et des Perses, des Macedoniens, des Grecs* (Paris: chez la Veuve Estienne).

ROMANELLI, PIETRO (1951): *see* BOTTI, GIUSEPPE.

ROMANO, GIULIO (1989): *Giulio Romano. Catalogue* of the Exhibition held in Mantua in 1989 (Milan: Electa).

—(1991): *Atti del Convegno Internazionale di Studi su Giulio Romano e l'espansione europea del Rinascimento'*, Mantua (1–5 October 1989) (Mantua: Accademia Nazionale Virgiliana).

ROOS, FRANK JOHN (1940): 'The Egyptian Style', in *Magazine of Art*, **xxxiii**, 218–223, 255, and 257.

ROSCHER, WILHELM HEINRICH (*Ed.*) (1884–1937): *Ausführliches Lexikon der griechischen und römischen Mythologie* (Leipzig: B.G. Teubner).

ROSELLINI, IPPOLITO (1832–44): *I Monumenti dell'Egitto e della Nubia* (Pisa: N. Capurro).

—(1925): *Ippolito Rosellini e il suo Giornale della spedizione letteraria Toscana in Egitto negli anni 1828–1829*, edited by GIUSEPPE GABRIELI (Rome: Tipografia Befani).

ROSENAU, HELEN (1953): *Treatise on Architecture: a complete presentation of the Architecture Essai sur l'Art, which forms part of the Boullée papers (MS. 9153) in the Bibliothèque Nationale* (London: A. Tiranti).

—(1960): 'The Engravings of the Grands Prix of the French Academy of Architecture', in *Architectural History, Journal of the Society of Architectural Historians of Great Britain*, **iii**, 17–180.

—(1974): *The Ideal City, its Architectural Evolution* (London: Studio Vista).

—(1976): *Boullée and Visionary Architecture* (London: Academy Editions).

ROSENBERG, ALFONS (1972): *Die Zauberflöte; Geschichte und Deutung von Mozarts Oper* (Munich: Prestel).

ROSENBERG, PIERRE (*Commissaire de l'Exposition*), and DUPUY, MARIE-ANNE (*Commissaire délégué*) (1999): *Dominique-Vivant Denon. L'œil de Napoléon. Catalogue* of an Exhibition held at the Musée du Louvre, Paris (20 October 1999–17 January 2000) (Paris: Éditions de la Réunion des Musées Nationaux).

ROSENBERG-ORSINI, JUSTINE (WYNNE), GRÄFIN VON (1787): *Alticchiero*, edited by COUNT BENINCASA (Padua: s.n.).

ROSENGARTEN, A. (1893): *A Handbook of Architectural Styles*, translated from the German by W. COLLETT-SANDARS (London: Chatto & Windus).

ROSENBLUM, ROBERT (1970): *Transformations in Late Eighteenth-Century Art* (Princeton, NJ: Princeton University Press).

ROSENSTRAUCH-KÖNIGSBERG, EDITH (1975): *Freimaurer im Josephinischen Wien* (Vienna and Stuttgart: W. Braumüller).

ROSSI-SACCHETTI, V. (1911): 'L'Art de Carlo Bugatti', in *L'Art Décoratif*, **xxv**, 301–8.

ROSTOVTSEV, MIKHAIL IVANOVICH (1941): *The Social and Economic History of the Hellenistic World* (Oxford: The Clarendon Press).

ROTHMAN, DAVID J. (1971): *The Discovery of the Asylum: Social Order and Disorder in the New Republic* (Boston, MA: Little, Brown).

RÖTTGEN, STEFFI (1980): 'Das Papyruskabinett von Mengs in der Biblioteca Vaticana. Ein Beitrag zur Idee und Geschichte des Museo Pio- Clementio', in *Münchener Jahrbuch des Kunstgeschichte*, **xxxi**, 189–246.

ROUGÉ, GEORGES-LOUIS LE (1771): *Description du Colisée, élevé aux Champs-Élysées sur les dessins de M. Le Camus* (Paris: Libraires Associés). See *Curiosités de Paris, de Versailles ... augmentée de la description de tous les nouveaux monumens ...* , etc. by GEORGES-LOUIS LE ROUGÉ, (Paris: Libraires Associés, 1771).

ROUGÉ, JEAN (1987): 'Valentinien et la religion, 364–365', in *Ktèma*, **xii**, 285–97.

ROUGÉ, OLIVIER CHARLES CAMILLE EMMANUEL, VICOMTE DE (1883): *Notice des monuments exposés dans la galerie d'antiquités égyptiennes au Musée du Louvre* (Paris: Société Anonyme des Imprimeurs Réunies).

ROULLET, ANNE (1972): *The Egyptian and Egyptianizing Monuments of Imperial Rome* (Leiden: E.J. Brill).

ROULLIARD, S. (1628): *Histoire de Melun* (Paris: G. Loyson).

ROUSSEAU (1844, 1846): *see* LASSALLE, ÉMILE.

ROUSSEL, PIERRE (1915–16): *Les Cultes Égyptiens à Délos du III^e au I^{er} siècle av. J.-C.* (Nancy: Berger-Levrault).

—(1942): *Étude sur le principe de l'ancienneté dans le monde hellénique du V^e siècle av. J.-C. à l'époque romaine* (Paris: Imprimerie Nationale).

ROUSSEL, PIERRE DÉSIRÉ (1875): *Histoire et description du Château d'Anet depuis le dixième siècle jusqu'à nos jours* (Paris: Jouaust).

ROUTLEDGE, G. & SONS (1854): *Routledge's Guide to the Crystal Palace and Park at Sydenham* (London: G. Routledge & Sons).

ROWLAND, R. J. (1966): 'Numismatic Propaganda under Cinna', in *Transactions and Proceedings of the American Philological Association*, **xcvii**, 407–19.

RUBIN, Z. (1980): *Civil War. Propaganda and Historiography*, in *Latomus*, **clxxiii** (Brussels: Latomus).

RUBINSTEIN, R. (1986): *see* BOBER, P. B.

RUESCH, ARNOLD (1911): *Guida illustrata del Museo nazionale di Napoli* (Naples: Richter & Co.).

RUFFINIÈRE DU PREY, PIERRE DE LA (1994): *The Villas of Pliny from Antiquity to Posterity* (Chicago, IL., and London: University of Chicago Press).

RUGA, PIETRO (1811): *see* ROCCHEGGIANI, LORENZO.

RUNDLE CLARK, R. J. (1959): *Myth and Symbol in Ancient Egypt* (London: Thames & Hudson).

RUSCH, ADOLF (1906): *De Serapide et Iside in Græcia Cultis* (Berlin: H.S. Hermann).

RUSSELL, D. (1986): 'Emblems and Hieroglyphics: Some Observations on the Beginnings and the Nature of Emblematic Forms', in *Emblematica*, **i**, 227–43.

RUSSELL, WHITWORTH (1837): *see* CRAWFORD, WILLIAM.

S.'.M.'.R.'.DE (1833): *see* REGHELLINI – OF SCIO.

SÄFLUND, GÖSTA (1932): *Le mura di Roma republicane* (Lund: C. W. K. Gleerup).

SAGUAR QUER, CARLOS (1996a): 'La Egiptomania en la España de Goya', in *GOYA Revisita de Arte*, **252** (May–June), 367–81.

—(1996b): 'De la Vallée des Rois à la "Valle de los Caídos": pyramides, obélisques et hypogées dans l'architecture espagnole', in HUMBERT (*Ed.*) (1996), 307–41.

—(1997): 'Egiptomania y Arquitectura en España (1840–1940)', in *GOYA Revisita de Arte*, **259–60** (July–October), 386–406.

ST.-A . . . , P. DE (1816): *Promenade aux Cimetières de Paris, aux Sépultures Royales de Saint-Denis, et aux Catacombes* (Paris: C.-L.-F. Panckoucke). *See* also the same author's *Promenade . . . avec quarante-huit dessins . . .*, published in 1825.

SAINT-ALBIN, J. S. C. DE (1819): *Voyages de Paul Béranger dans Paris après 45 ans d'absence* (Paris: Lerouge).

ST JOHN, JAMES AUGUSTUS (1834): *Egypt and Mohammed Ali; or, Travels in the Valley of the Nile* (London: Longman, Rees, Orme, Brown, Green, & Longman).

—(1845): *Egypt and Nubia . . .* (London: Chapman & Hall).

—(1853): *Isis: an Egyptian Pilgrimage* (London: Longman, Brown, Green, & Longman).

SAINT-NON, JEAN-CLAUDE RICHARD DE (1781–86): *Voyage Pittoresque; ou description des royaumes de Naples et de Sicile* (Paris: Clousier).

SAINT-SAUVEUR, DAPHNÉ DE (1979): 'Le Retour du Style "Retour d'Egypte"', in *Le Figaro Magazine*, **x**/926 (1 December), 156–158.

SAINT-VICTOR, JACQUES-BENJAMIN (1808): *Tableau Historique et Pittoresque de Paris, depuis les Gaulois jusqu'a nos jours* (Paris: De l'Imprimerie des Frères Mame).

SAINTYVES, P. (1908, 1936): *see* NOURRY.

SALAČ, ANTONÍN (1915): *Isis, Sarapis a božstva sdružená dle svědectví řeckých a latinských nápisů* (Prague: Nákl. České akademie císare Frantiska Josefa pro vedy, Slovesnost a umení).

SALANDRA, SERAFINO DELLA (1647): *Adamo Caduto* (Cosenza: G.B. Moio & F. Rodella).

SALEH, A.-A. (1969): 'The so-called "Primeval Hill" and other related excavations in Ancient Egyptian mythology', in *Mitteilungen des deutschen Archäologischen Instituts, Kairo*, **xxv**, 110–120.

SALOMIES, OLLI (1987): *Die römischen Vornamen: Studien zur römischen Namengebung. Societas Scientiarum Fennica, Commentationes Humanarum Litterarum*, **lxxxii** (Helsinki: Societas Scientarum Fennica).

SALVERTE, COMTE FRANÇOIS DE (1962): *Les Ebénistes du XVIII^e siècle* (Paris: F. de Nobele).

SALZMAN, MICHEL RENÉE (1990): *On Roman Time. The Codex-Calendar of 354 and the Rhythms of Urban Life in Late Antiquity* (Berkeley, CA, Los Angeles, CA, and London: University of California Press).

SAMOYAULT, JEAN-PIERRE (1977): 'Chefs d'oeuvre en tôle vernie de l'époque consulaire et impériale (1801–1806)', in *La Revue du Louvre et des Musées de France*, Nos 5/6, 322–34.

SAMSON, JULIA (1985): *Nefertiti and Cleopatra. Queen-Monarchs of Ancient Egypt* (London: Rubicon Press).

SAMTER, ERNST (1901): *Familienfeste der Griechen und Römer* (Berlin: G. Reimer).

SANDE, ANTON VAN DE (1995): *Vrijmetselarij in de Lage Landen. Een mysterieuze broederschap zonder geheimen* (Zutphen: Walburg Pers).

SANDWICH, JOHN MONTAGU, 4TH EARL OF (1799): *A Voyage Performed by the late Earl of Sandwich round the Mediterranean in the years 1728 and 1739* (London: Cadell & Davies, 1799).

SANDYS, GEORGE (1615): *Relation of a Journey begun An: Dom: 1610 . . . Containing a Description of the Turkish Empire of Ægypt, of the Holy Land, of the remote parts of Italy, and Ilands Adioyning* (London: W. Barrett).

SANDYS, J. E. (1899): *see* SEYFFERT, OSKAR.

SARTON, G. (1949): 'Agrippa, Fontana, and Pigafetta: the erection of the Vatican Obelisk in 1586', in *Archives Internationales d'Histoire des Sciences*, **ii**, 827–54.

SASS, ELSE KAI (1963–65): *Thorvaldsens Portrætbuster* (Copenhagen: Selskabet til udgivelse af danske Mindesmærker).

SAULNIER, S. (1822): *Notice sur le voyage de M. Lelorrain en Égypte* (Paris: S. Saulnier).

SAUNERON, SERGE (1959): Article on astrology in *Dictionnaire de la Civilisation Égyptienne*, edited by G. POSENER (Paris: Hazan).

SAUNIER, CHARLES (1902): *Les Conquêtes artistiques de la Révolution et de l'Empire* (Paris: H. Laurens).

SAVARESE, G., and GAREFFI, A. (1980): *La letteratura delle immagini nel Cinquecento* (Rome: Bulzoni).

SAVARY, CLAUDE-ÉTIENNE (1785–86): *Lettres sur l'Égypte, où l'on offre le parallèle des mœurs anciennes et modernes de ses habitans . . .* (Paris: Onfroi).

SÄVE-SÖDERBERGH, TORGNY (*Ed.*) (1987): *Temples and Tombs of Ancient Nubia: the international rescue campaign at Abu Simbel, Philæ, and other sites* (New York, NY: Thames & Hudson, and Paris: UNESCO).

SAVREUX, MAURICE (1923): *see* LECHEVALLIER-CHEVIGNARD, GEORGES.

SAXL, FRITZ (1957): *Lectures* (London: Warburg Institute, University of London). *See* especially 'The Appartamento Borgia'.

—, and WITTKOWER, RUDOLF (1969): *British Art and the Mediterranean* (London: Oxford University Press).

SBORDONE, FRANCESCO (*Ed.*) (1940): *Hori Apollonis Hieroglyphica* (Naples: L. Loffredo).

SCALICKI, W. (1956): *see MASKE UND KOTHURN*.

SCAMUZZI, ERNESTO (1939): *La "Mensa Isiaca" del Regio Museo di Antichità di Torino* (Rome:Giovanni Bardi).

—(1965): *Egyptian Art in the Egyptian Museum of Turin* (New York, NY: H. N. Abrams).

SCHAAFHAUSEN, H. (1883): 'Über den römischen Isis-Dienst am Rhein', in *Bonner Jahrbücher*, **lxxvi**, 31–62.

SCHÄFER, HEINRICH (1974): *Principles of Egyptian Art*, edited, and with an Epilogue, by EMMA BRUNNER-TRAUT, *tr.* by JOHN BAINES (Oxford: The Clarendon Press).

SCHAMPHELEIRE, M. DE (1984): *see* MACLOT, PETRA.

SCHARF, J. (1938): *Studien zur Bevölkerungsgeschichte der Rheinlande auf epigraphischer Grundlage. Neue Deutsche Forschungen.* Abteilung: Alte Geschichte, **iii** (Berlin: Junker & Dünnhaupt).

SCHEFER, CHARLES-HENRI-AUGUSTE (*Ed.*) (1892): *Le Voyage d'Outremer de Bertrandon de la Broquière* (Paris: E. Leroux).

SCHEFOLD, KARL (1949): *Orient, Hellas, und Rom in der archäologischen Forschung seit 1939* (Berne: A. Francke).

—(1952): *Pompejanische Malerei, Sinn- und Ideengeschichte* (Basel: B. Schwabe).

—(1957): *Die Wände Pompejis: topographisches Verzeichnis der Bildmotive* (Berlin: De Gruyter).

—(1962): *Vergessenes Pompeji: unveröffentlichte Bilder römischer Wanddekorationen in geschichtlicher Folge* (Berne: A. Francke).

SCHEID, JOHN (1985): *Religion et piété à Rome* (Paris: Découverte).

SCHÉLE, SUNE (1965): *Cornelis Bos: a study of the origins of the Netherland Grotesque* (Stockholm: Almqvist & Wiksell).

SCHIFFMANN, GUSTAV ADOLF (1881): *Die Freimaurerei in Frankreich in der ersten Hälfte de XVIII. Jahrhunderts* (Leipzig: Zechel).

SCHINKEL, KARL FRIEDRICH (1823): *see* THIELE, CARL FRIEDRICH.

SCHLEIERMACHER, WILHELM (1960): 'Augustus Vindelicum', in *Germania Romana I: Römerstädte in Deutschland. Gymnasium* Beiheft **i** (Heidelberg: C. Winter), 78–89.

SCHLOSSER, JULIUS, RITTER VON (1908): *Die Kunst-und Wunderkammern der Spätrenaissance* (Leipzig: Klinkhardt & Biermann).

SCHMITTER, PETER, AND SCHMITZ, H. WALTER (*Eds*) (1989): *Innovationen in Zeichentheorien* (Münster: Nodus).

SCHMITZ, HERMANN (1914): *Berliner Baumeister von Ausgang des achtzehnten Jahrhunderts* (Berlin: Verlag für Kunstwissenschaft).

—(1923): *Deutsche Möbel des Klassizismus* (Stuttgart: J. Hoffmann).

SCHMITZ, H. WALTER (*Ed.*) (1989): *see* SCHMITTER, PETER.

SCHNAPPER, ANTOINE (1985): *see* LOSTE, SÉBASTIEN.

SCHNEIDER, HANS D. (1979): *Taffeh: Rond de wederopbouw van een Nubische tempel* (Den Haag: Staatsuitgeverij).

—, and RAVEN, MAARTEN J. (1981): *De Egyptisch oudheid* ('s-Gravenhage: Staatsuitgeverij).

SCHNEIDER, L. (1990): 'Leon Battista Alberti: Some Biographical Implications of the Winged Eye', in *Art Bulletin*, **lxxii**, 261–70.

SCHNEIDER, RENÉ (1910): *Quatremère de Quincy et son intervention dans les arts, 1788–1830* (Paris: Hachette & Cie).

SCHOLZ, J. (1822): *Reise in die Gegend zwischen Alexandrien und Paratonium* (Leipzig: bey Friedrich Fleischer).

SCHOLZ, JÁNOS (*Ed.*) (1950): *Baroque and Romantic Stage Design* (New York, NY: H. Bittner).

SCHÖN, DORIT (1988): *Orientalischen Kulte im römischen Österreich* (Vienna: Böhlau).

SCHÖN, FRANZ (1986): *Der Beginn der römischen Herrschaft in Raetien* (Sigmaringen: J. Thorbecke).

SCHÖNE, GÜNTER (1959): *see* THEATERMUSEUM DER CLARA ZIEGLER STIFTUNG, MUNICH.

SCHRÖMBGES, P. (1986): *Tiberius und die 'Res publica Romana'. Untersuchungen zur Institutionalisierung des frühen römischen Prinzipats* (Bonn: Habelt).

SCHUBERT, JOHANNES (1954): *see* MORENZ, SIEGFRIED.

SCHUYLER, DAVID (*Ed.*) (1984): *see* HUNT, JOHN DIXON.

SCHWALLER DE LUBICZ, R.A. (1958): *Le Temple de l'Homme: Apet du Sud à Louqsor* (Paris: Caractères).

SCHWERTHEIM E. (1986): 'Orientalische Religionen in Deutschland', in *Aufstieg und Niedergang der römischen Welt. Geschichte und Kultur Roms im Spiegel der neueren Forschung*, **ii**, 18.1 (Berlin and New York, NY: de Gruyter), 795–813.

SCOTT, CHARLES ROCHFORT (1837): *Rambles in Egypt and Candia* (London: H. Colburn).

SCOTT, KENNETH (1975): *The Imperial Cult under the Flavians* (New York, NY: Arno Press).

SCOTTISH ARTS COUNCIL (1981): *Artist Adventurer: David Roberts 1796–1864* (Edinburgh: Scottish Arts Council).

SCRIPTORES HISTORIÆ AUGUSTÆ (1930–32): *The Scriptores Historiæ Augustæ* (London: Heinemann).

SCULLARD, HOWARD HAYES (1961): *From the Gracchi to Nero: a history of Rome from 133 BC to AD 68* (London: Methuen).

—(1981): *Festivals and Ceremonies of the Roman Republic* (Ithaca, NY: Cornell University Press).

SEAGER, ROBIN (1972): *Tiberius* (London: Eyre Methuen Ltd).

SEARIGHT, SARAH (1969): *The British in the Middle East* (London: Weidenfeld & Nicolson). *See also* the second edition (1979).

'SECRETS DES PYRAMIDES' (1989): *Elle*, **ii**/257 (10 April), 118–121.

SEDLMAYR, HANS (1953): *Verlust der Mitte: die bildende Kunst des 19. und 20. Jahrhunderts als Symptom und Symbol der Zeit* (Salzburg: O. Müller).

—(1956): *Johann Bernhard Fischer von Erlach* (Vienna: Herold).

SEECK, O. (1908): 'Zur Geschichte des Isiskultes in Rom', in *Hermes*, **xliii**, 642–3.

SEEL, HEINRICH (1823): *Die Mithrageheimnisse während der Vor- und Urchristlichen Zeit . . .* (Arau: H.R. Sauerländer).

SEIPEL, WILFRIED (1989): *Ägypten: Götter, Gräber, und die Kunst 4000 Jahre Jenseitsglaube* (Linz: Oberösterreichisches Landesmuseum).

SEMPER, HANS (1880): *Gottfried Semper: Ein Bild seines Lebens und Wirkens* (Berlin: Calvary).

SEMPRINI, G. (*Ed.*) (1936): *La filosofia di Pico della Mirandola* (Milan: Libreria Lombarda).

SERBANESCO, DEMETER GÉRARD ROGER (1963–66): *Histoire de la Franc-Maçonnerie Universelle* (Paris: Hachette).

SERLIO, SEBASTIANO (1551): *Livre extraordinaire de architecture* . . . (Lyon: Jean de Tournes).

—(1584): *Tutte l'Opere d'Architettura* . . . (Venice: F. de' Franceschi).

SERRULAZ, MAURICE (1938) (*Ed.*): *see BONAPARTE EN ÉGYPTE.*

SESLER, B. (1952–3): 'Arco di Domiziano all' Iseo Campense in Roma', in *Revista Italiana di Numismatica e Scienze Affini*, **i**, Ser. 4, 54–55, 88–93.

SETHE, KURT HEINRICH (1929): 'Das Papyrusszepter der ägyptischen Göttinnen und seine Entstehung', in *Zeitschrift für ägyptische Sprache und Altertumskunde*, **lxiv**, 6–9.

—(1939–62): *Übersetzung und Kommentar zu den altägyptischen Pyramidentexten* (Glückstadt: J. J. Augustin).

SETON-WILLIAMS, MARJORY VERONICA (1978): *Ptolemaic Temples* (Cambridge: The Author).

—(1988): *Egyptian Legends and Stories* (London: Rubicon Press).

—(1989): *A Short History of Egypt* (London: Rubicon Press).

—, and STOCKS, PETER (1988): *Egypt* (Blue Guide) (London: E. Benn, and New York, NY: W. W. Norton).

SÈVRES, MANUFACTURE NATIONALE DE PORCELAINE, MUSÉE CÉRAMIQUE (1951): *Les Grands Services de Sèvres. Catalogue* of the Exhibition (25 May–29 July 1951) (Paris: Éditions des Musées Nationaux).

SEWELL, BRIAN (1983): 'Israel in Egypt', in *Art and Artists*, **cc** (May).

SEYFFERT, OSKAR (1899): *A Dictionary of Classical Antiquities Mythology, Religion, Literature & Art*, revised by HENRY NETTLESHIP and J.E. SANDYS (London: S. Sonnenschein & Co. and New York, NY: Macmillan).

SEZNEC, JEAN (1953): *The Survival of the Pagan Gods: the Mythological Tradition and its place in Renaissance Humanism and Art* (New York, NY: Pantheon Books).

SHACKLETON-BAILY, DAVID ROY (1999): *Cicero's Letters to Atticus* (Cambridge, MA: Harvard University Press).

SHAPIRO, ALAN (*tr.*) (1988): *see* ZANKER, PAUL.

SHARMAN, RUTH (*tr.*) (1992): *see* VERCOUTTER, JEAN.

SHAW, EDWARD (1856): *The Modern Architect; or, Every Carpenter His Own Master* . . . (Boston, MA: Wentworth).

SHAW, THOMAS (1738): *Travels, or Observations relating to Several Parts of Barbary and the Levant* (Oxford: Printed at the Theatre).

SHERATON, THOMAS (1970): *The Cabinet Dictionary* (New York, NY: Praeger).

SHERER, MOYLE (1824): *Scenes and Impressions in Egypt and in Italy* (London: Longman, Hurst, Rees, Orme, Brown, & Green).

SHILS, EDWARD (1982): *The Constitution of Society* (Chicago, IL: University of Chicago Press).

SHORTER, ALAN WYNN (1931): *An Introduction to Egyptian Religion* (London: K. Paul, Trench, Trübner & Co. Ltd).

—(1932): *Everyday Life in Ancient Egypt* (London: S. Low, Marston & Co. Ltd).

—(1937): *The Egyptian Gods: A Handbook* (London: K. Paul, Trench, Trübner & Co. Ltd).

SICARD, CLAUDE (1780): *Plan d'un ouvrage sur l'Égypte ancienne et moderne* (Paris: J. G. Mérigot).

—(1845): *Description de l'Égypte* (Lyon: Librairie d'éducation de Perisse Frères).

SIEVERNICH, GEREON, and BUDDE, HENDRIK (*Eds*) (1989): *Europa und der Orient 800–1900. Catalogue* of the Exhibition held in the Martin-Gropius-Bau, Berlin (28 May–27 August) (Gütersloh/Munich: Bertelsmann Lexikon Verlag GmbH). It contains an enormous amount of information, and articles by GILET, LEOSPO, SYNDRAM, *ET AL*.

SIEVERS, JOHANNES (1950): *Karl Friedrich Schinkel - Die Möbel* (Berlin: Deutscher Kunstverlag).

SILEX (1979): On the occasion of the second world congress on Egyptology, held in Grenoble in 1979, the journal *Silex* devoted the whole of No. 13 (September), entitled *La Rêve Égyptien*, to matters Egyptian. The authors include BERNARD, BOUGNOUX, HARI, HUMBERT, LECLANT, and THEVOZ.

SIMOND, CHARLES (1900–1901): *La Vie Parisienne à travers le XIXe siècle: Paris de 1800 à 1900* (Paris: Plon-Nourrit et cie.).

SIMOND, LOUIS (1817): *Journal of a Tour and Residence in Great Britain, during the Years 1810 and 1811, by a French Traveller* (Edinburgh: A. Constable & Co.).

SIMPSON, R. S. (1999): *see* PARKINSON, RICHARD.

SIMPSON, WILLIAM KELLY (*Ed.*) (1973): *The Literature of Ancient Egypt: An Anthology of Stories, Instructions, and Poetry* (New Haven, CT: Yale University Press).

SINGER, DOROTHEA WALEY (1950): *Giordano Bruno, His Life and Thought* (New York, NY: Schuman).

SIRÉN OSVALD (1950): *China and Gardens of Europe of the Eighteenth Century* (New York, NY: Ronald Press Co.).

SKALICKI, W. (1956): 'Das Bühnenbild der Zauberflöte', in *Maske und Kothurn*, **ii** (Vienna: Institut für Theaterwissenschaft an der Universität Wien).

SKY, ALISON, AND STONE, MICHELLE (1976): *Unbuilt America: forgotten Architecture in the United States from Thomas Jefferson to the Space Age* (New York, NY: McGraw Hill).

SMALLWOOD, E. M. (1956): 'Some Notes on the Jews under Tiberius', in *Latomus*, **xv**, 314–29.

SMITH, GEORGE (1808): *Collection of Designs for Household Furniture and Interior Decoration, in the most Approved and Elegant Taste* (London: J. Taylor).

—(1812): *A Collection of Ornamental Designs, after the Manner of the Antique, Compos'd for the Use of Architects* . . . (London: M. Taylor).

—(1826): *The Cabinet-Maker's & Upholsterer's Guide, Drawing Book, and Repository of New and Original Designs for Household Furniture and Interior Decoration in the Most Approved and Modern Taste; Including Specimens of the Egyptian, Grecian, Gothic, Arabesque, French, English, and Other Schools of the Art* (London: Jones & Co.).

SMITH, HAROLD CLIFFORD (1931): *Buckingham Palace: its Furniture Decoration, & History* (London: Country Life).

SMITH, J. JAY (1846): *see* WALTER, THOMAS U.

SMITH, M. H. (1989): 'François Ier, l'Italie et le château de Blois', in *Bulletin Monumental*, **cxlvii**, 307–23.

SMITH, OLIVER P. (1854): *The Domestic Architect; comprising a series of original designs for rural and ornamental cottages* (Buffalo, NY: Phinney).

SMITH, W. STEVENSON (1998): *The Art and Architecture of Ancient Egypt* (London: Yale University Press).

SMITH, SIR WILLIAM (Ed.) (1863): *A Dictionary of the Bible* (London: John Murray).

—(1870): *Dictionary of Greek and Roman Geography* (London: James Watson & John Murray).

SMITS, J. (1988): *De Verenigde Nederlanden op zoek naar het Oude Egypte (1570–1780). De traditie gevolgd en gewogen* (Culemborg: Boekhandel Boldingh).

SMYTH, WILLIAM HENRY (1851): *Ædes Hartwellianæ* (London: J. B. Nichols & Son).

—(1851–64): *Addenda to the Ædes Hartwellianæ* (London: The Author).

SNIJDER, GEERTO AEILKO SEBO (1920): *De forma matris cum infante sedentis apud antiquos* (Utrecht: s.n.).

SNODIN, MICHAEL (Ed.) (1991): *Karl Friedrich Schinkel: A Universal Man* (New Haven, CT, and London: Yale University Press in assocation with the Victoria & Albert Museum. Issued to coincide with the Exhibition of 31 July–27 October 1991 at the V & A Museum).

SNOWDEN, F. M. (1956): 'Ethiopians and the Isiac Worship', in *L'Antiquité classique*, **xxv**, 112–16.

SOANE, SIR JOHN (1778): *Designs in Architecture . . .* (London: J. Taylor).

—(1788): *Plans, Elevations, and Sections of Buildings Executed . . .* (London: J. Taylor).

—(1929): *Lectures on Architecture* (London: Jordan-Gaskell).

SOCIÉTÉ ROYALE D'ARCHÉOLOGIE D' ALEXANDRIE (from 1926): *Monuments de l'Égypte gréco-romaine* (Bergamo: Officine dell' Istituto Italiano d'arti grafiche).

SOLÉ, JACQUES (1972): 'Un exemple d'archéologie des sciences humaines: l'étude de l'égyptomanie du XVIe au XVIIIe Siècle', in *Annales. Sociétés. Civilisations*, 473–482.

SOLMSEN, FRIEDRICH (1979): *Isis among the Greeks and Romans* (Cambridge, MA: Harvard University Press).

SOLOMON, JON (1978): *The Ancient World in the Cinema* (Cranbury, NJ: Barnes & Co.).

SOMMERARD, EDMOND DU (1883): *Musée des Thermes et de l'Hôtel de Cluny: Catalogue et Description des Objets d'Art* (Paris: Hôtel de Cluny).

SOMMERVOGEL, CARLOS (from 1890): *Bibliothèque de la Compagnie de Jésus* (Brussels: O. Schepens and Paris: A. Picart).

SOUCHAL, FRANÇOIS (1967): *Les Slodtz, sculpteurs et décorateurs du roi (1685–1764)* (Paris: É. de Boccard).

SOULTRAIT, G. DE, and THIOLLIER, F. (1886): *Le château de la Bastie d'Urfé et ses seigneurs* (Saint-Étienne: F. Thiollier).

SPARTIANUS (1930–32): *see SCRIPTORES HIS-TORIÆ AUGUSTÆ.*

SPAWFORTH, ANTONY (Ed.) (1996): *see HORN-BLOWER, SIMON.*

SPEIER, HERMINE (Ed.) (1963–72): *see* HELBIG, WOLFGANG.

SPERLICH, HANS G. (1960): *see* CONRADS, ULRICH.

'SPHINX AND THE LOTUS, THE' (1990): *The Egyptian Movement in American Decorative Arts, 1869–1939.* Catalogue of an Exhibition at the Hudson River Museum, Yonkers, NY (February to April).

SPIERS, PHENÉ (1893): *The Orders of Architecture, Greek, Roman, and Italian. Sketched from Normand's Parallel and Other Authorities* (London: B. T. Batsford Ltd).

SPONENBURGH, M. (1956): 'Egyptian Influence in the sculpture of the United States', in *Bulletin de l'Institut d'Égypte*, **xxxvii**/2 (Session 1954–5), 153–67.

SQUARCIAPINO, MARIO FLORIANI (1962): *I culti orientali ad Ostia* (Leiden: E. J. Brill).

SQUARZINA, S. DANESI (Ed.) (1989): *Roma, centro ideale delle cultura dell'Antico nei secoli XV e XVI* (Milan: Electa). Contains an essay on the Pinturrichio decorations of the *Appartamento Borgia* in the Vatican by C. CERIA VIA (pp. 185–200).

STAEHELIN, ELISABETH (1990): 'Zum Motiv der Pyramiden als Prüfungs-und Einweihungsstätten', in ISRAELIT-GROLL (Ed.), 889–932.

STAFFORD-DEITSCH, JEREMY (2001): *The Monuments of Ancient Egypt* (London: British Museum Press).

STAMBAUGH, JOHN E. (1972): *Sarapis under the Early Ptolemies* (Leiden: E. J. Brill).

—(1978): 'The Functions of Roman Temples', in *Aufstieg und Niedergang der römische Welt. Geschichte und Kultur Roms im Spiegel der neueren Forschung*, **ii**/16.1 (Berlin and New York, NY: W. de Gruyter), 554–608.

—(1988): *The Ancient Roman City* (Baltimore, MD: Johns Hopkins University Press).

STAMP, GAVIN (Ed.) (1999): *The Light of Truth and Beauty. The Lectures of Alexander 'Greek' Thomson Architect 1817–1875* (Glasgow: The Alexander Thomson Society).

—and MCKINSTRY, SAM (Eds) (1994): *'Greek' Thomson* (Edinburgh: Edinburgh University Press Ltd).

STAMPFLE, FELICE (1948): 'An Unknown Group of Drawings by Giovanni Battista Piranesi', in *The Art Bulletin* (June), 122–41.

STANHOPE, LADY HESTER LUCY (1846): *Travels of Lady Hester Stanhope* (London: H. Colburn).

STARCK, JOHANN AUGUST, FREIHERR VON (1782): *Ueber die alten und neuen Mysterien* (Berlin: F. Maurer).

STARR, CHESTER G. (1941): *The Roman Imperial Navy to the Age of Diocletian* (Ithaca, NY: Cornell University Press).

STATHAM, HENRY HEATHCOTE (1950): *A History of Architecture*, revised by HUGH BRAUN (London: B. T. Batsford Ltd).

STEEGMULLER, F. (tr.)(1972): *see* FLAUBERT, G.

STEIN, A. (1944): *Die Reichsbeamten von Dazien* (Budapest: Magyar Nemzeti Müzeum).

STEIN, G. (1932): *Die kaiserlichen Beamten und Truppenkörper im römischen Deutschland unter dem Prinzipat* (Vienna: Seidel).

STEINER, RUDOLF (1980): *Isis und Madonna* (Dornach: Rudolf Steiner Verlag).

STERN, JEAN (1930): À l'ombre de Sophie Arnould. François-Joseph Bélanger, architecte des Menus-Plaisirs, Premier architecte du comte d'Artois (Paris: Plon).

STEWART, J. DOUGLAS (1980): review of CAR-ROTT'S The Egyptian Revival in Revue d'Art Canadienne/Canadian Art Review, **vii**/1–2, 142–143.

STOLTE, B. H. (1986): 'Die religiösen Verhältnisse in Niedergermanien', in Aufstieg und Niedergang der römischen Welt. Geschichte und Kultur Roms im Spiegel der neueren Forschung, **ii**/18.1 (Berlin and New York, NY: W. de Gruyter), 591–671.

STONE, MICHELLE (1976): see SKY, ALISON.

STREBEL, HARALD (1991): Freimaurer Wolfgang Amadeus Mozart (Stäfa: Rothenhäusler Verlag).

STREET, GEORGE EDMUND (1883): Sepulchral Monuments of Italy . . . photographed and described by Stephen Thompson (London: Arundel Society).

STROUD, DOROTHY (1966): Henry Holland: his Life and Architecture (London: Country Life).

—(1971): George Dance, Architect, 1741–1825 (London: Faber).

STUART, JAMES, and REVETT, NICHOLAS (1762–1830): The Antiquities of Athens (London: J. Haberkorn).

STUART-JONES, HENRY (Ed.) (1912): The Sculptures of the Musei Capitolini (Oxford: The Clarendon Press).

—(1926): The Sculptures of the Palazzo dei Conservatori (Oxford: The Clarendon Press).

'STYLE "D'ACTUALITÉ", LE RETOUR D'ÉGYPTE, UN' (1954): Connaissance des Arts, **xxxiii** (15 November), 62–7.

'STYLE ÉGYPTIEN DANS L'ŒUVRE DE JULIUS SCHNORR VON CAROLSFELD' (1981): Alte und Moderne Kunst, **clxxvi**.

SUETONIUS (GAIUS SUETONIUS TRANQUILLUS) (1923): De Vita Duodecim Cæsarum. See especially the version tr. PHILEMON HOLLAND (London: Routledge).

SUMMERSON, SIR JOHN NEWENHAM (1952): Sir John Soane, 1753–1837 (London: Art & Technics).

—(1953): Architecture in Britain, 1530 to 1830 (Harmondsworth: Penguin Books Ltd).

SUMNER, GEORGE (1847): The Pennsylvania System of Prison Discipline Triumphant in France (Philadelphia, PA: Acting Committee of the Philadelphia Society for the Alleviation of the Miseries of Public Prisons).

SWANSON, VERN G. (1977): Alma-Tadema: the painter of the Victorian vision of the ancient world (New York, NY: Scribner).

SWOBODA, ERICH (1964): Carnuntum, seine Geschichte und seine Denkmäler (Graz: H. Böhlhus Nachf.)

SYME, RONALD (1934): 'Lentulus and the Origin of Moesia', in Journal of Roman Studies, **xxiv**, 117–37.

—(1958): Tacitus (London: Oxford University Press).

—(1960): The Roman Revolution (London: Oxford University Press).

—(1965): 'Hadrian the Intellectual', in PIGANIOL, A. (Ed.), 243–9.

SYMONDS, R.W. (1957): 'Thomas Hope and the Greek Revival', in The Connoisseur, **cxl**/563 (July–December), 226–230.

SYNDRAM, DIRK (1988): 'Rätselhafte Hieroglyphen. Porzellane des 18. Jahrhunderts mit ägyptisierendem Dekor', in Jahrbuch des Museums für Kunst und Gewerbe in Hamburg, Bd. **6/7**.

—(1989): Ägypten - Faszinationen. Untersuchungen zum Ägyptenbild im europäischen Klassizismus bis 1800 (Frankfurt-am-Main: Lang).

—(1996): 'Les sources de l'inspiration: l'influence des modèles iconographiques sur l'égyptomanie du XVIIIᵉ siècle', in HUMBERT (Ed.) (1996), 39–58 and fig. 4 (54).

SZAMBIEN, WERNER (1984): Jean-Nicolas-Louis Durand, 1760–1834 (Paris: Picard).

—(1986): Les Projets de l'an II (printemps 1794), Concours d'architecture de la période révolutionnaire (Paris: École nationale supérieure des beaux-arts).

SZENTLÉLEKY, TIHAMÉR (1965): A szombathelyi Isis-szentlély (Szombathely: Savaria Múzeum).

—(1965): 'Az Iseum jelentösége Savariában', in Savaria, the Bulletin of the Museums of Komitates Vas, 153–8.

TABLEAU HISTORIQUE ET PITTORESQUE DE PARIS (1809): see SAINT-VICTOR.

TACHEVA-HITOVA, M. (1983): Eastern Cults in Moesia Inferior and Thracia (Leiden: E. J. Brill).

TACITUS, P. CORNELIUS (1990): Cornelii Taciti historiarum libri, edited by C. D. FISHER (Oxford: Clarendon Press). Reprinted from the 1911 edition.

TAEGER, FRITZ (1957–60): Charisma. Studien zur Geschichte des Kaiserkultes (Stuttgart: W. Kohlkammer).

TAGHER, J. (1950): 'Les locaux qui abritèrent la mission scolaire égyptienne à Paris existent encore', in Cahiers d'Hist. égyptienne, **ii**, 333–6.

TAKÁCS, SAROLTA A. (1995): Isis & Sarapis in the Roman World (Leiden: E. J. Brill).

TALON, PH. (Ed.) (1992): see BROZE, M.

TARDIEU, FEU (1825–50): see GOULIER, CHARLES-PIERRE.

TARDIEU, VINCENT (1987): 'Égyptomanie: l'édition mord sur le Nil', in Libération, No. 1791 (21–22 February), 30–31.

TARN, WILLIAM WOODTHORPE (1952): Hellenistic Civilisation (London: E. Arnold).

TATHAM, CHARLES HEATHCOTE (1794–c.1808): A Collection of Manuscript Drawings from Various Antique and other models made in Rome in 1794, 95, and 96, in the RIBA Drawings Collection. I am indebted to Mr Harris for drawing this to my attention.

—(1826): Etchings, representing the best examples of Grecian and Roman Architectural Ornament; Drawn from the Originals, and chiefly collated in Italy, before the late revolutions in that Country (London: Priestley & Weale).

TAUTE, REINHOLD (1886): Maurerische Bücherkunde. Ein Wegweiser durch die Literatur der Freimaurerei mit literarisch–kritischen Notizen und Zugleich ein Supplement zu Kloss' Bibliographie (Leipzig: J.G. Findel).

TAYLOR, ISIDORE-JUSTIN-SÉVERIN, BARON (1856a): La Syrie, l'Égypte, la Palestine, et la Judée (Paris: A. F. Lemaitre).

—(1856b): L'Égypte (Paris: Lemaitre).

TAYLOR, JOHN RUSSELL (1983): 'In the wake of Tutankhamen', in Art and Artists, **cc** (May), 9–10.

TAYLOR, LILY ROSS (1914): 'Augustales, Seviri Augustales, and Seviri. A Chronological Study', in Transactions and Proceedings of the American Philological Association, **xlv**, 231–53.

—(1920): 'The Worship of Augustus during his Lifetime', in Transactions and Proceedings of the American Philological Association, **li**, 116–33.

—(1931): *The Divinity of the Roman Emperor* (Middletown, CN: American Philological Assn.).

—(1985): *The Cults of Ostia. Greek and Roman Gods – Imperial Cult – Oriental Gods* (Chicago, IL: Ares).

TERNER, URSULA (2001): *Freimaurerische Bildwelten: Die Ikonographie der freimaurerischen Symbolik anhand von englischen, schottischen und französischen Freimaurerdiplomen* (Petersberg: Michael Imhof Verlag).

TERRASSON, JEAN (1731): *Séthos, Histoire ou Vie Tirée des Monumens Anecdotes de l'ancienne Égypte. Traduit d'un manuscrit grec* (Paris: Hippolyte-Louis Guérin). *See also* the 1732 translation by THOMAS LEDIARD.

TERREAUX, CLAUDE (1995): *see* CHAMPION, VIRGINIE.

TERVARENT, G. DE (1959): *Attributs et Symboles dans l'art profane 1450–1600* (Geneva: Droz).

TEYSSÈDRE, BERNARD (1967): *L'Art français au siècle de Louis XIV* (Paris: Librairie Générale Française).

TEXIER, SIMON (1994): *see* ANDIA, BÉATRICE DE.

THEATERMUSEUM DER CLARA ZIEGLER STIFTUNG, MUNICH (1959): *Das Bühnenbild im 19. Jahrhundert. Catalogue* of Exhibition prepared by GÜNTER SCHÖNE and HELLMUTH VRIESEN (Munich: Theatermuseum).

THÉVENOT, JEAN DE (1664–84): *Relations d'un Voyage fait au Levant* (Paris: L. Billaine).

THEVET, A. (1554 and 1556): *Cosmographie de Levant* (Lyon: J. de Tournes & G. Gazeau).

THIELE, C. F. (1823): *Decoration auf den beiden Königlichen Theatern in Berlin unter der General-Intendantur des Herrn Grafen von Brühl* (Berlin: C. F. Thiele).

THIÈME, ULRICH, and BECKER, FELIX (1950–53): *Allgemeines Lexikon der bildenden Künstler von der Antike bis zur Gegenwart* (Leipzig: Seeman).

THIÉRY, LUC-VINCENT (1787): *Guide des Amateurs et des Étrangers Voyageurs à Paris* (Paris: Hardouin & Gattey).

—(1784): *Almanach du Voyageur à Paris . . .* (Paris: Hardouin).

THIOLLIER, F. (1886): *see* SOULTRAIT, G. DE.

THOM, J. C. (1995): *The Pythagorean Golden Verses* (Leiden: E. J. Brill).

THOMA, HANS (1937): *Residenz München* (Munich: Bayerische Verwaltung der staatlichen Schlösser Gärten, und Seen).

THOMAS, HYLTON (1954): *The Drawings of Giovanni Battista Piranesi* (London: Faber).

THOMPSON, EDWARD ARTHUR (1947): *The Historical Work of Ammianus Marcellinus* (Cambridge: Cambridge University Press).

THOMPSON, F. H. (*Ed.*) (1985): *see* MACREADY, SARAH.

THOMPSON, STEPHEN (1883): *see* STREET, GEORGE EDMUND.

THOMSON, D. (1966): *Europe since Napoleon* (Harmondsworth: Penguin Books Ltd).

THORY, C. A. (1815): *Acta Latomorum, ou Chronologie de l'histoire de la Franche-Maçonnerie française et étrangère* (Paris: P. E. Dufart).

TIRARD, H. M. (*tr.*) (1894): *see* ERMAN, ADOLF.

TISSERAND, LAZARE MAURICE (1874–5): *Les Armoiries de la ville de Paris* (Paris: Imprimerie Nationale).

TOBIN, V. A. (1991): 'Isis and Demeter: Symbols of Divine Motherhood', in *Jahrbuch für Antike and Christentum*, **xxviii**, 187–200.

TORMO Y MONZÓ, ELÍAS (1940): *Os desenhos das antigualhas que vio d'Ollanda, pintor portugués* (Madrid: Tormo).

TORREY, HARRY BEAL (1938): 'Athanasius Kircher and the Progress of Medicine', in *Osiris*, **v** (Brugge), 246–275.

TÓTH, I. (1974): 'Eine Doppelheit der Geschichte des Isis- und Sarapiskultes in Pannonien', in *Az Eötvös Loránd Tudományegyeten Ókori Történeti Tanszékeinek Kiadványai*, **ix**, Studia Ægyptiaca, **i**, 345–60.

—(1976): 'Marcus Aurelius's Miracle of the Rain and the Egyptian Cults in the Danube Region', in *Az Eötvös Loránd Tudományegyeten Ókori Történeti Tanszékeinek Kiadványai*, **xvii**, Studia Ægyptiaca, **ii**, 101–13.

—(1977): 'Ein "Viergötterstein" mit ägyptischen Göttern aus Savaria (af CIL III 10908 = SIRIS 662)', in *Az Eötvös Loránd Tudományegyeten Ókori Történeti Tanszékeinek Kiadványai*, **xxi**, Studia Ægyptiaca, **iii**, 131–48.

TOUTAIN, J. (1911): *Les cultes païens dans l'Empire romain* (Paris: E. Leroux).

'TOUTANKHAMON-MANIE' (1979): *Connaissance des Arts*, **cccxxvi** (April), 47.

TOWER, FAYETTE BARTHOLEMEW (1843): *Illustrations of the Croton Aqueduct* (New York, NY, and London: Wiley and Putnam).

TOYNBEE, JOCELYN M.C. (1967): *The Hadrianic School: a Chapter in the History of Greek Art* (Rome: 'L'Erma' di Bretschneider).

—(1971): *Death and Burial in the Roman World* (London: Thames & Hudson).

TRAMONTIN, G. B. (1650): *see* VALLE, PIETRO DELLA.

TRAN TAM TINH, VINCENT (1964): *Essai sur le culte d'Isis à Pompéi* (Paris: E. de Boccard).

—(1971): *Le Culte des Divinités Orientales à Herculanum* (Leiden: E. J. Brill).

—(1972): *Le Culte des Divinités Orientales en Campanie en dehors de Pompéi, de Stabies et d'Herculanum* (Leiden: E. J. Brill).

—(1973): *Isis Lactans. Corpus des Monuments Greco-Romains d'Isis allaitant Harpocrate* (with YVETTE LABRECQUE) (Leiden: E. J. Brill).

—(1983): *Sérapis Debout. Corpus des monuments de Sérapis debout et étude iconographique* (Leiden: E. J. Brill).

TRANIÉ, JEAN, and CARMIGNIANI, JUAN CARLOS (1988): *Bonaparte: La Campagne d'Égypte* (Paris: Pygmalion/G. Watelet).

TRASK, WILLARD R. (*tr.*) (1978–85): *see* ELIADE, MIRCEA.

TREDE, THEODOR (1889–91): *Das Heidentum in der römischen Kirche. Bilder aus dem Religiösen und sittlichen Leben Süditaliens* (Gotha: F.A. Perthes).

TREGGIARI, SUSAN (1969): *Roman Freedmen during the Late Republic* (Oxford: The Clarendon Press).

TRENCSÉNYI-WALDAPFEL, IMRE (1966): *Untersuchungen zur Religionsgeschichte* (Budapest: Akadémiai Kiadó).

TRIGGER, BRUCE G. (1976): *Nubia under the Pharaohs* (London: Thames & Hudson Ltd).

TROMBLEY, F. R. (1995): *Hellenic Religion and Christianization* (Leiden: E. J. Brill).

TRUMAN, CHARLES (1979): 'Emperor, King, and Duke', in *The Connoisseur*, **ccii**/813 (November), 148–55.

—(1982): *The Sèvres Egyptian Service, 1810–1812* (London: HMSO).

TSCHUDIN, PETER FRIEDRICH (1962): *Isis in Rom* (Aarau: Keller).

TULARD, JEAN (1970): *Nouvelle Histoire de Paris: Le Consulat et l'Empire 1800–1815* (Paris: Hachette).

—(1971): *Le Mythe de Napoléon* (Paris: A. Colin).

TURCAN, ROBERT (1967): *Sénèque et les religions orientales. Latomus*, **xci** (Brussels: Latomus).

—(1985): *Héliogabale et le sacre du soleil* (Paris: A. Michel).

—(1987): *Vivre à la cour des Césars* (Paris: Belles Lettres).

—(1988): *Religion romaine* (Leiden: E. J. Brill).

—(1989): *Les cultes orientaux dans le monde romain* (Paris: Belles Lettres).

—(2000): *The Gods of Ancient Rome*, tr. ANTONIA NEVILL (Edinburgh: Edinburgh University Press).

TURNER, JANE SHOAF (*Ed.*) (1998): *The Dictionary of Art* (London: Macmillan Publishers Ltd).

TURNER, WILLIAM (1820): *Journal of a Tour in the Levant* (London: J. Murray).

TUTHILL, LOUISA CAROLINE (1848): *History of Architecture, from the Earliest Times* . . . (Philadelphia, PA: Lindsay & Blakiston).

UDY, DAVID (1971): 'Neo-Classicism of Charles Heathcote Tatham', in *The Connoisseur*, **clxxvii**/711–714 (May–August), 269–76.

ULRICHS, L. VON (1889): *Beiträge zur Geschichte der Glyptothek, Zweiundzwanzigstes Programm des von Wagner'schen Kunstinstituts der Universität Würzburg* (Würzburg: In Commission bei Stahel).

UPHILL, ERIC P. (1972): *see* DAWSON, WARREN ROYALE.

USENER, HERMANN KARL (1879): *Legenden der heiligen Pelagia* (Bonn: A. Marcus).

USICK, PATRICIA (2002): *Adventures in Egypt and Nubia: the Travels of William John Bankes (1786–1855)* (London: British Museum Publications).

VACQUIER, JULES FÉLIX (1908–37): *Les Vieux Hôtels de Paris* . . . (Paris: F. Contet).

—(1914–30): *Le Style Empire; décorations extérieures et intérieures* . . . (Paris: F. Contet).

VALADIER, GIUSEPPE (1843): *Aggiunte e correzioni all'opera sugli edifizi antichi di Roma dell'architetto A. Desgodetz* . . . (Rome: Tipi della Rev. Cam. Apostolica).

VALERIANO BOLZANI, GIOVANNI PIERIO (1556): *Hieroglyphica, sive De sacris Ægyptiorum* . . . (Basel: Palma Ising).

—(1592): *Aphorismi Hieroglyphici* . . . (Leipzig: V. Vögel).

VALLE, PIETRO DELLA (1650): *Viaggi* (Rome: V. Mascardi). *See also* the version published in Venice by G.B. TRAMONTIN, 1681.

VANDERBECK, G. (1948): *De Interpretatio Græca van de Isisfigur* (Leiden: E.J. Brill).

VANDIER, JACQUES (1949): *La Religion Égyptienne* (Paris: Presses Universitaires de France).

VANDIER D'ABBADIE, J. (1963): *Nestor L'Hôte (1804–1842): choix de documents conservés à la Bibliothèque Nationale et aux archives du Musée du Louvre* (Leiden: E.J. Brill).

VANLATHEM, MARIE-PAULE (1987): *Catalogue* of the Exhibition *Manie en Mythe, Égypte* (12 September to 4 October) (Tentoolstellings-huis Hellemans).

VARTANIAN, ARAM (1953): *Diderot and Descartes. A Study of Scientific Naturalism in the Enlightenment* (Princeton, NJ: Princeton University Press).

VATICAN MUSEUM (1979): *Guida ai Musei Vaticani* (Città del Vaticano: Museum).

VAUDOYER, A.-L.-T. (1791): *Idées d'un citoyen François sur le lieu destiné à la sépulture des hommes illustres de la France* (Paris: Didot, fils aîné).

—(1806 and 1818–34): *see* ACADÉMIE DES BEAUX-ARTS.

VAUTHIER, G. (1912): 'La Place des Victoires de 1792 à 1815', in *Bulletin de la Société de l'Histoire de l'Art français*, 186–206.

VAUX, RICHARD (1884): *The Pennsylvania Prison System* (Philadelphia, PA: Allen Lane, & Scott).

VAYSSE, FRANÇOISE (1991): 'Un nouveau "temple de la culture" près de l'Étoile', in *Le Monde* (15 November), 25.

VEITH, GEORG (1914): *Die Feldzüge des C. Iulius Cæsar Octavianus in Illyrien* (Vienna: A. Holder).

VENDITTI, ARNALDO (1961): *Architettura Neoclassica a Napoli* (Naples: Edizioni Scientifiche Italiane).

VENTURA, GASTONE (1975): *I Riti massonici di Misraïm e Memphis* (Rome: Anator). A French edition was published in Paris in 1986.

VENTURI, ADOLFO (1890): *The Vatican Gallery* (Rome: La Società Laziale).

—(1901 etc.): *Storia dell'arte Italiana* (Milan: U. Hoepli.)

VERARDI, LOUIS (1834): *see* BOITARD, PIERRE.

VERCOUTTER, JEAN (1945): *Les objets égyptiens et égyptisants du mobilier funéraire carthaginois* (Paris: P. Geuthner).

—(1986): 'Le Style Retour d'Égypte', in *À la recherche de l'Égypte oubliée* (Paris), 142–3.

—(1992): *The Search for Ancient Egypt*, tr. RUTH SHARMAN (London: Thames & Hudson Ltd).

VERDI, GIUSEPPE (1976): *Aïda. L'Avant-Scène Opéra*, **iv** (July–August).

VERHEYEN, E. (1972): 'Studien zur Baugeschichte des Palazzo del Te zu Mantua', in *Mitteilungen des Kunsthistorischen Instituts in Florenz*, **xvi**, 73–114.

—(1977): *The Palazzo del Tè in Mantua. Images of Love and Politics* (Baltimore, MD: The Johns Hopkins University Press).

VERLET, PIERRE, GRANDJEAN, SERGE, and BRUNET, M. (1953): *Sèvres* (Paris: G. Le Prat).

VERMASEREN, M. J. (1975): *see* KATER-SIBBES, G. J. F.

—(*Ed.*) (1981): *Die orientalischen Religionen in Römerreich* (Leiden: E. J. Brill).

VERMEULE, CORNELIUS CLARKSON (1960): 'The Dal Pozzo-Albani drawings of Classical Antiquities in the British Museum', in *Transactions of the American Philosophical Society*, **l**/5.

—(1961): *A Græco-Roman portrait of the Third Century A.D., and the Græco-Asiatic tradition in Imperial portraiture from Gallienus to Diocletian* (Cambridge, MA: Dumbarton Oaks Papers), 1–22.

—(1966): *The Dal Pozzo-Albani drawings of Classical Antiquities in the Royal Library at Windsor Castle* (Philadelphia: American Philosophical Society). *Transactions of the American Philosophical Society*, New Series, **lvi**/2.

—(1977): 'Commodus, Caracalla, und Hercules', in *Festschrift F. Brommer* (Mainz-am-Rhein: P. von Zabern), 289–94.

VERNINAC DE SAINT-MAUR, RAIMOND-JEAN-BAPTISTE DE (1835): *Voyage du Luxor en Égypte* (Paris: A. Bertrand).

VETTERS, H. (1977): 'Virunum' and 'Lauriacum', in *Aufstieg und Niedergang der römischen Welt. Geschichte und Kultur Roms im Spiegel der neueren Forschung*, **ii**/6 (Berlin and New York, NY: W. de Gruyter), 302–54 and 355–79.

VEYRIN-FORRER, JEANNE, and MERCIER, ALAIN (1989): 'Contribution à l'étude iconographique des assignats', in *Les Nouvelles de l'Estampe*, **cvi** (July–August), 31–4.

VIA, C. CERIA (1989): *see* SQUARZINA, S. DANESI (*Ed.*).

VIALE FERRERO, MERCEDES (1996): 'Aïda à Milan. L'image de l'Égypte aux archives Ricordi', in HUMBERT (*Ed.*) (1996), 533–50.

VIATOR (*pseudonym*) (1833): *Sur l'emplacement de l'obélisque de Louqsor* (Paris: Impr. de Decourchant).

VIDLER, ANTHONY (1976): 'The Architecture of the Lodges: Ritual Form and Associational Life in the Eighteenth Century', in *Oppositions*, **v**, 75–97.

—(1987): *The Writing of the Walls. Architectural Theory in the Late Enlightenment* (Princeton, NJ: Princeton Architectural Press).

—(1990): *Claude-Nicolas Ledoux: Architecture and Social Reform at the End of the Ancien Régime* (Cambridge, MA, and London: M.I.T. Press).

VIDMAN, LADISŁAW (1965): 'Die Isis- und Sarapisverehrung im 3. Jahrhundert unserer Zeit', in *Neue Beiträge zur Geschichte der alten Welt*, **ii**. *Römisches Reich* edited by ELISABETH CHARLOTTE WELSKOPF (Berlin: Akademie-Verlag), 389–400.

—(1966): 'Träger des Isis- und Sarapiskultes in der römischen Provinzen', in *Eirene*, **v**, 107–16.

—(1969): *Sylloge inscriptionum religionis Isiacæ et Sarapiacæ. Religionsgeschichtliche Versuche und Vorarbeiten*, **xxviii** (Berlin: De Gruyter).

—(1970): *Isis und Sarapis bei den Griechen und Römern. Epigraphische Studien zu den Trägern des ägyptischen Kultes. Religionsgeschichtliche Versuche und Vorarbeiten*, **xxix** (Berlin: De Gruyter).

—(1981): 'Isis und Sarapis', in VERMASEREN, M. J. (*Ed.*) 121–56.

VIEL DE SAINT-MAUX, CHARLES-FRANÇOIS (1797): *Principes de l'ordonnance et de la construction des bâtiments* (Paris: Perronneau).

—(1800): *Décadence de l'Architecture à la fin du 18ᵉ siècle* (Paris: The Author and Perronneau).

VIGHI, ROBERTO (1959): *Villa Hadriana* (Rome: Tip. Artistica).

VIGIÉ, ALBERT (1884): *Études sur les impôts indirects romains de douanes dans l'empire romain* (Paris: E. Thorin).

VIGNOLA, GIACOMO BAROZZIO DA (1763): *Regola delli cinque ordine d'architettura* (Rome and Naples: Rossi).

VIMONT, MAURICE (1936): *Histoire de la Rue Saint-Denis de ses origins à nos jours* (Paris: Les Presses Modernes).

VINCK, CARL DE, and VUAFLART, ALBERT (1928): *La Place de l'Institut, sa galerie marchande des Autres-Nations et ses étalages d'estampes, 1660–1880* (Paris: Maurice Rousseau).

VISCONTI, ENNIO QUIRINO (1782–1853): *Il Museo Pio-Clementino* (Rome: L. Mirri).

VITA, ANTONINO DI (1983–4): *see* BONACASA, NICOLA.

VITA DEL VENERABILE SERVO DI DIO FRA EGIDIO DA S. GIUSEPPE LAICO PROFESSO ALCONTARINO (1876): (Naples: s.n.).

VITTINGHOFF, FRIEDRICH (1977): 'Zur Municipalisierung des lateinischen Donau- und Balkanraums', in *Aufstieg und Niedergang der römischen Welt. Geschichte und Kultur Roms im Spiegel der neueren Forschung*, **ii**/6 (Berlin and New York, NY: W. de Gruyter), 3–51.

—(1978): '"Stadt" und Urbanisierung in der griechisch-römischen Antike', in *Historische Zeitschrift*, **ccxxvi**, 547–63.

—(1982): 'Zur Entwicklung der städtischen Selbstverwaltung – einige Britische Anmerkungen', in *Stadt und Herrschaft. Römische Kaiserzeit bis Hohes Mittelalter, Historische Zeitschrift*. Beiheft **vii** (Munich: R. Oldenbourg), 107–46.

VOGEL, HANS MARTIN ERASMUS (1928–29): 'Ägyptisierende Baukunst des Klassizismus', in *Zeitschrift für Bildende Kunst*, **xlii**, 160–5.

—(1937): *Deutsche Baukunst des Klassizismus* (Berlin: Mann).

VOÏART, L. (1822): *Monumens des victories et conquêtes des Français. Recueil de tous les objets d'arts . . . etc., consacrés à célébrer les victoires des Français de 1792 à 1815* (Paris: s.n., but later published by C.-L.-F. Panckoucke).

VOLAIT, MERCEDES (1996): 'Les architectures d'inspiration pharaonique en Égypte: formes et fondements', in HUMBERT (*Ed.*) (1996), 437–58.

—, and CROSNIER-LECONTE, MARIE-LAURE (1998): *Catalogue* of the exhibition *L'Égypte d'un architecture: Ambroise Baudry, 1838–1906* (Paris: Somogy Éditions d'art).

VOLKMANN, LUDWIG (1923): *Bilderschriften der Renaissance: Hieroglyphik und Emblematik in ihren Beziehungen und Fortwirkungen* (Leipzig: K.W. Hiersemann). A new edition was published in Nieuwkoop by De Graaf in 1969.

VOLNEY, CONSTANTIN-FRANÇOIS CHASEBŒUF, COMTE DE (1787): *Voyage en Égypte et en Syrie* (Paris: Desenne).

VOS, MARIETTE DE (1980): *L'Egittomania in pitture e mosaici romano-campani della prima età imperiale* (Leiden: E.J. Brill).

—(1982): *see* BRAGANTINI, IRENE.

VOSSNACK, LIESE LOTTE (1938): *Pierre Michel d'Ixnard, 1723–1795* (Remscheid: Vossnack).

VRIES, F.B. DE (1983): 'Egypte, bereisd, beroofd, bewaard, beschreven', in *Phoenix*, **xxix**.

VRIESEN, HELLMUTH (1959): *see* THEATERMUSEUM DER CLARA ZIEGLER STIFTUNG, MUNICH.

VUAFLART, ALBERT (1928): *see* VINCK, CARL DE.

VYSE, H. (1840–42): *see* HOWARD-VYSE, RICHARD WILLIAM HOWARD.

WADDINGTON, G. (1822): *Journal of a Visit to some parts of Ethiopia* (London: J. Murray).

WAINWRIGHT, GERALD AVERAY (1937): *The Sky Religion of Egypt* (Cambridge: Cambridge University Press).

528

WAITE, ARTHUR EDWARD (1970): *A New Encyclopædia of Freemasonry* (New Hyde Park, NY: University Books).

WALKER, DAVID (1968): see GOMME, ANDOR.

—, and McWILLIAM, COLIN (1971): 'Cairness, Aberdeenshire', in *Country Life*, **cxlix** (28 January and 4 February), 184–187 and 248–51.

WALPOLE, HORACE (1786): *Anecdotes of Painting in England . . .* (London: J. Dodsley).

WALSH, DAVID (1903): 'A Scheme for a Great National Monument', in *The Strand Magazine* (April), 404–9.

WALTER, THOMAS USTICK, and SMITH, J. JAY (1846): *Two hundred designs for cottages and villas . . .* (Philadelphia, PA: Carey & Hart).

WALTERS, HENRY BEAUCHAMP (1934): *The Art of the Greeks* (New York, NY: Macmillan).

WALTZING, JEAN-PIERRE (1895): *Étude historique sur les corporations professionnelles chez les Romains* (Louvain: C. Peeters).

WARD, ALLEN MASON (1977: *Marcus Crassus and the late Roman Republic* (Columbia, MO: University of Missouri Press).

WARD, WILLIAM HENRY (1926): *The Architecture of the Renaissance in France. A History of the Evolution of the Arts of Building, Decoration, and Garden Design under Classical Influence from 1495 to 1830* (London: B.T. Batsford Ltd).

WARDMAN, ALAN (1982): *Religion and Statecraft among the Romans* (London: Granada).

WARD-PERKINS, JOHN BRYAN (1970): see BOËTHIUS, AXEL.

—(1974): *Cities of Ancient Greece and Italy: Planning in Classical Antiquity* (New York, NY: G. Braziller).

—(1977): *Roman Architecture* (New York, NY: H.N. Abrams).

—, and CLARIDGE, A. (1978): *Pompeii AD 79* (Boston, MA: Museum of Fine Arts).

WARMENBOL, EUGÈNE (1991): see DELVAUX, LUC.

—(1992a): 'Avec des obélisques pour uniques montagnes', in BROZE and TALON (*Eds*) (1992).

—(1992b): 'Graven van maçons en maçonnieke graven op het Antwerpse Schoonselhof', in *Epitaaf*, **v**/17, 2–4.

—(1993): see DELVAUX, LUC.

—(1995a): 'La Religion et la civilisation égyptiennes dans l'œuvre de Goblet d'Alviella. Sources, interprétations et dérivations', in DIERKENS, ALAIN (*Ed.*) (1995b), 95–106.

—(1995b): 'Alexandrië aan de Schelde', in GUBEL *ET AL.* (1995), 27–48.

—(1996): 'Le sphinx réfléchi ou les sources de l'égyptomanie au XIXe siècle', in HUMBERT (*Ed.*) (1996), 61–96.

—(1997): 'Architectures égyptiennes et franc-maçonnerie', in *Les Nouvelles du Patrimoine*, **lxxii**, 22–3.

—(1998): 'De loge L'Aménité te Sint Niklaas (1817–1844) in historisch en kunsthistorisch perspectief', in *Trigonum Coronatum Jahrboek*, **vi**, 71–107.

—(2001): 'L'Égypte, trios points, c'est tout', in *Les Cahiers d'Urbanisme*, **xxxvii** (December), 60–8.

—, and DELVAUX, LUC (1988): 'Oud-Egyptische teksten uit de tijd van Farao Leopold I van Opper- en Neder-Belgie', in *M&L. Monumenten en Landschappen*, **vii**/2, 63–8.

—, and MACLOT, PETRA (1988): 'Tempel en stal in één: de Egyptische temple in de Antwerpse zoo in kunsthistorisch en historisch perspectief', in *M&L. Monumenten en Landschappen*, **vii**/2, 24–35.

—, and MACLOT, PETRA (1991): 'Tafelen met Isis en Osiris. De egyptiserende aetzaal van kasteel Moeland te Sint-Niklaas', in *M&L. Monumenten en Landschappen*, **x**/6, 45–59.

—, and WASSEIGE, MANOËLLE (1989): 'Egyptomanie in de 19de-eeuwse architectuur: België in de ban van Egypte', in *Bulletin van de Antwerpse Verening voor Bodem- en Grotenderzoek* (1990), **ii** (NEO. Recherches sur l'art et l'architecture du XIX siècle. Journée d'études du 12 mai 1989).

—, and WASSEIGE, MANOËLLE (1990): 'À la recherche de l'Égypte perdue: l'égyptomanie en Belgique au XIXe siècle', in *Art & Fact. Revue des Historiens de l'art, des archéologues, des musicologues et des orientalistes de l'Université de Liège*, **ix**, 105–12.

—(1998): 'L'Égypte éphémère, 1930 de notre ère. Le temple pharaonique de l'Exposition internationale de Liège', in *Maisons d'Hier et d'Aujourd'hui*, **xii** (December), 16–29.

WARNER, MARINA (1976): *Alone of All Her Sex: The Myth and the Cult of the Virgin Mary* (London: Weidenfeld & Nicolson).

WARNER, OLIVER (1960): *The Battle of the Nile* (London: B. T. Batsford Ltd).

WASSEIGE, MANOËLLE (1990): see WARMENBOL, EUGÈNE.

WATERSCHOOT, W. (1978): 'Hieroglyphica te Gent in 1584', in *Verslagen en Mededelingen van de Koninklijke Academie voor Nederlandse Taal-en Letterkunde* (Gent), 47–85.

WATKIN, DAVID (1968): *Thomas Hope 1769–1831 and the Neo-Classical Idea* (London: J. Murray).

—, and LEVER, JILL (1980): 'A Sketch-Book by Thomas Hope', in *Architectural History*, **xxiii**, 55–9 and plate 38b.

—, and MELLINGHOFF, TILMAN (1987): *German Architecture and the Classical Ideal 1740–1840* (London: Thames & Hudson Ltd).

WATTERS, D., and PATCH, D. (1986): 'Pittsburgh discovers Ancient Egypt', in *The Carnegie Magazine*, **lviii**/2 (March–April) (Carnegie Museum of National History).

WATZDORF, ERNA VON (1962): *Johann Melchior Dinglinger: der Goldschmied des deutschen Barock* (Berlin: Mann).

WEATHERLEY, W. SAMUEL (1887): see BRINDLEY, WILLIAM.

WEBER, MAX (1963): *The Sociology of Religion*, tr. EPHRAIM FISCHOFF (Boston, MA: Beacon Press).

WEBER, WILHELM (1910): 'Ein Hermes-Tempel des Kaisers Marcus', in *Sitzungsberichte der Heidelberger Akademie der Wissenschaften* Bd. 1, Abh 7 (Heidelberg: C. Winter).

—(1912): *Ægyptische-griechische Götter im Hellenismus* (Groningen: J.B. Wolters).

—(1914): *Die ägyptisch-griechischen Terrakotten* (Berlin: K. Curtius).

WEGNER, M. (1966): *Die Musensarkophage* (Berlin: Mann).

WEIGHTMAN, DOREEN (1959): see MONTET, PIERRE.

WEINGÄRTNER, DIETER GEORG (1969): *Die Ägyptenreise des Germanicus, Papyrologische Texte und Abhandlungen*, **ii** (Bonn: R. Habelt).

WEINREICH, OTTO (1909): *Antike Heilungswunder* (Giessen: Töpelmann).

WEINSTOCK, S. (1957): 'Victor and Invictus', in *Harvard Theological Review*, **l**, 211–47.

WEIPPERT, OTTO (1972): *Alexander-Imitatio und römische Politik in republikanischer Zeit* (Augsburg: University of Augsburg Dissertation).

WELLEN, G.A. (1961): *Theotokos: eine ikonographische Abhandlung über das Gottesmutterbild in frühchristlicher Zeit* (Utrecht: Spectrum).

WELLESLEY, LORD GERALD (1937): 'Regency Furniture', in *Burlington Magazine*, **lxx**/cdx (May), 233–40.

WELSKOPF, ELISABETH CHARLOTTE (*Ed.*) (1965): *see* VIDMAN, LADISŁAW.

WESSELY, CARL (1893): *Neue griechische Zauberpapyri* (Vienna: F. Tempsky).

WESSETSKY, V. (1961): *Die ägyptischen Kulte zur Römerzeit in Ungarn* (Leiden: E. J. Brill).

—(1964): 'Der Isis-Altar von Sopron. Ein Beitrag zur Charakteristik der ägyptischen Kulte in den römischen Provinzen zur Kaiserzeit', in *Das Altertum*, **x**, 154–9.

—(1967): 'Zur Wertung de ägyptischen Totenkultes in Pannonien', in *Acta antiqua Academiæ Scientiarum Hungaricæ*, **xv**, 451–7.

—(1969a): 'Neuere Belege zur Deutung des Isiskultes in Pannonien', in *Mitteilungen des deutschen archäologischen Instituts, Abteilung Kairo*, **xxv**, 198–201.

—(1969b): 'Die Bedeutung der ägyptischen Kultdenkmäler aus dem Komitat Veszprém', in *A Veszprém Megyei Muzeumok Közleményei*, **viii**, 147–51.

—(1981): 'Ein Beitrag zur Geschichte der ägyptischen Kulte in Brigetio', in *Hommages à M. J. Vermaseren* (Leiden: E. J. Brill).

For Wessetsky's important publications on Osiris, and other matters, *see* MALAISE, M. (1984).

WESTCOTT, WILLIAM WYNN (1976): *The Isiac Tablet: or The Bembine Table of Isis* (Los Angeles, CA: Philosophical Research Society).

WESTMACOTT, CHARLES MOLLOY (1824): *British Galleries of Painting and Sculpture* (London: Sherwood, 1824).

WHISTLER, LAURENCE (1954): *The Imagination of Vanbrugh and his Fellow Artists* (London: Art & Technics).

WHITAKER, HENRY (1847): *The Practical Cabinet Maker & Upholsterer's Treasury of Designs, House-Furnishing & Decorating Assistant . . .* (London: P. Jackson).

WHITEHOUSE, HELEN (1981): 'Egypt in Western Art', in *Atlas of Ancient Egypt* (Oxford: Oxford University Press), 222–3.

—(1983): 'Egypt on the Grand Tour', in *Art and Artists*, **cc** (May).

—(1996): 'L'Égypte sous la neige', in HUMBERT (*Ed.*) (1996), 163–86.

WHITTOCK, NATHANIEL (1827): *The Decorative Painters' and Glaziers' Guide* (London: Virtue).

—(1840): *On the Construction and Decoration of the Shop Fronts of London* (London: Sherwood, Gilbert, & Piper).

WIEBENSON, DORA (1976): 'Le Parc Monceau et ses "Fabriques"', in *Les Monuments Historiques de la France*, 16–19.

WIEGAND, WILFRIED (1985): *see* HUMBERT, JEAN-MARCEL (1985b).

WIGHTWICK, GEORGE: Collection of Drawings in the RIBA British Architectural Library Drawings Collection.

—(1840): *The Palace of Architecture: A Romance of Art and History* (London: J. Fraser). Contains several original and curious illustations.

WILD, HENRI (*tr.*) (1937): *see* ERMAN, ADOLF.

WILD, NICOLE (1989): *Dictionnaire des théâtres parisiens aux XIXᵉ siècle* (Paris: Aux Amateurs de Livres).

—(1994): 'L'Égypte à l'opéra', in HUMBERT, PANTAZZI, and ZIEGLER (*Eds*) (1994), 390–447.

—(1996): 'Eugène Lacoste et la première d'*Aïda* à l'Opéra de Paris', in HUMBERT (*Ed.*) (1996), 507–29.

WILD, R. A. (1981): *Water in the Celtic Worship of Isis and Serapis* (Leiden: E. J. Brill).

WILDUNG, DIETRICH (1977): *Imhotep and Amenhotep. Gottwerdung im alten Ägypten* (Munich: Deutscher Kunstverlag).

—(1979): 'Imhotep', in *Lexikon der Ägyptologie*, **iii**, c. 145–8. *See* HELCK, HANS WOLFGANG, and OTTO, EBERHARD (*Eds*) (1975–85).

WILKINSON, ALIX (1998): *The Garden in Ancient Egypt* (London: Rubicon Press).

WILKINSON, SIR JOHN GARDNER (1835): *Topography of Thebes, and General View of Egypt* (London: J. Murray).

—(1851): *The Fragments of the hieratic papyrus at Turin* (London: T. Richards).

—(1878): *The Manners and Customs of the Ancient Egyptians*, revised by SAMUEL BIRCH (London: J. Murray). First published 1837.

WILLARD, SOLOMON (1843): *Plans and Sections of the Obelisk on Bunker's Hill* (Boston, MA: S.N. Dickinson).

WILLE, JOHANN GEORG (1857): *Mémoires et Journal* (Paris: Ve J. Renouard).

WILLIAMS, STEPHEN (1985): *Diocletian and the Roman Recovery* (London: B. T. Batsford Ltd).

WILLIAMS-LEHMANN, P. (1977): *Cyriacus of Ancona's Egyptian Visit and its Reflections in Gentile Bellini and Hieronymus Bosch* (Locust Valley, NY: J. J. Augustin).

WILLS, JESSE E. (1952): 'An Echo from Egypt. A History of the Building Occupied by the First Presbyterian Church, Nashville, Tennessee', in *Tennessee Historical Quarterly*, **xi** (March), 63–77.

WILLSON, THOMAS (*c.*1831): *The Pyramid. A General Metropolitan Cemetery to be Erected in the Vicinity of Primrose Hill* (London: Willson, 11 New Cavendish Street).

WILMOWSKY, TILO, FREIHERR VON (1978): *Der Hügel* (Essen: Fried. Krupp GmbH).

WILSON, JOAN (1975): 'Little gifts keep friendship alive - An historic Sèvres dessert service', in *Apollo*, **cii**/161 (July), 50–60.

WILSON, JOHN ALBERT (1964): *Signs and Wonders upon Pharaoh: A History of American Egyptology* (Chicago, IL: University of Chicago Press).

WILSON, SIR ROBERT THOMAS (1802): *History of the British Expedition to Egypt* (London: C. Roworth & T. Egerton).

WILSON, ROBERT McLACHLAN (*Ed.*) (1962): *The Coptic Gospel of Philip* (London: A.R. Mowbray).

WILSON, SAMUEL (1959): *A Guide to the Architecture of New Orleans, 1699–1959* (New York, NY: Reinhold).

WILSON, WILLIAM RAE (1823): *Travels in Egypt and the Holy Land* (London: Longman, Hurst, Rees, Orme, & Brown).

WILTON-ELY, JOHN (*Ed.*) (1972): *see* PIRANESI, GIOVANNI BATTISTA.

—(1978*a*): *Piranesi* (London: Arts Council of Great Britain).

—(1978*b*): *The Mind and Art of Giovanni Battista Piranesi* (London: Thames & Hudson Ltd).

WIMMER, G. A. (*tr.*) (1830): *see* RIFAUD, JEAN-JACQUES.

WINCKELMANN, JOHANN JOACHIM (1756): *Gedanken über die Nachahmung der griechischer Werke in der Malerey und Bildhauerkunst* (Dresden: Walther).

—(1764–67): *Geschichte der Kunst des Alterthums* (Dresden: Walther).

—(1767): *Monumenti antichi inediti spiegate et illustrati* (Rome: the Author).

WIND, E. (1980): *Pagan Mysteries in the Renaissance* (Oxford: Oxford University Press).

WINKLER, GERHARD (1969): *Die Reichsbeamten von Noricum und ihr Personal bis zum Ende der römischen Herrschaft* (Vienna, Köln, Graz: Böhlau).

—(1971): 'Die Statthalter der römischen Provinz Raetien unter dem Prinzipat', in *Bayerische Vorgeschichtsblätter*, **xxxvi**, 50–101.

—(1977): 'Noricum und Rom', in *Aufstieg und Niedergang der römischen Welt. Geschichte und Kultur Roms im Spiegel der neueren Forschung*, **ii**/6 (Berlin and New York, NY: W. de Gruyter), 183–262.

WINKLER, SUSANNE (*Ed.*) (1992): *see* DÜRIEGL, GÜNTER.

WINNEFELD, HERMANN (1895): *Die Villa des Hadrian bei Tivoli* (Berlin: G. Reimer). See also *Jahrbuch des Kaiserlich deutschen archäologischen Instituts* (1895), 150–68.

WISCHNITZER, RACHEL (1951): *The Egyptian Revival in Synagogue Architecture*, reprinted from *Publications of the American Jewish Historical Society*, **xli**/1 (September) (New York, NY), 61–75.

—(1955): *Synagogue Architecture in the United States; History and Interpretation* (Philadelphia, PA: Jewish Publication Society of America).

WISEMAN, TIMOTHY PETER (1971): *New Men in the Roman Senate 139 BC–AD 14* (London: Oxford University Press).

WISSOWA, GEORG (1902): *Religion und Kultus der Römer* (Munich: C. H. Beck).

—(1958): 'Augustales', in *Realenzyklopädie der klassischen Altertumswissenschaft*, **iv**/2 (Stuttgart: J. B. Metzlersche Verlagsbuchhandlung), 2349–61.

WITT, REGINALD ELDRED (1966*a*): 'The Importance of Isis for the Fathers', in *Studia Patristica*, **viii**, *Texte und Untersuchungen zur Geschichte der altchristlichen Literatur*, **xciii** (Berlin: Akademie-Verlag), 135–45.

—(1966*b*): 'Isis-Hellas', in *Proceedings of the Cambridge Philological Society*, **cxcii**, 48–69.

—(1971): *Isis in the Græco-Roman World* (London: Thames & Hudson Ltd).

WITTE, E. (1985): 'Overzicht van het onderzoek naar de Belgische vrijmetselarij in de XIXe eeuw', in *Revue belge d'histoire contemporaine*, **xvi**/3–4, 523–42.

WITTKOWER, RUDOLF (1938–39): 'Piranesi's "Parere su l'architettura"', in *Journal of the Warburg Institute*, **ii**, 147–58.

—(1967): 'Piranesi e il gusto egiziano', in *Civilta europea e civilta veneziana, aspetti e problemi, V: Sensibilità e Razionalità nel Settecento, a cura di Vittore Branca* (Venice), 659–74.

—(1969): *see* SAXL, FRITZ .

—(1973): *Art and Architecture in Italy, 1600 to 1750* (Harmondsworth: Penguin Books Ltd).

—(1975): *Studies in the Italian Baroque* (London: Thames & Hudson).

—(1977): *Architectural Principles in the Age of Humanism* (London: Academy Editions).

—(1983): *Allegorie und der Wandel der Symbole in Antike und Renaissance* (Köln: Du Mont).

—(1989): 'Egypt and Europe', 'The Obelisk', 'Hieroglyphics', and 'Piranesi's Contribution to European Egyptomania', in REYNOLDS, DONALD MARTIN (*Ed.*), 36–59, 60–93, 94–126, and 127–44.

—, and JAFFÉ, IRMA B. (1972): *Baroque Art: the Jesuit Contribution* (New York, NY: Fordham University Press).

WOHL, H. (1992): 'New Light on the Artistic Patronage of Sixtus V', in *Art Christien*, **lxxx**, 123–34.

WOLDERING, IRMGARD (1963): *The Art of the Pharaohs tr.* ANN E. KEEP (London: Methuen).

—(1967): *The Arts of Egypt tr.* ANN E. KEEP (London: Thames & Hudson Ltd).

WOLFERS, NANCY, and MAZZONI, PAOLO (1980): *La Firenza di Giuseppe Martelli (1792–1876): l'architettura della città fra ragione e storia: mostra documentaria* (Florence: Museo di Firenze coméra).

WOLLIN, NILS GUSTAF AXELSSON (1935): *Desprez en Italie: dessins topographiques et d'architecture . . . etc.* (Malmö: J. Kroon).

—(1939): *Desprez en Suède; sa vie et ses travaux . . .* (Stockholm: Bokförlags-a.-b. Thule).

—(1933): *Gravures originales de Desprez* (Malmö: J. Kroon).

WOLZOGEN UND NEUHAUS, ALFRED FREIHERR VON (1864): *Schinkel als Architekt, Maler und Kunstphilosoph* (Berlin: Ernst & Korn).

WOOD, ALEXANDER, and OLDHAM, FRANK (1954): *Thomas Young, natural philosopher* (Cambridge: Cambridge University Press).

WOOD, G. BERNARD (1960): 'Egyptian Temple Architecture in Leeds', in *Country Life*, **cxxviii**/3326 (1 December), 1363–1365.

WORTHAM, JOHN DAVID (1972): *British Egyptology 1549–1906* (Newton Abbot: David & Charles).

WRIGLEY, EDWARD ANTHONY (*Ed.*) (1978): *see* HOPKINS, KEITH.

WÜLKER, L. (1903): *Die geschichtliche Entwicklung des Prodigienwesen bei den Römern* (Leipzig: E. Glausch).

WYTZES, J. (1977): *Der letzte Kampf des Heidentums in Rom* (Leiden: E. J. Brill).

YALE CLASSICAL STUDIES (from 1928): (New Haven, CT: Department of Classical Studies, Yale University).

YATES, FRANCES AMELIA (1947): *The French Academies of the Sixteenth Century* (London: The Warburg Institute, University of London).

—(1964): *Giordano Bruno and the Hermetic Tradition* (London: Routledge & Kegan Paul).

—(1966): *The Art of Memory* (London: Routledge & Kegan Paul).

—(1972): *The Rosicrucian Enlightenment* (London: Routledge & Kegan Paul).

YON, MARGUERITE (1981): *see* CAUBET, ANNIE.

YOUNG, THOMAS (1823): *An Account of some recent discoveries in hieroglyphical literature and Egyptian antiquities* (London: J. Murray).

YOYOTTE, J., and CHUVIN, P. (1988): 'Le Zeus Casios de Péluse à Tivoli: Une hypothèse', in *Bulletin de l'Institut Français d'Archéologie Orientale*, **lxxxviii**, 165–80.

YUEN, T. (1979): 'Giulio Romano, Giovanni da Udine, and Raphael: Some Influences from the Minor Arts of Antiquities', in *Journal of the Warburg and Courtauld Institutes*, **xlii**, 263–72.

ŽABKAR, LOUIS VICO (1968): *A Study of the Ba Concept in Ancient Egyptian Texts*, in *Studies in Ancient Oriental Civilization*, **xxxiv** (Chicago, IL: University of Chicago Press).

ZANKER, PAUL (1988): *The Power of Images in the Age of Augustus*, tr. ALAN SHAPIRO (Ann Arbor, MI: University of Michigan Press).

ZEITSCHRIFT FÜR ÄGYPTISCHE SPRACHE UND ALTERTUMSKUNDE (from 1863): (Leipzig: J.C. Hinrichs).

ZEITSCHRIFT FÜR BILDENDE KUNST (1866–1932): (Leipzig: E.A. Seemann, *but see especially* 1928–1929.

ZEITSCHRIFT FÜR KUNSTGESCHICHTE (from 1932): (Berlin: De Gruyter).

ZICK-NISSEN, JOANNA (1984): *see* BRUNNER-TRAUT, EMMA and HELLMUT.

ZIEGLER, CHRISTIANE (1984): 'Sistrum', in *Lexikon der Ägyptologie*, **v**, c.959–63.

—(*Ed.*) (1994): *see* HUMBERT, JEAN-MARCEL *ET AL.* (*Eds*) (1994).

—(1996): 'L'Égypte et le décor des musées européens au XIXᵉ siècle', in HUMBERT (*Ed.*) (1996), 139–58.

ZIEHEN, J. (1898): 'Ein Ciceronianum zur Geschichte des Isiskultes in Rom', in *Hermes*, **xxxiii**, 341–2.

ZILLER, HERMANN (1897): *Schinkel* (Bielefeld and Leipzig: Velhagen & Klasing).

ZIVIE-COCHE, CHRISTIANE (1991): *Giza au premier millénaire. Autour du temple d'Isis, dame des pyramides* (Boston, MA: Museum of Fine Arts).

ZOEGA, GEORG (1797): *De origine et usu obeliscorum ad Pium Sextum, pontificem maximum* (Rome: Typis Lazzarinii).

ZOO ANVERS (1988): No. 4 (April), 1–53, was devoted to the Egyptian temple at Antwerp Zoo, with contributions from G.J. BRAL, L. DELVAUX, G. DEMOOR, L. FORNOVILLE, B. DE GRYSE, P. MACLOT, B. VAN PUIJENBROECK, and E. WARMENBOL.

ZOO (1957): *Uitgave van de Koninklijke Maatschappij voor Dierkunde van Antwerpen*, No. 3 (January). Contains an article by W. VAN DEN BERGH on 'De Egyptische Tempel een Eeuw Oud', 80–3.

ZOTOVIČ, L. (1966): *Les cultes orientaux sur le territoire de la Mésie Supérieure* (Leiden: E. J. Brill).

ZUCKER, PAUL (1925): *Die Theaterdekoration des Klassizismus; eine Kunstgeschichte des Bühnenbildes* (Berlin: R. Kæmmerer).

ZUKOWSKY, JOHN (1976): 'Monumental American Obelisks: Centennial Vistas', in *Art Bulletin*, **lviii**/4, 574–81.

INDEX

Osiris . . .
hic docuit teneram palis adiungere vitem,
hic viridem dura cædere falce comam.
illi iucundos primum matura sapores
expressa incultis uva dedit pedibus.

(Osiris . . .
instructed on the tying to poles of the tender vines,
taught lopping of green strands with pruning-hooks.
To him ripe grapes crushed by peasant feet
first produced entrancing flavours).

ALBIUS TIBULLUS (*c*.54 - *c*.18 BC):
Elegies, Book 1, Elegy VII, lines 33-36.

Les livres ne se font pas comme les enfants, mais comme les pyramides . . .
et ça reste dans le désert! . . .
Les chacals pissent au bas et les bourgeois montent dessus.

(Books are made not like children but like pyramids . . .
and remain in the desert!
Jackals piss at their base, and the bourgeois climb up on them).

GUSTAVE FLAUBERT (1821-80): NADEAU, M. (*Ed.*):
Correspondence 1857-64 (1965) – letter to Ernest Feydeau, November/December 1857.

In the following Index (compiled by Frances Mather), a single asterisk indicates a black-and-white illustration or caption; a double asterisk indicates a colour-plate or caption; 'n' indicates a footnote entry; *SIG* means "*See* in Glossary".